THE *ILIAD* IN A NUTSHELL

Published with the assistance of the Alexander von Humboldt-Stiftung

Unterstützt von / Supported by

Alexander von Humboldt
Stiftung / Foundation

The *Iliad* in a Nutshell

Visualizing Epic on the *Tabulae Iliacae*

MICHAEL SQUIRE

OXFORD

UNIVERSITY PRESS

OXFORD

UNIVERSITY PRESS

Great Clarendon Street, Oxford OX2 6DP

Oxford University Press is a department of the University of Oxford.
It furthers the University's objective of excellence in research, scholarship,
and education by publishing worldwide in

Oxford New York

Auckland Cape Town Dar es Salaam Hong Kong Karachi
Kuala Lumpur Madrid Melbourne Mexico City Nairobi
New Delhi Shanghai Taipei Toronto

With offices in

Argentina Austria Brazil Chile Czech Republic France Greece
Guatemala Hungary Italy Japan Poland Portugal Singapore
South Korea Switzerland Thailand Turkey Ukraine Vietnam

Oxford is a registered trade mark of Oxford University Press
in the UK and in certain other countries

Published in the United States
by Oxford University Press Inc., New York

British Library Cataloguing in Publication Data

Data available

Library of Congress Cataloging in Publication Data

Data available

Typeset by SPI Publisher Services, Pondicherry, India
Printed in Great Britain
on acid-free paper by
CPI Antony Rowe, Chippenham, Wiltshire

ISBN 978-0-19-960244-5

1 3 5 7 9 10 8 6 4 2

To K.M.R.
with love

Nescit, crede mihi, quid sint epigrammata, Flacce,
 qui tantum lusus illa iocosque uocat.

Believe me, Flaccus: anybody who calls them just
frivolities and jests, doesn't know what epigrams are.

<div align="right">Martial 4.49.1–2</div>

It's a small world after all,
It's a small world after all,
It's a small world after all,
It's a small, small world.

It's a world of laughter, a world of tears;
It's a world of hopes, and a world of fear.
There's so much that we share
That it's time we're aware:
It's a small world after all.

There is just one moon, one golden sun,
And a smile means friendship to everyone.
Though the mountains divide,
And the oceans are wide,
It's a small, small world.

It's a small world after all,
It's a small world after all,
It's a small world after all,
It's a small, small world.

<div align="right">Robert B. Sherman and Richard B. Sherman (1964)</div>

ACKNOWLEDGEMENTS

Although composed in a short space of time, this book has been long in gestation. The topic was first conceived during an undergraduate supervision with Sorcha Carey and developed in relation to an MPhil thesis in 2002; in an endless recession of scales, it was subsequently enlarged into a miniature aside in an earlier book (Squire 2009: 134–9), a chapter in an edited volume (Squire 2010e), and a self-standing article (Squire 2010c). It quickly became apparent that none of these was sufficient: a whole book was required—the first monograph on the Iliac tablets in English. It would have to lay out both the little fragments and the larger picture; explain why these microscopic objects are so macroscopic in significance; and diagnose how this material could have been so spectacularly undervalued. It is wholly typical of the tablets that what started out as a footnote has grown into a book that could itself be expanded ad infinitum: the big in the small, and the small in the big.

Written during the course of one hot summer in Berlin—nourished by the vibrancy of this grand cosmopolis (miniaturized in my own Bergmannkiez in Kreuzberg)—the book was made possible thanks to the generous *Unterstützung* of the Alexander von Humboldt-Stiftung. I am grateful to my academic host, Luca Giuliani, and to everyone else at the Winckelmann–Institut für Klassische Archäologie at the Humboldt-Universität zu Berlin, especially Susanne Muth, Nikolaus Dietrich, and Karin Schmidt. The support in Berlin has not been solely academic: sincere thanks to Berliner friends both old and new, especially Andreas Bücker, Monika Diecks, Lena Gestin, Michael Goodhart, Susan Hoppe, Liz Irwin, Zsuzsanna Jávor-Bürge, James Navarro, Uli Räther, Gerson Schade, Anne Vallée, and Toon Van Hal. Encouragement has come from other quarters besides: in addition to Rolf Schneider in Munich, I am grateful to Peter Agocs, Dirk Booms, Georg Gerleigner, Simon Goldhill, Martin Henig, François Lissarrague, Katharina Lorenz, Robin Osborne, Andrej Petrovic, Ivana Petrovic, Verity Platt, Jim Porter, and Martin West; along with the press's two anonymous reviewers, Marco Fantuzzi, John Henderson, and Jeremy Tanner read the penultimate draft with characteristic care and generosity, each improving it in distinctive ways.

Quite apart from their financial contribution to the book's production, the Alexander von Humboldt-Stiftung met the substantial costs of visiting the tablets and acquiring photographs. This would have been impossible without the collaboration of numerous curators and assistants: it is a pleasure to acknowledge the particular aid of Mathilde Avisseau-Broustet (Cabinet des Médailles), Sylvia Brehme (Antikensammlung der Staatlichen Museen zu Berlin), Angela

Carbonaro and Daniela Velestino (Musei Capitolini), Witold Dobrowolski and Aleksandra Oleksiak (Muzeum Narodowe w Warszawie), Daniel Gräpler (Archäologisches Institut und Sammlung der Gipsabgüsse, Georg-August-Universität, Göttingen), Kenneth Lapatin (J. Paul Getty Museum), Claudia Legi (Musei Vaticani), Joan Mertens (Metropolitan Museum of Art), Giuseppe Proietti (Museo Archeologico Nazionale di Napoli), and Alex Truscott (British Museum). For their help in supplying pictures, my additional thanks to Rita Amedick, Francesco de Angelis, John Clarke, Stefan Eckhardt, Karin Kob, Daria Lanzuolo, Katharina Lorenz, Maria Pia Malvezzi at the British School at Rome, Dimitris Plantzos, Verity Platt, Philip Schmitz, Rolf Schneider, Helga Schutze, John Williamson, and the Fotoarchiv des Museums für Abgüsse Klassischer Bildwerke at the Ludwig-Maximilians-Universität in Munich. I am also grateful to Hilary O'Shea and her wonderful team at Oxford University Press who nurtured this nutty project from beginning to end: in particular, Taryn Campbell (assistant commissioning editor), Tessa Eaton (production editor), and the eagle-eyed Ian McAuslan (copy-editor). Mike O'Malley of Chartwell Illustrators deserves particular acknowledgement for his patient assistance with diagrams, drawings, and reconstructions.

Whether or not this will be the first English monograph on the Iliac tablets remains to be seen. On the other side of the Atlantic, David Petrain is completing a book of his own. In a scholarly climate that has dismissed the material for so long, it has been a great pleasure to discuss ideas with someone studying them with such care and diligence; I am also grateful to David for showing me the second and fifth chapters of his doctoral thesis, as acknowledged in the footnotes. The fragments might be tiny, but there is ample enough room for both studies, and our respective projects are intended in a spirit of collaboration not competition.

Countless others deserve to be acknowledged, above all my friends and family. Without them, this book would never have been written. Nor, indeed, would it have been rewritten, after the theft of my laptop while working with the Parisian tablets (so much lost in so little a machine!). To edit a book and assemble photographs once is hard work; to do so a second time is soul-destroying—and a lifelong lesson in data backup. That there is any soul left is thanks to two people in particular: first, Jaś Elsner, an endless source of inspiration, both academic and otherwise; and above all, Christopher Whitton, who has shared all the adventures of this book (and many more besides).

The final product is dedicated to the memory of someone whose sense of fun knew no bounds, and whom I miss, terribly. She would have loved hearing about these tablets. And I would have loved telling her about them.

CONTENTS

LIST OF FIGURES

Every effort has been made to contact the relevant museums and individuals in possession of the copyright of the images reproduced in this book. In the event of any error, copyright holders are requested to inform the publishers so that due accreditation can be sought for any future edition of the work.

LIST OF TABLES

LIST OF COLOUR PLATES

LIST OF ABBREVIATIONS

Most abbreviations of ancient authors and texts follow those listed in the third edition of *The Oxford Classical Dictionary*. The most familiar journal periodicals have been abbreviated as they are in *L'Année philologique*: otherwise, full journal titles have been supplied. The titles and room numbers of Pompeian houses are consistent, where possible, with those in *Pompei: pitture e mosaici* (= *PPM* below).

AE	*Année épigraphique. Revue des publications épigraphiques relatives à l'antiquité romaine*. 1888–. Paris.
ANRW	H. Temporini (ed.), *Aufstieg und Niedergang der römischen Welt*. 1972–. Berlin and New York.
AntP	Antike Plastik. 1962–. Berlin.
*ARV*²	J. D. Beazley, *Attic Red-Figure Vase-Painters*. Second edition. 1963. Oxford.
BE	*Bulletin épigraphique*. 1938–. Paris.
BNP	H. Cancik and J. Schneider (eds.), *Brill's New Pauly: Encyclopaedia of the Ancient World*. 2002–. Leiden and Boston.
CEG	P. A. Hansen (ed.), *Carmina Epigraphica Graeca*. 1989. Berlin.
CIL	*Corpus Inscriptionum Latinarum*. 1862–. Berlin.
CLE	F. Bücheler and E. Lommatzsch (eds.), *Carmina Latina Epigraphica*. 1895–1926. Leipzig.
EAA	*Enciclopedia dell'arte antica classica e orientale*. 1958–66. Rome.
EV	*Enciclopedia virgiliana*. 1984–91. Rome.
FGHist	F. Jacoby (ed.), *Die Fragmente der griechischen Historiker*. 1923–58. Berlin and Leiden.
GL	H. Keil (ed.), 1857–70. *Grammatici Latini*. Leipzig.
HWRh	G. Ueding (ed.), *Historisches Wörterbuch der Rhetorik*. 1992–2011. Tübingen.
IG	*Inscriptiones Graecae*. 1873–. Berlin.
IGUR	L. Moretti (ed.), *Inscriptiones Graecae Urbis Romae*. 1968–90. Rome.
KLA	R. Vollkommer (ed.), *Künstlerlexikon der Antike*. 2002–4. Munich and Leipzig.
LGPN	P. M. Fraser and E. Matthews (eds.), *A Lexicon of Greek Personal Names*. 1987–. Oxford.
LIMC	*Lexicon Iconographicum Mythologiae Classicae*. 1981–97. Zurich and Munich.
LSJ	H. G. Liddell, R. Scott, and H. S. Jones (eds.), *A Greek–English Lexicon*. Ninth edition. 1940. Oxford.

OED J. A. H. Murray et al. (eds.), *Oxford English Dictionary*. Compact edition. 1973. Oxford.

OLD *Oxford Latin Dictionary*. 1996. Second edition. Oxford.

PMG D. L. Page (ed.), *Poetae Melici Graeci*. 1962. Oxford.

PPM G. Pugliese Caratelli (ed.), *Pompei: pitture e mosaici*. 1990–2003. Rome.

RE A. Pauly, G. Wissowa, and W. Kroll (eds.), *Real-Encyclopädie der classischen Altertumswissenschaft*. 1893–1980. Stuttgart.

SEG *Supplementum Epigraphicum Graecum*. 1923–. Amsterdam.

Oculorum acies uel maxime fidem excedentia inuenit exempla. in nuce inclusam Iliadem Homeri carmen in membrana scriptum tradit Cicero. idem fuisse qui peruideret CXXXV milia passuum. huic et nomen M. Varro reddit, Strabonem uocatum; solitum autem Punico bello a Lilybaeo Siciliae promunturio, exeunte classe e Carthaginis portu, etiam numerum nauium dicere. Callicrates ex ebore formicas et alia tam parua fecit animalia, ut partes eorum a ceteris cerni non possent. Myrmecides quidem in eodem genere inclaruit quadriga ex eadem materia, quam musca integeret alis, fabricata et naue, quam apicula pinnis absconderet.

Perhaps the most incredible cases are those involving keenness of sight. Cicero records that Homer's *Iliad* poem was written onto parchment which was encased within a nutshell. He also records the case of a man who could see for 135 miles. Marcus Varro also gives this man's name, Strabo: he reports that, during the Punic War, Strabo would look from the promontory of Lilybaeum in Sicily and actually count the number of ships as the fleet sailed out from the Carthaginian harbour. Callicrates made ants and other creatures out of ivory which were so small that nobody else could make out their components. As for Myrmecides, he became famous through the same genre: by making a four-horse chariot (also from ivory) which a fly could cover with its wings, and a ship which a little bee could conceal with its wings.

Pliny the Elder, *Natural History* 7.85

ONE

Opening Sesame: The Book in a Nutshell

In the seventh book of his *Natural History* (*HN* 7.85), Pliny the Elder records a series of curious anecdotes about 'keenness of sight' (*oculorum acies*). At one extreme, a certain Strabo is credited with being able to see the 135 Roman miles from Sicily to Carthage. At the other is a truly miniature feat: a story about Homer's *Iliad*—the heftiest and most canonical work of all Greek literature—shrunk onto a piece of parchment small enough to fit within the shell of a nut. The story encapsulates the ultimate in miniaturization: here, to have and to hold, was the *Iliad* in a nutshell.[1]

Pliny does not attribute the feat, and Strabo ('Mr Squinty')[2] likewise goes unmentioned in the annals of Greek and Roman history. Although we know of ancient minuscule manuscripts, all are somewhat later in date, and in any case rather different in appearance and context (e.g. Figs. 135–6).[3] But stories about the '*Iliad* in a nutshell' continued. Writing some 50 years later, Plutarch relates a similar tale about 'Callicrates, Myrmecides, and their followers', credited (among other miniature accomplishments) with inscribing Homer's epic on a sesame seed (*Mor.* (*Comm. not.*) 1083d–e):

οἱ δὲ περὶ Καλλικράτη καὶ Μυρμηκίδην λέγονται δημιουργεῖν ἅρματα μυίας πτεροῖς καλυπτόμενα καὶ διατορεύειν ἐν σησάμῳ γράμμασιν ἔπη τῶν Ὁμήρου.

Callicrates, Myrmecides, and their followers are said to fashion chariots that were concealed beneath the wings of a fly, and to engrave on a sesame seed the epics of Homer in letters/lines [*grammasin*].

[1] For some preliminary comments, see Schilling (ed.) 1977: 165–6, who compares Val. Max. 1.8.14 and Varro, *Ling.* 7.1. For a discussion of sources, see Münzer 1897: 172–4, concluding derivation from 'griechischen Wunderbüchern' (173); cf. Beagon (ed.) 2005: 268–9.

[2] Pliny clearly meant us to see the irony of the name: just a few chapters earlier (*HN* 7.54), he explicitly discussed the etymology in the context of a different 'Strabo', named after 'the appearance of his eyes' (*a specie oculorum*).

[3] The Mani-codex derives from the late fifth century AD (cf. below, p. 280 n. 97). But earlier 'manuscripts' evidently played with scale, and within related cultic contexts: the best example are the numerous gold 'Orphic tablets', dating from between the late fifth century BC to third century AD, inscribed with Greek writing 'minuscule in size' (Bernabé and Jiménez San Cristóbal 2008: 2): cf. Graf and Iles Johnston 2007; Edmonds (ed.) 2010.

In a series of diminishing recessions, Pliny's tall tale act of miniaturization is itself outsized. The *Iliad* in a nutshell is reduced to the Homeric poems on a sesame seed—we progress from parchment enclosure to inscribed object, from nut to tiny kernel, and from one poem to 'the epics of Homer' at large.[4]

Aelian's second-century *Historical Miscellany* records a similar story, albeit slightly differently. Aelian specifies that it was not the whole Homeric text, but rather a single elegiac couplet that Callicrates and Myrmecides composed, again inscribing it in gold *grammata* (*VH* 1.17):

> ταῦτα ἄρα ἐστὶ τὰ θαυμαζόμενα Μυρμηκίδου τοῦ Μιλησίου καὶ Καλλικράτους τοῦ Λακεδαιμονίου τὰ μικρὰ ἔργα. τέθριππα μὲν ἐποίησαν ὑπὸ μυίας καλυπτόμενα, καὶ ἐν σησάμῳ δίστιχον ἐλεγεῖον χρυσοῖς γράμμασιν ἐπέγραψαν.

> The following are the admired products of Myrmecides the Milesian and Callicrates the Lacaedemonian, their miniature pieces: they made four-horse chariots that were concealed beneath a fly, and they inscribed an elegiac couplet in gold letters/lines [*grammasin*] on a sesame pod.

Whichever version we (do not) believe, the underlying conceit remains the same: the feat lies in *rescaling* epic—exchanging the manuscript for a more minute medium, or else converting ponderous hexameters into a light-footed epigrammatic distich.

This is not a book about Callicrates or Myrmecides. Nor does it deal with the miniaturist creations attributed to them—long since lost, even if they ever existed.[5] My subject, rather, is at once grander and more specific: to explore this gargantuan discourse through a single miniature case study—the so-called 'Iliac tablets', or *Tabulae Iliacae*. These 22 Greek-cum-Roman miniature marble reliefs, most of them from the late first century BC or early first century AD, bring together visual and verbal synopses of (among other subjects) Homeric epic, precisely after the manner of Callicrates, Myrmecides, and others. Scattered across some dozen museums in Europe and America, often hidden in storerooms, sometimes missing or lost without trace, the objects are little known among philologists and art historians today. But there are epic tales to be told about the tablets' games with medium, narrative, and scale—the immeasurably

[4] The meaning of *epê* is left inherently vague (referring to 'epic poems', or just to 'stories' or 'words' after Homer?); so too is the nature of these *grammata*, as both written 'letters' and drawn 'lines' (see below, pp. 123, 237–40). For other stories about Myrmecides and Callicrates, see below, pp. 260–1.

[5] The incredibility of such stories in antiquity (*maxime fidem excedentia*: Plin. *HN* 7.85) is precisely what attracted subsequent interest. Most famous is the discussion in Isaac Disraeli's early nineteenth-century *Curiosities of Literature*. Comparing Aelian and Peter Bales's Elizabethan Bible 'in an English walnut no bigger than a hen's egg', Disraeli relays the (equally curious) story of Pierre Daniel Huet, who attempted to prove the authenticity of Pliny's anecdote in the eighteenth century (Disraeli 1881: 1.276). For more recent examples of books contained in nutshells, see Bromer and Edison 2007: 178–83.

fecund ways in which these *bijou* reliefs toy with the semiotics of word and image. For all their diminutive proportions, the Iliac tablets' miniature visualizations of epic render readable the fictions of representation at large: *their* stories, in *our* hands.[6]

NUTCASES?

Aelian had little patience for such frivolous *micrologia*.[7] 'As I see it,' Aelian concludes of Callicrates' and Myrmecides' 'works in miniature' (μικρὰ ἔργα), 'neither of these feats will earn the approval of a *serious* person: for what are these things other than a waste of time?' (ὧν, ἐμοὶ δοκεῖν, ὁ σπουδαῖος οὐδέτερον ἐπαινέσεται· τί γὰρ ἄλλο ἐστὶ ταῦτα ἢ χρόνου παρανάλωμα;). Before getting to the tablets, then, it seems worth first addressing a more fundamental question: why bother?

Critical theory has hugely downplayed the hermeneutics of scale. If—as everyone knows—size matters, it has generally mattered less within the academy. The most important exception is Susan Stewart, to whose celebrated essay *On Longing* the intellectual thrust of this book is partly indebted.[8] Stewart explores size as one of many metaphors for figuring mediation: by offering alternative versions of the world, the miniature and the gigantic, no less than the souvenir and the collection, rescale—and thereby interrogate—our systems of subjective human experience. Scale matters, in short, because it sizes up the conventions through which we live out our lives. Miniaturization magnifies the mechanics of making meaning: 'the remarkableness of minute writing depends upon the contrast between the physical and abstract features of the mark', as Stewart puts it. 'Nearly invisible, the mark continues to signify; it is a signification which is increased rather than diminished by its minuteness.'[9] One need only think of the nostalgic (and slightly creepy) utopias of a model miniature village like Bekonscot in

[6] On the (modern) generic name, see below, p. 28 n. 6, and p. 32 n. 29; for a supposed twenty-third tablet, published while this book was in production (Gasparri 2009), see Appendix II (pp. 413–16). I am not the first to compare the tablets to these stories about Callicrates and Myrmecides, championing their 'playfulness'. The earliest (and long since forgotten) comparison comes in Stephani 1854: 244: 'Diese Richtung der Kunst ist es, welche auch die sogenannten Ilischen Täfelchen hervorgerufen hat, Spielereien . . . [die] eine Masse mythologischen, litterar-historischen und chronologischen Wissens auf den kleinsten Raum zusammendrängen.' That was over 150 years ago: later nineteenth-, twentieth-, and twenty-first-century scholars have all too often forgotten the art of the *Spiel*.

[7] For the term, see below, pp. 270–1.

[8] S. Stewart 1993 (originally published in 1984): Stewart discusses the miniature at 37–69.

[9] Ibid. 38. For a guide to the modern genre of 'miniature books'—defined as less than 7.6 cm in height—see Bondy 1981, and the well-illustrated introduction of Bromer and Edison 2007: neither mention the anecdotes about the *Iliad* in a nutshell, or indeed, Callicrates and Myrmecides.

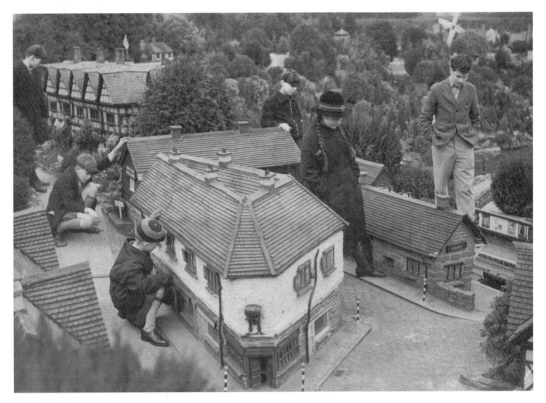

FIGURE 1. Bekonscot Model Village, as seen in the 1940s.

Beaconsfield (Fig. 1), or else of Willard Wigan's mesmerizing microsculptures—
his celebratory 2008 portrait of the Obama family, comfortably squeezed within
the eye of a needle (Fig. 2).[10] This is what Claude Lévy-Strauss labelled the
'modèle reduit'—'not just protections or passive homologues of the object', but
'a real experiment with it'.[11]

[10] On Wigan's method of making such microsculptures—working each detail between individual
heartbeats—see Wigan 2009: 48–59.

[11] Lévy-Strauss 1966: 23–4, translating idem 1962: 38; for discussion, see Scobie 1979: 111–13 and
Wiseman 2007: 35–7, 126–7. But I would disagree with Lévy-Strauss's subsequent conclusion that 'by
being quantitatively diminished, it [*sc.* the aesthetic object] seems to us qualitatively simplified'. The
reduction of one aspect of an object—whether literally (in terms of scale), or metaphorically (the reduction
of a moving subject to a motionless statue, for example, or the 'simplification' of three dimensions to
two)—might help us to understand the totality as an intellectual whole ('this quantitative transposition
extends and diversifies our power over a homologue of the thing, and by means of it the latter can be
grasped, assessed and apprehended at a glance'). But in the case of the miniature, the gesture does so by
drawing attention to the simulation involved: it *shows up* the illusion, making a problem of 'standard'
hermeneutic reactions.

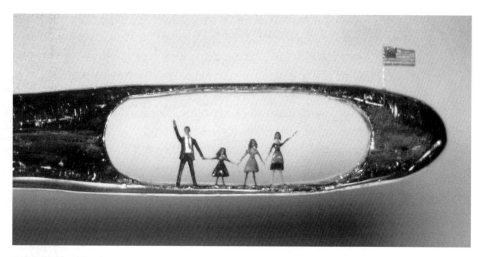

FIGURE 2. Willard Wigan, *Presidential Victory* (2008): Barack Obama and family in the eye of a needle. Carved by hand; mixed media (nylon, acrylic, paper); the length of the needle-eye measures *c*.1.5 mm.

Of course, Wigan's contemporary 'micro-art' pertains to sculpted *visual* objects, whereas Pliny's *Iliad* in a nutshell was a miniaturized *verbal* text. But the very nature of miniaturization contests such straightforward categorizations. If the miniature changes the nature of subjective experience, it does so by exposing the fictitious delineation between 'texts' and 'objects' in the first place. Encased in its nutshell, inscribed on a sesame seed, or written in gold letters, micrographic manuscripts take on a material significance that transcends their function as 'lexigraphic' signs.[12] The para-text merges with (and into) the para-image: miniaturization objectifies the written surface, bestowing on its marks, letters, and lines a kind of *iconic* significance.[13] Eyesight or technology allowing, one might try to read the nutshell-contained manuscript. But the nutty object simultaneously demands a different mode of experiencing it. The new spatial arrangement interrogates the linear temporality upon which the text—precisely as

[12] This explains why Stewart's essay on the miniature opens with Jacques Derrida (S. Stewart 1993: 37). In Derridean terms, the miniature problematizes the unspoken alliance between words and books, as indeed between writing and text: the book, that 'encyclopaedic protection of theology and of logocentrism', is shown to be at once more and less than the 'aphoristic energy' of writing that it contains (Derrida 1976: 18). Derrida's dialectic relates to a much grander polemic against the Western philosophical tradition, with its inherent privileging of signified referents over signifying signs: extremes of scale, we might say, capture the Derridean proposition *in nuce*—namely, that writing 'supplements' rather than simply 'conveys' meaning.

[13] For the 'paratext', see Genette 1997: especially 1–15, defining it after Philippe Lejeune as 'the fringe of the printed text which in reality controls one's whole reading of the text' (2). English lacks a word to capture the ensuing picture-aspect of the written text: Krämer 2005: 24 nicely gets the measure, labelling it 'Schriftbildlichkeit' ('writing-picture-ness').

'text'—relies. Such presentations of the *Iliad* would not be something to digest 'from cover to cover', or indeed from 'scroll to scroll': we are invited to (try to) *view* these squiggles rather than 'simply' to *read* them.[14]

Although not a literal abridgement, the apocryphal nutshell text offered an abbreviated version of the *Iliad*, and one that called for a *different* mode of readerly response: here was a synoptic object, allowing readers to *see* the text together and all at once. This interwoven aesthetic discourse, whereby variations in scale are bound up with issues of verbality and visuality, is a mainstay of ancient literary criticism, extending back to the discussion of epic and tragedy in Aristotle's *Poetics*.[15] By the same token, it is worth noticing how Pliny introduces his miniature manuscript as a feat of viewing rather than of writing or reading: the words are testimony to a certain 'keenness of sight' (*oculorum acies*). Plutarch and Aelian arguably imply something similar when they say that the sesame-seed *Iliad* was inscribed with *grammata*: the Greek noun *gramma* refers to lines that are drawn as well as to letters that are written.[16] So does our sesame represent the 'epics of Homer' as picture or text? Is the object designed to be read or to be viewed? Indeed, what are the differences between the two—and are those differences reduced or enlarged by the vicissitudes of scale?

Callicrates and Myrmecides understood the point only too well: that these questions are—in the truest sense—seminal to every project of cultural production. The polymath Aelian, on the other hand, was not amused. According to his *Historical Miscellany*, the *spoudaios*—the person who is earnest/weighty/zealous/serious/honest/swift (the word encompasses all of these meanings and more)—will not take such miniaturist antics seriously: they are frivolous, lightweight, and trifling. For all its micrographic summation, the miniature poses a destabilizing threat to the sorts of *spoudaia* that the *spoudaios* epitomizes. Certainly, the Homeric poems are reduced to a (quite literal) digest. And yet the physical reduction of the text simultaneously affects a reduction in the text's authority precisely *as* text. By rescaling the poem—by changing the dimensions by which we make (non-) sense of it—miniature *Iliad*s challenge nothing less than the semiotics of reading. The very act of containing the text encapsulates, paradoxically, the limits of signification: the miniaturized words risk rendering words meaningless. To (fail to) read the *Iliad* in a nutshell is to acknowledge the failures of *all* representation—to view *en miniature* the gaps of signification *en masse*. No wonder that

[14] Cf. S. Stewart 1993: 43: 'Such experiments with the scale of writing as we find in micrographia and the miniature book exaggerate the divergent relation between the abstract and the material nature of the sign.'

[15] See below, pp. 251–3.

[16] On the wordplay in the context of both the earliest tradition of ecphrastic epigram and the *Tabulae Iliacae*, see below, pp. 237–40. More generally on puns on the verb *graphein* in Greek, see Squire 2009: 147–8.

Aelian should prove so belittling: if Callicrates and Myrmecides were wasting their time, what of Aelian's own project of textual epitomization? Was his self-confessed attempt at containment not guilty of precisely the same folly? Indeed, does Aelian's *Historical Miscellany* not simply encapsulate such nuttiness, only in a much *larger* book?

When expressed in these terms, it is clear that the stories about the *Iliad* in a nutshell, as indeed about, Myrmecides and Callicrates, encase a much grander set of debates and anxieties. As we shall see, the dialectic between the big and the small intersects with numerous other discourses on an ever-expanding scale—the distinction between Greek and Roman, original and imitation, the serious and the unimportant, signifiers and signifieds, and not least between text and image. But the issue thereby also pertains to the very aesthetics of delimitation—about how (if at all) to bound, confine, or circumscribe meaning. That we should find the first reference to these 'miniatures' in Pliny the Elder's *Natural History* is especially revealing: as an encyclopaedic representation of what can be known, the *Natural History* is a microcosm in its own written right—a world contained in words, or rather (as Pliny puts it) 2,000 books contained in one.[17] Where Pliny's nameless artists encapsulates Homer within a nutshell, the first book of the *Natural History* strives to represent its own representation by way of a summarizing table of contents.[18] This microscopic dream of enclosure pertains not just to an abstract philosophy of representation, in other words. It miniaturizes much more macroscopic issues about power, authority, and control.[19] The nutshell *Iliad* encapsulates a whole rhetoric of encapsulation: it contains—and withholds—an ideology of containment.[20]

[17] See *HN* praef. 17: Pliny's work is said to contain 20,000 noteworthy facts and to summarize 2,000 books. On the imperial associations at work, see Rouveret 1987; Naas 2002: especially 416–38; Carey 2003; Murphy 2004.

[18] For an excellent analysis, see Carey 2003: 17–40, along with the more detailed comments of Naas 2002: 171–234. B.-J. Schröder 1999: 106–15 shows Pliny's index to have been a highly new and original manoeuvre.

[19] As Rimell 2008 shows, these minimizing-maximizing games are equally pertinent to Pliny's near-contemporary, Martial. By composing gargantuan collections of little poems, Martial offers readers the 'whole world in our hands' (Rimell 2008: 7–14)—'a Rome in miniature, an oxymoronic microcosm of monumental spaces made tight and constraining' (ibid. 182). Cf. pp. 279–83 below, on Martial's playful *shrinking* of the Homeric poems into an elegiac distich (14.184).

[20] Something similar can be said for the subsequent interest in the story during the eighteenth and nineteenth centuries, not least for a collector of 'curiosities' like Isaac Disraeli. Disraeli charts the anecdotes about ancient micrographic texts alongside more recent examples (cf. above, p. 2 n. 5); but he does so within a work which bills itself as 'a diversified miscellany of literary, artistic, and political history, of critical disquisition and biographic anecdote, such as it is believed cannot be elsewhere found gathered together in a form so agreeable and so attainable' (Disraeli 1881: 1.vii). (The edition cited here is a later amalgamation of Disraeli's three books—sadly, though in a triple- rather than single-book edition.)

HOM(ER)ING IN

The fact that Homer is the subject of such miniaturizing zeal is in and of itself significant. It is not just *any* text that ancient miniaturists like Callicrates and Myrmecides chose to synopsize. Their fragile little objects engage with the biggest and weightiest of all literary genres.[21]

As the founding poem of classical literature, Homer's epic is truly all-encompassing—the source and sea from and to which everything flows.[22] Critically speaking, Homeric epic is inherently *big*, bound up with 'greatness' (*megethos*), measuring up to what Pseudo-Longinus called *hypsos* ('height', 'loftiness', 'sublimity': *Subl.* 9.4–15).[23] We find a related sentiment visually monumentalized in a relief signed by Archelaus of Priene, usually dated to the late third or second century BC (Fig. 3): the poet is seated at the bottom left of the relief, flanked by his literary progeny (the *Iliad* and *Odyssey* kneel by his side), and heralded by all manner of further labelled personifications ('Myth', 'History', 'Poetry', 'Tragedy', 'Comedy', 'Nature', 'Excellence', 'Mindfulness', 'Trustworthiness', 'Wisdom' (*Sophia*)); in the friezes above are depicted the Muses, Apollo, and (supreme at the top) a reclining Zeus. As for the two figures depicted behind Homer, crowning him with his wreath, inscriptions identify them as *Chronos* and *Oikoumenê*, or 'Time' and the 'Inhabited World': Homer's prodigious poetry is the fountainhead of all thinking. It is everlasting—and everywhere.[24]

Although ancient critics celebrated Homeric poetry for its grandeur and universality, they simultaneously admired the (relatively) little format. As was well known, the *Iliad* compresses and distends the ten-year span of the Trojan

[21] The smallest modern edition of the *Iliad* and *Odyssey* known to me is a two-volume set printed by Charles Whittingham in 1831, and measuring 9 x 5 cm (Bondy 1981: 89–90). S. Stewart 1993: 40 makes a similar point about the post-antique Bible: 'as the book of greatest significance, the book holding the world both past and future, is a volume often chosen for miniaturisation'. Stewart's critical idea was materialized in 2005 by the 'world's smallest reconstruction of a book' (as certified by *Guiness World Records*): a crystalline silicon chip measuring 0.5 x 0.5 cm holds the 180,568 words of the King James New Testament, written in 24 ct gold (Bromer and Edison 2007: 199).

[22] The key anglophone analysis of 'visions and revisions of Homer' is Zeitlin 2001, who cites the following ancient discussions of Homer's comprehensiveness at 205 n. 17: Pl. *Ion* 531c–d; Dio Chrys. *Or.* 12.68; [Plut.] *Vit. Hom.* 63, 74–5; Quint. *Inst.* 10.1.46–51; Max. Tyr. *Or.* 26.1; cf. Hillgruber (ed.) 1994–9: 1.5–35. On ancient allegorical readings—Homer as a sage theologian—see Lamberton 1986.

[23] Cf. Demetr. *Eloc.* 5, associating the size of the 'heroic' Homeric hexameter with its larger-than-life heroic subjects. On 'size matters' in relation to Homeric literary criticism, see Hunter 2009: 149–60.

[24] On the relief (British Museum inv. Sc. 2191), the most detailed discussion is Pinkwart 1965: 19–90 (arguing it to be a votive offering). Cf. e.g. Webster 1964: 144–7; Onians 1979: 103–6; Pollitt 1986: 15–16; Ridgway 1990: 257–68; P. Zanker 1995b: 158–64; Zeitlin 2001: 197–203; Newby 2007b. The relief is often associated with a supposed Homereion at Alexandria, founded by Ptolemy IV Philopator (hence the portrait correspondences between *Chronos* and *Oikoumenê* and Ptolemy IV and Arsinoe III: see Newby 2007b: 170); whatever its origins, though, the relief was displayed at a villa complex south-east of Rome (Messer Paolo)—the same site as the most famous Iliac tablet (see below, p. 66).

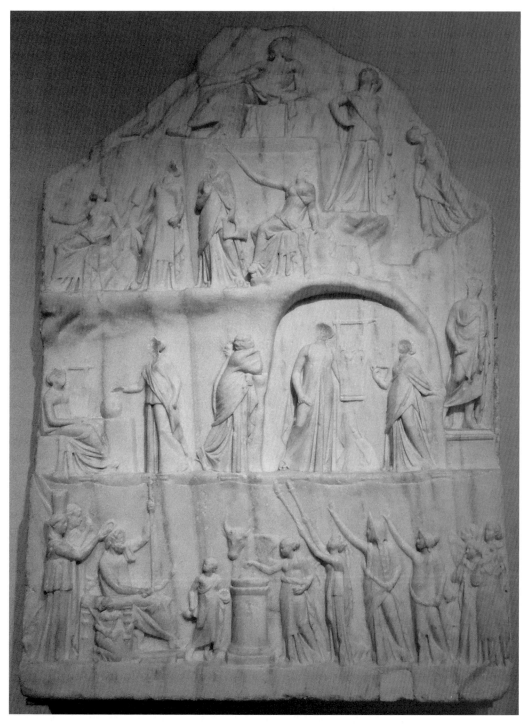

FIGURE 3. Marble relief of the so-called 'Apotheosis of Homer' signed by Archelaus of Priene, probably second century BC (British Museum Sc. 2191; height: c.1.18 m).

War, not to mention its epic pre- and post-history, into a period of just some 42 days (according to one subjective count), treated in just 24 books: the poem does not hatch from the twin eggs laid by Leda, as Horace puts it, but instead 'hastens straight to the point and spirits the listener into the middle of things as if they were already known' (*semper ad euentum festinat et in medias res | non secus ac notas auditorem rapit*, Hor. *Ars P.* 148–9).[25] Alexandrian commentators had duly taken note some two centuries earlier, looking to the big narrative lessons, all the while scrutinizing each tiny jewelled expression.[26]

Homer was the undisputed master of proportion. As one first-century AD commentator puts it, the poet could 'provide a measure' (ἐμέτρησε) for the whole cosmos in just one single line.[27] 'No one has surpassed [Homer's] sublimity when it comes to great things, nor his propriety when it comes to small,' adds Quintilian (*hunc nemo in magnis rebus sublimitate, in paruis proprietate superauerit*). A stream of paradoxes ensue (*Inst.* 10.1.46):

> Idem laetus ac pressus, iucundus et grauis, tum copia tum breuitate mirabilis, nec poetica modo, sed oratoria uirtute eminentissimus.
>
> He is at once luxuriant and concise, light and heavy, marvellous in thoroughness and brevity alike, pre-eminent not only in his poetic manner but also in his oratorical brilliance.

Like the shield of Achilles described in the eighteenth book (*Il.* 18.478–608), in whose circular frame the whole cosmos is contained, the *Iliad* is at once microscopic *and* macroscopic in outlook. The creations of Myrmecides, Callicrates, and others vacillate between these same dialectical dynamics: at once under- and overwhelming their audiences, leaving them unsure whether to zoom out or to zoom in—should they try and look, or try and read?—these graphic artefacts replicate in miniature the synoptic poetics of their larger epic model.[28] The *Iliad* might *look* big, just as these miniaturist fancies *look* small. In each case, however, scale depends upon the perspectives of the viewing and reading audience.

The shield of Achilles—made by the great Hephaestus, and perfectly in-scale with the larger-than-life hero—is relevant to these micrographic materializations of epic in another sense besides. By objectifying the *Iliad*, turning it into a

[25] On the Homeric manipulation of time, see de Jong 2007. The precise timescale of the *Iliad* was debated in antiquity; appropriately enough, it was also a theme with which the *Tabulae Iliacae* engaged (below, pp. 99–101).

[26] Cf. Hutchinson 2008: 67: 'The Hellenistic period both pondered the large issues of structure which the Homeric poems exemplified and investigated the Homeric text in extremely close detail.'

[27] Cf. Heraclitus, *Quaest. Hom.* 36.4 (Russell and Konstan (eds.) 2005: 64), on *Il.* 8.16: 'Homer gives us the measure of the sphere of the universe in a single line' (τὸ δὲ σφαιρικὸν ἡμῖν τοῦ κόσμου σχῆμα δι' ἑνὸς ἐμέτρησε στίχου); compare also [Longinus], *Subl.* 9.5.

[28] The phrase 'dynamics of scale' is taken from Porter forthcoming: see below, p. 248.

wonder of writing, the '*Iliad* in a nutshell' inverts the epic tradition of representing vision in words. As we shall see, the shield of Achilles stands as the paradigmatic example of ecphrasis, whereby the set-piece description of a visual object occasions contemplation about the overarching epic narrative (and, in time, its literary archaeology): by describing the ecphrastic artefact, the poem sketches out, in miniature, its grander cosmic-cum-literary frame.[29] But the miniatures of Callicrates, Myrmecides, and others turn ecphrasis inside out. Rather than the epic poem containing and framing the ecphrastic set-piece description of an object, an object here contains and frames the epic poem; rather than (the verbal evocation of) an image encapsulating the text, moreover, the text is literally encapsulated in an artefact that is itself designed not just for reading, but also for viewing. The commensurability of the little and large serves to figure the incommensurability between words and pictures: the dynamics of scale synthesize the dynamics of visualizing texts, no less than verbalizing images.[30]

TOO BIG TO HANDLE

The surviving *Tabulae Iliacae* are in some ways very different from the miniaturist fancies described by Pliny, Plutarch, and Aelian. For one thing—were we to be petty—the tablets are never *quite* as small as a nut or sesame seed. For another, these objects combine verbal inscriptions with figurative reliefs. The tablets do not just miniaturize texts, in other words, they also arrange and edit: they translate the sayable into the seeable, while simultaneously reversing the process, setting their images alongside miniature texts.

The most complete fragment, held in the Capitoline Museums in Rome, provides an example of what one of these tablets looked like (Fig. 4). I save a more detailed description for the following chapter (pp. 34–9). For now, the point to emphasize concerns the grand design on the one hand, and the diminutive scale on the other. The suriving fragment measures just 25 x 30 cm: this is

[29] On this prototypical Homeric ecphrasis, see chapter 7 below. The secondary literature on ecphrasis is formidable, and I have attempted a brief review in Squire 2009: 139–46. Unlike much recent work on ancient ecphrasis (e.g. Webb 2009: especially 28–37), the present book emphasizes the proximity rather than distance between ancient and modern understandings of the term (cf. Squire 2008): despite its different emphases, ancient discourse about how vision could (not) be represented through words prefigures some of the most original post-structuralist criticism of the late twentieth century, e.g. Foucault 1983; Baxandall 1985; Bal 1991; Krieger 1992; Heffernan 1993; Mitchell 1994: 151–81 (cf. idem 2003); Hollander 1995.

[30] The additional irony should not be overlooked. By verbally describing such artificial artefacts, Pliny, Plutarch, and Aelian themselves invert the 'nutty' inversions of Homeric ecphrastic inversion: words on images on words on images ad infinitum.

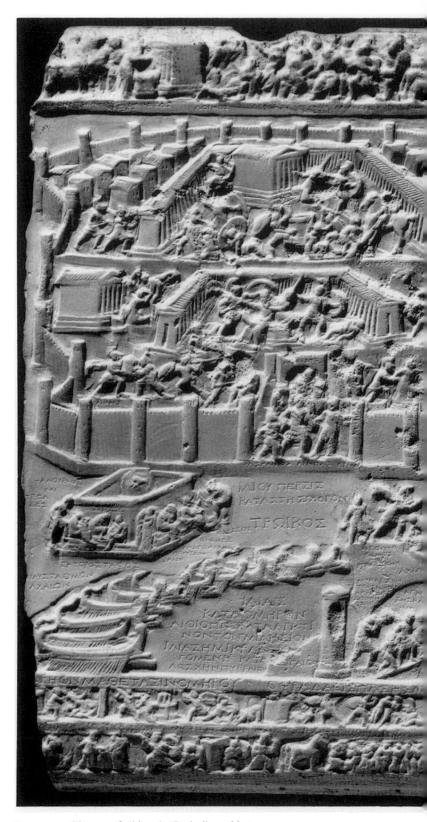

FIGURE 4. Obverse of tablet 1A (Capitoline tablet).

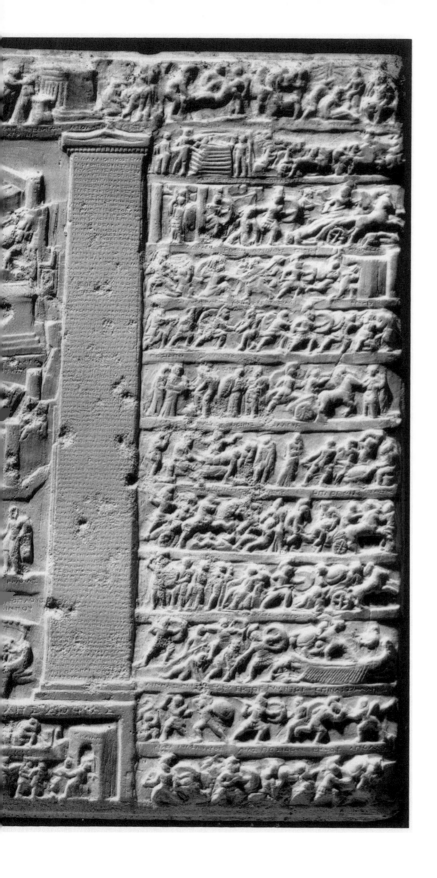

the original height, although the length was once somewhat bigger at just over 40 cm (the tablet's left-hand side is missing). Despite these small proportions, there are over 250 figures in the surviving portion alone (i.e. *c*.0.075 m^2): we are offered a panoramic overview of a variety of epic texts—the *Ilioupersis* (or 'Sack of Troy') in the middle, the *Aethiopis* and *Little Iliad* below, and the 24 books of the *Iliad* to the side (only the latter 12 friezes survive, to the right of the monumental pilaster (Figs. 5–7)). If the pictures are small, the Greek texts accompanying them are even smaller. Observe, for example, the pilaster to the right of the central scene, inscribed with no fewer than 108 lines. Remember that the whole tablet is only 25 cm in height—and that this stela occupies around three-quarters of it. Like the tiny *Tabula*, this epitome at once minimizes, materializes, and monumentalizes: it offers yet *another* miniature synopsis of the (images of the) poetic text.

The argument of this book—in a nutshell—is that the *Tabulae Iliacae* must be understood within the same discursive traditions as our opening stories about Callicrates, Myrmecides, and others. The Iliac tablets might be small, but they treat the grand panoramas of epic history, turning text into image, and image into text. As such, the *Tabulae Iliacae* encapsulate the largest problems of containing representation: they interrogate *how* to find meaning in what we see and say.

Like the cultural products of our legendary opening miniaturists, these objects toy with the aesthetics of containment—the verbal in the visual, the Greek in the Roman, the signified in the signifier (and vice versa). Better, they represent for us the ruse of representation itself: as miniature fictions, they probe the artifice of all signification, challenging us to view and to read them *differently*—indeed, to rethink our bipartite discrimination between 'viewing' and 'reading' in the first place. Rather than simply 'communicate' ideas or stories, the tablets prod, spur, and goad. They throw the challenges of interpretation back on to their users: can *we* contain *them*?[31]

The *Tabulae Iliacae* are truly radical objects. But they have fared little better among modern-day scholars than the apocryphal labours of ancient miniaturists. Just as Aelian dismissed the sesame-seed Homer as a 'waste of time', critics have tended to dismiss the *Tabulae* as dawdling trivialities. 'Treasure houses of misapplied ingenuity': that was Nicholas Horsfall's assessment, and it is one that (at least in the English-speaking world) continues to hold sway. Doubtless

[31] On Roman art's manifold games with viewing, the key text is Elsner 1995; for related discussions, albeit from a different national perspective, see P. Zanker 1997 and 2000. Such concern with the 'viewer's share' has now attracted a wide and varied bibliography, whether concerned with Roman wall painting (cf. especially Bergmann 1994, developed by K. Lorenz 2008), mosaics (cf. especially Muth 1998 and 2005), or sculptural reliefs (cf. especially Newby 2002).

the tablets frustrated modern philological scholarship's own mode of *spoudaia*. Like Aelian, Horsfall sees only gobbledygook: he concludes that 'the educated owner of a library could not have derived much joy from the possession of any of the *Tabulae*';[32] indeed, that 'the *serious* lover of Greek literature would have been appalled by such a combination of the obvious, the trivial and the false', just as 'the *serious* lover of art cannot have derived much pleasure from pictures so tiny that the sculptor could add little if anything of his own interpretations and emotions'.[33]

Such proverbial small-mindedness has led countless scholars to lose sight of the bigger picture. Like so many others, Horsfall engages in a microscopic analysis of the tablets' images and inscriptions ('easily legible with a magnifying glass'[34]). But he overlooks the more macroscopic stakes. As a 'serious lover of Greek literature' himself, no doubt, Horsfall earnestly scrutinizes the tablets, offering many important observations along the way. And yet he proves blind to the fun and games, no less than to the larger intellectual stakes that the tablets encapsulate. The consequences, in my view, prove serious indeed.[35]

That the 22 *Tabulae Iliacae* should be so unfamiliar to students and scholars is not for any want of catalogues (cf. below, pp. 28–31). The first was written in German by Otto Jahn—an interpretive discussion of twelve objects, published posthumously in 1873.[36] Anna Sadurska included analysis of seven further tablets in her subsequent catalogue of 1964.[37] Then, in 2004, Nina Valenzuela Montenegro published by far the most exhaustive taxonomy of the tablets, based on her 2002 Munich doctoral dissertation.[38] It is testimony to the sophistication of these little objects that, despite Valenzuela Montenegro's

[32] Horsfall 1979a: 35.

[33] Idem 1994: 79 (my emphasis). On Horsfall's interpretation, see pp. 87–92 below.

[34] Idem 1979a: 33 (on tablet 4N). Such recourse to the magnifying glass has a long history in scholarship on the *Tabulae*: cf. e.g. de Longpérier 1845: 439 on the need for the 'aide de la loupe'.

[35] The classic critique of such (un)critical 'seriousness' is Barthes 1974: 4: 'Our literature is characterized by the pitiless divorce which the literary institution maintains between the producer of the text and its user, between its owner and its consumer, between its author and its reader. This reader is therefore plunged into a kind of idleness—he is intransitive; he is, in short, *serious*; instead of functioning himself, instead of gaining access to the magic of the signifier, to the pleasure of writing, he is left with no more than the poor freedom either to accept or reject the text: reading is nothing more than a *referendum*' (his emphases).

[36] O. Jahn 1873.

[37] Sadurska 1964.

[38] See Valenzuela Montenegro 2004—foreshadowed by eadem 2002. The author devotes most energy to demonstrating that the tablets are 'ein genuines Produkt der römischen Kunst' (2004: 413): in doing so, she combines detailed philological analysis of the inscriptions with a very rich analysis of their iconographic derivation (in particular their relationship with Pompeian wall-painting cycles). In this book, however, I wish to go further than Valenzuela Montenegro in emphasizing the visual–verbal games that the tablets play with their users. While Valenzuela Montenegro retreats to various modern comparanda ('wie in einem modernen Comic Strip', ibid. 8; cf. 337), I draw attention to the sophisticated intermediality of these tablets *between* images and texts.

nigh on 500 pages—not to mention 2531 footnotes—there should still be so much more to say. But it is no small indictment of the 'catalogue' as *wissenschaftliches* genre that, for all its encyclopaedic aspirations, so many of the most interesting questions remain unasked. Thanks largely to Valenzuela Montenegro's efforts, we are now in a better position to understand the multifaceted iconographic derivation of the tablets—allowing us to bury (hopefully for the last time) the diehard argument that they were derived from 'illustrated manuscripts';[39] with the exception of the longest (and arguably most interesting) inscription around the rim of one tablet, moreover, most of the texts inscribed on the tablets have been integrated into the relevant scholarly reference volumes like *Inscriptiones Graecae*, *Die Fragmente der griechischen Historiker*, *Inscriptiones Graecae Urbis Romae*, and the *Supplementum Epigraphicum Graecum*.[40] So too are the tablets sized up in all the normal reference volumes—the *Dictionnaire des antiquités grecques et romaines*, *Real-Encyclopädie der classischen Altertumswissenschaft*, *Enciclopedia dell'arte antica classica e orientale*, etc.[41] But here comes the irony: the more the tablets have been catalogued, classified, and categorized, the less classical archaeologists and philologists seem to have understood them.

Quite how to explain this neglect is one of the larger questions tackled in this book. To be sure, the *Tabulae Iliacae* have not *always* been so belittled: early nineteenth-century critics were much more appreciative of their miniaturist feats.[42] As will become clear, there are a number of modern disciplinary factors in play—not just the 'sizeism' of classical art historians,[43] but also the segregation of the 'Greek' from the 'Roman', the divisions between 'classical art history' and archaeology, and most importantly of all, the residual split between

[39] See below, pp. 129–48, as well as Valenzuela Montenegro 2004: 337–46.

[40] See *IG* 14: 328–47, nos. 1284–93 (tablets 1A, 3C/9D, 6B, 12F, 13Ta, 14G, 8E, 11H, 10K, 19J); *FGHist* 252 (18L); *SEG* 29.993 and 33.800–2; *IGUR* 4: 93–8, nos. 1612–33: earlier publications of these texts are referenced in O. Jahn 1873: 2–9. On the Greek text around the outer rim of tablet 4N, see below, pp. 360–7: although Bienkowski 1891: 201–7 comments on the text, it has not yet been transcribed— this in spite of the fact that it must be one of the earliest known testimonies of *Il.* 18.483–608 (*P. Ashm.* 82/ 76(b) (ii–iii) contains only lines 510–15 and *P. Ashm.* 105/146(a) (i–ii) contains only lines 515–21). Although there is a passing reference to the inscription in the 1800 papyri surveyed by e.g. West (ed.) 1998: 86–138 and 2001: 86–138 (West (ed.) 1998: i.xliv, no. 276; 2001: 98, no. 276; cf. e.g. Pack 1960: 62 n. 960), the text has not yet received the attention it deserves. Such unfamiliarity is also reflected in the mistaken lacuna that scholars have hitherto supposed (see below, p. 360–1 n. 143).

[41] See Michon 1899; Lippold 1932; Bulas 1966.

[42] Cf. Welcker 1829: 227: 'Je crois apercevoir dans la Table iliaque, d'une manière non équivoque, un tel dessein spécial et distinct, ou le mérite d'une ingénieuse invention, d'après laquelle toute la composition est exécutée et portée à une unité parfaite.'

[43] For the complaint that classical art historians undervalue the small, and associate it with the unoriginal and derivative, see e.g. Lapatin 2003 (on so-called *Kleinkunst*, especially in metal); Bartman 1992: 9–15 (on Roman miniature 'copies'); and Henig 1990 and Platt 2006: 89 (especially on gems).

the study of ancient 'material' and 'literary' cultures.[44] The diverse and polyglot bibliography—nearly all of it in German, French, and Italian—has hardly helped matters, especially in Britain and the USA. In an anglophone research culture that has grown increasingly monoglot in its conversations, it is regrettably becoming ever more pardonable to overlook contributions in other languages.

Interestingly, though, English-speaking scholarship is not alone in bypassing the *Tabulae Iliacae*. They are in fact underplayed in almost every history of Graeco-Roman art and literature—whether in French, German, Italian, Spanish, Greek, or any other modern European language. Certainly, the tablets go unmentioned in most standard catalogues of Hellenistic and Roman art,[45] as well as in more general studies on Hellenistic 'poetry and art' or associated 'modes of viewing';[46] despite their epic subjects, moreover, they also go without reference in recent work on Hellenistic epic and so-called 'epyllion'.[47] Still more surprising is the fact that the tablets have not played more of a role in scholarship on Greek (or indeed Latin) epigram. The publication in 2001 of Posidippus' third-century book of mini-epigrams (*P. Mil. Vogl.*, inv. 1295), many of them on artistic subjects, has led to a whole re-evaluation of the genre and its Roman reception.[48] And yet, despite playing with that tradition of ecphrastic response to artworks—indeed, although sometimes inscribing epigrams alongside their own miniature pictorial visualizations of texts—the tablets have barely received a single mention.[49] The small handful of examples where (anglophone) scholars *have* attempted to do something more interesting with the tablets, moreover, contain

[44] See below, pp. 372–81.

[45] I find no mention of the objects in the stock-trade guidebooks on 'Greek' and 'Hellenistic art': e.g. Webster 1967; Robertson 1975; Onians 1979; B. H. Fowler 1989; Smith 1991; Bejor, Castoldi, and Lambrugo 2008. Likewise, they are omitted in pretty much all books on 'Roman art': e.g. Picard 1962; Hanfmann 1966; Bianchi-Bandinelli 1970; Andreae 1973; Baratte 1996; P. Stewart 2004; F. S. Kleiner 2007; P. Zanker 2007; Ramage and Ramage 2009. Among the only 'introductory' discussions known to me are the following: Brilliant 1984: 53–9; Pollitt 1986: 202–4; Schefold and Jung 1989: 177–81; Ridgway 1990: 264–6; M. J. Anderson 1997: 1–5; Small 2003: 93–6; Burn 2004: 133–5.

[46] No reference by e.g. Webster 1964, G. Zanker 2004, or Prioux 2007. Nor, more generally, do they feature in most guides to myth in Greek and Roman art: no reference by e.g. Woodford 1993 and 2003 (despite the interest in 'transforming words into images', 2003: 13–53), or Junker 2005.

[47] The *Tabulae Iliacae* are conspicuously absent in e.g. Sistakou 2008.

[48] The new Posidippus is most easily accessible in c. Austin and Bastianini (eds.) 2002. Amid a truly formidable bibliography, there are four excellent edited guides: Bastianini and Casanova (eds.) 2002; Acosta-Hughes, Kosmetatou, and Baumbach (eds.) 2004; Gutzwiller (ed.) 2005; Marco, Palumbo, and Lelli (eds.) 2005. Note also the excellent discussion of Prioux 2008: 159–252, which cites extensive further bibliography.

[49] The one exception is Porter forthcoming (on the *Tabulae Iliacae* in relation to Hellenistic concepts of *leptotēs*). Valenzuela Montenegro 2004: 412 makes some initial perceptive comments on the tablets' size, but despite the combined artistic-literary perspective that she promises (17), the author pays minimal attention to the larger Hellenistic literary agenda at play.

crippling errors of fact and interpretation.[50] The *Tabulae Iliacae* continue to slip through the scholarly net—and not just, I think, on account of their size.[51]

In fact, scholars of every language and nationality have had recourse to the tablets in association with a remarkably narrow range of questions. There has been a tendency to fixate on four issues in particular. First and foremost has been the question of illustration—of how (if indeed at all) the tablets reflect an otherwise lost tradition of Hellenistic and Roman manuscript illumination. This academic trend harks back to the very earliest discussions of the tablets, and to the work of Otto Jahn in particular;[52] but it reached its climax in the mid twentieth century with the Byzantinist scholar, Kurt Weitzmann, who reconstructed the supposed appearance of Hellenistic illustrated manuscripts on the basis of such 'secondary' objects (Fig. 44).[53] A second academic controversy is closely related: the attempt to reconstruct Stesichorus' lost sixth-century lyric poem on the fall of Troy, the *Ilioupersis*, on the basis of representations on the *Tabulae* (especially on the Capitoline tablet (Figs. 58–9)).[54] Third, scholars have related the tablets to the

[50] So it is, for example, that in her discussion of the *Parallel Worlds of Classical Art and Text*, Small 2003: 93 misconstrues the content of the largest inscriptions on one of the best surviving tablets, positing of tablet 1A that 'a pilaster to the right carries a summary of Books 12–24' (rather than books 7–24: see below, pp. 34–5, 167 n. 104), and counts only 20 tablets: as with nearly all anglophone discussions (see below, pp. 91–2), Small was clearly dependent on the English discussion by Nicholas Horsfall (Horsfall 1979a). Likewise in one of the few English analyses of the tablets' reverse inscriptions (and one of the most stimulating in any language), Thomas Habinek accidentally confuses two tablets that have very different forms and appearances: Habinek 2009: 127–9 mistakes tablet 4N for the *Tabula Iliaca Capitolina* (1A), and wrongly suggests that it was found 'near Bovillae in Latium'. Such errors are to be found in the work of even the most respected classical archaeologists: cf. e.g. S. Morris 1995: 229, referring to a singular *Tabula Iliaca* and comparing its 'Late Antique illustrations' to those of the 'Vatican Virgil'.

[51] In addition to Valenzuela Montenegro 2004, there are some other indications that the tide may finally be turning: first, in 1997, Nikolai Kazansky's commentary on the *Tabula Capitolina* attempted the first systematic reading of the tablet alongside two Oxyrhynchus papyri that preserve fragmentary sections of Stesichorus (*P. Oxy.* 2619 and *P. Oxy.* 2803: Kazansky 1997); then, in 2002, Cristina Salimbene published a useful review of scholarship and a revised table of attribution (Salimbene 2002); next, in 2006, David Petrain's doctoral thesis offered the first major English reappraisal of their tablets, arguing that they 'need to be brought into contact with the full spectrum of discourses on narrative, Homeric epic, and the contentious relationship between Greek and Roman literature that characterize the early Empire' (Petrain 2006: 189–90); most recently, in 2009, Paola Puppo provided a revised synthesis of scholarship (Puppo 2009).

[52] See O. Jahn 1873: especially 86–90, concluding that the tablets derive not from the Homeric text, but rather from an illustrated epitome of it intended for use in the schoolroom.

[53] See especially Weitzmann 1947: 36–44 and 1959: 31–62, especially 34–7. I return to the theme below, pp. 129–48, especially 129–36.

[54] The question again goes back to some of the earliest research on the tablets—including Welcker 1829: 233–40; Paulcke 1897 (*non uidi*); Mancuso 1912: especially 174–89; Vürtheim 1919: 34–44; cf. *PMG* 110–11, no. 205. Nicholas Horsfall argues that the *Tabulae* were crafted independently of Stesichorus' poem, despite the overt claim to the contrary: see especially Horsfall 1979a: 35–43, restated in 2008: 587–91 (and cf. independently Bowra 2001: 104–6). Others have taken issue with Horsfall's method and conclusions: in addition to Kazansky 1997: especially 55–102, see e.g. Gruen 1992: 13–16; Malkin 1998: 191–4;

sorts of mythographic *epitomai* preserved by (among others) Apollodorus and Diodorus Siculus, using this to shed light on their supposed workshops and creators.[55] All of these issues, finally, have been used to shed light on a fourth question: the original purpose, function, and display context of the *Tabulae*.[56]

Although this book will touch upon all of these questions—some of them at greater length than others—its overarching aim is rather different. True, part of my objective is to offer the first survey of this material in English. But I also set out to emphasize the tablets' games, taking them at once more playfully and more seriously. By flirting with grand dialectics of the big and the small, the epic and the epigrammatic, the visual and the verbal, and the original and the copy, these self-referential objects contest a system of representation even as they perform and represent it. The *Tabulae Iliacae*, I repeat, play games with their users. And they demand that their users play games with them in return.

MINIATURIZING THE BOOK

As this book developed, I was forced again and again to rethink its structure. The problem was not just one of size—about how best to confine and expand the complexities of the material. Rather, the issue has been how to navigate a way in and around the tablets: how to structure a narrative; how to turn the visual–verbal discourse back into language; how to demonstrate the various games through visual means.

Needless to say, this could have been a much *bigger* book. But it was only relatively late—and after many (rather less amusing) foiled attempts to restructure the project—that I came to appreciate the prank: that these are the questions which the *Tabulae Iliacae* themselves posed of their original users; that the makers of the tablets had not only faced these challenges, but staged their own sort of meta-solution. Because the *Tabulae Iliacae* toy with the promise and failure of containing their grandiose subjects—because they constantly challenge the stories we tell of them—one cannot help but *re*think one's initial mode of response. The book had to emulate the tablets' own emulative games.

Wachter 2001: 316–17; Scafoglio 2005. Galinsky 1969: 106–13 still provides one of the most balanced overviews; for three more recent discussions (each unaware of the other), see Salimbene 2002 (with further bibliography at 8 n. 8), Debiasi 2004: 161–77 and Valenzuela Montenegro 2004: 382–401. I should come clean about my own position: in my view, the question has been framed in the mistaken terms of 'illustration'. Whatever we make of the Capitoline tablet's central images, the question needs to be reconsidered in light of the epigram's overt literary allusion to the *Ilioupersis* text (see below, pp. 106–8).

[55] For a review of bibliography and discussion, see Valenzuela Montenegro 2004: 368–76, along with van Rossum-Steenbeek 1998: 70–1 (apparently unknown to Valenzuela Montenegro).

[56] See below, pp. 67–85, as well as Valenzuela Montenegro 2004: 402–7.

Once again, the catalogue becomes the butt of the joke. What Jahn, Sadurska, and Valenzuela Montenegro all fail to acknowledge is that, as pseudo-catalogues themselves, the *Tabulae Iliacae* pre-empt their cataloguing mode. Through their size and form, the tablets attempt to tabulate their many subjects—to structure, to organize, to impose order; in an analogous sense, the classical archaeologist strives to put the fragments together—to systematize, to categorize, to taxono-mize. But where the size of the original tablets is inversely proportional to their intellectual scope—where the tablets play with the promise and failure of en-capsulating their subjects—modern catalogues just keep on getting bigger. This is not just a game about scale, but also a question of epistemology: the more energy expended on containing the tablets—the larger, the weightier, the more expansive the book—the more the objects elude us.[57] If the tablets purport to catalogue epic, they also (encourage us to) blow raspberries at such a positivist gesture: as with the stories that they visually and verbally represent, the *Tabulae* mischievously resist (en)closure. One thinks once again of the *spoudaios* scholar with his magnifying glass, at once making the miniature gargantuan and mistak-ing the gargantuan for the miniature. For all its self-confessed goal of 'Vollstän-digkeit', the catalogue is both too big *and* too small.[58]

How then to begin, proceed, and end? I eventually settled on a series of independent but overlapping chapters, intended to be read both in isolation and in sequence. Each deals with a different aspect of the tablets—turning them round, flipping them over, subjecting them to different interpretive lenses. To repeat: the book is *not* a catalogue, but instead treats the tablets as a collective whole. Still, like the maker(s) of the *Tabulae*, I could not resist the *gesture* of containment. For that reason, I have included an appendix (Appendix I, pp. 387–412), which provides an overview of individual tablets. Rather than describe their images, still less transpose their inscriptions (Valenzuela Monte-negro has done that already), this appendix is intended as a sort of curtain call. Its aim is threefold: first, to collect some basic information about each tablet (its size, material, state of preservation, provenance etc.); second, to give an overview of subject matter and form; and third to refer readers back to earlier discussions, and above all to earlier pictures, details, and drawings (via the thumbnail images). In

[57] On the (problematic) epistemology of the catalogue, and its historical place in classical archaeology, cf. e.g. Shanks 1996: 92–7.

[58] Valenzuela Montenegro 2004 betrays this aim inadvertently—explaining that her inclusion of tablet 16Sa 'nur der Vollständigkeit halber genannt sein soll' (335; cf. e.g. 402 n. 2462). Earlier, the author declared her foremost objective as being 'die Tafeln neu zu erschließen und einer möglichst objektiven, wertfreien Betrachtung zu unterziehen': 'Eine genaue ikonographische Analyse der einzelnen Tafeln mit heutigen Mitteln und Methoden sehe ich daher als wichtiges Fundament meiner Arbeit an. Diese kombiniere ich mit einem möglichst objektiven Vergleich mit dem Text, der nicht mehr von aprioristischen Annahmen verfälscht sein soll' (15–16). For this claim to objectivity, see below, pp. 30–1.

this appendix, as throughout the book, I refer to the tablets both by means of a number (between 1 and 22—following the system devised by Anna Sadurska) and by alphabetical letters (this is how Otto Jahn organized the material, and Nina Valenzuela Montenegro uses the system exclusively).[59]

As for the structure of the book, the following chapter ('Putting the Pieces Together') begins with a preliminary survey of the *Tabulae* and their history of scholarship. This is intended as a precis of what is known about the tablets and their archaeological contexts, particularly in the aftermath of Nina Valenzuela Montenegro's study: it focusses on not only the history of studying the tablets, but also the relationship between the extant examples—among other things, their workshops, date, materials, provenance, and function. One of the chapter's overriding questions is whether the tablets should be understood as a coherent 'genre' of Roman art: to ask what sense there is in talking about them as a collective in the first place. Another is to introduce debates about their use and purpose—a question to which the book will recurrently return.

The second chapter is intended as an overview of the material, especially for those uninterested in (or unconvinced by) the interpretive discussions that follow. The third chapter ('Mastering Theodorean *Technê*') proceeds to take issue with one of the most ubiquitous myths about the *Tabulae*: namely, that they were gauche objects destined for a semi-literate clientele. The 'nouveaux riches' interpretation remains the standard (indeed, by and large the *only*) account of the tablets in anglophone scholarship. But it is founded on a number of mistaken assumptions. To demonstrate the point, the chapter focusses on two related Greek epigrams, inscribed on two separate fragments (1A and 2NY). These mini-epigrams, with their string of highbrow Greek allusions, point to a macroscopic truth: that the tablets are exceedingly sophisticated objects, invoking a highly erudite mode of visual and verbal response. As knowingly 'intermedial' objects, the *Tabulae Iliacae* oscillate *between* images and texts: that is their *technê* – and indeed their *sophia*.[60]

Having established a sophisticated and urbane framework for understanding the tablets' inscriptions, the fourth chapter ('Choosing Your Own Adventure') begins to look at the images themselves. Although most scholars have studied the iconography of the *Tabulae Iliacae* in light of a supposed tradition of Hellenistic

[59] Jahn's alphabetical system was in fact foreshadowed by Reifferscheid 1862: 105–6. Sadurska's numerical system is devised in association with her arguments of attribution: see below, pp. 55–6. It is presumably because of her objections to those assumptions that Valenzuela Montenegro 2004 uses alphabetical demarcations alone (the author does not mention Sadurska when justifying the system (19–20), and confusingly *does* maintain it for what she calls 'Tabula Froehner 20' and 'Tabula Froehner 21').

[60] My language of 'intermediality' here is indebted above all to the work of W. J. T. Mitchell, in particular Mitchell 1994 ('all media are mixed media', 5; cf. Mitchell 2005: 201–21, especially 215). For the intellectual background, see most recently the essays in Elleström (ed.) 2010.

book illustration, the tablets toy with a much more sophisticated and self-conscious set of ideas about converting texts for reading into images for viewing. The very act of visualizing Homer posits a challenge to the narrative flow of the text: although in one sense containing epic, translating it into pictures, the tablets also invite viewers to experiment with different modes for making visual sense of the verbal stories depicted. Words and pictures are designed to work together and in conflict: our collaborative and competing responses to the two media lead to a fecund process of *cross*-pollination. Reader-viewers embark on an adventure that is at once intermedial and kaleidoscopic, moving from image to text as well as from the detail to the overview (and back again). The closer we look—and indeed the more we widen our focus—the more startling the discovery: that these pictures do not contain the words at all.

If the fourth chapter looks to the obverse of the tablets, the fifth ('Turning the Tables') flips the *Tabulae Iliacae* over, examining their visualizations of epic in reverse. It is a little mentioned fact that, of the 22 tablets, 12 of them were decorated on both sides. The fifth chapter focusses on the most common sort of inscription, found on seven different tablets: according to the rationale of these so-called 'magic squares', letters are arranged in what I call a 'diagrammatic' way, readable in a plurality of different directions. As two surviving epigrams explicitly instruct, the objective was to move out from the central letter and proceed in whatever direction readers should choose. In order to understand the text hidden in the pseudo-picture (always some form of verbal title for the visual scenes depicted on the obverse), readers had first to *view* the composition, zigzagging across it at whim. Such circular games with the relations between visual and verbal communication lead us squarely back to the games of Hellenistic poets: they miniaturize a much larger concern with the boundaries between spoken, written, and visual communication.[61] In the context of the *Tabulae* themselves, moreover, these visual—verbal games constitute the flipside of the verbal—visual games inscribed on their obverse: they reverse the movement from text to image on the tablets' recto. Grand poems turned into miniature pictures, images transformed to words, verbal signs arranged to form visual diagrams: there is no end to the tablets' conceptual—or indeed literal—turn-arounds.

Chapter 6 ('The Art and Poetics of Scale') returns to the size of the tablets, relating the artifice of their visual—verbal games to the fiction of their miniature forms: the self-pronounced *metron* of the tablets' scale, it argues, magnifies the *technê* involved in translating texts into images (and back again). The *Tabulae Iliacae* have to be understood within a much longer Graeco-Roman tradition of

[61] The most important analysis is Männlein-Robert 2007b.

size games. But they also resonate with a set of Hellenistic aesthetic debates in particular. It was first in Hellenistic Alexandria, and particularly among Alexandrian poets like Callimachus, that scale came to encapsulate certain theories of representation: it epitomized much larger cultural anxieties about originality, innovation, and control; anxieties, moreover, that resonated all the more poignantly with those Roman writers who themselves 'came after' their Hellenistic predecessors—with neoteric poets such as Catullus, the Augustan elegists and not least Imperial epigrammatists like Martial.

The tablets visualize this thoroughly Hellenistic concern with *multum in parvo*, combining the big with the small, and indeed the small with the big: they embodied the dynamic 'contrast of extremes' that characterizes Callimachean *leptotês* ('thinness', 'fineness', 'delicacy'), synthesizing this with their own dynamic amalgamation of visual and verbal media. This aspect, the chapter concludes, may shed new light on the individual 'technician' with whom six surviving fragments associate themselves: not for nothing was 'Theodorus' also the name of an Archaic Greek sculptor renowned, at least by the third century BC, for his miniaturist sculptural creations; not for nothing, too, does Posidippus' newly discovered book of epigrams appropriate this 'Theodorean' figure as an artistic personification for its own micro—macro poetics.

The seventh chapter ('Ecphrastic Circles') explores the tablets in association with epic's own paradigmatic attempts at visualizing images in words: the ecphrastic evocation of the shield of Achilles in the eighteenth book of the *Iliad*. Several tablets represent this legendary shield crafted by Hephaestus. Of these, two objects purport to actualize the shield: they pose as self-contained miniature monumentalizations of epic's grandest attempt at verbally containing pictures. The chapter focusses on the best surviving example (tablet 4N). If this object trumps the Homeric description by the remarkable scale of its *micrologia*, it also does so by visually imag(in)ing what Homer could only verbally 'periphrase'. Indeed, the tablet *reverses* the ecphrastic direction of the Homeric description, representing though images Homer's own depiction in words. It is in this capacity that we should understand the almost imperceptible squiggles surrounding the object's minuscule outer band, where the text of the Homeric ecphrasis in inscribed in its entirety. Like the circular tablet, derived from a *ritornello* ecphrasis, the representational games here run round in rings (and run rings around the object): from a verbal evocation of a visual subject, to a visual materialization of that text, back to the 'original' representation of the 'copy' in words—just about visible, but hardly now readable. Perhaps most wondrously of all, this text is inscribed within the minuscule outer rim of this truly tiny circular tablet—just 17.8 cm in diameter.

A final postlude ('Taking the Tablets') returns to the themes of this opening introduction. It rearticulates my overarching thesis: that, far from 'expensive

rubbish',[62] the tablets play with the meaning of representation and the representation of meaning, and that they do so in mind-bogglingly sophisticated ways. But the chapter also looks at the bigger picture: how can it be that such truly remarkable materials have *not* received the attention they so patently deserve?

Circling from the microscopic to the macroscopic and back again, my project is both historicist and transhistorical in orientation. On the one hand, the aim is to understand the tablets within the literary, artistic, and intellectual cultural contexts that contained them; on the other, the book looks beyond the historical frame. There are a number of 'Hellenistic' and 'Roman' lessons to be learned here—about size, narrative, and the hermeneutics of containment. But by toying with *what* representation is—with *how* signification works—the tablets lay claim to a macroscopic significance beyond the narrow historicist confines of classics (and most classicists). Cultural historical contextualization sheds light on an infinitely more extensive tradition of theorizing representation *across* the ages.

'Play', 'question', 'flaunt', 'flirt', 'contest', 'perform', 'toy': it is precisely the ludic qualities of the tablets that this book seeks to tease out. For all their games, however, the *Tabulae Iliacae* are no joke. Behind their apparent triviality— indeed, framed within it—are the kernels of a much more momentous vision. If, as I argue, the tablets materialize a culturally grounded, Hellenistic aesthetics of play, that aesthetic can deliver a timely and much-needed corrective to our own models of figuring visual and verbal communication in the twenty-first century.[63] Myrmecides and Callicrates would have very much appreciated the point: size might not be everything, but sometimes even the smallest objects have the greatest capacity to rescale *how* we think.

CODA: A TEXT IN *YOUR* HANDS

Like the miniaturist projects with which this chapter began, and indeed like the *Tabulae Iliacae* themselves, this book is a small artefact with big ambitions. Despite (or rather because of) my little subjects, the objective is to use the *Tabulae Iliacae* to tease out some of the largest and most pressing questions facing the study of classics, classical archaeology, and classical art history—and indeed the humanities at large.

For this reason, the book is intended to address a variety of readers: not just classical scholars and students, but anyone interested in the knotty problems that

[62] Horsfall 1994: 80.

[63] As such, the project is intended as a sequel to ideas explored in Squire 2009: especially 1–193; where that book looks to the grand theoretical macroscale, this book focusses on a single miniature case study.

bind together cultural discourses of signification across times, places, and cultures. As always, the *Tabulae* have foreshadowed my project. Some will doubtless read the book as most classicists have read the *Tabulae*—scrutinizing its details, magnifying glass to the fore; others will turn over that lens, making its details smaller, zooming out beyond the specificities of Graeco-Roman cultural history, perusing the bigger picture. With this divided audience in mind, I have tried not to omit points of detail and bibliography; but I have tended to relegate them to the footnotes, which are deliberately extensive. As is already clear from this opening chapter, these references may either be dissected or deferred, according to personal preference: 'glide whichever way you choose'.

One final word about citations. The book will translate all 'primary' passages of ancient Greek and Latin. As for 'secondary' sources in languages other than English, it seemed right to translate these in the main text (with the original provided in the footnotes). But it struck me as overly *künstlich* to translate citations in the footnotes: after all, the tablets themselves toy with the fictions (and wit) of translation—in size, medium, and language; writing the book in a country where English is not the *lingua franca*, moreover, I have learned from bittersweet experience that ideas must always depend upon our modes of formulating them. If nothing else, these citations will give a spectrum of some alternative voices—and thereby, I hope, some alternative approaches.

Putting the Pieces Together

Such an upbeat introduction to the *Tabulae Iliacae* will perhaps court disappointment. At first sight, the tablets look deeply unpromising objects, conspicuous not for 'iconotextual' quality but rather for their (grossly) fragmentary state of preservation. Some of the fragments are just a few centimetres square, while others have chipped surfaces that are at best worn, at worst indecipherable. In fact, only two of the 22 *Tabulae Iliacae* survive more or less complete (17M, 19J): the others present fragmented fractions of what was once to be seen. To make matters worse, two of the tablets were lost in the twentieth century: the so-called *Tabula Sarti* (6B) is known only through nineteenth-century descriptions and a line drawing, and the *Tabula Thierry* (7Ti) survives through a single photograph.[1]

But by looking carefully at the fragments, and by comparing individual examples, it is nevertheless possible to reconstruct some of the original designs, compositions, and appearances. What emerges is a group of objects which are in some senses different from one another, but in other ways closely aligned and affiliated: for all the differences in outward form, there are similarities in both concept and execution. Despite having only limited information about find contexts and provenance, moreover, it is possible to say something about the date of the tablets, as well as about their functions.

This chapter therefore begins by offering an overview of the *Tabulae* and their history of scholarship. The aim is not only to provide a formal introduction to the tablets, but also to tackle head-on some of the trickier issues about production and consumption: their coherence as a 'genre', their attribution, their date and medium, and not least the contested issue of their purpose. The exercise of comparing and contrasting tablets necessarily leads to the taxonomic nitty-gritty:

[1] On the (unknown) fate of *Tabula Sarti* (6B), see Sadurska 1964: 48 (the drawing was found among the unpublished works of Emiliano Sarti); on tablet *Tabula Thierry* (7Ti—once part of a private collection, dispersed after 1907) see Sadurska 1964: 51. Salimbene 2002: 15 is nevertheless wrong to label another tablet (3C) 'perduta'. Although it was (apparently?) seen by Nina Valenzuela Montenegro, I have been unable to trace the *Tabula Chigi* (17M): I am told that the tablet is neither in the Palazzo Chigi at Rome nor in Ariccia (sincere thanks to Maria Pia Malvezzi at the British School at Rome for her help). I delay reference to a supposed twenty-third tablet from Cumae, published in 2009, to Appendix II (pp. 413–16).

those interested in such technical details are invited to proceed at my pace; those anxious first to glimpse the bigger argument, returning to minutiae later, might choose to head straight for the conclusions on pp. 85–6—and then glide directly to chapter 3.

ASSEMBLING THE COLLECTION

The *Tabulae Iliacae* have long been the subject of scholarly speculation. Already by the seventeenth century we find them discussed by antiquarians—Raffaello Fabretti, for instance, who mentions some of the tablets in his 1683 dissertation on Trajan's column.[2] Winckelmann also knew the material, referring to the most famous tablet (1A) on two occasions in his ground-breaking 1764 *Geschichte der Kunst des Alterthums*.[3]

As for the attempt to relate different tablets to one another, this gained momentum in the mid to late nineteenth century.[4] The first monograph to treat the tablets as an ensemble was Otto Jahn's catalogue of 1873.[5] Jahn examined all of the 12 *Tabulae Iliacae* known to him, labelling them *A* to *M* (omitting *I*): given the diversity of the material, he preferred the looser generic title 'Griechische Bilderchroniken' ('Greek chronicles in pictures'), associating them with a distinctive development in Greek as opposed to Roman art.[6] Jahn died in 1869, and never completed the project. The final publication of the book was therefore

[2] See Fabretti 1683: 315–84 on tablet 1A, describing the tablet as discovered only recently (*non multis annis ab hinc . . .* , 316). Fabretti 1683: 316 also mentions tablet 14G, and elsewhere he talks of tablets 3C and 10K (cf. Myres 1958: 55–6 and Micheli 2006). Tablet 19J seems to have been known and discussed even earlier: see Stephani 1854: 4–13, Cain 1989: 194–5, and Herklotz 1999: 90–1 (the earliest mention is by Pietro Vettori, *c.*1534). The earliest literary reference to a lost but evidently similar tablet (inscribed in Greek) is by Michael Psellos, in a letter most likely written to the Emperor Constantine X Doukas in the eleventh century: Psellos describes a tablet with Odyssean scenes and Greek captions (see Dostálová 1986 on Kurtz and Drexl (eds.) 1941: 207–9, no. 188).

[3] See (in English translation) Winckelmann 2006: 206, 310; cf. the earlier discussion of idem 1760: 384.

[4] On the earlier history of scholarship, see generally Sadurska 1964: 21–2 (together with ibid. 25 on tablet 1A specifically); Valenzuela Montenegro 2004: 11–15; and Puppo 2009: 839–40.

[5] See O. Jahn 1873. As Sadursks 1964: 21 emphasizes, there were nevertheless earlier articles that attempted to do something similar: particularly noteworthy are de Longpérier 1845, Stephani 1854 (especially 206–83), and Reifferscheid 1862 (on the collective function of the tablets).

[6] O. Jahn 1873 contained only one tablet (12F) that had not previously been published: see ibid. 6, 25. The title 'Bilderchroniken' seems to have been borrowed from a group of late fifteenth- and early sixteenth-century Swiss books which combined pictures and texts to chronicle the history of the Swiss Confederacy on the eve of the Reformation: the name apparently reflects the view that the tablets had an elite, political relevance, but neither Jahn nor Michaelis comment on the preferred generic title. Lippold 1932: 1886 judges Jahn's name for these ' "kyklische" Tafeln' preferable to 'Tabulae Iliacae', although it has otherwise found little favour.

undertaken by Jahn's equally distinguished nephew, Adolf Michaelis (the dual authorship accounting for some of the discrepancies in argument between the volume's different parts).[7] Like his uncle before him, Michaelis had been trained first and foremost as a classical philologist: revealingly, the authors consequently chose to treat the visual aspects of the tablets separately from their verbal texts—surveying first their iconography, and second their inscriptions.[8]

The appearance of Jahn and Michaelis's German catalogue sparked immediate interest in the tablets. On the one hand, fragments which had long since been known received revised iconographic analyses, in keeping with the scientific standards of the newly professionalized discipline.[9] On the other, new tablets continued to be published in Jahn's wake. By the end of the nineteenth century, 18 such objects were known.[10] New discoveries and publications meant that discussions remained almost as piecemeal as the fragmentary tablets themselves. In the late nineteenth century, as in the twentieth, moreover, different scholars occupied themselves with different (albeit interrelated) questions: the subjects of the lost poems depicted,[11] their relationship with Latin literary works (especially the *Ilias Latina*),[12] and, above all, their association with a Hellenistic tradition of book illustration.[13]

The fragmentation of these various discussions provided the impetus for Anna Sadurska's French catalogue of 1964, published in association with the Centre of Mediterranean Archaeology at the Polish Academy of Sciences in Warsaw.[14]

[7] Michaelis explains his own contributions in O. Jahn 1873: v–viii: his own work is said to begin at p. 54.

[8] See ibid. 9–60 (on the iconography) and 60–92 (on the inscriptions). Such separation of the material into 'images' and 'texts' very much continues: it is epitomized by the publication of the tablets in *IG* 14: 328–47, nos. 1284–93, which, while discussing the inscriptions, makes only passing reference to the images.

[9] Fundamental here is Mancuso 1909 – a very detailed analysis of tablet 1A which (among other things) established a new reading of the tablet's epigrammatic distich (see below, pp. 103–4).

[10] Five additional fragments were published during the final quarter of the nineteenth century: see Robert 1875 (on 13Ta); Rayet 1882 (= Rayet 1888: 184–8) (on 7Ti); Stornaiuolo 1882 and 1891 (on 16Sa: following Michon 1899: 376 and Weitzmann 1941: 166; I have not been able to consult the publication); Bienkowski 1891 (on 4N and 5O). Michon 1899: 373–6 counts only 12 tablets (1A, 3C, 4N, 5O, 6B, 7Ti, 8E, 9D, 11H, 12F, 13Ta, 16Sa—following the later numbering system) because non-Trojan subjects are omitted.

[11] Particularly important was the attempt to use tablet 1A as a means of reconstructing the *Ilioupersis* of Stesichorus—an ongoing scholarly endeavour (see above, pp. 18–19 n. 54): see e.g. O. Jahn 1873: 32–8, Paulcke 1897 (*non uidi*), and Mancuso 1909: 704–26.

[12] See e.g. Brüning 1894, with review of bibliography in Michon 1899: 378–9.

[13] Cf. e.g. Wilamowitz-Moellendorff 1898. Michon 1899 offers the best survey of research at the end of the nineteenth century.

[14] Sadurska 1964—with arguments anticipated in eadem 1959 and 1963. Fundamental to Sadurska's new arguments about attribution and workshops was tablet 2NY, purchased by the New York Metropolitan Museum of Art in the early twentieth century (see Pinney 1924: 240–1), and reappraised in an influential article by Kazimierz Bulas (Bulas 1950: 112–14).

Sadurska states that her research was founded upon the rediscovery of a single tablet (11H) in Warsaw's Muzeum Narodowe, lost for some 200 years:[15] in the course of researching that tablet, Sadurska claims, she recognized the need for a holistic reappraisal of the material.[16] Sadurska's catalogue discussed 19 tablets in total, including one fragment (15Ber) that had not previously been published.[17] Devising a numerical system for cataloguing the tablets from 1 to 19, and combining this with a series of alphabetical letters after the manner of Jahn's catalogue almost a century earlier,[18] Sadurska divided her study into three parts. Although the book offers a three-chapter introduction on 'généralités', as well as a two-page conclusion on the epic cycle in ancient art, its main focus was to provide an up-to-date inventory of the material (this second part of the book occupies 72 of the 108 pages). The description is accompanied by 19 black and white plates: although of variable quality, these loose pages have provided the most accessible photographic archive to date.[19]

Three additional tablets have been published since 1964, all of them closely associated with the other objects in Sadurska's catalogue (20Par, 21Fro, 22Get).[20] Although Sadurska's book has remained the standard reference for all subsequent discussions, there were nevertheless problems, not least with Sadurska's brief visual analyses, and more generally with her reluctance to discuss iconographic parallels: in fact, at 108 pages, her book had aimed at brevity and consolidation rather than encyclopaedic totality.[21] This explains the genesis of by far the biggest and most detailed catalogue, written by Nina Valenzuela Montenegro and published in 2004. While Valenzuela Montenegro proceeds to tackle much grander questions—about ancient book illustration, for example, the philological contents of the tablets, and their purpose—the bulk of her book is

[15] Cf. Sadurska 1959: 119; 1961.

[16] See Sadurska 1964: 5: 'Lorsque j'étais en train de préparer la publication il fût évident que toute la catégorie de monuments dont ce relief faisait partie a été négligée, sinon oubliée, depuis de longues années. Et pourtant elle présente une valeur indéniable au point de vue esthétique et documentaire, puisqu'elle constitue un témoignage archéologique, fort important pour l'histoire de la société romaine au début de l'empire.'

[17] Cf. ibid. 71.

[18] The 'désignation' is explained in ibid. 7: cf. below, pp. 55–6.

[19] The 46 plates in Valenzuela Montenegro 2004 are not only much smaller, but also of poorer quality. Interestingly, neither Sadurska nor Valenzuela Montenegro provide pictures of other iconographic comparanda: such is the epistemology of the catalogue.

[20] Two tablets were published from the Froehner collection (for the history, see Hellmann 1983): Sadurska herself published the first (Sadurska 1966 on 20Par—but omitting reference to the reverse 'magic square' inscription: cf. Horsfall 1983: 144–5); Horsfall 1983 published the second (21Fro). A third tablet (22Get) was published by Burstein 1984 (with additional comments in Merkelbach 1989). The first assemblage of all 22 tablets was by Nicholas Horsfall in *IGUR* 4: 93–8, nos. 1612–33.

[21] Cf. Sadurska 1964: 95: 'nous présentons brièvement les monuments et la discussion dont ils ont été l'objet, tout en notant la bibliographie la plus récente qui les concerne'.

dedicated to a thorough and 'objective examination' ('wertfreie Betrachtung') of the objects themselves.[22] Quite how 'value-free' this study really is may be open to debate: one of the aims of the current project is to show how (the tablets show how) ideology must always belie classification, especially when window-dressed as 'objective'.[23] Still, the depth and breadth of Valenzuela Montenegro's study makes it foundational to all subsequent work on the *Tabulae*—this book very much included.

ONE GENRE OR MANY?

For all their differences in approach and presentation, the catalogues by Jahn, Sadurska, and Valenzuela Montenegro all assume one thing: that the tablets can be understood as a single genre of Roman (or in Jahn's case 'Greek') art.[24] Certainly, the tablets have their miniature scale in common, as well as their marble medium; all of the tablets, moreover, combine low figurative reliefs with Greek inscriptions.[25] Other than that, though, the tablets are remarkably diverse: 'the common name', writes Nicholas Horsfall, 'conceals a bewildering artistic farrago'.[26] As we shall see, at least one of the tablets is considerably later in date than the others.[27] It is also clear that a variety of compositions and shapes were employed: while some tablets were square, others were certainly rectangular, and two (tablets 4N and 5O) seem to have been circular (see Table 1).[28]

[22] Valenzuela Montenegro 2004: 15, discussed above, p. 20. The subsequent catalogue occupies over three-quarters of the book (19–335), with 'übergreifende Fragestellungen' reserved for its final section.

[23] Contrast the sage comments of Gordon 1979; 1980: 200–1: 'It must surely be obvious that the task of exploring relationships between complex artefacts in the history of art can never be "value-free" in the sense that is so frequently pretended' (201). Valenzuela Montenegro's work derives from a 2002 Munich doctoral dissertation: if the truth of Gordon's complaint is still not 'obvious' to many Anglo-American classical archaeologists, it is still less acknowledged within the German doctoral system from which Valenzuela Montenegro's study derives.

[24] Cf. e.g. Bulas 1929: 124, calling the 'tables troyennes' 'un groupe très homogène'.

[25] The size of the tablets, together with their Greek inscriptions, have been central to most twentieth-century attempts to define the 'genre': cf. e.g. Sadurska 1964: 7; Salimbene 2002: 5; Valenzuela Montenegro 2004: 9. For some earlier attempts to define the tablets as a 'class', cf. e.g. O. Jahn 1873: 1 and Lippold 1932: 1891.

[26] Horsfall 1979a: 26. As will become clear in what follows, my own thinking is closer to that of Valenzuela Montenegro 2004 ('Material, Technik und Format verbinden die Tabulae Iliacae zu einer unter sich eng zusammengehörigen Gruppe', 298). But I am not so convinced about Valenzuela Montenegro's theory of a single workshop (cf. below, pp. 57–8).

[27] See below, pp. 60–1 on tablet 19J.

[28] Table 1 is adapted from Sadurska 1964: 13–14; cf. Salimbene 2002: 18–19 and Puppo 2009: 830–2.

TABLE I. Table listing the size of surviving fragments and their supposed original dimensions (following the proposed sizes of Sadurska 1964).

	Size of surviving fragment, mostly following Sadurska 1964 (cm: height, width, and maximum depth where known or measurable)	Original surface area, as proposed by Sadurska 1964 (cm: height, width)*
1A	25 X 30 X 1.5	25 X 40
2NY	18.1 X 17.6 X 2.5	29 X 29
3C	10 X 10 X 2.2	24 X 26
4N	17.8 (diameter); 4.2 (depth)	17.8 (diameter)
5O	10 X 15.5 X 1.5	c.40 (diameter)
6B	unknown	unspecified
7Ti	7 X 10	17.5 X 20
8E	8 X 11 X 0.8	22 X 23
9D	5.5 X 6.7 X 1.3	24 X 24
10K	4.5 X 8.5 X 1.1	unspecified
11H	11 X 14.5 X 0.6	11 X 14.5
12F	5 X 7 X 1.2	5 X 8
13Ta	9 X 8.7 X 0.6	15 X 8.5
14G	10.3 X 7 X 2.2	unspecified
15Ber	9.3 X 6.5 X 2.4	unspecified
16Sa	20.4 X 17.2 X 1.6	20.4 X 22
17M	15.5 X 9	15.5 X 9
18L	8 X 9 X 1.6	unspecified
19J	25 X 24	25 X 24
20Par	6.5 X 8.8 X 2	n/a
21Fro	7 X 6.4 X 1.8	n/a
22Get	7.5 X 5 X 2	n/a

*The present book offers some alternative reconstructions of size: see the discussions below of tablets 2NY (pp. 178–81n. 116) and 5O (p. 307n. 7); cf. also below pp. 186–90 on tablets 9D and 20Par.

Even more diverse are the subjects represented on the tablets (see Table 2). As Jahn recognized in 1873, 'Tabulae Iliacae' is in some sense too restrictive a name for these objects: by no means all of them deal with 'Iliac' (i.e. 'Trojan') subjects, and still fewer engage with the *Iliad* per se.[29] While thirteen tablets are very clearly associated with the *Iliad* (or at least episodes from it), five of these depict the epic alongside other

[29] Sadurska 1964: 7 notes that the first usage of the name *Tabula Iliaca* (in association with tablet 1A) was by Beger 1699. Appropriately enough, the adjective *Iliaca* at once suggests the *Iliad* while outwardly referring simply to anything 'Trojan': the German translation 'Ilias-Tafeln' (uncritically accepted by e.g. Valenzuela Montenegro 2004: 9) effaces that ambiguity. Although not all the Iliac tablets are in fact 'Iliac' in subject matter, this book preserve the title—not just out of academic convenience, but also to convey the overarching semantic coherence of the Ilias-Tafeln.

TABLE 2. Table detailing the various subjects of the *Tabulae Iliacae*, based on the identification of their surviving sections; (ins.) indicates extant inscriptions that refer to non-extant parts of the fragments.

	1A	2NY	3C	4N	5O	6B	7Ti	8E	9D	10K	11H	12F	13Ta	14G	15Ber	16Sa	17M	18L	19J	20Par	21Fro	22Get
Iliad (Books)	• 1, 13–24	• 19–24	• 1–5	• 18	• 18	• 1–9			• 22–24			• 24	• 22 (+?)	• 14–18	• ?3					• 17–20	• 22–24	
Ilioupersis	•	•	•	•	•	•	•	•	•													
Aethiopis	•						•		•											•		
Little Iliad	•						• (ins.)															
Odyssey (Books)							• (ins.)					• 10					• ? 3–16					
Theban cycle									? (ins.)													
Heraclean cycle										•									•			
Historical subjects																	•	•		•		•

poems from the Trojan cycle—the *Little Iliad*, *Aethiopis*, and most frequently the *Ilioupersis*—and one tablet depicts Homer reading a scroll alongside a verbal résumé of the *Iliad*. Moreover, five additional tablets, at least in their surviving state, refer to epic events other than those in the *Iliad*. As for the remaining four tablets, one represents Alexander's victory at Arbela (Gaugamela), two depict chronicles of Graeco-Roman history, and a fourth catalogues the various labours of Heracles.

So what, if anything, do the tablets have in common? How do their designs, subjects and compositions compare? Indeed, is there any sense in talking of a category of '*Tabulae Iliacae*' in the first place?

To begin answering those questions, it might be helpful to look in further detail at one of the best surviving and most detailed fragments, already introduced in the previous chapter (Fig. 4). This object, tablet 1A, by far the most famous of the *Tabulae*, is to be found in Rome's Musei Capitolini—hence its widespread modern name, the *Tabula Capitolina* or 'Capitoline tablet'.[30] As we have said, the surviving fragment measures 25 x 30 cm: it is nevertheless packed with some 250 figures, many of them labelled in accompanying inscriptions. The composition is split into several discrete but overlapping parts: I reproduce here a drawing by Louis Schulz, commissioned to accompany Jahn's 1873 catalogue (Fig. 5).[31] To the centre left of the tablet is depicted the sack of Troy: above, we see the city surrounded by its walls, and below the area immediately outside it. The protagonists of this lower scene are individually named in a series of inscriptions—to the left, the tomb of Hector, to the right, the sacrifice of Polyxena; below, in a receding line, we see the Greek ships and (in another ship opposite them) the departure of Aeneas from Troy. To the right of this large central scene is a monumental stela, inscribed with 108 lines of Greek: the text offers a prose summary of events described in the *Iliad*, starting at around *Il.* 7.433, and ending with the final book of the poem.[32]

The stela has a structural as well as an epigraphic function, separating the different parts of the composition. If we witness on one side the fall of Troy, a series of 12 self-contained friezes occupies the other. These lateral bands are arranged in vertical order and correspond to the final 12 books of the *Iliad*: each frieze is inscribed (at its upper left) with the corresponding letter of the book that it depicts—from *nu* (book 12, at the bottom) to *omega* (book 24, at the top). Because, contrary to Feodor Ivanovich's early nineteenth-century reconstruction (Fig. 41), the straight right-hand extremity of the tablet survives (Colour Plate III.4), we

[30] For a much more detailed examination of this tablet's composition, with an extensive bibliography (including material up to 2002), see now Valenzuela Montenegro 2004: 22–149. I have not been able to consult Maras (ed.) 1999.

[31] On the drawing, see O. Jahn 1873: 3.

[32] For the text (with German translation), see Valenzuela Montenegro 2004: 28–32, together with the discussion at 368–76; cf. Sadurska 1964: 29–31 and *IG* 14: 328–33, no. 1284.

know that these lateral bands formed the tablet's original edge: at its right-hand side, at least, the *Tabula Capitolina* tabulated the *Iliad* in pictures, just as the words on the stela monumentalized the poem in words.

The compositional layout of the surviving right-hand part of the tablet allows us to be confident in reconstructing its missing left-hand edge: a parallel pilaster once flanked the other edge of the central *Ilioupersis* scene (Fig. 6).[33] The design, in other words, was symmetrical: where the surviving right-hand stela summarized the seventh to twenty-fourth books, the left-hand stela must have offered a synopsis of the poem's earlier part.[34] Just as books 12 to 24 of the *Iliad* were depicted to the right of the surviving stela, moreover, the first twelve books, from *alpha* to *mu*, were arranged in a series of corresponding friezes to the left of the left-hand pilaster (Fig. 7). The frieze directly above the central depiction of the *Ilioupersis* confirms the point. As the iconography and inscriptions confirm, the band relates to the first book of the *Iliad*—from Chryses' expedition to Agamemnon (at the left of the surviving tablet) to Thetis' appeal to Zeus (above the surviving right-hand pilaster). The first book of the poem meets and joins with the last (Fig. 64): stretching from the left-hand extremity and over the centre of the tablet, this upper frieze was given a length and importance exceeding all others.[35]

Below the central scene of the Fall of Troy is an additional pair of friezes, laid out within a single pictorial frame. As with all the other poems depicted, a series of inscriptions name the subjects (Fig. 35): just as the inscription below the gates of Troy labels the central panel as the '*Ilioupersis* by Stesichorus', the inscriptions directly above this lower frame identify the various other poetic subjects—the '*Iliad* by Homer, *Aethiopis* by Arctinus of Miletus, *Little Iliad* as told by Lesches of Pyrrhaea'.[36] The upper border of the frame is inscribed with an additional inscription—this time an elegiac couplet, written in still larger capital letters. This epigram, and its relation to an associated couplet inscribed on tablet 2NY, will be the subject of the following chapter (pp. 102–21). For our immediate purposes, it is enough simply to note that the distich connects the object with

[33] See Mancuso 1909. In fact, this mode of reconstructing the tablet seems as old as its discovery itself. According to Fabretti 1683: 316, the canon who discovered it (Arcangelo Spagna) spent much time subsequently searching the area for its missing left-hand section: he immediately recognized the original compositional layout.

[34] Valenzuela Montenegro 2004: 368 suggests that the left-hand epitome of the poem must simply have been more detailed than that inscribed on the right-hand pillar; she also notes a similar prioritizing of the earlier books of the poem in the *Ilias Latina* (following e.g. Mancuso 1909: 694 n. 2). It is possible (though unlikely) that the left-hand stela offered synopses of other texts besides.

[35] On the interpretive significance of this composition, see below, pp. 166–71.

[36] The series of inscriptions read as follows: Ἰλίου πέρσις κατὰ Στησίχορον. Τρωικός· Ἰλιὰς κατὰ Ὅμηρον, Αἰθιοπὶς κατὰ Ἀρκτῖνον τὸν Μιλήσιον, Ἰλιὰς ἡ μικρὰ λεγομένη κατὰ Λέσχην Πυρραῖον. On the central adjective Τρωικός ('Trojan')—written in the largest letters—see below, p. 253.

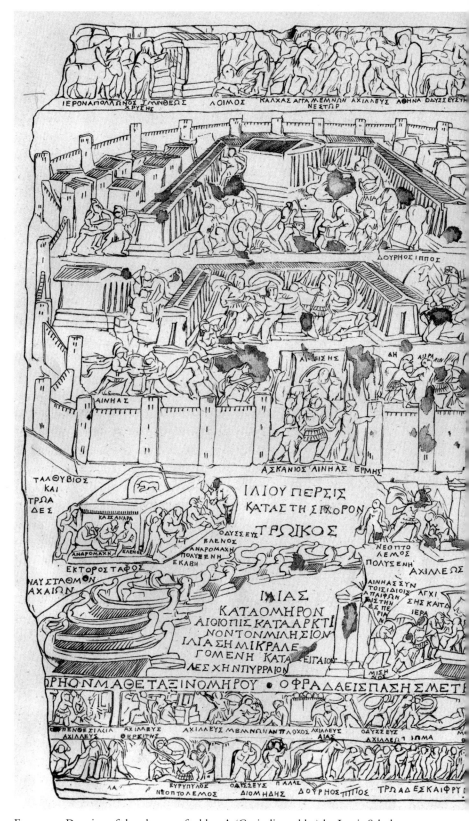

FIGURE 5. Drawing of the obverse of tablet 1A (Capitoline tablet) by Louis Schulz.

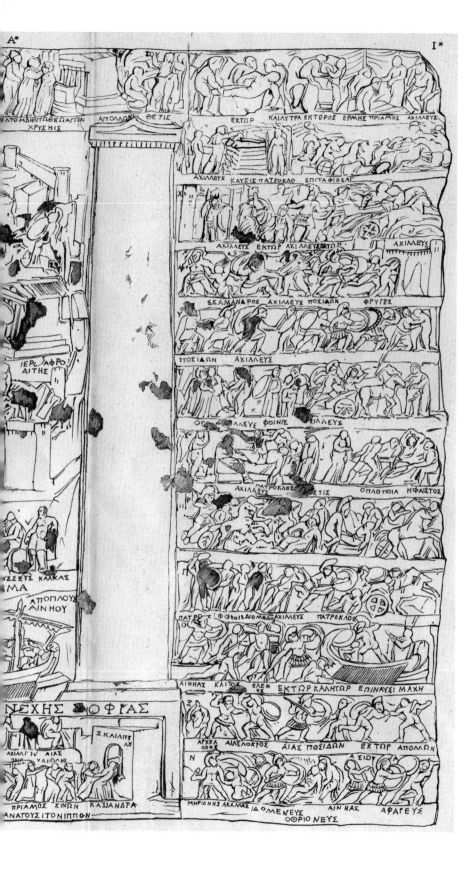

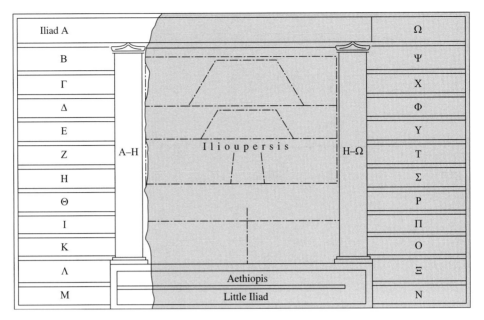

FIGURE 6. Reconstruction of the obverse of tablet 1A.

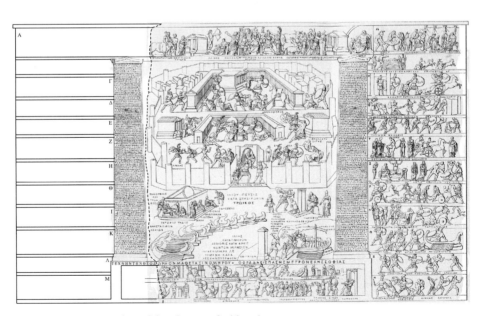

FIGURE 7. Reconstruction of the obverse of tablet 1A.

a particular name: it associates the tablet with what it labels 'Theodorean *technê*' — that is to say, with the 'craftsmanship' of a certain 'Theodorus'.[37]

How typical is tablet 1A of the *Tabulae Iliacae* at large? As always with these objects, there are both similarities and differences (Table 3).[38] Certainly, as we shall see in the fourth chapter, no other fragment shared the Capitoline tablet's compositional arrangement precisely. But the way in which the tablet arranged the individual books of the *Iliad* around a central *Ilioupersis* scene is nonetheless paralleled on at least four other reliefs (2NY, 3C, 6B, and 9D): despite preserving the tablet's upper left-hand corner alone, for example, fragment 3C preserves a similar layout, with friezes of the first five books of the *Iliad* framing a central Trojan cityscape (Fig. 8); similarly, the telltale city walls to the right of fragment 9D suggest a similar composition on this tablet (Fig. 9). The general compositional formula, whereby the events of other Trojan epics are structured around a focal *Ilioupersis*, also bears comparison with two additional fragments — the first (7Ti) depicting the *Aethiopis* around the *Ilioupersis*, and the second (8E) inscribed with a scholarly controversy about the number of days described in the first book of the *Iliad* (Fig. 10).[39] Although some of the other tablets depicting the *Iliad* are more fragmentary, it is at least possible that their original compositions attempted something similar to the *Tabula Capitolina*. We cannot be absolutely certain about the arrangement of tablets 12F (Fig. 11), 13Ta, 15Ber, 20Par, and 21Fro, for example; still, it is nevertheless probable that at least some of these fragments formed part of comparable compositions, even if scaled down or abridged.[40]

There are further affinities between the Capitoline tablet and the others. A number of fragments mirror the Capitoline tablet's mode of juxtaposing visual

[37] See below, pp. 105–21 on the significance of the Greek noun *technê*, as well as pp. 283–302 on the 'Theodorean' identity behind it.

[38] For a rather different (and much more detailed) discussion of the compositional and conceptual ways in which tablet 1A relates to the other fragments, see Valenzuela Montenegro 2004: 298–304 (especially 298–300).

[39] On the 'Zenodotean' inscription of tablet 8E, see below, pp. 99–101. Both fragments display an unmistakeable structural parallel with the Capitoline tablet: fragment 7Ti very clearly mirrors the overall composition of the Capitoline tablet's *Ilioupersis* scene; the inscribed text of tablet 8E, moreover, also occupies the same sort of monumental pilaster that is used to frame the Capitoline tablet's *Ilioupersis* scene. The letters inscribed on tablet 8E are even smaller than those of the pilaster on tablet 1A: the band measures 8.5 x 2.3 cm, and is inscribed with 64 lines of text (cf. de Longpérier 1845: 441). There is also a compositional difference: unlike other tablets (e.g. Fig. 60), 8E depicted Troy with one trapezoidal portico rather than two, with scenes of battle above, and two rows of figures to the left (cf. Valenzuela Montenegro 2004: 207).

[40] Tablets 12F and 13Ta appear to relate to only a single book (12F) or a few books (13Ta) of the *Iliad*, even though they preserve some of their original edges: like tablet 11H, these fragments formed probably part of 'kleinere[n] Tafeln' (Valenzuela Montenegro 2004: 20). For the arrangement of scenes on tablets 20Par and 21Fro, see below, pp. 185, 187–91.

TABLE 3. Table detailing some of the common features of the surviving *Tabulae Iliacae* fragments.

	1A	2NY	3C	4N	5O	6B	7Ti	8E	9D	10K	11H	12F	13Ta	14G	15Ber	16Sa	17M	18L	19J	20Par	21Fro	22Get
Organized around central *Ilioupersis*	•	•	•	•		•	•	•	•											?	?	
Inscribed Greek verbal summaries	•	•	•	•	•	•	•	• ('Zenodotean')	•	•	•	•		•			•	•	•	•	•	•
'Theodorean' ascription	•	•	•	•	•															•		
Reverse inscription (+ 'magic square' formation?)		+	+	+	+		+		•	•				•	+			•		+		•

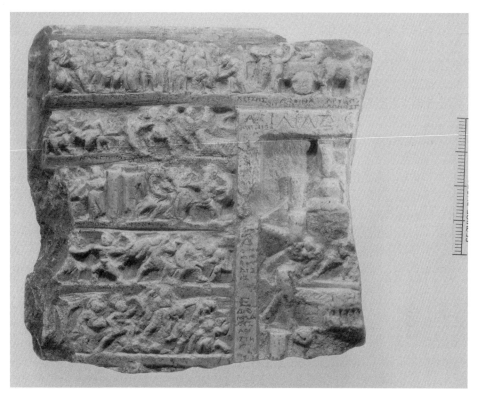

FIGURE 8. Obverse of tablet 3C.

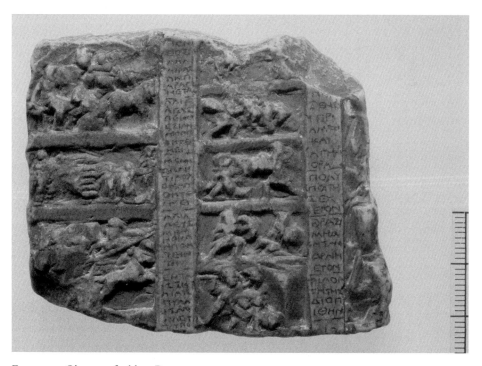

FIGURE 9. Obverse of tablet 9D.

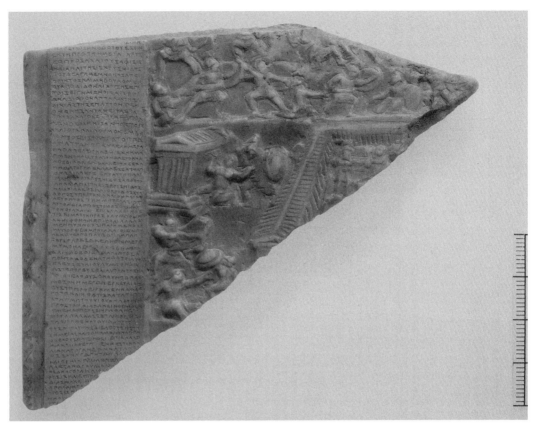

FIGURE 10. Obverse of tablet 8E.

depictions of the *Iliad* with epitomes in prose or verse, for example;[41] and the way in which the Capitoline tablet associates itself with 'Theodorean *technê*' is paralleled on five further fragments (2NY, 3C, 4N, 5O, and 20Par). So too are a number of tablets decorated on both their reverse and obverse sides. While the Capitoline tablet is decorated only on its recto, seven other tablets—some again boasting their 'Theodorean *technê*', and some with an obverse design very similar to that of the *Tabula Capitolina*—were inscribed with a 'magic square' diagram on their reverse, establishing a further matrix of connections (2NY, 3C, 4N, 5O, 7Ti, 15Ber, and 20Par).[42] These 'diagrammatic' inscriptions will be the subject of the fifth chapter: their letters, as we shall see, were laid out in grid formation,

[41] A number of tablets (2NY, 3C, 6B) summarized events in a few titular phrases inscribed underneath the carved scenes; but at least two (6B, 12F) did so through additional metrical résumés (see below, pp. 96–7).

[42] Of these seven objects, moreover, tablets 2NY, 3C, and 20Par clearly parallel the recto compositional arrangements of the Capitoline tablet (albeit in individual, creative ways); there are also clear iconographic parallels between the Capitoline tablet and tablet 4N (see below, pp. 331–5).

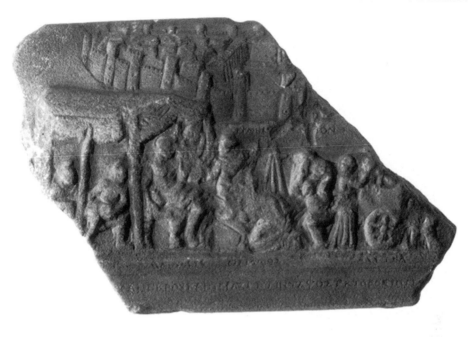

FIGURE 11. Obverse of tablet 12F.

allowing readers to move across the inscribed texts 'in whatever direction' they choose.

So far we have touched upon just 14 of the fragments (1A, 2NY, 3C, 4N, 5O, 6B, 7Ti, 8E, 9D, 12F, 13Ta, 15Ber, 20Par, 21Fro). What, then, of the remaining tablets: to what extent can these be compared with the subjects, inscriptions, and compositions of the *Tabulae Capitolina*? It is worth emphasizing outright that there are conspicuous differences in theme and appearance. Still, the various iconographic and conceptual affinities suggest the heuristic value of discussing the tablets as a collective. This is particularly clear in the case of a fifteenth fragment, tablet 14G, which offers on one side a portrait of Homer with a scroll (set below a highly fragmentary summary of the *Iliad*), and on the other a single image of combat (drawn either from the *Iliad*—or perhaps more likely, from the *Ilioupersis*): despite its compositional differences, the rationale of this tablet is clearly related to that of others.[43]

As for the remaining seven *Tabulae Iliacae* (10K, 11H, 16Sa, 17M, 18L, 19J, 22Get), the connection relates as much to their conception as to their design. So

[43] For the interpretation that the verso depicts the *Ilioupersis*, see O. Jahn 1873: 38, 57 (followed by Valenzuela Montenegro 2004: 253).

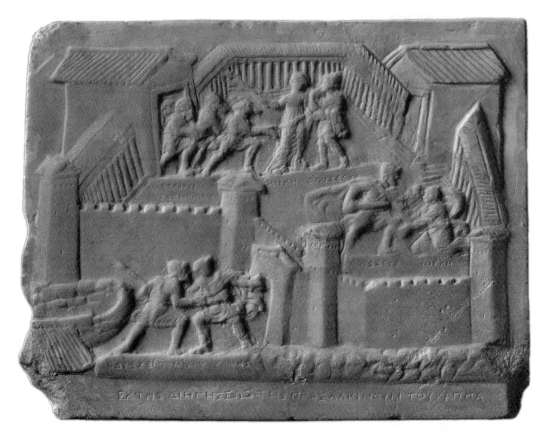

FIGURE 12. Obverse of tablet 11H.

it is, for example, that four tablets perform for other epic poems the sorts of pictorial synthesis that the *Tabula Capitolina* acts out for the Trojan cycle (10K, 11H, 16Sa, 19J). Two of these objects relate to the *Odyssey*. Where other *Tabulae* visualize events from the *Iliad*, Tablets 11H and 16Sa tabulate scenes from the *Odyssey*: tablet 11H relates to the poem's tenth book alone (Fig. 12), while 16Sa winds its single-book pictorial summaries around a central image of Poseidon (just as other tablets arrange their scenes around a central sack of Troy) (Fig. 13).[44] Something similar can be said for tablets 10K and 19J, which relate respectively to a Theban epic cycle and to the heroic exploits of Heracles. Tablet 10K evidently set out to depict a series of Theban subjects in the manner that

[44] On the arrangement of scenes on tablet 11H and 16Sa, see below, pp. 182–5. At least one tablet (6B) seems to have depicted the *Odyssey* alongside the *Iliad* and *Ilioupersis*: the inscription at the top of the fragment suggests that the 24 books of the *Odyssey* were represented at the tablet's base. For an eleventh-century description of another (lost) tablet derived from the *Odyssey*, see above, p. 28 n. 2.

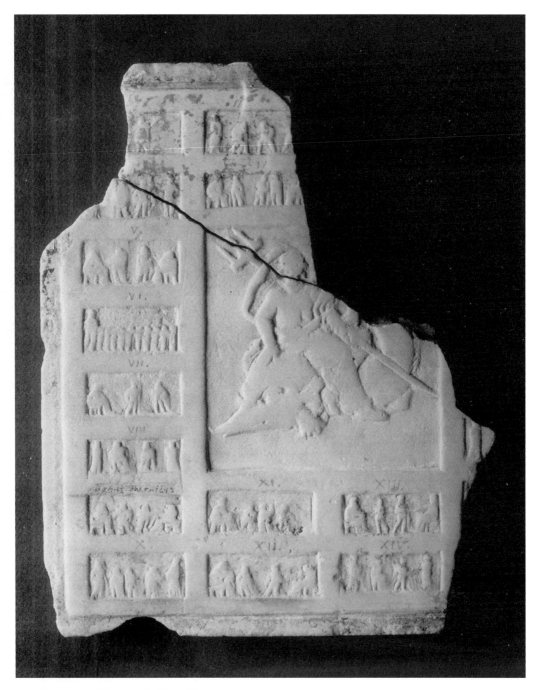

FIGURE 13. Obverse of tablet 16Sa.

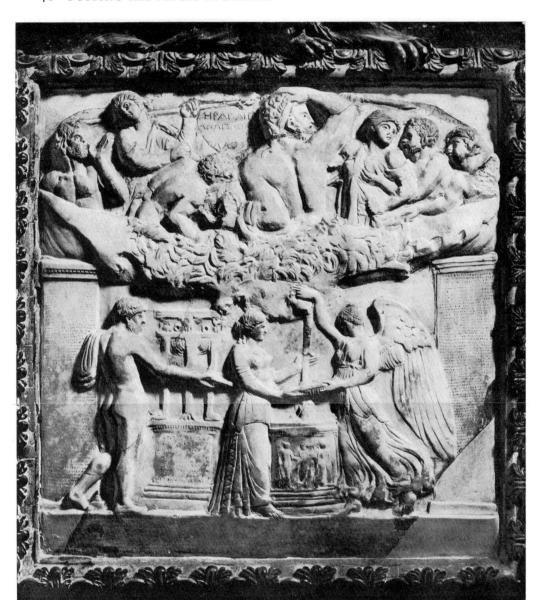

FIGURE 14. Obverse of tablet 19J (in a modern frame).

other *Tabulae* engaged with Trojan stories.[45] Likewise, tablet 19J (Fig. 14) constructs a sort of mini epic around the mythological deeds of Heracles. This tablet—one of the best surviving *Tabulae*, and known since the sixteenth century—does not engage with a known epic text at all. And yet its compositional organization—arranged into different registers, themselves framed to their left and right with symmetrical monumental inscribed pillars—has something in keeping with the design of the Capitoline tablet:[46] the object does for Heracles what other objects had done for Trojan heroes, including not only a monumentalized prose summary, but also 19 hexameter Greek verses (inscribed at the base of the relief).[47]

Our final three tablets (17M, 18L, and 22Get) deviate more substantially from the others. Rather than relating to the literary genre of epic, these tablets are decorated with (epic) historical themes.[48] Alexander the Great provides a common subject on all three tablets: 17M depicts personifications of Europe and Asia supporting a monumental shield, framed by an epigram celebrating Alexander's victory at Arbela in 331 BC;[49] tablets 18L and 22Get, on the other hand, seem to juxtapose images from the life of Alexander the Great on their obverse with lengthy retro inscriptions that chronicle Greek and Roman history.[50]

[45] Note, moreover, that the text inscribed on the obverse of tablet 10K, explaining the genealogy of Cadmus, is manifestly related to a similar inscription found on the reverse of tablet 9D—even though tablet 9D depicted a Trojan cycle of myths on its recto: as Valenzuela Montenegro 2004: 264 concludes, the words 'sind denen der Tabula Veronensis II (D) sehr ähnlich, aber völlig nicht [*sic*] identisch' (the common source seems to have been Apollod. *Bibl.* 3.4.2: cf. Valenzuela Montenegro 2004: 194, and below, pp. 99 n. 47). The surviving fragments are very small, but it is at least conceivable that tablets 9D and 10K depicted *both* Trojan and Theban epic cycles alongside each other. The two myth cycles circulating around Troy and Thebes were understood as different but intricately connected—a sort of narratological yin and yang (cf. e.g. Prop. 2.8.10): it would be wholly typical of the tablets to bring together not only a variety of poems within an epic cycle, but also whole different epic cycles within their frames (*pace* e.g. Horsfall 1979a: 47 n. 177).

[46] For more iconographic and conceptual parallels between tablet 19J and the others, see below, pp. 60–1.

[47] On the relationship between the prose summaries and the inscribed hexameters on tablet 19J, see Valenzuela Montenegro 2004: 411–12. We know that other artists made a pseudo-epic out of the labours of Heracles, and in related ways: cf. the 'Fourth Style' mural cycle in oecus h of the Casa di Octavius Quartio (Pompeii II.2.2) (Figs. 47–8), discussed below, pp. 145–7.

[48] Tablets 17M, 18L, and 22Get are often treated in isolation from the others: for an astute response, see Valenzuela Montenegro 2004: 299–300. It is worth adding that, at least in the Hellenistic and Roman cultural imaginary, the epic deeds of Alexander the Great were intricately bound up with the heroic mythologies of Homer (cf. Zeitlin 2001: 203–7): according to Plutarch, Alexander bemoaned how, unlike Achilles, he lacked a 'great' poet like Homer to immortalize his deeds (*Alex.* 15.8).

[49] See Sadurska 1964: 74–8 and Valenzuela Montenegro 2004: 268–75. I have not been able to consult Puppo 2008.

[50] For the identification of scenes on the obverse of the reliefs, see Valenzuela Montenegro 2004: 294–5; Burstein 1984: 157 instead suggests 'some aspect of the reign of the Persian king Xerxes'. There are no grounds for associating the obverse of 18L with a Virgilian theme, as argued by Sadurska 1964: 82; for bibliography, see Salimbene 2002: 8 n. 7 and Valenzuela Montenegro 2004: 287–8.

FIGURE 15. Obverse of tablet 17M (in a modern frame).

The three tablets might depict a different sort of subject from the others, but their thinking and iconography is nevertheless related. Take first of all tablet 17M (Fig. 15). The way in which the formal composition is arranged around a central image of a shield, supported by two standing female figures, relates to the design of other tablets (not least tablet 6B, with its central upper image of the shield of Achilles);[51] moreover, the circular altar beneath the central shield mirrors similar-looking altars on both tablets 14G and 19J.[52] Tablet 17M seems also to share with the other objects a contemporary political relevance. The issue of the tablets' date is something to which we shall return later in the chapter: as we shall see, almost all of the reliefs can be dated to the late first century BC or early first century AD, and there is a clear Augustan resonance to their particular visions of the Trojan War (with Aeneas frequently taking centre stage). Although the subject of tablet 17M is markedly different, the personification of Europe and Asia might be interpreted as sounding a related Julio-Claudian note: is this meeting of East and West intended as a veiled allusion to the battle of Actium in 31 BC—a commemoration of not only Alexanders' global empire, but also Augustus' own?[53]

Tablets 18L (Figs. 16–17) and 22Get (Figs. 18–19) perhaps also relate to a similar sort of Augustan or Julio-Claudian ideology. Significant here are the interrelated texts inscribed on the reverse of the two fragments: both of them deliver historical chronicles of the past. Of course, the very fact that the tablets are inscribed on both sides establishes a structural affinity with ten other *Tabulae* (see Table 3). But by inviting their users to look at the past through a modern-day perspective, tablets 18L and 22Get also perform something similar to those objects treating Trojan literary themes.[54] Certainly, the two tablets are organized somewhat

[51] The point is well made by Valenzuela Montenegro 2004: 299. We might also note that the very gesture of representing a shield develops an epic ecphrastic conceit: see below, p. 358–9 n. 137.

[52] On the iconographic relationship between these altars, see Valenzuela Montenegro 2004: 271, 299–300. The four-line epigram inscribed on the upper and lower frame of tablet 17M also mirrors those of other tablets—not least the couplet inscribed on one of the internal frames of the Capitoline tablet: for discussion and bibliography, see Valenzuela Montenegro 2004: 269–70.

[53] See especially Sadurska 1964: 77–8 and Valenzuela Montenegro 2004: 418: 'Die Tabula Chigi . . . lässt sich gut im Rahmen der augusteischen Ideologie denken, in der die Überwindung dieser Antinomie eine große Rolle spielt.' The interpretation is challenged by Hardie 1985: 31 ('I see no compelling reason to take it in this way, when the inscriptions so unambiguously refer it to the exploits of Alexander'). But Valenzuela Montenegro 2004: 275 is surely right in seeing the dancing figures depicted on the relief's lower altar, especially the central *citharoedus*, as having a possible Augustan relevance (for the cultural background, cf. Miller 2009: especially 1–14). The tablet materializes a recession of meanings: just as the relief contains a further set of reliefs within it (on the Augustan-charged neo-Attic altar), the Alexandrian past frames a contemporary Augustan relevance. On the tablet's date, see below, p. 61 n. 92.

[54] Valenzuela Montenegro 2004: 300 observes a number of formal similarities between these two tablets and the others. Apart from the miniature format, learned Greek inscriptions and the shallow and stylized manner of the sculptural reliefs, she comments on the presentation of their inscriptions and the

FIGURE 16. Obverse of tablet 18L.

differently to the others: although fragmentary (making it nigh on impossible to
determine overall designs), the lengthy verso texts seem to have been set against
fewer images on their recto side.[55] We can be certain, though, that both frag-
ments privilege the hindsight of the present: the verso texts label each and every
history-defining event in terms of its *distance* from the current year, which can be
calculated as AD 15/16.[56] Just as Aeneas seems to have been central to tablets

retrograde arrangement of tablet 18L's inscribed columns (proceeding from right to left, like the inscrip-
tions on tablet 10K: cf. below, p. 192). She also notes the distinctive and common hand, relating it to that of
tablets 9D and 10K ('der *ductus litterarum* ist zudem identisch mit D and K', with reference to Sadurska
1964: 14; cf. ibid. 304): 'deshalb sehe ich keinen Zweifel, dass diese beiden Tafeln sich ebenfalls der
Gattung der Tabulae Iliacae anschließen'.

[55] The closest parallel is tablet 14G—with its single image of battle on one side, and its portrait and
Iliadic synopsis on the other.

[56] The significance of this date has been much contested, and some have associated it with the founding
of a temple in Bovillae, dedicated to the *Gens Iulia* (following Tac. *Ann.* 2.41: cf. O. Jahn 1873: 81–2): for a
review of bibliography, see Sadurska 1964: 80–2, along with Valenzuela Montenegro 2004: 286–7 (with

FIGURE 17. Reverse of a plaster cast of tablet 18L.

visualizing epic poetic histories, thereby tying the Greek past to the Julio-Claudian present, tablets 18L and 22Get orientate their chronicles around the modern-day. Where other tablets condensed the world of epic poetry into miniature objects to hold in the hand, moreover, these tablets contained the highlights of *all* Graeco-Roman history within their literal and conceptual frames. Despite their different subjects, tablets 17M, 18L, and 22Get extend the concerns of other *Tabulae Iliacae*.

This has been a long survey, briefly introducing each of the 22 tablets along the way. So where does it leave the question of coherence: to what extent do the tablets comprise a single collective group? Despite the discrepancies between surviving fragments, a number of recurring characteristics emerge. These are not just formal characteristics—the miniature size of all the tablets, their Greek

further comments at 295, 296, and 418). But the exact provenance of both tablets 18L and 22Get is unknown; there is also no evidence to associate them—or indeed any other tablet—with Bovillae specifically (see below, pp. 66, 72).

FIGURE 18. Obverse of tablet 22Get.

inscriptions, or repeated compositional traits. As an assemblage, rather, the *Tabulae Iliacae* play upon a shared set of cultural ideas. For all their discrepancies in composition, form, and even arrangement, the tablets engage with a series of related discourses about truncating the large in the little, synthesizing the verbal through the visual, and binding the (Greek) past with the (Roman) present. Comparison has rightly been made to other Hellenistic-Roman artistic products: Archelaus' relief of Homer, for example, with its playful games with image and

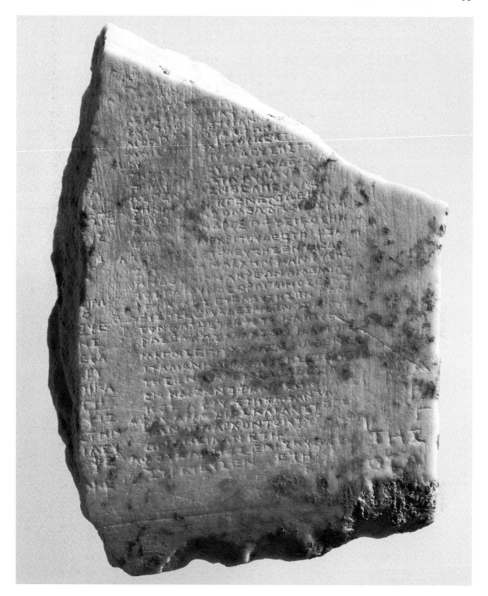

FIGURE 19. Reverse of tablet 22Get.

inscription (Fig. 3);[57] or the so-called Roman 'Mithraic' panels, with their comparable panelled friezes structured around central compositions.[58] Some

[57] On the relief, see above, pp. 8–10. As noted below (p. 66), the Archelaus relief seems once to have been displayed in the same villa as tablet 1A. But with a height of 1.18 m, the object is considerably larger than that Capitoline tablet.

[58] See especially Saxl 1931: 37–40; cf. Will 1955: 432–7; Horsfall 1979a: 35 n. 66; Brilliant 1984: 176 n. 18; Turcan 1993: 59–60; Salimbene 2002: 13; Valenzuela Montenegro 2004: 22–3; Kirichenko 2005: 3. The

have even compared the tablets and their display contexts with the so-called *oscilla*—masks, sculptural reliefs, and circular disks that were hung between columns in Roman gardens so as to 'oscillate' in the wind.[59] But while the tablets share certain traits with other Greek and Roman forms—while, moreover, all scholarly attempts to delimit and contain the boundaries of the 'genre' are bound to be artificial—there is nevertheless something special about the design and rationale of these objects. In sum, this 'farrago' is not quite as 'bewildering' as we have been led to believe.

In this connection, it is worth noting just how many tablets survive. The fact that some 22 *Tabulae* are known to us, each one uniquely different from the other, establishes these apparently 'minor' objects as a fairly major artistic and cultural phenomenon. Most importantly of all, we can be confident that there must once have been still more tablets: the 22 fragments surveyed here probably comprise only a small sample of what was originally a much larger (and perhaps yet more diffuse) band of objects.[60]

WORKING WITH WORKSHOPS

One way of explaining the coherence of the *Tabulae Iliacae*—as well as their deviations in design, subject, and execution—has been to relate them to different albeit related workshops. As so often in classical archaeology, scholars have attributed variables of concept, style, and form to variables of artistic attribution. Although there were earlier precedents, Anna Sadurska's 1964 catalogue epitomizes the endeavour.[61] For Sadurska, close inspection of the 19 tablets

comparison is important: as Gordon 1980 brilliantly shows, the Mithraic panels play with strategies of visual organization, and in ways very similar to those of the *Tabulae Iliacae* (cf. chapter 4 below). But the Mithraic panels are very different in scale and function. They tend to be much less portable objects, intended for a different sort of display context, and without the same literary pretensions: I imagine them to have extended the narrative games of the *Tabulae* within a new religious setting, transforming the tablets' visual–verbal play into a decisive trait of Mithraic cult, epiphany, mysticism, and doctrine. Other scholars have tried to incorporate additional objects within the category of *Tabulae Iliacae*, but they have done so rather less successfully (cf. Valenzuela Montenegro 2004: 16 n. 29): the Gandharan relief classed as a '*Tabula Iliaca*' by Allan 1946, for example, bears no relation to the conceptual and compositional principles of the Iliac tablets.

[59] Cf. below, p. 69 n. 122.

[60] Cf. Valenzuela Montenegro 2004: 304: 'Es muss also relativ viele Tabulae Iliacae gegeben haben, da eine ganze Anzahl von Kunsthandwerkern mit ihrer Herstellung betraut wurde'; Sadurska 1964: 19.

[61] See Sadurksa 1964: 10–15, summarized in Salimbene 2002: 17–29—albeit with numerous mistakes in the table at 18–19: Sadurska 1964: 55 relates tablet 8E to her second group, not to the third (despite Salimbene's own conclusion at 22); likewise, although positing that it was 'une imitation de tables iliaques des ateliers "théodoréens"'(Sadurska 1964: 11), and hence *possibly* attributable to the second group, Sadurska nonetheless associates tablet 16Sa with her third class of workshop. Salimbene appears to have misunderstood the

surveyed proved that a number of distinct and distinctive workshops were in operation: looking not only at the subjects of the tablets, but also at their material, dimensions, composition, style, and script, Sadurska assigned them to four discrete 'groups' of artists, each working with different concerns, in different styles, and with different consumers in mind.[62]

Sadurska's numerical system of cataloguing the objects was very much conceived with this attributive schema in mind. Numbered from 1 to 19, the tablets were related to four separate artistic groups: Sadurska deems that tablets 1–5 correspond with Group I, tablets 6–10 with Group II, tablets 11–16 with Group III, and tablets 17–19 with Group IV.[63] The first category, Sadurska argues, are all explicitly signed by 'Theodorus' (1A, 2NY, 3C, 4N, 5O); what is more, they all depict Iliadic subjects, and most often do so in association with other Trojan poems. The subject matter depicted on Sadurska's second group of objects is similar—and like the first group, often orientated towards contemporary political ends—although these five tablets (6B, 7Ti, 8E, 9D, 10K) do not mention Theodorus by name, and are perhaps slightly later in date.[64] As for the third group, Sadurska labels their artist the 'master of individual scenes' (11H, 12F, 13Ta, 14G, 15Ber, 16Sa): all the reliefs are concerned with the two Homeric epics, arranging their compositions around a central panel; rather than engage with cyclical modes of pictorial narrative, however, this third group experiments with more concise modes of epitomization.[65] Finally, the tablets of Sadurska's fourth group (17M, 18L, and 19J) are judged to exhibit a different mode of design, dealing with historical rather than epic themes: as such, these last three tablets deviate from (what she terms) the illustrative function of the other three groups.[66]

fundamental rationale of Sadurska's catalogue: namely, that her numerical system of referring to the tablets mirrors the system of artistic attribution. For earlier comments on attribution, see e.g. O. Jahn 1873: 26, Lippold 1932: 1891, and the detailed survey in Valenzuela Montenegro 2004: 298–304.

[62] Earlier, Sadurska 1959: 123 had declared that 'l'analyse du style peut donc fournir des preuves qu'il existaient deux ou trois ateliers différents, qui exécutaient les tables iliaques'.

[63] Eadem 1964: 16–17 also assigns a particular chronology to each group.

[64] Ibid. 11: 'Le second atelier—s'il y en avait un—fut sans doute fondé un peu plus tard que le premier, car il ne fait qu'imiter son prédécesseur.' But she nevertheless concedes that at least some of these tablets (especially 6B, 7Ti, and 8E) might also belong to the first group, in which case 'la signature s'étant trouvée soit sur la partie du monument qui ne s'est pas conservée, soit sur un verso que nous n'avons pas connu'. On the supposed attribution of tablet 10K, cf. also McLeod 1985: 154–5.

[65] See Sadurska 1964: 11: 'La manière dont "le maître des scènes uniques" compose son relief est tout à fait différente; il se borne notamment à façonner deux ou trois scènes au plus, chacune ne contenant qu'un petit groupe de personnes, d'habitude deux et ces scènes sont superposées.' Sadurska also suppose that these 'third group' tablets represent Iliadic and Odyssean scenes in isolation from other epic cycles, and to a significantly larger scale.

[66] Ibid. 12: 'Pour tout le IVe groupe nous n'avons trouvé qu'un critérium qui soit commun à tous les monuments qui en font partie, notamment celui, que les sujets des reliefs n'ont aucun rapport avec les poèmes d'Homère.'

As for the stylistic differences between the tablets in each group, and indeed the stylistic affinities between tablets ascribed to different categories, Sadurska suggests an additional variable: different sculptors are supposed to have worked for different groups; sometimes, moreover, recurring stylistic traits show an individual hand to have worked for more than one artistic workshop. Although offering no formal explanation of her criteria, Sadurska identified five hands in total, labelling these from *a* to *e*.[67]

Sadurska's typology has exerted a remarkable influence, and the three tablets published after her 1964 catalogue have each been understood within her broad attributive framework.[68] Challenges to Sadurska's scheme have for the most part pertained to taxonomic detail: there has been remarkably little critique of Sadurska's overarching rationale.[69] Cristina Salimbene, for example, has recently criticized Sadurska's method for its overly schematic delineation of workshops, but she nevertheless holds to many of Sadurska's underlying assumptions.[70] Maintaining a single 'workshop of Theodorus', Salimbene categorizes the tablets according to their supposed 'certain' (1A, 2NY, 3C, 4N, 5O, 20Par), 'very probable' (6B, 7Ti, 8E, 21Fro), 'probable' (9D, 10K, 11H, 12F, 13Ta, 14G, 16Sa), 'uncertain' (15Ber, 18L, 22Get), and 'improbable' (17M, 19J) relation to it. As the inventory numbers once again testify, now stretching from 1 to 22, this revisionist organizational mode simply shuffles tablets between Sadurska's second and third groups: in essence, it subdivides into three categories the tablets which Sadurska had classified into two.

Although it clearly makes sense to compare and contrast the surviving Iliac tablets, such attempts to distinguish so neatly between individual workshops have proved rather flawed.[71] Part of the problem with Sadurska's scheme (and to

[67] Ibid. 14. Sadurska omits the inscriptions on tablets 13Ta and 16Sa on the grounds of their preservation; 6B goes unmentioned, presumably because it is lost (although Sadurska does analyse inscriptions from the lost tablet 7Ti). The other sixteen tablets are attributed as follows: 'Lapicide a' (1A); 'Lapicide b' (2NY, 3C, 4N, 5O, 7Ti, 15Ber); 'Lapicide c' (8E, 11H, 12F, 14G, 17M); 'Lapicide d' (9D, 10K, 18L); 'Lapicide e' (19J).

[68] Cf. e.g. *IGUR* 4:96. Tablet 20Par has been associated with the first group on the grounds of its reverse 'Theodorean' inscription (e.g. Salimbene 2002: 25: cf. Sadurska 1966; Horsfall 1983: 145). Tablets 21Fro and 22Get have been connected with the second and fourth groups on account of their subject matter: on 21Fro, see Horsfall 1983: 146 and Salimbene 2002: 25; on 22Get, see Burstein 1984: 153 ('The Getty *Tabula Iliaca* is the work of Sadurska's Cutter d . . .').

[69] One example is Bua 1971: 13–14: contrary to Sadurska, Bua associates tablets 6B, 7Ti, and 15Ber with the 'bottega di Theodoros' (i.e. with Sadurska's first group)—in the case of 7Ti and 15Ber, on the grounds of their verso 'giuoco alfabetico' inscription.

[70] Cf. Salimbene 2002: 21: 'L'osservazione delle caratteristiche compositive tematiche delle Tabulae Iliacae non permette però di operare una netta suddivisione in botteghe.' But this 'suddivisione' is precisely what Salimbene proceeds to offer in her table at 25.

[71] For related comments, see Valenzuela Montenegro 2004: 300–2, concluding that 'diese [*sc.* vier] Gruppen sollten daher aufgegeben werden' (301).

a lesser extent Salimbene's revision of it) is that the criteria change between different groups: factors that are privileged in characterizing one artistic group do not seem to matter when considering another. If Sadurska's variables vacillate between supposed signature, subject matter, 'quality', and narrative technique, so too her concepts of 'groupe' and 'atelier' slide between 'artist' and 'workshop' accordingly: the separate identification of 'stone-cutters' only aggravates the problem. Then there are the romantic assumptions which Sadurska brings to her understanding of each group: there is absolutely no reason to suppose that the first group of tablets catered specifically to the court of Augustus, for example—and still less to think that the third group was destined for poets, writers, and 'in a word, Roman intellectuals'.[72]

The larger epistemological problem here lies in the assumption that 'similarities' between tablets necessarily prove a single workshop, or conversely that 'differences' necessarily point to different attributions. The argumentation is often circular—not just formal features being used to explain workshops, but conversely workshops being used to explain formal features. It is simply not the case, for example, that all the tablets associating themselves with 'Theodorean *technê*' (Sadurska's first group—tablets 1A, 2NY, 3C, 4N, 5O, 20Par) were produced by a single hand: as we shall see in the sixth chapter, there is more to this 'Theodorean' attribution than some straightforward objective 'signature' alone.[73]

The question of workshop therefore returns us to the overarching issue of the tablets' coherence as a genre. Whenever we try to differentiate between the tablets, we are recurrently brought back to analogies between them: artistic attribution is helpful only in so far as it draws out the simultaneous cohesion and disparity of the *Tabulae Iliacae* as a group.[74] For this reason, it is no less problematic to ascribe the *Tabulae Iliacae* to a *single* workshop than it is to associate them with different artistic groups. This is Nina Valenzuela Montenegro's preferred solution, concluding that the close relationship between the

[72] Cf. Sadurska 1964: 12: 'Si, comme nous l'avons dit, les tables de Théodorus étaient commandées par la cour, on peut bien s'imaginer que celles du IIIe groupe aient orné les maisons des poètes, des écrivains peut-être, en un mot des intellectuels romains, admirateurs d'Homère' (and cf. ibid. 19). For a justly swingeing response, see Valenzuela Montenegro 2004: 410.

[73] For the stylistic differences, see especially Valenzuela Montenegro 2004: 300–2 (on the qualitative difference between tablets 1A and 3C in particular), as well as below, p. 301.

[74] Cf. ibid. 302: 'Hände voneinander zu unterscheiden, ist in Anbetracht der geringen Grösse der Fragmente ein riskantes Unterfangen'—although Valenzuela Montenegro attempts to do so nonetheless (302–4), and her conclusions prove critical to her overall explanation of differences between the tablets (cf. 414). Whether or not we accept the different sculptors that Valenzuela Montenegro identifies, we can surely agree with her conclusion—namely that there were *many* different hands, and that still more artists worked on tablets that no longer survive (304).

tablets points to just one workshop, albeit one that employed multiple artists.[75] And yet, as the author herself admits, by no means *all* of the 22 tablets can be dated to the same period: at least one of them (19J) seem to have been produced at a somewhat later date, and she also prefers to view another tablet (16Sa) as a subsequent—and wholly inferior—'imitation'.[76] If, as Valenzuela Montenegro concludes, the tablets reflect a specific 'whim of fashion' (*Modelaune*), they also seem to have exerted a visual presence within a much longer tradition of Graeco-Roman art.[77]

TECHNICAL QUESTIONS (DATE, MATERIALS, AND PROVENANCE)

Before turning to those supposed later imitations, let me first lay out what *can* generally be said about the tablets' date. Critical here are two different factors, relating first to a point of iconography (the schema of Aeneas fleeing Troy), and second to a chronological detail in the reverse inscriptions of tablets 18L and 22Get (which both count back their histories from the year AD 15/16). These features, corroborated by several others, suggest an early Imperial date, at least for the majority of the tablets—most probably between the late first century BC and early first century AD.[78]

[75] Cf. ibid. 415: 'Der innere Vergleich der Darstellungen hat zusätzlich gezeigt, dass der Zusammenhang zwischen den Tabulae so eng ist, dass man von einer einzigen Werkstatt ausgehen muss, in der die Tafeln in chronologisch dichter Folge entstanden sind, wobei daran mit Sicherheit mehrere Künstler beteiligt waren.'

[76] Ibid. 16 therefore counts only 20 of the tablets as 'proper' *Tabulae Iliacae* (cf. ibid. 415). The mid-to-late second-century date for tablet 19J is beyond question (cf. below, pp. 60–1). But I cannot agree with Valenzuela Montenegro's conclusion about tablet 16Sa ('Jedoch unterscheidet sie [*sc.* Tafel 16Sa] sich von den Tabula [*sic*] Iliacae durch das Fehlen von Szenen, die sich in die ikonographischen Traditionen einordnen lassen, ebenso wie das einer großen Zahl von Inschriften...', 334–5): see below, p. 61 n. 91.

[77] Cf. ibid. 304: 'Eine lange Tradition ist der kleinen Reliefgattung aber nicht beschieden gewesen: Es handelte sich offenbar um eine Modelaune' (and also 412: 'eine eher kurzlebige Modeerscheinung'). For an earlier version of same argument, see e.g. Lippold 1932: 1892: 'es sieht vielmehr so aus, als seien alle Tafeln in einem beschränkten örtlichen und zeitlichen Umkreis entstanden, wobei sich Verbindungen hin und her ergeben mußten'.

[78] For a more detailed analysis of the tablets' date, and a review of earlier bibliography, see Valenzuela Montenegro 2004: 305–9, who argues for a date in the first quarter of the first century AD. Unlike Valenzuela Montenegro, I am not convinced that Sadurska 1964: 16–17 is necessarily wrong to posit a slightly earlier date, in the last quarter of the first century BC, at least for some of the tablets. Again, the issue comes down to the coherence of the tablets as a group and their supposed attribution: for Valenzuela Montenegro the tablets, 'die sich ja inhaltlich und stilistisch als Produkte einer Werkstatt zusammenschliessen' (305) are 'vergleichsweise homogen' (309); they are therefore dated to within just a few decades of one another ('ein Zeitraum von einigen Jahrzehnten wahrscheinlich', 306). To my mind, Salimbene 2002: 26–7 does better in interpreting the tablets as a slightly more motley assemblage of objects displaying common traits; they are part of a cultural and artistic phenomenon that can be loosely dated to the 'prima

The first, iconographic trait can best be seen at the centre of the Capitoline tablet (1A). Here, in the middle of the tablet (as in the middle of several others), appears a story at the heart of Augustus' new political and cultural ideology (Figs. 49–50): we see Aeneas leaving Troy, accompanied by Anchises and Ascanius—a narrative further developed to the upper left (where 'pious' Aeneas rescues the Penates from Troy), and to the lower right (where Aeneas boards his ship departing, as the inscription puts it, 'to the Western Land' (*sc.* Italy)) (Fig. 56).[79] There can be no doubting the contemporary resonance of this scene, most famously recounted in the *Aeneid* of Virgil (composed in the 20s, and published after Virgil's death in 19 BC). As the fourth chapter explains in greater detail, one of the stories on which Augustus founded his political vision for Imperial Rome was that of Aeneas' own supposed refounding of Troy. Legend has it that Augustus' step-nephew even penned an epigram on Troy after visiting the city in AD 18; 'renowned Ilium is rising again' (*Ilios en surgit rursum inclita*), as Germanicus puts it, so that the whole world is 'under the sway of Aeneas' great descendants' (*magnis . . . sub Aeneadis*).[80] Even more significant is the precise iconographic schema employed for depicting Aeneas at the gates of Troy. The iconography appears to derive from a particular model: a larger-than-life sculptural group set up in Rome's Forum of Augustus (Figs. 51–2).[81] Although begun in 17 BC, this project was only finished in 5 BC—a date which has sometimes been thought to provide an approximate *terminus post quem* for the Capitoline tablet.[82]

età imperiale', but which continued to resonate even in the second century AD (cf. below, p. 61). The throwaway claim by Torelli 1997: 121–2 that the tablets 'non sono augustee, ma sono della prima metà del I sec. a.C.' remains unsubstantiated, as does the associated claim that they were displayed in the tablinum of Roman Republican houses.

[79] Αἰνήας σὺν τοῖς ἰδίοις ἀπαί[ρ]ων εἰς τὴν Ἑσπερίαν ('Aeneas with his family setting sail to the Western Land (*sc.* Italy)'): the scene is discussed by Valenzuela Montenegro 2004: 143–5, and the meaning of the inscription analysed by Galinsky 1969: 106–12. On the significance of these scenes, see below, pp. 148–58: parallels can be found on tablets 2NY, 3C, and perhaps 7Ti (cf. below, p. 178 n. 115).

[80] Cf. especially Sage 2000: 213–14 and Schneider 2007: 69–70. The poem is collected in Riese (ed.) 1869–70: 2.159, no. 708; there is also an interesting translation in *Anth. Pal.* 9.387 (the Greek translation inverting the Roman claim to inversion—making Greek once more Rome's own translation of the Greek myth . . .); cf. also Kay (ed.) 2006: 287–8 on Riese (ed.) 1869–70: 1.125, no. 162. More generally on Rome's relationship with Troy during this period, see Rose 2003, Dench 2005: 248–53, and Schmitzer 2005 (with further bibliography).

[81] See Valenzuela Montenegro 2004: 130–2, 306–7, further discussed below, pp. 149–53. Other tablets duplicated the composition: see below, p. 178 n. 115 on tablets 2NY, 3C, and 7Ti.

[82] Cf. e.g. Spannagel 1999: 103, with further discussion below, pp. 149–51. The date is rather more approximate than many scholars have cared to admit. After all, the group in the Forum of Augustus itself relates to a much longer iconographic tradition: in the painted frieze of the Casa del Criptoportico, Pompeii I.6.2, for example, we find Aeneas, Anchises, and Ascanius 'closing' the cycle, even though the room seems to have been decorated *c.*30 BC, before either the dedication of Augustus' forum or the *Aeneid*'s publication (cf. Valenzuela Montenegro 2004: 390–1). On the other hand, it is surely significant

As for the epigraphic clue on tablets 18L and 22Get, we have touched upon this already: namely, that both tablets chronicle their histories from the perspective of AD 15/16.[83] Every event is dated according to its temporal distance from this year (counting in 'Olympiad' units of four). Although it does not necessarily follow that *all* the tablets stem from AD 15/16, it seems likely that at least these two examples were made at or around this time.[84] What is more, the date tallies with what can be gauged from the stylistic study of the tablets' iconography and orthography. Certain epigraphic features corroborate an early Imperial date.[85] So too the so-called *sfumato* style of the tablets' sculpted surface—the way in which artists blended the outlines of individual figures into their background space—is a notable feature of Augustan sculpture, both in private contexts and on civic monuments like the Ara Pacis.[86]

We can therefore be sanguine about the dates of at least most tablets. But there are nonetheless exceptions. This is where tablet 19J is especially relevant, because the relief is undoubtedly later than the others. As we have said (above, p. 67), aspects of this so-called 'Albani tablet' (Fig. 14) recall features of other tablets— the manner of inscribing the catalogue of Heracles' labours on two symmetrical pilasters (as on tablet 1A), the two female figures that frame its neo-Attic altar (as on tablet 17M), and not least its size (25 x 24 cm).[87] Stylistically, though, this

that, prior to the dedication of the Forum, that image could adopt a very different iconography (see Aurigemma 1953: 955–6, with fig. 971; Horsfall 1979a: 42; *PPM* 1: 222, no. 46).

[83] Cf. O. Jahn 1873: 79–82; Mancuso 1909: 726; Sadurska 1964: 16; Valenzuela Montenegro 2004: 286–7, 307.

[84] Cf. e.g. Valenzuela Montenegro 2004: 307: 'Es ist demnach anzunehmen, dass die Tabulae Iliacae insgesamt in der Zeit um dieses Jahr enstanden sind.'

[85] Remarkably little attention has been paid to these issues: the only serious orthographic study (of the twelve inscribed tablets known to him) is O. Jahn 1873: 78–9, concluding of the writing that 'die Tafeln auch dadurch sich als zusammengehörig erweisen' (79).

[86] See Sadurska 1964: 8 and Valenzuela Montenegro 2004: 297–8, along with 307 (for other examples of Augustan *sfumato*). There is no evidence to suggest that the tablets were 'incomplete', as though this alone would explain their style (*contra* e.g. Schöne 1866: 157 on tablet 19J as 'unfertige Arbeit', or Bienkowski 1891: 186 on tablet 4N). Quite what to make of the stylistic feature is difficult to gauge, especially given that surfaces are so worn: my own view is that it has probably to do with the tablets' original painted surface (cf. below, pp. 64–5); I also wonder whether certain details were left deliberately vague—as, so to speak, outward formal prompts for viewer supplementation. Valenzuela Montenegro 2004: 307–9 notes numerous other stylistic parallels besides, not least between the tablets' various classicizing features and the neoclassicism of early Julio-Claudian monuments.

[87] Other textual and iconographic details recall those of other tablets too—the learned allusions of the 19 surviving hexameter verses at the bottom of the tablet (cf. below, pp. 97–9, 258–9), the labelling of continents at its top (recalling those on tablet 17M), the recourse to 'priestesses of Hera' to mark the chronology of events (as on tablets 9D and 10K), and the adornment of the lower altar (a similar grouping and cithara-player is to be found on tablets 14G and 17M): some of these are discussed by Valenzuela Montenegro 2004: 324–33. Note, though, that none of these features are attributable to any single tablet. Rather than a second-century copy of just one first-century tablet (ibid. 333: 'Eine Lösung bietet sich darin an, dass es sich um eine spätere Kopie *einer* Tabula Iliaca aus dem frühen 1. Jh. n. Chr. handelt'—my

object can only date to the second century: observe the elongated bodies and hairstyles of the tablet's figures, their compact configuration, and the abundant use of the drill (not least in the telltale pupils of the eyes).[88] If, as Valenzuela Montenegro concludes, the tablet is a deliberate second-century *imitation* of earlier objects, it follows that at least some of the tablets attracted attention long after their original production. People continued to look at these sorts of objects for some 150 years after their manufacture, reproducing (and changing) their original design and effects.[89] Valenzuela Montenegro's 'set of closely related examples' is therefore not quite as limited, exclusive, or constrained as we might at first have thought.[90]

As far as we can tell, such later 'imitations' are the exception not the rule. There is no inherent reason to think that tablet 16Sa (Fig. 13) is later than the others, for example,[91] nor to challenge the Augustan date of tablet 17M (Fig. 15).[92] Still, tablet 19J nonetheless suffices to show the tablets' enduring presence—and indeed artistic influence—beyond the late first century BC or early first century AD.

In this connection, the question must arise as to whether the surviving tablets reflect a phenomenon in another medium. Are the tablets marble copies of earlier Hellenistic works, whether in precious metal, ivory, or wood? Indeed,

emphasis), 19J seems to amalgamate a number of eclectic features, bringing them together to form a new and innovative subject and composition (cf. Cain 1989: 197).

[88] Cf. Valenzuela Montenegro 2004: 331–3. The Antonine date had already been noted by Sadurska (1964: 92–4), leading her to the somewhat desperate conclusion that 'la chronologie du IVe groupe comprend le dernier quart du Ier siècle avant n.è. ainsi que les années 15–20 de n.è. et l'époque des Antonins' (17).

[89] Cf. Salimbene 2002: 27: 'Così presentata, tale operazione pare assumere i toni di una "rievocazione antiquaria", e si giustificherebbe solo presupponendo che il fenomeno artistico rappresentato dalle Tabulae Iliacae abbia rivestito un ruolo non secondario nelle vicende culturali della prima età imperiale.'

[90] Valenzuela Montenegro 2004: 10: 'eine Reihe eng verwandter Exemplare'.

[91] For the argument that tablet 16Sa is an 'imitation'—on the basis of its sparse inscriptions, supposed heraldic composition, pictorial 'errors', and departures from iconographic norms—see Valenzuela Montenegro 2004: 334–5: 'das einfache Relief Tomasetti . . . ist dagegen eher ein "Imitat", da keine ikonographischen Verbindungen festzustellen waren' (415). But Valenzuela Montenegro offers no stylistic commentary about the date in her brief discussion, nor do I see any inherent reason to challenge the 'Augustan' attribution of Sadurska 1964: 74. My own view aligns with that of Sadurska 1964: 73: 'La table Sa n'était donc pas d'une qualité inférieure; l'artiste avait tout simplement employé une technique différente, plus simple. En effet, il est plus facile de peindre les détails que de les sculpter lorsque le motif est très petit.'

[92] For the supposed Antonine date of 17M (partly on the grounds of similarities with 19J), see Moreno 1974: 136, no. 120, followed by Salimbene 2002: 24, 27. Valenzuela Montenegro 2004: 308–9 is right to reject the argument; as Sadurska 1964: 77–8 had earlier demonstrated, the tablet is best understood alongside first-century BC neo-Attic comparanda.

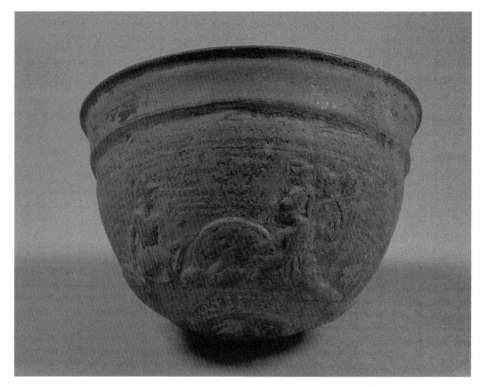

FIGURE 20. 'Megarian' Homeric cup with scenes relating to *Odyssey* 22, second century BC (Berlin, Antikensammlung V.I 3161n: upper diameter 11.3 cm; height 7.2 cm).

FIGURE 21. Diagram showing the layout of scenes on the same cup.

does this explain the later 'copying' of tablet 19J?[93] Although, as we shall see, the tablets bring a number of distinctly Roman perspectives to the stories depicted, there are numerous Hellenistic parallels for their project of rendering epic into pictures, and indeed of doing so on this sort of minuscule scale. The terracotta so-called 'Megarian' relief cups, of which over 50 are associated with epic subjects, offer just one collective example: not only do these cups turn famous literary texts into pictorial bands, they do so in miniature format, juxtaposing their images with identificatory inscriptions, even short citations of Homeric text (Figs. 20–1, with citations from *Od.* 22.205–8, 226–7, 233–4).[94] But there are also differences between these objects and the *Tabulae Iliacae*: where the relief cups tend to concentrate on individual episodes, the tablets attempt something more synthetic, summarizing whole poems, poetic cycles, or indeed panoramic vistas of history within their diminutive frames;[95] while the terracotta cups are moulded from casts, moreover, the tablets are individually carved from marble. Many have argued that both the 'Megarian' cups and *Tabulae Iliacae* are secondary imitations of works in another medium—namely, illustrated papyrus manuscripts. As we shall see in the fourth chapter, however, the suggestion loses sight of the specific material properties of the tablets' marmoreal medium. In the dearth of any evidence, we must resist the inherent philological urge towards *Quellenforschung*: it is wholly typical of classical archaeologists to judge objects that do survive as secondary copies of supposed prototypes that do not.[96]

[93] For the suggestion of earlier Hellenistic archetypes, see e.g. Kontoleon 1964: 198–9 (on the tablets as imitations of multimedia reliefs displayed in Hellenistic gymnasia); Sadurska 1964: 10 ('L'invention des tables ne fut pas une idée absolument originale'); Bua 1971: 23 (associating them with Alexandrian prototypes); Amedick 1999: 195–205 (on tablets 4N and 5O). On the whole issue, cf. Valenzuela Montenegro 2004: 344–6. There is no evidence to support Kazansky's thesis that the '*Tabulae Iliacae* are simply copies of a famous picture' (Kazansky 1997: 60)—namely, a set of third-century mosaics: see below, pp. 249–50.

[94] For an overview of these objects and their origins, see Rotroff 1982: 6–13: the best analysis of their visual–verbal relations is L. Giuliani 2003: 263–80 (arguing for a second-century BC date), but there are other well-referenced English discussions in Webster 1964: 147–53, Brilliant 1984: 41–3, and Small 2003: 80–90. Sinn 1979 offers a much more detailed catalogue, surveying 137 cups dating from between the late third and the first centuries BC: he associates 14 with the *Iliad*, eight with the *Odyssey* and 14 with other poems from the epic cycle; the cup pictured in Figs. 20–1 is catalogued as MB 21 and discussed at 90–1, but the most important analysis is still Robert 1890: 8–20. Many more comparanda have been found since Sinn's catalogue, although they usually go unreferenced: cf. e.g. *SEG* 45.785 (16 moulded second-century clay vessels from Pella, including five of the *Ilioupersis*); *SEG* 48.805 (two relief cups with Homeric scenes from Kelle); *SEG* 50.533 on seven additional Hellenistic relief cups from Pherae; and Schmid 2006: 53–69 on 17 cups from Eretria, many decorated with epic themes (e.g. 27, no. B7).

[95] Cf. below, pp. 254–5.

[96] See below, pp. 129–36. One conspicuous example of such philological approaches is Kopff 1983, who uses the tablets to reconstruct the textual transmission of the *Aethiopis* (associating them with 'strand C', 58–9).

To describe that medium simply as 'marble' is not quite accurate: the *Tabulae* are derived from a variety of different stones, by no means all of them identified.[97] The most common material is palombino, employed in some eight fragments.[98] Palombino is a fine-grained dolomite stone, used in mosaics and paving, as well as in sculpture.[99] But other tablets are composed of harder and still more precious materials—some in yellowish giallo antico,[100] and one fragment (4N) in an orangey-pinkish marble which Anna Sadurska identified as porta santa.[101]

All of these stones were, at least in theory, pale enough to have been painted.[102] Although the issue has been conspicuously downplayed by scholars, traces of red as well as gold paint are very clearly visible on tablet 16Sa: both the bottom and left-hand side of the tablet preserve vestiges of what was once a gold surface, and extant (albeit faint) lines of red paint suggest that this outer frame was delimited in a separate colour besides.[103] Similar traces can be detected on other tablets too, although these have (so far as I can tell) gone as yet unnoticed. The clearest instance is tablet 3C, where two horizontal bands of gold paint can still be seen in the upper band (above the seated Achilles to the left and the kneeling Chryses to the right) (Colour Plate VII.8); more traces survive towards the left-hand edge of the fifth frieze below, as well as in numerous other sections—gold paint seems to

[97] On the materials, see Sadurska 1964: 13; Amedick 1999: 198; Valenzuela Montenegro 2004: 297–8.

[98] Following Valenzuela Montenegro 2004: 297 n. 1718, on tablets 1A, 5O, 11H, 18L, 19J, 20Par, 21Fro, 22Get (albeit rendered in different sorts of palombino). As the author notes, many of the materials have not been decisively identified—'die Angaben sind nicht immer eindeutig': the materials listed in Appendix I largely follow the identifications of Sadurska 1964, while indicating discrepancies.

[99] Valenzuela Montenegro 2004: 297 is not quite right in saying that palombino is used 'seltener für Skulpturen': certainly, palombino was especially popular as paving material (cf. e.g. Mielsch 1985: 52–3, nos. 398–401), but it was also 'molto adoperato per oggetti ed elementi decorativi di piccole dimensioni' (Borghini (ed.) 1989: 263, no. 108; cf. Gnoli 1988: 260: 'Il "palombino" ... fu occasionalmente usato anche per vasi e talvolta anche nella scultura'). As Price 2007: 98 notes, the material could have been sourced locally (e.g. from Tolfa and Subiaco in Lazio).

[100] Tablets 13Ta and 17M are identified as giallo antico by Sadurska 1964: 13: on the material, see Gnoli 1988: 166–8; Borghini (ed.) 1989: 285–7, no. 125; Price 2007: 90–1. Other materials are simply described as 'yellow marble' (tablets 3C, 8E, 9D, 12F, and 10K).

[101] Sadurska 1964: 43. But the identification is surely mistaken: see below, p. 305 n. 5. For the specific medial significance of marble (as opposed to e.g. ivory or wood), see below, pp. 254–5.

[102] There are some preliminary comments in Stuart Jones 1912: 165 (no. 83) and 172 (no. 83a); Sadurska 1964: 8; Valenzuela Montenegro 2004: 297–8 (with further bibliography, concluding 'die Frage der Bemalung und ihres Umfangs ist m.E. nicht vollständig zu klären', 298). Amedick 1999: 198 argues that the tablets were not painted on the grounds of their expensive materials ('Wenn der Stein wegen seiner Farbe kostbar war, ist es unwahrscheinlich, daß er durch eine farbige Fassung verdeckt werden sollte ...'). But there is much more evidence for the use of paint than has yet been considered.

[103] I was not permitted to take my own photographs, but my thanks to Guido Cornini for inspecting the tablet with me. Weitzmann 1941 makes no reference to the paint; Sadurska 1964: 72 mentions the 'bande dorée' and the traces of a painted inscription; like Valenzuela Montenegro 2004: 334–5, though, she omits reference to the clear traces of red paint in the outer frame.

have been liberally applied over the whole tablet.[104] Under the right conditions (a dark room, using a magnifier light and halogen torch), I was able to detect the possible residual traces of reflective gold paint on three other tablets besides, albeit somewhat less confidently.[105] Sometimes, dark paint was also applied to the tablet inscriptions, so as to make the writing stand out against the pale marble background: Sadurska noted as much of the recto inscriptions on tablet 19J,[106] and something similar can be seen on the verso of tablet 9D. The fragmentary nature of the evidence means that we are unable to reconstruct precise appearances. But it stands to reason that at least some of the tablets were once painted. What is more, the feature probably also explains the *sfumato* sculpted surface: certain details were not only carved, but also added in colour.[107]

I turn, finally, to the tablets' provenance.[108] Once again, this question is made difficult by the unreliable nature of our evidence. But it seems likely that all of the objects were discovered in Rome or the area immediately surrounding the city. Of the 22 tablets, 17 are vaguely associated with such findspots.[109] That leaves five tablets, of which three (2NY, 6B, and 22Get) have no associated provenance information, and two (8E, 13Ta) have highly suspect archaeological attributions: in the absence of proof, it seems highly dubious that tablet 8E was found in the south of France, or that tablet 13Ta hails from Tarentum in Puglia, as claimed in the nineteenth century.[110]

[104] e.g. on the left knee of the figure standing to the right of the seated Achilles in the upper frieze, and in at least two sections in the band below (above the Thersites inscription and just below the Agamemnon inscription of the upper frieze). Specks of gold paint also appear within the *Ilioupersis* scene (e.g. to the right of the lower mural watchtower).

[105] In the upper left rim of the shield held by the male figure (third from the left) on Iliadic scene T on tablet 20Par; to the right of the uppermost surviving *Aethiopis* scene on tablet 9D; and in the *Ilioupersis* scene of tablet 8E (the right leg of the archer standing second from the bottom).

[106] See Sadurska 1964: 83, on how there are 'dans les lettres traces de noir qu'on a employé pour dechiffrer l'inscription'.

[107] Cf. e.g. Lippold 1932: 1896: 'Manche Einzelheiten werden durch die Farbe verdeutlicht worden sein; dabei sind die Bilder doch nicht plastisch verstärkte Zeichnungen, sondern sollen wirklich plastisch, als Reliefs wirken.' On the whole issue of painted sculpture in antiquity—albeit primarily concerned with architectural and free-standing statues—see Brinkmann and Wünsche (eds.) 2004 and Brinkmann and Scholl (eds.) 2010.

[108] For some general introductory comments, see especially Sadurska 1964: 12–13; Salimbene 2002: 27–9; Valenzuela Montenegro 2004: 405; Petrain 2006: 139–47.

[109] It should be stressed, however, that very few of these supposed provenances are verifiable: of the 19 objects surveyed, the table of Sadurska 1964: 13 labels nine tablets as having 'uncertain' or 'very uncertain' provenances in Rome. A newfound marble fragment from the forum at Cumae, claimed by Gasparri: 2009 to be 'un nuovo rilievo della serie delle "tabulae iliacae"', would be the only tablet with a scientifically documented provenance; but problems remain with this relief (see Appendix II, pp. 413–16).

[110] The supposed findspot of tablet 8E is reported by de Longpérier 1845: 440 n. 1 ('on suppose toutefois qu'il a été trouvé dans le midi de la France'), but challenged by Sadurska 1964: 55. For the complex history of tablet 13Ta, see Robert 1875: 267–8; Sadurska 1964: 67 doubts the provenance, and

Three tablets yield slightly better information about provenance: tablets 1A, 7Ti, and 17M suggest findspots not just in Rome, but more specifically in Roman aristocratic villas. The most interesting evidence concerns tablet 1A, which Raffaello Fabretti records as having been discovered at the same site that yielded the famous Archelaus relief (Fig. 3), as well as a trophaic monument with a portrait of the emperor Claudius 'being carried to heaven by an eagle'.[111] Fabretti identified the place as Bovillae (*apud Bouillas*), a small town some 12 miles south-east of Rome along the Via Appia, and associated the portrait of Claudius with a supposed *Sacrarium Iuliae gentis*.[112] From what we know of the other two objects from the site, however, it seems that Fabretti's topographical description should be more loosely understood: as Thomas Ashby has long since shown, all three objects seem to derive from 'the ruins of a very large villa' just north-east of Bovillae, in an area known as Messer Paolo (east of Marino, in the Alban hills).[113] Whether or not we accept Maria Grazia Granino Cecere's suggestion that the property belonged to the Mamurrana family (or indeed that it was later appropriated by the Claudians), there can be no doubt about the sumptuousness of this villa and its decoration.[114]

Available records point to related provenances for Tablets 7Ti and 17M. We do not know precisely where in Tivoli Charles Alphonse Thierry discovered his eponymous Tabula Thierry (7Ti) in 1860: later reports simply refer to a provenance 'around' the temple of Hercules Victor.[115] But the description is

Horsfall 1983: 147 likewise concludes that 'an Apulian provenance (let alone workmanship) does not seem at all securely established'. For earlier suspicions about these two provenances, cf. Lippold 1932: 1891.

[111] See Fabretti 1683: 316, 383, along with Reifferscheid 1862: 105. On the Archelaus relief, see above, p. 8. On the 'apotheosis of Claudius' monument (in fact two works mistakenly joined together), see S. F. Schröder 2004: 470–81, along with Ridgway 2005: 626–7; my thanks to Brunilde Ridgway for her guidance here. For a full archaeology of the sources, see Ashby 1910: 282–3 and Granino Cecere 1995: 377–84, along with Sadurska 1964: 24, 32, Petrain 2006: 141–2, and Valenzuela Montenegro 2004: 26–7. As far as I know, Winckelmann was the first to make the topographical association between these various objects in 1764 (Winckelmann 2006: 310).

[112] See Fabretti 1683: 383, as discussed by Valenzuela Montenegro 2004: 26. Following O. Jahn 1873: 2, many subsequent scholars have accepted this provenance without critique (e.g. Schefold 1975: 130: 'die besterhaltene [Tafel] wurde im Heiligtum der Julier bei Bovillae gefunden').

[113] See Ashby 1910: 282–6 (quotation from 202), with further discussion in Horsfall 1979a: 32 and Salimbene 2002: 27–8; cf. independently Lippold 1932: 1887: 'Die Vermutung, daß hier Bovillae gelegen habe und die Funde aus dem dortigen Sacrarium der Gens Iulia stammten, ist nicht zu beweisen'. On the 'Torre di Messer Paolo', see de Rossi 1979: 382–7 (who puzzlingly omits reference to the Capitoline tablet) and Granino Cecere 1995 (mentioning this tablet at 380–1); cf. Buranelli and Turchetti (eds.) 2003: 100, withs figs. 40.1 and 40.2.

[114] See Granino Cecere 1995, who argues that 'l'area di Tor Messer Paolo era di proprietà dell'imperatore' (386); cf. Salimbene 2002: 28 and Petrain 2006: 144–7. As Ashby 1910 concludes, 'the villa itself must have been immense' (285): his survey discusses not only the topography, but also the sculpture, *opus sectile* mosaics, and architectural remains (including porta santa columns and a large cryptoporticus).

[115] See Rayet 1882: 17 (= 1888: 184), describing it as discovered 'autour du temple d'Hercule vainqueur à Tivoli'.

sufficiently vague to allow for a domestic provenance not within the temple precinct, but rather from one of the several Roman villas close to it.[116] This sort of aristocratic domestic findspot is most clearly documented in the case of tablet 17M. Discovered in 1780 by Sigismond Chigi in Porcigliano, tablet 17M is known to have been found at the seaside villa of Tor Paterno, near Laurentum, about 15 miles south-west of Rome.[117] In this case we can be fairly certain about the other objects found alongside the tablet: as Richard Neudecker has catalogued, the *Tabula Chigi* was once displayed amid a wealth of other political and cultural symbols—not only Imperial busts, but also a seated statue group of three Muses and a poet, and perhaps even a portrait of Homer himself.[118]

BUT WHAT WERE THEY FOR?

Bound up with the issue of the tablets' provenance is a more fundamental question: how were they exhibited and used? The tablets themselves offer very little indication about their mode of display. Some have suggested that they were placed on free-standing columns or pilasters; others that they were fixed to walls or else encased in revolving stands.[119] Two tablets—6B, 13Ta (Fig. 22)—feature small round piercings which have sometimes been taken as evidence that all the tablets were originally hung on the wall: in fact, though, the two holes through the lost tablet 6B are almost certainly modern,[120] and while the piercing

[116] Cf. Salimbene 2002: 29, followed by Petrain 2006: 139–40; the suggestion is made independently by Valenzuela Montenegro 2004: 405 n. 2484. On the topography of the site, see C. F. Giuliani 1970: 164–201, and 162 on the surrounding 'numerose ville private'.

[117] According to Visconti 1830: 63–83: see Sadurska 1964: 74 (who wrongly gives the date as 1777) and Valenzuela Montenegro 2004: 268. The area is known to have been home to numerous villas of the Imperial period—not least Pliny the Younger's (*Ep.* 2.17).

[118] For the collected sculptural finds from the site, see Neudecker 1988: 237–40 (especially 239, nos. 69.19, 69.20, and 69.22), together with the bibliography cited by Salimbene 2002: 29 n. 37. Visconti 1830: 63 n. 1 explicitly associates the site ('la ferme de *Porcigliano*') with Tor Paterno, describing this 'rare monument' alongside other finds: 'Plusieurs morceaux intéressants d'Antiquité revirent le jour par cette fouille, et les plus curieux peut-être après ce bas-relief, étoient des plastiques grecques, ou bas-reliefs en terre cuite, d'un style très-ancien et digne d'admiration' (63).

[119] On the tablets' display, see e.g. Horsfall 1983: 147; Salimbene 2002: 30–2; Valenzuela Montenegro 2004: 404–5; Petrain 2006: 182–3. On architectonic display strategies of related Roman marble reliefs, see Froning 1981: 8–32 (without reference to these tablets); to my mind, the smaller scale of the *Tabulae Iliacae* reliefs and inscriptions called for a much more intimate mode of display.

[120] For the two holes on (the lost) tablet 6B, one to the centre left of its upper frame, the other at the lower edge of the surviving fragment (in the ninth frieze from the top), see Sadurska 1964: 47, 50 and Valenzuela Montenegro 2004: 150 n. 915. Valenzuela Montenegro 2004: 404 argues that the holes on both this tablet and on 13Ta are ancient—and that 'dies lässt an eine freie Aufhängung denken' (cf. 418). In the case of tablet 6B, though, the piercings were surely modern—hence the fact that the lower hole was drilled at the lower extremity of the surviving fragment (a most unlikely place for the original object), and the

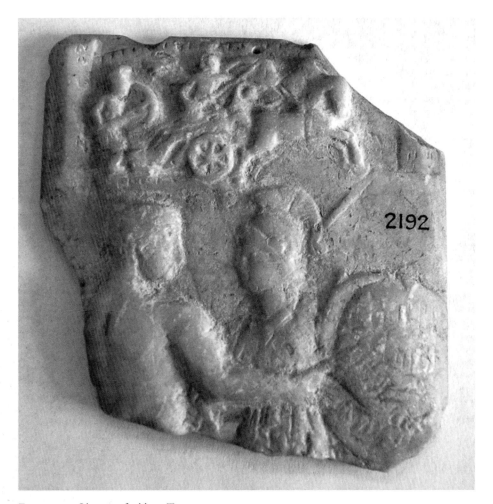

FIGURE 22. Obverse of tablet 13Ta.

on fragment 13Ta is more likely to be ancient, the tablet's layout and form seems to have been specially adapted to suit this different display context.[121] In the case of fragment 13Ta, it is therefore at least possible that the tablet was mounted

asymmetrical upper hole. Incidentally the holes drilled into the sides of tablets 2NY, 14G, and 15Ber are modern alterations, designed to support the metal rods of the display case.

[121] For the hole at the tablet's original upper centre, see Sadurska 1964: 67; Horsfall 1983: 147; Valenzuela Montenegro 2004: 210. Sadurska 1964: 50 dismisses the hole (like that on tablet 6B) as modern, but without explaining her rationale. In this case, the piercing seems more likely than not to have been ancient: it is neatly drilled in the upper border of the tablet's original upper centre amid the city castellations; and unlike most other fragments, the verso of the tablet has been smoothed (without bevelled edging) so that the tablet could hang flush against a wall. To my mind, tablet 13Ta is therefore the exception not the rule, found on one of the most exceptional examples (much thinner in depth, different in its elongated rectangular shape, and lighter than most other tablets, with the extant fragment weighing 104 grams).

FIGURE 23. Side view of tablet
14G (showing the left-hand side).

against the wall. But it seems to me very unlikely that this or any of the other tablets functioned as *oscilla*—i.e. hanging 'mobiles' set up in peristyles and domestic gardens.[122] Still less conclusive is the hypothesis that the tablets were mounted on a stand. The suggestion that tablet 22Get preserves traces of a protruding tenon must remain speculative.[123] Slightly more persuasive is the thin groove

[122] On *oscilla* and their display contexts, see Corswandt 1982. For the comparison with the *Tabulae Iliacae*, see e.g. Bielefeld 1965: 430 and Salimbene 2002: 30–1. But the scale of the *Tabulae* figurative reliefs and inscriptions weigh against such 'distant' modes of viewing; and the surviving *oscilla* provide no parallels for the compositions, detailed decoration, or subjects of the tablets (cf. e.g. Corswandt 1982: 67–9).

[123] See Burstein 1984: 153 on 'what appear to be the remains of a tenon, presumably for mounting the monument in a slotted stand'—although I was unable to identify any such feature on the broken surface. For such display stands (reconstructed largely on the basis of domestic relief plaques from Pompeii), see Froning 1981: especially 8–10.

neatly carved into the left-hand side of tablet 14G (Fig. 23), which might just possibly suggest that the tablet was slotted into an additional frame or mounting device.[124]

Different tablets were surely used and displayed in different ways. The fact that twelve tablets were adorned on both sides, moreover, suggests a viewing context where audiences could inspect verso and recto alike, and presumably at close hand (see above, p. 40, Table 3). In this connection, it is worth emphasizing how light and mobile these objects were. Given the fragmentary nature of most of the pieces, comments about original weights must remain speculative (and modern museum supports make it impractical to weigh all the objects). But the tablets seem to have been as portable and light as the modern-day notebook computer. At 1.515 kg, tablet 1A suggests an original weight in the range of around 2 kg (just under 4.5 pounds); tablet 4N originally weighed something similar (the mass of the surviving fragment is 1.29 kg). Tablets 2NY and 3C were in the same sort of range: the surviving fragments weigh 1.117 kg and 0.38 kg respectively, giving an original mass (following Sadurska's reconstructions) of around 3 kg for tablet 2NY and less than 2.5 kg for tablet 3C. Some tablets evidently weighed even less: at just 0.8 cm in depth, for example, fragment 8E weighs 0.105 kg—suggesting an original mass (again following Sadurska's reconstruction) of under 0.6 kg. These monuments could be passed conveniently around the room: it is easiest to imagine them as having no 'fixed' display context at all.[125]

As for the tablets' function, three explanations have predominated: they have been variously interpreted as didactic, votive, or decorative objects.[126] The didactic interpretation is the oldest, and still finds modern advocates:[127] the

[124] So far as I can tell, the feature has gone unnoticed. No less interesting are the chiselled diagonal 'slats' of the tablet's verso (Figs. 32, 99)—a marble imitation of a wooden frame? My thanks to Katharina Lorenz and Sylvia Brehme for their advice while inspecting the tablet with me.

[125] The only possible exception is tablet 5O, depending on how we reconstruct its original size: see below, p. 307 n. 7. But the fragment's slight depth (1.5 cm) must have made even this object fairly light and portable: like Callimachus' muse, the tablets are literally and metaphorically thin (*leptos*). The guestimates of weights by Horsfall 1983: 147 (e.g. 1A as 'some 4 kg') are inaccurate.

[126] On the tablets' function, see the helpful bibliographic reviews in Sadurska 1964: 18–19; Horsfall 1979a: 31–5; Rouveret 1988: 166–7 n. 3 and 1989: 358–9; Salimbene 2002: 6–9; Valenzuela Montenegro 2004: 402–7 (with detailed citations), 417–18; Petrain 2006: 179–81; Puppo 2009: 833–5.

[127] Cf. e.g. Barthélemy writing in 1801 (quoted in Valenzuela Montenegro 2004: 402 n. 2457): 'je pense qu'ils étoient destinés par les rhéteurs grecs, chargés de l'éducation des jeunes Romains, à leur remettre sous les yeux les principaux traits de la mythologie'; cf. even earlier Barthélemy 1761: 561. Aspects of the thesis were accepted by O. Jahn 1873: 86–92 (despite the objections raised at e.g. 89)—and hence became the standard explanation in the later nineteenth and earlier twentieth centuries, especially in Germany (for nineteenth-century references, see Michon 1899: 381). A number of more recent scholars have broadly concurred: see e.g. Scherer 1964: xi ('these may have been visual aids for teaching young Romans the legends of their Founding Fathers'); Hellmann 1983: 44; Pollitt 1986: 204 ('The tablet's purpose, as the inscription states, was a didactic one: to teach the order and content, within their proper mythological contexts, of the Homeric poems'); van Rossum-Steenbeek 1999: 71–2 n. 47.

earliest arguments were based on the Capitoline tablet (1A), with its synopsis of so many different epic poems and its inscribed epigrammatic instruction to 'understand the order of Homer' (μάθε τάξιν ʿΟμήρου).[128] For nineteenth-century archaeologists, the tablet therefore seemed the ancient equivalent of the modern 'schoolboy crib': as such, it was compared with the sorts of inscriptions found on tablet 18L—similarly deemed a kind of 'cramming' revision guide to ancient history (the ancient equivalent of the modern-day 'history ruler'). At the same time, the diminutive size of the tablet seemed to suggest a diminutive sort of reader: the tablet was judged a children's 'toy', even a school-prize awarded in recognition of some special academic diligence.[129]

Needless to say, there are numerous problems with this explanation. On the one hand, it overlooks the tablets' formal properties—not only the size of their texts and reliefs, but also the rationale of their collective combination. On the other, it forgets the very different 'syllabus' that many of the *Tabulae Iliacae* represent: why should teachers or students have especially interested themselves in the *Ilioupersis*, *Aethiopis*, or *Little Iliad*?[130] The 'schoolboy' interpretation is also premised upon a broader set of anachronistic and mistaken assumptions: about ancient (as opposed to Victorian) systems of education, the modern ideology of illustration, and indeed the nature of the miniature.

Although the argument has been widely discredited, aspects of it nevertheless endure. We will return in the following chapter, for example, to Nicholas Horsfall's widespread thesis that the tablets worked as 'vehicles for elementary *adult* education'—that they were intended for a popular market 'where ignorance is to be hidden and memories have to be jolted at every step'.[131] Something of the didactic argument also remains in Agnès Rouveret's more subtle interpretation, associating the tablets with ancient mnemonic systems: in order to remember the sequence of a speech, Rouveret explains, ancient rhetoricians recurrently advised orators to visualize its content—to imagine the themes in relation to a set of images, themselves spatially arranged; by progressing conceptually through that imagined space, speakers could recover the architecture of

[128] On the inscription, see below, pp. 102–21: the didactic interpretation furnished a most unlikely reconstruction of the couplet's hexameter.

[129] For the suggestion, see Bethe 1945: 77. Cf. Pinney 1924: 240–1: 'They may have been hung on the walls of schoolrooms, as they were too heavy for children to carry about.' On the underlying ideology, whereby the miniatures are belittled as 'toys', see S. Stewart 1993: 56–62.

[130] While Homer remained a canonical text, some of the other represented epics played a much smaller educational role: why, for example, would a 'schoolboy crib' give the *Ilioupersis* pride of place? The historical chronicles of tablets 18L and 22Get are also highly selective, and it is difficult to explain what the labours of Heracles on tablet 19J (themselves described in *Doric* Greek) would have to do with school 'curricula'. For all of these objections (and others), see Mancuso 1909: 728–9, restated in e.g. Horsfall 1979a: 31–2 and Valenzuela Montenegro 2004: 402–3, 417–18.

[131] See Horsfall 1979a: 33–5 (quotations from 35): cf. below, pp. 87–92.

the speech itself.[132] Rouveret's thesis has much to recommend it—not least its careful consideration of display context and the interest it takes in *both* sides of the tablets. As the following chapters aim to demonstrate, however, the sophistication of the tablets transcends this sort of 'practical' or 'utilitarian' interpretation. Crucially, Rouveret's grand story also overlooks the tiny dimensions of the tablets—a theme to which we will return in the sixth chapter in particular.[133]

In their search to find a non-didactic explanation for the tablets, other scholars have argued that they served as votive offerings to the gods.[134] Two sorts of evidence have been adduced here: first, the inscription on tablet 4N, which suggests that the tablet was dedicated from 'a priestess to the priest' (ἱέρεια ἱερεῖ); and second, the supposed archaeological provenance of tablets 1A and 7Ti—the assumption that tablet 1A derives from a *sacrarium* to the Julian family at Bovillae, and 7Ti from a temple dedicated to Heracles at Tivoli. We will return to the inscription on 4N in the seventh chapter (Figs. 105, 145): as I hope to show, this palindromic 'dedicatory' inscription cannot be taken at its word (it is better understood in relation to the make-believe altar of letters above, and has therefore been cited out of context).[135] As for the archaeological contexts of tablets 1A and 7Ti, we have already seen that these are in fact mistaken. Even if we follow an ancient literary reference that associates Bovillae with a *sacrarium* to the Julian family (Tac. *Ann.* 2.41, 15.23), tablet 1A stems from a private villa north-east of the town;[136] likewise, tablet 7Ti probably came from one of the villas around the Tivoli temple, not from the precinct itself.[137]

[132] See Rouveret 1988, rearticulated in 1989: 359–69: 'leur fabrication même révèle un goût pour la présentation abrégée d'une œuvre littéraire, sa transcription en image, la recherche de l'énigme, touts traits qui sont apparus également à l'arrière-plan des textes consacrés à l'art de la mémoire' (369); cf. Small 1997: 236; Carruthers 1998: 201–2; Corbier 2006: 119–21. For the counter-argument, see Valenzuela Montenegro 2004: 403.

[133] Cf. Carruthers 1998: 202, noting that 'an artifact like the Iliac tablet would not have been used to best effect by students memorizing the text for the first time'; also Salimbene 2002: 9, on how 'le piccole dimensioni e l'accentuato miniaturismo delle scene e delle iscrizioni' militates against Rouveret's interpretation.

[134] Valenzuela Montenegro 2004: 404 attributes the first articulation of the argument to de Longpérier 1845: 440, who labels the tablets 'monuments de piété'. But plenty of twentieth-century scholars have followed suit: e.g. Veyne 1967: 643; cf. Schefold 1954: 214–15 and 1975: 40: 'Die Tabulae Iliacae sind vermutlich Weihgeschenke, wie der Fundort der besterhaltenen nahelegt'.

[135] See below, pp. 348–9, 369. This explanation also accounts for the other oddities of this fictional 'votive' offering, which makes no reference to the dedicant or god (and why should a 'priestess' dedicate something to a 'priest'?).

[136] See above, p. 66. The mistaken association of the Capitoline tablet with a Julian *sacrarium* was central to the argument of de Longpérier 1845: 439–40—namely, that tablet 1A was designed as a votive articulating the heroic Trojan origins of the Imperial family.

[137] See above, pp. 66–7.

To my mind, such rich, aristocratic villas provide the best interpretive frame-work against which to understand the *Tabulae Iliacae*—as domestic party-pieces, designed to stimulate erudite conversation. To call this function 'decorative', as many scholars have done, would be only partly correct: as springboards for discussion and debate, the tablets demanded a more dynamic mode of interactive response.[138] As the following chapters propose, the tablets serve as emblems of sophistication—as instruments that enabled consumers to show off their literary leanings and learnings in a variety of different ways. This is not to imply, as others have done, that the tablets should be associated with particular rooms within the villa, still less that they have to do with 'private' libraries (themselves modelled on 'public' prototypes). This suggestion goes back to an argument first advocated in the nineteenth century, and it at least recognizes the tablets' intellectual ethos—what Otto Jahn rightly called their *Gelehrsamkeit*.[139] It has been revived, in more subtle form, by David Petrain, who argues that the culture of the library provides an 'interpretive background' for the tablets—that the *Tabulae Iliacae* 'draw on a corpus of decorative motifs related to a specific type of space, the ancient library'.[140] Domestic library complexes certainly did become a popular feature of Roman villas, and although its 'library' proper seems to have been a small and humble space, designed simply to store Greek papyrus scrolls, the Villa dei Papiri at Herculaneum testifies to the rich decora-tive backdrop.[141] But it is not necessary to home in on the library as a sole or even

[138] For some parallel explanations, see O. Jahn 1873: 82–3 (together with the schoolroom interpretation of 86–92); Lippold 1932: 1893; Sadurska 1959: 124 and 1964: 18–19; Guarducci 1974: 425; Chaniotis 1988: 231–3; Amedick 1999: 199 (on tablet 4N and its relation to 'das kulturelle Milieu der kosmopolitischen, literarisch gebildeten Eliten in den hellenistischen Metropolen'); Valenzuela Montenegro 2002: especially 88–9 and 2004: 404–12; Simon 2008: 237.

[139] Cf. O. Jahn 1873: 79–86: 'Wenn es unter dieser Voraussetzung nicht unwahrscheinlich ist, dass die alexandrinische Bibliothek die eigentliche Heimath dieses gelehrten Reliefschmuckes gewesen sei, so musste es römischen Alexandrinern und Liebhabern gelehrter Studien nur natürlich sein, mit den kleinen Täfelchen ebenso ihre Bibliotheken und Studierzimmer in und um Rom zu schmücken' (83). The library suggestion is also (somewhat puzzlingly) followed by Horsfall 1979a: 34 n. 60 (cf. 1983: 147 on tablet 4N). For the initial suggestion that tablet 1A might originally have been displayed in a library—attached to the Julian Sacrarium at Bovillae—cf. Reifferscheid 1862: 112–15, apparently followed by Sadurska 1964: 32. Valenzuela Montene-gro 2004: 405–7 provides a more detailed exploration of the whole issue.

[140] Petrain 2006: 148–88 (quotations from 148, 164). Petrain is careful not to suggest that all the tablets functioned in this manner; rather, he finds it 'more fruitful to consider the multi-media displays of the ancient library as an implicit background for the *Tabulae*, one that informed their unusual decorative programs and helped render them comprehensible, even familiar, for Roman viewers' (164): 'our tablets' ubiquitous references to library décor . . . activate viewers' familiarity with this rhetoric and encourage them to use it in parsing the tablets' own representations of the epic tradition' (166).

[141] On Greek and Roman libraries, the best archaeological guides are Strocka 1981 and Blanck 1992: 133–78; cf. Strocka 1993 on a private library in Pompeii VI.17.41 (a parallel for the library in the Casa del Menandro, Pompeii I.10.4); Fedeli 1988 on public and private Roman libraries; and Neudecker 2004 and Dix and Houston 2006 on the ideology behind public libraries in the Roman Empire. For the

dominant space for displaying and exercising erudition in the Roman world; what is more, Roman concepts of domestic space did not distinguish between rooms on the grounds of function to anything like the same extent as we do.[142] Rather, the *Tabulae Iliacae* could serve as subjects of discussion and debate in *different* parts of the villa—albeit within a related set of social and cultural practices.

AMUSE-BOUCHES

To explain what I mean here, it is important to appreciate the ideological associations of the villa within the Roman cultural imaginary. The villa epitomized a certain mode of leisurely *otium*: on the one hand, it was a place of scholarly retreat (a *Bildungslandschaft*, as Harald Mielsch put it); on the other, it was a forum for all manner of social engagements—a site for cashing in on accumulated cultural capital.[143] The objective, writes Paul Zanker, was to conjure up an impression of learning, while also exploiting this for social gain: 'in the overly competitive climate of the late Republic and Early Imperial period, cultural pretensions quickly became a vehicle for winning distinction'.[144]

Because of his correct insistence on the villa's visual context, Zanker's discussion of *otium* is particularly relevant when thinking about the *Tabulae Iliacae*. Roman ideologies of *otium* are implicated within what Zanker labels the 'world of pictures', or *Bilderwelt*, of the Roman villa at large.[145] This provides the sociological rationale for the sorts of elaborate architectural, sculptural, and painted programmes installed in villas: the sculptural finds from the Villa

decoration of the Villa dei Papiri, see Mattusch 2005: given the unprepossessing size and décor of room v, the papyri rolls stored there were presumably intended to be read *throughout* the villa; the same surely holds true for the *Tabulae Iliacae*.

[142] Cf. Valenzuela Montenegro 2004: 406–7; the key discussion here is P. Zanker 1995b: 206, on how 'intellectual pursuits [*geistige Tätigkeit*] were not as a rule restricted to special rooms within the house' (translating P. Zanker 1995a: 197). Cf. independently Salimbene 2002: 29–30: 'Non necessariamente si deve pensare a biblioteche: le epigrafi "letterarie" connotavano infatti non solo gli ambienti specializzati nella conservazione e classificazione del sapere, ma anche quelli destinati più genericamente all'incontro di personaggi colti.'

[143] See Mielsch 1987; also 1989: 448: 'Die Villa wird vor allem aufgefaßt als eine Stätte der Bildung, d. h. vor allem der griechischen Literatur und Kunst.' More generally on the villa as 'cultural symbol' and 'powerhouse', cf. Wallace-Hadrill 1998, revised in 2008: 196–208, along with e.g. Hales 2003: especially 32–6. Mattusch (ed.) 2008 provides a useful introductory overview of Campanian villas, while Marzano 2007 offers the best overall archaeological guide; for Roman maritime villas, see Lafon 2001.

[144] P. Zanker 1995b: 198–217 (quotation from 206).

[145] See P. Zanker 1995a: 194–201 on 'die "Freizeit-Intellektuellen" in der Bilderwelt des *otium*'; the English translation (P. Zanker 1995b: 203–10) rather misses the inherently pictorial point, translating the phrase simply as 'the world of *otium* and the gentleman scholar'.

FIGURE 24. Drawing of a bust
of Homer, inscribed with three
Greek epigrams, from the Villa
Aeliana outside Rome.

Aeliana, just outside Rome's Porta Trigemina, provide one preliminary example,
in which an Imperial bust of Homer (paired alongside another portrait
of Menander) was juxtaposed with three inscribed epigrams on the poet
(Fig. 24).[146] Villas like these were not just places for affecting learning, they
were also places in which to flaunt learning for social effect. To my mind, the Iliac
tablets epitomize this thinking.[147]

[146] On the Homeric bust and epigrams (14 lines in total) see *IG* 14: 314–15, no.1188; *IGUR* 4: 37–8,
no. 1532, along with Bowie 1989: 244–7 ('a pleasing and intellectually stimulating ensemble that would
mark out the herms' owner-poet as a discerning man of letters', 247), and Prioux 2008: 123–49. For the
related argument that such aristocratic decorative programmes, descended from Hellenistic prototypes,
provided models for humbler Pompeian houses, see P. Zanker 1979 and 1998: 135–203. It is worth
emphasizing that such self-consciously 'learned' programmes are by no means chronologically limited to
the early Imperial period, nor are they restricted to Roman Italy or unique to a sculptural medium: cf. e.g.
Stirling 2005: especially 165–227.

[147] In this regard, we should recall some of the other objects found alongside tablets 1A and 17M—the
Archelaus relief from Messer Paolo (Fig. 3), as well as the literary artefacts from Tor Paterno (above,
pp. 66–7).

Highbrow literary themes were among the favourite sculptural subjects to adorn Roman villas.[148] They also filtered their way into somewhat more humble contexts, and indeed less expensive media. Writing under Augustus, Vitruvius comments on the general popularity of wall paintings depicting 'the battles of Troy or the wanderings of Odysseus through landscapes' (*Troianas pugnas seu Ulixis errationes per topia*, 7.5.2), modelled perhaps after a related series of paintings on the Trojan War that came to be displayed in Rome's Portico of Philip, attributed to a certain Theorus (*bellumque Iliacum pluribus tabulis*, Plin. *HN* 35.144).[149] Such subjects were also famous enough to be burlesqued in Petronius' *Satyricon*—not only in the mural decoration of Trimalchio's hall (said to have been adorned with an *Iliad* and *Odyssey*, albeit tellingly set beside an image of gladiatorial games, *Sat.* 29.4), but also in a panel painting of the sack of Troy (*Troiae halosin, Sat.* 89), hung on the walls of an imaginary picture gallery.[150]

Theorus' paintings are lost. But four related cycles of wall paintings are known from the material record, all of them (like the *Tabulae Iliacae*) dating from either the late first century BC or first century AD. Three friezes relating to the *Iliad* are known from Pompeii: two of them were displayed in separate rooms of what was once the same house (the Casa del Criptoportico, Pompeii I.6.2 and Casa del Sacello Iliaco, Pompeii I.6.4—the first 'Second Style' series of paintings installed at around 30 BC, and a later 'Fourth Style' cycle dated to almost a century later, this time rendered in painted stucco); a third series of 'Fourth Style' paintings adorns an oecus overlooking the nymphaeum of the Casa di Octavius Quartio (also known as the Casa di Loreius Tiburtinus), Pompeii II.2.2, installed in the AD 70s (Figs. 47–8).[151] Although somewhat different in topography and design, the so-called 'Odyssey landscapes' from the Esquiline

[148] For some introductions to such sculptural programmes more generally, see e.g. Neudecker 1988: especially 64–74 and 1998; Bartman 1994; Newby 2002; Tanner 2006: 274–5. For two excellent articles on Roman artistic engagements with Homeric epic specifically, see Simon 2001 and 2008; cf. Solomon 2007: 500–3.

[149] The most famous depictions of the sack of Troy seem to have been by Polygnotus in the fifth century BC, one in the Stoa Poikile in Athens, the other in the Lesche of the Cnidians at Delphi: see Paus. 1.15.3 and 10.25–7, along with the other sources collected in Overbeck 1868: 188–201, nos. 1050–7; for discussion and reconstruction, see Stansbury-O'Donnell 1989; cf. also idem 1990 on Paus. 10.28–31 (a painting in the same building at Delphi drawn from *Odyssey* 11).

[150] On the painting, and Eumolpus' ecphrastic response to it, see below, pp. 157–8.

[151] The three Pompeian cycles are published by Aurigemma 1953, and further discussed by Schefold 1975: 129–34; Brilliant 1984: 60–5; Croisille 2005: 154–65; Santoro 2005: 106–9, 113–14 (with detailed bibliography). On the paintings from cryptoporticus 17 of the Casa del Criptoportico (inscribed in Greek), see *PPM* 1: 201–28, nos. 13–61—along with *PPM* 1: 193–5 on the history of the house. On the painted reliefs from room e of the so-called Casa del Sacello Iliaco (uninscribed), see *PPM* 1: 295–305, nos. 19–43. On the paintings from oecus h of the Casa di Octavius Quartio (inscribed in Latin), see *PPM* 3: 82–98, nos. 64–85, as well as below, pp. 145–7. The three-couch arrangement of the room in the Casa di

similarly relate to events described in the tenth to twelfth books of that poem, arranged around a series of painted architectural supports. These 'Second Style' paintings are even earlier than those in the Casa del Criptoportico, dating to around 50 BC. While only seven complete panels survive, they originally formed part of a march larger series (some put the number at 35, others suggest as many as 100 panels).[152]

We cannot be sure about the functions of all four rooms where these mural cycles were installed; in any case, we have already noted that in the Pompeian household, as opposed to the modern Western home, individual activities were not restricted to individual domestic rooms. Still, there is one Roman ritual that was especially well suited to such lavishly decorated spaces: the Roman dinner, or 'cena'. The festivities of dining and drinking provided a particular sort of domestic forum for flexing one's social, cultural, and economic muscle, and for doing so before a captive audience of family, friends, and rivals.[153] Numerous scholars have shown how Pompeian mythological panel paintings could serve as prompts for learned conversation in such contexts.[154] Throughout the Roman Empire, more-over, we find mosaics laid down in dining spaces, many of them drawn from the epic subjects of the *Iliad* and *Odyssey* specifically.[155]

Learned discussions of myth, history, and literature were the bread and butter of the Roman cena. Though he might get his own wonderfully wrong, even Petronius' Trimalchio appreciates that 'one must know one's philology at dinner' (*oportet enim inter cenandum philologiam nosse*, *Sat.* 39.3): Trimalchio proceeds not only to introduce a troop of Homeric actors (*Homeristae*, Petron. *Sat.* 59), but also to boast of his silver cups and jugs, said to depict a host of Trojan themes

Octavius Quartio, with its offset western doorway, suggests that it was conceived first and foremost as a space for dining.

[152] Biering 1995 provides the most detailed publication; other important discussions include Schefold and Jung 1989: 350–7; Coarelli 1998 (especially 25 for the relation to the 'erudite elaborations of Hellenistic philology'); Andreae 1999: 242–57; O'Sullivan 2007 (with review of bibliography on 500–4). Compare too the continuous painted frieze of the founding of Rome from an Esquiline tomb: Cappelli 1998 provides an excellent introduction.

[153] On the visual culture of Roman dining, cf. e.g. Dunbabin 1996, along with Jones 1991 (on 'dinner theatre'—i.e. 'the visual entertainment that hosts in antiquity offered to their guests over dinner', 185) and d'Arms 1999 (on dinner itself as spectacle). I have not yet been able to consult Nadeau 2010.

[154] Cf. e.g. Bergmann 1999, along with Ling 1995: 247–8 on the preference for mythological themes in triclinium wall paintings. Trojan themes were a favourite among Pompeian panel paintings: Hodske 2007: 34 counts 106 examples (14% of his total). Cf. also F. G. J. M. Müller 1994: 129–31 on how Trojan scenes in the oecus of the Villa di Fannius Synistor at Boscoreale might have complemented the recitation of Homeric hexameters at dinner.

[155] See e.g. Stefanou 2006: especially 51–176, counting 26 mosaics on Iliadic and Odyssean subjects: 'Die besprochenen Darstellungen mythologischer bzw. literarischer Thematik sind vor allem auf Mosaiken anzutreffen, die zur Ausstattung von Empfangsräumen und Triklinien gehörten' (p. 347); cf. also Muth 2007.

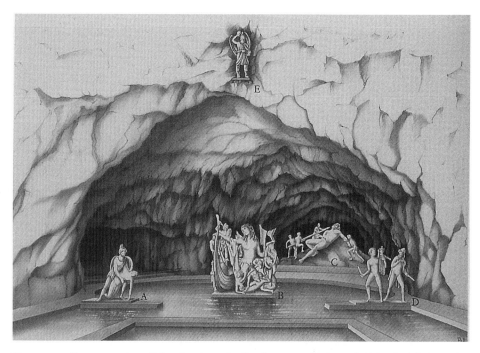

FIGURE 25. Reconstruction of the view into the Sperlonga grotto from the island triclinium: the letters refer to the Pasquino group (A), the Scylla group (B), the Polyphemus group (C: Fig. 132), the theft of the Palladium group (D), and Ganymede and the eagle (E).

(*Sat.* 52).[156] Whether or not Jeremy Tanner is right in characterizing Trimalchio as the categorical 'antitype of true connoisseurship',[157] the social satire evidently lay in reversing established practices of artistic display. Although associated with a very different class of dinner guest, the epic sculptural groups set up in the Imperial grotto at Sperlonga—Odysseus' encounters with Polyphemus and Scylla, the Pasquino group, and the theft of Troy's Palladium (among other subjects)—provide a related set of comparanda (Fig. 25).[158] As I have argued elsewhere, the juxtaposition of these diverse Homeric/Ovidian/Virgilian scenes, interspersed among other subjects, was deliberately polyvalent: the sculptures

[156] See below, p. 82. Cf. e.g. Plin. *Ep.* 3.1.9 (commending to Calvinius Rufus how, at Spurinna's house too, 'comedies are often performed between courses at dinner, so that the pleasure of dining is seasoned with literary studies': *Frequenter comoedis cena distinguitur, ut uoluptates quoque studiis condiantur*); Sen. *Ep.* 88.6–8, which, although disparaging, expertly describes the sorts of literary questions that characterize *liberalia studia*; Ov. *Her.* 1.31–6—a witty, mythologized pastiche. For two recent surveys of the interconnectedness between reading and dining, see W. A. Johnson 2010: 127–9 and Too 2010: 100–10.

[157] Tanner 2006: 250.

[158] For two concise overviews of the sculptures and their setting, see Ridgway 2000 and Sauron 2009: 155–95. The placement of the groups is discussed by Conticello and Andreae 1974: 15–20, while Cassieri 2000 provides a well-illustrated guide to the excavations and museum.

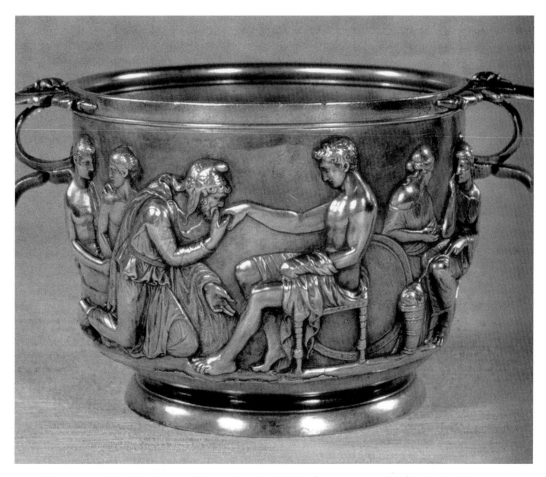

FIGURE 26. Silver 'Hoby cup' of the embassy to Achilles, first century BC (Dnf. 10/20; height: 10.6 cm; diameter: 13.5 cm).

catered to the dining audiences seated in the adjoining triclinium, encouraging them to explain the significance of the theme-park-style assemblage during the course of the other festivities.[159]

It is against a similar sort of learned background that the *Tabulae Iliacae* should also be understood. As riddling rebuses, the tablets tested the ingenuity of those who engaged with them, furnishing guests with centrepieces for conversation. Of course, the cena cannot have been the *only* context for viewing the *Tabulae*: nursed in a user's lap, the tablets could be enjoyed in individual solitude as well as

[159] See Squire 2003; 2007: 116–17; 2009: 219–20. Cf. e.g. Schmid 2003: 215–16: 'Wie gezeigt, haben alle [*sc.* Gruppen] eine direkte Verbindung zu der Funktion der Grotte als Ort des Symposion...'. This cultural agenda became all the more pressing with the subsequent addition of a ten-line hexameter ecphrastic poem (probably in the late third or early fourth century AD)—quite literally inscribing Virgil into subsequent viewings of the grotto: see Squire 2009: 221–9.

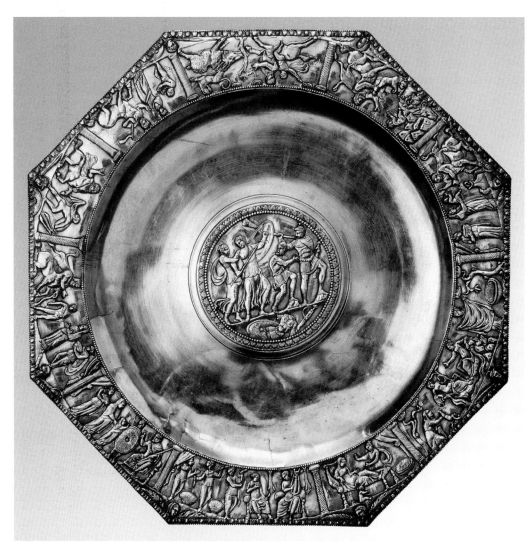

FIGURE 27. Silver plate from the Kaiseraugst Treasure, fourth century AD (height and width: 53 cm).

in company—a bit like our modern handheld 'games consoles' today (the dimensions are not all that far from those of a Nintendo DS, Kindle, or iPad). As with all such twenty-first century devices, playing on one's own prepared the ground for sharing with (and bragging to) friends, colleagues or rivals: the dinner party provided one ideal opportunity for such discourse and display.[160]

[160] For some related conclusions about the *Tabulae* (albeit without the associated rhetoric of the *cena*), see e.g. Brüning 1894: 165, associating both tablet 1A and the *Ilias Latina* with 'alexandrinische[r] in Gelehrsamkeit'; Lippold 1932: 1893 ('Die ganze Aufmachung spricht... für die [Verwendung] im Hause des Gebildeten, wo die Tafeln zugleich auch zum Schmuck dienten'); Sadurska 1964: 9 ('les tables iliaques étaient commandées par des romains cultivés et instruits', foreshadowed in Sadurska 1959: 123–4);

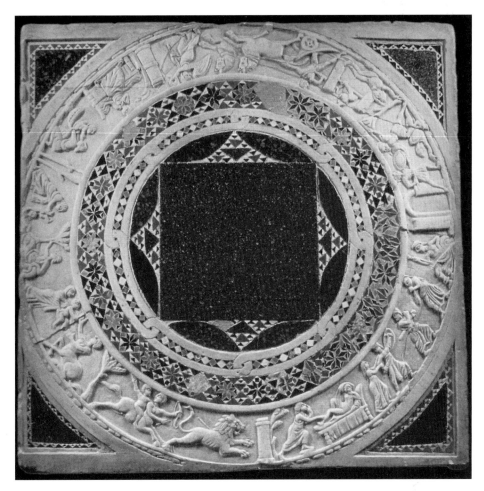

FIGURE 28. Marble table with circular frieze with events from the life of Achilles, inlaid with glass and precious stones, fifth century AD (Musei Capitolini inv. 64; 103 x 103 cm).

Rather than propose a single space for viewing the tablets, my suggestion pertains to a particular sort of cultural milieu. The tablets do not lend themselves to a utilitarian function, unlike the aforementioned 'Megarian' relief cups, designed first and foremost as vessels from which to drink (Figs. 20–1). But one can imagine the *Tabulae* catering to precisely the same sorts of learned discussion. As Lucilla Burn has recently concluded, the 'Megarian' cups likewise lent

Guarducci 1974: 502 (on their 'ambiente di cultura e di richezza'); Hellmann 1983: 44 (on the 'très érudites' inscriptions); Schefold and Jung 1989: 177 (on the tablets as 'Symbole der unsterblich machenden Bildung'); Salimbene 2002: 29 (concerning 'celebrazione di prodotti letterari'); and Valenzuela Montenegro 2004: 408–12 (understanding the tablets as an 'Einladung zum gelehrten Diskurs'). The thesis has yet to penetrate anglophone scholarship.

themselves to a 'scholarly clientele who may, perhaps, have enjoyed the cups at literary symposia, turning them in their hands and taking it in turns to recite the stories shown';[161] in this sympotic context, writes Luca Giuliani, 'the more diverse their images and the more riddlesome the citations, the more appealing the game'.[162]

Most of the 'Megarian' cups known to us date from the second century BC, making them considerably earlier than the *Tabulae Iliacae*. But their Homeric subjects are nevertheless paralleled on a number of early Imperial silver vessels: one extant vessel represents Odysseus' visit to the Underworld, for example, and one of the 'Hoby cups' depicts Priam's embassy to Achilles (Fig. 26), pairing this with a related epic episode on a second matching example (the Philoctetes cup was signed by the same 'Cheirisophos' artist, and was found alongside it on the Danish island of Lolland (Figs. 137–8)).[163] These are the sorts of silver vessels to which Trimalchio aspires in the *Satyricon*, claiming that he owns 'about a hundred four-gallon cups [*scyphos urnales*] engraved with Cassandra killing her sons', and a 'thousand jugs [*capides*] . . . on which Daedalus encloses Niobe in the Trojan horse' (*Sat.* 52). If the Petronian joke lies in Trimalchio's mistaken readings of myth (and not least in the grotesque scale of the cups), we know that Roman emperors were not averse to collecting such 'epic' objects of their own: Suetonius records how, in the tumults of AD 68, Nero angrily 'tipped over a table, dashing to the ground two favourite drinking cups which he called "Homeric" because they were carved with scenes from Homer's poems'.[164] These suave sorts of dining paraphernalia evidently remained popular late into Late Antiquity: numerous silver vessels depict scenes from the life of Achilles, including the lavish plate found in Augst near Basel with its central image of Achilles at Scyros (Fig. 27), and an additional example amid the controversial Sevso Treasure.[165]

[161] Burn 2004: 133.

[162] L. Giuliani 2003: 277: 'Je vielfältiger die Bilder und je rätselhafter die Zitate, desto reizvoller das Spiel.' Although rather humbler in design, Roman *terra sigillata* cups also catered to diners wanting to spice up their dinners with Trojan mythological themes: see e.g. Oswald 1936–7: 30, nos. 228–32 (Greeks landing at Troy); 30, no. 238 (Neoptolemus and Polyxena); 76, nos. 982–3 (Odysseus and Polyphemus).

[163] Cf. Simon 2008: 235–6, and note too Pannuti 1984 on a small, silver early Imperial *kalathos* vase showing the apotheosis of the poet beside personifications of the *Iliad* and the *Odyssey*. For this particular Hoby cup, see C. W. Müller 1994: 322–9: as we shall see below (pp. 293–5), the two cups were deliberately designed as a diptych—the one set at the beginning of the Trojan War, the other set towards its end; drinkers were no doubt intended to extemporize on the 'cleverly handled' pairing.

[164] Suet. *Ner.* 47: . . . *mensam subuertit, duos scyphos gratissimi usus, quos Homericos a caelatura carminum Homeri uocabat*. The story was evidently anecdotal: Plin. *HN* 37.29 recounts the same tale, though adding that the two cups were made of crystal (*duos calices crystallinos*). For the comparison with the 'Megarian' cups, see e.g. Robert 1890: 1–2; Michon 1899: 372; Guarducci 1974: 503.

[165] For the Augst plate, the most important analysis is Cahn and Kaufmann-Heinimann (eds.) 1984: especially 225–308; for the Sevso Achilles plate, see Mango and Bennett 1994: 153–80. The two silver dishes are discussed by Leader-Newby 2004: 125–41; cf. Latacz (ed.) 2008: 350–1, no. 85 and Grassigli 2006:

Other artefacts projected such epic cycles into different sorts of drinking and dining objects: compare, for instance, a fourth-century table, inlaid with glass and precious stones, and framed with a literal cycle of Achillean scenes (Fig. 28). Here, as on the Augst plate, Achilles' deeds spin an endless circular course around the object, from the hero's birth to his dragging of Hector's corpse around the city walls of Troy (and back again).[166]

I end this chapter, however, with one particular (learned citation of a) cup, and one which has remarkable parallels with the *Tabulae Iliacae*. The object does not survive, and we know of it only through Athenaeus' purported description in the *Deipnosophistae*, written in the late second or early third century AD. In the context of a whole book dealing with famous drinking cups, many of them related to epic subjects, Athenaeus evokes a 'Heraclean cup' adorned with the sack of Troy: the object, Athenaeus continues, was crafted by a certain 'Mys', but it was inscribed with a two-line epigram by 'Parrhasius' (11.782b):

> ἔνδοξοι δὲ τορευταὶ Ἀθηνοκλῆς, Κράτης, Στρατόνικος, Μυρμηκίδης ὁ Μιλήσιος, Καλλικράτης ὁ Λάκων καὶ Μῦς, οὗ εἴδομεν σκύφον Ἡρακλεωτικὸν τεχνικῶς ἔχοντα Ἰλίου ἐντετορευμένην πόρθησιν, ἔχοντα ἐπίγραμμα τόδε·
>
> γραμμὰ Παρρασίοιο, τέχνα Μυός. ἐμμὶ δὲ ἔργον
> Ἰλίου αἰπεινᾶς, ἂν ἕλον Αἰακίδαι.

Famous workers in sculptural relief were Athenocles, Crates, Stratonicus, Myrmecides of Miletus, Callicrates of Laconia, and Mys—whose Heraclean cup we have seen. The cup is artistically *(technikôs)* rendered in relief with the Sack of Troy and has the following epigram: 'The figurative line *(grammê)* is by Parrhasius, the craftsmanship *(technê)* by Mys. I am a work of lofty Troy, which the Aeacidae captured.'

The analogies between this cup and the *Tabulae Iliacae* are numerous and fascinating: quite apart from the games of scale—not for nothing is this larger-than-life 'Heraclean' cup associated with Myrmecides and Callicrates, whose notorious miniaturist *Iliads* were explored in the previous chapter (pp. 1–11)— notice the parallel *Ilioupersis* subject matter.[167] Then there are the games with poem and picture. As on the *Tabulae Iliacae*, the epigram's language of *technê*, *grammê*, and *ergon* knowingly blurs the boundaries between the object's verbal and visual decoration: since all three nouns can apply to things that are both

129–30. Kemp-Lindemann 1975: 232–42 lists further late antique examples, complete with similar cycles of images: for other cups and plates, cf. e.g. Childs 1979; Cutler 1990: 13–15; Moraw 2005.

[166] See Dresken-Weiland 1991: 83–99 and Bottini and Torelli (eds.) 2006: 153–5 (with further bibliography). Related late antique images of Achilles are discussed by Grassigli 2006 and Ghedini 2007: 156–8 (with references to earlier work).

[167] For the epigrams on tablets 1A and 2NY, see below, pp. 102–21.

written and drawn, the inscription at once asserts and denies a difference between artist and poet (whose was the figured text and whose the inscribed image?).[168] Perhaps most interesting of all is the playful attribution to 'Parrhasius' and 'Mys'. Anyone who knew their 'Great Masters' could perhaps have been expected to appreciate the joke: the original fifth-century 'Mys' and 'Parrhasius' were between them responsible for the gigantic shield of Pheidias' Athena Promachos statue on the Athenian Acropolis; *this* eponymous artistic duo, by contrast, has cheekily turned that shield's gigantic representation of the Centauromachy into a miniature representation of the sack of Troy.[169] As I suggest in the sixth chapter, the 'Theodorus' of six *Tabulae Iliacae* played upon a similar *nom de plume*, and in a related manner.[170]

Athenaeus' description of this cup by 'Mys' and 'Parrhasius' does not only parallel the forms and conceits of the *Tabulae Iliacae*. It also parallels some of their functions and display contexts. Not for nothing are Athenaeus' comments to be found in a text called *Deipnosophistae* (literally 'Sophists at dinner')—a work whose self-conscious concern is with dining (*deipnon*) as an occasion for displaying 'wisdom' (*sophia*). As a cup, the object that Athenaeus describes is necessarily bound up with festivities of eating and drinking. But the dinner party also provides a cultural framework for the cup's phenomenological or 'ontological' play more generally—its self-conscious staging of, no less than oscillation between, a myriad of different representational realms. So erudite are these games, in fact, that they become a topic in their own right, the subject of the secondary 'dinner conversation' recorded in Athenaeus' *Deipnosophistae*: Athenaeus capitalizes on a dinner conversation that in turn capitalized on the cultural capital (the visual-cum-verbal *sophia*) of this cup—even when it was not available for visual inspection by the diners, or (at third remove) by Athenaeus' community of readers. The claim to have *seen* the cup (εἴδομεν) ricochets from monumental cup seen, through purported oral conversation heard, to textual anecdote read from the record of the page. The recessions, moreover, mirror those of the described object—simultaneously and at once a grand Heraclean cup thrust into mortal hands, a depiction of lofty Troy in miniature relief, and a *grammê* and *technê* (vacillating between something seen and something read—a virtuoso creation of a make-believe

[168] Both terms are used in parallel senses on the *Tabulae Iliacae*: see below, pp. 102–21 on *technê*, and below, pp. 235–43 on *gramma*.

[169] For the story—whereby Parrhasius drew the original designs for the shield, which Mys subsequently turned into reliefs—see Paus. 1.28.2, where it is attributed to hearsay (λέγουσι): cf. Overbeck 1868: 326, no. 1720, with detailed discussion in Hitzig and Blümner (eds.) 1896: 302–3. As far as I know, no commentator has noticed the onomastic play here, instead taking Athenaeus (as ever) at his word: e.g. Rumpf 1951: 1, who follows Overbeck 1868: 326, no. 1721 in simply identifying this 'Parrhasius' with the fifth-century painter.

[170] See below, pp. 283–302.

artistic-cum-literary duo). The task is to tease out the delicious fictions of the object, and to do so during the course of an evening's entertainment.[171]

Each of the following chapters sets out to show the related cultural capital of the *Tabulae Iliacae*. Like the 'Heraclean cup', the tablets could serve as conversation pieces in similar ways. The rituals of the cena, moreover, provide one exemplary backdrop for understanding the medial games that they materialize.

CONCLUSION: TABLETS FOR HIGH TABLES

This has been an at once detailed and broad-brush introduction, surveying a range of themes and scholarly controversies. My foremost objective has been to tabulate, summarize, and review. Despite the fragmentary nature of the evidence, we have moved towards some preliminary conclusions.

Quite apart from their formal affinities, the tablets share a common conceptual derivation: although working to different designs, with different subject matter, and despite being rendered in different materials, the *Tabulae Iliacae* play with a related set of cultural ideas. Available evidence indicates an early Julio-Claudian date, although at least one second-century example (19J) suggests that the tablets exerted a longer artistic presence, and indeed influence. Artistic attribution alone cannot explain the formal similarities and differences between these objects: the simultaneous homogeneity and heterogeneity of the assemblage frustrates any such schematic classification. By the same token, there is no inherent reason for attributing all the tablets to one single workshop, still less to a certain 'Theodorus': the Antonine date of tablet 19J problematizes all such attempts to 'localize' artistic production too narrowly.

Formal questions of date, material, and provenance also yield some initial clues about use, display context, and purpose. The *Tabulae Iliacae* were clearly luxury

[171] Before dismissing such conceits as thoroughly 'Hellenistic', or else as unique to the particular cultural poetics of the Second Sophistic, it is worth remembering 'Nestor's cup', made in the eighth century BC. This object from Pithecusae, inscribed with three dactylic hexameters, is among the earliest Greek graffiti known to us (*SEG* 26.1144; *CEG* 1.454: cf. Powell 1991: 163–7; Malkin 1998: 156–60; Meyer 2005: 49–51; R. Osborne and Pappas 2007: 132–9; Livingstone and Nisbet 2010: 68–9). The inscription forges a clear connection between the present cup and the myths of Homeric epic—not only in terms of content, but also through the epigram's metre and use of epithets; at the same time, the writing is framed in such a way 'as if to accord with the decoration' (Powell 1991: 164). Although the humble object compares itself to the fine chalice that Nestor alone could lift without effort when full (*Il.* 11.632–7), this little cup is no less prepossessing in physical size than its epigram proves diminutive in length (see Bing 1998: 33 n. 38): it is just 10.3 cm in height and 15.1 cm in upper diameter. Already in the eighth century, in other words, such conceits of size, medium, and onomastic attribution seem to have befitted the 'symposion as an arena congenial to allusive play' (Bing 2009: 155; cf. Danek 1994–5). Much later references to the same cup during the course of the symposium testify to the literary object's sympotic *longue durée* (e.g. Ath. 11.461d).

objects, destined for an affluent elite. The little information that is known about provenance reinforces the argument: housed in the villas of the rich and well-to-do, the tablets seem to have capitalized on the opulence and cultural aspirations of their owners. Doubtless the tablets were viewed and experienced in a variety of ways. But the cultural rituals of the cena provide a particularly helpful social context in which to make sense of their visual–verbal subjects. The point, as the following chapter argues, becomes all the starker when we look at tablets' actual inscriptions. For everything about these tablets confirms a highly literate and sophisticated class of clientele.

Mastering Theodorean *Technê*

The painstaking labour that was evidently expended on the *Tabulae Iliacae* suggests that they were luxury products. As the previous chapter concluded, the tablets could not have belonged to any sort of mass market, and the little we know about archaeological provenance reinforces the argument. So who then commissioned these objects, and what level of cultural knowledge do they assume?

In anglophone scholarship, it is usual to associate the tablets with a particular class of owner: the tablets, according to this hypothesis, offered the ultimate in 'bling' for those who knew no better. As banal and puerile objects, the *Tabulae* catered to a vulgar and at best semi-literate audience, usually composed of freedmen, and in any case descended from a new Imperial breed of Roman *nouveaux riches*. It is Nicholas Horsfall who has championed the thesis in a handful of important articles on the tablets, their relationship to lost poetic texts and their supposed derivation from illustrated texts. It is an argument that very much endures: the tablets, writes Wallace McLeod, are best understood as 'a piece of marketplace trumpery designed to massage the ego and lighten the pocketbook of the newly rich'.[1]

This chapter sketches a very different sort of market for the *Tabulae*. Rather than 'inadvertently' misrepresent their subjects, I suggest, the tablets played with their partial and miniature remouldings of established literary models. What this means for the iconography of the tablets will be the subject of the following chapter. My specific concern in this chapter, rather, is with the tablet's inscriptions, and especially the programmatic epigrams inscribed on fragments 1A and 2NY. As I hope to show, the literary sophistication of these two epigrams catered to readers who not only knew their Greek texts, but who reconsidered those texts in the light of the pictorial-poetic objects beheld.

[1] McLeod 1985: 135. For the same sentiment earlier, cf. idem 1973: 408, labelling these 'minor artistic creations' 'carelessly executed reliefs intended to illustrate literary works'.

BALDERDASH AND TRIVIAL PURSUITS

Before proceeding, it is worth saying a little more about Nicholas Horsfall's particular interpretation of the tablets. Although revisited in a series of subsequent discussions (most recently in 2008), the classic articulation of Horsfall's 'Trimalchio thesis' came in 1979.[2] Horsfall's conclusions were at once concerned with the production of the *Tabulae* and with their consumption: on the one hand, Horsfall uses both the tablets' images and texts to argue that 'Theodorus was concerned not with concinnity, but with convenience'; on the other, he surmises that 'above all, the *Tabulae* belong *chez* Trimalchio'.[3] The manifest mistakes in manufacture point to a misinformed market. The tablets, like their original owners, are coarse, crass, and uncouth: as vulgar and proletarian objects, concludes Horsfall, they can *only* have catered to the sorts of tasteless freedmen that Petronius' *Satyricon* describes.

To understand Horsfall's argument, it is necessary to understand how it relates to a much grander thesis about a lost tradition of Archaic Greek poetry. As Horsfall freely admits, his objective was not to provide 'an overall survey' of the tablets, but instead to offer 'a revival of discussion in areas where it appeared that a fresh approach might yield profit'.[4] For Horsfall, what matters is the information the *Tabulae* might reveal about the non-extant poems depicted, especially a text like Stesichorus' sixth-century *Ilioupersis*, about which we otherwise know so little. Horsfall consequently proceeds in three stages: he comments first on 'Theodorus' origins and role . . . and the distinctive market at which his works were aimed'; second, on the central *Ilioupersis* panel of the *Tabula Capitolina* (tablet 1A); and third, on the tablets' collective place within the history of book illustration. Horsfall's conclusions concerning the three themes are manifestly related. His comments on issues one and three provide the answer to his second question: the vulgar market of the tablets, together with their supposed derivation from so-called *Bilderbücher* (i.e. books of pictures with labelled figures), are central to Horsfall's overarching proposal about 'Stesichorus at Bovillae'—namely, that the tablets provide an unreliable source for reconstructing Stesichorus' lyric poem. 'We are compelled to infer that Theodorus, even if he did have access to a text or epitome of Stesichorus (which is now evidently far from certain) had no scruple about abandoning it and betraying his own *Quellenangabe*', as Horsfall puts it; 'there is really nothing to prove what the source of

[2] See Horsfall 1979a, and cf. idem 1979b: 375–6; 1994: 67–82; 2008: 587–91; Brenner and Horsfall 1987: 14–15. For a related critique, see Squire 2010c: especially 69–72.

[3] Horsfall 1979a: 46, 35.

[4] Ibid. 26.

the several *Iliou Persis* panels to derive from Theodorus' workshop actually was: a farrago of names and sources in a mythological handbook—including the unexpected and impressive Stesichorus—is, I suspect, the likeliest hypothesis'.[5]

Fundamental to this methodology is a certain mode of construing relations between texts and images. In order to engage with a text, Horsfall assumes, an image must follow it to the letter; if the *minutiae* of a picture depart from those of a poem, moreover, we are thought to have evidence that the two spheres operated in isolation from one another. By comparing the central *Ilioupersis* scene on the Capitoline tablet with what can be inferred about Stesichorus' poem from other sources, Horsfall proceeds to detect a number of discrepancies. The fact that we know so little about Stesichorus—a handful of literary references and a series of fragmentary papyri (above all, *P. Oxy.* 2619 and 2803, with fragmented sections from the *Ilioupersis*)—proves no serious deterrent.[6] Because picture seems not to tally with poem, we must ignore the tablet's own profession to descend from Stesichorus, emblazoned below its central scene ('the *Ilioupersis* after Stesichorus': *ΙΛΙΟΥ ΠΕΡΣΙΣ ΚΑΤΑ ΣΤΗΣΙΧΟΡΟΝ* (Fig. 35)): the images of the Capitoline tablet have nothing to do with the 'original' Stesichorean text.[7]

If these assumptions inform Horsfall's interpretation of the *Tabula Capitolina*'s *Ilioupersis* scene in particular, they also lie behind his belittling judgement of the *Tabulae Iliacae* at large. The tablets are deemed lowbrow objects on the grounds of their associated 'inaccuracies' in both word and image. Once again, Horsfall turns to the Capitoline tablet as an example, examining first the miniature epitome inscribed on its right-hand pilaster, and second its pictorial summaries of *Iliad* 13–24: just as the tablet's inscribed summary 'departs' from the Homeric text,[8] Horsfall concludes, so too is its iconography inconsistent with the details and emphases both of the original Iliadic poem and of the inscribed prose

[5] Ibid. 38, 43. As Horsfall argues elsewhere at greater length (1979b), this thesis is in turn significant for reconstructing the pre-Virgilian treatment of the Aeneas legend: 'what we have lost is one of the pillars which supported the traditional reconstruction of how the Aeneas-legend developed' (1979a: 43).

[6] The papyrological evidence means that it is not quite right to declare, as does e.g. Simon 2008: 237, that 'wir wissen von diesem Werk nur durch die *Tabula Capitolina*'. For the twentieth-century papyrological discoveries, see Schade 2003: 1–9, especially 3–5 on *P. Oxy.* 2619 and 2803; Schade 2003: 141–68 is the most accessible edition of these *Ilioupersis* fragments, but cf. also Campbell (ed.) 1991: 101–20; Davies (ed.) 1991: 183–205; Kazansky 1997.

[7] Cf. Horsfall 1979a: 38: 'Where comparison between the tabulae and the fragments is possible, it does nothing to increase Theodorus' credibility.' In fact, the author continues (38–40), 'close study' of the pictorial details instead suggests derivation from a more immediate poetic source: Virgil's *Aeneid* (cf. below, pp. 148–58).

[8] Cf. idem 1994: 79: 'The summaries of the poems, like that running down the pilaster on the *Tabula Iliaca Capitolina*, are appallingly jejune and sometimes quite simply wrong, which is indeed what have [*sic*] come to expect in the Vulgarerzählung of ancient mythology.'

epitome.[9] It is not just the reliefs that are here 'faulty and jejune', in other words, but also the 'explanatory texts': 'the workshop must have contemplated with equanimity a clientèle which…was content with a few names of participants and a confused visual impression of what the cycle poems had recounted':[10]

> Text and illustration alike suggest a clientèle unacquainted with Homer himself. For some of the most familiar scenes in Greek mythology these users regularly required an explanatory text, and one that was itself restricted to the barest sequence of characters and events—short enough, that is, not to strain their attention! Their eyes might rove over the generous provision of illustrations, but these were equally simple and so small that the artist could add little if anything of his own emotions and interpretations to the narrative. This clientèle was not so ignorant of Greek that it could not cope with the simple linguistic demands made by Theodorus' texts, but its general cultural level was not high.[11]

Horsfall does at times admit certain 'ingenuities' among the tablets, albeit somewhat begrudgingly: 'the *Gelehrsamkeit* of the inscriptions is intermittently distinctive'.[12] Quite apart from the tablets' content, Horsfall also draws attention to the aesthetic 'skill and elegance' of (at least some of) the inscribed writing.[13] Still, the analysis leaves readers in no doubt: the tablets' textual infidelities mean that they can only ever be 'scraps of high erudition'. However 'miniaturised, elegant, attractive' the tablets may seem, such 'curious works' must have been 'profoundly trivial'. The *Tabulae Iliacae* are at heart *Tabulae Illitteratae*: 'the serious lover of Greek literature would surely have been appalled by such a combination of the obvious, the trivial and the *false*'.[14]

So who *did* use the tablets? Although proceeding from a close inspection of the inscriptions and images on the tablets, Horsfall's ultimate conclusions are drawn up from a series of more or less contemporary Latin texts. 'If the educated owner of a library could not have derived much joy from the possession of any of the *Tabulae*', Horsfall explains, 'there were others'. Making recourse to the Younger Seneca's complaint about those 'lacking even a child's knowledge of letters who

[9] Cf. idem 1979a: 45–6: 'These fluid relationships confirm that Theodorus is likely to have derived texts and reliefs from distinct and independent sources. The discrepancies between texts, reliefs and the text of Homer have long vexed scholars, but they are easily explained if we suppose that before Theodorus selected an ὑπόθεσις of suitable length—or perhaps mangled one to suit the area available to accompany a series of reliefs, the reliefs and texts had no connexion with each other' (46). Mancuso 1909: 694–5 gives a more detailed list of such supposed 'discrepanze'.

[10] Horsfall 1979a: 33, 34. There are earlier precedents for these criticisms: cf. e.g. Bulas 1929: 131 on how 'les auteurs des tables troyennes aient été exposés à des malentendus, omissions et erreurs'.

[11] Horsfall 1979a: 34.

[12] Ibid. 33; cf. 29 ('flickering *Gelehrsamkeit*…regularly put to trivial and bizarre uses').

[13] See ibid. 32–3 on the verso of tablet 4N; cf. idem 1994: 79, characterizing the lettering on that tablet's obverse side as 'a remarkable tour de force'.

[14] Idem 1994: 79 (my emphasis). For the underlying ideology of 'seriousness', see above, p. 15.

still use books, not as tools of learning, but rather to decorate the dining-room' (*sicut plerisque ignaris etiam puerilium litterarum libri non studiorum instrumenta sed cenationum ornamenta sunt*: Sen. *Tranq.* 9.5), Horsfall argues that 'we are thus brought firmly back to the world of Trimalchio':[15] 'this expensive rubbish belonged in the homes of the nouveaux riches—of men such as Calvisius Sabinus, who forgot the names of Achilles, Priam and Ulysses[,] and Trimalchio himself, whom Petronius portrays as having Homeric cups, Homeric scenes on the walls and readings of Homer at dinner and yet as utterly ignorant of myth'.[16] Crucially, moreover, this supposed 'Trimalchionesque' context is again used to illuminate the independence of the tablet from Stesichorus' *Ilioupersis*: 'If the cultural context of the *TIC* [*sc. Tabula Iliaca Capitolina*] was . . . the exuberant pretensions of the semi-educated, then it becomes much easier to understand the reference to Stes. [*sc.* Stesichorus] as source . . . In such a context, to cite a lyric, rather than an epic, source is to score high.'[17]

INSCRIBED ERUDITION

'Trivial', 'faulty and jejune', 'confused', 'simple,' 'ignorant', 'scraps', 'rubbish': Horsfall's rhetoric proves as revealing as his explicit argument. But the fact that Horsfall is one of the very few anglophone scholars to have paid *any* attention to the tablets means that his interpretation has established itself as orthodoxy, at least in the English-speaking world.[18] Just as Horsfall designates (at least some of) the tablets as 'vehicles for adult education' and '*aides-mémoire* for Rome's *nouveaux-riches*',[19] for example, Wallace McLeod similarly characterizes tablet 10K as 'a pretence of literacy for the unlettered'—condemning the tablets *tout court* as 'tawdry gewgaws intended to provide the illusion of sophistication for those who had none'.[20] Richard Brilliant's conclusion is strikingly similar: citing

[15] Idem 1979a: 35. Horsfall also compares Lucian's later Greek diatribe against the 'ignorant book collector' (*Adv. indoctum*) as well as Seneca's portrait of Calvisius Sabinus (*Ep.* 27.6): on these and other sources for the library as (pseudo-)aristocratic 'ornament', see Fedeli 1988: 46–7.

[16] Horsfall 1994: 80. For the 'Trimalchio' passages to which Horsfall refers, see above, pp. 76–8, 82.

[17] Idem 2008: 589. Idem 2003 explores this associated 'culture of the Roman *plebs*' in much greater detail.

[18] Horsfall 1979a is the standard point of reference in nearly all English discussions of the tablets: e.g. McLeod 1985: 164; Ridgway 1990: 264–6; M. J. Anderson 1997: 1–5; Burgess 2001: 17; Small 2003: 93–6; Newby 2007a: 3. The account is also enshrined in *SEG* 29.993, on Theodorus 'mangling together' material for patrons who 'pretended to have erudition'.

[19] Horsfall 1979a: 35; 2008: 588.

[20] McLeod 1985: 165, 164; as the author continues, 'from a scholarly point of view it [*sc.* tablet 10K] is a travesty' (165). Similar assessments of Horsfall's thesis are also to be found in Geyer 1989: 96–7; Rouveret

Horsfall's 1979 article some eight times in about as many pages, Brilliant likewise surmises that Theodorus worked 'for a vulgar clientele that cared little for learning but appreciated the visible trappings of some familiarity with the "classics"'.[21] Although there are alternative accounts of the tablets—all of them published in French, German, and Italian—it is Horsfall's view that predominates in Britain and America.[22]

To my mind, this 'nouveaux riches' interpretation is founded upon a set of mistaken assumptions. Quite apart from ironing out the complexities of Petronius' text—turning a blind eye to Petronius' masterly authorial control over his theatre of characters (the *Satyricon*, we must remember, can never be taken at face value)[23]—Horsfall's thesis derives full circle from a certain ideology of visual–verbal relations. I save further comment on the problematic notion of 'illustration' at work here until the following chapter: as we shall see, we are dealing with a modern and wholly anachronistic mode of aligning words with pictures, and one that collapses the medial differences between them. For now, it is enough to point out that, behind this logocentric prioritizing of text over the image, there lies an associated assumption that any 'departure' from a text must signal the 'general ignorance' of the artist or writer.[24] The *Tabulae Iliacae* are lowbrow objects, it seems, precisely because they fail to reproduce their literary

1989: 362 ('notre hypothèse sur les tables iliaques s'accorde par ailleurs avec le constat de N. Horsfall'); Gruen 1992: 13–14; Clarke 1998: 140; Bodel 2001: 27–9; Tybout 2011: 124–5. Cf. Stewart 1996: 51 on the tablets as 'probably the Roman equivalent of students' flash cards'.

[21] Brilliant 1984: 53–9 (quotation from 57). As Carruthers 1998: 202 notes, Brilliant's analysis totters uneasily between condemnation of the 'unduly famous' (54) and 'visually confusing' (55) *Tabula Capitolina*, with its 'seriously flawed epitomized chronicle' (57), and the very occasional (and tentative) suggestion that there might nevertheless be a more complex significance: 'this failure of synchronization seems to indicate a capricious or insensitive adaptation of epitomized texts and illustrated cycles by Theodorus, which may, however, have been programmatically sophisticated' (ibid.). Still, Brilliant ultimately sides with Horsfall's 'adult education' suggestion: he characterizes the tablets as 'perhaps . . . an ancient equivalent to the *Classics Comics*, so popular a generation ago, when the classics of English literature were still known by name, although few read them in the original'.

[22] See crucially O. Jahn 1873: 79–86 on the 'Zusammenhang der Tafeln mit der alexandrinischen Gelehrsamkeit': for subsequent bibliography, cf. above, pp. 80–1 n. 160. The only comparable example of such an interpretation in anglophone scholarship that I have found—interestingly published ten years prior to Horsfall's analysis—is Galinsky 1969: 107, on tablet 1A adorning 'the home of an erudite Augustan connoisseur'. As Valenzuela Montenegro 2004: 15 bemoans, Horsfall's arguments 'sind in der neueren Forschung oft erstaunlich kritiklos als Faktum übernommen worden'.

[23] On the need for a more critical art historical engagement with the fabricated character of Trimalchio, so as thereby to 'problematize scholarly dependence on Petronian stereotypes' (12), see e.g. Petersen 2006: 1–13 (though without reference to the *Tabulae*). The most important attempt to read between the socio-historical lines of Petronius' text is Veyne 1991: 13–56; on the narratological games, see Rimell 2002. Horsfall adopts a very different attitude to the 'evidence' of Petronius' text: cf. Horsfall 1989a and 1989b.

[24] Cf. Horsfall 1994: 82 (in the explicit context of an 'illustrated edition of Homer'): 'their general ignorance of the text constitutes a major difficulty'.

models—not only visually (in the relief imagery), but also verbally (through their inscriptions).

Even when talking about words rather than pictures, it is necessary to ask ourselves: do 'deviations' from a text necessarily signal ignorance of it? Although the poem goes unmentioned in his key 1979 article, Horsfall would no doubt chastise the author of the so-called *Ilias Latina* in related terms. Most probably written by Baebius Italicus in the AD 60s, this mini-epic text set out to epitomize the *Iliad* in just 1070 hexameters, and in Latin rather than Greek.[25] The poem has found little favour among modern-day classical philologists: as a 'modern translation' of Greek epic, scholars have decried its numerous departures from the Homeric original, not least its uneven coverage (so that over half of the poem is dedicated to the first nine books).[26] But the very gesture of translating the *Iliad* from Greek into Latin, and on this scale, demonstrates that there was more at stake here than reproducing Homer *verbatim*.[27] The objective was not merely to summarize the poem but, in doing so, to turn it into something new: witness, for example, the homage to the Julian household (lines 899–902), the opening and closing acrostics that reveal the author's name (*Italicus...scripsit*, 1–8, 1063–70), and not least the numerous allusive nods to Virgil and Ovid.[28] There was learned pleasure to be had from tracing the 'infidelities'—in noting the similarities *and* the differences between prototype and creative imitation.

Whatever we decide about the intended audience of the *Ilias Latina*, we can be sure that the *Tabulae Iliacae* were likewise designed to do more than 'rehash' their grand epic subjects. 'Can someone who knew their Homer have had such a weak imagination', asks Karl Schefold, 'as to need little pictures like these as reading aids?'[29] But the problem here lies in the assumption that, rather than innovative

[25] For text and commentary, see Scaffai (ed.) 1982, with discussion of authorship and date at 11–29; Kennedy 1998 provides a more recent edition, complete with English translation. On the poem's (markedly more upbeat) late antique and mediaeval reception, see Marshall 1983.

[26] Cf. Grillo 1988: 97. Books 1–9 of the *Iliad* are covered in lines 1–685, whereas lines 686–1062 cover books 10–24: a similar distribution can be found on the two pilasters of the Capitoline tablet, where the left-hand pilaster apparently summarized the first to seventh books, and the right-hand pilaster deals with events from *Il.* 7.433 up to the end of the poem (see above, pp. 34–5). Brüning 1894 discusses 15 other iconographic/textual parallels between the *Ilias Latina* and the Capitoline tablet, associating both with an earlier Alexandrian 'Meisterwerk' (164–5).

[27] On earlier Republican 'translations' of the Trojan myth into Latin epic, see S. Jahn 2007: 39–91 (especially 48–51 on Livius Andronicus' third-century BC *Odusia*).

[28] For two brief overviews of the poem's conceptual, formal, and metrical debts to Virgil in particular, see Scaffai 1985a; 1985b: especially 1932–6. On the acrostics (and the textual emendation that allows them), see Courtney 1990: 12–13, along with the discussion below, pp. 224–6: there is a distinguished epic tradition for such name games, both Greek *and* Latin (not least in Ennius: Cic. *Div.* 2.111–12).

[29] Schefold 1975: 135: 'Kann ein Homer-Kenner eine so schwache Phantasie gehabt haben, um solche Bildchen als Lesehilfe zu brauchen?'. For two different responses to the question, cf. Horsfall 1979a: 34 and Valenzuela Montenegro 2004: 410.

creations in their own visual–verbal right, the tablets functioned as *aids* for reading (*Lesehilfe*) in the first place. However 'complete' the *Iliad*, there was (and is) always more to be said, just as there are different ways of saying it (epic or epigrammatic, long or short, Greek or Latin, verbal epitome or visual synopsis, etc.). The *Tabulae Iliacae* do not just recycle the epic cycle, nor were they merely objects to be 'read': these visual depictions re-spin the verbal story, turning 'Troy' into a never-ending sort of *Dynasty* soap opera, each episodic closure reopening some new signature beginning. Even in the Homeric *Iliad*, as Statius famously puts it in the proem of his *Achilleid*, numerous aspects of the story are missing: as with Statius' renewed Imperial epic, the tablets draw on the old to deliver something new and more complete—despite (or rather because) of their apparent scale.[30]

This, at least, is the larger thesis of this book: that the size, media, and compositional arrangements of the tablets resonate against a set of highbrow literary and aesthetic concerns. What are so often interpreted as 'infidelities' might equally point to artists or audiences familiar with the visual and iconographic traditions, able to comment upon the possible significance of such adaptations in any given scenario. The inscriptions are able to be so short and terse ('confusing', 'of limited utility', 'not explanation enough', 'laconic'[31]), I would add, precisely because their objective was more ambitious than simply to convey the content and order of their models.

The various texts inscribed on the tablets very much corroborate the point: they address readers who were not only already acquainted with the subjects depicted, but also well versed in the broader fields of Greek (and arguably Latin) literature. As Nina Valenzuela Montenegro has shown, this is especially true of the prose epitome inscribed on the monumental pilaster to the right of the surviving *Tabula Capitolina* (Fig. 4). Like the images that flank the summarizing text, the inscription downplays certain episodes in the *Iliad*, essentially omitting books 13–15 altogether.[32] And yet this miniature text simultaneously demands a

[30] Cf. Stat. *Achil.* 1.3–10: 'Although the man's deeds are much famed in Aeonian song, still more is missing: suffer me (for such is my desire) to traverse the *whole* hero, bringing him forth with Dulichian trump from his hiding place in Scyros and—not stopping with the dragging of Hector's body—to carry the youth instead through the *complete* tale of Troy. If, Apollo, I have worthily drained the old source with my draught, grant me springs that are new, binding my hair with a second garland' (*Quamquam acta uiri multum inclita cantu | Maeonio, sed plura uacant: nos ire per omnem | (sic amor est) heroa uelis Scyroque latentem | Dulichia proferre tuba nec in Hectore tracto | sistere, sed tota iuuenem deducere Troia. | tu modo, si ueterem digno depleuimus haustu, | da fontes mihi, Phoebe, nouos ac fronde secunda | necte comas*). On the significance of Statius' programmatic (and highly allusive) opening, see Barchiesi 1996, together with Heslin 2005: 71–86.

[31] Horsfall 1979a: 34.

[32] On the omission, see O. Jahn 1873: 4, associating the inscription with 'ein Versehen des Graveurs', but also with 'grammatische Gelehrsamkeit'. Cf. Mancuso 1909: 694–5; Sadurska 1964: 32 (making a related complaint about the summary of the twentieth book); Valenzuela Montenegro 2004: 368–9. My

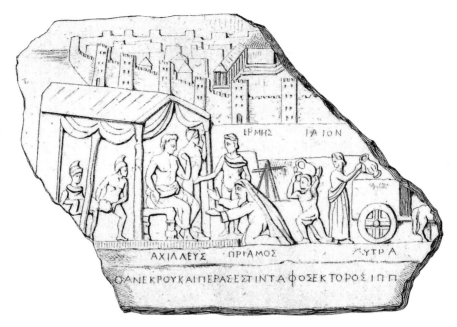

FIGURE 29. Drawing of the obverse of tablet 12F.

different sort of reading from the poem that it summarizes.[33] As a precis of the *Iliad*, the text was in one sense superfluous. Its significance lay not in microscopic content alone, but also in the self-critical derivation from an established genre of mythographic synopsis: this presumably explains the numerous echoes between the tablet's inscribed prose epitome and the surviving summary of the story in (for example) the *Library* of Apollodorus.[34] Indeed, given that the division of the *Iliad* into 24 books seems to have been a relatively recent phenomenon—and one

own position concerning such omissions aligns with Valenzuela Montenegro's: 'Es handelt sich also nicht um einen Fehler, sondern um ein Charakteristikum des kurzen Resümees, weniger wichtige Ereignisse auszulassen' (369).

[33] Cf. Valenzuela Montenegro 2002: 79–83; 2004: 368–76, 416–17: 'Aus diesem Grunde sind die Inschriften nicht so sehr als "Lesehilfe" gedacht, sondern als spielerische Verweise, gewissermaßen "Homerzitate", die sich an den gebildeten Betrachter wenden' (373, repeated from 2002: 87).

[34] See van Rossum-Steenbeek 1998: 70–1 and Valenzuela Montenegro 2004: 368–70, 374–6, relating the résumé to Apollod. *Epit.* 4.1–7: there are parallels both in content and presentation (most strikingly the preponderance of present indicative verbs), which may possibly suggest a related source for both texts. The same holds true for the prose summary of the deeds of Heracles on the second-century tablet 19J: the inscription contains numerous details that resonate with the accounts both of Apollodorus and Diodorus Siculus (Valenzuela Montenegro 2004: 317–23). In any case, there is no evidence for Horsfall's throwaway dismissal that the genre of the epitome was 'by its very nature a *pis-aller*' (Horsfall 1979a: 46). As argued below, the Capitoline tablet's epitome of the *Iliad* has to be understood alongside both the larger visual games of summation (offering a variety of competing techniques to structure, organize, and arrange the Iliadic subject matter: below, pp. 158–77), and the self-conscious play with scale (the 24 books are monumentalized into a miniature pair of synoptic inscribed stelae, visible all at once: below, pp. 252–9).

itself bound up with Alexandrian scholarship—the juxtaposition of this continuous prose résumé alongside 24 individually numbered friezes must have been noteworthy in its own right: it once again indicates the 'cult of education' that the tablets materialize.[35]

The argument becomes all the clearer when we compare other sorts of inscriptions, as found on other tablets.[36] Just as the engraved reliefs explore different modes of visualizing their literary subjects, the epigraphic texts evidently probed different ways of encapsulating their visual subjects in words. One way was to summarize events not in prose (as on the Capitoline tablet) but in poetry. Tablets 6B and 12F (Fig. 29) both set a single verse beside the corresponding Homeric scenes, poetically summing up events from the fourth to seventh and in the twenty-fourth books of the *Iliad* respectively.[37] Such translation of the grand themes of epic into miniature epigram is a mainstay of the *Palatine Anthology*.[38] Indeed, the inscriptions on tablets 6B and 12F bear particular comparison with a surviving poem (*Anth. Pal.* 9.385) in which each book of the *Iliad* is likewise summarized in a single cataloguing verse, thereby forming a 24-line acrostic stretching from *alpha* (book 1) to *omega* (book 24):[39]

Ἄλφα λιτὰς Χρύσου, λοιμὸν στρατοῦ, ἔχθος ἀνάκτων,
Βῆτα δ' ὄνειρον ἔχει, ἀγορήν, καὶ νῆας ἀριθμεῖ . . .

[35] For the tablets' association with Roman 'Bildungskult', cf. Valenzuela Montenegro 2004: 413. On the numbering of Iliadic and Odyssean books, see Pfeiffer 1968: 195, along with Higbie 2010 (discussing the Iliac tablets at 10–11); cf. Valenzuela Montenegro 2002: 87–8 and 2004: 373–4.

[36] The most accessible presentation of the inscriptions discussed in what follows (1A, 6B, 8E, 10K, 12F, 14G, 17M, 19J) is O. Jahn 1873: 60–92: the texts are tabulated thematically alongside an apparatus criticus, and with parallels listed and discussed.

[37] See the discussion in Valenzuela Montenegro 2002: 85–6.

[38] For an excellent introduction to Hellenistic epigrammatic engagements with Homer, see Harder 2007, demonstrating how 'scenes in Homer are reduced in such a way as to fit the space allowed in epigram' (411); cf. Bolmarcich 2002 (on sepulchral epigrams on Homer) and Sistakou 2008: 55–61. Interestingly five distichs/tristichs of the *Iliad* came to be considered as 'epigrams' in their own right (Vox 1975; Elmer 2005), deriving the generic origins of epigram from epic (and vice versa).

[39] *Anth. Pal.* 9.385.1–2: cf. O. Jahn 1873: 85–6; Kaibel 1878: 494–5, no. 1095; Vogt 1966: 81; Valenzuela Montenegro 2004: 372. On the (Hellenistic) intellectual context of the poem, cf. Sistakou 2008: 60–1. The epigram is attributed to a late antique grammarian named Stephanus, but it is doubtless representative of an earlier poetic tradition. Three parallels strike me as particularly significant: first, the numerous epigrammatic plot summaries of Plautus' comedies which spell out each play's title in acrostic (discussed by e.g. Habinek 2009: 129, and deemed 'vielleicht noch vor Christus' by Brand 1992: 314–15); second, two epigrammatic hymns to Apollo and Dionysus which contain the god's epithets in alphabetical order (*Anth. Pal.* 9.524–5), as well as two other fragmentary epigrams which likewise order their quatrains around an alphabetic acrostic (*P. Oxy.* 0015 and 1795, with further parallels in Guéraud and Jouguet 1938: xvii); third, we might compare Grenfell and Hunt 1900: 1.23–8 on an early Christian hymn of 24 verses comprising 'an elaborate metrical acrostic' (23 on *P. Amh.* 2). Such playful acrostics were evidently a mainstay of epigram.

Alpha contains Chryses' entreaties, a plague in the army, and a quarrel of kings; *Beta* contains a dream, a council, and numbers the ships . . .

Rather than abridge events in an epyllion of hexameters like the opening lines of this epigram, tablets 6B and 12F reveal an additional sophistication besides: they were written in a more playful sort of verse, usually reconstructed as anapaestic tetrameter catalectic (but, at least in the case of 12F, in fact readable in a variety of different ways).[40] The metrical allusions were perhaps significant in their own right, especially in the case of anapaestic tetrameter catalectic (known, for example, from Aristophanic comedy): whether a challenge to find the funny side of epic, or indeed to chart the different genres lying latent in Homer, there seems to have been method and meaning to such metrical mismatch.

Two other tablets—this time not associated with Homeric subjects—similarly juxtaposed inscriptions in prose with inscriptions in verse. The four-line elegiac couplet on Alexander the Great inscribed on the upper and lower frame of tablet 17M (Fig. 30) has at least one surviving epigrammatic parallel in the *Palatine Anthology* (*Anth. Pal.* 6.97),[41] and tablet 19J set a lengthy prose summary of the deeds of Heracles against a pithy synopsis of his 12 labours in hexameters. As with tablet 17M, there is an (anonymous) epigrammatic parallel for the poem inscribed at the bottom of the second-century tablet 19J: just as *Anth. Pal.* 9.385 summed up each book of the *Iliad* in a single verse, *Anth. Plan.* 92 renders each of Heracles' labours into one of its 14 hexameter lines, ending not with Heracles' twelfth labour, but cheekily adding a thirteenth—his sleeping with 50 virgins in a single night.[42] In this case, there is a clear verbal as well as conceptual bond between the *Planudean Anthology* poem and the epigram inscribed on tablet 19J:

[40] For a discussion of metre, with further references, see especially Sadurska 1964: 50 (on 6B) and 65–6 (on 12F). The fragmentary nature of the inscriptions on 6B facilitates a variety of different metrical reconstructions (cf. Valenzuela Montenegro 2004: 152). But we can be more sanguine about the text of 12F: [Ὦ Λύτρ]α νεκροῦ καὶ πέρας ἐστὶν τάφος Ἕκτορος ἱππ[οδάμοιο] ('Book *omega*: The ransom of the corpse and finally there's the burial of horse-taming Hector'). The first thing to notice are the final three words—not only the second half of a dactylic hexameter, but the final words of the *Iliad* (24.804). But what of the line as a whole? Discounting the opening *omega* we might construct two choriambs followed by four dactyls (– ◡ ◡ – | – ◡ ◡ – ‖ – ◡ ◡ – | – ◡ ◡ – | – ◡ ◡ – | – ◡); were we to include that letter, we might instead read an anapaestic tetrameter catalectic (– ◡ ◡ – | – – | – ◡ ◡ – | – – ‖ ◡ ◡ – | ◡ ◡ – | ◡ ◡ – | –); pronouncing the letter complete (not *ō*, but trisyllabic *ŏmĕgă*)—while also changing ἱπποδάμοιο for ἱππ[οδάμου] and reading ἐστί for ἐστίν—we might possibly convert the line into three hemiepes (– ◡ ◡ – ◡ ◡ – | – ◡ ◡ – ◡ ◡ – | – ◡ ◡ – ◡ ◡ –). Valenzuela Montenegro 2004: 213, 372 refers to the anapaestic tetrameter catalectic interpretation alone and relates this to comic dialogue (cf. eadem 2002: 85: 'hier weist die Inschrift also ebenfalls auf hellenistische Gelehrsamkeit'). But it would be in keeping with the tablets if audiences were in fact invited to *play* with different metrical readings—and thereby with different sorts of generic interpretation.

[41] Cf. Hardie 1985: 29–31 and Valenzuela Montenegro 2004: 269–70. *Anth. Pal.* 6.97 is admittedly much later in date, ascribed to Antiphilus.

[42] For discussion, see O. Jahn 1873: 85–6, along with Grant 1983: 107–8 and Valenzuela Montenegro 2004: 317. It is unclear whether *Anth. Plan.* 92 should also be read as a poem responding to a picture.

FIGURE 30. Drawing of the obverse of tablet 17M.

not only does the surviving inscription recount the 12 labours, the second line reproduces the same verse found in the first line of the anthologized poem (πρῶτα μὲν ἐν Νεμέῃ βριαρὸν κατέπεφνε λέοντα, 'First in Nemea he slew the mighty lion': *Anth. Plan.* 92.1).

Other tablets proved equally creative in cataloguing their visual subjects through inscribed verbal language. Tablet 14G, for instance, summarized the *Iliad* in a series of key terms above a portrait of Homer—'flight of the Trojans', 'battle by the ships', 'death of Sarpedon', 'death of Patroclus', 'forging of weapons', etc.—setting this against a single image of battle on its verso (Figs. 31–2).[43] These sorts of labels can be traced back to a philological tradition of pinpointing and categorizing *lemmata* (i.e. 'received' glosses) in the Alexandria library.[44] As on numerous other tablets, each Homeric episode is summed up in an apposite word or catchphrase.[45] Perhaps still more revealing are the texts on the recto and verso of tablet 10K. Although the texts are fragmentary, it is clear that the inscriptions glossed not only the Theban cycle poems depicted—their titles, authors, even the number of lines—but also the genealogy of its central protagonist.[46] A clearly related geneaological inscription is to be found on the verso of tablet 9D (Fig. 33), again centred around Cadmus, just as on the recto of 10K.[47]

By far the best indication of the erudition involved in this process is tablet 8E, which juxtaposed its central depiction of the *Ilioupersis* with a lengthy diatribe on the chronology of the *Iliad* (Fig. 34).[48] The issue of how many days were treated in the poem exercised ancient scholars (just as it does modern): already by the third century BC the controversy seems to have been famous, associated with the rival opinions of Zenodotus, the first librarian at Alexandria, and Aristarchus, a subsequent second-century successor.[49] It is Zenodotus' account that is followed on tablet 8E, with the scholar himself named near the beginning of the text. In setting forth its chronological interpretation, moreover, the inscription cites

[43] For the inscriptions, see O. Jahn 1873: 65, Sadurska 1964: 69 and Valenzuela Montenegro 2004: 252–3.

[44] Cf. Valenzuela Montenegro 2002: 86 and 2004: 372–3, 416.

[45] On tablet 14G, these sorts of verbal *lemmata* are provided without accompanying visual summaries. But other tablets paired their visual scenes with such Greek inscriptions, and often the same *lemmata* recur: there are numerous examples on tablets 1A, 2NY, 3C, 6B, 9D, 11H, 12F, 20Par, 21Fro.

[46] See Valenzuela Montenegro 2004: 377–80, *contra* McLeod 1985. The verso inscription glossing the exact numbers of lines (mentioning an *Oedipodeia*, *Danais*, and *Thebaid*) is too damaged to enable any definitive reading, but see Petrain 2008: 83 (responding to e.g. McLeod 1985: 157–63) for a recent interpretation.

[47] For the relation between the two genealogical inscriptions on tablets 9D and 10K, see O. Jahn 1873: 75–6, Sadurska 1964: 55–61, and Valenzuela Montenegro 2004: 194.

[48] On this complex inscription, and its relation to second-century scholarly debates, see Valenzuela Montenegro 2002: 83–5 and 2004: 371–2.

[49] On Zenodotus and this particular controversy, see Pfeiffer 1968: 105–17 (especially 116–17).

FIGURE 32. Drawing of the reverse of tablet 14G.

FIGURE 31. Drawing of the obverse of tablet 14G.

```
      ]ΛΑ٧  ΜΟΝΙ[
     ]ΛΩΣΚΑΙΑΦΡΟΔΙΤΗ[
    ΓΥΝΝΑΚΟΙΑΣ Δ ΙΝΩΑΓΑΥ
    ΗΝΑΥΤΟΝΟΗΝΣΕΜΕΛΗΝ
    ΥΙΟΝΔΕΠΟΛΥΔΩΡΟΝ
   ΑΡΙΣΤΑΙΟΥΔΕΚΑΙΑΥΤΟΝΟΗΣΑΚΤΑΙΩΝ
   ΑΘΑΜΑΝΤΟΣΔΕΚΑΙΙΝΟΥΣΛΕ
     ΑΡΧΟΣΚΑΙΜΕΑΙΚΕΡΤΗΣ
              ΟΝΟ
   ΕΞΕΙΟΣΔΕΣΠΑΡΤΟΥΚΑΙΑΓΑΥ
    ΗΣΓΕΝΝΑΤΑΙΠΕΝΘΕΥΣ
    ΖΕΥΣΣΕΜΕΛΗΠΛΗΣΙΑΣΚΑΙΚΕΡ
    ΑΥΝΩΣΑΣΑΥΤΗΝΑΝΕΛΟΜΕ
    ΝΟΣ ΤΟΝΔΙΟΝΥΣΟΝΚΑΙΕΝΡΑΥ
    ΑΣΕΙΣΤΟΝΜΗΡΟΝΥΣΤΕΡΟΝ
    ΔΙΑΩΣΙΝΙΝΩΤΡΕΦΕΙΝ
   ΗΡΑΣΑΡΓΕΙΑΣΙΕΡΕΙΑΕΥΡΥ[
```

FIGURE 33. Drawing of the reverse of tablet 9D.

numerous details from the first book of the poem—including six whole lines of text (*Il.* 1.420–5). There can be little doubt that the inscription served to incite erudite conversation among well-educated guests.[50] But the highbrow aspirations become all the more obvious when we remember that, in visual terms, the inscription was set not against images of the *Iliad* (which does not seems to have been depicted on the tablet at all), but rather against an *Ilioupersis* scene. As we shall see in the following chapter (pp. 158–65), this central depiction of the fall of Troy raised all sorts of questions about narrative order and temporal sequence. Here, though, such visual questions about the timescale of the *Ilioupersis* are framed around questions concerning the *Iliad*: readers were invited to read the handling of time in the *Iliad* through this visualization of the *Ilioupersis* (and vice versa).[51] On one level, the text's relevance proves purely academic. And yet, on another, these words change our view of the juxtaposed picture.

[50] Cf. Wilamowitz-Moellendorff 1898: 228, labelling the inscription 'ein so rares Stück grammatischer Gelehrsamkeit'. Valenzuela Montenegro 2004: 411 gives one account of the erudite conversations that might follow: 'Fragen, die wir uns heute stellen, wird wohl ein antiker Betrachter ebenfalls gesehen haben: Wieso "nach Zenodot"? Gibt es denn noch eine andere Tagezählung als diese? Welche ist "richtiger"? Oder ist Homer vielleicht inkonsequent in seiner Zählung? Auf diesem Wege könnte sich ein Gespräch über mögliche "Brüche" im homerischen Text oder die Komposition der Ilias entspinnen.'

[51] The point seems to have been lost on Horsfall 1979a: 34 ('Paradoxically, even the relatively learned Zenodotus *Tabula* gives the spectator no help at all with the *Iliou Persis* scenes').

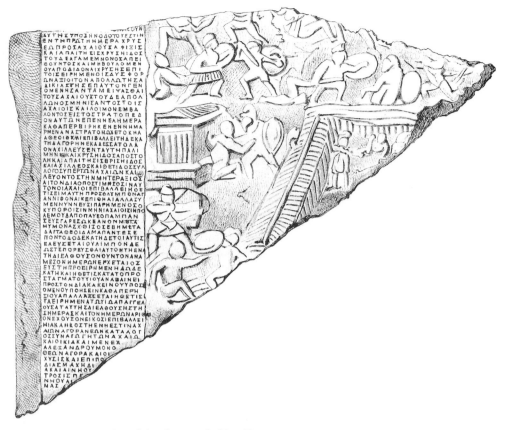

FIGURE 34. Drawing of the obverse of tablet 8E.

ELUSIVE ALLUSIONS

Such highbrow epigraphic references, as found in the inscriptions of the eight tablets already surveyed (1A, 6B, 8E, 10K, 12F, 14G, 17M, 19J), can leave no doubt about the intellectual aspirations of the *Tabulae Iliacae* at large.[52] Nina Valenzuela Montenegro's more detailed examination makes further analysis redundant here: these texts evidently point not to an audience 'utterly ignorant of myth', but rather to a clientele acquainted with a mighty corpus of different

[52] The above survey is by no means exhaustive: cf. e.g. Burstein 1984: 161 on tablet 22Get and its debt to the second-century BC *Chronica* of Apollodorus of Athens, concluding that 'despite his [*sc.* the artist's] close dependence on Apollodorus' book for information', the tablet maintained 'its own distinct approach and point of view'. Cf. also below, pp. 333–5 on the Zodiacal figures around tablet 4N, referring to Crates' allegorical interpretation of Homeric cosmology: as Amedick 1999: 190–4 concludes of similar Zodiacal figures on fragment 6B, the tablets—or, in Amedick's terms, their prototypes—clearly descend from 'einem Zentrum der hellenistischen Gelehrsamkeit' (206).

literary works. 'For anyone who does not know these texts', as Valenzuela Montenegro concludes, 'both the images and the inscriptions remain silent'.[53]

As we have already noted, these inscriptions do not assume knowledge of Homeric epic alone: they allude to a much wider range of literary genres—Greek epigram, comedy, and mythographic epitomes among them; indeed, in the case of tablet 8E, the inscribed text even refers to a secondary scholarly bibliography. But it is the intertextual allusiveness of these inscriptions that I want to draw out in the remainder of the chapter. Concentrating on two inscribed elegiac couplets that have not yet received the attention they deserve, my aim is to show how the programmatic instructions on tablets 1A and 2NY evoked a host of Greek literary precedents, from Archaic lyric all the way through to contemporary epigram. If such allusive inscriptions suggest an audience familiar with the various Greek texts evoked (many of them relatively obscure in the first century AD), they also raise questions about the intermedial nature of the tablets on which they are figured. As we shall see, the two epigrams deliver a metapoetic meditation on the combined pictorial and poetic properties of the objects at hand. The gesture of doing so, moreover, must be understood within the literary agenda of Hellenistic poetry, and that of Hellenistic epigram in particular.[54]

Both the epigrams on the *Tabula Capitolina* (1A) and New York tablet (2NY) are fragmentary. We can nevertheless be confident about the reconstruction of the elegiac couplet on the *Tabula Capitolina*, and it is clear that the pentameter of the New York couplet was very closely related. The Capitoline epigram occupies the upper border of the lower pictorial frame: it is inscribed between the depictions of the *Ilioupersis* (above) and the *Aethiopis* and *Little Iliad* (below), and in prominent letters (the largest on the tablet). The text must have originally stretched from the centre of the left-hand pilaster to that of the right, and the line division between the hexameter and pentameter is marked by a gap and circular dot at the centre of the inscription (Fig. 35):[55]

[τέχνην τὴν Θεοδ]ώρηον μάθε τάξιν Ὁμήρου
ὄφρα δαεὶς πάσης μέτρον ἔχῃς σοφίας.

Understand [the *technê* of Theo]dorus, so that, knowing the order of Homer, you may have the measure of all wisdom.

[53] Valenzuela Montenegro 2004: 409: 'Die Bildsequenzen sind in den Einzelheiten "lesbar"—aber *nur* für denjenigen, der mit dem Inhalt der Epen und der Ikonographie von Trojabilder vertraut ist. Für jemanden, der diese nicht kennt, bleiben die Bilder und auch die Inschriften stumm.'

[54] The following section develops ideas first explored in Squire 2010c: 72–7.

[55] For earlier discussions of the epigram, see especially Bulas 1950: 114; Sadurska 1964: 39; Horsfall 1979a: 27; Bua 1971: 5; Valenzuela Montenegro 2004: 351–6; Petrain 2006: 43–59 (who notes numerous epigraphic parallels).

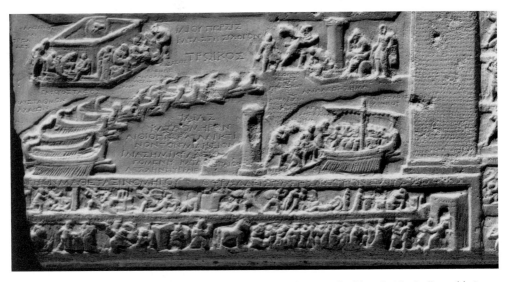

FIGURE 35. Detail of the lower central section on the obverse of tablet 1A (Capitoline tablet), including epigrammatic inscription.

Although the missing left-hand extremity of the frame means that we have lost the first two feet of the hexameter, there can be no doubting Umberto Mancuso's 1909 reconstruction.[56] The rectos of four other tablets associate themselves with 'Theodorean *technê*' (Θεοδώρηος ἡ τέχνη) in precisely analogous manner, and at least two of these (tablets 2NY, 3C) display a very similar obverse composition to that of the *Tabula Capitolina* (p. 40, Table 3).[57]

A manifestly related inscription can be found on the New York tablet. The text is located in an equally prominent position, although this time written towards the top of the object, next to its moulded edge (Fig. 36). Only 16 letters survive, but the spacing of the inscription, together with its surviving pentameter fragment, confirms that it too originally comprised an elegiac couplet. Using the Capitoline tablet as his model, Kazimierz Bulas proposed the following reconstruction:[58]

[56] For the supplement, see Mancuso 1909: 729–30, responding to the unlikely earlier reconstruction [ὦ φίλε παῖ, Θεοδ]ώρηον μάθε τάξιν Ὁμήρου ('Learn, my child, the Theodorean order of Homer': cf. e.g. O. Jahn 1873: 91). This supplement was founded upon the highly suspect assumption that the tablet served as a 'schoolboy' crib: see above, pp. 70–1.

[57] The phrase Θεοδώρηος ἡ τέχνη recurs on the verso inscriptions of 2NY, 3C, 5O, and 20Par (see below, p. 208), and perhaps also on the recto of tablet 4N (see below, p. 311). The only scholar to have challenged the reading is Lippold 1932: 1893, writing that the suggestion 'erscheint zu künstlich'; but Lippold knew of only tablets 3C and 5O—the subsequent publication of tablets 2NY and 20Par must surely quash Lippold's qualms.

[58] See Bulas 1950: 114.

FIGURE 36. Detail of the epigrammatic inscription on the obverse of tablet 2NY.

$$[-\smile | - \Theta\epsilon o\delta\omega\rho\eta ov\ \mu\acute{a}\theta\epsilon\ \tau\acute{a}\xi\iota v\ {}^{\prime}O\mu\acute{\eta}\rho ov$$
$$\mathring{o}\phi\rho a\ \delta a\epsilon\grave{\iota}s\ \tau]\acute{\epsilon}\chi\nu\eta v\ \mu\acute{\epsilon}\tau\rho ov\ \mathring{\epsilon}\chi\eta s\ \sigma o[\phi\acute{\iota}as].$$

'... of Theodorus, learn the order of Homer so that, knowing his *technê*, you may have the measure of wisdom.

David Petrain is rightly cautious, judging Bulas' reconstruction 'highly uncertain'.[59] But even if the distich did not reproduce the 1A hexameter complete, we can be sure that it at least offered some variation on that verse, just as it did in the pentameter: there is a parallel for every word of the New York epigram in the *Tabula Capitolina* poem. The two inscriptions on the reverse side of this New York tablet are also clearly related to those on the obverse of the *Tabula Capitolina*. As we shall see (pp. 202–5), a verso hexameter inscription directly addressed the viewer of the New York tablet in imperative form, as in the Capitoline tablet's hexameter, and a second verso inscription (this time in the form of a 'magic square' diagram) likewise related the '*Iliad* of Homer' to 'the Theodorean *technê*' ([$'I\lambda\iota$]$\grave{a}s\ {}^{\prime}O\mu\acute{\eta}\rho ov,\ \Theta\epsilon o\delta\acute{\omega}\rho\eta os\ \mathring{\eta}\{\iota\}\ \tau\acute{\epsilon}\chi\nu\eta$).

Discussion of these two epigrams has tended to concentrate on the precise connotations of the noun *technê*, which I have deliberately left untranslated.[60] The overriding issue has been whether the term refers to the artistic or grammatical workmanship of Theodorus: is 'Theodorus' the craftsman responsible for this carefully fashioned object (*technê* as pertaining either to artistry at large, or else to this artwork in particular);[61] alternatively, should we understand 'Theodorus' as the grammarian behind this specific Homeric epitome (so that *technê* alludes to a more literary form of authorial 'craftsmanship')?[62] To my mind, this has been a

[59] Petrain 2006: 44 n. 2.

[60] See especially Horsfall 1979a: 27, 31 (responding to Sadurska 1964: 39), together with e.g. Kazansky 1997: 57 and Valenzuela Montenegro 2004: 350–5 (with full references).

[61] As argued by e.g. Lippold 1932: 1893; Sadurska 1964: 9–10; Horsfall 1979a: 27; Valenzuela Montenegro 2004: 350–8; Petrain 2006: 44–5 n. 3.

[62] As argued by e.g. O. Jahn 1873: 91–2; Schefold 1975: 130; Rouveret 1988: 173.

rather sterile debate, conducted in isolation from the broader intellectual context of the tablets. For as I hope to show, both inscriptions play upon the *dual* registers of *technê* and *sophia*, self-consciously toying with the shared critical vocabulary of artistic and literary production alike.[63]

Fundamental here is the literary allusiveness of both the Capitoline and New York epigrams—an allusiveness that has been distinctly underplayed, especially among classical archaeologists.[64] Perhaps most revealing of all is a fragment of Stesichorus' lyric poem on the *Ilioupersis* itself (*P. Oxy.* 2619), first published in 1967 (S 89.6–8 Davies):[65]

$$... \dot{\alpha}\nu\dot{\eta}\rho$$
$$[\theta]\epsilon\hat{\alpha}s\ \dot{\iota}[\dot{o}]\tau\alpha\tau\iota\ \delta\alpha\epsilon\dot{\iota}s\ \sigma\epsilon\mu\nu[\hat{\alpha}s\ \ddot{A}\theta\dot{\alpha}\nu\alpha s]$$
$$\mu\dot{\epsilon}\tau[\rho\alpha]\ \tau\epsilon\ \kappa\alpha\dot{\iota}\ \sigma\sigma\phi\dot{\iota}\alpha\nu\ \tau\sigma\hat{\upsilon}...$$

The man who learned by the will of the august goddess Athena the measures and wisdom of...

Of course, literary allusiveness is always difficult to establish: intertextual reference necessarily depends upon the person reading a text, not simply the author writing it. But in the case of the Capitoline tablet, the Stesichorean nod seems fairly secure: this explains the collocation of the (relatively rare) aorist participle δαείς with the nouns σοφία and μέτρον.[66] Still more importantly, there is an explicit prompt to think of Stesichorus in the words inscribed above this epigrammatic inscription. Just as the *Tabula Capitolina* claims pictorial derivation

[63] My thinking about terminology has been influenced by two studies in particular: first, Rudolf Löbl's three-volume history of the Greek language of *technê* (Löbl 1997; 2003; 2008); second, Gladigow 1965 on early Greek concepts of *sophia*. Those seeking a shorter history of these terms might consult the masterly synopsis of Maffei 1991: especially 595–607.

[64] For a corrective, see especially Carlini 1982, together with Petrain 2006: 45–59: 'The epigram's elaborate diction and syntax will yield much...about how Theodorus presents his creation, and his role as artist, in relation to the poetry of Homer' (45). Petrain places particular emphasis on the connotations of the aorist participle δαείς: although the participle is relatively rare in extant Greek literature (Petrain notes 20 instances in the entire literary and epigraphic corpus, all of them in verse), the verbal root is usually associated with the acquisition of a technical ability or the mastery of knowledge. The collocation ὄφρα δαείς, Petrain demonstrates (51), is also distinctively epic in diction (citing e.g. *Il.* 10.425, 16.423, *Od.* 9.280).

[65] See Davies (ed.) 1991: 186 for text and apparatus criticus, derived from West 1969: 140–1. For an excellent commentary, see Schade 2003: 199–203, together with Kazansky 1997: 36–43.

[66] The allusion has been conspicuously overlooked: it goes unmentioned in e.g. Valenzuela Montenegro 2004, and Horsfall offers only a passing reference to *P. Oxy.* 2803 in a footnote (1979a: 37 n. 76; cf. 2008: 588). There are short philological discussions in Lehnus 1972: 54–5; Carlini 1982: 632–3; Kazansky 1997: 58–59; Schade 2003: 202 ('eine ähnliche Wendung erscheint auf der Tabula Iliaca Capitolina, wo auf die Kunstfertigkeit des Theodoros angespielt wird'). There is also brief mention in Petrain 2006: 50–1 and Porter forthcoming. But nobody has yet associated the allusion with the original Stesichorean context of the passage, describing Epeius' *artistic* craftsmanship.

from the *Ilioupersis*—'the *Ilioupersis* after Stesichorus', as the large central inscription reads (Fig. 35)—this programmatic epigram is literally mediated through the language of that poem.[67] If, as Nikolai Kazansky has argued, the cited passage comes from the poem's opening strophe, the allusion would have been all the more conspicuous, imbuing these visual objects with the same Greek poetic force that gave rise to the *Ilioupersis* itself.[68] The inscription might instruct that we learn the order of Homeric epic, then, but it simultaneously alludes to the alternative lyric world of Stesichorus; better, perhaps, the pictorial framing of the *Ilioupersis* through the *Iliad* on this miniature tablet is itself verbally paralleled (and indeed encapsulated) in this mini-epigram's own Stesichorean mediation of Homer.[69]

Still more significant is the original context in which the Stesichorean passage appeared. Luigi Lehnus, who was the first to note the connection with the Capitoline inscription, has convincingly shown that the lines describe the craftsmanship of the Greek artist Epeius:[70] the 'measures and wisdom' evoked by Stesichorus refer to Epeius' crafty ruse of the wooden horse, aided (as we know from numerous other sources) by the goddess Athena.[71] On the Capitoline tablet, the Stesichorean allusion therefore establishes both an artistic and a literary paradigm for Theodorus' project (within an epigram itself attached to a series of visual representations of this and other poems). On the one hand, the epigram assimilates Theodorus to the craftsman responsible for the Trojan horse (i.e. the 'god-given gift' represented both in the *Ilioupersis* scene above and the

[67] There is arguably another Stesichorean hint in the words δούρηος ἵππος ('wooden horse') inscribed beneath the 'wooden horse' in the upper register of the *Ilioupersis* scene (repeated below: Fig. 73). By at least the first century AD, this seems to have been an *alternative* name for Stesichorus' *Ilioupersis*, or at least this section of it (at any rate, not a different poem, as argued by Page 1973: 64–5): this is apparently why *P. Oxy.* 2803 contains the titular gloss Στη[σιχόρου ἵππ]ος δούρειος.

[68] See Kazansky 1997: 36–43. But the argument must remain tentative, founded upon a supposed hymnic invocation in the first strophe.

[69] Rather intriguingly, Horsfall's latest discussion acknowledges that 'while it has long been established that there is a verbal echo of Stes. *Il.pers.* in Theodorus' epigrams on *TIC* [*sc. Tabula Iliaca Capitolina*] and 2NY, there is, clearly enough, much on the *TIC* that cannot be Stesichorean' (Horsfall 2008: 589). But quite apart from the fact that Horsfall leaves the 'long established' allusion conspicuously unmentioned in his earlier discussions, the admission surely deals a devastating blow to the author's overarching thesis that the tablets belong *'chez* Trimalchio'. In the light of this concession, can we really still treat the Capitoline tablet's Stesichorean boast 'with deepest scepticism' (idem 1979a: 43)?

[70] See Lehnus 1972: 54–5, along with Kazansky 1997: 36–7 and Schade 2003: 199–200. Specifically on the Hellenistic reception of Epeius, see Sistakou 2008: 159–63: one such reference comes in Simmias' picture poem of an axe (*Anth. Pal.* 15.22) which purports to be the very axe that Epeius offered to Athena—a related combined poetic-pictorial tribute to Simmias' own poetic-pictorial *technê* (cf. Strodel 2002: 158–98, 275).

[71] Cf. e.g. *Od.* 8.493 and Verg. *Aen.* 2.264. Cf. Quint. Smyrn. 12.80–3, describing Epeius' crafting of the horse—'whom Athena taught his lore' (δέδαεν δέ μιν ἔργον Ἀθήνη, v. 83).

Little Iliad scene below).[72] On the other, it presents Theodorus as a modern-day Stesichorus—as not just resembling the artist Epeius ('Mr Epic'?), but as also akin to the poet Stesichorus who describes Epeius' craftsmanship through his verse, turning the stuff of epic poetry into lyric, just as this epigram translates (Theodorus' visual depictions of) epic into an elegiac couplet. Such is the self-referential sophistication with which Theodorus strikes this allusion that the resulting object would seem to make both artists and poets of those who subsequently learn from it: through our careful inspection of its combined visual and verbal features, we too can possess 'the measures and of *all* wisdom', pictorial and poetic alike.

It is perhaps also worth relishing the epigram's ironic association of Theodorus' small, inscribed relief with the epic grandeur of Epeius' own artistic product. While Epeius constructs a colossus—something so large as to conceal the Greek soldiers within—Theodorus makes much of his miniature craftsmanship; where Epeius' colossal wooden horse is destined to contain men, moreover, Theodorus' tablet is designed to be contained in the viewers' hands (cf. Fig. 171). If Theodorus' *technê* parallels that of Epeius, it might also be said to invert it: Theodorus' alleged 'order of Homer' is not quite what it seems, just as Epeius' horse is an object 'whose external appearance belied its internal reality'.[73] Despite the conspicuous differences of scale between their respective creations, the 'measures and wisdom' of Epeius and Theodorus are nevertheless closely related: in the same way that Epeius mediates Athena's inspiration to construct the Trojan horse, Theodorus intervenes between his audience and his poetic sources to construct this particular visual mediation of a series of verbal texts.[74]

That these epigrams are punning on a shared language of artistic and poetic invention is confirmed by a second allusion—to a clearly related Archaic poem, attributed to Solon. Despite the shared language between Stesichorus and Solon, we cannot be absolutely sure about the chronology (whether Stesichorus' poem anticipated Solon's, as seems most likely, or Solon's poem predates that of Stesichorus). At any rate, it is clear that the *Tabulae* epigrams have as much in common with Solon's poem as they have with the *Ilioupersis* of Stesichorus (13.49–52 West):[75]

[72] On the two Trojan horse depictions, see Valenzuela Montenegro 2004: 112–13, 119–21 (with further bibliography). On the literal significance of the 'Theodorean' attribution, cf. below, pp. 367–70.

[73] D. T. Steiner 2001: 83 n. 16.

[74] In this regard, it is worth noting the active force of the participle δαείς both in this Stesichorean passage and in the passage of Solon cited below: does the Capitoline tablet's form of the verb point to an independent mode of learning, as opposed to e.g. a generic *sophia* that is granted by the muses?

[75] See West (ed.) 1971–2: 2.129; Gladigow 1965: 16–20 wisely discusses the *sophia* semantics, and compare Löbl 1997: 62, no. 43. For the connection with the Capitoline epigram, cf. Guarducci 1974: 430; Kazansky 1997: 58 n. 23; Valenzuela Montenegro 2004: 352; Petrain 2006: 48–9. On the passage's relation to Stesichorus, see Schade 2003: 202.

ἄλλος Ἀθηναίης τε καὶ Ἡφαίστου πολυτέχνεω
ἔργα δαεὶς χειροῖν ξυλλέγεται βίοτον,
ἄλλος Ὀλυμπιάδων Μουσέων πάρα δῶρα διδαχθεὶς
ἱμερτῆς σοφίης μέτρον ἐπιστάμενος.

One man, after he has learned the works of Athena and much-skilled Hephaestus, makes his living with his two hands; another does so, after having been taught his gifts from the Olympian Muses, by understanding the measure of desirable wisdom.

There are of course differences between this passage and the phrasing of our tablet poems. Squeezing two couplets into its single pentameter, the Capitoline epigram seems to make the 'order of Homer' (τάξιν Ὁμήρου) the direct object of the participle δαείς, while nonetheless maintaining the integrity of the phrase σοφίης μέτρον (ὄφρα δαεὶς πάσης μέτρον ἔχῃς σοφίας).[76] These were evidently famous lines. An epitaph on Hesiod, ascribed to Pindar, seems to refer to them,[77] as does a tradition of sympotic poetry, descended from Theognis.[78] Once again, however, the context of Solon's lines is surely significant. Where Solon characterizes two distinct livelihoods—artistic craftsmanship on the one hand, and poetic mastery on the other—our tablet epigrams collapse the two cultural spheres into one discrete entity. The *Tabulae*, in short, fuse artistic with poetic craftsmanship: Theodorus' *technê* is both a feat of manual craftsmanship, as learned from Athena and 'much-skilled' (πολυτέχνεω) Hephaestus, and poetologically derived, the measure of poetic *sophia*.[79]

[76] For the (deliberately ambiguous) phraseology, see below, pp. 195–6.

[77] The epitaph is preserved in the *Tzetzae Vita* (see Merkelbach and West (eds.) 1970: 3) and discussed by Page (ed.) 1981: 159–60: χαῖρε δὶς ἡβήσας καὶ δὶς τάφου ἀντιβολήσας | Ἡσίοδ', ἀνθρώποις μέτρον ἔχων σοφίης ('Farewell Hesiod, you who blossomed twice and twice met your grave, holding for men the measure of wisdom'). The connection with the Capitoline epigram is noted by Lehnus 1972: 54 n. 15; Carlini 1982: 632; Valenzuela Montenegro 2004: 352; Petrain 2006: 53. The shared verb ἔχειν is particularly significant, as is the sequence of words.

[78] See Theognis 876 (West): μέτρον ἔχων σοφίας, with commentary in van Groningen (ed.) 1966: 333–4. Cf. also *Anth. Pal.* 11.45.6 on wine as the 'sufficient measure of all enjoyment' (μέτρον ἐμοὶ πάσης ἄρκιον εὐφροσύνης).

[79] I therefore respectfully part ways here with Petrain 2006: 43–56, who argues instead that 'the pentameter . . . employs language traditionally associated with the acquisition of knowledge about *poetry*, so that we remain acutely aware of the epic narrative underlying the visual presentation' (45, his emphasis). Although Petrain ibid. 52–6 uses a number of further literary and especially epigraphic parallels to suggest that the participle δαείς 'is reserved for the acquisition of the knowledge necessary to practice the art of poetry' (54), it is surely significant that Solon uses the active form of δαείς in the context of *artistic* production (as opposed to the passive form διδαχθείς used of the poet); we also find a related use of the verb in *Il.* 15.411–12—a passage which clearly refers to *artistic* craftsmanship, and which, as Petrain earlier notes (49–50), has a direct relevance for our epigram. While Petrain offers a stimulating account, I therefore think his final interpretation of diction a little too reductive: 'τέχνη here is most likely equivalent to τέχνημα, "work of art" (LSJ s.v. "τέχνη" IV), and so refers to the the *Capitolina* itself; Theodorus is the artisan who created the *Tabulae*, or at least supervised their making' (44). As Löbl 1997: 9–33 demonstrates,

The particular phrasing of the Capitoline epigram, with its promise of possessing the 'measure of *all* wisdom' (πάσης μέτρον . . . σοφίας), finds further parallels in epic evocations of both artistic and poetic craftsmanship. On the one hand, it might remind us of the only use of the word *sophia* in the *Iliad*, in which the labour of the warring Greeks and Trojans is compared to that of 'a workman skilled in his handiwork, well versed in all wisdom through the counsels of Athena' (. . . τέκτονος ἐν παλάμῃσι δαήμενος, ὅς ῥά τε πάσης | εὖ εἰδῇ σοφίης ὑποθημοσύνῃσιν Ἀθήνης, *Il.* 15.411–12). Although *sophia* is associated in this Homeric passage with artistic know-how (as later commentators explicitly noted),[80] the specific wording of the Capitoline epigram might also lead readers to think of a *poetic* sort of *sophia*. One striking comparison lies in Pigres' alleged attempt to recast Homeric epic into a series of elegiac couplets.[81] By inserting a pentameter after the opening hexameter of the *Iliad*, Pigres began his elegiac epic by invoking 'the Muse who possesses the limits of all wisdom' (Μοῦσα, σὺ γὰρ πάσης πείρατ' ἔχεις σοφίης)—offering a rival poetic form that at once appropriated and adapted Homeric *sophia*. Although we know next to nothing about this Carian poet—supposedly the brother of Artemisia, and working in the fifth century BC—Pigres may well have had the Solonic passage in mind. And it is at least possible that the Theodorean craftsman (and his audience) knew Pigres' pentameter in turn, preserved in the metrical structure of the Capitoline tablet's verse (πάσης μέτρον ἔχῃς σοφίας).[82]

What do these various resonances mean for the author and readers of our two inscribed epigrams? To my mind, the allusive texture establishes the *Tabulae* as a two-sided feat of *both* visual and verbal dexterity. The epigrams excavate a literary archaeology that leaves the precise nature of 'Theodorean *technê*' ambiguous: they bring together intersecting critical discourses about material objects crafted for viewing and literary texts composed for hearing and reading. These are epigrams that resonate in surround stereoscopic-stereophonic sound: they attribute the objects on which they are monumentally inscribed with a combined form of artistic and poetic craftsmanship.[83]

technê had *always* had a pluralistic, intermedial sense—'und das schon bei Homer, wie seine eigene Kunst beweist: auch das Können des Rhapsoden ist eine *technē*, auch wenn sie in den Gedichten selbst nicht so genannt wird' (30).

[80] See Gladigow 1965: 9–15 and Löbl 2008: 13, along with p. 112 below.

[81] See West (ed.) 1971–2: 2.93–4. On the parallel, see Lehnus 1972: 54 n. 15; Carlini 1982: 632; Petrain 2006: 56–7.

[82] Pigres' elegiac reply to Homeric epic stands behind later 'short-footed' skips at the same gesture—not least Ovid's famous response to Virgil at *Am.* 1.1–4.

[83] However we reconstruct the elegiac couplet of tablet 2NY (above, pp. 104–5), this epigram certainly punned upon similar ideas: how to square 'Theodorean' *technê* with the *technê* of Homer? We shall never know the formulation of the tablet's hexameter, nor whether (like the Capitoline epigram) the recto mentioned Theodorus specifically. Still, it is nevertheless significant that the tablet's verso 'magic square' diagram championed 'Theodorean *technê*' explicitly, adding a further pictorial-poetic twist to the use of the term in the recto's inscribed pentameter.

TECHNÊ SQUARED

Enough has been said, I hope, to indicate how the Capitoline and New York epigrams toy not only with Homer, but with a much broader spectrum of literary precedents. Readers are invited to mobilize their full knowledge of Greek literature and to bring it to bear on the objects in hand. The result is a far cry from the 'simple linguistic demands' so often supposed.[84]

As I hope currently to show, however, the self-referential way in which the two epigrams present their tablets as both visual and verbal products is itself a literary conceit with a distinguished poetic ancestry. The language of *technê* and *sophia* drives home the point, as applicable to the art of poetic composition as to the craftsmanship of sculpture and painting. In the wake of Plato's discussion of poetic and pictorial mimesis, and in particular Aristotle's subsequent discussion of 'poetic craftsmanship' (ποιητικὴ τέχνη), artistic and literary composition came to be conceived as ever more parallel projects in the fourth century BC.[85] Aristotle himself mused upon the shared critical language: while elsewhere discussing poetry as a form of mimetic *technê* that parallels that of painting,[86] Aristotle notes that 'we apply the word *sophia* in the arts [ταῖς τέχναις] to those men who are most precise in respect to their *technai* [ἀκριβεστάτοις τὰς τέχνας], like Pheidias the stonecarver and Polyclitus who makes statues; in this instance, we take *sophia* to mean nothing other than their excellence in *technê* [οὐδὲν ἄλλο σημαίνοντες τὴν σοφίαν ἢ ὅτι ἀρετὴ τέχνης ἐστίν]' (*Eth. Nic.* 6.7, 1141a9).[87] The epigrams on tablets 1A and 2NY encapsulate a related mode of poetic-cum-pictorial dexterity. In doing so, they play with a subsequent critical tradition: the inscribed couplets capitalize upon a discourse of relating the pictorial to the poetic that gained particular cultural currency in the Hellenistic world.

Following Simon Goldhill's seminal 1994 article on 'ecphrasis and the culture of viewing in the Hellenistic world',[88] numerous scholars have drawn attention

[84] Horsfall 1979a: 34.

[85] Cf. Löbl 2003: 61–178 (on Plato) and 178–264 (on Aristotle).

[86] The first chapter of Aristotle's *Poetics* nicely demonstrates the thinking (1447a17–22): 'Just as people use colours and shapes to render mimetic images of many things (whether by formal *technê*, or by habitual practice), and just as others again do so by means of the voice, so too all the *technai* mentioned produce mimesis in rhythm, language, and melody, whether resorting to these individually or as a collective'; ὥσπερ γὰρ καὶ χρώμασι καὶ σχήμασι πολλὰ μιμοῦνταί τινες ἀπεικάζοντες (οἱ μὲν διὰ τέχνης οἱ δὲ διὰ συνηθείας), ἕτεροι δὲ διὰ τῆς φωνῆς, οὕτω κἂν ταῖς εἰρημέναις τέχναις ἅπασαι μὲν ποιοῦνται τὴν μίμησιν ἐν ῥυθμῷ καὶ λόγῳ καὶ ἁρμονίᾳ, τούτοις δ' ἢ χωρὶς ἢ μεμιγμένοις.

[87] For the passage, see e.g. Pollitt 1974: 146, along with Maffei 1991: 599–600. Pollitt offers some more general introductions to the art historical terminology at 32–7 (concerning *technê*) and 92–3 n. 28 (concerning *sophia*).

[88] See Goldhill 1994: especially 210: 'The philosophy of vision, the poetry of responding to art, and the cultural frame in which art and poetry are perceived, together mark a changing *discourse of viewing* in the Hellenistic period'. Cf. idem 1996: 21–4; 2001: 157–67; 2007: 1–3.

to the ways in which the crafted products of the artist could serve as metapoetic figures for the literary creations of the Hellenistic poet.[89] The *locus classicus* is arguably Theocritus' fifteenth *Idyll*, in which two women respond not only to an embroidered tapestry displayed in Alexandria, but also to a set-piece hymn—a sung poem that is placed, with characteristic self-reflexivity, within the larger frame of Theocritus' own performative poem. Gorgo and Praxinoa discuss the two media in closely related terms: Gorgo's superlative praise of the female hymn singer (τὸ χρῆμα σοφώτατον ἁ θήλεια, 'the woman is a creature of exceeding wisdom', *Id.* 15.145) develops Praxinoa's evaluation of those who had woven the tapestry (σοφόν τι χρῆμ' ἄνθρωπος, 'mankind is a creature of wisdom', *Id.* 15.83).[90]

Such play on the language of *sophia*, pertaining both to pictorial and poetic artistry, stretches back to the very origins of Greek literature, as Burkhard Gladigow long ago showed.[91] Already with Homer, we have said, *sophia* was a term used of the material artist 'well versed in all wisdom' (*Il.* 15.411–12). But subsequent commentators made much of the terminology and its manifold frame of reference. Attempting to define the concept, the Suda notes that *sophia* 'commonly [denotes] the knowledge of all things—*technê*, thought, understanding, mind'. His attention then falls on the Iliadic passage: 'Homer used the term "*sophia*" only once', he adds, 'although not to denote the development of character through word and deeds, but rather tectonic *technê*'.[92] Wise writers like Theocritus could trace their sophisticated Hellenistic puns all the way back to the poetic *sophia* of Homer himself.

The epigrams inscribed on the Capitoline and New York tablets develop this dual literary and artistic register, associating their *sophia* and *technê* both with poetry (the epic texts depicted) and with pictures (the images mediating the texts). On both tablets, the shared critical vocabulary is used to blur the boundaries between the crafted products of Homer and those of Theodorus—the visual objects in our hands, the epic poems with which they engage, and indeed the two couplets that now knowingly occupy both registers at once: the words and

<hr>

[89] Most important is now Männlein-Robert 2007b. Cf. Rossi 2001: especially 15–27; Gutzwiller 2002a; Meyer 2005 and 2007; Männlein-Robert 2007a; Prioux 2007 and 2008; Tueller 2008: especially 155–65.

[90] On the parallel between the arts in this idyll, see especially Burton 1995: 118–19; cf. Manakidou 1993: 40–50; Goldhill 1994: 216–23; Hunter 1996a: 116–23 and 1996b (reprinted in 2008: 233–56); Skinner 2001; DuBois 2007: 47–54; Männlein-Robert 2007b: 283–303.

[91] See Gladigow 1965: 11: 'Die Klammer für beide Modi des Wissens, des handwerklichen und des philosophischen, liegt in dem Begriff der σοφία.' Cf. Stieber 2011: 415–26 on the Euripidean use of the term.

[92] See Adler (ed.) 1928–38: 4.400, s.v. σοφίαν: κοινῶς ἁπάντων μάθησιν, καὶ τὴν τέχνην, τὴν φρόνησιν, καὶ ἐπιστήμην, τὸν νοῦν. ἅπαξ ἐχρήσατο Ὅμηρος σοφίᾳ, οὐ καθάπερ νῦν τὴν διὰ λόγου καὶ πραγμάτων ἐπισκευὴν τοῦ ἤθους, ἀλλὰ τὴν τεκτονικὴν τέχνην. εὖ εἰδῇ σοφίης. Other ancient commentaries on *Il.* 15.411–12 are noted by Gladigow 1965: 9 n. 2.

images are each as sophisticated and well crafted as the other. It is wholly typical of Philostratus the Elder's self-styled *Imagines* (i.e. 'pictures'—*Eikones* in Greek), that the first sentence of the proem should begin with a similar sort of wordplay (*Imag.* 1 praef. 1):[93]

ὅστις μὴ ἀσπάζεται τὴν ζωγραφίαν, ἀδικεῖ τὴν ἀλήθειαν, ἀδικεῖ καὶ σοφίαν, ὁπόση ἐς ποιητὰς ἥκει, φορὰ γὰρ ἴση ἀμφοῖν ἐς τὰ τῶν ἡρώων ἔργα καὶ εἴδη, ξυμμετρίαν τε οὐκ ἐπαινεῖ, δι' ἣν καὶ λόγου ἡ τέχνη ἅπτεται.

Whoever scorns painting is unjust to truth; he is also unjust to the wisdom [*sophian*] that has been bestowed upon poets (for poets and painters make equal contribution to our knowledge of the deeds and the forms of heroes); whoever scorns painting, moreover, withholds his praise from due symmetry of proportion [*xymmetrian*], whereby art [*technê*] partakes of reason [*logou*].

Philostratus' treatise, we must remember, is a verbal evocation of a collection of visual paintings. How appropriate, then, to open this picture text by declaring that texts and pictures can make an equal claim to *sophia*—moreover, that both painted and written *technê* partake of the same verbal reason (*logos*).[94] As with the *Tabulae*, the *sophia* of Philostratus' text lies in its oscillation between words and pictures—its multistable telescoping, moreover, from the perspectives of the speaker to those of the boy addressed, the viewers of the gallery, and the subjects within each painting evoked (all puppeteered by the 'clever' *technê*-cum-*logos* of the authorial technician pulling the strings).[95]

 A still closer parallel for the tablets' intermedial concern with *technê* and *sophia* is to be found in Hellenistic epigram, and especially those 'ecphrastic' epigrams posing as make-believe monumental inscriptions on artworks.[96] The genre of epigram will prove a recurrent point of comparison in the discussions that follow, and in the fifth and sixth chapters in particular: by interrogating the rhetoric of representation, and doing so through combined visual and verbal means, the *Tabulae Iliacae* offer a sort of material equivalent (and simulative retort) to

[93] The key discussion of this hugely challenging opening sentence is Maffei 1991 (especially 261). Cf. Schönberger and Kalinka (eds.) 1968: especially 46–56, 269–270; Michel 1974; Boeder 1996: 145–9; Abbondanza 2001; Thein 2002; L. Giuliani 2006; Graziani 2006; Newby 2009: 324–6; see also Pugliara 2004: 13–14 on the proem of the Younger Philostratus' *Imagines*.

[94] The claim is already encapsulated in the word ζωγραφία: the *graph-* root of the term (verbally) demonstrates how visual drawing always betokens written description, and vice versa.

[95] For an introduction to Philostratus' 'poetics of ecphrasis', and for further literary comparanda, see now Webb 2009: 167–91 (especially 187–90), as well as the essays in Costantini, Graziani, and Rolet (eds.) 2006 on 'l'image sophistique'. My own interpretation of the *Imagines* is sized up in Squire forthcoming c; cf. Elsner and Squire forthcoming. I take the notion of 'multistable' images (forged after 'multistable' texts) from Mitchell 1994: 45–57.

[96] On the 'ecphrastic' label, see below, pp. 275–6 n. 78.

epigram's own 'poetics of simulation'.[97] For now, though, it is sufficient to introduce the *history* of epigram as poetic genre: originally inscribed on the face of material monuments, epigrams came (at least by the Hellenistic period) to be transcribed into self-standing papyrus scroll anthologies. Although intended to be experienced in conjunction with the monuments with which they engage, such poems came to be read within—and increasingly composed for—literary collections circulating *independently* of the visual monuments to which they supposedly refer.[98]

The genre's cultural and literary history made for poems acutely sensitive to their ambiguous ontology between physical reality and poetic fiction. Epigram is a phenomenon that exists *between* imposing visual monuments on the one hand (as though actually chiselled in letters below the objects to which they refer), and verbal fabrications on the other (literary texts collected within the confines of the poetic anthology). Mediating their crafted objects, and appropriating the standard language of artistic craftsmanship for their own metapoetic ends, epigrams are made to encompass both material *and* literary forms of *technê* and *sophia*.

Our two *Tabulae* inscriptions function as ecphrastic epigrams in a closely related sense. As single elegiac couplets detailing the name of the 'Theodorean' artist, both the Capitoline and New York inscriptions bear comparison with epigrammatic poems that functioned as (purported) artistic signatures for the images (purportedly) attached to them.[99] But the tablet epigrams go still further, attributing a function and rationale to their artistic objects. As such, their combined poetic-pictorial rhetoric is best paralleled by the 36 extant Greek poems that came to be written on Myron's cow, supplemented in 2001 by a further epigram from the new Posidippus.[100] These poems, gathered together in the ninth book of the *Palatine Anthology* (*Anth. Pal.* 9.713–42, 793–8), expressly parade their *technê* and

[97] For the term, see Squire 2010a; for the thinking, cf. idem 2009: 161–8 and 2010d. On the ontological games of Hellenistic ecphrastic epigram, posing at once as artwork and text, the key analysis is Bing 1998: especially 29–35 (revised in 2009: 194–216); cf. Gutzwiller 2002a: especially 104–9; Platt 2002b: especially 38–40; Fantuzzi and Hunter 2004: 289–91; Meyer 2005: especially 107–26 and 2007; A. Petrovic 2005; Männlein-Robert 2007a: especially 269–71 and 2007b.

[98] Cf. below, pp. 230–1. On this generic development, compare a number of essays in Bing and Bruss (eds.) 2007—especially Bettenworth 2007 and Day 2007 (with further bibliography). Important earlier work includes Goldhill 1994; Bing 1995; Gutzwiller 1998: 47–119 and 2007: 178–88; Fantuzzi and Hunter 2004: 306–38; Bruss 2005: 168–71; Meyer 2005: 25–126; Tueller 2008. I have not seen Baumbach, Petrovic, and Petrovic (eds.) 2010.

[99] For discussion of such epigrams, see Lausberg 1982: 192–8.

[100] Posidippus' poem (66 A–B) may be the earliest poem on the theme now known: see Gutzwiller 2002b: 54 and Männlein-Robert 2007b: 70–1. On the metapoetic significance of Myron's virtuoso *technê*, portending the make-believe of ecphrastic epigram at large, see Squire 2010a. For some more general discussions of these epigrams, see Fuà 1973; Speyer 1975; Lausberg 1982: 223–37; Laurens 1989: 83–5; Gutzwiller 1998: 245–50; Männlein-Robert 2007a: 265–9 and 2007b: 83–103; Goldhill 2007: 15–19. For the chronology and formation of the collection, cf. Cameron 1993: 82–3.

sophia, relating these qualities both to Myron (who sculpted the original bronze statue of the heifer), and to the epigrammatic poet (now celebrating that sculpture through verse). Within the surviving sequence of epigrams, which spans the early Hellenistic to late Byzantine worlds, there are some dozen references to the *technê* of Myron's make-believe *simulacrum*;[101] what is more, the description of the 'wise Myron' (Μύρων σοφός, *Anth. Pal.* 9.795.1), who has forged this 'wise thing' (σοφὸν χρέος, Posid. 66.3 A–B), is made to prefigure the carefully wrought textual creations of the clever poet and editor, herded together within the literary confines of the anthology.[102]

Although engaging with the generic conceits of epigram at large, the physical monumentality of the two tablet inscriptions adds a new dimension to their epigrammatic claims to *technê* and *sophia*. Where Hellenistic epigram explores the visual–verbal *sophia* involved in ecphrastically turning artistic *technê* into the *technê* of language, the *Tabulae* present viewer-readers with *technê* squared: their *sophia* embodies a *combined* form of poetic and artistic craftsmanship. As we have said, one of the defining features of anthologized ecphrastic epigram is its circulation apart from the images that it purports to describe: in paying tribute to the absent image, ecphrastic epigram replaces the monumental object, interrogating what it means to 'see' in the first place.[103] The New York and Capitoline tablets, by contrast, reverse this ecphrastic movement from image to text. In describing the artist's intermedial feat in words, these epigrammatic inscriptions do not substitute the artwork that they evoke, but rather appear alongside—and indeed as part of—its visual imagery. The inscriptions even bestow on the objects a voice of their own: although calling upon the viewer, instructing him on how to

[101] See *Anth. Pal.* 9.721.2, 729.2, 737.1, 738.1, 738.3, 741.3, 742.4, 793.2, 794.2, 798.2; cf. *Anth. Pal.* 9.740.3 (τεχνίτας) and 9.727.2 (ἐτεχνάσατο). I focus on the Myron's cow poems here, although there are many other comparanda: cf. e.g. Platt 2002b on the Aphrodite epigrams (collected with associated themes in *Anth. Plan.* 159–82). For other Hellenistic epigrammatic invocations of artistic *technê* (based on those poems included in Gow and Page (eds.) 1965, eidem (eds.) 1968, and Page (ed.) 1981), cf. e.g. *Anth. Pal.* 6.260.1, 3; 6.337.6; 9.709.5; 9.752.2; 9.756.1; 9.777.1, 8; *Anth. Plan.* 166.4; 205.4, 6; compare too Posid. 12.1; 63.5; 65.2; 68.3, 5; 95.7 A–B. Some of these uses are discussed by Löbl 2008: 33–41, nos. 553–60 and 47–50, nos. 576–9.

[102] Compare here *Anth. Pal.* 6.352—one of the earliest and most influential 'ecphrastic' epigrams known to us, attributed to Erinna—in which the wisdom (σοφία) ascribed to the painter is simultaneously claimed by the poet (cf. below pp. 238–9). Callistratus further developed such themes in his late antique *Imagines*, frequently describing 'statues' that are modelled after established epigrammatic treatments, and punning upon the visual–verbal *technê* involved in the process: cf. e.g. the discussion of the respective *technai* of sculptors, poets, and prose authors that opens the description of a Bacchant statue—leading the speaker to ask (rhetorically) 'why should I not too describe for you from the beginning the inspiration for this *technê*?' (τί δὲ ὑμῖν οὐκ ἄνωθεν τὸν ἐνθουσιασμὸν τῆς τέχνης διηγοῦμαι; *Imag.* 2.1; for other opening references to *technê*, cf. e.g. *Imag.* 3.1, 9.1, 11.1).

[103] Cf. Gutzwiller 2002a: 86: 'The actual reader [*sc.* of an ecphrastic epigram] is now at one remove from the representation that is the work of art, and may experience it only through the lens of a represented viewing…'

proceed ('understand the *technê* of Theodorus!'), these poems stand before us as object—they have a sort of authentic, objective, tangible presence.[104]

As I have argued elsewhere, there are numerous parallels for these sorts of phenomenological epigrammatic games, whereby epigram brings together and encapsulates multiple levels of representation. Among the most illuminating are those scenarios where a series of brain-teasing Greek epigrams were inscribed alongside the paintings that they poetically purport to 'caption'—in the eponymous exedra of the Casa degli Epigrammi, Pompeii V.1.18, for example, or in the cryptoporticus of the so-called 'House of Propertius' in Assisi. The very combination of text and image in both settings reopened ecphrastic questions about pictorial or poetic priority—about how image and text should be understood to relate to each other (no less than about the epigram's inscribed and monumental literary heritage): which comes first, the image mediated through the poem, or the poem mediated through the image?[105] These are the themes that the 'picture poems' in the final book of the *Palatine Anthology* also explored (*Anth. Pal.* 15.21–2, 24–7) (Figs. 115, 117). As we shall see, these so-called *technopaegnia* (i.e. 'games of *technê*') used their literal form to figure the visual appearances of the objects which they verbally evoked: posing at once as texts and images, the epigrams really do monumentalize the subjects that they simultaneously render into language. Such is the self-professed *technê* of the poet, as one such epigram puts it (*Anth. Pal.* 15.25.16), that the calligrammatic text is able to visualize the altar that it verbally paraphrases—by means of its varying verse lengths.[106]

Like the *technopaegnia*, the *Tabulae* stress their visual–verbal *technê* at every available opportunity. In addition to the epigrammatic inscriptions on 1A and 2NY, three other tablets announce their *technê* on their reverse (3C, 5O, 20Par), always qualifying it with the adjective 'Theodorean'. As the fifth chapter explores (especially pp. 228–46), these inscriptions are themselves figured so as to operate between words and images: their diagrammatic form materializes a literary *and* artistic *technê* that interrogates the very boundaries between visual and verbal modes of representation. As ever, the *sophia* of 'Theodorean *technê*' lies in cross-breeding pictorial *technê* with the *technê* of poetry.

Other Hellenistic authors paraded their intermedial credentials in no less sophisticated ways. One of the most revealing examples is the so-called 'Eudoxus

[104] The key discussion of voice, art, and 'slippage' in Hellenistic epigram is Tueller 2008, on the 'elision of the difference between a piece of representational art and that thing or being that it represents' (204).

[105] See Squire 2009: 176–89, 239–93 and forthcoming a; cf. also Prioux 2008: 25–140. There are numerous other examples: e.g. the Pero picture and epigram in the Casa di Lucretius Fronto, Pompeii V.4.11 (*PPM* 3: 1005, no. 78a–b, 1006, no. 81: cf. most recently Sauron 2009: 252–60), as well as the second-century BC Menophila relief from Sardis (Fig. 108).

[106] See below, pp. 231–5. Specifically on the name '*technopaegnia*', see p. 231 n. 89.

papyrus', held in the Louvre (*P. Par.* 1). This manuscript, containing a prose astronomical treatise, appears to have been composed in the early second century BC: a brief colophon on the recto gives the title as *Ouranios Didaskaleia* ('Celestial Teaching'), associating the text with a certain Leptines. Two aspects of this papyrus strike me as particularly significant: first, the fact that it was abundantly decorated, and with all manner of coloured figures, diagrams and pictures (Fig. 37); and second, the intriguing peculiarity whereby the manuscript opens with a poetic invocation in iambics, associating Leptines' prose treatise with a fourth-century Cnidian astronomer named Eudoxus.[107] Here is the poem in full:

Ἐν τῷδε δείξω πᾶσιν ἐκμαθεῖν σοφὴν
Ὑμῖν πόλου σύνταξιν ἐν βραχεῖ λόγῳ
Δοὺς τῆσδε τέχνης εἰδέναι σαφῆ πέρι.
Οὐδεὶς γάρ ἐστιν ἐνδεὴς γνώμης ὅτῳ
Ξένον φανεῖται, ταῦτ' ἐὰν ξυνῇ καλῶς.
Ὁ μὲν στίχος μείς ἐστι, γράμμα δ' ἡμέρα.
Ὑμῖν ἀριθμὸν δ' ἴσον ἔχει τὰ γράμματα
Ταῖς ἡμέραισιν ἃς ἄγει μέγας χρόνος.
Ἐνιαύσιον βροτοῖσι περίοδόν τ' ἔχει
Χρόνος διοικῶν ἀστέρων γνωρίσματα.
Νικᾷ δὲ τούτων οὐθὲν ἕτερον, ἀλλ' ἀεὶ
Ἥκει τὰ πάντα ἐς ταὐτὸν ὅτε ἀνέλθῃ χρόνος.

Herewith I will reveal to you all the wise [*sophên*] composition of the heavens, and give you certain knowledge of this *technê* in a few words. There is nobody so lacking in intelligence that what follows would seem strange to him, so long as he understands these verses well. The line stands for a month, the letter for a day; the letters provide you with a number equal to the days which a Great Year brings. Time brings to men a yearly circle, as it governs the starry signs: of which none outrivals another, but always all come to the same point, when the time comes round.

Some of the parallels between the Eudoxus poem and the epigrams on tablets 1A and 2NY have been noted by other scholars: just as the Capitoline epigram instructs its audience to 'learn' (μάθε) 'Theodorean *technê*', the poem declares 'knowledge' (ἐκμαθεῖν) as its purpose; just as the tablet promises to teach the 'order of Homer' (τάξιν Ὁμήρου), moreover, so that audiences will thereby

[107] For a text and introduction to the poem, see Page (ed.) 1941: 467–9—whose translation is adapted here: the most important publication and discussion was in 1887, reprinted in Blass 1997 (see especially 88); Luz 2010: 58–63 appeared while this book was in production, discussing the poem as 'eine Art Rätselspiel'. The later reuse of the papyrus' verso gives a *terminus ante quem* of 165–164 BC. For two recent overviews of the papyrus (with some further bibliography), see Evans 2004: 32–5 and Parsons 2009: 32–3; there are colour images in Legras 2002: pl. XI, and Gallazzi and Settis (eds.) 2006: 276 discuss it in relation to *P. Artemid*. More generally on the use of drawings and figures in Greek and Roman technical treatises, see below, p. 138 n. 27.

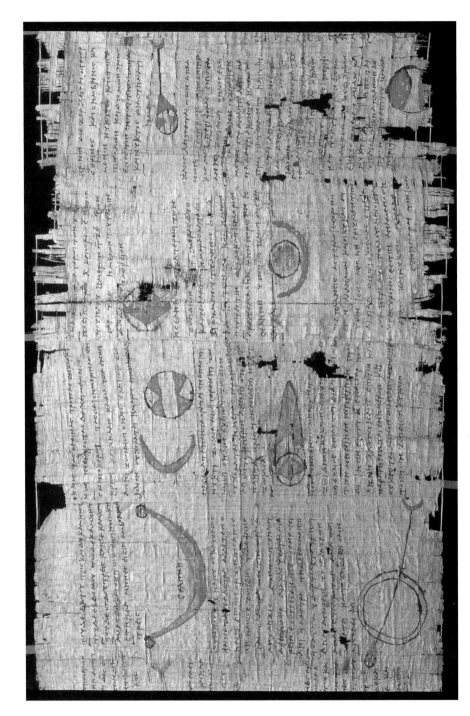

FIGURE 37. Detail of the 'Eudoxus papyrus' (*P. Par.* 1), second century BC.

possess the 'measure of all wisdom' (πάσης μέτρον σοφίας), the poem promises to teach the 'wise system of the heavens' (σοφὴν | ... πόλου σύνταξιν).[108]

To my mind, the shared poetic agenda between the tablet inscriptions and this penned epigram runs somewhat deeper: at play are related concepts of *technê* and *sophia*. If the Eudoxus epigram's claim to brevity (ἐν βραχεῖ λόγῳ) mirrors the tablets' own miniaturizing agenda, both texts claim *technê* in their associated modes of encapsulation. As revealed in its sixth to eighth lines, the Eudoxus papyrus p(r)oem purports to embody the whole papyrus through this epigrammatic summation. But it does so in a highly complex manner: the 12-line epigram, we are told, matches the length of a 12-month year. By the same token, we see how the grand number of letters equals the total number of days in a leap year: there are 365 *grammata* altogether, of which 30 are contained in each of the first 11 one-month lines, while 35 are found in the final verse. This mini-text thus serves as a sort of cryptic blueprint: as the second line puts it, the poem captures all time and space, and yet does so in just a few words.[109]

But what strikes me as particularly significant is the way in which the papyrus' poem labels all this as *technê*. Running down the left-hand side of the epigram we find an acrostic that explicitly relates the poem and manuscript to the 'technê of Eudoxus' (Εὐδόξου τέχνη); in the third line, we find another reference to 'this *technê*' (τῆσδε τέχνης)—the deictic leaving the precise subject knowingly vague. Such allusions to *technê* are evidently multilayered. And yet they are also at once poetic and pictorial in visual–verbal orientation. As the epigram itself states, it is written in *grammata*. Reading the poem, however, audiences see how, thanks to *technê* of the poem, these *grammata* embody something more figurative—not only through the hidden acrostic, but also by having attributed to them a numerical sort of significance (each *gramma* equating to a single day of the year).[110] Thanks to the *technê* of Eudoxus, letters can take on a more than (or rather *less* than?) literal meaning.

Quite apart from the poem's parallels with the spatial games played out in the seven *Tabulae Iliacae* 'magic square' inscriptions, explored in the fifth chapter, it is worth noting how the word *technê* introduces an additional semantic resonance besides. Like the *Tabulae*, the 'Eudoxus papyrus' combined words with pictures, not only analysing the constellations verbally, but also depicting them in a series

[108] For (preliminary) discussion, see O. Jahn 1873: 91; Bua 1971: 18–20 (with earlier bibliography); Guarducci 1978: 1738–9; Rouveret 1989: 359–60; Valenzuela Montenegro 2004: 353. Horsfall 1979a: 29–31, by contrast, concludes that the papyrus' relevance to the tablets 'has been exaggerated and should be delimited with care' (31).

[109] For the underlying poetic theme of constructing the universe as text (and vice versa), cf. Volk 2009: 195–6 on e.g. Lucr. 1.823–7, 2.688–99, 1013–22, and Manilius 1.20–4.

[110] As such, the poem parallels the self-conscious language of *grammata* on the verso of tablets 2NY and 3C, referring to 'lines' that are both—and verbal in significance: see below, pp. 202–5, 235–43.

of astronomical drawings. The manuscript is in fact the oldest surviving example of a technical treatise that juxtaposed text with diagrams: it delivers *grammata* in the sense of both literal 'letters' and figurative visual 'lines'. The claim to *technê* in other words, is not just a boast about the literary dexterity of the poem; it also draws attention to the combined visual properties of the papyrus more generally. The poet introducing the papyrus puns on the *dual* nature of the manuscript's *technê*—pertaining at once to the science of the text (and to this masterly poetic summation of it), as well as to the pictorial craftsmanship of the accompanying images. *Sophia* indeed.[111]

Like the *technê* of the Eudoxus poem, the *technê* of the *Tabulae Iliacae* operates on a variety of different levels. As we have seen, the term refers simultaneously to words and pictures. But it also serves to encapsulate numerous other innovations besides: the order that the tablets impose on their subjects; their various juxtapositions of different stories, epic cycles, and indeed literary genres; and not least their novel medium. Perhaps the greatest *technê* of all, though, is the miniature size. The scale of the tablets is a theme upon which the sixth chapter expands. But for our immediate purposes, it is enough to demonstrate how the language of the Capitoline and New York epigrams (no less than the Eudoxus poem) nods to the opening of one of antiquity's most famous aesthetic manifestos: the prologue to Callimachus' *Aetia*. In each case, talk of *sophia* and *technê* calls to mind Callimachus' programmatic instruction 'henceforth to judge poetic-wisdom [*sophia*] by its craft [*technê*] and not by the Persian measuring-rope' (αὖθι δὲ τέχνῃ | κρίνετε, μὴ σχοίνῳ Περσίδι, τὴν σοφίην, Callim. *Aet.* frg. 1.17–18).[112] This is not just an allusion to the Callimachean aesthetic of *leptotês*. As is well known, Callimachus' programmatic comments have a purported artistic context, just like the programmatic inscriptions on our two tablets: they are framed as a reply to the 'Telchines', a group of (epic-sounding) critics named after a legendary group of chthonic pre-Olympian figures from Rhodes, famous for their metal-working.[113] Where the

[111] *Pace* Horsfall 1979a: 31, who suggests that 'the word [*sc. technê*] is employed either for convenience or from pretentious ignorance'. The manuscript calls for a fresh scholarly re-examination: the images alone suggest the need to temper e.g. Thurston 1994: 117, who claims that 'the contents of the papyrus are of no interest and its connection with Eudoxus is purely nominal'.

[112] On the metapoetics of the *Aetia* prologue, see especially Asper 1997: 209–34, along with Acosta-Hughes and Stephens 2002, Fantuzzi and Hunter 2004: 66–76, and I. Petrovic 2006: 24–36.

[113] On the identity of the Telchines, see the sources collected in Overbeck: 1868: 7–9, nos. 40–55; cf. Herter 1934; Hopkinson (ed.) 1988: 91–2; Brillante 1993; Asper 1997: 145–7. As I. Petrovic 2006: 26–30 rightly emphasizes, the fact that the Telchines were themselves artists (τεχνῖται), famed for inventing 'certain *technai* and other useful things' (τεχνῶν τινων . . . καὶ ἄλλων τῶν χρησίμων, Diod. Sic. 5.55.2), adds an important material dimension to Callimachus' (intermedial) discussion of scale. Note too Acosta-Hughes and Stephens 2002: 241, concluding that, since the Telchines were 'primitive artists', 'the subsequent discussion of poetry proceeds to demonstrate the aesthetic limitations of the Telchines while it justifies Callimachus' own aesthetic supplanting theirs'. For one explicit attempt to reactivate the association of the

Telchines criticize poetry by applying criteria of scale that are usually restricted to material objects, Callimachus inverts their sizeism, while nevertheless casting his poetics within the same materialist imagery of artistic craftsmanship:[114] 'what matters is *techne*, "poetic craft",' write Marco Fantuzzi and Richard Hunter, 'however long the poem'.[115]

Encapsulating the grand world of epic in miniature pictures, miniature verbal synopses, and indeed in these self-consciously miniature epigrams, the Capitoline and New York tablets flaunt their allegiance to this 'Callimachean' poetic programme. Set against an epic literary backdrop, translating grand themes into something small, refined, and 'crafted', the epigrams draw explicit attention to a *technê* and *sophia* that is on the one hand transmedial, and on the other transitive in scale: true to the Callimachean mould, these objects are both visually and verbally crafted, and both little and large. This, I think, sheds additional light on the two playful references to *metron* in both the Capitoline and New York epigrams. As we shall see, the term not only draws attention to the tablets' various adaptations of Homeric hexameter verse (within the pentameter of each of these two epigrams), but also alludes to the literal scale of these images-cum-texts—to their manner of at once *celebrating* Homer's great *sophia*, and *trumping* it through their miniature words and pictures.[116] A sophisticated aesthetic programme is evidently in operation: the epigrams size up all of the themes developed in this book, while doing so through a plethora of allusive literary yardsticks.

CONCLUSION: THE CULTURE OF INTERMEDIAL PLAY

We have come a long way from the dismissal of the *Tabulae* as 'expensive rubbish' with which this chapter began. By concentrating on just some of the texts inscribed on the tablets, I hope to have demonstrated a much more erudite and learned readership than scholars (and anglophone scholars in particular) have tended to suppose. Far from catering to the 'eager delight' of Trimalchio alone,[117] the tablets assume familiarity with a wide range of different texts. But they also exploit that familiarity, inviting readers to apply their knowledge of different literary forms to the images and texts here materialized. The

Telchines with their metal-making—within a not-so-miniature ecphrastic poem on a tiny 'Heracles Epitrapezios' statue—see below, pp. 270 n. 60 on Stat. *Silv.* 4.6.47–9.

[114] On the literal and metaphorical dialectics of size in Callimachus, see Asper 1997: 135–207, along with Prioux 2007: especially 77–130.

[115] Fantuzzi and Hunter 2004: 69. For Callimachean notions of *technê*, cf. Löbl 2008: 42–5, nos. 561–8.

[116] See below, pp. 248–52.

[117] Horsfall 1979a: 35.

programmatic inscriptions of the Capitoline and New York inscriptions demon-
strate the point with particular clarity: by echoing an anthology of earlier literary
precedents—not least the *Ilioupersis* of Stesichorus—these epigrams replicate a
shared critical language of artistic and poetic replication; in doing so, they allude
to a Hellenistic tradition of playing with (and indeed breaking down) the
boundaries between visual and verbal representation in the first place. The act
of visualizing epic is presented as a self-consciously literary art.

I end this chapter with one final *comparandum*: an anonymous dialogue that
has come to be called the *Tablet of Cebes*. The text was written in Greek, and
produced at about the same time as the *Tabulae Iliacae* (it was most probably
composed in the early first century AD):[118] the work purports to describe
'a certain tablet' (πίναξ τις, *Tab. Ceb.* 1.1) installed as a votive offering outside a
temple of Cronus. The way in which the text lays out its subject is important in its
own right. Our speaker tells how, seeing the tablet, he stopped to take a look at
the painted subject: was that a walled city depicted at its centre (as in the middle
of so many *Tabulae* (e.g. Figs. 58–9)), or was it a walled military camp? No one-
word explanation will suffice: 'on it there was a strange painting/description
[*graphê*] complete with stories [*mythous*] all of its own, and we were not able to
make out what they could possibly have been' (ἐν ᾧ ἦν γραφὴ ξένη τις καὶ μύθους
ἔχουσα ἰδίους, οὓς οὐκ ἠδυνάμεθα συμβαλεῖν, τίνες καί ποτε ἦσαν, *Tab. Ceb.* 1.1).

While the gathering crowd becomes lost in looking at the enigmatic picture
(ἀπορούντων), a mysterious old man (πρεσβύτης τις, *Tab. Ceb.* 2.1) appears: the
sage philosopher comes to the viewers' interpretive aid, answering their ques-
tions and explaining the allegorical significance of each and every pictorial
detail.[119] A Platonic-style dialogue between naive onlooker and expert guru
ensues. Verbal exegesis replies to visual *aporia*: literal and metaphorical salvation
is (said to be) found in the performance of philosophical *Paideia* ('Education'—
not for nothing one of the tablet's subjects: *Tab. Ceb.* 32).[120]

Despite their differing subjects and agendas, the *Tablet of Cebes* has much in
common with the *Tabulae Iliacae*. Those who pay attention to this reading of the
tablet, declares the old man of his own exegesis, will be 'wise and happy' (φρόνιμοι
καὶ εὐδαίμονες), whereas those who do not will 'become unwise and unhappy,
morose and unlearned [*amatheis*]—you will lead a bad sort of life' (ἄφρονες καὶ

[118] The best edition is Hirsch-Luipold et al. 2005, with a facing German translation and a multi-
authored series of essays (discussing the text's date at 29–30); for two English translations, see J. T.
Fitzgerald and White (eds.) 1983 (with the introduction at 1–47) and Seddon 2005: 175–84. The wisest
modern reading of this wise ancient reading of the wise tablet object has to be Elsner 1995: 39–46.

[119] For this mode of 'dialogical ecphrasis', see J. T. Fitzgerald and White (eds.) 1983: 12–14.

[120] See Hirsch-Luipold et al. 2005: 156–61. The learned philosophical mix encompasses the Pythago-
rean, Socratic, Platonic, Stoic, and Cynic—and much else besides: cf. J. T. Fitzgerald and White (eds.)
1983: 20–7 and Trapp 1997: especially 168–71.

κακοδαίμονες καὶ πικροὶ καὶ ἀμαθεῖς γενόμενοι κακῶς βιώσεσθε, *Tab. Ceb.* 3.1). The epigrams on tablets 1A and 2NY stake a related claim about *technê* and *sophia*. Indeed, the Capitoline tablet privileges a similar instruction of learning (μάθε), structured around the 'order' (τάξιν) of what can be seen and read, mirroring the *taxis* that the *Tablet of Cebes* text imposes on the riddlesome picture.

Still more significantly, though, the *Tablet of Cebes* parallels the *Tabulae*'s simulative games of visual–verbal intermediality. Both the Iliac tablets and the *Tablet of Cebes* play upon their nature as *grammata*—and thereby their image-text encapsulation of *all* knowledge (γράμματα καὶ . . . τὰ μαθήματα, *Tab. Ceb.* 34.3; cf. 33.3).[121] The *Tablet of Cebes* is founded upon the ambiguity. Is the 'tablet' a picture or a text? And just who is this 'Cebes' with whom the 'tablet' associates itself—the artist of the image, the old man who explains it, the speaker who recounts the story, or some other bystander who tabulates all these levels of representation and more?

If the *graphê* of the viewable object gives rise to the *graphê* of the readable *Tablet* text, the (writing down of the) verbal performance likewise derives full circle from the prescriptions of the visualized image. Within the 'depiction'/ 'description' (τὸ γεγραμμένον) of the tablet, we are told, there was a round enclosure with two more enclosures within it, one large and one small' (περίβολος ἦν ἐν αὐτῷ ἔχων ἑτέρους περιβόλους δύο, τὸν μὲν μείζω, τὸν δὲ ἐλάττω, *Tab. Ceb.* 1.2); before the gate to this first *peribolos*, moreover, was depicted 'a certain old man, standing there, as though laying out some sort of arrangements for the crowd as it entered in' (γέρων τις ἑστὼς ἔμφασιν ἐποίει ὡς προστάττων τι τῷ εἰσιόντι ὄχλῳ, *Tab. Ceb.* 1.3). The old man in the picture is consequently made to prefigure the old man who acts as ambassador in and for the text; by the same token, the crowd depicted in the picture mirrors the crowd that is now said to be gathering around the *graphê*. The *mise en abyme* ripples outwards from the tablet's centre, drawing the *reading* audience now into its ring—we move from the crowd in the picture, through the crowd described in the text, to the metaphorical crowd now reading this text in wonder and amazement . . .[122]

[121] The pun on the Greek verb *graphein* and its cognates—referring both to the acts of drawing and to writing—is a mainstay of Greek literature, and something also developed on the *Tabulae Iliacae*: see below, pp. 235–43. For related puns in Philostratus the Elder's *Imagines*, see e.g. Boeder 1996: 145–65; Squire 2009: 347–8, 421–2; Webb 2009: especially 128–33. We might compare the familiar Second Sophistic trope of Greek novels beginning with a painting description (cf. e.g. Morales 2004: 36–95 on the Europa/Selene painting at Ach. Tat. 1.1); still more conspicuous is Longus 1 praef. 2, with its punning gesture of written/ painterly retort to the landscape writing/painting, ἀντιγράψαι τῇ γραφῇ, drawing conspicuous attention to the self-styled *technê*.

[122] Cf. Elsner 1995: 42–3 (comparing Philostratus the Elder's *Imagines*) on how 'the picture mirrors its literary context and the frame turns out to be re-enacting the prescriptions of the picture it purports to describe'. It is also worth noting the knowing transition in media performed through and during the text: we purport to move from seeing in the first sentence (ἐθεωροῦμεν, *Tab. Ceb.* 1.1), via 'the spoken things'

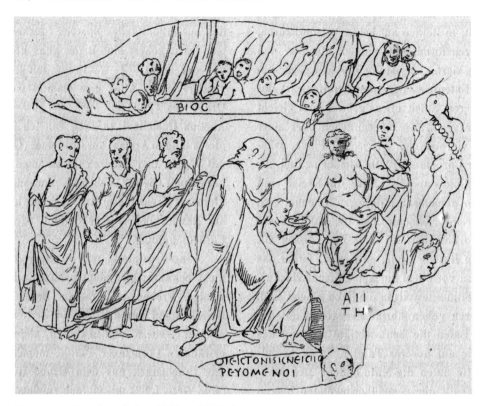

FIGURE 38. Drawing of a lost 'Tablet of Cebes'.

Given the text's phenomenological sophistication, it should be no surprise that at least one ancient artist aspired to turn the *Tabula Cebetis* back into images—to back-pedal the ecphrasis, materializing the supposed object around which the whole drama encircles. The *Tablet of Cebes* must have become famous relatively quickly in antiquity, because we find the object materialized in a little-known miniature relief, preserved through a drawing in Berlin's Kupfertischkabinett (Fig. 38).[123] If the worlds of word and picture collide in the verbal frame of the

introduced by the old man (τὰ λεγόμενα), to the instruction 'not to mishear' (μὴ παρακούετε, *Tab. Ceb.* 3.4). All the while, the text is peppered with invocations to actually *see* (ὁρᾶτε): the true philosophical insight of textual *hermeneusis* is pitched against the material *theoria* of the picture; but does true knowledge lie in material or immaterial things?

[123] On the relief, see K. Müller and Robert 1884, who persuasively conclude that they have 'das Relief nach den Worten des Kebes erklärt' (126). The wonderful irony should not go unnoticed: like the old man of the tablet text, who explains the old man in the tablet picture, these clever old exegetes subject the material relief to a wholly analogous mode of word-led exegesis—and demonstrate their *own* 'Education' in the process. Cf. *IG* 14: 350, no. 1298; *IGUR* 4:98, no. 1634; *LIMC* 3.1: 116, s.v. 'Bios' no. 4; Hirsch-Luipold et al. 2005: 179–82. I can find no grounds for Rainer Vollkommer's throwaway claim that this relief, 'wenn es je wirklich existiert hat', was probably 'ein in der Renaissance geschaffenes Werk' (*LIMC* 4.1: 471, s.v. 'Hedone'); indeed, Harald Mielsch has argued that another ancient image (a Roman funerary painting

tablet-text, this material object reconfigures them anew, framing the text within the pictorial *peribolos* of the picture. The *sophia* of the ecphrastic text is turned inside out and hung out to dry. In the process, something even more sophisticated is revealed: an image inside the inner sanctum of the text (itself describing the *peribolos* picture). We are faced with a further range of replicative ripples: a tablet of the tablet of the tablet ad infinitum. But does the pictorial *graphê* really hit the bullseye? Is this object the actual 'tablet of Cebes' that drew all knowledge into its visual–verbal vortex? Or does the object itself run rings around a more central mode of *verbal* hermeneusis (i.e. the established Vor-text of the *Tabula Cebetis*)? The giddy games spiral round and round. Does true *sophia* lie in the material tablet (or at least this copy of it?); in what we say about the tablet (on the basis of the preceding text?); or, then again, does it lie in the Greek inscriptions which encircle the sculpted reliefs (verbalizing once again the visualization of the verbalization of the text describing the image . . .)?[124]

The *Tabulae Iliacae*, I suggest, go still further in their intermedial spin. The Capitoline and New York epigrams demonstrate as much, parading their seeable and sayable credentials explicitly, inscribing themselves *between* the *peribolos* parameters of image and text. As we shall see in the seventh chapter, the tablets also mirror the circular logic of the materialized *Tabula Cebetis* tablet (Fig. 170): in verbalizing its own concrete visualization of the Homeric verbal description of the shield of Achilles—laying out the text of *Iliad* 18.483–608 around its circular pictorialization of the verbal description—tablet 4N turns the very wheels of Homeric ecphrasis, replicating the ecphrastic gesture of replicating words after a replicated image. Like the (tablet of the) *Tablet of Cebes*, the *Tabulae Iliacae* ask which *sophia* is the bigger—the *technê* of words, or the *technê* of pictures.

To my mind, the Iliac tablets therefore lead full circle to some of antiquity's most sophisticated texts and images. On the one hand, the tablets look back to a literary tradition of evoking images in words—from Homeric epic to the self-referential games of Philostratus' *Imagines*.[125] As with the *Tablet of Cebes*, however, literary ecphrasis reveals only half the story: the *Tabulae Iliacae*'s combination of words and images simultaneously echo the visual–verbal games

from the Viale Manzoni) also engaged with the surviving text (*LIMC* 7.1: 832, s.v. 'Tabula Cebetis'), and another drawing of the same relief survives in the Gabinetto Disegni e Stampe degli Uffizi in Florence, attributed to G. Clovio (see Micheli 2006: 90–2, with fig. 8).

[124] All of these themes are paralleled on the Iliac tablets: for the ringed *peribolos* around which the 'epic cycle' rotates, see e.g. below, p. 165; for the tablets' central 'bullseye' (and the iconographic references to an *un*spoken text), see below, pp. 148–58; for the verso 'magic square' inscriptions that flip the image–text games, all the while privileging the self-styled 'central *gramma*' (i.e. both written and drawn 'stroke'), see below, pp. 235–43.

[125] For an excellent one-stop guide to this Greek and Latin ecphrastic tradition, see Elsner 2002. P. Friedländer 1912 still remains one of the most important surveys.

of Graeco-Roman material culture, from Archaic vase inscriptions through to late antique sarcophagi and beyond. Such puzzling over the nature of visual and verbal signification transcends modern distinctions between the 'high' and the 'low': it takes us to the erudite games of the Second Sophistic as much as to the surviving grafitti of Pompeii. Above all, I think, it takes us to the sorts of urbane conversations that seasoned the Greek symposium and the Roman cena, themselves rippling through a variety of different social and cultural *milieux*.

Remarkably few modern-day scholars have written about the tablet of the *Tablet of Cebes*, and nobody (so far as I know) has semantically engaged with the object's own semantics of engaging with the tablet text. Traditionally, the study of ancient literary texts has been carried out in isolation from the study of archaeological remains. Faced with the material record, moreover, classicists have been happier to ascribe *sophia* to the imaginary authors known to us through books than to the banausic craftsmen who live on through their crafted objects. As ever, mastering 'Theodorean *technê*' means seeing and reading things differently: if the *Tabulae Iliacae* demonstrate anything, it is that the *realia* of the ground can prove no less recondite than the texts of the library. The tablet of the *Tablet of Cebes* offers a critical corroborative comparandum.

Choosing Your Own Adventure

How do images relate to texts, or indeed texts to images? Where are the boundaries between visual and verbal representation? And in what ways do pictures evoke stories like (and indeed unlike) words?

As the previous chapter began to demonstrate, these are precisely the questions that the *Tabulae Iliacae* encapsulated and materialized. Embodying a combined pictorial and poetic mode of *technê* and *sophia*, the tablets interrogate the limits of visual and verbal representation. As knowingly intermedial objects, they demand at once to be read *and* to be viewed.

But scholarship on the *Tabulae* has very much downplayed such questions. Rather than engage with the tablets' circular representational games, the objective has been to square them with post-Enlightenment modes of aligning words with pictures. Assuming that the objects set out to 'illustrate' their various texts, scholars have had recourse to a supposed tradition of lost illuminated manuscripts, whereby the 'illustrating' pictures set out to follow the 'illustrated' text to the letter. This has led to stark criticism of the tablets' 'infidelities', 'imprecisions', and outright 'blunders'. Whenever one medium does not line up with the other, it is the tablets that are found wanting, not the prescriptive and anachronistic intellectual frameworks imposed upon them: easier to rubbish a small set of objects than to rethink one's ideology of visual–verbal relations altogether.[1]

This chapter proceeds differently. Paying greater heed to the materiality of the tablets' imagery, I set out to demonstrate the much more playful manner in which image and text engaged with one another: my thesis, *in nuce*, is that the *Tabulae* exploit their visual medium not simply to 'follow' poems (as though images could ever reproduce the textural fabric of words); instead, the tablets manipulate their formal properties so as to recalibrate verbal viewings and visual readings, and in all sorts of sophisticated ways. Above all, as we shall see, the tablets champion the perspective of the subjective viewer—the player who holds

[1] On the 'ideological' agendas underlying different cultural understandings of words and pictures, the classic account is Mitchell 1986.

the tablet in the hands, mediating the images' pictorial mediation of the verbal stories depicted. There follows a process of *inter*medial cross-fertilization.

As always with the *Tabulae*, there are some bigger lessons to be learned from these miniature games with iconography, order, and composition. In this case, the tablets' take-home is about how visual imagery engages with verbal stories, and vice versa. 'Pictorial narrative' has become something of a buzzword among departments of art history in the late twentieth and early twenty-first century: derived from the study of linguistics, the trend can be traced back to the structuralist aspirations of the first literary 'narratologists' (above all, Russian Formalists, with their talk of *fabula* and *syuzhet*), and then to the poststructuralist rejoinder (Roland Barthes, Mikhail Bahktin, Jacques Derrida, et al.); with the 'new art history' of the 1980s and 1990s, such theories began to be applied to visual as well as to verbal 'texts' (thanks in particular to the influence of Norman Bryson and Mieke Bal).[2] In terms of Roman visual culture specifically, the breakthrough came in 1984, with Richard Brilliant's landmark book on 'story-telling in Etruscan and Roman art'. The rich and manifold perspectives that Brilliant brings to his material remain gospel for many, especially in the US. Not for nothing, though, does Brilliant's own word-orientated semantics lead him to a wholly negative view of our material. As we saw in the previous chapter, Brilliant finds the tablets wanting in comparison to the Homeric text: he proceeds to note the narratological 'dissonance', 'plot distortions', and 'dissociative message' between poem and picture, concluding that the objects are 'capricious', 'insensitive', 'visually confusing', even 'seriously flawed' in visual presentation; ultimately, Brilliant sides with Nicholas Horsfall, concluding that the tablets were intended for a 'vulgar clientele that cared little for learning'. For visual narratologists, pictorial 'learning' all too often means following (the narrative mechanisms of) a text.[3]

By re-evaluating the imagery of the Iliac tablets, this chapter seeks to overhaul such rhetoric, arguing that narratives exist not *in* but rather *through* pictures. Ancient artists played with this truism, and in much more self-conscious ways than modern critics. As Susanne Muth nicely puts it in a wholly

[2] For these new disciplinary directions in the context of 'ancient art', see especially Holliday (ed.) 1993.

[3] Brilliant 1984: 53–9, discussed above, p. 92 n. 21. In rethinking how images construct stories—or rather, how viewers construct stories out of images—this chapter finds a methodological ally (and inspiration) in Gordon 1980. Although dealing with a rather different set of objects, and from rather different cultural contexts (Imperial Roman Mithraic reliefs), Richard Gordon lays out precisely the problem of assuming pictorial 'narratives': as with Gordon's cultic reliefs, my argument is that the Iliac tablets too expose the anachronistic 'hypothesis of a regular reading order', 'based upon the assumption that the scenes record a narrative sequence, and that this is their primary rôle' (203).

different context, Roman viewing communities came to their images with a
markedly different set of assumptions: they were less concerned with a given
mythological *narrative* than with the specific qualities of a given mythological
picture.[4]

IN SEARCH OF THE ILLUSTRATION

To understand where this rhetoric of the tablets' 'pictorial narrative' has come
from, it is necessary to explain one particular aspect of their study in the twentieth
century: the association with a supposed tradition of Hellenistic book illustra-
tion. This line of enquiry goes back to some of the earliest research on the tablets,
above all that of Otto Jahn.[5] It reached its climax, though, in the twentieth-
century work of the Byzantinist scholar Kurt Weitzmann: during an academic
career that stretched from the early 1940s to his death in 1993, Weitzmann
attempted to show how the tablets derived from an earlier tradition of illustrated
papyrus scrolls—a tradition, Weitzmann argued, that originated in Hellenistic
Alexandria.[6]

Weitzmann applied to his subject a wholly philological mode of critique.[7] In the
same way that textual critics attempt to reconstruct an original text from a series of
derived manuscript copies, Weitzmann set out to reconstruct the appearance of
Hellenistic illustrated papyri from 'secondary' evidence. As Weitzmann freely
admits, 'pictures or even the simplest kind of drawings are extremely rare among
the listed literary papyri':[8] the only substantive evidence for Greek (or indeed
Latin) poems accompanied by pictures are not Hellenistic rolls, but bound codices

[4] See Muth 1999: 129: 'Für unsere Bewertung der Mythenbilder in den Häusern hat dies Konsequen-
zen: was sie für die römische Gesellschaft interessant machte, war weniger die Mythen*erzählung*, als
vielmehr die spezifische Qualität des Mythen*bildes*' (her emphasis).

[5] See O. Jahn 1873: especially 86–90; cf. e.g. Robert 1881: 46–51 (discussing the *Tabulae Iliacae* on 48–9)
and 1919: 186. Ulrich von Wilamowitz-Moellendorff was among the many nineteenth-century scholars
who grafted the Iliac tablets to his thesis of ancient book illumination, concluding 'wir dürfen da wohl
etwas von der Illustrationsfreudigkeit für möglich halten, die wir namentlich in Deutschland an der Jugend
des Buchdrucks und Holzschnitts bewundern' (1898: 229). Some of Weitzmann's conclusions about the
Iliac tablets were also foreshadowed in Bulas 1929: 77–138, although Bulas was somewhat more sensitive to
the ideological stakes behind the 'question d'illustrations à l'Iliade dans le sens moderne du mot', arguing
that 'on voit la tradition artistique jouer son rôle comme on a pu le constater surtout sur les tables
troyennes' (138).

[6] See Weitzmann 1947: 36–44 and 1959: 31–62, especially 34–7; cf. idem 1941: 180–1 (on tablet 16Sa). For
further bibliography, see Schefold 1975: 39–40, with 197 n. 209; Horsfall 1979a: 43–8; Rouveret 1989: 356–
8; Salimbene 2002: 11–13; Valenzuela Montenegro 2004: 337–50.

[7] For the philological paradigm behind Weitzmann's method, see J. Williams 1999: 4–5, on what he
nicely labels the 'tyranny of the archetype'.

[8] Weitzmann 1959: 32.

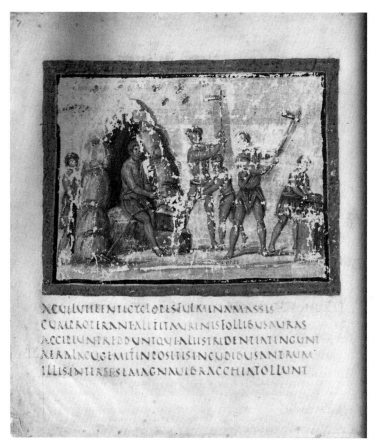

FIGURE 39. Folio 8v of the 'Vatican Virgil' (Vaticanus Codex Latinus 3225), showing the Cyclopes at their forge, alongside Verg. *G.* 4.170–4; early fifth century AD.

FIGURE 40. Fragment of the 'Ilias Ambrosiana' (Codex Ambrosianus F. 205), late fifth century AD: this fragment (folio 28b) juxtaposes two images relating to the opening of *Iliad* 9 (see Bianchi-Bandinelli 1955: 69–70, miniatures 31 and 32, subjects 68 and 69).

from the fourth and fifth centuries AD.[9] Two manuscripts in the Vatican preserve various sections of Virgilian text juxtaposed with pictures (e.g. Fig. 39), and the famous 'Ilias Ambrosiana' in Milan set a series of images drawn from the *Iliad* besides its written text (Fig. 40).[10] But these codices are some seven or eight centuries later than the earliest Hellenistic illustrated manuscripts that Weitzmann supposed. For this reason, writes Weitzmann, 'the history of ancient book illustration... must be based primarily on derived material in other media': Hellenistic prototypes have to be reconstructed from sources like Pompeian wall painting, 'Megarian' cups, Roman sarcophagi, and yes—the Iliac tablets themselves.[11]

During the course of his research, Weitzmann discussed many different *Tabulae Iliacae*. Still, it was the Capitoline tablet (1A)—or rather an early nineteenth-century line drawing of it (Fig. 41)—which proved most important for his argument.[12] Inspect the upper left-hand frieze of the tablet, Weitzmann proposed, and you will find seven discrete scenes, all of them relating to the first book of the *Iliad* (Fig. 42). Today only six of the seven scenes are visible, because the left-hand side of the tablet is lost; but comparison with tablet 3C (where the corresponding scenes do survive (Fig. 43)) allowed Weitzmann to recover the seven subjects as follows:[13]

[9] For some recent summaries of the literary and material evidence for ancient illustrated manuscripts, see Geyer 1989: 29–104; Blanck 1992: 102–12; Horak (ed.) 1992: 42–52; Small 2003: 118–54. Incidentally, the recent publication of papyri from Berlin and Vienna (Froschauer (ed.) 2008) does nothing to change this picture: most of the 26 fragments are non-figurative doodles, and none of them are accompanied by texts.

[10] Buonocore (ed.) 1996: 142–58, nos. 1–3, provides a good overview with colour plates. Of the three best-surviving parchment codices, one contains extracts from the *Georgics* and *Aeneid* (the so-called 'Vatican Virgil', Codex Latinus 3225, with 50 miniatures: de Wit 1959 is still key, but see too Stevenson 1983; Geyer 1989: 205–32; Wright 1993); one contains sections from the *Eclogues*, *Georgics*, and *Aeneid* (the 'Roman Virgil', Codex Latinus 3867, also in the Vatican Library, with 19 miniatures: see especially Liversidge 1997: 92–3; Wright 2001); and one contains sections from the *Iliad* (the 'Ilias Ambrosiana' in Milan, Codex Ambrosianus F. 205 Inf., with 58 surviving miniatures: see especially Bulas 1929: 131–6; Bianchi-Bandinelli 1955; Weitzmann 1981: ii.241–65, together with the facsimile of Calderini 1953). There are numerous other much smaller fragments, most of them of similar date: for a recent survey, see Elsner 2009: 40–2 (although to my eyes rather optimistic in presupposing a 'broad range' of narrative illustrations in the Hellenistic Greek world).

[11] Weitzmann 1947: 46, with further comments in Geyer 1989: 94–8. The method and conclusion still have their adherents: cf. e.g. Giuliano 1996 (with recourse to the Iliac tablets at 43) and Reinhardt 2008: 93–102 (on the 'Megarian' cups—supposing that 'frühe Papyrusillustrationen dürften kaum anders ausgesehen haben als die Szenenfolgen der Becher...').

[12] On this drawing, made by Feodor Ivanovich in the early nineteenth century, see O. Jahn 1873: 2–3. The drawing in Reinach 1909: 286–7 is also based on Feodor Ivanovich's diagram (while artificially pulling apart the relief's different sections): it is therefore not reproduced here.

[13] For the comparison, see below, pp. 170–1. In my view, the upper Capitoline frieze must originally have contained more than the seven scenes that Weitzmann postulated: too much of the left-hand side is missing for it to have depicted one 'miniature' alone, and comparison with tablet 3C perhaps suggests that other scenes from the *Cypria* were also added. Note too the artificiality of Weitzmann's neat division: the 'scenes' that Weitzmann identifies as discrete entities form part of a single overlapping composition. Look in particular at the central composition, and compare Weitzmann's scheme: is it really fair to pull apart the 'third', 'fourth', and 'fifth' scenes—and if so, why stop at just three motifs?

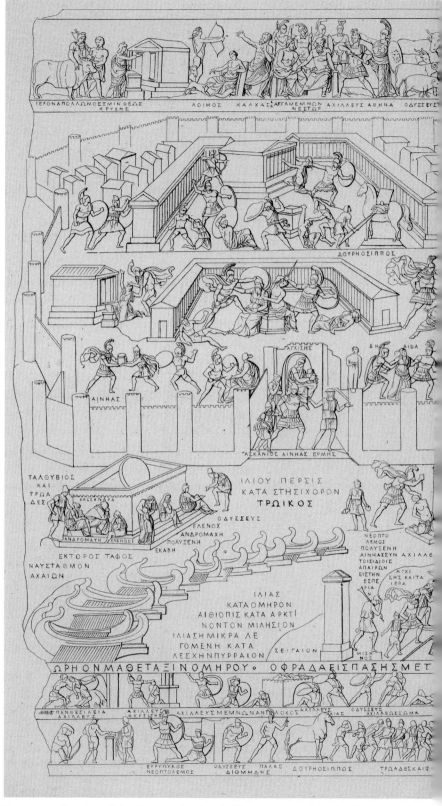

FIGURE 41. Drawing of the obverse of tablet 1A (Capitoline tablet) by Feodor Ivanovich.

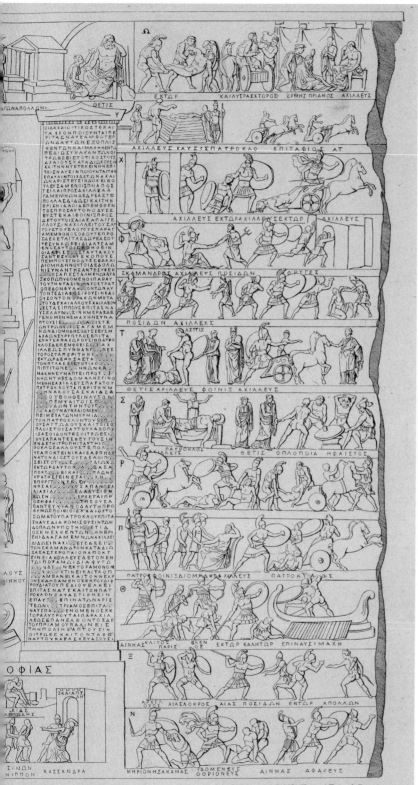

Lith. Just. d. rh. Fr. Wilh. Univ. v. A. Henry in Bonn.

FIGURE 42. Drawing detail of the central upper frieze on the obverse of tablet 1A, relating to *Iliad* 1 (frieze *alpha*).

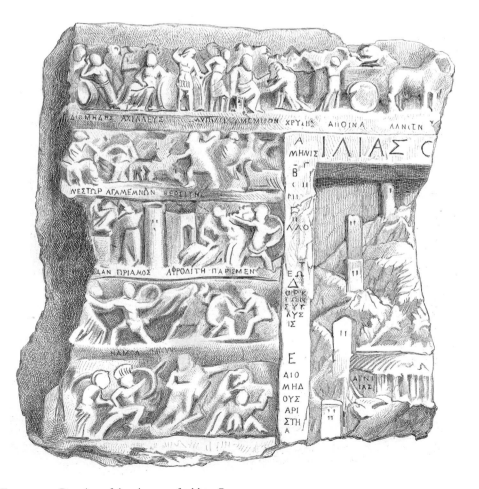

FIGURE 43. Drawing of the obverse of tablet 3C.

(1) Chryses kneeling before Agamemnon, while the Achaeans unload the ransom from the cart (vv. 22 ff.).
(2) Chryses praying before the temple of Apollo Smintheus (vv. 34 ff.).
(3) Apollo, revenging [*sic*] Chryses, is killing the Achaeans (vv. 43–52).
(4) Calchas speaking in the assembly (vv. 74 ff.) (Only the figure of the seer is left of this scene).
(5) The meeting of the Achaeans in which Achilles draws his sword against Agamemnon (vv. 197 ff.).
(6) Odysseus bringing Chryseis to Chryses (vv. 497 ff.)
(7) Thetis kneeling before Zeus (v. 500).[14]

At work here, Weitzmann argues, are two distinct illustrative modes, the one replicating its papyrus model image by image, the other selecting from it. On the one hand, the first four scenes each cover around 20 lines of text (some 75 lines in total), preserving a partial section of an original cycle of illustrations. Scenes five to seven, by contrast, cover a much larger section of the poem (over 500 lines between them): these images, in other words, condense an original cycle into a three-part epitome. The (hopelessly careless!) artist, as Weitzmann puts it, 'apparently had a full cycle as model, which he started out to copy in its original density, but when he realised that there was not space enough to continue on the same scale, he changed the system and filled the rest of the friezes with selected scenes'.[15]

Regardless of what we make of scenes five to seven, Weitzmann proposed that the proportions between text and image in the first four images tally with what

[14] See Weitzmann 1947: 38–41 (quotation from 39); cf. idem 1959: 35–7.
[15] Idem 1947: 39.

can otherwise be known about Hellenistic papyri. A 'good literary papyrus' would have contained some 28 lines of text in each writing column.[16] Were one image to be inserted within each column, moreover, this number would have had to be reduced accordingly: one picture would fit alongside 20 or so lines of the poem—a density which corresponds precisely to the ratio of scenes in scenes one to four. On the basis of such calculations, Weitzmann attempted to reconstruct the original appearance of an ancient illustrated papyrus roll of the corresponding book of the *Iliad* (Fig. 44).[17] If illustrators restricted themselves to one illustration per column, each book of the *Iliad* could have been covered in 30 or so columns. Since there are 24 books in total, the whole poem must therefore have been accompanied by some 720 (30 x 24) miniatures. The illustrated manuscript, Weitzmann concludes, is the only medium that 'could comprehend the enormous amount of scenes of a fully illustrated Homer and at the same time easily be available to the copyists of very disparate branches of art'.[18]

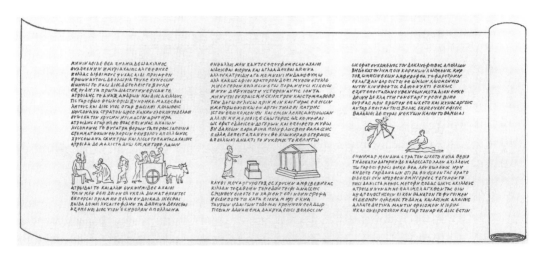

FIGURE 44. Kurt Weitzmann's reconstruction of an illustrated Hellenistic scroll with text and pictures from *Iliad* 1.

[16] Weitzmann corroborates this approximate figure by comparing not only the 'Megarian' cups, but also tablet 16SA. This object, Weitzmann notes, illustrates every book of the *Odyssey* in a single miniature. And yet it does so by representing events described at the supposed *beginning* of each book: cf. idem 1941; 1947: 37–8; 1959: 40.

[17] For a similar argument, postulating a similar-looking reconstruction of an illustrated *Odyssey*, cf. idem 1958: 86.

[18] Idem 1947: 40; cf. 1959: 37. Weitzmann reaches a related (albeit 'conservative') number of illustrations from the 'Megarian' cups: 'all twenty-four books together would require about 168 cups in order to illustrate the Odyssey by roughly five hundred scenes. Assuming the same amount of scenes for the Iliad, which was also illustrated on the cups as surviving copies prove, one is faced with the astonishing number of about a thousand scenes for the two Homeric poems' (1947: 38). But it would be mistaken to assume that the 'Megarian' cups are derived from a two-dimensional medium: see below, p. 138 n. 30.

Advocates of Weitzmann's thesis have long pointed to other external evidence to corroborate his argument. It is true, for example, that some of the Capitoline tablet's compositions correspond with the earliest surviving illustrated text of the *Iliad*, the aforementioned 'Ilias Ambrosiana' from the late fifth century AD, with its 58 isolated miniatures.[19] The fact that at least some of the tablet's iconographic schemata also tally with the 25 painted Trojan episodes surviving from the Casa del Criptoportico, Pompeii I.6.2 might also point to a 'common recension', at least for a handful of scenes.[20] But not all of these comparanda correspond in their iconography with the *Tabulae Iliacae*: often the tablets depict the same scene in remarkably different ways from the three Iliadic cycles surviving from Pompeii.[21] Weitzmann himself recognized as much, suggesting that differences between 'cycles' (including individual tablets) point to more than one 'source': 'as in textual criticism it would, of course, be hazardous to base the notion of two different recensions on such a single instance'.[22] Numerous scholars have consequently responded by refining Weitzmann's argument and method: Karl Schefold, for example, suggested that the *Tabulae Iliacae* descend from labelled 'books of pictures' (*Bilderbücher*) rather than illustrated texts of the poem;[23] and Nicholas Horsfall has demonstrated how the tablets descend from a plurality of different media—not *just* illustrated papyri (although, he maintains, these must have played an important role).[24]

But even in its revised form, problems remain with Weitzmann's thesis. We are dealing, in essence, with an argument from silence: simply put, there is no evidence whatsoever that literary manuscripts were set out with accompanying pictures until

[19] Cf. Bianchi-Bandinelli 1955: especially 25–32, along with Weitzmann 1947: 42–4 and 1959: 32–7. Note, for example, the shared iconographic treatment in miniature 54 of the 'Ilias Ambrosiana' (cf. Bianchi-Bandinelli 1955: 81, with figs. 90, 149) and the Capitoline tablet of an episode in *Il.* 22: both alike depict Hector standing at the Scaean gate, shield in hand (see discussion in Weitzmann 1947: 43–4; 1959: 34–5; Bianchi-Bandinelli 1955: 114–15; Sadurska 1964: 98; Valenzuela Montenegro 2004: 81, 226).

[20] Cf. Weitzmann 1959: 37–8: the example he hits upon is the killing of Lycaon in *Il.* 21. When one looks at the image from the Casa del Criptoportico (Aurigemma 1953: 938–40, with figs. 949–51), however, it is the iconographic departures rather than similarities that are most striking (for further discussion, cf. Bulas 1929: 125 and Valenzuela Montenegro 2004: 77–8, 225): more convincing, on a parallel between depicted events from *Il.* 18, is Aurigemma 1953: 926–9, especially 928–9 (with Valenzuela Montenegro 2004: 63–6).

[21] Cf. e.g. Schefold 1975: 215 n. 636 and Horsfall 1979a: 41–2, 44. The key discussion is Valenzuela Montenegro 2004: 216–38. For the three Pompeian cycles, see above, pp. 76–7 n. 151.

[22] Weitzmann 1959: 39. Cf. Sadurska 1964: 10–11 and Horsfall 1979a: 44, with bibliography in n. 138.

[23] Cf. especially Schefold 1949: 212–16; 1975: 125–8, 129–34; idem and Jung 1989: 181: 'Mit anderen Worten: die Vorlagen waren Bilderzählungen, nicht illustrierte Manuskripte.' On the supposed (high) quality of these models, cf. also Schefold 1976, reconstructing them on the basis of extant Roman sarcophagi. For an earlier related view, see Bethe 1945: 75–83.

[24] Cf. Horsfall 1979a: 43–8; 1994: 83: 'We are therefore, I would suggest, compelled to infer the existence of a large number of cycles, iconographically in part independent, yet regularly contaminating each other.'

very late in antiquity. And there is still less evidence that 'in Hellenistic-Roman times the most frequently illustrated text had undoubtedly been the *Iliad*'.[25]

In terms of the *Tabulae Iliacae* specifically, Nina Valenzuela Montenegro has now championed the point.[26] The only surviving illustrated literary papyri from Egypt are relatively late in date, and in any case simple 'skits', far removed from the sorts of complex composition to be seen on the tablets. Although there are earlier instances of images in technical and scientific works—as with the 'Eudoxus papyrus' encountered in the previous chapter (Fig. 37), and the newly discovered *Geographoumena* of Artemidorus (if indeed genuine)[27]—the principle seems to have been applied to narrative texts only much later in antiquity, when the parchment codex gradually came to be preferred over and above the papyrus scroll. This explains why the iconography of the *Tabulae Iliacae* derives from so many different sources—some old, but others relatively new.[28] It also explains the tablets' interest not only in Homer, but also in comparatively obscure texts—poems that were not within the mainstream of the Greek literary canon, and which must have been even less likely to have attracted *Bilderbücher*, 'books of images'.[29]

All manner of recent studies have converged around related conclusions, and on the basis of disparate materials. The 'Megarian' cups (Figs. 20–1) that were once so fundamental to Weitzmann's argument, for example, are now rightfully understood as having been specifically conceived for three-dimensional plastic moulding: as Luca Giuliani has argued, the design of the cups is inherently unsuited to the two-dimensional papyrus medium.[30] Something similar can be said for the so-called epic 'cycles' preserved in Pompeii, each one thought out in connection with a particular domestic space rather than reflecting some simple pre-existing prototype.[31] Although fundamental to Weitzmann's illustration

[25] Weitzmann 1981: vi.56. Contrast e.g. Turner 1987: 137, noting how, 'despite the very large number of Homeric papyri, none has illustrations'.

[26] See Valenzuela Montenegro 2004: 337–46 (with full bibliography), along with 13–14, 415–16.

[27] The key edition is now Gallazzi, Kramer, and Settis (eds.) 2008, although note the scepticism of e.g. Canfora 2007: for an overview, see the essays in Brodersen and Elsner (eds.) 2009. The most important discussion of the use of images, diagrams, and figures in ancient technical treatises is Stückelberger 1994, but Small 2003: 121–9 offers a well referenced English discussion of diagrams and figures in ancient technical texts (including Vitruvius' ten references to the pictures accompanying his Latin treatise).

[28] See Valenzuela Montenegro 2004: 216–38.

[29] Cf. ibid. 341–4, *contra* e.g. Weitzmann 1959: 35: 'Insgesamt sehe ich also keinen Anhaltspunkt dafür, noch an Weitzmanns Verbindung der Tabulae Iliacae mit den postulierten hellenistischen Buchausgaben festzuhalten' (344).

[30] See L. Giuliani 2003: 276–8: 'Die Ikonographie des Bechers ist offenkundig von Anfang an auf die spezifische Form des Gefäßes hin entworfen worden...Die Becher sind also kaum geeignet, die Existenz illustrierter Papyri zu begründen' (276–7). For related conclusions, cf. e.g. Webster 1967: 106; Brilliant 1984: 41–3; A. Stewart 1996: 47.

[31] Cf. Bianchi-Bandinelli 1954: 6–25 (especially 16–21: 'quindi non possiamo trovare riflessi di illustra-zioni nei fregi dipinti...', 21). The originality of these compositions is best demonstrated by the Iliadic

thesis, Roman mosaics have been subject to this sort of revisionist critique too: the most recent analysis of the fourth-century mosaic from Lowham, once associated with an illustrated manuscript of Virgil, concludes (again, correctly in my view) that 'such dependency is extremely unlikely'.[32]

Perhaps most decisively of all, scholarship on surviving codices has come to realize that the placing of images beside narrative texts in manuscripts was a specific invention of the (very) late antique world. Examining the earliest Judaeo-Christian manuscripts known to us, John Lowden concludes that there was 'no single normative procedure for biblical illustration': the 'extraordinary extent of their differences' suggests that 'most biblical manuscripts in the early period did *not* have images in them'.[33] The small handful of fifth-century codices featuring figurative images are best understood as reflections of this early Byzantine development, bound up with the intellectual history of Christian theology at large. The 'Roman Virgil', 'Vatican Virgil' (Fig. 39) and 'Ilias Ambrosiana' (Fig. 40): these are all expensive and costly exceptions. Before the late fourth century, pictures were only seldom found accompanying manuscripts of narrative texts.[34]

THE LITERALIST FALLACY—OR, THE IRRECONCILABILITY OF WORDS AND PICTURES

All of these criticisms hold true: as I have argued elsewhere, there is no evidence for the widespread use of images in ancient papyri inscribed with narrative literary texts (at least not until Late Antiquity).[35] But to engage with Weitzmann's thesis on its own terms runs the risk of overlooking the deeper ideological foundations. If Weitzmann's conclusions are mistaken, it is because they are also based on a wrong-headed working assumption—one that supposes the priority (in every sense) of poem over picture. Weitzmann's notion of illustration does

frieze of oecus h in the Casa di Octavius Quartio, Pompeii II.2.2, 'tailor-made for this room' (Clarke 1991: 203): see below, pp. 145–7, and compare e.g. O'Sullivan 2007 on the Esquiline Odyssey frieze.

[32] See Stefanou 2006: 25–32: 'doch ist eine solche Abhängigkeit äußerst unwahrscheinlich... Der Mosaikkünstler hat sich durch die Erzählung im ersten und vierten Buch der Aeneis inspirieren lassen und eine originale Bildschöpfung vorgelegt, die als eigene ikonographische Leistung zu bewerten ist' (49). Crucial here is the work of Philippe Bruneau (especially Bruneau 1984 and 2000), arguing against the *Bilderbuch* hypothesis.

[33] Lowden 1999: 51, 49, 57.

[34] Cf. e.g. Stevenson 1983: 18–23 and Geyer 1989: 29–55. The thesis is not new: cf. especially de Wit 1959: 209, labelling the few manuscripts known to us as 'vorläufig kostspielige Ausnahmen'; 'es muß in diesem Zusammenhang ausdrücklich darauf hingewiesen werden, daß es in der Antike nicht Sitte war, literarische Texte zu illustrieren.' For my own interpretation of this underlying Christian theological-intellectual shift, see e.g. Squire 2011: 154–201, especially 174–86.

[35] See Squire 2009: especially 122–39.

not just pertain to Greek and Latin manuscripts containing images. The stakes of the argument are very much larger: they are about the differences between ancient and modern ideologies of images, texts, and visual–verbal relations.

For Weitzmann, pictures follow words. The premise informs Weitzmann's argument at every level, not least his working definition of 'illustration'—an image that is 'physically bound to the text whose content the illustrator wants to clarify by pictorial means'.[36] According to Weitzmann, words dictate the 'content' of an image, and the image sets out to 'clarify' that 'content' as best it can. Whatever the specific medium—be it a painting, sculpture, or a relief—graphic pictures always strive after the narrative model of texts. The illustrated manuscript provides only the clearest example of the process:

> In no other medium could the full text and the full picture cycle be brought together in a complete unity. Here a painter could, under the immediate stimulation of the text, most easily transform the content of each consecutive passage into a picture, and place it at the proper place between the lines of writing. Such an arrangement gives the reader the perfect control for appreciating how closely the painter's invention conforms to the text.[37]

Weitzmann talks of 'unity', but his language leaves no doubt as to the dominant partner in this marriage: the text provides the 'stimulation' for the image, directing its 'proper' arrangement, and thereby ensuring that it 'conforms to the text'. By 'illustrating' a text, the image follows it to the letter, faithful to its various narrative particulars; by the same token, note how Weitzmann's viewers always and necessarily merge into 'readers'. This is not the place to embark upon a full intellectual history of 'illustration' that informs Weitzmann's thinking. As I have argued at length elsewhere, Weitzmann's notion of 'illustration' descends from the eighteenth-century Enlightenment (and Lessing's 1766 essay on the *Laocoon* in particular), itself derived from a post-Reformation theological tradition that routinely privileges words over pictures. Suffice it to say—in cultural historical terms—that such logocentrism is modern rather than ancient: Graeco-Roman antiquity did not have 'illustrated manuscripts' because it did not conceive of 'illustration' in our terms. Indeed, the very word 'illustration' only came to describe images juxtaposed to texts in the early nineteenth century.[38]

[36] Weitzmann 1959: 1. The conceptual definition very much remains, especially among classical archaeologists (cf. e.g. Leach 1988: 8–9: 'Illustration, as we commonly understand it, involves a close correspondence between literary images and graphic representation', 9).

[37] Weitzmann 1947: 40.

[38] See Squire 2009: 1–193, especially 17–41 (on the Reformation), 90–111 (on Lessing's Protestant *Grenzen* between painting and poetry), and 129–30 (for the history and etymology of the term 'illustration'; cf. *OED* s.v. 'illustration', no. 4). An important comparison here is L. Giuliani 2003: 263–80, especially 276–80, discussing visual–verbal relations on the second-century BC 'Megarian' cups. After dismissing Weitzmann's claim that the objects derive from illustrated manuscripts, and privileging individual pictorial

Historians of mediaeval art, culture, and intellectual history—spearheaded by the likes of Meyer Schapiro, Michael Camille, Michael Rifaterre, and Mary Carruthers—have championed a related point.[39] Late twentieth-century scholarship has demonstrated how the combination of visual and verbal forms within mediaeval manuscripts (and indeed other media) worked very differently from 'illustrations' in the modern sense: the mediaeval manuscript functioned, in Michael Riffaterre's definition, as 'a bag of tricks . . . that aid readers in the rapid discovery of vastly *more* extensive remembered representation'.[40] The rich interchange between visual and verbal signification in illuminated manuscripts could destabilize as much as anchor meaning: images might play a *maverick* role alongside words (and vice versa).[41] As applied to mediaeval verbal and visual engagements, our post-Enlightenment notions of 'illustration' are literally outdated, rooted in anachronistic concepts of text–image relations: images mediate between text and reader-viewer in a multiplicity of different ways. To return to Weitzmann's definition of the 'illustration', visual images could in fact *complicate* as much as *clarify* a verbal text: writers and artists alike tended towards a more playful, less rigid, and more engaged attitude to visual and verbal relations.[42]

Classicists—and English-speaking classicist scholars in particular—have been somewhat slower on the uptake.[43] Greek and Roman archaeologists still

innovation ('hier sind die Bilder primär, und die Texte eine sekundäre Zugabe', 278), Giuliani contrasts this ancient material with modern understandings of 'illustration' (cf. ibid. 364–5 n. 29, noting that 'Der Begriff—im Sinn von Bildern, die in einen Text eingefügt sind und einen engen Bezug dazu aufweisen—kommt erst im frühen 19. Jahrhundert in England auf'). But I would go still further in critiquing the underlying modern intellectual frameworks, taking issue with Giuliani's assumed 'birth' of illustration in Hellenistic Greece (the chapter is entitled 'Bilder für Leser—die Geburt der Illustration im 2. Jahrhundert': no doubt here, at least, Weitzmann would have approved!). At stake is not just the language of 'illustration', I think, but the modern, post-Enlightenment mode of logocentrism sustaining it: this ideology is rooted in a particular theological paradigm, rationalized in the eighteenth century, and culturally removed from ancient thought and practice.

[39] See e.g. Schapiro 1973; Camille 1985a and 1985b; Carruthers 1990; Riffaterre 1991. The most important attempt to relate this groundwork back to the Weitzmann's overarching 'illustration' thesis are the essays in J. Williams (ed.) 1999: although the book is dedicated to Weitzmann's memory, it bemoans how 'in a history infatuated with the archetype, the artist tends to remain a passive agent of descent and is seldom granted the role of creative respondent to expectations that go beyond mere replication' (5).

[40] Riffaterre 1991: 30.

[41] Crucial here is Camille 1992, on images occupying the (literal and metaphorical) 'edge' of the text.

[42] Cf. Lewis 1995: xxii on the recent shift in 'theoretical focus from more traditional philological methods and notions of image as passive "object" to an approach that recognises a more dynamic process of interaction between viewer, text and image'; cf. also Lowden 1999: especially 48–58 and D. Scott 1990: especially 244. For a related revisionist approach to Byzantine manuscripts juxtaposing images and texts, see the essays in James (ed.) 2007.

[43] One notable (but little known) exception is Nisbet 2002, on a Greek papyrus fragment with pictures from Oxyrhynchus (*P. Oxy.* 2331): in a revisionist discussion of Weitzmann 1959: 100, Nisbet demonstrates that the 'very basic assumption of Weitzmann and of all subsequent interpreters—that the pictures do what the text says—is incorrect' (17; cf. Squire 2009: 132–3 and Nisbet 2011).

frequently assume that images and texts intersect with each other only when the particulars of one medium correspond with the telltale minutiae of the other; moreover, that each works independently of the other when those details do not converge.[44] The clearest example is the debates that have surged about the influence of Homeric poetry on early Greek figurative art. From Knud Friis Johansen's championing of 'the reasonable assumption that...Attic vase painters...were inspired by descriptions of the exploits of the heroic age which they knew from poetry',[45] to Anthony Snodgrass's more recent conclusion that 'the innumerable surviving portrayals of legendary scenes in the art of early Greece...were in fact seldom if ever inspired by the Homeric poems',[46] a common assumption holds fast: despite their polar conclusions, both Johansen and Snodgrass alike suppose that to see a poetic resonance in a picture, one must find evidence of 'some acknowledgement of the debt to the literary source... either by the use of an explicit title, or...by a confluence in the details of action, attribute and setting'.[47] That we are dealing here not with a peculiar branch of classical scholarship but rather a peculiarity of our modern cultural wiring is evident from the multiple media to which this model of 'illustration' has been applied—among them Attic and Apulian vases 'illustrating' theatrical texts,[48] 'illustrative' Roman wall paintings,[49] even later Imperial 'literary illustrations' in mosaic.[50] Whatever the medium, the premise is that *verbatim* correspondences between image and text provide the measure of visual–verbal interaction: deviation from (and especially contradiction of) the 'salient details' of one medium in the other is assumed to indicate the 'parallel worlds of classical art and text', where

[44] Geyer 1989: 231 nicely labels this the 'Diskrepanzprinzip'.

[45] Johansen 1967: 22.

[46] Snodgrass 1998: ix. The conclusion is foreshadowed in a number of Snodgrass's earlier publications, as well as by e.g. Cook 1983 and Ahlberg-Cornell 1992.

[47] Snodgrass 1998: 67. On the whole issue, see Squire 2009: 123–6. For a more theoretically engaged approach to the question, see e.g. L. Giuliani 1998: 87–107, 2003 and 2010; cf. idem 2001 (providing a critical review of Snodgrass's method) and Junker 2003: especially 29–32.

[48] Cf. Squire 2009: 127–8 on e.g. Taplin 2007, as well as (most influentially) Trendall and Webster 1971. For some correctives, see especially L. Giuliani 1996, with further comments in 2003: 248–61 and 2010; cf. L. Giuliani and Most 2007.

[49] Cf. e.g. Gigante 1979: 49–70 on 'Homeric' imagery from Pompeii, or Small 2003: 100–4 comparing the details of the Ovidian representation of the Narcissus myth with Pompeian wall painting.

[50] Cf. e.g. Lancha 1997: 297–300, on 'literary' mosaics from the Roman western provinces. According to Lancha, only when the details of a surviving mosaic correspond with those of a known text do we have evidence of 'la culture livresque' (299) of the patron, as opposed to his general knowledge of a well-known folk tale. Much more sensitive to the visual stakes is Stefanou 2006 (e.g. his discussion of the mosaics of the 'House of Seven Wise Men' from Mérida on 77–87, 173–4, privileging the idea of innovation and learned conversation rather than iconographic 'fidelity' to the text).

'the dominant pattern is one of artists and writers pursuing independent and parallel worlds with only occasional intersections'.[51]

The *Tabulae Iliacae* pose a particular problem for such conventional methodologies. On the one hand, they explicitly engage with literary works: both in their reliefs, and in their inscriptions, they demand to be understood in the light of established texts. On the other hand, the tablets display numerous 'infidelities' to the poems that they evoke, 'deviating' from their textual details. As we have seen, the traditional response has been to dismiss the tablets as gauche vulgarizations of highbrow illustrated prototypes: in the original manuscripts from which these derivative 'copies' descend, it seems, images *did* 'properly' follow texts, and to the smug satisfaction of their elite and erudite readers (the '*serious* lover of Greek literature').[52]

Culpability lies here not with the Iliac tablets, but rather with the flawed assumptions of our modern critical frameworks. Simply put, 'discrepancies' between image and text need not point to 'the independence of the Homeric scenes and inscriptions from the *Iliad*':[53] the tablets aimed at something *more*—and indeed something wholly more intellectually ambitious—than simply transcribing the poems into pictures. Far from providing evidence for book illumination, the tablets deliver a miniature corrective to the literalist fallacy of 'illustration' at large.[54]

One detail—drawn from the top right corner of the *Tabula Capitolina* (Fig. 45)—can quickly demonstrate the point. The subject is the ransom of Hector, a favourite theme of Graeco-Roman artists, and one that stretches back to the very origins of Greek figurative art. The question therefore inevitably arises: how to determine whether an image of this scene engages with the Homeric rendition of the story (*Il.* 24.448–71)? Examining the Homeric text alongside one Archaic Greek example (a bronze mirror handle in Berlin (Fig. 46)), Snodgrass compares and contrasts the narrative minutiae: Achilles stands on the left, Priam

[51] Small 2003: 175. The author discusses the importance of 'salient details' at 29–31: 'If the pictures do not match the texts we have,' Small maintains, 'it is more parsimonious [*sic*] to assume that they were not meant to than to offer explanations for why they deviate' (25–6).

[52] For the phrase, see above, p. 15. Although in other ways fairly sensitive to the tablets' complexities, even Weitzmann has to conclude that the tablets' craftsmen are 'artistically rather weak' when compared to the hypothetical 'first inventors of the miniature archetype [who] were already capable of rendering the epic content somewhat more vividly and forcefully' (1959: 42).

[53] Horsfall 1979a: 39.

[54] My general argument here is anticipated by Carruthers 1998: 202: 'The debate among Roman historians over the use of this object and many others like it seems to me to incorporate a flawed assumption about the relationship of images and texts—that picture books are for the textually unsophisticated, either children or vulgarians...The Iliac frieze thus both recalls *summatim* a text already known and invites further reflection, a sort of tropology of pagan history.' More generally on the uses of writing in Roman art, cf. Corbier 1995 (revised and updated in 2006: 91–128), arguing that 'le petit nombre des légendes suggère que l'image se suffit normalement à elle-même, et que l'addition de l'écrit est toujours volontaire et significative' (1995: 153).

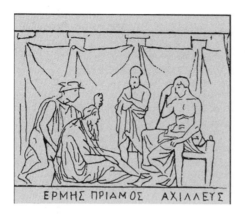

FIGURE 45. Drawing of the upper right-hand corner of the obverse of tablet 1A.

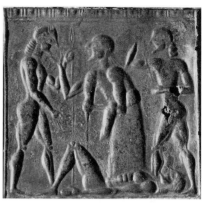

FIGURE 46. Bronze relief showing Priam's embassy to Achilles, from a sixth-century BC mirror handle (Berlin, Antikensammlung 8099).

in the middle, and Hermes to the right; Hector's corpse, on the other hand, lies stretched out below. The verdict is swift: 'strictly speaking,' Snodgrass concludes 'Hermes should have withdrawn before Priam entered Achilles' presence'; the relief ultimately shows 'no very specific acknowledgement' of the text.[55]

So what should we make of the same scene represented on the Capitoline tablet (Fig. 45)? In this context, where image evidently *was* designed to recall the Iliadic scene (and vice versa), we find a related iconography: Hermes is clearly shown *inside* Achilles' tent, wearing the traditional divine attributes of winged helmet and *kerykeion* wand; according to the poem, though, Hermes should not have entered the tent—and, in any case, should be disguised in mortal garb.[56] As for the fourth figure between Priam and Achilles, the *Iliad* is conspicuously silent about any additional bystander: despite being asked to view this imagery through the *Iliad*, we would be hard pushed to explain his presence in terms of the 'salient details' of the poem. Once again, image does not 'match' (Snodgrass's reading of) the Homeric poem. But 'acknowledging' the text can surely mean 'following' the narrative particulars in a variety of different ways. If poem and picture seem irreconcilable here, it is not through any blunder on the part of the artist (or indeed writer). Rather, the problem lies with our quest for

[55] Snodgrass 1998: 133. On this mirror handle (Berlin, Antikensammlung 8099) and eight other Archaic depictions of the scene, see Bulas 1929: 23–8 and E. Kunze 1950: 145–8. For the iconography, see Kemp-Lindemann 1975: 180–8; C. W. Müller 1994: 349–51; *LIMC* I.1: 147–61, s.v. 'Achilleus' nos. 642–716.

[56] Of course, such apparent 'discrepancies' from the text might instead be interpreted as 'fidelities': Hermes is directing the action, but the fact that the god is not shown in mortal costume makes him *in*visible, at least from inside the tent. As always, our criteria for playing '*Snap!*' between images with texts are dependent upon the perspectives of the viewer and reader: the problem lies in the assumption of 'scientific' objectivity.

reconcilability in the first place. The tablets show in their own right how visual and verbal media are each inexhaustible in the terms/images of the other: 'poems will never be fully illustrated, nor can the plates ever be fully understood with reference to the poem...', as Mieke Bal writes: 'text and picture, even when presented as a whole, do not match'.[57] Images will never be homologous with texts because they do not enshrine the same *verbal* logic.

The Iliac tablets were not alone in interrogating the visual–verbal stakes. Consider again surviving Pompeian mural 'cycles' of the *Iliad*, which used once to be introduced as standard comparanda for the tablets' 'illustrations'. The most enlightening case study comes in the Heraclean and Iliadic 'cycles' installed after the earthquake of AD 62 in oecus h of the Casa di Octavius Quartio, Pompeii II.2.2 (Fig. 47).[58] Rather than prioritize the narratives of the text (in any case fabricated, at least in the case of the room's Heracles frieze), the visual arrangement of these scenes played with narrative direction in all manner of innovative ways.[59] In this large room, well suited for summer dining (with framed views out on to the garden and long canal), an Iliadic frieze was set below a second frieze pertaining to the 'epic' labours of Heracles; not only was the Iliadic frieze much smaller in height than the Heraclean band (30 cm as opposed to 80 cm), it proceeds in a *different* series of directions, changing narrative trajectory between the east and west walls, proceeding in an s-shape motion (Fig. 48).[60] In a quite literal sense, the pictures do not follow the text. As Katharina Lorenz concludes,

[57] Bal 1991: 34 (analysing Rembrandt's pictorial engagements with the Old Testament). For the fundamental point, cf. Foucault 1974: 9: 'It is not that words are imperfect, or that, when confronted with the visible, they prove insuperably inadequate. Neither can be reduced to the others' terms: it is in vain that we say what we see; what we see never resides in what we say. And it is in vain that we attempt to show, by the use of images, metaphors, or similes, what we are saying; the space where they achieve their splendour is not that deployed by our eyes but that defined by the sequential elements of syntax.'

[58] On the room and its decoration, the key publication is Aurigemma 1953: 971–1008; cf. Bianchi-Bandinelli 1955: 29–30; Brilliant 1984: 60–1; Clarke 1991: 201–7; de Vos 1993: 86–9; Coralini 2001a (*non uidi*) and 2001b: 78–81, 249, no. P038; Croisille 2005: 161–5; Santoro 2005: 113–14; K. Lorenz forthcoming. On the house generally, see *PPM* 3: 42–108. For other Pompeian Iliadic cycles, see above, pp. 76–7.

[59] For the connection of the friezes with illustrated manuscripts, cf. e.g. Weitzmann 1959: 37–9, followed by e.g. Brilliant 1984: 60 (suggesting 'an origin in illustrated manuscripts or picture books', but complaining that the scenes 'were readable only with a great deal of effort'). Ling 1991: 111–12 notes only the 'narrative' discrepancies, leading to a (typically) dismissive appraisal: 'the sequence of episodes is... illogically organised... The heroic compositions have clearly been reproduced without a great deal of care or conviction' (112).

[60] According to Coralini's reconstruction—based on the identifications of scenes in Aurigemma 1953: 971–1008—the Heracles frieze began in the north-east corner of the north wall and unfolded clockwise (along the east, south, west, and north walls), while the Iliadic frieze begins diagonally opposite, in the south-west corner of the south wall, and vacillates in an s-shape around the room, ending in the middle of east wall. Aurigemma ibid. effaces the spatial play by isolating the 14 surviving Iliadic scenes (barely mentioning the Heracles frieze): he treats each scene individually, privileging the order of the Homeric poem rather than the spatial arrangement within the room.

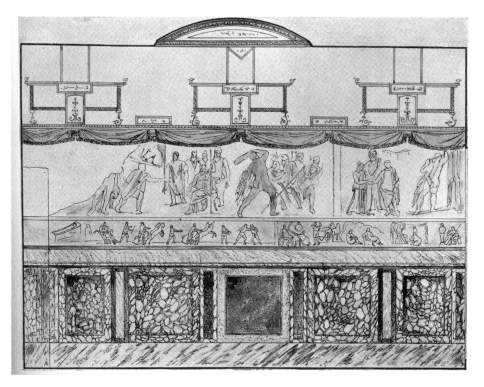

FIGURE 47. Drawing of the east wall of oecus h in the Casa di Octavius Quartio, Pompeii II.2.2, with the large Heracles frieze above, and the smaller Iliadic frieze below. The lower frieze shows first scenes from the end of the poem—the funerary games of Patroclus at the left, and the embassy to Achilles to the central right; it then switches to earlier episodes—Phoenix beseeching Achilles, and Achilles sulking alone in his tent.

such play with juxtaposition and spatial order was intended to 'stimulate forms of comparative viewing which are deliberately geared towards deconstructing the consecutive frieze narratives'.[61] The game, in other words, lay in not only putting the friezes together, but also in zigzagging back and forwards across the room:

[61] K. Lorenz forthcoming. One nice example of this visual deconstruction comes in the Iliadic frieze at the centre of the east wall (the right-hand section of the lower frieze in Fig. 47): by adapting the order of the frieze, the artist juxtaposes the scenes of Phoenix beseeching Achilles on the one hand (Fig. 48, no. 5: cf. Aurigemma 1953: 982–4) with Priam beseeching Achilles on the other (Fig. 48, no. 13: cf. Aurigemma ibid. 1003–5), thereby making the second scene reverse the iconographic schema of the first; an additional parallel comes at the right-hand corner of this wall, where we see the sulking Achilles in the same schema, so that the composition is repeated no less than three times in the space of a half-wall length (Fig. 48, no. 4: Aurigemma ibid. 981–2; cf. below, pp. 167–71 for related iconographic variation on the top frieze of tablet 1A). A series of *visual* parallels is exploited here, in other words, to prompt new reflection about the poem's *verbal* narrative flow. The spatial play evidently privileged different views through the opening of the south wall, with its framed perspectives out into the pergola, garden, and canal; indeed different topographical views through the garden prompt new views of the poem (and vice versa).

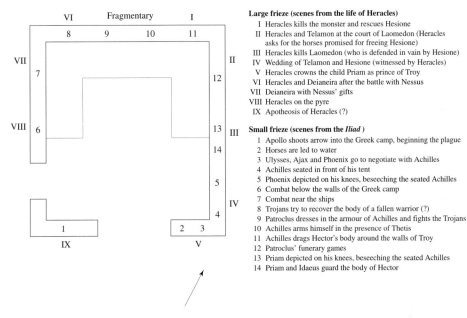

Large frieze (scenes from the life of Heracles)

 I Heracles kills the monster and rescues Hesione
 II Heracles and Telamon at the court of Laomedon (Heracles asks for the horses promised for freeing Hesione)
 III Heracles kills Laomedon (who is defended in vain by Hesione)
 IV Wedding of Telamon and Hesione (witnessed by Heracles)
 V Heracles crowns the child Priam as prince of Troy
 VI Heracles and Deianeira after the battle with Nessus
 VII Deianeira with Nessus' gifts
 VIII Heracles on the pyre
 IX Apotheosis of Heracles (?)

Small frieze (scenes from the *Iliad*)

 1 Apollo shoots arrow into the Greek camp, beginning the plague
 2 Horses are led to water
 3 Ulysses, Ajax and Phoenix go to negotiate with Achilles
 4 Achilles seated in front of his tent
 5 Phoenix depicted on his knees, beseeching the seated Achilles
 6 Combat below the walls of the Greek camp
 7 Combat near the ships
 8 Trojans try to recover the body of a fallen warrior (?)
 9 Patroclus dresses in the armour of Achilles and fights the Trojans
 10 Achilles arms himself in the presence of Thetis
 11 Achilles drags Hector's body around the walls of Troy
 12 Patroclus' funerary games
 13 Priam depicted on his knees, beseeching the seated Achilles
 14 Priam and Idaeus guard the body of Hector

FIGURE 48. Diagram showing the arrangement of scenes in oecus h of the Casa di Octavius Quartio, Pompeii II.2.2 (following the identifications of Aurigemma 1953: 971–1027 and Coralini 2001b: 78–81).

the exercise was to pull apart the stories—and then put them back together anew during the course of dinner.

In what follows, I construct a related argument about the *Tabulae Iliacae* and their playful visual games. Thanks to Nina Valenzuela Montenegro's research, we are better equipped to appreciate the iconographic originality of the tablets: instead of secondary copies derived from any single medium, the tablets bring together an eclectic variety of different visual languages from a miscellany of sources; indeed, their significance lay partly in assembling a range of iconographies—some old, some markedly new—within their single, miniature confines.[62] And yet, critiquing Weitzmann's hypothesis, even Valenzuela Montenegro falls victim to the ideology of illustration that she sets out to refute: comparing the details of the poem with those of the text, she notes frequent 'errors' in correspondence between poem and picture, concluding that the artists worked not from the texts themselves, but from a later (second-rate?) epitome.[63] As we shall

[62] Compare Valenzuela Montenegro 2004: 216–38; cf. ibid. 393: 'Weder Text noch Bild hat sich der Künstler willkürlich ausgedacht, sondern er nahm Quellen zur Hand—auf der einen Seite die ikonographische Tradition, auf der anderen mythographische Handbücher.' For a related point, cf. e.g. Amedick 1999: 195 n. 150.

[63] Valenzuela Montenegro 2004: 234–8, and even more starkly ibid. 414: 'Durch den Textvergleich ist darüber hinaus klar erwiesen worden, dass dem Künstler auch hier die originalen Homerverse nicht vorgelegen haben können—abzuleiten ist dies von logischen und chronologischen Fehlern.' Cf. also

see, the methodology seems to me mistaken: the tablets' imagery can *engage* with epic precisely by 'departing' from the narrative specifics.

Rather than focussing on the artists behind the *Tabulae Iliacae*, the remainder of this chapter asks what it might have meant actually to *view* the tablets: I privilege the tablets' consumption, not just issues (many unanswerable) about their production.[64] All the standard apologies apply: needless to say, there were as many modes of viewing these objects as there were viewing subjects.[65] But in one sense, this is all grist to my proverbial mill: as we shall see, the Iliac tablets manipulate such subjective plurality for playful hermeneutic effect. Instead of merely 'clarifying' the 'content' of the poem 'by pictorial means', these objects invited viewers to look anew at their epic subjects. The aim was to negotiate and navigate response—and in doing so, to rethink the interstices between visual and verbal modes.

AENEAS AND THE UNINSCRIBED EPIC

To demonstrate the point, let me turn again to the Capitoline tablet, and in particular its central depiction of the sack of Troy. As we explained in the second chapter (pp. 34–9), the fragment takes us on a grand literary tour: this panoramic epic vista amalgamates several different poems in its single pictorial space—the *Iliad* to the left and right, the *Ilioupersis* in the centre, and the *Little Iliad* and *Aethiopis* below (Fig. 41). The Greek inscriptions radiating around the central 'Trojan' adjective claim descent from a variety of Greek poetic sources ('*Iliad* by Homer, *Aethiopis* by Arctinus of Miletus, *Little Iliad* as told by Lesches of Pyrrhaea').[66] In terms of its imagery, though, pride of place is reserved for an episode with a defiantly Roman aetiology (Figs. 49–50). Whatever its relation to the original Archaic Greek Trojan cycle,[67] the schema at the original centre of the tablet prompts us to think not of Greek epic tradition, but rather of a Roman founding myth, enshrined in a more contemporary Latin text: the *Aeneid* of Virgil.[68] Inscriptions identify each of the three protagonists:

ibid. 400, concluding of the central scene of the *Ilioupersis* that 'die Textkenntnis ist also lediglich mittelbar, ähnlich wie bei den kyklischen Epen'.

[64] The foundational text on the 'death of the author' hardly needs citing: Barthes 1977: 142–8 (first published in 1967).

[65] For the criticism, see e.g. Clarke 2003: 9–13 (repeated in e.g. idem 2007: 9–11) and P. Stewart 2008: 123–7.

[66] For the 'Trojan' inscription, see below, p. 253.

[67] For an independent literary analysis of the role of Aeneas in the *Ilioupersis* (with further bibliography), see M. J. Anderson 1997: 62–74.

[68] For the earliest discussion, see Fabretti 1683: 382. Valenzuela Montenegro 2004: 130–2 and 306–7 provides a detailed bibliography and iconographic analysis. On the way in which 'The central panel...

FIGURE 49. Detail of the central group of Aeneas, Ascanius, Anchises, and Hermes at the original centre of the obverse of tablet 1A.

FIGURE 50. Drawing of the same detail.

we see Ascanius, Aeneas, and Anchises, guided to the right by Hermes. But the image type—slightly enlarged on the tablet to drive home the dramatic effect—needed no identifying label: 'everybody, in the Augustan age, had some familiarity with the family group of Aeneas, Anchises, the Penates, and Iulus'.[69]

The most famous image of this type was to be found in the Forum of Augustus in Rome (Figs. 51–2). In the centre of the complex's northern exedra, facing a statue of Romulus directly opposite, stood Augustan Rome's founding hero in this pose, with Anchises and Ascanius again in tow; the group was surrounded on either side by Aeneas' latter-day descendants—the first Trojan kings in Latium, the Julian heirs, and last but not least Julius Caesar (Augustus' own 'father', and the implicit honorand of the adjoining temple).[70] All manner of other Roman

transforms the end of an episode into a beginning in medias res, for which a past has been given circumstantially, and circumferentially, while the future has been left to the imagination of the viewer', see Brilliant 1984: 58. Other discussions include Horsfall 1979b: 375–6; Schefold and Jung 1989: 177–9; Canciani: 1990: 4–5; Valenzuela Montenegro 2004: 130–133, 418; Simon 2008: 237.

[69] Barchiesi 2005: 297. For other instances of the schema in Greek and Roman art, see *LIMC* I.1: 386–390, s.v. 'Aineias' nos. 59–154 (with commentary at 394–5). W. Fuchs 1973 provides a full discussion of iconographic precedents, discussing Roman representations and their relation to Virgil at 624–31; cf. Aichholzer 1983: 2–29, with nos. 1–73, and de Vos 1991. Particularly noteworthy is the presence of Hermes—an iconographic peculiarity of the tablets, albeit with further parallels (cf. Spannagel 1999: 109). For the (female?) figure behind Ascanius on the tablet, see Valenzuela Montenegro 2004: 132–3: the surface is too damaged to allow any firm conclusions.

[70] On the context of the group in the Forum of Augustus, see P. Zanker 1968: especially 16–19 and 1988: 192–215, especially 201–3; Galinsky 1996: 204–6; Ungaro (ed.) 2007: 159–69; Geiger 2008. The most detailed discussion of the group's iconography, date, and political significance is Spannagel 1999: 90–131

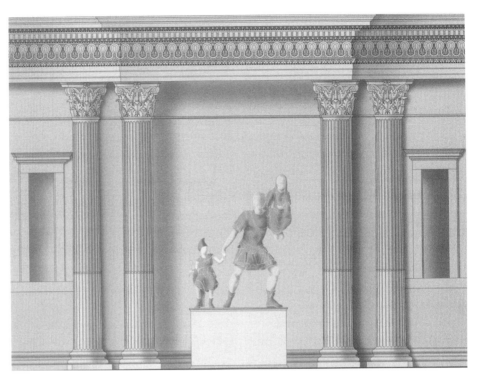

FIGURE 51. Reconstruction of the Aeneas, Ascanius, and Anchises statue group, framed in the centre of the northern exedra in the Forum of Augustus, installed at the end of the first century BC.

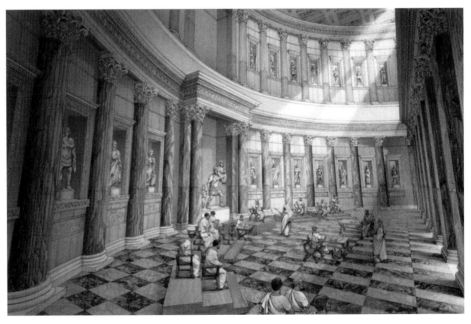

FIGURE 52. Reconstruction of the central aedicula in the northern exedra of the Forum of Augustus, with framed statue group of Aeneas, Ascanius, and Anchises.

FIGURE 53. First-century AD terra-cotta figurine of Aeneas, Ascanius, and Anchises from Pompeii (Museo Archeologico Nazionale di Napoli inv. 110338).

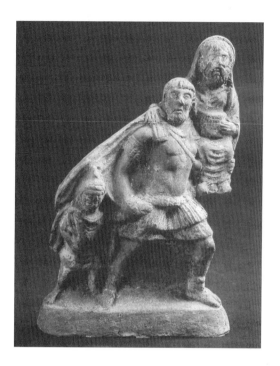

objects subsequently quoted the motif, and in every corner of the Empire: witness, for instance, a first-century AD terracotta figurine from Pompeii (Fig. 53), or a contemporary marble altar from Libya (Fig. 54).[71] The group also became subject to irreverent burlesque. One well-known example is the wall painting from the Masseria di Cuomo in Pompeii (Fig. 55): this image quite literally apes Rome's founder, giving him and his clan comic drooping penises, and replacing Aeneas' sacred *cista sacra* with dice (a cheeky reference to the gambling habits of Julius Caesar).[72]

The Capitoline tablet likewise adapts the Augustan Forum prototype, albeit rather differently. Surviving fragments of the Forum group, placed in the central exedra, confirm that it was originally some four metres tall, and placed atop a high monumental base, inscribed with a (now lost) Latin inscription

(comparing the *Tabula Capitolina* at III), with summary at 360–1. For some introductory comments on the underlying Augustan ideology of 'pious Aeneas', see e.g. Galinsky 1969: 3–61 and Severy 2003: 99–112.

[71] Cf. P. Zanker 1988: 209–10, on how 'the new mythological imagery was widely spread through Roman cities, and not only in the public sphere'. The most important study is now Geiger 2008: 179–204.

[72] For the burlesque, see especially Maiuri 1950; Brendel 1953–4; P. Zanker 2002a: 79–82; Clarke 2007: 143–7. On Julius Caesar as a gambler—and the 'aleatory' terms in which he was said to have described his crossing of the Rubicon in 49 BC—see e.g. Purcell 1995: 26–7.

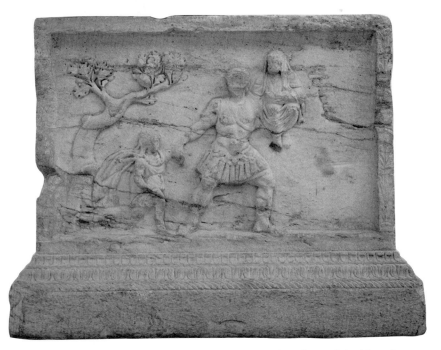

FIGURE 54. Funerary altar from Carthage, showing Aeneas, Ascanius, and Anchises, first century AD (Bardo Museum).

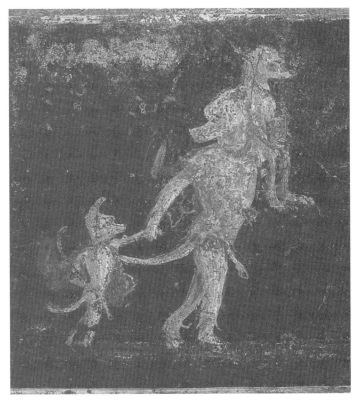

FIGURE 55. Painted burlesque of Aeneas, Ascanius, and Anchises from the Masseria di Cuomo in Pompeii (Museo Archeologico Nazionale di Napoli inv. 9089).

(Fig. 51). Although the tablet's framing of the motif recalls the framed monumentality of the Forum group—placing the group at its prominent centre, labelling the figures this time in Greek, and translating the architectural aedicula into symmetrical city gate (Figs. 49–50)—the grand Augustan statue is here turned into a *miniature* emblem: it becomes just one tiny detail, set alongside countless others.

The tablet's central depiction of Aeneas is one of three scenes that relate to Rome's founder in this central *Ilioupersis* relief (Fig. 56). In an approximately diagonal motion, Aeneas appears once again to the left (within the city walls,

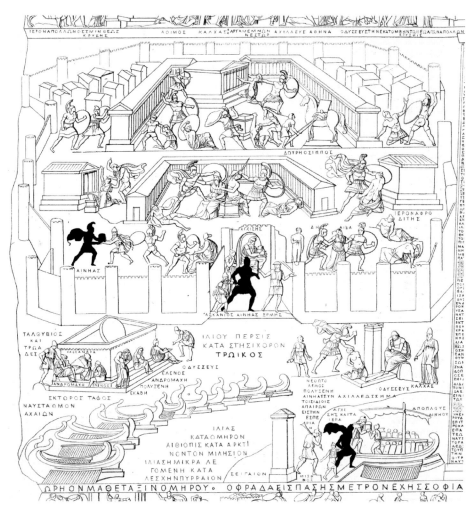

FIGURE 56. Drawing of the central *Ilioupersis* scene on the obverse of tablet 1A, highlighting the repetitions of Aeneas.

piously rescuing the Penates which he will take to Lavinium), and finally to the lower right of the panel (boarding a ship bound 'for the Western Land'): each time, Aeneas appears in the same costume and accompanied by an inscription.[73] Although more fragmentary, three further tablets (2NY, 3C, 7Ti) suggest that Aeneas was privileged in this way on numerous other *Tabulae Iliacae*.[74]

At the literal and metaphorical heart of this tablet, then, is a visual emblem that reframes the Greek epic panorama in more subjective Roman terms.[75] The world of Greek epic is repackaged as the prequel to a distinctly Roman cultural, social, and literary history: where the Trojan cycle traditionally ends with the home-coming of Odysseus, it is *Aeneas* who is turned into prototypical wandering hero. The representational twist invited Roman viewers, as Aeneas' modern-day des-cendants, to rethink their own relation to the Trojan–Greek struggle depicted. It also attributed to these scenes an immediate political resonance: we are pointed not just to the myth of Rome's origins, but also to the mythologized genealogy of the 'Julian' Imperial family, manipulated by Augustus for sheer political gain. The Capitoline tablet is stamped with an Augustan political logo.[76]

This immediate Roman relevance goes unspoken in the various inscriptions, invariably inscribed in Greek: there is no place for Virgil amid the references to Homer, Stesichorus, Arctinus, and Lesches. But the rival pull between text and image is set against a parallel tension between the Greek and Roman. An interesting detail enshrines the play: notice how, to the left of the lower figure of Aeneas, beside the scene of his boarding the ship, there stands an uninscribed stela (Fig. 57). The shape of the monument clearly recalls the two stelae inscribed with the Greek résumé of the *Iliad*, one of which borders this scene to the right. Not only is the little stela next to Aeneas much smaller than its right-hand counterpart, though, it is also left conspicuously *un*written. In a *mise en abyme* of texts within texts and images within images, there is room on this miniature monumental tablet within the tablet for infinite (and unprescribed) narrative expansion.[77]

[73] On the two images, see Valenzuela Montenegro 2004: 127–9, 143–5.

[74] See below, p. 178 n. 115.

[75] For an introduction to Homer as 'the undisputed model for Romans' desire to record their history in epic', see Zeitlin 2001: 233–42, at 236.

[76] More generally on the political framing of the tablets, see Valenzuela Montenegro 2004: 418. The classic discussion of the 'new mythology' in Augustan art is P. Zanker 1988: especially 167–263. In addition to the Forum of Augustus, note the appearance of Aeneas on the west side of the Ara Pacis, where the sacrifice offered by Aeneas (accompanied by his son, Iulus) foreshadows the sacrificial procession of Aeneas' descendant, the emperor Augustus: cf. D. E. E. Kleiner 2005: 221–5.

[77] An inscription to the left of the stela specifies the locality: Cape Sigeum ([Σ]είγαιον—i.e. 'Silence'?). Valenzuela Montenegro 2004: 143 (following e.g. O. Jahn 1873: 37 and Mancuso 1909: 719) identifies the monument as the grave stela of Achilles, repeating the monument depicted to the upper right (and identified as the *sêma Achilleôs*), but leaves unmentioned the striking resemblance to the monumental

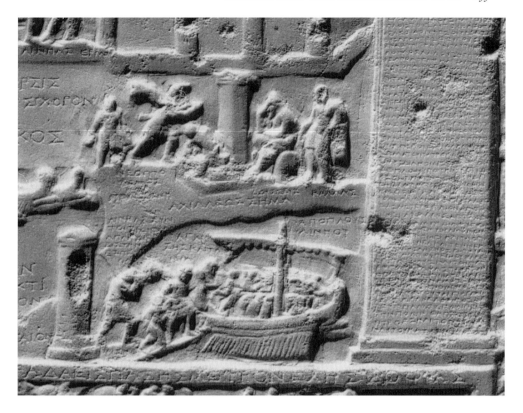

FIGURE 57. Detail of the lower right-hand corner of the *Ilioupersis* scene on the obverse of tablet 1A.

To what extent does Virgil specifically lurk behind this central representation? True to 'illustrative' remit, scholars have compared the minutiae of the image with various lines of the *Aeneid*, in particular Aeneas' description of Troy's destruction, as recounted to Dido in the second book of the poem. Summarizing and responding to earlier criticism, Nina Valenzuela Montenegro shows how numerous details both align with and depart from the lines of the Virgilian text (the central Aeneas group, the fragmentary figure behind it, the inscribed figure of Misenus at the tablet's lower right, the inscribed departure by ship 'to the Western Land', to name just a few examples).[78]

As we have seen, however, pictures do not have to follow the 'salient details' of texts in order to resonate against them. To my mind, the centrality of Aeneas is

pilaster to the right: there are multiple σήματα ('tombs', 'marks', 'signs') here, each one juxtaposed to/ embedded within the other (cf. below, p. 164 n. 98).

[78] Cf. Valenzuela Montenegro 2004: 387–91 (with detailed bibliography of previous scholarship). In the final analysis, Valenzuela Montenegro proves sceptical of any direct Virgilian influence, subsuming it under what she calls an *interpretatio Romana*: 'Insgesamt sehe ich also keinen Anhaltspunkt für einen konkreten inhaltlichen Einfluss der Aeneis auf die Darstellung der Tabula' (391).

enough to establish the possibility of a Virgilian (re)viewing of the tablet. Recall here how Virgil's rendition of the story very quickly established itself as *the* account of Troy's fall. One might think, for instance, of the mass of Virgilian lines scribbled as Pompeian graffiti, as well as written testimonies like the 'Masada papyrus' or Vindolanda tablets: whatever Virgil might have felt about the feat, his poetry established itself as the poetic inner voice of the Roman Empire.[79] For many, it can have made little difference whether or not these images of Aeneas' departure are deemed to depart from the *Aeneid*'s description (*Aen.* 2.721–4). How could one conceptualize this story *without* thinking of Virgil?[80]

Once suggested, the Virgilian framework quickly takes root. Most significantly, Virgil himself provides an epic model for every response to the 'Trojan' pictures in hand. Just as viewers look at the Capitoline tablet's Greek epic scenes, the opening book of the *Aeneid* evokes a series of pictorial representations, drawn from the *Iliad*'s account (*Aen.* 1.446–93).[81] Like so many of the Iliac tablets, the unfinished *picturae* adorning Juno's temple at Carthage are described as representing 'the Trojan/Iliadic battles in order' (*Iliacas ex ordine pugnas*, *Aen.* 1.456):[82] lost in amazement, Aeneas 'feeds his mind on the empty picture' (*Aen.* 1.464 *animum pictura pascit inani*), even recognizing himself in the imagery (*Aen.* 1.487–8)—a metaliterary nod to the poem's own literary archaeology, textually

[79] On Virgilian graffiti from Pompeii, see e.g. Gigante 1979: 163–83; Ziolkowski and Putnam (eds.) 2008: 42–4; Milnor 2009. Other evidence for this diffusion, both literary and material is collected in Ziolkowski and Putnam (eds.) 2008: 1–178; cf. Tarrant 1997.

[80] The *Aeneid* seems aware of the fundamental iconographic schema. As Barchiesi 2005: 298 nicely puts it, 'Virgil pointedly avoids a regular description of the group through the narrative: what we get is a first-person account by Aeneas, where the iconography is being revisited from within'.

[81] The bibliography on the passage is extensive, but see especially W. R. Johnson 1976: 99–105; DuBois 1982: 32–4; Leach 1988: 311–18; D. P. Fowler 1991: 31–3; Lowenstam 1993; Barchiesi 1994: 114–24; Laird 1996: 87–94; Bartsch 1998: 326–9; Putnam 1998: 23–54; Beck 2007; Elsner 2007a: 79–82. The precise medium of the 'pictures' is significantly left ambiguous: cf. e.g. Leach 1988: 312–13 and Boyd 1995: 81–3.

[82] The *Aeneid*'s particular concern with *ordo* goes hand in hand with the Capitoline epigram's explicit emphasis on 'the order of Homer' (τάξιν Ὁμήρου: cf. below, pp. 195–6.). Despite the protestation of 'order' (*ex ordine*), Aeneas' viewing of these images plays fast and loose with narrative sequence (mirroring the *Aeneid*'s own creative re-rendition of Homeric precedent): the second episode depicted/described is based on *Iliad* 10, while the third retreats to pre-Iliadic subjects, demonstrating to readers that 'Virgil's purpose is more than the mere exposition of historical detail' (Putnam 1998: 27). As on the *Tabulae Iliacae*, viewing the pictures not only breaks poetic narrative sequence, but also leads *beyond* the *Iliad* per se (*saeuum . . . Achillem*, 1.458)—in the description of Penthesilea, for example, drawn not from the *Iliad* but apparently from the *Aethiopis* (1.490–3), or the story of Troilus which was told in the *Cypria* (1.474–8). Indeed, Aeneas' very act of viewing and addressing these images, crying and feasting his soul on the 'empty picture' (*inani . . . pictura*, 1.464), finds a precedent not just in Odysseus' weeping at the song of Demodocus (*Od.* 8.83–96; cf. W. R. Johnson 1976: 100–3; Beck 2007: 540–6), but also in *Odyssey* 11: there Odysseus finds a sort of pleasure in weeping before the soul of his mother (*Od.* 11.87)—a substanceless semblance that can be seen, but not grasped or embraced (εἴδωλον: *Od.* 11.213).

figured through these pictures.[83] Despite the suggestion of due narrative order, Aeneas is said to respond to the imagery in a wholly individualized way, allowing the reading audience an in-depth view not of the pictures, but rather of the protagonist looking upon them: 'more than any other ancient poet', as Alessandro Barchiesi puts it, 'Virgil stresses the importance of the viewing subject in the construction of visual meaning'.[84] As we shall see, the *Tabulae* materialize this self-same concern with both order (*taxis*) and individual subjectivity. The manner in which Aeneas rewrites Homer—composing a series of subjective verbal responses, to an unfinished cycle of images—provides an epic model for our viewing and reading. There can be no escaping Virgil: whatever *ordo* we construct of the 'Iliadic battles', our mode of ecphrastic response is refracted through the literary lens of Virgilian ecphrasis.[85]

By the mid first century AD, revisiting Troy (or indeed the genre of ecphrasis) evidently meant revisiting Virgil. As in the visual arts (Fig. 55), moreover, Augustan reverence quickly gave way to comic pastiche. One revealing send-up comes in Petronius' *Satyricon* when, in the context of a visit to a *pinacotheca* (painting gallery), Eumolpus delivers a lampooning ecphrasis of a supposed *Ilioupersis* picture (*Sat.* 89). Noting that his audience's attention is focussed not on his own wonderfully confused history of art, but on a painting of the *Troiae Halosis*, Eumolpus embarks upon a poetic response of his own: 65 iambic verses ensue, maintaining the six feet of epic hexameter, but irreverently converting them into *senarii*.[86] As Victoria Rimell has shown, it is all but impossible to 'reconstruct' the imaginary picture behind the poem; indeed, this seems to have been very much the point.[87] Still, Petronius' witticism lies in the make-believe

<hr/>

[83] On the para-poetic paradox whereby Aeneas recognizes himself in the 'empty' or 'insubstantial' picture (*pictura . . . inani*)—about to be written through the present text—cf. e.g. Porter 2004: 143.

[84] Barchiesi 1997: 275. For the way in which the purported description toys with 'our ability, as constructed by Virgil, both to share Aeneas' response (to view with him) and also to watch him viewing and to stand back from his engagement', see especially Elsner 2007a: 81–2; cf. DuBois 1982: 35 ('through distancing techniques, Vergil emphasizes the filtering of versions of the past through the teller'); D. P. Fowler 1991: 33; Bartsch 1998: 338; Beck 2007: 536–40.

[85] For the parallel with the Iliac tablets, cf. Barchiesi 1994: 117, concluding that 'le "tavole iliache" sono il corrispettivo romano (e reale) del tempio di Cartagine'.

[86] *Sat.* 89.1: *Sed uideo te totum in illa haerere tabula, quae Troiae halosin ostendit. itaque conabor opus uersibus pandere* ('But I see your attention is fully focussed on that picture [*tabula*] which shows the fall of Troy: well, I shall attempt to explain the work in verse'). On the whole episode, see Elsner 1993 (reprinted in 2007a: 177–99, with 194–6 on this particular passage) along with Slater 1987; Beaujou 1982 is useful on the contextual background (especially 674–5). On the Petronian *Troiae Halosis* and its various Senecan and Virgilian allusions, see especially Rimell 2002: 60–81, developing Sullivan 1968: 165–89, Zeitlin 1971: 58–67, Slater 1990: 95–101, 186–90, and Connors 1998: 84–99. Other poetic models may well also have been lampooned here, among them Lucan's *Pharsalia* and the Emperor Nero's own *Troica* (cf. Rudich 1997: 226–8).

[87] See Rimell 2002: 66–7.

evocation of something seen through something read.[88] Whatever the painting, Eumolpus inscribes an unabashedly *Virgilian* view into his description of it, lampooning not only the second book of the *Aeneid*, but also Aeneas' own subjective responses to the pictures at Carthage (as portrayed by Virgil).[89]

The Capitoline tablet explores no less sophisticated themes, albeit this time through pictures rather than through ecphrastic texts. All manner of writable stories lie latent in what we can see. And yet everything depends on the eye of the beholder. If the pictures interrogate the subjectivity of our ecphrastic reaction, their very manner of doing so finds Virgilian precedent: like the Iliac pictures seen by Aeneas, this imagery both *is* and is *not* 'empty' (*Aen.* 1.464). The paradox is delicious: even to view these visualizations as void of Virgilian value is to think back to a Virgilian prototype.

NARRATIVES THROUGH PICTURES

If the centrality of Aeneas reframes *what* we make of Trojan epic on the Capitoline tablet, the central panel also leads us to revise *how* we engage with its imagery. Let me begin by slowly zooming outwards, with a photograph and drawing of the central *Iliouopersis* panel (Figs. 58–9). It has sometimes been noted how this single scene, framed on all four sides, combines a number of different viewpoints: on the one hand, it offers a 'bird's eye view'—an oblique aerial perspective from above; on the other, the individual buildings are drawn frontally (according to a so-called 'central perspective' from the same horizontal plane).[90] As we shall see, this multiple perspective is paralleled by a multiplicity of pictorial narrative strategies. Aeneas, shown at the moment of his departure

[88] For the point, see especially Slater 1987: 172 and 1990: 244.

[89] All this within a text that itself monumentalizes the subjective perspective of Encolpius—refracting that view through the prism of Petronius' own satiric evocation. Cf. Elsner 2007a: 194–5: 'In its literary reference to the *Aeneid* . . . the *Troiae Halosis* recalls not only Aeneas' account of the fall of Troy in Book 2 but also his confrontation with the pictures of the Trojan War on the walls of Dido's temple in Carthage (Book 1, vv. 450–93). In effect, the *Troiae Halosis* recapitulates not just the theme of the capture of Troy but, more significantly, the problematic of response to that theme' (195).

[90] The effect is what Mikocki 1990: 112–16 calls 'la perspective mixte' (discussing eight *Tabulae Iliacae* at 114–15); cf. Blanckenhagen 1957, arguing that the ' "illogical" and incoherent combination of bird's eye and "normal" view . . . can be shown to have a long history in Roman representations of actual events' (83); Holliday 2002: 106–10. On the synthesis of different pictorial perspectives, and their association with a Roman tradition of map-making and *topographia*, see Leach 1988: 81–3 and Valenzuela Montenegro 2004: 23–5, associating this aspect of the tablet with a distinctive feature of Roman rather than Hellenistic Greek art ('die Durchbrechung des Realismus durch die Verbindung verschiedener Perspektiven geschieht erst in Rom', 25). One famous example is the eponymous Roman wall painting of the Pompeian amphitheatre in the Casa della Pittura dell'Antifeatro, Pompeii I.3.23 (Mikocki 1990: 112), though others are discussed by Erath 1997: 260–76.

from Troy, stands at the centre of a composition that is structured according to a variety of competing and collaborating rationales: the panel is arranged both topographically and sequentially, demanding to be viewed at once simultaneously and in succession.[91]

To talk of 'pictorial' or 'visual narrative' here is not quite right. Although, as we noted at the beginning of this chapter, 'narratology' has developed into a popular branch of 'new art history', the thinking betrays a residual logocentric bias: narratives do not inhere in images, but are rather constructed by viewers responding to them; stories can be evoked *through* pictures, in other words, but they cannot reside *in* them.[92] The central panel of the Capitoline tablet embodies the principle, demonstrating a remarkable sensitivity to the ways in which pictures engender stories both like and unlike texts.

To explain what I mean, we need to look carefully at the arrangement of the central panel. As opposed to the continuous and progressive friezes that radiate around it on all four sides, the *Ilioupersis* metope offers a single geographical vision of Troy's fall. Above, surrounded by a single set of walls snaking around a double set of porticoes, we see the city of Troy, attacked from within; below, we see events taking place outside the city's gates—the tomb of Hector (on the left), a memorial to Achilles (on the right), and below them the shore. As far as the geography of the city is concerned, we look upon a unified space, laid out topographically: this is the 'Trojan' urban landscape (in the description of the prominent inscription below the central Aeneas).[93]

But despite the spatial organization of this panel, there is also a temporal rationale to the events depicted. In the language of modern classical archaeological scholarship, this is a 'synoptic', 'synchronic', or perhaps better 'polychronic' image, whereby one physical setting encompasses a number of different moments.[94] The inscribed 'Aeneases' already demonstrate the point (Fig. 56): Aeneas is depicted three times, and in closely related iconographic poses, first (centre left) rescuing the Penates, second (centre) before the city's gate, and finally (bottom right) boarding his ship. As with the Aeneas scenes, the action

[91] For a more detailed analysis of the central panel, and its miscellaneous iconographic debts, see Valenzuela Montenegro 2004: 116–45.

[92] The point is made most succinctly by Davis 1992: 234–55 (cf. 1993: 49–53 n. 1), albeit in a rather different context. In addition to Brilliant 1984 (on Roman and Etruscan art), the most influential study of Greek 'pictorial narrative' is Stansbury-O'Donnell 1999: especially 1–17: although by no means overlooking the viewer's share, Stansbury-O'Donnell's founding principle is that 'images can tell stories' (191).

[93] For the 'Trojan' inscription, see below, p. 253. On the topography, cf. Petrain 2006: 159–62, who supposes this a 'pseudo-cartographic' depiction, influenced by Greek and Roman maps: Petrain cites this as further evidence of the tablets' association with the library (cf. above, p. 73).

[94] For discussion of the terminology, see Stansbury-O'Donnell 1999: 5–7.

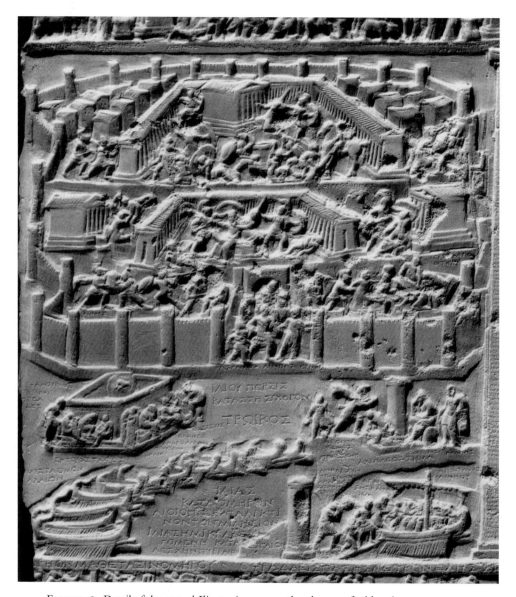

FIGURE 58. Detail of the central *Ilioupersis* scene on the obverse of tablet 1A.

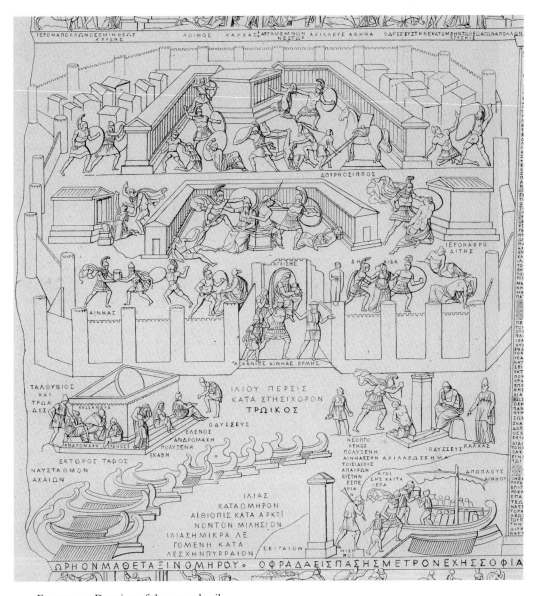

FIGURE 59. Drawing of the same detail.

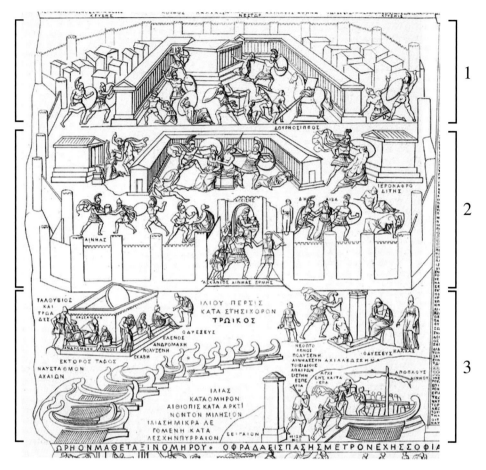

FIGURE 60. Drawing of the central *Ilioupersis* scene on the obverse of tablet 1A, showing the division of scenes: first, the ambush of the Trojan horse; second, the destruction of the city; and third, events outside Troy's walls following the city's destruction.

of this *Ilioupersis* scene seems to unfold from top to bottom. We might divide the panel into three approximate parts, each roughly corresponding to the space of three friezes framing the composition to the side (Fig. 60).[95] Above, we see the

[95] Others have divided the panel into more registers: Sadurska 1964: 28–9 identifies seven 'zones'; Brilliant 1984: 109–10 suggests four (as opposed to the 'seven' he had earlier specified: 1967: 225), while Valenzuela Montenegro 2004: 116 segregates the scene into five discrete parts. Any such schematic delineation of the picture is bound to be artificial. To my mind, though, the iconographic repetition of the three-sided colonnade establishes a correspondence between what I label the first and second registers (whereas Valenzuela Montenegro divides this second register into two); moreover, the Greek ships at the base of the panel, stretching from bottom to top, and from left to right, bind together all of the scenes depicted outside the city gates and after Troy's fall (again, Valenzuela Montenegro divides this area into two registers).

Greeks descending from the Trojan horse in order to lay waste the city; next we see the rape, pillage, and slaughter that follows; and then finally, in the lower part of the panel, we see the aftermath of the war (with Aeneas' departure in the lower right-hand corner, accompanied by Misenus). Thus the sack of Troy occupies the first and second registers (with a similar-looking three-sided colonnade recurring in both);[96] the third register, by contrast, represents events occurring not only topographically *outside* the city walls, but also chronologically *after* its destruction.

The effect of this duplicate organizational strategy is to invite viewers to make sense of the image *both* synchronically *and* in linear sequence. While offering a single geographical snapshot of Troy at the time of its destruction, the panel leads us to construct a series of discrete narrative moments, each unfolding in time rather than merely in space. Fundamental to this process is the remarkable symmetry of the composition, which lends itself to a holistic mode of visual interpretation (focussing on the overall arrangement of the image), as well as to a more fragmented gaze (whereby viewers look for semantic correspondences between its different but symmetrically arranged parts). The patterning works along both a horizontal and vertical axis: not only does the three-sided portico of the upper scene mirror that below, but the lower portico is itself flanked on either side by two symmetrical temples; in a further visual echo, note how these temples themselves balance a third temple above (framed within the portico), as well as the fleeing Aeneas group below. The rhombus arrangement cannot have been accidental: could there be a better mode for visually structuring 'pious Aeneas'?[97]

Once we begin to look for it, such concern with balance and equilibrium is everywhere to be seen: the mirroring two warrior groups that flank the sides of the upper register, the violent scenes that take place before the temples below (a single man assaulting a single woman), the labelled tomb of Hector set against the inscribed memorial *sêma* of Achilles, and not least the ships of the Greeks reflecting the single ship of Aeneas at the bottom right. Additional associations across this symmetrical arrangement encourage us to view these scenes in programmatic association: note, for instance, how Polyxena appears twice outside the city walls, both times identified by inscriptions (to the left by Hecuba's side, and to the right before her sacrifice by Neoptolemus); or how Odysseus, also named, appears on both the left- and the right-hand side of the lower register, addressing the Trojan women, and woefully witnessing the sacrifice of Polyxena.

[96] The same composition recurs on other tablets—most conspicuously on fragments 2NY (Valenzuela Montenegro 2004: 190–1) and 7Ti (ibid. 203).

[97] On the additional two symmetrical temples above this central *Ilioupersis* panel, within the frieze relating to the first book of the *Iliad* (Fig. 71), see below, p. 171.

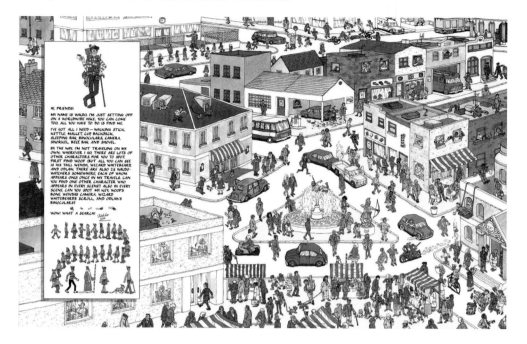

FIGURE 61. Detail from a *Where's Wally?* picture-puzzle: the challenge is to find Wally—known as Waldo in North America—within the cityscape; 'Wally' is to the right of the building in the lower left-hand corner, but can you spot 'Woof', 'Wenda', 'Wizard Whitebeard', 'Olda', and 25 other stock 'Wally watchers'?

The row of ships at the bottom of the panel, receding from left to right, serves to unite these different horizontal and vertical planes.[98]

Much thought has gone into this central *Ilioupersis* scene. Whatever our temporal interpretation, the image (at the same time) maintains an overarching geographical coherence: we are to make sense of it spatially as well as temporally, and from left to right, as well as from top to bottom. While providing a single 'still' of the city, both within and without, the stories are also shown to unfold along/down/across a variety of different registers, and in a variety of different directions. The cumulative effect resembles something like *Where's Wally?* (Fig. 61): scanning the geographically arranged picture, we search for individual characters; all the while, though, our attention is distracted by the suggestion of a seemingly endless array of *other* stories to be told.[99] The fact that the Capitoline tablet reverberates

[98] By leading viewers back to the image of Polyxena's sacrifice, just outside the gates of Troy, and witnessed by Odysseus and Pallas Athena, the ships arguably lead us *beyond* Troy altogether. There are, in other words, still further epic stories of *nostoi* to be told, whereby the doomed homecoming of the Greek heroes from Troy parallels Aeneas' own uninscribed odyssey (just as the uninscribed monumental tablet next to Aeneas parallels the unwritten stela next to Odysseus).

[99] My thanks to the Turner family—James, Victoria, and George—for showing me the point.

against pre-existing stories, recounted in all manner of verbal narratives, makes its sophisticated games all the more exciting and dynamic: looking for repetitions of word and image, we glance across a miscellany of pictorial planes, forging new narrative associations and connections between the diverse and divergent scenes—all together, from side to side, and from one end to the other.

TROY STORY

Every aspect of the *Tabula Capitolina* develops this playful hermeneutic agenda. The tablet at once gives the semblance of straightforward narrative order and undermines the suggestion, inviting viewers to choose their *own* pictorial adventure. Some have consequently grumbled that the resulting object has a 'confused visual impression'.[100] And yet such complaints overlook (or rather *under*look) the *multiple* organizational strategies at play.

The central *Ilioupersis* panel demonstrates these multiple strategies in its own right. Viewers are to experiment by looking not just from top to bottom or from side to side (and each the other way round), but also in a diagonal motion: remember, for instance, the connection between the three depictions of Aeneas, pivoting around the central scene of his flight from Troy. The circuit of walls around the central scene of Troy encapsulates this interpretive circularity. What had long since been termed an epic *cycle* (ἐπικὸς κύκλος), wheeling its way around an inner ring of connected stories, is materialized here in a literal sort of sense.[101]

Put the central *Ilioupersis* scene back in the context of the Capitoline tablet as a whole, and we see how these compositional games are further developed through those surrounding it. Whatever verbal sense we devise from the central panel, our interpretation is always open to visual revision. The imagery immediately to the right of Aeneas' departing ship provides a preliminary example (Figs. 62–3). Although the inscribed pilaster serves to separate the framed *Ilioupersis* from the scenes depicted in row *omicron* to the right (relating to the fifteenth book of the *Iliad*), the inscriptions and iconography establish additional connections between the different figurative sections: not for nothing is 'Aeneas' labelled as the first figure of that frieze, even though he is named only once (and wholly peripherally) towards the middle of the book (*Il.* 15.332); note too how the ship at the right of the frieze playfully recalls Aeneas' own. Just after (or before?) Aeneas sails off in his ship 'to the Western Land', he seems to drift into this rather different Iliadic scene.

[100] Horsfall 1979a: 34. Only marginally less dismissive is Bianchi-Bandinelli 1954: 6: 'Questo significa che si atteneva espressamente a una composizione semplice che risultasse ben chiara come esposizione di una narratazione, sacrificando eleganze artistiche.'

[101] On the concept of the 'epic cycle' and its history, see Cameron 1995: 394–9, together with Valenzuela Montenegro 2002: 70–2. I develop the point in Squire forthcoming d.

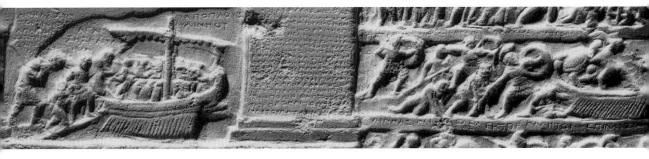

FIGURE 62. Detail of the obverse of tablet 1A, showing the lower right-hand corner of the *Ilioupersis*, the right-hand pilaster, and scenes relating to *Iliad* 15 (frieze *omicron*).

The iconographic motif certainly connects the story of Aeneas' departure after Troy's destruction to the battle of the ships within the *Iliad*; if we look left, though, we see that the schema also leads viewers in the opposite direction, back to the row of ships in Troy's harbour. Think once again of *Where's Wally?*: the game is to search for visual repetitions and clues—is this the very *same* ship as that figured in book 15?[102] Visual and verbal associations prompt *new* narrative connections, not only within separated sections of the tablet, but also between them.

Such connections have to be understood within the Capitoline tablet's larger play with structural arrangement. On the most basic compositional level, the tablet organizes its subjects in a variety of different ways. Take the various friezes that frame the central image of the *Ilioupersis* above, below and to the two sides. On the one hand, individual books of the *Iliad* are arranged here along a horizontal axis, proceeding from left to right (Fig. 64). On the other, though, these individual frames are also laid out vertically: the first 12 books of the *Iliad* seem to have been arranged in descending order from the tablet's top to its bottom, while the last 12 books are set out in ascending order from bottom to top (Fig. 65).[103] We are dealing with images that unfold at once along a

[102] For an iconographic guide to the images from frieze *omicron*, see Valenzuela Montenegro 2004: 50–5: she rightly draws attention to the artistic licences of the frieze (55; cf. ibid. 221–2), as well as its play with the Homeric order of events (52). Concentrating on each section of the frieze in isolation from every other, though, Valenzuela Montenegro overlooks the visual associations between the different parts of the tablet. In this connection, note how Aeneas is named at the lower right-hand corner of the tablet: if Aeneas occupies pride of place at the tablet's centre, he is also shown fighting in frieze *nu*, continuing the diagonal that runs from the tablet's central panel.

[103] The conclusion of Brilliant 1967: 225–6 that 'two entirely different schemes of narrative composition exist side-by-side in the Capitoline tablet' (225) is therefore too reductionist in scope: the 'direction of movement' in the registers surrounding the central scene is by no means 'unilateral', and the tablet overtly problematizes any 'equation of space with time'. Although otherwise more sophisticated in its analysis, Carruthers 1998: 201 is also too schematic in reconstructing a single viewing order: 'one would read this tablet from left to right across the top; look left and down, and then right and up, in a more-or-less counter-clockwise movement'.

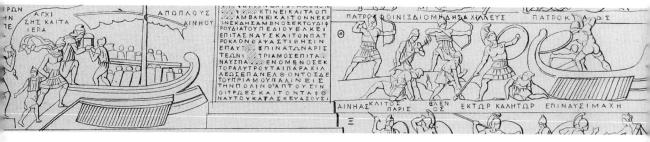

FIGURE 63. Drawing of the same detail.

horizontal *and* vertical plane: as with the letters inscribed on the surviving pilaster—arranged from left to right, but also in 108 overlaping but consecutive lines—we have to look from side to side as well as up and down.[104]

This spatial arrangement is complicated still further by the position of the tablet's upper frieze, relating to the first book of the *Iliad*. As we have observed, this frieze stretches from the left-hand corner across the entire central width of the Capitoline tablet, just as it did on tablets 3C and 6B: the first book of the poem is here set against the last, so that row *alpha* leads directly to the row inscribed as *omega* (and the other way around). As a result of this arrangement, it is possible to approach the tablet in *both* clockwise (Fig. 66) *and* also anticlockwise (Fig. 67) order: the opening and closing events of the poem meet above the surviving right-hand stela, inviting us to bypass the intervening 23 books—to move directly from beginning to end, or indeed from end to beginning. The friezes run rings around a self-contained epic cycle, and yet the particular *mode* of circumnavigation is left to the viewer's own individual circumstance.

Iconographic echoes along the length of this upper frieze corroborate the point (Figs. 68–9). It is surely significant that, directly above the inscribed stela—which serves as a sort of arrow, directing our gaze—the frieze representing the first book of the *Iliad* ends with Thetis' supplication of Zeus (*Il.* 1.493–530): Thetis kneels before the god, but Zeus turns away, avoiding her gaze. Of course, the whole story of the *Iliad* depends upon Zeus' decision at this moment: will Zeus yield to Thetis' request (put to him twice) and grant the upper hand to the Trojans until the Achaeans make amends, or will he leave her prayers unanswered? If the decision seems to hang in the balance, the fact that Zeus looks *behind* him—to the pictorial events of book 24—quite literally points viewers to

[104] Notice here how the inscribed epitome itself monumentalizes the tablet's compositional (a)symmetry. Despite visual appearances, the verbal summary is—on a literal level—out of sync with the pictorial representations to which it refers: rather than allocating equal space to both halves of the poem, the artist has inscribed books 1–7 on the left-hand pilaster, and books 7–24 on the right (see above, pp. 34–5). Of the 108 lines, moreover, some 69 end with words that are split from one line to the next, regardless of syllabic length: one *has* to read both horizontally and vertically at once.

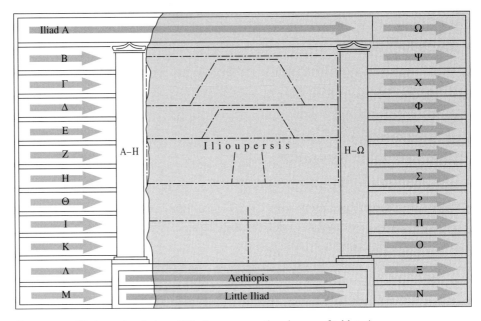

FIGURE 64. Horizontal ordering of Iliadic scenes on the obverse of tablet 1A.

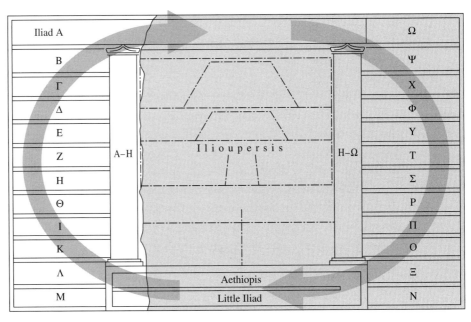

FIGURE 66. Clockwise interpretation of Iliadic scenes on the obverse of tablet 1A.

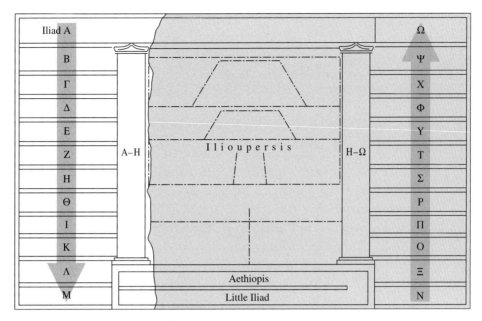

FIGURE 65. Vertical ordering of Iliadic scenes on the obverse of tablet 1A.

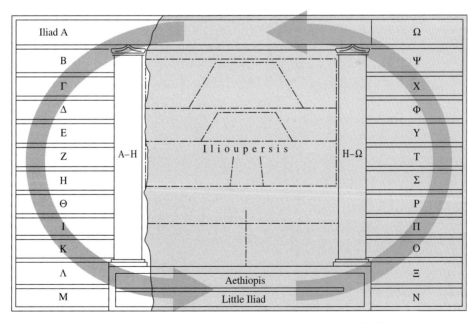

FIGURE 67. Anticlockwise interpretation of Iliadic scenes on the obverse of tablet 1A.

FIGURE 68. Detail of the obverse of tablet 1A, showing the upper frieze (*alpha* and *omega*).

his verdict, and hence to the conclusion of the poem in its final book.[105] As we have said, the seated Achilles is to be seen at the end of the tablet, receiving the embassy of Priam (Fig. 45). But in this connection, it is worth observing how the gesture of Achilles, beseeched by Priam, itself mirrors that of Zeus supplicated by Thetis. Achilles' half-naked torso, the position of his legs, the arm raised to his head: all of these features (ironically) recall and refigure the scene to the left.

If we look along to the left of this upper frieze, we see related scenes recurring at regular intervals along its length. Although the original left-hand portion of the frieze is missing, comparison with tablets 6B and 3C (Fig. 70) suggests that at least part of it was occupied with a view of Chryses petitioning Agamemnon: the imagery here, with the elderly Chryses kneeling before the seated Agamemnon, now petitioning for the return of *his* child, clearly draws upon the iconography of Priam's embassy to Achilles.[106] These scenes might frame opposite ends of the frieze, in other words, but they establish a visual correspondence across books *alpha* to *omega*. The iconographic parallels—themselves echoed in the image of Thetis entreating Zeus, as well as in the schema of the seated Agamemnon at the very centre of the band—incite viewers to formulate new associations between these selected highlights, drawn from the poem's opening and close. Agamemnon's rejection of Chryses, Agamemnon's angry words to Achilles, Zeus' reception of Thetis, and finally Achilles' hosting of Priam: we are invited to see connections across individual books that—verbally speaking—(must) go unstated.[107]

[105] The scene finds only one secure iconographic parallel—in the later 'Ilias Ambrosiana' manuscript (cf. *LIMC* 8.1: 11, s.v. 'Thetis' no. 43; Bianchi-Bandinelli 1955: 57). It is perhaps significant, though, that the 'Ilias Ambrosiana' scene is displayed in reverse order to this one, so that Thetis kneels to the right of Zeus (cf. Valenzuela Montenegro 2004: 217): here, as elsewhere, the artist seems to have thought carefully about pictorial arrangement, even (and indeed especially) when that meant adjusting standard iconographic formulae.

[106] The association is noted by Valenzuela Montenegro 2004: 216: cf. ibid. 33–5 (on tablet 1A), 153 (on tablet 6B), and 171–3 (on tablet 3C).

[107] This careful attention to order and iconography surely explains why some of the most popular scenes drawn from the *Iliad*'s first book are not represented here. 'Erstaunlich ist aber dennoch', writes Valenzuela Montenegro 2004: 217, 'dass nicht gezeigt wird, wie Briseis auf Anweisung des Agamemnon aus dem Zelt des Achill abgeholt wird, obwohl dies eine wichtige Standard-Episode war.' But the artist's evident eye for visual mirroring—concerned with the overall rhythm of the frieze's composition,

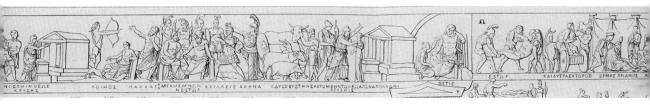

FIGURE 69. Drawing of the same detail.

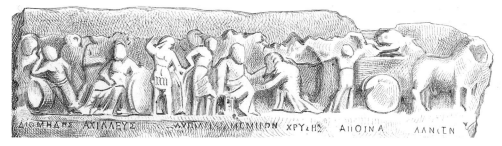

FIGURE 70. Drawing detail of the upper frieze on the obverse of tablet 3C.

Quite how the scene of Chryses and Agamemnon would have related to the other scenes in the upper register of the Capitoline tablet remains contested. Comparison with tablets 3C and 6B, with their cattle-drawn chariot of Chryses, suggests that it occupied the area immediately to the left of the surviving fragment. This raises the question of what originally occupied the lost section of this frieze at its far left side.[108] As on tablet 3C, the Capitoline tablet seems to have begun with scenes that in fact prefigured the opening of the *Iliad*, possibly inspired by other poems like the *Cypria*: if so, the upper register encapsulated in its single line not just the whole *Iliad*—from *alpha* to *omega*—but an epic cycle that actually stretched beyond that single poem.[109]

While the visual resonances across the upper frieze of the *Tabula Capitolina* incite viewers to construct links across its horizontal length (and thereby across events described in the first and twenty-fourth books of the poem), other iconographic echoes suggest connections along a vertical axis. We have already noted the symmetrical temples arranged in the central *Ilioupersis* scene (p. 163). But if we now view this central panel in association with the frieze running above it, we notice a corresponding pair of temples framing the band's central point (Fig. 71). Compare too, to the right of that upper left-hand temple, the motif of

and therefore choosing instead the argument between Agamemnon and Achilles as its iconographic centrepiece—helps to account for such 'surprising' omissions.

[108] Cf. ibid. 35.

[109] On tablet 3C, see O. Jahn 1873: 9; Weitzmann 1959: 42; Sadurska 1964: 41; Valenzuela Montenegro 2004: 171, together with ibid. 216 on the implications for other tablets.

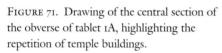

FIGURE 71. Drawing of the central section of the obverse of tablet 1A, highlighting the repetition of temple buildings.

FIGURE 72. Drawing of the central section of the obverse of tablet 1A, highlighting two iconographic echoes between the upper frieze relating to *Iliad* 1 and the central *Ilioupersis* scene.

Apollo aiming his bow, recalled by the schema of the warrior in the central panel below;[110] or indeed the seated Agamemnon at the centre of the upper frieze, which relates to the seated Priam towards the centre of the central scene of Troy's destruction (where Achilles draws his sword to the right of Agamemnon, Achilles' son, Neoptolemus, lunges at King Priam) (Fig. 72). Events outside the walls of Troy and before its fall mirror those inside the city and during the course of its destruction: the images of the *Iliad* at once anticipate and follow on from those of the *Ilioupersis*.

If such interpictorial echoes establish connections along a central vertical axis, the tablet nevertheless frustrates any *linear* reading from top to bottom. Much care has been expended on the vertical alignment of scenes. Yes, the symmetrical placing of the quarrel between Achilles and Agamemnon at the centre of the tablet's upper band, directly above Aeneas' flight from Troy, might suggest a programmatic connection between these two episodes. And yet the two separately framed scenes of the *Aethiopis* and *Little Iliad*, at the base of the tablet, simultaneously complicate any implication of unilinear temporal progression.

[110] Admittedly, questions must remain here about the scene's damaged appearance (cf. O. Jahn 1873: 11): still, the upper figure of Apollo with his bow seems to have been visible to Feodor Ivanovich when drawing the tablet, and there are numerous iconographic parallels (cf. Valenzuela Montenegro 2004: 36–7).

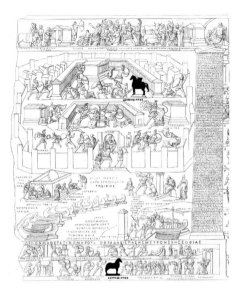

FIGURE 73. Drawing of the central section of the obverse of tablet 1A, highlighting the repetition of the Trojan horse.

Although we have only fragmentary information about these two mini-epics (based largely on Proclus' fifth-century summaries), we know that both poems described events taking place *between* the end of the *Iliad* and the final sack of Troy.[111] On this tablet, however, the friezes relating to these two poems are placed underneath the *Ilioupersis*, forming an additional but separate geographical unit.[112] Just when viewers seem to have moved *beyond* the fall of Troy, with Aeneas' departure figured directly above, these scenes, framed on either side by the central books of the *Iliad*, lead us back to the city and its looming destruction. Resisting narrative progression from the tablet's top to bottom, the panel serves not as an epilogue but rather as a preface to the *Ilioupersis*: we start all over again. As ever, iconographic echoes underscore the point. Observe, for example, how the *Little Iliad* frieze anticipates the whole story laid out above: the wooden horse towards the centre of the lower panel—roughly aligning with the Agamemnon–Achilles scene at the tablet's top, and the flight of Aeneas scene in its middle—

[111] Davies 1989 provides an excellent short guide to the epic cycle, treating the two poems at 53–73. On the scenes from the *Aethiopis* and *Little Iliad* here, see Valenzuela Montenegro 2004: 96–115, together with 362–8.

[112] The Scaean gate at the right of the frame, identified with an inscription (Σκαιὴ πύλη), neatly combines the two registers: in a literal sense, the 'big' *Iliad* lies just the other side of these 'little' (or at least 'littler') epitomes of the *Little Iliad*: cf. below, p. 255.

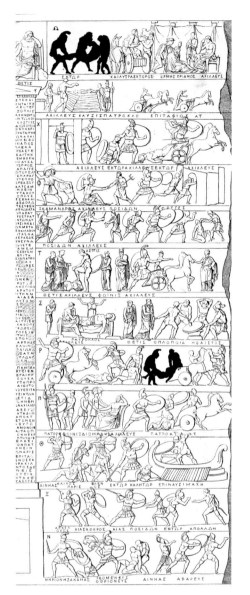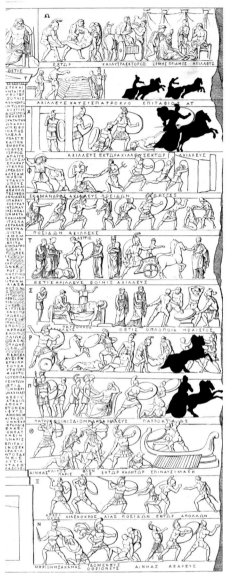

FIGURE 74. Drawing of the right-hand side of the obverse of tablet 1A, highlighting an iconographic connection between friezes *rho* and *omega*.

FIGURE 75. Drawing of the right-hand side of the obverse of tablet 1A, highlighting an iconographic connection between friezes *pi*, *rho*, *chi*, and *psi*.

recalls and reverses the wooden horse in the *upper* register of the *Ilioupersis* scene, inscribed with the same words (δούρηος ἵππος: 'wooden horse') (Fig. 73).[113]

These iconographic connections across both horizontal and vertical axes do not just encourage us to forge new stories. They also draw out associations that are integral to the Homeric verbal treatment. Take the upper right-hand corner of the tablet, where Hector's body is lifted by three warriors: this is frieze *omega*, corresponding to the final book of the poem. Not for nothing, however, does the iconography of this uppermost frieze visually recall the schema seven friezes below (in register *rho*, pertaining to the seventeenth book of the poem) (Fig. 74). In that lower scene, it is Patroclus' corpse that is likewise lifted and loaded on to a chariot. And yet, iconographically, Hector's corpse in row *omega* is depicted in analogous terms to Patroclus' in frieze *rho*, suggesting a semantic relationship between these two deaths—Patroclus' slaughter at the hands of Hector, and Achilles' consequent killing of Hector. The two penultimate registers, which refer to the twenty-second and twenty-third books of the poem, further develop the parallel. To the right of register *chi*, Achilles is shown dragging the body of Hector around the walls of Troy in his chariot; above (in row *psi*) we see on the left the outstretched body of Patroclus, and on the right the funeral games held in Patroclus' honour. Once again, iconographic correspondences suggest an analogy between these parallel deaths: just as the outstretched body of Hector is echoed in the supine body of Patroclus on top of his funerary pyre, the rearing horses of Achilles' chariot are mirrored in the two chariots racing in honour of Patroclus above. Visual rhymes materialize semantic associations that are integral to the narrative texture of the *Iliad*.

The *Tabula Capitolina* toys with such iconographic analogies with incredible sophistication. Look again at the repeated horse and chariot motif of friezes *psi* and *chi*. If we scan the other friezes of the tablet, we find this schema in other registers besides; in each case, the motif's recurrence suggests still further narrative connections (Fig. 75). We might compare, for instance, the horse-drawn wagon above in row *omega*—this time containing Priam's gifts to Achilles, and facing the other way (prompting us to look to the left, at Hector's outstretched corpse). On the other hand, the schema might lead us to look *down* the composition, comparing the charioteer scene in row *tau*, where, in the nineteenth book of the *Iliad*, Achilles first sets out to avenge Patroclus. In each case, visual resemblances weave together narratological causes and effects: Hector's killing of Patroclus, Achilles' killing of Hector, the funerary games held in Patroclus' honour, the embassy of Priam to Achilles to reclaim Hector's body for proper burial...

[113] On the two wooden horse scenes, see Valenzuela Montenegro 2004: 112–13, 119–21; for the Trojan horse in Roman art, cf. Sparkes 1971 and M. Fuchs 2007.

An even more striking iconographic parallel is to be found still lower on the tablet, in rows *pi* and *rho* (referring to the sixteenth and seventeenth books of the poem). As in rows *psi* and *chi* above, two chariots occupy the right-hand of these two registers, each teamed by a pair of rearing horses. If the schema in register *rho*, visualizing the death of Patroclus in book 17, thereby reinforces the analogy with the events depicted in the upper three registers, it also establishes a visual connection with the episode depicted immediately below. To the right of frieze *pi* we see Patroclus' greatest heroic feat—the death of the Lycian Sarpedon, who fought on the Trojan side; directly above it, though, we witness Patroclus' own death at the hands of Hector. In pictorial terms, the two episodes are presented as in some sense analogous. At the same time, the schema of Hector standing astride his chariot, framing the other side of register *rho*, echoes that of Achilles in rows *tau* and *chi*: iconographically, there is a clear association between Hector, proceeding on his chariot to slay Patroclus, and Achilles above him, also riding out on his chariot, but now dragging the body of Hector behind him in his determination to avenge Patroclus' death. On the level of the individual frieze, the iconographic echo gives frieze *rho* its own independent symmetry: the frieze starts with Hector astride his chariot, and ends with Patroclus' body being loaded on to a Greek chariot. In terms of this collective series of friezes, the interpictorial allusion between registers provokes new narrative connections: it guides our eye in all manner of different directions and stories.

THE *TABULAE ILIACAE* AND THE AESTHETICS OF PLAY

Countless more examples could be cited, but they would not alter my overarching point: that, while purporting to arrange these episodes in linear sequence, the Capitoline tablet prompts us to construct multiple spatial connections between the scenes it depicts. The visual correspondences between the tablet's different parts give viewers free rein to weave different verbal stories around its visual imagery, exploiting iconographic connections for innovative interpretive effect: they self-consciously invite audiences not just to *follow* the verbal account, but to *play* with the images (and texts) in hand.

The visual nature of this play makes it impossible to articulate the infinite number of associations; the loss of the left side of the tablet also means that there can be no final word on overall layout. Still, we can be sure that, in visualizing epic, this tablet evidently *did* things to the stories depicted. This surely explains why so many figures break free from their horizontal frames, puncturing the registers above and below (in rows *omicron*, *pi*, and *rho*, for example, corresponding to the fifteenth to seventeenth books of the poem (Fig. 41)): the spatial configuration of the *Iliad* means that the poem's heroes and highlights

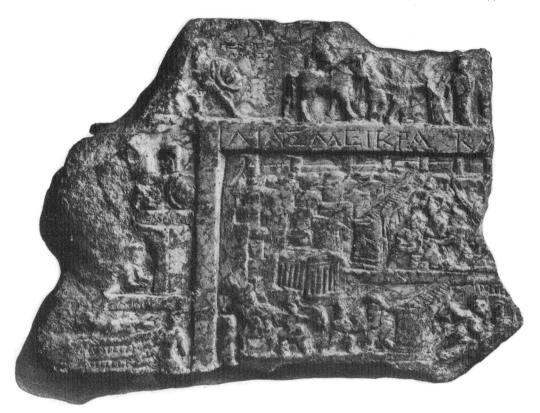

FIGURE 76. Obverse of tablet 7Ti.

cannot be contained in sequential order, but rather interact with each other in *inter*-pictorial ways.[114]

So far in this chapter I have focussed on the spatial and iconographic games of the Capitoline tablet alone. As one of the most complete *Tabulae Iliacae*, this miniature case study best conveys the interpretive gymnastics of responding to the tablets at large. But the playful visual aesthetics of the Capitoline tablet find numerous comparanda on other fragments. We have already mentioned some of the compositional parallels between the *Tabula Capitolina* and the 21 other tablets in the second chapter (pp. 39–54): as we have said, at least four fragments parallel the tablet's structuring of the *Iliad* around the *Ilioupersis* (2NY, 3C, 6B, and 9D). We can also be sure that the schema of Aeneas leaving Troy

[114] The fact that so many scenes and characters go uninscribed leaves infinite verbal room for visual speculation and reappraisal. In this connection, notice how one Iliadic frieze lacks *any* inscriptions whatsoever (frieze *rho*, relating to the poem's sixteenth book: cf. Valenzuela Montenegro 2004: 60–2). The absence of inscribed text leaves space for a sort of 'Homeric karaoke': it is now the viewer's turn to fill in the gaps, label the figures, add the voice, and play/sing along.

recurred at the centre of fragment 2NY, and traces of the same arrangement can also be found on tablets 3C and 7Ti (Fig. 76).[115]

For all these parallels, however, different tablets instituted different spatial and compositional variations. While the tablets are remarkably diverse in their arrangement and layout, each toys with the suggestion of linearity in related ways. The fragmentary nature of the evidence must make reconstruction speculative, at least at times. But there can be no doubting the overarching argument.

Let me begin with tablet 2NY (Fig. 120). Where tablets 3C and 6B, like tablet 1A, placed the opening book of the *Iliad* above the central *Ilioupersis* scene, this tablet clearly juxtaposed single metopes of the second, first, twenty-fourth, and twenty-third books in its upper band (Fig. 77). Only the right-hand section of the upper register remains, pertaining to books 24 and 23 (to the right, with book 22 then placed below that: Fig. 78). Given the most likely reconstruction of the large inscription above the *Ilioupersis* scene ([*ΙΛΙΑΣ ΚΑΤΑ ΟΜΗΡΟ*]*Ν ΚΑΙ ΙΛΙΟΥ ΠΕΡΣΙΣ*), and the iconography of the metope pertaining to book 24, we can be confident about the upper band's horizontal arrangement.[116] If the juxtaposition

[115] For the central image of Aeneas, Anchises, and Ascanius before Troy's city gates on 2NY, see Valenzuela Montenegro 2004: 191, together with Bulas 1950: 112–13 (on the close relationship between the *Ilioupersis* scenes on tablets 1A and 2NY). Likewise, the name of Aeneas is the only surviving inscription on the fragmentary *Ilioupersis* scene of 3C (cf. e.g. *IG* 14: 334, no. 1285, along with Valenzuela Montenegro 2004: 170); although the tablet is lost, remnants of the same image of Aeneas collecting the Penates were also possibly to be found to the bottom left of the *Ilioupersis* scene on tablet 7Ti (Fig. 76) (see Valenzuela Montenegro 2004: 203). Perhaps still more interestingly, Aeneas receives a reference in the long 'Zenodotean' inscription on tablet 8E (line 61), as noted by de Longpérier 1845: 445–6: might Aeneas have occupied the centre of that composition too?

[116] Cf. Squire forthcoming e. According to my reconstruction, books *beta* (2) to *mu* (12) would occupy a left-hand column, and books *nu* (13) to *psi* (23) the column to the right. This arrangement, with four metopes in the upper band, is confirmed by the iconography not only of the central *Ilioupersis* scene, but also that of metope *omega*, which contains to its left just enough space for the standing Achilles mentioned in the inscribed label below (an almost exact iconographic parallel can be found on tablet 21Fro). So much for the horizontal span. But what about the tablet's original vertical length? Bulas 1950: 112 suggests that scenes from the *Aethiopis* or *Little Iliad* were most likely represented at the base of the tablet. Valenzuela Montenegro 2004: 186 challenges Bulas's suggestion: 'Genausogut wäre es auch denkbar, dass das Zentralbild allein von Ilias-Bildern eingefasst war—dies ist heute nicht mehr zu entscheiden'. But Valenzuela Montenegro's suggestion seems to me unlikely. If (as seems probable given its correspondence in so many other respects) the *Ilioupersis* scene on 2NY was of similar compositional design to that on tablet 1A, the surviving fragment preserves approximately two-thirds of the scene's original length, even though it is flanked by only four Iliadic friezes (books 19–22): there could therefore be room for at most two and a half additional scenes below book 19 on the right of the tablet, not the five or so friezes (books 14–18) that Valenzuela Montenegro's suggestion would necessitate. The additional space below the central *Ilioupersis* scene—relating to other epics, or else perhaps inscribed with a verbal synopsis—would therefore extend the tablet's vertical length, providing more room for the Iliadic scenes to the left and right. This length is confirmed independently by the 'magic square' on the tablet's verso. By comparing the extant section of this square (Fig. 119) with a reconstruction of the whole (Fig. 103), it is clear that the maximum dimensions of the surviving fragment preserve just over half of both the original width and length: the schema of Aeneas escaping Troy at the centre of tablet 1A did not occupy the exact symmetrical centre of the New

Iliad 2	Iliad 1	Iliad 24	Iliad 23
Iliad 3			Iliad 22
Iliad 4			Iliad 21
Iliad 5			Iliad 20
Iliad 6			Iliad 19
Iliad 7			Iliad 18
Iliad 8			Iliad 17
Iliad 9			Iliad 16
Iliad 10	OTHER IMAGES		Iliad 15
Iliad 11	OR INSCRIPTIONS		Iliad 14
Iliad 12	?		Iliad 13

FIGURE 77. Possible reconstruction of the obverse of tablet 2NY.

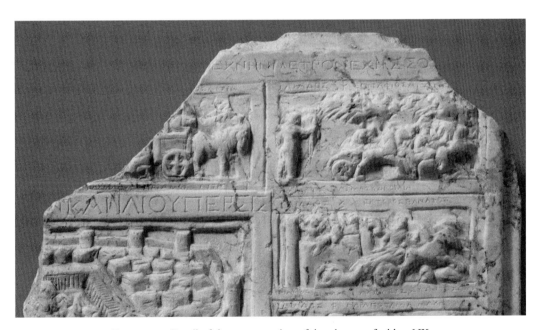

FIGURE 78. Detail of the upper section of the obverse of tablet 2NY.

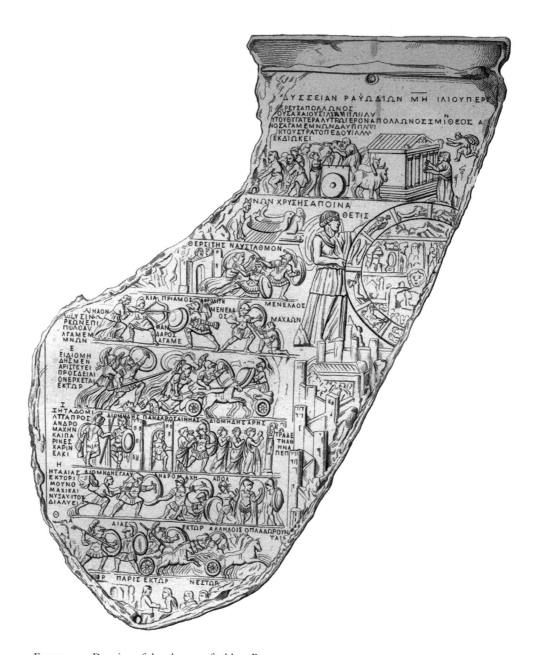

FIGURE 79. Drawing of the obverse of tablet 6B.

Iliad 1			Iliad 24
Iliad 2	Shield of Achilles		Iliad 23
Iliad 3			Iliad 22
Iliad 4			Iliad 21
Iliad 5	Ilioupersis		Iliad 20
Iliad 6			Iliad 19
Iliad 7			Iliad 18
Iliad 8			Iliad 17
Iliad 9			Iliad 16
Iliad 10			Iliad 15
Iliad 11			Iliad 14
Iliad 12			Iliad 13
O	d y s	s e	y
1–6	7–12	13–18	19–24

FIGURE 80. Possible reconstruction of the obverse of tablet 6B.

of Iliadic scenes in the upper register challenged any straightforward movement from books *alpha* to *omega*, the iconographic design seems to have performed something similar, drawing the viewer's eye in the *opposite* direction from the narrative order of the poem (Fig. 78). Observe, for example, how Priam's horse-drawn chariot at the surviving edge of the central upper metope travels from left to right (in stark contrast to the same detail on the Capitoline tablet): viewers are led to trot backwards from the twenty-fourth to the twenty-third book. Still more significantly, a related motif is repeated in the scene of chariot racing to the right (part of Patroclus' funerary games, as described in book 23), and then once again in the scene of Achilles dragging Hector's body from book 22 below (the iconographic parallel now leading viewers down the side of the tablet). Such visual prompts to proceed in *clockwise* motion encourage us to break free from the temporal order imposed by the text. Not for nothing, perhaps, is the ransoming of Hector's body twice labelled as λύτρα—not just 'ransoms', but also 'solutions' or 'settings free': are we being told not just of the 'ransom' of Hector in *Iliad* 24, but also of a sort of 'solution' to the poem at large—releasing viewers, as it were, from the narrative bind of the text?[117]

York tablet. The objection of Sadurska 1964: 39—namely, that such poems go unmentioned in the fragmentary inscription at the top of the tablet, which seems to have referenced the *Iliad* and *Ilioupersis* alone—proves inconsequential: the poetic subjects could easily have been inscribed directly above the scenes themselves, on the corresponding lower part of the *Ilioupersis* frame; alternatively, the subjects might have gone unmentioned in the inscription—just as the inscription on the tablet's verso refers only to the Homeric *Iliad*, and not to the *Ilioupersis* (see below, p. 208).

[117] The Greek pun works somewhat better in German than in English ('Lösung'): the fact that we find the word in the same context on tablets 1A (both in the stela inscription and inscribed underneath frieze *omega*), 12F (twice), and 20Par (twice), always in relation to the 'resolving' final book of the poem, is perhaps significant; for those inscriptions, see Valenzuela Montenegro 2004: 31, 89, 213, 183.

While in many ways similar in composition to the *Tabula Capitolina*, tablet 6B introduced three different spatial innovations of its own (Figs. 79–80). First, it placed a representation of the shield of Achilles (relating to the eighteenth book of the *Iliad*) directly above the central *Ilioupersis* scene. Second, it dispensed with the demarcated boundaries between its different spatially organized sections, so that the *Iliad* literally runs into the *Ilioupersis* (and vice versa). Third, and most importantly, the tablet seems to have interspersed scenes from the *Odyssey* either side of its Iliadic representations at the bottom of the tablet.[118] Between the two halves of this visualized *Iliad*, in other words, audiences were confronted with a later history which took place *after* the Trojan War. Spatial configurations are once again manipulated for playful hermeneutic effect.

The Odyssean scenes on tablet 6B no longer survive, and the object itself is today lost. But one extant tablet (16Sa) representing all 24 books of that poem evidently did play with narrative sequence in equally sophisticated ways (Figs. 81–2).[119] The Roman numerals are modern erroneous additions, and the surface of the tablet is heavily worn.[120] But enough survives to allow a plausible reconstruction of the sequence of scenes, arranged around a central image of Poseidon.[121] In contrast to the Capitoline tablet, these individual panels do not unfold from the top left corner in ascending and descending order. Instead, the metope pertaining to the first book of the poem seems originally to have been placed at the top of the third column from the left, so that the episodes opening the poem are set against those closing it at the top right. At the bottom of the tablet, moreover, books 13–16 are made to snake around the two lower registers, first from bottom to top, and then from top to bottom. Like numerous others, the object raises questions about where to start, in which direction to proceed, and indeed where to end. Here, though, the spear of Poseidon, criss-crossed against the body of the dolphin, meshes the whole composition together, directing our gaze diagonally around the tablet (rather in the manner of a modern Snakes and Ladders board, leading us at once up, down, and across the narrative structure of the associated verbal text). In a literal and metaphorical sense, the episodes go

[118] On the composition, see Lippold 1932: 1888; Weitzmann 1941: 167–9; Sadurska 1964: 48; Valenzuela Montenegro 2004: 150–1 (with further bibliography).

[119] As noted above (p. 61 n. 91), the tablet has sometimes been deemed a 'later imitation'. But the charge is unwarranted, and the spatial games are very much in keeping with those of other surviving tablets.

[120] For the modern numbers—'of recent date and made by a man who only wanted to enumerate the panels'—see Weitzmann 1941: 169.

[121] The identification of individual scenes here is based on Weitzmann 1941, followed by Sadurska 1964: 72–3, Brilliant 1984: 58–9, and Schefold and Jung 1989: 331–2—although, it should be said, the identifications are not without their problems. We can perhaps be more confident about the significance of organizing the 24 single images around the central panel of Poseidon: the cyclical story of the *Odyssey* is framed around this *deus ex machina*—one that sums up the full chronological sweep of Odysseus' adventures.

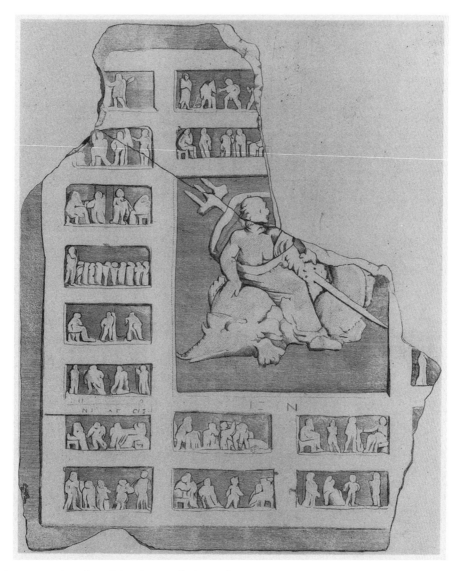

FIGURE 81. Drawing of the obverse of tablet 16Sa.

5	3	1	24
6	4	2	23
7			22
8		POSEIDON	21
9			20
10			19
11	14	15	18
12	13	16	17

FIGURE 82. Possible reconstruction of the obverse of tablet 16Sa.

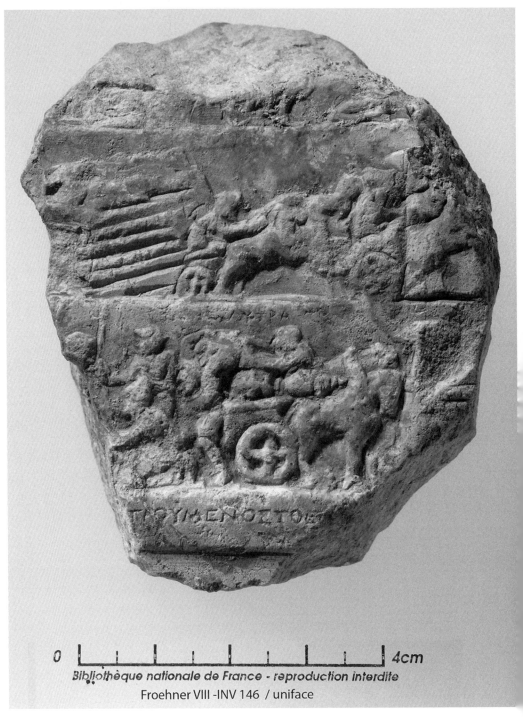

Froehner VIII -INV 146 / uniface

FIGURE 83. Obverse of tablet 21Fro.

round in circles: there are rival orders, histories, and narratives to be constructed, bound only by the circumferential imagination of the viewer.

Although they are more fragmentary, something similar might be said for tablets 7Ti and 21Fro, as well as for smaller fragments like 11H, 12F, and 13Ta. Tablet 7Ti is today known only from photographs, but it seems to have depicted the *Aethiopis* rather than the *Iliad* around its central *Ilioupersis* scene (Fig. 76); given that an inscription declares one of its subjects to be the *Little Iliad*, moreover, it is at least possible that, stretching the first book of the *Aethiopis* above the *Ilioupersis* scene, the beginning of the *Aethiopis* met with the closing of the *Little Iliad*, just as the Capitoline tablet juxtaposed the first and last books of the *Iliad*.[122] Unlike tablet 7Ti, which preserved parts of its lower left and upper frame, fragment 21Fro is broken on all sides, making it difficult to determine its original composition (Fig. 83). Nonetheless, the inscriptions and iconography indicate that the final two books of the *Iliad* represented here were arranged in the opposite order to that of the *Tabula Capitolina*: the books do not ascend from bottom to top, but rather descend from top to bottom.[123]

As we noted in the second chapter, tablets 11H, 12F, and 13Ta are still more fragmentary and we cannot always be sure about their overall visual structure. In their current state, each fragment relates to just one book of Homeric poetry (*Odyssey* 10, *Iliad* 23, and *Iliad* 22 respectively), and yet each tablet also seems to preserve original edges (and on two or three different sides).[124] If this suggests that these particular tablets depicted a smaller range of subjects, they nonetheless appear to have done so in no less playful ways: 11H (Fig. 84) synthesized a number of episodes in its single synoptic scene, with the inscription below relating the story to the larger frame of Odysseus' narrative to the Phaeacians ('From the description to Alcinous of book 10');[125] 12F set the final scene of the

[122] For the inscription, see Rayet 1882: 20 (= 1888: 186: the extant letters read *ΙΛΙΑΣ ΜΕΙΚΡΑ ΚΑ*[); for the composition, see Valenzuela Montenegro 2004: 200. Sadurska 1964: 52 instead suggests that 'la Petite Iliade mentionnée dans l'inscription devait être illustrée soit dans la partie latérale, soit dans la partie inférieure du bas-relief, aujourd'hui disparues'.

[123] Cf. Valenzuela Montenegro 2004: 183, further suggesting arrangement around a central *Ilioupersis* scene. The two chariot scenes laid on top of each other in the fragment (Patroclus' funerary games above, and Priam's wagon below) develop the same iconographic parallel observed on the Capitoline tablet (see above, pp. 175–6). For the record, it should be noted that the verso of the tablet preserves a ridged edge towards its base (unnoticed by Horsfall 1983: 86 and Valenzuela Montenegro 2004: 183), suggesting that the verso fragment was from the tablet's bottom part (i.e. the lower section recto also derives from the original lower extremity of the tablet).

[124] Original edges can be seen at the bottom, top, and top left corner of tablet 11H (cf. Valenzuela Montenegro 2004: 257); the bottom and top of tablet 12F (cf. ibid. 213); and the top, left-hand, and right-hand part of tablet 13Ta (cf. ibid. 210).

[125] ἐκ τῆς διηγήσεως τῆς πρὸς Ἀλκίνουν τοῦ κάππα: for discussion, see Valenzuela Montenegro 2004: 257–8.

FIGURE 84. Drawing of the obverse of tablet 11H.

Ilioupersis directly below the background of the city walls, so that this episode literally foreshadows the iconography of Troy's impending doom on other tablets;[126] although the identification of its lower scene remains uncertain, tablet 13Ta seems to have dispensed with strict spatial divisions between the depicted books of the *Iliad* altogether, representing different events and protagonists according to different scales.[127]

Still more significant is the way in which one tablet framed its central *Ilioupersis* scene with two interspersed subjects, at once vertically and horizontally arranged. To the right of fragment 9D can be made out the left-hand extremity of Troy's wall (Fig. 85): as on the Capitoline tablet, the central scene here originally depicted the sack of the city. But this image is framed to its left

[126] The similarity is noted by Valenzuela Montenegro, ibid. 214.

[127] For two reviews of the tablet's subjects, see Sadurska 1964: 67–8 and Valenzuela Montenegro 2004: 210–12: Valenzuela Montenegro follows Robert 1875: 268–9 in associating the lower scene with the shield of Achilles in book 18 of the *Iliad* (cf. below, p. 357 n. 134). Because the iconography of the upper scene clearly relates to the twenty-second book of the poem, the juxtaposition would raise interesting questions about narrative sequence: for some preliminary discussions, see Robert 1875: 271–2, although the preservation of left- and right-hand edges makes Robert's reconstruction impossible (Robert supposes a size of 36 x 36 cm).

not with one but rather with two sets of scenes, arranged in two vertical columns: on the far left are three images relating to the final three books of the *Iliad*, proceeding from bottom to top; to the right, though, are five scenes drawn from the *Aethiopis*, this time unfolding from top to bottom, and depicted on a smaller scale (Fig. 86).[128] Like the inscriptions to the side of each scene, laid out from left to right as well as from top to bottom, these individual images can be read in multiple directions: in a literal sense, viewers are invited to read the *Aethiopis* stories *between* those of the *Iliad* and *Ilioupersis*, moving horizontally between the columns as well as up and down along a vertical axis (Fig. 87 provides one possible reconstruction). The oscillating order in which these scenes are arranged—proceeding from above to below, as well as from below to above—further complicates response: the tablet's plurality of organizational strategies encourages viewers to construct a plurality of equivalent and unhierarchicized narrative frameworks.

It seems very likely that tablet 20Par attempted something similar (Fig. 88). Only the four scenes to the right of the fragment are identifiable, depicting episodes from the seventeenth to twentieth books of the *Iliad* (as indicated, apart from the inscriptions and iconography, by the two surviving letter inscriptions on the right—*sigma* and *tau*, relating to books 18 and 19 respectively). But the 'magic square' inscription on the tablet's reverse nevertheless aids in reconstructing the original appearance of its obverse: the verso (Fig. 102) preserves the right-hand side of the reverse 'magic square' (Fig. 89), and the text and arrangement of the inscription is almost identical to that on tablets 2NY and 3C (Fig. 103).[129] Two deductions follow: first that, just as the fragment preserves the right-hand part of the verso, it is the left-hand part of the recto which survives (more specifically from the central and lower central parts); second, that given the proportions of the surviving section of text (the right-hand row of squares preserves some 14 boxes from a total of 53), the fragment seems to preserve approximately a quarter of the tablet's original vertical length. Although Sadurska was surely correct to reconstruct the *Ilioupersis* to the right of the surviving fragment, her reconstruction of the composition is probably

[128] For the sequence of surviving scenes, see Sadurska 1964: 56 and Valenzuela Montenegro 2004: 195; the inscriptions leave no doubt about the arrangement, whereby the *Aethiopis* labels refer first to the arrival of Penthesilea, then (below) to her death at the hands of Achilles, third to Memnon's slaughter of Antilochus, fourth to Achilles' slaughter of Memnon, and fifth to Achilles standing at the Scaean gate. Cf. McLeod 1985: 156: 'The outer row ran clockwise, apparently beginning from the upper right side of the central panel; but here once again the inner row ran anti-clockwise, beginning from the upper left side of the central panel.' In the case of tablet 9D, it is just possible, given the verso inscription, that one of the recto's right-hand columns juxtaposed Trojan myths with scenes from a Theban epic cycle (cf. above, p. 47 n. 45).

[129] As noted by Horsfall 1983: 144: see below, pp. 202–4. Sadurska 1966 had made no reference to the verso inscription.

FIGURE 85. Drawing of the obverse of tablet 9D.

Iliad 22–24 Aethiopis Ilioupersis

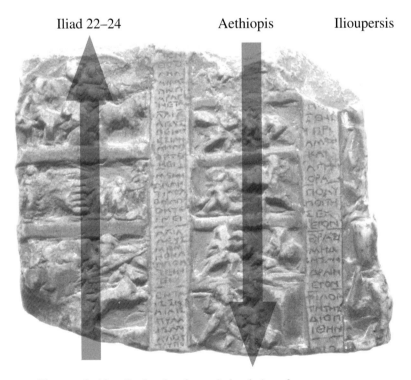

FIGURE 86. Obverse of tablet 9D, showing the vertical ordering of scenes.

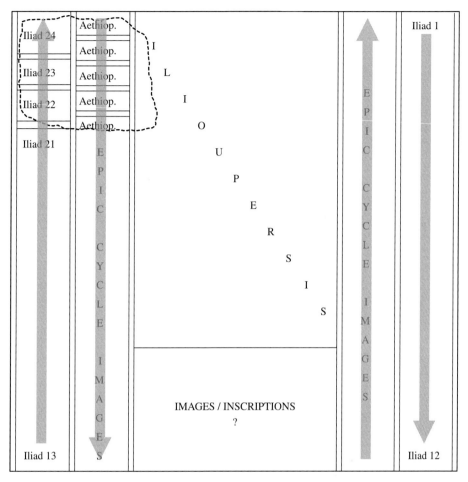

FIGURE 87. Possible reconstruction of the obverse of tablet 9D.

mistaken:[130] as Nina Valenzuela Montenegro has argued, the left-hand scenes can more plausibly be associated with the *Aethiopis* than with *Iliad* books 4–6. The subject matter and order of scenes on tablet 20Par closely parallel that of tablet 9D (Fig. 87).[131]

[130] Sadurska 1966: 653. Sadurska supposed that both surviving columns preserved scenes from the *Iliad*, with books 5 and 6 rendered to the left, and books 18–20 to the right: according to this argument, books 1–12 occupied the left-hand column, and books 13–24 the right (Sadurska 1966: 654, fig. 1b); assuming that 'ces deux rangs étaient placés d'un côté du panneau central', Sadurska added that 'l'autre côté était probablement consacré à l'Odyssée illustrée de même manière' (1966: 656).

[131] Cf. Valenzuela Montenegro 2004: 179, *contra* Sadurska 1966: 654–6. But it is wholly puzzling that Valenzuela Montenegro does not mention the tablet's *reverse* side: the symmetry of the magic square on the verso is crucial in working out the dimensions and scope of the recto.

Interestingly, though, tablet 20Par reverses the arrangement of tablet 9D. Rather than place the *Aethiopis* scenes *between* the *Iliad* and *Ilioupersis*, the object seems to break chronological sequence, depicting first (in the left-hand column) the chronologically later events of the *Aethiopis*, then (in the best surviving middle column) their antecedents in the *Iliad*, and only finally (in the centre) their culmination in the *Ilioupersis*. If this reconstruction is correct, the order must have been inverted in the right-hand part of the original tablet, moving from the *Ilioupersis*, back to the *Iliad*, and finally to other poems (Fig. 90). The tablet adds a whole new level—as it were—to the *Iliad*'s direction of events *in medias res*. What is more, it visualizes the sequential dissonance involved via the non-alignment of horizontal rows, opening up still further interpretive possibilities: each of these scenes can now be interpreted in the light not of one, but rather of two images flanking its single side.[132]

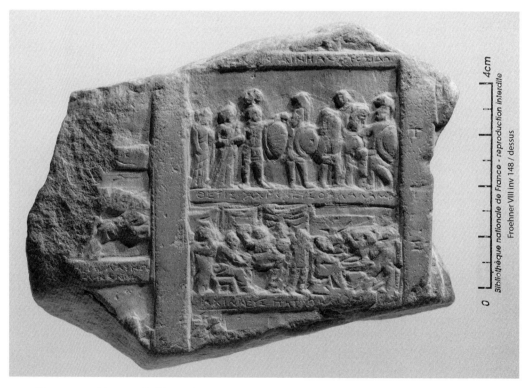

FIGURE 88. Obverse of tablet 20Par.

[132] The implications of these reconstructions for tablets 9D and 20Par are radical: in both fragments, the tablet's left-hand section depicts episodes from the latter books of the *Iliad*; events consequently unfold in clockwise rather than anticlockwise order, inverting the formal arrangements of e.g. tablets 1A, 2NY, 3C, and 6B.

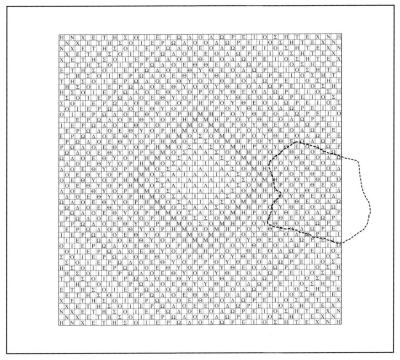

FIGURE 89. Reconstruction of the 'magic square' on the reverse of tablet 20Par.

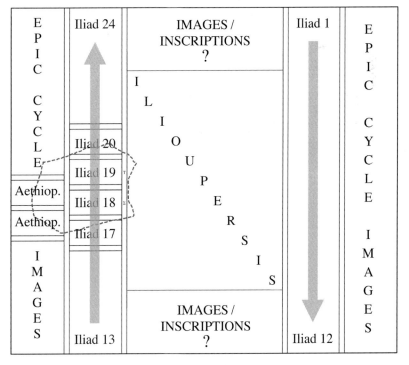

FIGURE 90. Possible reconstruction of the obverse of tablet 20Par.

That these spatial games are not restricted to tablets with Homeric or rather Trojan subjects is clear from two more tablets which, though fragmentary, evidently also invited viewers to play with compositional arrangement. The inscriptions suggest that tablet 10K dealt not with the *Iliad* but with a rival Theban epic cycle on its obverse (Fig. 91). But just as the Trojan tablets invited audiences to experiment with different directional modes of viewing, and along both a horizontal and vertical axis, this tablet seems to have arranged its inscribed obverse columns of text not from left to right, but rather from right to left:[133] although the individual letters of these inscriptions are to be read in one direction (left to right), the collective columns of text, like the images to which they relate, were to be interpreted in reverse order (right to left).[134] The other side of the same tablet evidently toyed with inscribed space in related ways (Fig. 92): we cannot know the order of the two columns inscribed on the top part of the verso fragment—while the full width of the right-hand column's six lines is readable, only a few letters survive from the eight lines of text to the left; and yet the seven lines at the base of the fragment occupy the space of *both* columns, stretching across its entire width.

A closely related phenomenon is to be found on tablet 18L, this time concerned not with epic texts at all, but rather with the 'epic' history of all antiquity (Figs. 93–4).[135] As on the reverse of tablet 10K, the texts of this verso were not juxtaposed with pictures. But the columns of text were nevertheless arranged from right to left rather than from left to right, as opposed to the direction of the individual letters *within* each line.[136] This chronicle of events could therefore be read in either direction, proceeding forwards or backwards in time—from the 'Greek' history on the right to the 'Roman' history on the left, or in reverse spatial and temporal order. Once again, moreover, the arrangement of the words on the tablet's reverse side must have affected responses to the pictures on its obverse, even though that composition today remains obscure: as the following chapter will explore, focussing on one sort of 'diagrammatic' inscription in particular, the concern with the linear sequentiality of words, and likewise with the figurative spatiality of pictures, often extended to *both* of the tablets' two sides.

[133] For the observation, see Valenzuela Montenegro 2004: 264, although leaving the rationale (and significance) of this unexplained, and ultimately concluding that 'Die Deutung sind [*sic*] allerdings nur mit Vorsicht aufzufassen—denn eigentlich ist das Fragment zu klein und zu beschädigt, um eine fundierte Interpretation zu erlauben' (267).

[134] The direction is noted by Valenzuela Montenegro 2004: 264.

[135] Cf. Sadurska 1964: 81–2: 'Les colonnes de gauche à droite contiennent l'histoire des époques de plus en plus anciennes, tandis que chaque colonne à part suit l'ordre inverse, c'est-à-dire qu'après les époques antérieures viennent les époques ultérieures'; the order of the columns is noted by Valenzuela Montenegro 2004: 279 (cf. ibid. 300), but its significance goes unexplored.

[136] For related games with the order of the microscopic text inscribed around the rim of tablet 4N, cf. below, p. 365 n. 147.

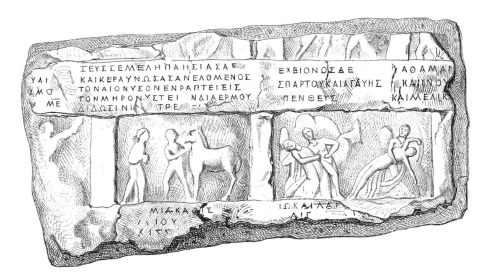

FIGURE 91. Drawing of the obverse of tablet 10K.

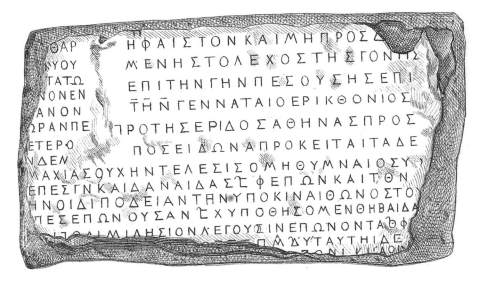

FIGURE 92. Drawing of the reverse of tablet 10K.

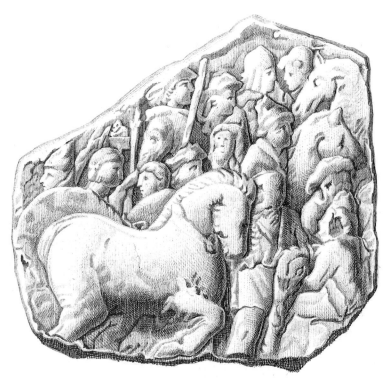

FIGURE 93. Drawing of the obverse of tablet 18L.

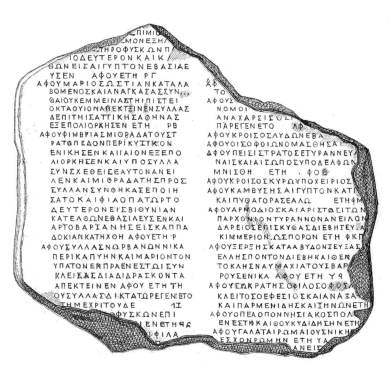

FIGURE 94. Drawing of the reverse of tablet 18L.

CONCLUSION: RE-VIEWING THE 'ORDER OF HOMER'

There is much more to say about the varied compositional arrangements and iconography of the Iliac tablets. But my aim in this chapter has been more miniature in scope: to demonstrate, by means of example, how these tablets are as sophisticated in their imagery as they are in their inscribed texts. Reading their images as 'illustrations'—as straightforward pictorial substitutes for texts—scholars have missed almost all the visual games that the tablets play with their viewers. These objects evidently present us with a *multi*-directional traffic between poems and picture: just as our knowledge of epic affects our viewing of this iconography, the reliefs actively modify, shape and revise our approaches to the stories depicted. Image and text explore and exploit the multiple ways in which each medium might take up, embellish, flirt with, develop, and even change outright the multiple meanings constructed out of the other.

With this in mind, let me end by revisiting the Capitoline epigram discussed in the previous chapter (pp. 102–21). The epigram, we remember, instructs us to learn the 'order of Homer' (τάξιν Ὁμήρου), associating this with both 'Theodorean *technê*' and the 'measure of all wisdom':

[τέχνην τήν Θεοδ]ώρηον μάθε τάξιν Ὁμήρου
ὄφρα δαείς πάσης μέτρον ἔχῃς σοφίας.

> Understand the *technê* of Theodorus, so that, knowing the order of Homer, you may have the measure of all wisdom.

It is surely significant here that the epigram explicitly flags *taxis* as one of the tablet's foremost concerns. As we have seen, the *Tabula Capitolina*—like the other Iliac tablets—at once constructs and destabilizes an infinite variety of viewing strategies and sequences: it exploits its visual arrangement to encapsulate established linear progressions of episodes, events, and indeed whole epic texts, all the while suggesting new spatial connections between them.

But it is inherently taxing, this self-declared *taxis*. If the tablet depicts the 'order', 'disposition', and 'serialization' that Homer himself imposes on 'Trojan' events, it also celebrates the *taxis* that Theodorus has in turn superimposed on Homeric epic—itself now subject to the visual whim of the viewer. The syntax of the epigram brilliantly captures the ambivalence. After all, are we to understand τάξιν Ὁμήρου as an appositional extension of 'Theodorean *technê*', with both phrases governed by a single verb ('understand the Theodorean craftsmanship, that is to say the order of Homer...')? Or do the two phrases in fact offer rival alternatives, each governed by different verbs ('understand the Theodorean craftsmanship, so that knowing the order of Homer'...)? Both readings are possible: the exact relationship between Homer and Theodorus—at once collaborative and competitive—remains as ambiguous as 'Theodorean *technê*' itself.

This ambivalence, I think, is further reflected in the phraseology of τάξιν Ὁμήρου, which lends itself to at least two different readings. On the one hand, the noun τάξις refers to any sort of 'listing' or 'treatise' as well as, more specifically, to a particular 'ordering' and 'arrangement'.[137] On the other, the way in which this noun is paired with the genitive Ὁμήρου raises additional questions about the tablet's relation to Homeric poetry: if the words refer to the *original* arrangement of Homeric epic (taking Ὁμήρου as a subjective genitive, deriving from Homer himself), they also simultaneously refer to an arrangement that Theodorus has *artistically* imposed on Homer (Ὁμήρου as objective genitive).[138] The epigram, then, renders our reading of this mini programmatic text no less ambiguous than our viewing of the tablet: if it instructs us to learn the 'order of Homer', it leaves open what that *taxis* might be. Whether dealing with its words or its images, nothing on these tablets is quite what it seems. Choose your *own* adventure.

[137] Cf. Valenzuela Montenegro 2004: 353: 'τάξις kann . . . konkret "Abhandlung" bedeuten, aber auch allgemein die Anordnung' (referring to LSJ s.v. τάξις, VII—albeit with only one example).

[138] *Pace* e.g. Kazansky 1997: 65: 'τάξιν Ὁμήρου means only that the structure of the narrative in the *Tabula* follows Homeric poems'. For discussions, see e.g. Mancuso 1909: 732 (in favour of subjective genitive) and Carlini 1982: 632 (objective genitive—drawing 'l'attenzione sulla qualità del suo prodotto artistico che in così breve spazio condensa tanto vasta materia epica'). I am grateful to Luca Giuliani for his help articulating the point.

Turning the Tables

So far in this book we have focussed on the obverse of the Iliac tablets. Exploring some of their inscriptions (chapter 3) as well as their imagery (chapter 4), I hope to have demonstrated the sophistication of these knowingly intermedial 'iconotexts'.[1] The objects may promise to materialize their stories in the manner of words, laying them out in linear sequence. But the more we look, and the more we follow up the unspoken suggestions of their visual form, the more we see those established verbal versions dissipate before our eyes. We are dealing, in short, with a mode of viewing akin to Roland Barthes's model of reading: 'we read on, we skip, we look up, we dip in again'.[2]

Central to this *jouissance* is the dynamic intervention of the viewer. To respond to the *Tabulae Iliacae* is to re-enact its stories and narrate them anew: the tablets may provide the spatial map, but the narrative journey is very much in the hands of the individual subject. In Barthes's terms, the objects provide 'textes scriptibles' rather than 'textes lisibles': the 'texts' are 'writable' rather than 'readable' because they demand that their audiences take an active role in their (re)narration.[3] But the visuality of the *Tabulae* also takes us beyond Barthes's critical framework: the tablets are not 'texts' at all, but rather objects which knowingly and self-referentially pitch their *lisibility* against their *visibility*—their capacity to be read (their verbal inscriptions, their literary referents, and not least the sequential arrangement of the images) against their capacity to be viewed (the multi-directionality of these images, the inter-pictorial visual allusions, their iconographic references beyond).[4]

With these themes in mind, the present chapter flips the tablets once more, demonstrating how the ideas of their obverse are played out—and indeed reversed—on their reverse sides. By exploring the 'magic squares' inscribed on seven different *Tabulae*, my aim is to associate the playful games of the verso with

[1] For the term, see Wagner 1995: 12 and 1996: 15–17; cf. Mitchell 1994: 83–107.

[2] Barthes 1990: 11–12: 'Thus, what I enjoy in a narrative is not directly its content or even its structure, but rather the abrasions I impose upon the fine surface: I read on, I skip, I look up, I dip in again.' For the relevance of Barthesian poststructuralism in relation to Greek and Roman visual materials, see Spivey 1995.

[3] See Barthes 1974: especially 3–4.

[4] I take the terms 'visibilité' and 'lisibilité' from Paris 1978.

those of the recto: to show how the visual–verbal games of the tablets' versos invert the verbal–visual games of their rectos (and vice versa). In one sense, both surfaces of these tablets make images out of texts: just as the obverse visualizes verbal epic poems (constructing pictures that at once imitate and depart from the linearity of words), so their reverse sides turn textual commentaries on the pictures back into make-believe imagery. Just as we devise our own reading path for viewing the recto, we are free to view the texts inscribed on their verso—'to glide whichever way we choose'. As we shall see, such diagrammatic picture texts lead us to some of the most sophisticated literary and artistic explorations of visual–verbal relations in the Graeco-Roman words. At the same time, however, these seven verso visual–verbal games also lead squarely back to the pictorial terms of the miniature *Tabulae* at large.[5]

ZIGZAGGING (OR AS YOU WILL)

As we observed in the second chapter, 12 of the 22 Iliac tablets were decorated on both sides (2NY, 3C, 4N, 5O, 7Ti, 9D, 10K, 14G, 15Ber, 18L, 20Par, 22Get). The relationship between these tablets' obverse and reverse is often interesting in its own right. The verso of tablet 9D (Fig. 95), for example, offered a genealogy of Cadmus (the Phoenician prince who founded Thebes), even though it is not clear how this relates to the Trojan scenes depicted on its recto; in similar vein, the reverse of 10K yields a synopsis and verbal résumé of the texts depicted on its obverse, as well as a commentary on their authorship, a statement about length and a related family history of Cadmus (Figs. 96–7).[6] With other tablets it remains still harder to determine exactly *which* side of the tablets to label 'recto' or 'verso': both sides of tablet 14G are adorned with images, for instance, each one offering different sorts of synopses—on the one hand a portrait of Homer surrounded by verbal summaries of the *Iliad* (Fig. 98), on the other a single image of battle (Fig. 99).[7] Although we cannot be sure about their original size and composition, something similar happens with the 'historical' tablets 18L and

[5] The discussions that follow in this chapter develop ideas first explored in Squire 2010c: 77–84. For a supposed twenty-third tablet published in 2009, which may just possibly preserve the remains of a related 'magic square' on its reverse side, see Appendix II (pp. 413–16).

[6] On the relationship between the reverse inscriptions of tablets 9D and 10K, see above, p. 47 n. 45; for discussion of the playful spatial arrangements on both the obverse and reverse sides of tablet 10K, see above, p. 192. We cannot know why both tablets should have chosen to focus on Cadmus specifically. In view of the objects' sensitivity to their own visual–verbal mediality, however, one possible explanation might lie in the invention for which Cadmus was most celebrated in antiquity: his introduction of the alphabet (cf. e.g. Hdt. 5.58).

[7] On this particular characterization of Homer, see Valenzuela Montenegro 2002: 86 and 2004: 254–6, together with Schefold 1997: 313 and P. Zanker 1995b: 194–7.

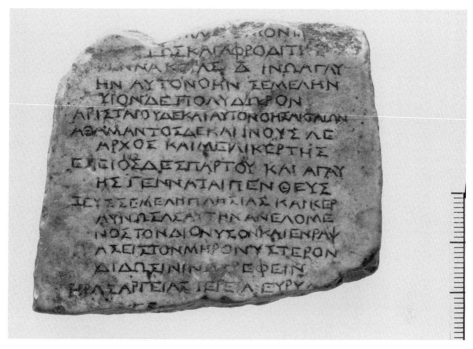

FIGURE 95. Reverse of tablet 9D.

22Get, which both juxtapose large chunks of text on one side with images on the other.[8] As we noted in the second chapter, such double-sided inscriptions further complicate the question of display context. While some have supposed that these two-sided tablets were suspended like *oscilla*, my own view is that they could have been clutched in the hands and passed around a room: viewers were free to turn them over at whim.[9]

This chapter focusses on one particular form of reverse inscription, found on no less than seven different tablets (2NY, 3C, 4N, 5O, 7Ti, 15Ber, 20Par). Most remarkable about these inscriptions is their formal mode of presentation: the individual letters of the text are laid out in the manner of a gridded checkerboard. 'Magic squares', 'Kreuzwortlabyrinthe', and 'giuochi alfabetici del *gramma meson*': these are just three modern ways of labelling the presentation, although there is no evidence that any such generic term was used in the first centuries

[8] See above, pp. 47–51, 192. On the direction of the text columns on the reverse of tablet 18L, and its relation to the spatial games of tablet 10K, see above, p. 192.

[9] Cf. above, pp. 67–85, *pace* e.g. Horsfall 1979a: 34 n. 60 ('One has probably to suppose that those panels where both recto and verso are inscribed were suspended from hooks, hinged or placed on mounts so that both sides could be read'); idem 1983: 147. On the issue in relation to the dual-sided inscriptions specifically, cf. Sadurska 1964: 18–19 (suggesting that versos were only inspected 'au moment d'achat de la table', 19); Bua 1971: 14; Rouveret 1989: 357, 367–9.

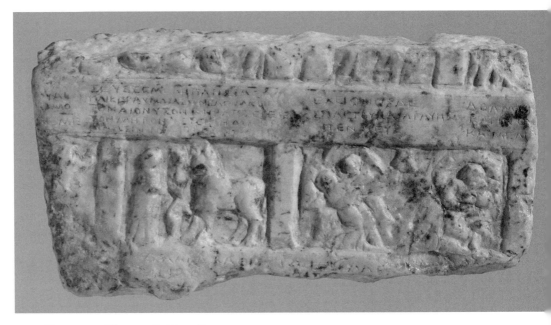

FIGURE 96. Obverse of tablet 10K.

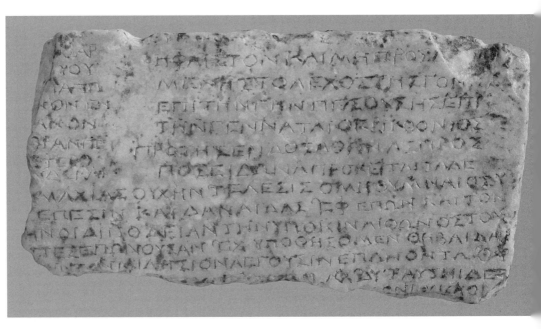

FIGURE 97. Reverse of tablet 10K.

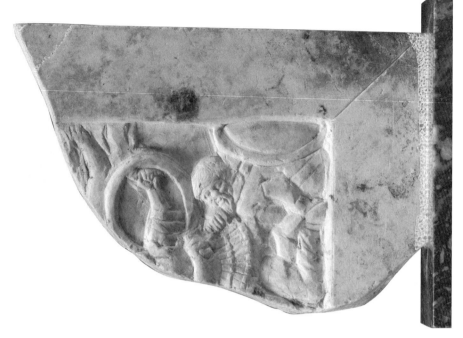

FIGURE 99. Reverse of tablet 14G.

FIGURE 98. Obverse of tablet 14G.

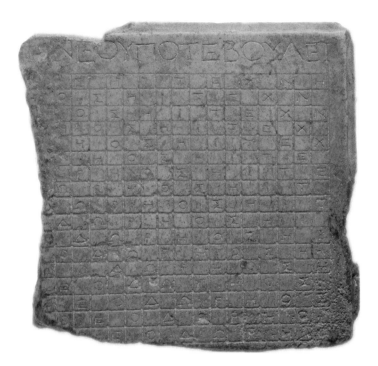

FIGURE 100. Reverse of tablet 3C.

BC or AD.[10] What is certain, however, is that ancient viewers were invited to read the cryptic verbal message of these texts in a variety of directions—horizontally, vertically, and diagonally: whichever way the reader approached them, the sequence of letters makes up the same set of words.

Although none of the grids survives complete, their compositions and texts were clearly related. In her important 1971 analysis of the tablets, Maria Teresa Bua rightly observed that the reverse of tablets 2NY (Fig. 119) and 3C (Figs. 100–1) originally reproduced the same pattern of letters, comprising a grid of 2809 squares (each side containing 53 boxed units: Fig. 103).[11] As we noted in the previous chapter, a very similar inscription and arrangement can be detected on the reverse of tablet 20Par (Fig. 102), helping us to reconstruct the overall

[10] On the later history of such letter games, particularly popular in the seventeenth century, see Bua 1971: 23–35; Hatherly 1986; Rypson 1986 and 1996. My description of these letter grids as 'magic squares' follows convention and should not imply any simple ('ritualistic') association of 'magic' per se (cf. Bua 1971: 15–16 and Kazansky 1997: 65–75). Luz 2010: xvii, 377–82 prefers the name *plinthides*.

[11] Bua 1971: especially 3–17 remains the most detailed analysis of these inscriptions, although puzzlingly Bua views them as evidence for the tablets' derivation from illustrated manuscripts (17–23). Subsequent analyses include Guarducci 1978: 1741–2; Rypson 1986: 71–3; Ernst 1991: 388–93; Salimbene 2002: 5–6; Valenzuela Montenegro 2004: 347–50; Petrain 2006: 59–65. For Agnès Rouveret's important discussion, see above, pp. 71–2, and below, p. 210.

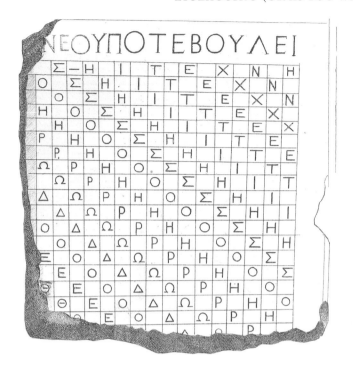

FIGURE 101. Drawing of the reverse of tablet 3C.

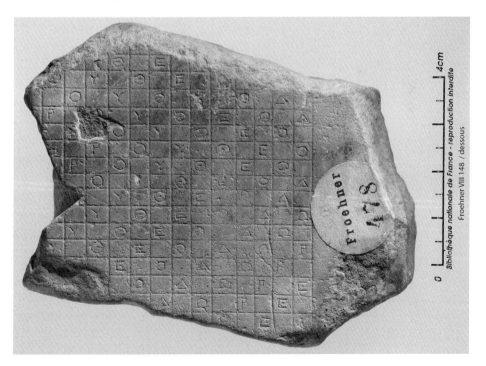

FIGURE 102. Reverse of tablet 20Par.

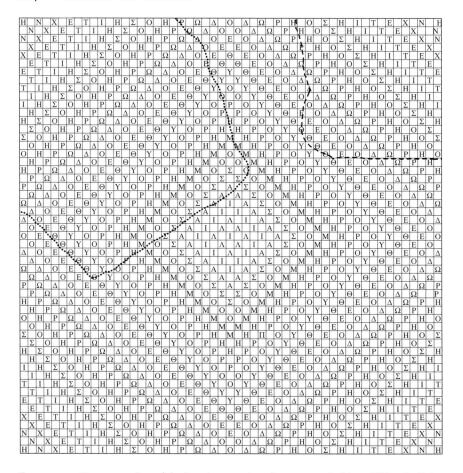

FIGURE 103. Reconstruction of the 'magic square' on the reverse of tablets 2NY and 3C, incorporating the surviving portions of tablet 2NY (top left) and 3C (top right).

composition of that object's obverse side (Figs. 89–90).[12] Particularly interesting about tablets 2NY and 3C are the remains of a second inscription—this time in hexameter form, written above the letter grid, and directly addressing the reader. Each fragment contains 14 letters, tablet 2NY (Fig. 119) preserving the beginning of the line and tablet 3C preserving its end (Figs. 100–1). Because the two tablets were surely inscribed with the same text, Bua put them together to formulate the following reconstruction:[13]

[12] See Bua 1971: 9–11. On the reverse inscription of tablet 20Par, and its relation to that of tablets 2NY and 3C, see above, pp. 187–90. Puppo 2009: fig. 690 is mistaken in reconstructing the same magic square for 20Par as for 2NY and 3C.
[13] See Bua 1971: 6–9, followed by Guarducci 1974: 426; for οὗ as an adverb of motion, see Bua 1971: 9, with n. 14. I return to the intermedial significance of the noun *gramma* below, pp. 235–43.

γράμμα μέσον καθ[ελὼν παρολίσθα]νε οὗ ποτε βούλει

Grasp the middle letter [*gramma*] and glide whichever way you choose.

Unsatisfied with the missing sections of the third, fourth, and fifth feet, Carlo Gallavotti proposed a different participle and imperative verb, although semantically similar:[14]

γράμμα μέσον καθ[ορῶν παραλάμβα]νε οὗ ποτε βούλει

Look at the middle letter [*gramma*] and *continue* with whichever/wherever you choose.

In the absence of any decisive evidence, readers must choose whichever reading they prefer.

Whatever we decide about the missing portion of these two hexameters, the epigram is explicit about the concentrically arranged letters below (Fig. 103). Starting from the 'middle *gramma*' (the *iota* in the centre of the grid), there are no fewer than eight opening manoeuvres to be made (moving to one of the eight *lambdas* surrounding it); proceeding outwards, there are then always between three and five different directions in which to turn.[15] Whichever path we choose, we can vary our visual course at will—vertically, diagonally, or horizontally. Readers have to zigzag, meander, and criss-cross, turning left, right, upwards, downwards, or diagonally. But so long as readers proceed away from the centre to the grid's peripheries, their reading will always end up with one of the *etas* in the four corners. Regardless of the interpretive trail, the passage of text remains the same: Ἰλιὰς Ὁμήρου Θεοδώρηος ἡ {ι} τέχνη ('the *Iliad* of Homer: the *technê* is Theodorean').[16]

[14] See Gallavotti 1989: 49. Petrain 2006: 63–4 n. 46 may be right to prefer Gallavotti's suggestion (cf. also idem 2010: 53–4), and there are perhaps circumstantial reasons for privileging a participle of 'looking' specifically (see below, p. 229 n. 82); the main verb παραλαμβάνω also works well in this context (the instruction being to 'proceed' or 'continue' with whichever *gramma* one wishes), and is better attested than the (medical-sounding) παρολισθάνειν. But the present participle still makes less satisfying sense than Gallavotti's aorist (although Petrain defends the present on the grounds that a reader 'must keep the middle letter in sight as he progresses through the grid'). The fragmentary nature of the text precludes certainty, although the sense is clear. One further speculative emendation of my own: we must surely reckon with at least the possibility of another verse at the bottom of these 'magic squares'—perhaps sandwiching the letter grid between an elegiac couplet (a pentameter answering to the hexameter above, and thereby mirroring the couplets on the obverse of tablets 1A and 2NY).

[15] Valenzuela Montenegro 2004: 347 is inaccurate in suggesting that 'der Mittelbuchstabe ist gemeinsames Zentrum, dann muss sich die Buchstabenzahl in alle vier Richtungen paritätisch aufteilen': the uninscribed boxes on the reverse of tablets 2NY, 3C, 5O, and 20Par meant that readers of these letter grids could proceed diagonally as well as horizontally and vertically from the central letter (i.e. in eight directions rather than four).

[16] Despite the verbal protestation of the inscription, it is not *quite* true to say that readers can go wherever they wish: readers must knowingly proceed outwards to the corners of the grid and resist repeating the same letter—a theme to which we return in this chapter's conclusion, pp. 243–6.

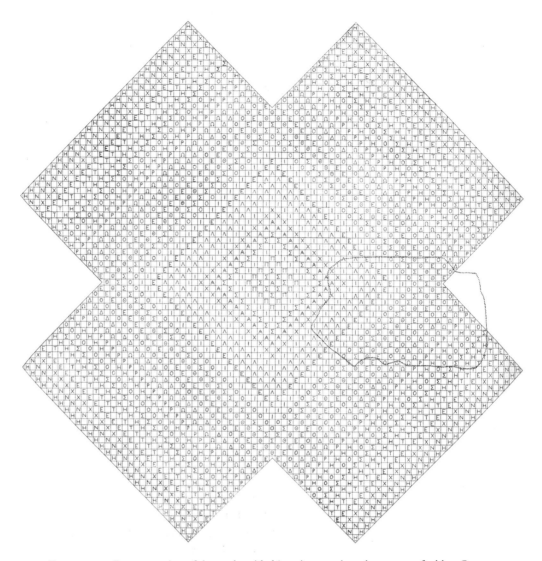

FIGURE 104. Reconstruction of the twelve-sided 'magic square' on the reverse of tablet 5O.

Although commonly referred to as 'squares', four of the inscriptions were clearly arranged to form other geometric patterns. The letters of tablet 5O seem to have been laid out in the shape of a 12-sided polygon (Fig. 104),[17] and those of tablets 7Ti and 15Ber (Fig. 126) were most probably organized to figure a lozenge.[18] By far the most complex arrangement, though, is to be found on tablet 4N, where, in the best surviving example of the principle, the letters are

[17] See Bua 1971: 11.

[18] Ibid. 11–13. As Bua admits of these examples (11), it is of course 'necessario premettere che non vi sono elementi sicuri per una ricostruzione soddisfacente dei giuochi alfabetici'. But in the case of the lost tablet

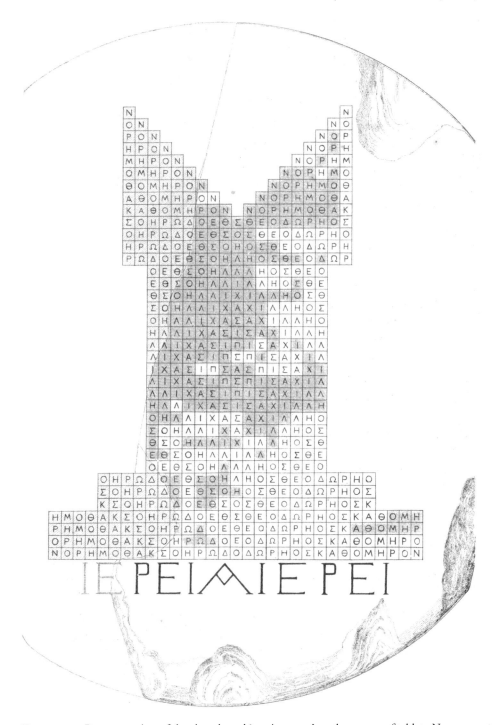

FIGURE 105. Reconstruction of the altar-shaped 'magic square' on the reverse of tablet 4N.

arranged in the form of an altar with no fewer than 52 sides. In this case, an additional palindromic inscription was inscribed below, similarly designed to be read from left to right and from right to left (Figs. 105, 145).[19]

Let me begin by transcribing all seven inscriptions in full:

2NY: [’Ιλι]ὰς ‘Ομήρου Θεοδώρηος ἡ{ι} τέχνη
The *Iliad* of Homer: the *technê* is Theodorean.[20]

3C: [’Ιλιὰς ‘Ομήρου] Θεοδώρηος ἡ{ι} τέχνη
The *Iliad* of Homer: the *technê* is Theodorean.[21]

4N: ἀσπὶς Ἀχιλλῆος Θεοδώρηος καθ’ ‘Ομηρον
The Achillean shield: Theodorean, after Homer.[22]

5O: [ἀσπὶς] Ἀχιλλεῖος Θεοδώρηος ἡ τ[έχνη]
The Achillean shield: the *technê* is Theodorean.[23]

7Ti: [’Ιλίου Π]έρσις
The *Ilioupersis*.[24]

15Ber: ἀνά]κτων σύνθεσ[ις
A collection of lords.[25]

20Par: [’Ιλιὰς ‘Ομ]ήρου Θεοδώρει[ος ἡ τέχνη]
The *Iliad* of Homer: the *technê* is Theodorean.[26]

7Ti, at least, Rayet 1882: 23 (= 1888: 188) expressly talked of a 'table quadrillée comme celle de Pythagore, mais disposée en losange'.

[19] On the relation to Greek and Latin 'figure poems' in the same shape, see below, pp. 234–5. We return to the verso of tablet 4N, and its relation to the tablet's recto, in chapter 7; it is worth noting here, however, that the newly found relief from Cumae may just parallel tablet 4N's altar grid pattern on its reverse side (see Appendix II, pp. 413–16).

[20] Cf. Sadurska 1964: 39; Bua 1971: 9–11; Valenzuela Montenegro 2004: 186.

[21] Cf. Sadurska 1964: 42; Bua 1971: 9–11; Valenzuela Montenegro 2004: 169–70. Although Horsfall prints only a truncated version of the inscription (presented as Θεοδώρηος ἡ<ι> τέχνη: Horsfall 1979a: 29; cf. *IGUR* 4: 97), there can be no doubting Bua's reconstruction.

[22] Cf. Bienkowski 1891: 200–1; Sadurska 1964: 45; Bua 1971: 5–6; Valenzuela Montenegro 2004: 240. Here, as with the parallel term on tablet 5O, I understand Ἀχιλλῆος as a two-termination adjective rather than a genitive singular noun (which the tablets exclusively render Ἀχιλλέως).

[23] Cf. Bienkowski 1891: 200; Sadurska 1964: 47; Bua 1971: 11; Valenzuela Montenegro 2004: 250.

[24] The tablet is lost, but the verso is discussed by Rayet 1882: 23 (= 1888: 188): cf. Sadurska 1964: 52; Bua 1971: 11–12; Valenzuela Montenegro 2004: 199–200. It is highly probable that, given the proportions of the tablet's surviving obverse, the inscription once contained more letters (for some suggestions, see Bua 1971: 11 n. 16).

[25] Following Sadurska 1964: 71, also offering ἀνά]κτων συνθεσ[ία (and comparing *Il.* 2.339): cf. Bua 1971: 12–13 and Valenzuela Montenegro 2004: 208 (rightly reminding that this was once part of a larger text). The problem, though, is how to reconstruct the centre of the inscription: the standard reconstruction requires three missing letters, but Bua's reconstruction (Fig. 126) leaves room for only two. For further discussion, see below, pp. 255–7.

[26] The inscription was published after Bua's analysis. On the reconstruction and comparison with tablets 2NY and 3C, see Horsfall 1983: 144, as well as above, pp. 187, 202–4.

Reading and viewing the inscriptions as a group, three aspects seem particularly striking. First, all seven reverse inscriptions provide some sort of caption or title for the scenes represented on their obverse: three refer to the '*Iliad* of Homer' (each using the same formula), two mention the 'Achillean shield', and the remaining two seem to allude to the *Ilioupersis* and a synthesis. The words of the inscriptions are interrelated in other ways too: note how each inscription lacks a verb or indeed a particle (to decrypt the enigmatic phrases, we have to look back to their obverse sides); perhaps most interestingly, five of the tablets explicitly associate themselves with 'Theodorean' *technê*—an attribution to which we will return in the following chapter.[27] The second point to emphasize regards a formal aspect of all seven diagrammatic presentations (so far as we are able to reconstruct them): each inscription appears to have originally comprised an odd number of letters, thereby forming a perfect square around a single central letter. In two cases this has been fairly easily arranged by substituting a diphthong for a long vowel: on tablet 20Par we find Θεοδώρειος rather than the standard form Θεοδώρηος (as occurs on five other tablets),[28] and on tablet 5O we find Ἀχιλλεῖος (as opposed to Ἀχιλλῆος on tablet 4N). But tablets 2NY and 3C adopt a different solution: as Bua argued, the artist inserted an additional *iota* after the definite article so as to achieve an odd rather than even number of letters (27 as opposed to 26).[29] A third observation has to do with a different sort of formal innovation, introduced in only some of the surviving examples. Most of the inscriptions insert uninscribed boxes between each letter (2NY, 3C, 5O, 20Par, and apparently 7Ti), although at least two of them leave no such spaces (4N, 15Ber): the advantage of the former system, with its blank spaces, was that it allowed the letters to be read in three directions rather than just two (i.e. along a diagonal as well as vertical and horizontal axis (Fig. 103)).[30]

Putting these three initial observations together, we can be sure that much thought went into these carefully crafted inscriptions. The reverse 'magic squares' have been devised in association with the obverse decoration, and various

[27] Ernst 2002: 232 consequently labels the Theodorean 'Kreuzwortlabyrinth' 'eine Art Firmenzeichen oder Künstlersignet'. On the attribution to 'Theodorus', see below, pp. 283–302; on the playful use of the term *technê* in this context, see below, pp. 229–30, 257–8.

[28] As noted by Valenzuela Montenegro 2004: 178 and Petrain 2006: 62. The conventional spelling is found on the verso of tablets 2NY, 3C, 4N, and 5O and on the recto of tablet 1A (as well as, most likely, on the recto of 4N).

[29] See Bua 1971: 6, 14, with further comments in Valenzuela Montenegro 2004: 169 and Petrain 2006: 62. It was once proposed that the letter bore a numerical significance (for bibliography, see Bua 1971: 8 n. 10)—an argument that Bua rightly rejects (ibid. n. 12).

[30] Cf. Bua ibid. 15. There survives no photographic record for the verso of the lost tablet 7Ti, but, following Bua 1971: 15, Valenzuela Montenegro 2004: 200 reconstructs it with 'einem Leerkästchen Abstand'. Note that the 'Moschion' stela (Figs. 106–7) contains no such empty spaces.

innovations are introduced across and within the series. The obvious question arises: *why?*

EGYPTIAN CONNECTIONS?

Scholarship has generally looked unfavourably on these 'magic squares'. Most often, they are left unmentioned, especially in English and American discussions of the tablets and their iconography.[31] The most important (francophone) exception is the work of Agnès Rouveret, who associated the spatially arranged images and inscriptions on recto and verso alike with ancient topographical and architectural systems (*technai*) of memory.[32] As for Nicholas Horsfall's interpretation, his rebuff of these 'trivial and bizarre' letter grids is very much in keeping with his belittling judgement of the tablets at large: 'it is . . . very tempting to imagine a Trimalchio explaining the palindrome and word-square with laborious pride'.[33]

Horsfall, like numerous scholars before and since, looked to the verso 'magic squares' as evidence for one thing in particular: namely, the tablets' supposed 'Egyptian connexions'. 'It was perhaps to an Egyptian craftsman that such a "jeu de lettres" might most naturally occur', as Horsfall claims, concluding that 'either Theodorus himself, or his craftsmen, or quite probably both, were of Egyptian origin'.[34] The thesis is founded on two misconceived hypotheses, and each needs upending in turn. The first concerns the specific form of the letter grid on tablet 4N (Fig. 105). Rolf Tybout has suggested that the 'horned' altar shape recalls a specifically Egyptian (or Syrian) prototype, and that this must indicate the origins

[31] There is no mention in e.g. Brilliant 1984: 53–9; Pollitt 1986: 202–4; Small 2003: 93–6. An exception is Elkins 1999: 241–4 who, in the context of his visual analysis of the 'domain of images', provides a superlative analysis of these inscriptions—but ironically omits the relation to the images inscribed on their obverse.

[32] See Rouveret 1988 and 1989: 359–69, discussed above, pp. 71–2. As Rouveret 1989: 368 tentatively concludes: 'Il se pourrait même que l'ordre des lettres dans la grille, au verso des "Tables Iliaques", ait un rapport avec l'ordre, le nombre des scènes figurées au recto. Mais comme toutes les tablettes conservées sont fragmentaires, il m'a été impossible de pousser plus avant l'hypothèse.'

[33] Horsfall 1994: 80. Cf. idem 1979a: 35: 'The eager delight with which a Trimalchio might have explained the "magic squares" . . . to his guests is not hard to imagine.' The 'trivial and bizarre' dismissal comes in Horsfall 1979a: 29, repeated at 32: it is indebted to the (rather less dismissive) appraisal of Bua 1971: 5 ('bizzarri giuochi alfabetici').

[34] Horsfall 1979a: 29. For the assumed association with Egypt, see Sadurska 1959: 122 and 1964: 10 (although here, puzzlingly, speculating a Lycian origin); Bua 1971: 23–6; Guarducci 1974: 433 and 1978: 1741–2; Horsfall 1979a: 27–31, 1983: 144, 1994: 79, and 2008: 588; McLeod 1985: 154 ('Theodore the Egyptian'); Rouveret 1988: 174 and 1989: 367; Rypson 1996: especially 10–11; Amedick 1999: 196–9; Salimbene 2002: 32; Valenzuela Montenegro 2004: 348–9 (but note also 356–8); Puppo 2009: 834, 836. Although founded on mere supposition, the 'Egyptian' interpretation has established itself as orthodoxy: see e.g. *SEG* 29.993, *IGUR* 4: 93 (*in sex Tabulis nomen Theodori artificis, origine Aegyptia, inciditur*), and ibid. p. 97 (*origo talium quadrarum . . . Theodorum Aegyptium esse proclamat*).

of the tablet, or at least its artist.[35] But this is surely to take too literalist a line. As we shall see (pp. 234–5), there are Greek and Latin parallels for poems arranged in altar shape (Figs. 116–17), all of which play with themes very similar to those on our Theodorean grids. As for this particular 'horned' rather than 'stepped' appearance, moreover, such a 52-sided shape best suited an artist intent on figuring his 'god-given' ingenuity in arranging the letters.[36]

A second argument has to do with other sorts of comparanda drawn from Egyptian magical papyri and hieroglyphic puzzles. One supposed 'Egyptian' parallel has played a particularly important role: a late second- or early third-century AD stela from a sacred precinct in Xois (modern-day Sakha, in the central Nile Delta), today preserved partly in Cairo (the large alabaster lunette, inscribed in Greek alone), and partly in Berlin (the lower 'body' of the relief) (Figs. 106–7).[37] At 86 x 81 x 25 cm, the lower fragment is fairly imposing in both its surface area and depth. The inscriptions inform that it was dedicated to Osiris by a certain 'Moschion', commemorating the healing of Moschion's foot. The (mostly lost) left-hand side of the Berlin section was inscribed in cursive Demotic Egyptian script, while the corresponding right-hand part of the relief was written in Greek. Both inscribed languages find their counterpart in the two 'magic squares' above, similar in design to those found on the Iliac tablets: working outwards from the middle letter, the 1521 boxes of the upper right-hand Greek inscription reveal a common sequence of letters, arranged in quadrangular grid ('Οσίριδι Μοσχίων ὑγιασθεὶς τὸν πόδα ἰατρείαις, 'to Osiris from Moschion, healed in his foot by medical treatments).[38] An epigram below the 'magic square'—again, written in both Demotic and Greek—explains the principle in 14 lines (in iambic tetrameter catalectic, with an appropriately lame limp in each final foot); beneath it, a further epigram contains a nine-line acrostic which spells out Moschion's name (in genitive form), bestowing on the 'magic square' a voice of its own: 'do not stare at me in amazement', it begins, 'if, rich in space [*polychôros*] I present an unclear vision [*phantasia*] to your eyes' (μή με θαυμάσῃς, εἰ πολύχωρος οὖσ' ἄδηλον | ὄμμασιν φέρω φαντασίην). Finally, in a pair of elegiac couplets isolated at the base, a third Greek epigram appears,

[35] Tybout's (short) addendum is published in *SEG* 29.993, and followed by Valenzuela Montenegro 2004: 417 ('das sehr seltene Buchstabenspiel des "magischen Quadrates" sowie dessen Form als Hörneraltar (Schild N) weisen auf eine persönliche Verbindung des Künstlers mit Ägypten').

[36] See below, pp. 367–70.

[37] On the stela (*SEG* 8.464), see especially Bernard 1969: 413–28, no. 108; Bua 1971: 23–6; Bresciani 1980; Rouveret 1989: 363–9; Ernst 1991: 393–7, with further bibliography in Valenzuela Montenegro 2004: 348 n. 2034. Luz 2010: 40–2, 378–9 appeared while this book was in proofs. For references to other Egyptian parallels, see Griffiths 1971, with response in Kazansky 1997: 66.

[38] As a perfect square, the number of letters in each row is of course odd, not even: the square comprises 39 x 39 boxes (not the 40 x 40 claimed by Kazansky 1997: 65).

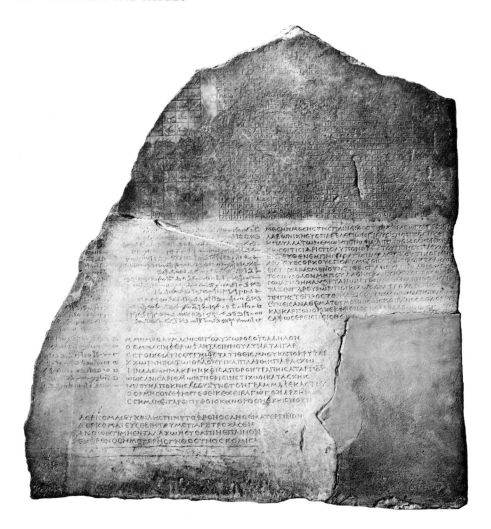

FIGURE 106. Alabaster stela of Moschion, probably late second or early third century AD (Berlin, Ägyptische Sammlung inv. 2135; 86 x 81 cm).

imagining Osiris' own words (and repeating four lines inscribed in the upper lunette): the god's response takes centre stage here, replying to the two earlier replies.

To what extent does this (much later) 'magic square' from Xois suggest an 'unambiguously Egyptian origin' for our seven *Tabulae Iliacae* letter grids?[39] Without wanting to get side-tracked by this fascinating and underappreciated object, it seems clear that its poetic themes are as much Greek and Roman in conception as they are Egyptian. On the one hand, the variations of voice—the

[39] Horsfall 1979a: 29; cf. Bresciani 1980: 125.

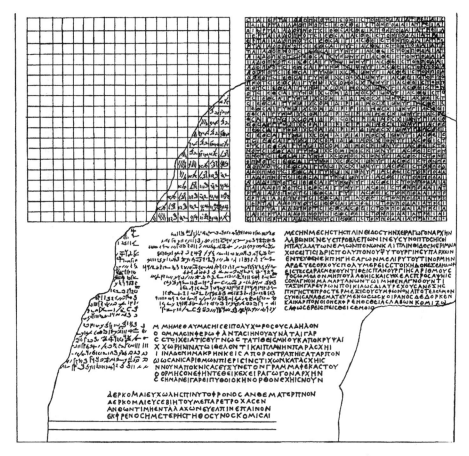

FIGURE 107. Reconstruction of the bottom section of the Moschion stela.

apostrophic play, whereby the speaking object oscillates between a number of different identities (Moschion, the 'magic square', the god Osiris himself)—lead resolutely back to the ontological games of Hellenistic epigram, themselves descending from a much longer Greek tradition of inscribed 'speaking objects'.[40] On the other, the stela puns upon the Greek language of divine epiphany (reflected in its highly charged use of the term *phantasia*): it negotiates an enigmatic material/immaterial apparition of the god that, like this relief, vacillates between words and pictures.[41] Most interestingly of all, this issue of image–text

[40] The two most important discussions of this phenomenon in Hellenistic epigram are Männlein-Robert 2007a (adapted from 2007b) and Tueller 2008, especially 150–5. On the longer tradition of Greek 'ventriloquist' epigram, bequeathing objects a first-person voice, see below, p. 233 n. 98.

[41] On epiphany and *phantasia*, especially in the Hellenistic and Second Sophistic Greek world, along with the related fantastic evocations of epiphanic images in ecphrastic epigram, see Platt forthcoming: ch. 4. In this connection, note how the first Greek epigram presents the 'magic square' as a sort of

relations is framed in terms of the contested *cultural* relations between Greece and Egypt. Differences between Egyptian and Greek linguistic systems—the one phonetic, the other descended from Egyptian logographic hieroglyphs—embody larger differences in identity and (out)look: the rapport between image and text serves to figure the relationship between Egyptian and Greek semiotic modes (and ultimately the supernal Osiris' transcendence of such earthly limitations, as laid out at the stela's own 'foot'). Replacing the linearity of the Greek letters with a visual form that allows them to be viewed like pictures, Moschion's 'magic square' asks whether and how this Greek alphabetic system might function in the more diagrammatic manner of Egyptian logograms. At the same time, the gesture of arranging individual Demotic characters in a square, pulling apart the compound logograms into smaller semantic units, makes the Egyptian script work in a more Greek, pseudo-alphabetical fashion: how does the Demotic *grammata* grid compare with the Greek?[42] Moschion cannot have been unaware of the cultural-cum-intellectual stakes: by describing itself as *polychôros* (literally 'rich in space'), the speaking inscription is made to recognize not only the multi-spatial arrangement of its 'magic square' inscription, but also its multi-spatial geographic orientation—deriving at once from Egyptian and Greek lands (*chôrai*).

There is much more to be written about this alabaster stela. But the point to emphasize here is the Greek intellectual debt: the various Western cultural resonances make a problem of distinguishing too schematically between 'Egyptian' and 'Graeco-Roman' thinking. By the same token, as we shall see, it is not necessary to hide behind some 'exotic' foreign culture when making sense of the *Tabulae* 'magic squares': their symbiosis of words and pictures finds an ancestry in Greek and Roman intellectual traditions as much as in Egyptian prototypes.

This is not to say that Egyptian culture played *no* role in stimulating Hellenistic concepts of visual and verbal representation. As John Onians long ago argued, there can be no denying that renewed Greek cultural contact with Egypt had a profound and long-lasting impact on Greek and Roman concepts of text and image, especially among the intellectual elite of Egyptian Alexandria.[43] But this new contact with Egyptian hieroglyphs acted only as a catalyst: Hellenistic concerns with turning things seen into things read (and the other way round)

'complete body' of its own (τὸ σῶμ' ὅλον, v. 8), figuring the healed body of Moschion himself: the order imposed over the alpha-graphic square by the viewer-reader (τάξιν, v. 10) re-enacts the order that Osiris established through healing Moschion's foot.

[42] The reference to *grammata* comes in the seventh line of the Moschion acrostic inscription (ἀποκνίσας εὐξύνετον γράμμ' ἀφ' ἑκάστου, 'having detached an easily grasped *gramma* from each line'): for the associated Greek pun, see below, pp. 237–9.

[43] Onians 1979: 95–118, especially 110–15. For some Greek discussions of Egyptian hieroglyphics, see e.g. Pl. *Phdr.* 274e–275b; Diod. Sic. 3.4; Plut. *Mor.* (*Quaest. conv.*) 670f.

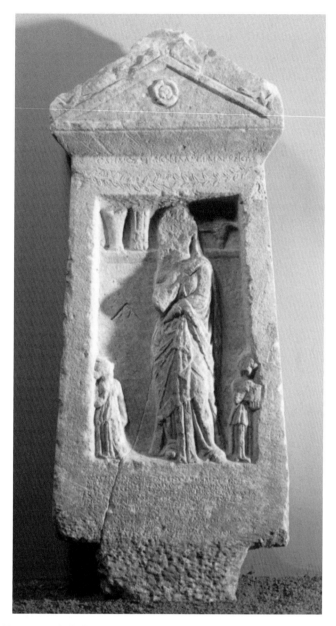

FIGURE 108. Funerary relief of Menophila, from Sardis, second century BC (Istanbul Archaeological Museum inv. 4033).

quickly took on an intellectual life of their own. Objects like the second-century funerary relief of Menophila from Sardis in western Turkey (Fig. 108) roundly demonstrate as much. Developing the literary tropes of Hellenistic epigram (and the epigrams of Antipater from Sidon in particular), a ten-line poem at the base of the relief provides a verbal commentary on the imagery depicted:

each picture is ascribed a pictographic meaning, as ideograms for abstract notions (the lily symbolizing her youth, the *alpha* that she was an only child, the basket that she was wise, etc.). At the same time, the words—and not least the images above—problematize the assumption that pictures work in any straightforward 'hieroglyphic' way, offering a sustained meditation on the nature of visual and verbal signification (the self-confessed *manumata* of this 'sign-loving' Meno-phila). The Menophila relief figures just one artistic-cum-literary example of the Hellenistic concern with the 'pictoriality' of verbal language, and indeed the 'writtenness' of visual artefacts. It is in this same Greek intellectual context that the *Tabulae Iliacae*—and their 'magic square' inscriptions in particular—must also be understood.[44]

PICTURES IN WORDS AND WORDS IN PICTURES

Produced at least two centuries before the Moschion stela, the *Tabulae Iliacae* provide the earliest surviving evidence for Greek 'magic square' inscriptions. But the archaeological record preserves numerous parallels. Some of these have been studied by Margherita Guarducci, who surveyed numerous Greek and Roman 'letter games' ('giochi letterali'), surviving from all corners of the Roman Empire.[45] Among the most famous examples are two Latin palindromic 'letter squares', one from Pompeii (*CIL* 4.8297) and Ostia (Fig. 109),[46] the other found in numerous contexts—including Ostia, Dura-Europos, Siena, and Watermore (near Cirencester) (Fig. 110):[47]

```
R O M A        S A T O R
O L I M        A R E P O
M I L O        T E N E T
A M O R        O P E R A
               R O T A S
```

[44] On the Menophila relief, and its resonance against Hellenistic discourses of words and pictures, see Squire 2009: 161–5; cf. Prioux 2007: 286–90. For related onomastic word games in Greek and Roman funerary reliefs, cf. Ritti 1973–4 and 1977.

[45] See Guarducci 1965: especially 260: 'Nel I secolo d. Cr. . . . *carmina figurata*, gli acrostici, i palindromi, gli anagrammi, ed anche le parole incrociate, erano di gran moda'; cf. eadem 1978: 1736–49 (comparing the *Tabulae Iliacae* at 1741–2).

[46] For discussion, see especially Guarducci 1965: 262–6 and Ernst 1991: 429–59. There are at least three parallels for the inscription: see Guarducci 1978: 1743 n. 26.

[47] Cf. Guarducci 1965: 266–70, along with the bibliography listed in eadem 1978: 1743–4 n. 27. Bua 1971: 16–17 discusses another, related example—a mosaic from a villa in Négrine el Kdima (north-east Algeria) which arranges the letters of the word *Flauiorum* in a grid of 90 boxes (ten letters running across the horizontal axis, and nine along the vertical).

FIGURE 109. 'Palindrome square' inscription from Ostia, (?) second century AD.

FIGURE 110. 'Palindrome square' inscription from Watermore near Cirencester, date uncertain.

Although the precise lexigraphic meaning of these texts remains unclear ('Rome—once—Milo—love'; 'Sower—Arepo—holds—by his handiwork (?)—the wheels'), their novelty lay in the formal arrangement of letters. As with the 'magic squares' on the tablets (and indeed the Moschion stela), the inscriptions play upon the epigraphic conventions of the so-called *stoichêdon* style, whereby letters are arranged in strict grid formation (i.e. *taxis*), each row and column aligned both vertically and horizontally (e.g. Fig. 111).[48] In the case of these palindrome squares and diagrammatic grids, however, the latticed letters could be read along both a horizontal and vertical axis—from left to right as from right to left, and indeed from top to bottom as from bottom to top. In the first instance (Fig. 109), the letters revolve around the rotating synecdoche in the middle: whether we proceed clockwise or anticlockwise, the mirroring replications belonging 'to this thing' composed/the thing that 'these people' have composed stays put (*ILLI*). In the second example, the foundational *tenet* that criss-crosses the centre quite literally 'holds' the synergetic game together (Fig. 110). These

[48] The classic discussion of the rigid *stoichêdon* style (which rigidly dominates Attic inscriptions in the fifth and fourth centuries) is R. P. Austin 1938, with some important further comments in M. J. Osborne 1973 and a useful overview in McLean 2002: 45–8. As Austin notes (at 125–6), the Moschion stela provides the earliest surviving attestation of the term in an epigraphic context (in v. 6 of the first Greek epigram reproduced in Fig. 107).

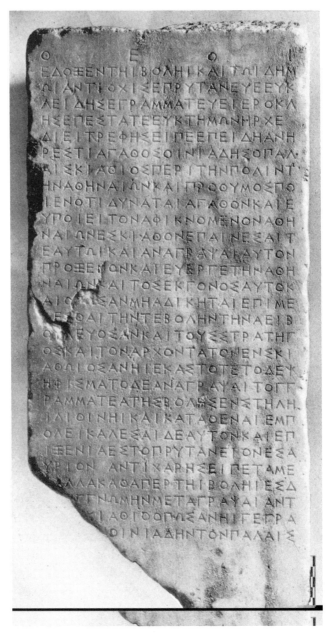

FIGURE III. Example of a Greek *stoichêdon* inscription (*IG* I².118): an Athenian 408/7 BC decree in honour of Oeniades of Palaesciathus.

visual–verbal objects are to be read both pictorially and poetically: Sator has 'begotten' a pictorial *opus* that wheels round just like the *rotae* evoked in the *opus* of the prosaic letter text.

There are differences between these two palindrome inscriptions and the *Tabulae* 'magic squares', of course. While both groups of inscriptions toy with multidirectional modes of reading, the 'magic squares' are arranged around a central letter, whereas the palindrome texts make verbal sense only when approached from side to side. But the general point nevertheless stands: both sets of inscriptions draw self-conscious attention to their medial form. Exploiting the field of their written surface, the inscriptions play with the possibility of readers *viewing* their texts, and they do so in a variety of different ways.[49]

So what class of 'viewer' do these sorts of letter games expect? Despite the reigning scholarly consensus, it would be mistaken to dismiss such comparanda as a sort of proto-'popular culture', pure and simple. By at least the early fourth century AD, whole poems were written according to the letter-grid principle. I refer here to the much neglected Latin poems of Optatian (Publilius Optatianus Porphyrius), which celebrate their spatial field in a closely affiliated way. Like the *Tabulae* 'magic squares' and palindrome inscriptions, Optatian's fourth-century AD poems—most often composed in hexameters—are laid out in *stoichēdon* form. In this case, though, figurative patterns seem to have been picked out in colour inside each architectural letter grid. Here more than ever, audiences were encouraged to read in a plurality of different directions: the game was to *see* symbolic patterns and lucid verbal commentaries figured within the textual fabric of the poem.[50]

A single paragraph is enough to allay any doubts: this is *ultra*-sophisticated stuff. Nor was Optatian blind to the broader intellectual stakes: as he (is said to have) said in an introductory letter to the Emperor Constantine, his *opera* were designed for seeing as much as for reading (*legendum serenis oculis tuis*, 'to be read by your serene eyes').[51] Take Optatian's eighth poem, laid out in a square comprising 1,225 letters (i.e. 35 rows of 35 letters) (Fig. 112). Quite apart from

[49] Habinek 2009: 133 nicely expresses the point: 'It is hard to see what function the palindromes have other than that of calling attention to writing's insistence on arbitrary patterns of visual perception.' I would consequently take issue with e.g. Griffiths 1971: 8, who argues that 'the "Sator" square, of course, goes beyond palindrome, and the only extant precedent to the crossword appears in Egypt'.

[50] Optatian's poems are well served by the most recent edition of Polara (ed.) 1973; but they remain woefully maligned (e.g. Courtney 1990: 5: 'the surrealist patterns of Publilius Optatianus Porphyrius have lost all contact with reality and do not merit discussion'). For the spatial games, see e.g. Doria 1979; Levitan 1985; Ernst 1986: 15–16 and 1991: 95–142; Polara 1987; J. S. Edwards 2005; Rühl 2006.

[51] Optatian's letter is edited (along with Constantine's supposed reply) by Polara (ed.) 1973: 1–6; the passage quoted comes from the first page (*Epist. Porf.* 3). The dual meanings of the verb *legere*, as both 'to see' and 'to read', were notorious—and widely commented upon by this time (cf. e.g. Squire 2009: 147–8 n. 221). The two letters may or may not be genuine (cf. Barnes 1975: 174 n. 4, *contra* Polara (ed.) 1973:

```
        5        10        15        20        25        30        35
  ACCIPE·PICTA·NOVIS·ELEGIS·LVX·AVREA·MVNDI
  CLEMENTIS·PIA·SIGNA·DEI·VOTVMQVE·PERENNE
  SVMME·FAVETE·TOTA·ROGAT·PLEBS·GAVDIA·RITE
  ET·MERITAM·CREDIT·CVM·SERVAT·IVSSA·T·IMORE
5 AVGVSTO·ET·FIDEI·CHRISTI·SVB·LEGE·PROBATA
  GLORIA·IAM·SAECLO·PROCESSIT·CANDIDA·MITI
  ADCVMVLANS·COETVS·ET·TOTA·ORNATA·SERENIS
  MVNERIBVS·PRAESTAN·S·NATIS·V·LAVRE·A·VOTA
  VIRTVTVM·TITVLOS·PRIMIS·IAM·DE·BEAT·ANNIS
10 PROGENIE·TALI·GENVIT·QVOS·NOBILE·SAECLVM
  HIS·DECVS·A·PROAVO·ET·VERAE·CONSCIA·PROLIS
  ROMA·CLVIT·PRINCEPS·INVICTI·MILITIS·ALMA
  OTIA·PACIS·AMANS·HAEC·SVNT·MITISSIMA·DONA
  HOC·ATAVI·MERITVM·VOTIS·POST·EDITVS·ORBIS
15 ERVM·PENS·DOCVIT·NE·NORINT·FRANGERE·F·IDEI
  OPTIMA·IVRA·PARES·CVRIS·SVB·MARTIS·IN·IQVI
  NVLLIS·LAESA·FIDES·HINC·IVGI·STAMINE·FATA
  VOBIS·FILA·LEGVNT·PLACIDA·PIETATE·SECVTA
  ET·RES·CONSTANTIN·VNCE·XERIT·INCLITA·FAMA
20 AVCTA·STIRPE·PIA·VOTO·ACCVMVLATA·PERENNI
  SANCTA·S·VASSEDES·ADMENTIS·GAVDIA·MIGRAT
  AETHERIO·RESIDEN·S·FELIX·IN·CARDINE·MVNDI
  IAM·PATRIAE·VIRTVTIS·OPVS·BELLINE·LABORE
  AN·IVSTI·MERITIS·DICAMMENTISQVE·SERENAE
25 ET·PIA·DONA·CANAM·FECVNDAQVE·PECTORA·NOTO
  RITE·DEOS·IC·MENTE·VIGENT·CVIGA·VDIA·CASTA
  CLAVDIVS·INVICTVS·BELLIS·INSIGNIA·MAGNA
  VIRTVTVM·TVLERIT·GOTHICODEMILITE·PARTA
  ET·PIETATE·POTENS·CONSTANTIVS·OMNIA·PACE
30 AC·IVSTIS·AVCTVS·COMPLERIT·SAECVLA·DONIS
  HAEC·POTIORE·FIDE·MERITIS·MAIORIBVS·ORTA
  ORBI·DONAT·VO·PRAESTAS·VPERASQVE·PRIORA
  PERQVE·TVOS·NATOS·VINCIS·PRAECONIA·MAGNA
  AC·TIBI·LEGE·DEI·IVS·SIS·QVE·PERENNIA·FIENT
35 SAECLA·PII·SCEPTRI·TE·CONSTANTINE·SERENO
```

FIGURE 112. Optatian Porphyry, poem 8 (Polara).

the 35 hexameter verses laid out from top to bottom, other so-called *uersus intexti* are woven into the visual fabric of the 'wordsearch' text; each one seems to have been figuratively highlighted, producing not only visual patterns, but also abbreviated hidden messages that are literally figured through the 'darting' letters (*IESUS*, centred around a criss-crossing *chi–rho* christogram in the middle).[52]

xxxi–xxxii, concluding '*de epistolarum fide dubitandum esse*', xxxi); in any case, they certainly do give an insight into the poems' early reception.

[52] The hidden letters reveal two elegiac couplets, with an appended final prose exhortation: *Alme, salutari nunc haec tibi pagina signo | scripta micat, resonans nominibus domini: | nate deo, solus saluator sancte bonorum, | tu deus es iusti, gratia tu fidei. sit uictoria comes Aug. et natis eius*; 'Gracious one, this page now glitters for you, written with the sign of salvation, resonating with the names of the lord: son of god, sole

If a poem like this probes the liminal borders between the literal and the figurative (and indeed between the old and the new),[53] others threw the boundaries between the 'Greek' and the 'Roman' into the gridded ring. Although poems 16, 19, and 23 (Fig. 113) are all written in Latin hexameters, the figuratively arranged *uersus intexti* are composed as make-believe *Greek* letters: if we read in Latin terms, the letters add up to 'nonsense'—rather, their 'sense' is purely visual and figurative, and not verbal and literal; switch now from Latin to Greek, though—taking the Roman A as *alpha*, *delta*, or *lambda*; C as *sigma*; H as *eta*; P as *rho*; X as *chi*, etc.—and these letters are shown to depict not only visual patterns, but also Greek texts concealed within and behind the Latin (three Greek hexameters in poem 16, one Greek hexameter in poem 23 (Fig. 113), even a Greek elegiac couplet replying to the Latin verse of poem 19).[54] The result is not just a field of epic-sounding poetry simultaneously shrunk into epigrammatic 'play' ('I, Publilius Optatianus Porfyrius, have toyed with these things'),[55] but one which knowingly pitches its poetic *ars* against the pictorial *opera* of old ('the page will dare to surpass the wax tablets of Apelles').[56] The grid poems draw knowing attention to the conventions of reading. At the same time they goad us into thinking (in every sense) *outside* the box.[57]

holy saviour of good people, you are the god of justice, you are the grace of our faith. May victory be the companion of Augustus Caesar and his sons.' Note how the *uersus intexti* thereby undercut the name of 'Jesus' figured through the letters: are these verses about God or god—i.e. about God the Father and God the Son, or else about the godly emperor Constantine and his wholly more mortal Imperial line? As ever with Optatian, the darting meaning (*signo . . . micat*) proves as ambiguous as the visual–verbal presentation.

[53] The idea of 'old' vs 'new' looms large in the two letters between Optatian and Constantine (e.g. *Epist. Const.* 9: Polara (ed.) 1973: 5). But it is most conspicuous in the manifold allusions that are woven into the texts—above all, to Ovid and Virgil. The best parallels in this sense are the dozen or so late antique Virgilian *centones* (well discussed by McGill 2005—but without reference to Optatian).

[54] Cf. Levitan 1985: 255–8, together with Polara (ed.) 1973: 63–5, 72–5, 90–2. The transliterated letters of poem 23 (Fig. 113), for example, hide a Greek hexameter which discloses the name of the adulterous culprit: Μάρκε, τεὴν ἄλοχον τὴν Ὑμνίδα Νεῖλος ἐλαύνει ('Marcus, Neilos is banging your wife Hymnis'). 'The Muse sounds in Greek' (*Musa sonat Graecis*, v. 10), as Optatian describes the unspoken picture of this anti-'hymn'; but by deciphering the Latin letters, the viewer can read that which is hidden (*haec occulta legens*, v. 3). In this connection, note how the hexameter zigzags its way up and down the ten verses—weaving not only the Greek into the Latin, but also the figurative into the verbal, the specific into the mythological, and the new into the old. Even if we decode the figurative pattern and find the concealed name, however, appearances are never quite what they seem: is this 'Neilos' a real individual, some unnamed Egyptian (personified as the river 'Nile' itself), or for that matter an empty rhetorical construct (punning on the Latin *nilum*)?

[55] I quote the first patterned *uersus intextus* in poem 21 (Polara (ed.) 1973: 83): *Publilius Optatianus Porfyrius haec lusi*. For related Greek and Latin signature acrostics, cf. below, p. 225 n. 68.

[56] The line is one of many patterned *uersus intexti* in poem 3 (Polara (ed.) 1973: 13): *uincere Apelleas audebit pagina ceras*.

[57] For Optatian's 'mediale Komplexität', see especially Rühl 2006: 76, concluding of poem 19: 'das Gedicht hat so viele Bedeutungen, wie der Leser ihm zu entlocken vermag' (88–90, quotation from 90).

```
         5          10          15          20          25          30          35
   I N G E M V I · G R A V I T E R · G R A E C V M · M I S E R A T V S · A M I C V M
   C V I · M E A · M E N S · A D M I S S A · D O L E N S · C V P I T · O M N I A · F A R I
   S O L V S · V T · H A E C · O C C V L T A · L E G E N S · S E · C O N C I T E T · I R A
   V N D E · Q V E A T · P L E X V M · V I N C L I S · S O N T E M Q V E · T E N E R E
 5 S E D · V I T A N S · M V L T O S · Q V O S · F O E D A · D · I V R G I A · C O I V X
   N O L V E R I T · T E S T E S · N E V · C A N D I D A · F E M I N A · G R A E C V M
   M O X · K A R I S · H E B E T E T · T E L I S · N I H I L · I M P R O B A · C Y G N I
   D E · P O S V I S S E · V I D E N S · H E L E N A M · C V I · G R A T I A · B I N I S
   M A I O R · A D V L T E R I I S · D O · N O M I N A · C V N C T A · L I B E N T E R
10 M V S A · S O N A T · G R A E C I S · F R Y X · C O I V X · C R E D E · C A N E N T I
```

Ingemui grauiter, Graecum miseratus amicum, *cui mea mens, admissa dolens, cupit omnia fari,* *solus ut haec occulta legens se concitet ira,* *unde queat plexum uinclis sontemque tenere.* *sed uitans multos, quos foeda ad iurgia coiux* *noluerit testes, neu candida femina Graecum* *mox karis hebetet telis, nihil improba cygni* *deposuisse uidens Helenam, cui gratia binis* *maior adulteriis, do nomina cuncta libenter:* *Musa sonat Graecis; Fryx coiux, crede canenti.*	Deeply I groaned, in sorrow for my Greek friend. Distressed at what has been done, my mind wants to tell him everything, so that, reading this secret message on his own, he will rouse himself in anger and be able to beat the guilty man and throw him in chains. But avoiding the many witnesses to his shameful quarrel (which a husband will not want), and for fear that the fair woman will blunt the Greek by and by with her lovely weapons, seeing as she does – wicked woman! – that the swan's daughter Helen lost nothing, but acquired greater fame by her double adultery, I gladly give all the names: my Muse sings to Greeks; Phrygian husband, believe her song.

Μάρκε, τεὴν ἄλοχον τὴν Ὑμνίδα Νεῖλος ἐλαύνει.	Marcus, Neilos is banging your wife Hymnis.

FIGURE 113. Optatian Porphyry, poem 23 (Polara).

William Levitan has argued that such innovations have to be understood within the particular cultural remits of Late Antiquity, and others have drawn attention to Optatian's Neoplatonic and Judaeo-Christian intellectual debts.[58] To be sure, there is something distinctly new in such riddling prototypical crosswords, bound up with a peculiarly Christian anxiety about the figurative and the literal.[59] And yet—and this is the crucial point—Optatian's concern with the presentational *materiality* of language was a mainstay of Greek and Latin writing: whether we look to texts penned on the scroll, or to humbler graffiti scratched and scribbled on the wall, we find a flood of words figured like pictures and pictures figured like words.

There is a fundamental disciplinary problem here, in that literary and epigraphic cultures are all too often channelled to different specialists, working to different epistemological agendas, and to different scholarly ends: the *Corpus*

[58] See Levitan 1985: especially 264–6 (with further bibliography); cf. Rühl 2006: 76–8, 81 on the new emphasis on hermeneutic plurality, distinct from e.g. surviving *technopaegnia* 'picture poems'.

[59] This same concern, I would add, would materialize itself in the newfound genre of Biblical manuscripts accompanied by pictures, in turn reflected in codices like the 'Roman Virgil', 'Vatican Virgil', and 'Ilias Ambrosiana': see above, p. 139.

Inscriptionum Latinarum sits not only on a different shelf from the Latin literary A-list, but sometimes even in a different library. Whatever else we make of the threefold German segregation of 'Klassische Philologie', 'Klassische Archäologie', and 'Alte Geschichte', it fails the epigraphic qualities of literary texts, no less than the literary qualities of epigraphic inscriptions. Take the following verse:

> ἤδη μοι Διὸς ἄρα πηγὴ παρά σοι, Διομήδη
> Here is the spring of Zeus, by your side, Diomedes.

The conceit is that the hexameter can be read from both left to right and right to left: poetic creativity is figured as a palindromic source (πηγή), and one that literally springs from one side of the line to the other. But what makes this verse particularly interesting is that it survives from both the 'literary' and 'epigraphic' record alike. While the hexameter provides the opening verse of a longer poem collected in the *Planudean Anthology* (*Anth. Plan.* 387c.1), it was also scratched as a graffito in Pompeii (with a Latin transcription 'sprung' from it drafted below).[60] This type of poem was evidently well known in antiquity, and in Latin as well as Greek. Later grammarians and critics sometimes referred to such poems as *karkinoi stichoi* or *uersus recurrentes*, and Martial comments upon them too, although distancing his own Latin work from those sorts of 'bend-over-backward' Greek compositions (*carmine ... supino*, 2.86.1).[61]

Such concern with written mediality evidently transcends our ideological distinctions between the 'literary' and the 'historical', as indeed between the 'high' and the 'low'. Martial might brush off reverse poems as 'difficult trifles' (*difficiles ... nugas*, 2.86.9)—all in the effort to forge flashy *nugae* of his own (Mart. 2.1.6)—but the learned *exempla* cited along the way (Sotades, Palaemon, galliambic verse, epigrams on Ladas) undermine any suggestion that these were merely popularizing crowd pleasers.[62] From humble inscriptions etched on to

[60] See Guarducci 1965: 254, 261, on *CIL* 4.2400a; the first eleven letters of the text are also found in *CIL* 4.2400b. The metrical irregularity of the anapaest in the third foot rhythmically alerts readers to the game, reversing even the metre in the middle of the line. There are numerous related examples: cf. e.g. Guarducci 1965: 249–56 on a second-century AD inscription from Obuda, as well as the shorter comparanda cited at 261–2 (with nn. 135–7).

[61] The surviving Greek epigrammatic *karkinoi stichoi* are collected in *Anth. Plan.* 387b–d (see Aubreton and Buffière (eds.) 1980: 226–8); for discussion, see Guarducci 1965: 252 and 1978: 1740–2; Gallavotti 1989: 49–54. On later Byzantine variants, see Ernst 1991: 738–65. For further discussion of examples and terminology, see Flores and Polara 1969: especially 111–16 and Levitan 1985: 247–8: other descriptions included *uersus reciproci*, *anacycli*, and *anastrephonta*.

[62] For the mock Callimachean claim—now coupled with *cinaedus* rear-ending invective—see Mart. 2.86.9–12: 'It is absurd to make poetic trifles difficult, and hard work on frivolities is foolish. Let Palaemon write his poems for the crowds: *my* pleasure lies in appealing to select ears' (*Turpe est difficiles habere nugas | et stultus labor est ineptiarum. | scribat carmina circulis Palaemon | me raris iuuat auribus placere*); cf.

the wall to the long and elaborate compositions of Alexandrian poets, Hellenistic and Roman writers displayed a remarkable sensitivity to the graphic depths of the written surface.

This is not the place to excavate the conceptual archaeology of the phenomenon. There are numerous Archaic and Classical Greek antecedents—from the playful arrangements of Greek vase inscriptions,[63] to theatrical performances like those of Callias' *Grammatikê Theôria* (with its 'Sesame Street' chorus of *grammata* dancing on to the stage).[64] Suffice it to say that the late fourth century provided something of a watershed. In particular, it was the Hellenistic establishment of the library that galvanized the process—the founding of monumental literary storehouses, where texts came to be experienced first and foremost not as oral performances, but rather through catalogued scrolls. Now more than ever, writers laboured over the physical presentation of their words: the Hellenistic culture of the book brought about a new attentiveness to the *taxis* of the page.[65]

Nothing better testifies to this agenda than the so-called *technopaegnia* 'picture poems', to which we shall turn later in the chapter (pp. 231–5). As we shall see, these epigrams, apparently originating in the early third century, materialize a Hellenistic obsession with graphic monumentality, prefiguring the sorts of poems found with Optatian some six centuries later. For now, it is the sophisticated literary backdrop that I want to emphasize—the word-puzzles, anagrams, and palindromes that adorn Alexandrian poems at almost every stroke. Hellenistic Greek acrostics are the best-attested source for the phenomenon. Trickling down the vertical rather than simply horizontal dimensions of the page, the acrostic materializes an intensified concern with the graphic and multilinear qualities of papyrus poetry: writing is understood not just as spoken word, but also as graphic script.[66]

L. Friedländer (ed.) 1886: 1.278–9, Kazansky 1997: 71, C. A. Williams (ed.) 2004: 260–4, especially 261–2. Contemporary writers were not unappreciative of such poetic compositional acrobatics: compare Quint. *Inst.* 9.4.90, associating a similar game of reverse poetry (whereby hexameters are turned into sotadics, and sotadics into iambic trimeters), with 'a poet of no mean repute' (*quondam non ignobilem poetam*); cf. also Connors 1998: 30–1 on Petr. *Sat.* 132.8.1–3, citing *inter alia* Dion. Hal. *Comp.* 24 and Plin. *Ep.* 5.3.2.

[63] Fundamental is the work of François Lissarrague, e.g. Lissarrague 1985; 1990: especially 125–35; 1992: especially 191–7; 1999; cf. e.g. Henderson 1994; Slater 1999; R. Osborne and Pappas 2007; A. Steiner 2007: 74–93. It is also worth comparing the material assembled by Ritti 1969, concerning the rise of inscribed emblems on Greek monumental reliefs, particularly between the fifth and third centuries.

[64] As reported in Ath. 7.276a and 10.448b: see especially Svenbro 1993: 182–6 and Slater 2002. Cf. e.g. Hurwit 1990: 193 on Eur. *Theseus* frg. 382 (Nauck)—an ecphrasis of an inscription, again on the 'live' fifth-century Athenian stage.

[65] The fundamental reappraisal of this Hellenistic 'book culture' is Bing 1988: especially 10–48. The most important discussion is now Luz 2010, which appeared while this book was in proofs.

[66] Cf. Gutzwiller 2007: 43, on how such 'puns and word plays cannot be appreciated in recitation; acrostics must be perceived by a reader looking at a written text'. The concern was not wholly new: for earlier acrostics in the late fifth and fourth centuries BC, see e.g. Kazansky 1997: 68 (on Epicharmus,

Hellenistic Greek poets delighted in acrostics.[67] Among the most famous are the two examples found in the extant works of Nicander (in each case spelling out the author's name),[68] as well as those in Aratus' *Phaenomena* (describing the *leptê* moon, for instance, all the while demonstrating the lithe *leptotês* of the poet—able to evoke that (meta)poetic quality not only verbally, but also through 'slender' vertical pattern).[69] Latin poets observed and imitated, inventing creative *ludi* of their own. Cicero recalls a signature acrostic by Ennius in the third or second century BC (*Q. Ennius fecit*: 'Q. Ennius made it': *Div.* 2.111–12), and we find as many acrostics in Latin epigrams as we do in Greek.[70] The Neoterics of the first century BC took such supple stunts to new poetic heights, not least in the somer-saulting *uersus recurrentes* already mentioned.[71] Imperial Latin poets were duly impressed in turn, improving upon the lettered acrobatics of their Neoteric fore-bears. It seems likely (as Don Fowler suggested) that Virgil endowed the seventh book of the *Aeneid* with a four-letter acrostic of his own (*Aen.* 7.601–4: MARS).[72]

Chaeremon, and Dionysius Metathemenus). Vogt 1966: 82–3 is surely right in judging an earlier supposed acrostic in *Il.* 24.1–5 (λευκή) coincidental; it is significant, though, that the acrostic seems to have been first spotted by Alexandrian scholiasts (cf. e.g. Gell. *NA* 14.6.4, with Somerville 2010: 202–3).

[67] For two overviews of Greek and Latin acrostics, see Vogt 1966 and Courtney 1990 (with more detailed survey of bibliography at 5–6); cf. also Danielewicz 2005 on the Hellenistic Greek material. Brand 1992 offers a useful review of acrostics through the ages.

[68] Cf. Nic. *Ther.* 345–53 and *Alex.* 266–74: see Lobel 1928; Kranz 1961: 99–100; Courtney 1990: 11–12. Such signature acrostics spurred numerous imitations: cf. e.g. Leue 1882–4 on Dionys. Per. 109–34, 513–32; above p. 93 on the *Ilias Latina* (*Italicus . . . scripsit*, vv. 1–8, 1063–70); above pp. 116–19 on the 'Eudoxus papyrus'; and above p. 221 n. 55 on Optatian poem 21.

[69] The acrostic at *Phaen.* 783–7 was first noted by Jacques 1960; Morgan 1993: 143 calls it a *'gamma-acrostic'*, whereby the hidden word is also introduced in the first line; cf. Courtney 1990: 10–11, Haslam 1992: 199–200, Hunter 2008: 1.161–3, and Volk 2010: 205–8 on the semantic importance. There were other acrostics in the poem, no less sophisticated: cf. Levitan 1979 (on πᾶσα, vv. 803–6) and Haslam 1992 (on the syllabic acrostic μέ-ση, vv. 807–8, with a waning anagram in the following two lines—itself apparently observed and adapted by Verg. *G.* 1.427–35: see Haslam 1992: 202–4 and Somerville 2010, along with Brown 1963: 63 and R. F. Thomas (ed.) 1988: 139). For a related opening pun on Aratus' name in the poem's second line, and its supposed adaptation in Verg. *G.* 1.1–2, see Bing 1990 and Katz 2008.

[70] For further acrostics in surviving Latin inscriptions, especially epitaphs, see e.g. Antonio 1913; Zarker 1966; Guarducci: 1978: 1740. Courtney (ed.) 1995 gives ten examples (nos. 26, 28, 39, 40, 42, 44, 48, 128, 174, 199); other Greek and Roman comparanda are discussed by Kazansky 1997: 71–4. On acrostics in both Greek and Latin epigrams, see also above, pp. 96–7 on *Anth. Pal.* 9.385 (with parallels listed at n. 39), as well as below, p. 235 on *Anth. Pal.* 15.25.

[71] For discussions, see e.g. *GL* 1.516–17 (Diomedes, *Ars Grammatica* 3), 6.113–14 (Marius Victorinus, *Ars Grammatica* 3.7), 4.467 (Servius, *De centum metris* 9): cf. Polara 1969: 111–16. Diomedes cites as an example a particular type of *uersus reciprocus* composed of two elegiac couplets: the order of words could be reversed from one couplet to the other, so that the four verses could be read either backwards or forwards, all the while skipping to the same metrical structure.

[72] See D. P. Fowler 1983, with further references in Damschen 2004: 108 n. 64. Countless further examples could be cited—among the works of Virgil (e.g. Clauss 1997 on Verg. *Ecl.* 1.5–8; Katz 2007 on *Aen.* 4.399–402), and others (e.g. Morgan 1993 on Hor. *Carm.* 1.18.11–15; Gale 2001 on related etymologi-cal play in Lucr. 1.112–19; Gore and Kershaw 2008 on Apul. *Met.* 4.33; Damschen 2004: 96–110 on Ov. *Met.*

There is an even clearer instance of a related poetry game (*ludus*) in *Ecl.* 9.34–8, where the playful acrostic *undis* splashes into a 'game within the waves'—*ludus in undis* (v. 39)—before a *faux naïf* recitation of Theocritus *Idyll* 11 (*Ecl.* 9.32–43):[73]

> Lycidas: ...et me fecere poetam
> Pierides; sunt et mihi carmina; me quoque dicunt
> uatem pastores: sed non ego credulus illis;
> nam neque adhuc Vario uideor nec dicere Cinna
> digna, sed argutos inter strepere anser olores.
>
> Moeris: id quidem ago et tacitus, Lycida, mecum ipse uoluto,
> si ualeam meminisse; neque est ignobile carmen:
> 'Huc ades, o Galatea: quis est nam **ludus in undis**?
> hic uer purpureum, uarios hic flumina circum
> fundit humus flores; hic candida populus antro
> imminet et lentae texunt umbracula uites.
> huc ades; insani feriant sine litora fluctus.

Lycidas: 'Me too have the Pierian maids made a poet; I too have songs; me too do the shepherds call a bard, even though I do not believe them. For I do not yet seem to sing anything worthy of a Varius or a Cinna, but instead to cackle like a goose among melodious swans.'

Moeris: 'This is what is occupying me, Lycidas, what I'm silently turning over in my mind, to see if I can remember it. And no mean song it is: "Come to me, Galatea! Just what is the fun in the waves [*ludus in undis*]? Here is rosy spring; here, by the rivers, Earth scatters her flowers of a thousand hues; here the white poplar bends over the cave, and the clinging vines weave shady bowers. Come to me and leave the wild waves to lash the shore."'

Here, as elsewhere, the evidence is overwhelming. The newest research is turning the tide of earlier scepticism: when the acrostics of one author streamline those of another, there can be absolutely no doubting the knowing, self-conscious play.[74]

12.235–44 and 15.194–8). Numerous Latin examples are discussed by Damschen 2004, who concludes that 'Die Technik des Akrostichons war vielmehr die ganze Zeit über in der lateinischen Literatur genauso lebendig wie in der griechischen Literatur derselben Zeit' (95).

[73] Grishin 2008 has noted the acrostic independently. But still more *ludi* lap their way between the acrostic's cascade—as yet unsurfed. Observe, for example, how the opening letters in vv. 34–6 spell out in acronym the name of the poet Cinna, who is explicitly mentioned (*credulus illis* | *nam neque adhuc*). Note too how the Neoteric poet Varius in v. 35 is floridly changed into *uarios...flores* in vv. 40–1: the variation *next* to the 'rivers' streams the verse's own undulation of the *undis* spray—thanks to the verb *fundit*, splish-splashed on top. All this rides the tide of an equally playful wave about poetry *between* speaking and making (*fecere poetam* | *...dicunt* | *uatem*, vv. 32–4): the 'silent' letter games ripple across the frozen transcript of Moeris' and Lycidas' liquid verse. Such an inundation, of course, must have been wholly 'worthy' of the Neoterics, despite Lycidas' opening bail-out. (This kooking deluge has learned from the hot-dogging of a master ripper: the totally rad John Henderson.)

[74] 'I await the men in white coats', as D. P. Fowler 1983: 298 concluded (and cf. e.g. Morgan 1993: 145 on the usual assumption of 'crankdom'). For acrostics adapting acrostics, see e.g. Jacques 1960 on Aratus

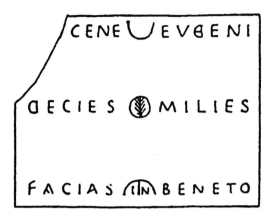

FIGURE 114. Example of a *tabula lusoria* from a catacomb on the Via Labicana: the letters read [EU]
GENE–EUGENI–DECIES–MILIES–FACIAS–BENETO ('Eugenic Eugenius, go on, make a
million for the Blues!').

The point to emphasize here is that such games of letters were an inherently
lettered pursuit. Whether dealing with palindrome squares, Optatian's grid
poems, *uersus recurrentes* or indeed Greek and Latin poetic acrostics, it is clear
that all of these phenomena probe a related set of issues. In each case, the written
sign is shown to figure a *more*-than-verbal meaning, redrawing the boundaries
between things written and read. This discourse evidently engaged players across
the full social spectrum. Optatian's Latin grid poems take their place beside not
only inscribed palindrome squares, but also still humbler-looking Roman graffiti,
which likewise delighted in figuring words out of pictures and articulating
pictures from words.[75] Comparison might also be made with the 200 or so
surviving 'gaming tablets' (*tabulae lusoriae*), which arguably demonstrate a similar
self-consciousness about the playful gamble of rolling out meaning (e.g.
Fig. 114).[76] Whatever we make of Nicholas Purcell's scrabbling conclusion that

intentionally adapting a Homeric acrostic (although the latter is surely accidental); Brown 1963: 102–5,
Haslam 1992, and Somerville 2010: 207–8 on Virgil adapting Aratus; Reeve 1996–7: 247 on Dionysius
Periegetes adapting Nicander; and Hendry 1994: 108 on the possibility of Virgil's 'Mars' acrostic at *Aen.*
7.601–4 referring back to an acronym by Ennius. No more men in white coats, I hope.

[75] On Latin graffiti making pictures out of words (and vice versa), see e.g. Courtney (ed.) 1995: 328–9,
no. 120 and Ernst 2002: 232–3 (on *CIL* 4.1595 = *CLE* 927: two snaking couplets on snake-charming);
cf. Clarke 2007: 44–9, as well as the more detailed catalogue of Langner 2001.

[76] For the Roman 'gaming tablets' known to us, see especially Ferrua 1946 (counting 52 examples),
supplemented by idem 1948 and 1964, together with Purcell 1995: 17–28 (with earlier bibliography cited at
18 n. 69). 'The most eloquent historically' (Purcell 1995: 19) seem to have been made up of six words of six
letters (i.e. 36 spaces in total, with 12 letters per line), usually interspersed with various images and symbols:
the objective was evidently to move across the tablet with gaming pieces, 'playing' with and through the
letters. On Fig. 114, see *AE* 1949.83 and Ferrua 1946: 56–7, no. 6.

the *tabulae lusoriae* grant 'direct contact...with the snorting plebeians', their graphic games can also be contextualized alongside some of the most elite forms of Latin literary production.[77] 'The playfulness of the script on the game boards', as Thomas Habinek concludes, mirrors 'certain kinds of play in literary texts': 'they are manifestations of the same underlying attitude to writing, which treats it not just as an expression of speech but also as a distinctive means of graphic communication that entails strictures and constraints not characteristic of spoken language'.[78]

FLIPSIDES

This has been a small overview of a very large topic. But what does it mean for our *Tabulae Iliacae* 'magic square' inscriptions? My argument is twofold: first, that the 'magic square' inscriptions have as much to do with Greek and Roman cultures as they do with Egyptian; and second, that their interest in writerly space relates to a much wider set of discourses in the Hellenistic and Roman worlds—one which permeated a range of social strata, from everyday graffiti to highfalutin didactic poetry (and back again). If we rubbish the Iliac tablet verso inscriptions as inherently 'low class' or 'lowbrow' ('quite the reverse of high literary culture', as Nicholas Horsfall suggests), we must conclude the same of writers like Nicander and Aratus, even Ennius and Virgil: Horsfall's 'serious lover of literature' would have remarkably little literature left to love.[79]

If the tablet 'magic squares' can therefore be contextualized alongside all sorts of Greek and Roman comparanda, they arguably go still further in their medial play, pointing to the artefactual *arbitrariness* of writing. By drawing explicit attention to their spatial distribution, the verso inscriptions defamiliarize the assumption of semiotic inherence: their picture texts point knowingly and self-referentially to

[77] Purcell 1995: 19. But, as the author concludes (28–37), such 'playful writing' was as much a game for the rich as for the poor.

[78] Habinek 2009: 125–7 (quotation from 125). Habinek therefore provides the revisionist, checkmate manoeuvre: comparing poems from the *Latin Anthology* similarly made up of six words of six letters (albeit now in dactylic hexameters), he shows how such 'writing games...cross boundaries between the literary and nonliterary, the textual and inscriptional, and the symbolic and embodied' (127); they therefore demonstrate 'a certain self-consciousness with respect to the interrelated processes of reading, writing, and playing' (126). Like the *Tabulae Iliacae*, the *tabulae lusoriae* have evidently suffered from too dogmatic (and ideologized) a distinction between 'high' and 'low' culture.

[79] The evaluation comes from Horsfall 1979a: 28 (in the context of tablet 4N): noting some of the exempla discussed above (especially the *uersus recurrentes*), Horsfall despairs that 'they too appear to have seeped into our literary texts from popular culture' (ibid. 29). Kazansky 1997: 65–75 reaches a similar conclusion to my own, noting that 'such a constellation of names makes it obvious that this kind of verse was not intended exclusively for Trimalchios' (74).

PLATE I

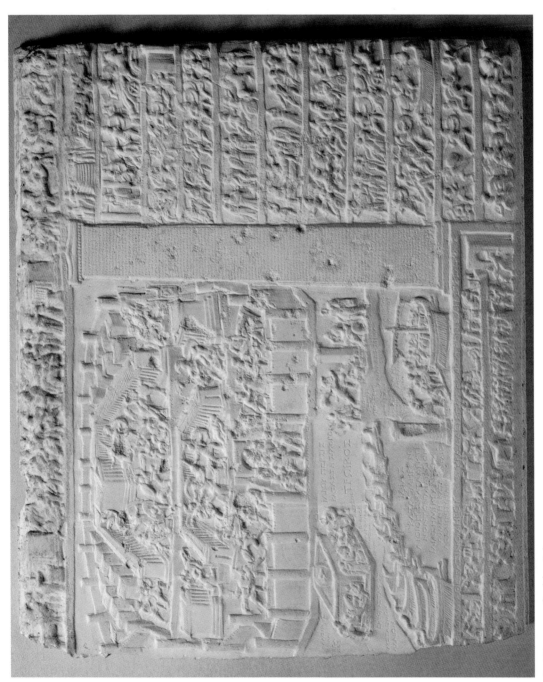

1. Obverse of tablet 1A.

PLATE II

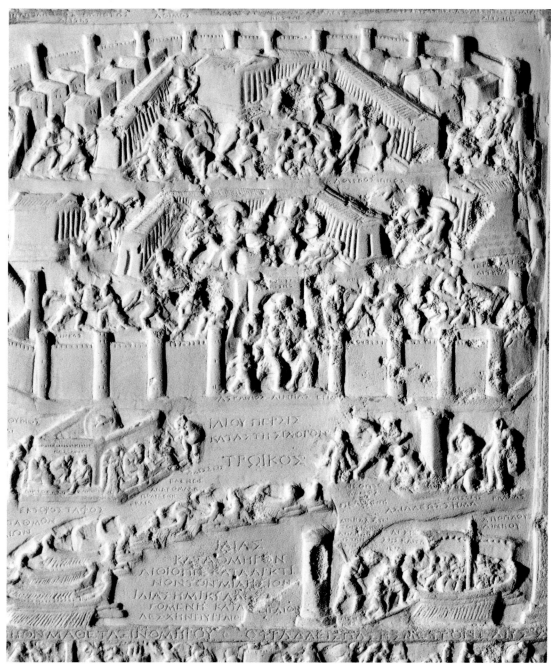

2. Detail of the *Ilioupersis* scene on the obverse of tablet 1A.

PLATE III

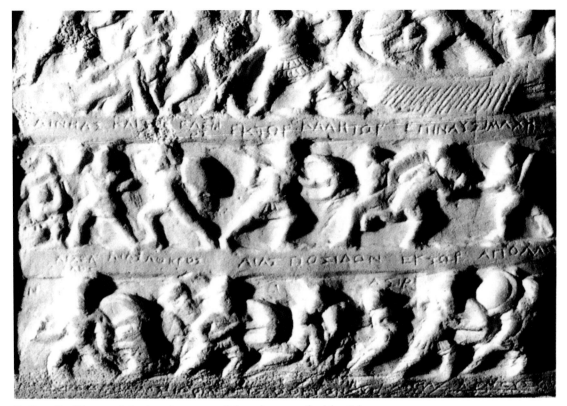

3. Detail of lower right-hand corner of the obverse of tablet 1A.

4. Tablet 1A as seen from the surviving right-hand side.

PLATE IV

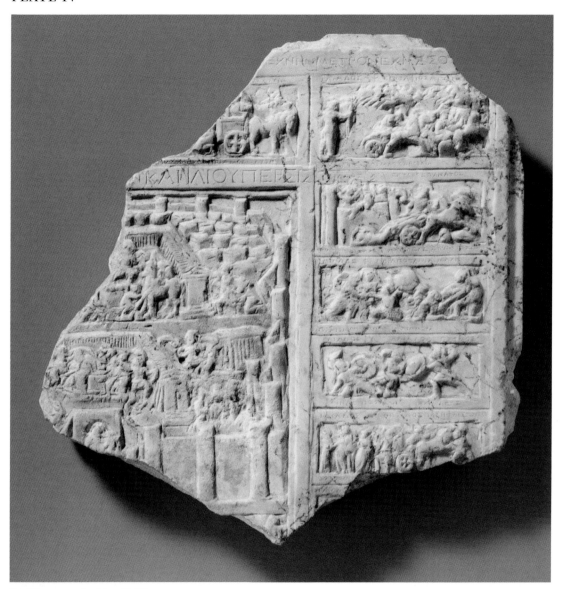

5. Obverse of tablet 2NY.

PLATE V

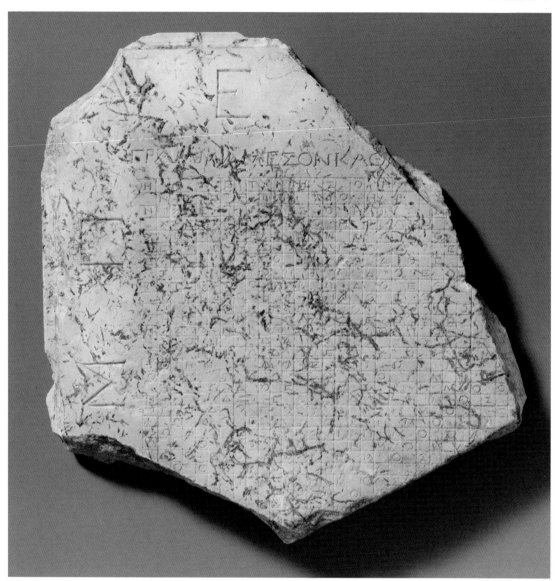

6. Reverse of tablet 2NY.

PLATE VI

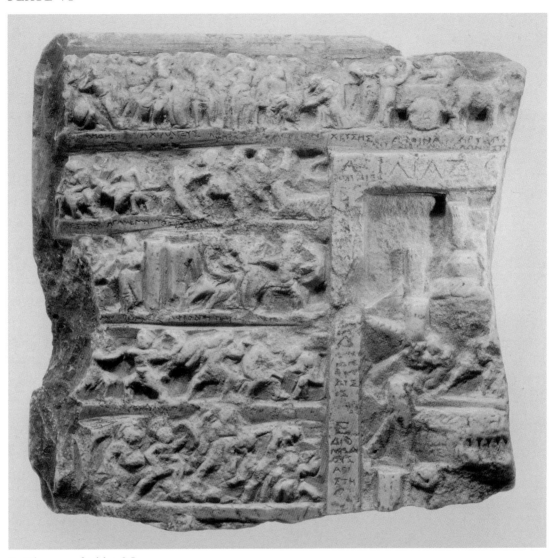

7. Obverse of tablet 3C.

PLATE VII

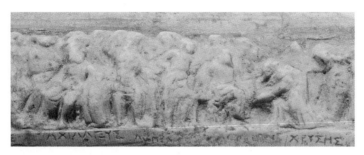

8. Detail of the upper frieze on the obverse of tablet 3C,
showing traces of gold paint.

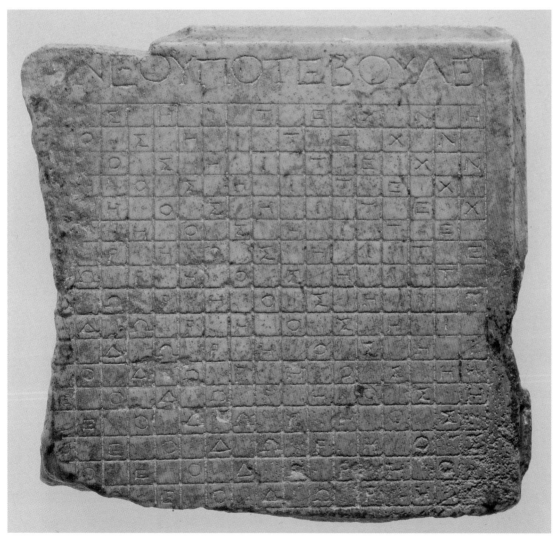

9. Reverse of tablet 3C.

PLATE VIII

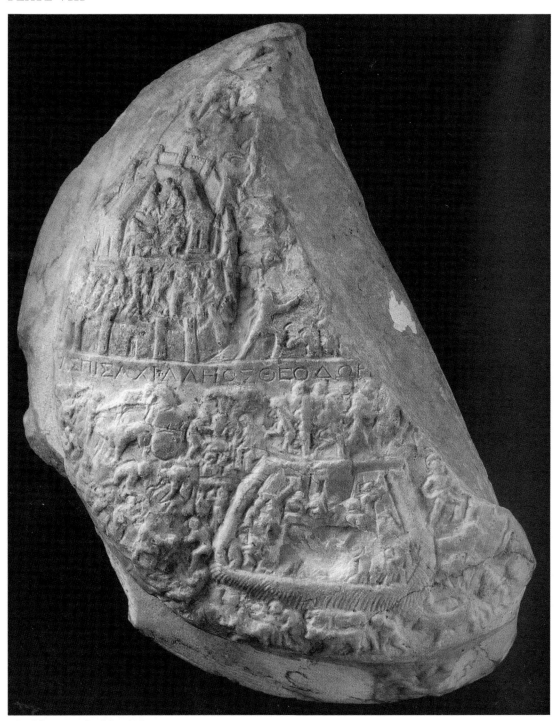

10. Obverse of tablet 4N.

PLATE IX

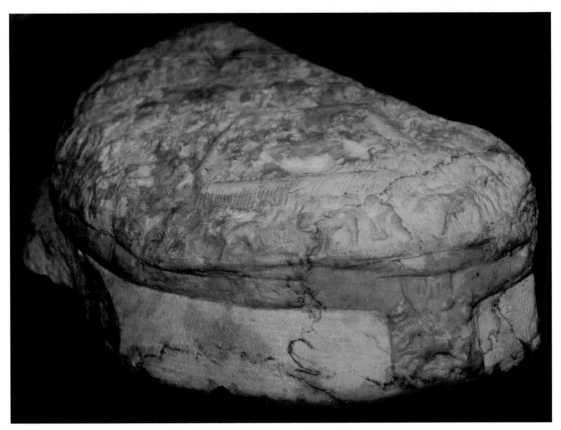

11. Obverse of tablet 4N, as seen from the bottom up.

PLATE X

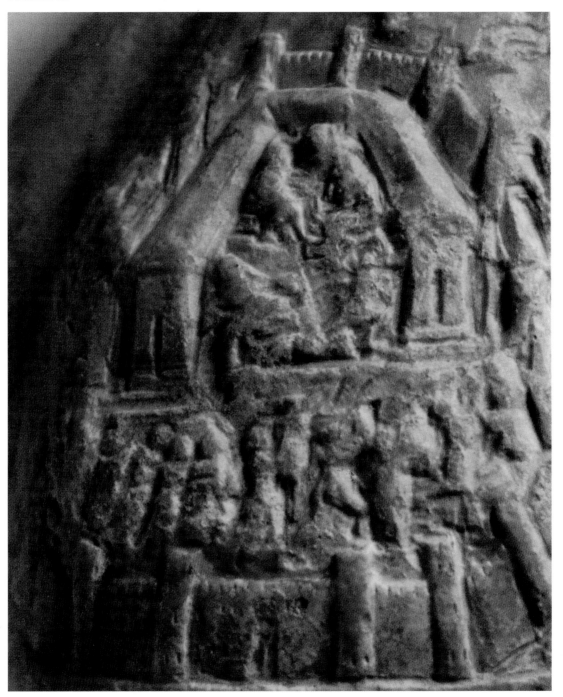

12. Detail of the 'city at peace' on the obverse of tablet 4N.

PLATE XI

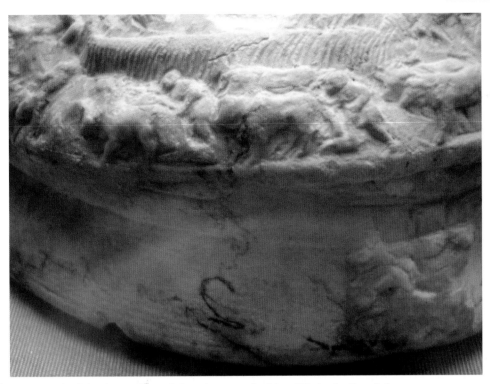

13. Detail of the lower rim of the obverse of tablet 4N, including Selene.

14. Outer rim of the obverse of tablet 4N, inscribed with the second (left: *Il.* 18.493–504) and third (right: *Il.* 18.505–19) columns of text.

PLATE XII

15. Outer rim of the obverse of tablet 4N, inscribed with the fifth column of text (*Il.* 18.533–45).

PLATE XIII

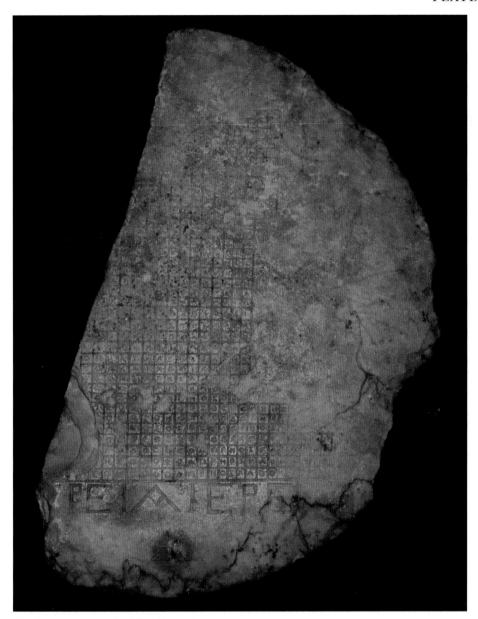

Fig. 16. Reverse of tablet 4N.

PLATE XIV

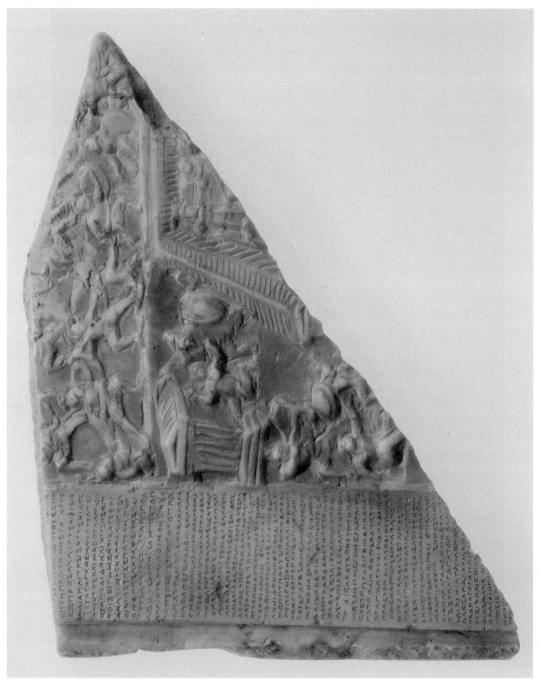

17. Obverse of tablet 8E.

PLATE XV

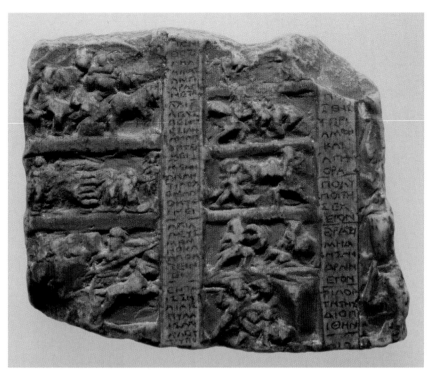

18. Obverse of tablet 9D.

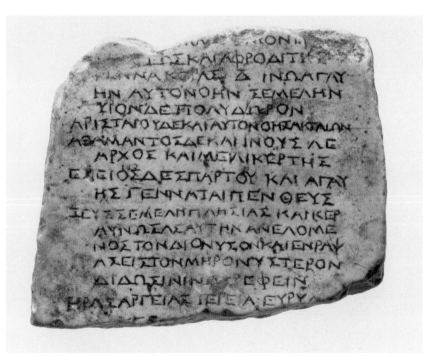

19. Reverse of tablet 9D.

PLATE XVI

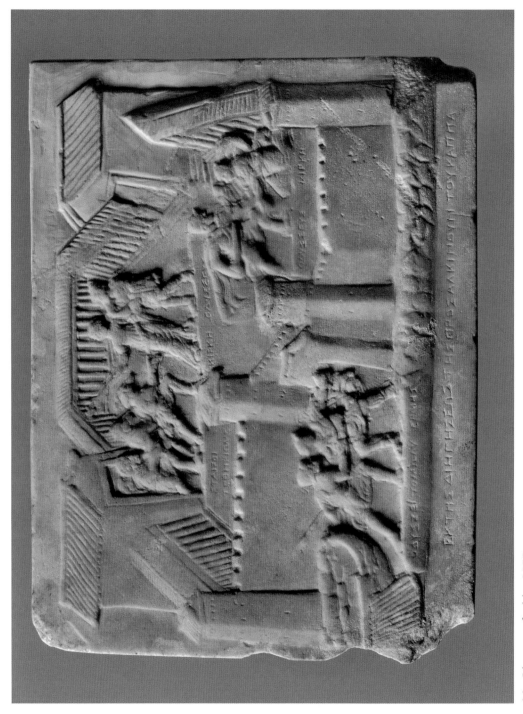

20. Obverse of tablet 11H.

PLATE XVII

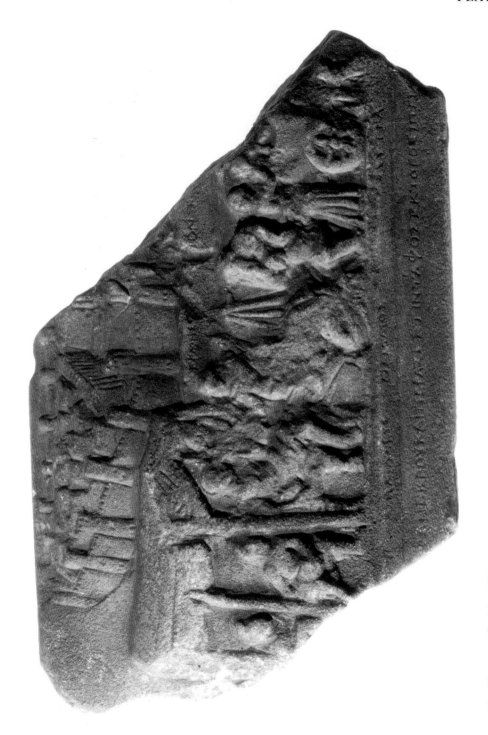

21. Obverse of tablet 12F.

PLATE XVIII

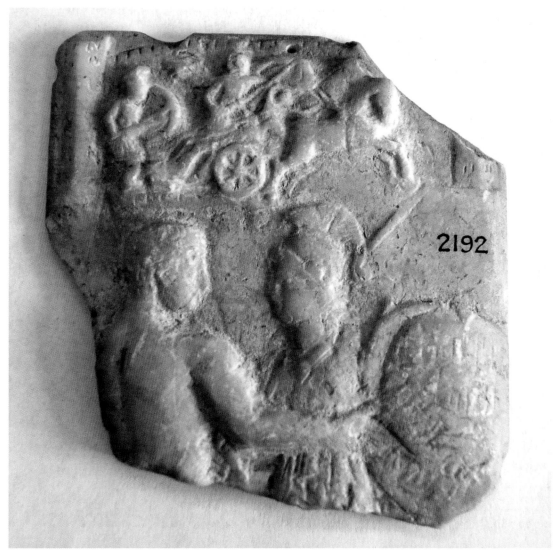

22. Obverse of tablet 13Ta.

PLATE XIX

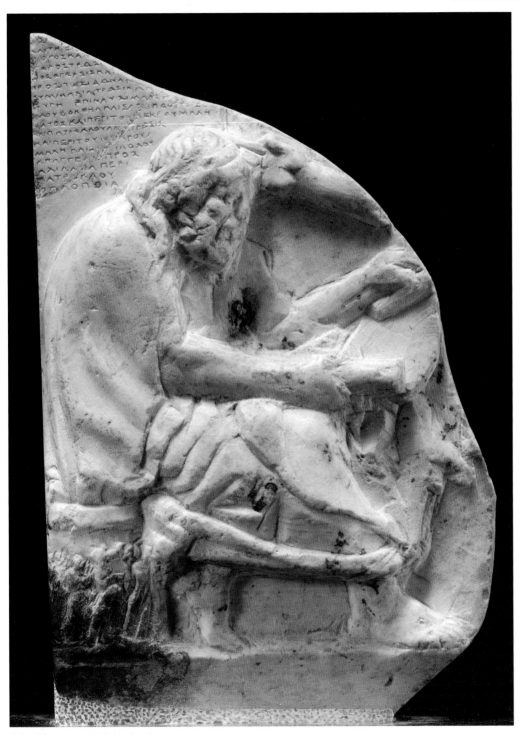

23. Obverse of tablet 14G.

PLATE XX

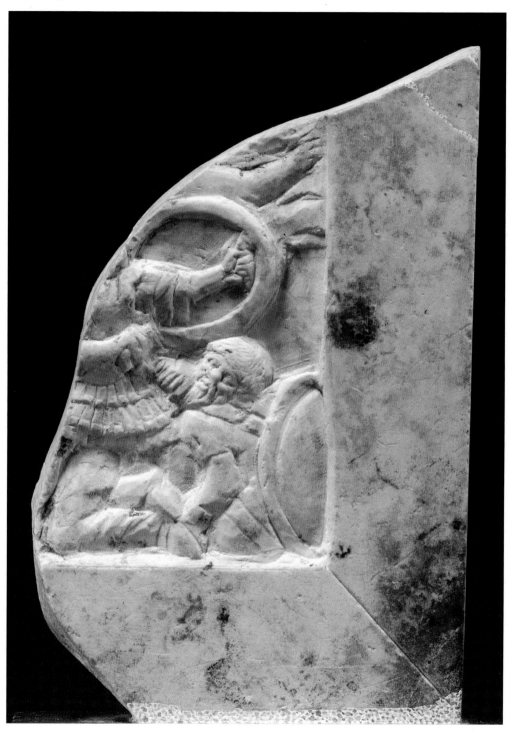

24. Reverse of tablet 14G.

PLATE XXI

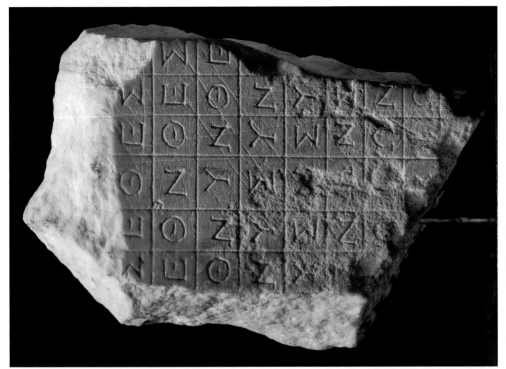

26. Reverse of tablet 15Ber.

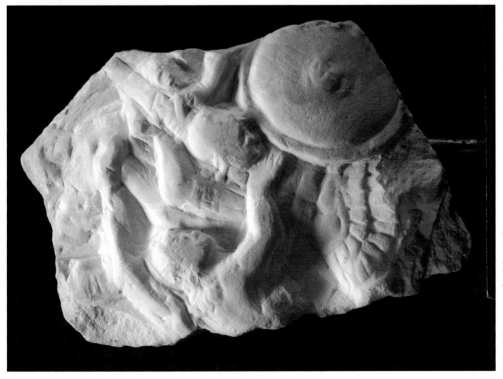

25. Obverse of tablet 15Ber.

PLATE XXII

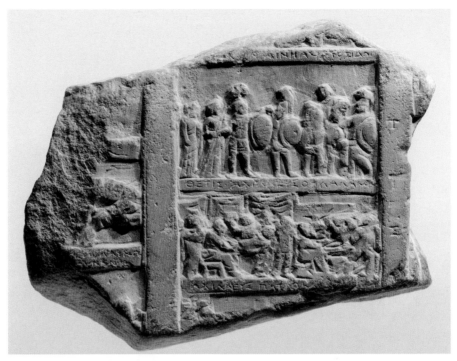

27. Obverse of tablet 20Par.

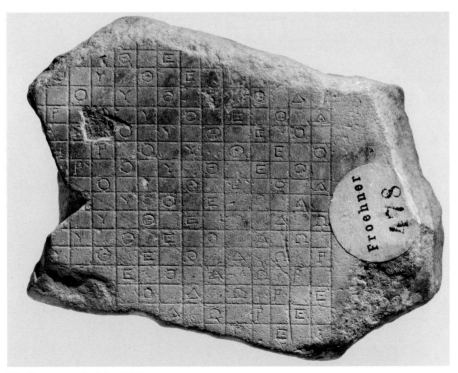

28. Reverse of tablet 20Par.

PLATE XXIII

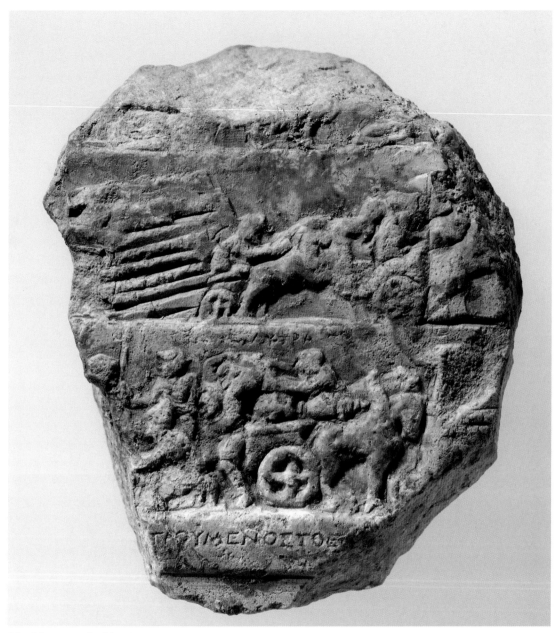

29. Obverse of tablet 21Fro.

PLATE XXIV

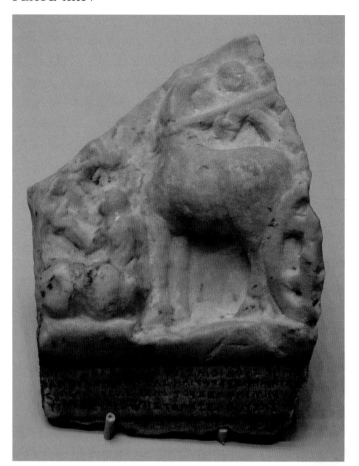

30. Obverse of tablet 22Get.

31. Side view of tablet 22Get.

the excess between signifying writing and meaning signified.[80] Reading the inscriptions as if we were looking upon a visual composition, we make logical sense of these alphabetic compositions only by facing up to the spatiality of their pictorial arrangement: our eye rambles and roves around the series of letters, each time responding to them in new and creative ways—whether upwards, downwards, or across to right or left.[81] Slowly but surely, a verbal code emerges from the puzzling cryptogram. For this to happen, though, readers must first play along as viewers, denying the sequentiality of the written text only then to reinscribe it at whim; we have to resist (if not unlearn) the internalized assumption of unidirectional readerly mode. Addressees are instructed to suspend readerly rules and go it alone: the spatial arrangement of these diagrams imbues the verbal linearity of the written text with an adventurous new *pictorial* dimension.[82]

So how, then, to make sense of this phenomenon within the particular context of the *Tabulae Iliacae*? To my mind, there can be absolutely no doubt: the boundaries between visual and verbal representation probed on the reverse of the tablets have to be understood in terms of the teasing conceits of their rectos. On the one side, the tablets take epic texts and visualize them in pictures, all the while interrogating their capacity to imitate the linearity of words; on the other, the verso 'magic squares' summarize those pictures by means of a verbal title that is itself laid out in a figurative, and indeed pseudo-pictorial, way. Literally and metaphorically, the intermedial games inscribed on the recto comprise the flipsides of those of the verso (and the other way round).[83]

Within such diagrams of letters, the boast of *technê* on four different reverse 'magic square' inscriptions (2NY, 3C, 5O, 20Par) proves particularly poignant. As

[80] The point returns us to the writings of Jacques Derrida: see above, p. 5 n. 12. On 'script' as a language in its own right—textual organization revealing patterns of significance that are at once distinct *and* indistinguishable from the structures of linguistic convention—the key discussion is Kristeva 1989: especially 23–30.

[81] Cf. Elkins 1999: 242: 'The odd thing about the *Tabulae Iliacae* is that they can be read in a practical infinity of different orders: two squares right, then four up, two more right, six up... any zigzag that continuously increases its distance from the origin will do, and after a while the entire grid seems to be suffused with half-legible words and phrases. It passes from nearly perfect opacity to a kind of symphonic obviousness...'

[82] This pictorial aspect raises further questions about the restoration of the Greek hexameter instruction on tablets 2NY and 3C (above, p. 205). If Gallavotti 1989: 49 is indeed correct in reconstructing the instruction as to '*look* for the middle letter and *continue* with whichever one/wherever you choose' (γράμμα μέσον καθ[ορῶν παραλάμβα]νε οὗ ποτε βούλει), the visual–verbal game would have been all the more explicit: these are letters for beholding (καθορῶν), not for linear reading; it follows that there should be a multitude of successive viewing directions with which to proceed (παραλάμβανε).

[83] To suggest, like Valenzuela Montenegro 2004: 349, that 'eine tiefergründige Bedeutung ist hinter dem "magischen Quadrat" nicht zu erwarten' is therefore to overlook (and under-read) the sophistication of the visual–verbal play. 'Es handelt sich um ein Spiel, das die Aufmerksamkeit des Betrachters auf sich lenken soll, der sich an der raffinierten Anordnung einer sonst eher einfachen Inschrift erfreuen kann', the author earnestly concludes.

we saw in chapter 3, Hellenistic poets made much of the dual register of the term, pertaining at once to the literary and to the visual arts (pp. 111–21); when the iambic preface of the 'Eudoxus papyrus' begins by heralding the '*technê Eudoxou*', moreover, and doing so through hidden acrostic, the reference seems to be at once to the technical virtuosity of the poet and the figurative diagrams of the manuscript (not to mention the combined visual–verbal dexterity of this opening visual–verbal poetic spread).[84] The epigrams on the recto of the Capitoline and New York tablets (1A, 2NY), we noted, flag their combined literary and artefactual *technê* in a closely related sense—as something between words and pictures. In the context of the 'magic square' inscriptions, such self-referential talk of *technê* becomes all the more tactical. What we called the '*technê* squared' of the recto is squared in the literal sense on the verso: each letter of the title inscription is enclosed in an individual grid, and those grids collectively amount both to a written picture and graphic text.

It is not just that these 'magic square' diagrams can be read *like* pictures. The fact that a number of the inscriptions arranged their boxed letters to form geometric images—most spectacularly on tablet 4N, laid out in the shape of an altar (Fig. 105)—suggests that they could also be viewed *as* pictures. It is only after unscrambling the 614 boxed letters of tablet 4N's altar—comparing (and indeed contrasting) its visual potential with its contained verbal message—that we are able to recognize the hexametrical verse hidden within the picture: 'the Achillean shield: Theodorean, after Homer' (ἀσπὶς Ἀχιλλῆος Θεοδώρηος καθ' Ὅμηρον).[85]

Such self-conscious experimentation with the relations between text and image was a mainstay of both literary and visual culture in the Hellenistic world, as we have said. But it is epitomized in the genre of epigram, and of epigrams on artistic subjects in particular. We came across this genre in chapter 3 (pp. 113–15), and we shall return to it again in the following chapter, examining its relation to a distinctly Hellenistic credo of *leptotês*. The point to stress here, though, is that these poetic compositions offered verbal commentaries on the images that they evoked: as such, they work against the remit of ecphrasis, whereby the objective (as one later Greek rhetorician rationalized it) was to bring about 'seeing through hearing'.[86] In posing as monumental inscriptions attached to the artworks described, ecphrastic epigrams like those on Myron's cow toyed with their own ontological status between imposing physical object and collectible text on the

[84] See above, pp. 116–20.

[85] See Bienkowski 1891: 200–1. The hexameter was noted by Mancuso 1909: 665 and Guarducci 1974: 431: I reserve discussion of this hexameter picture poem—and of the additional palindromic inscription underneath it—for the seventh chapter.

[86] Cf. Hermog. *Prog.* 10.49: 'for the explanation must almost bring about seeing through hearing (δεῖ γὰρ τὴν ἑρμηνείαν διὰ τῆς ἀκοῆς σχεδὸν τὴν ὄψιν μηχανᾶσθαι): for discussion, see below, pp. 326–8.

page: the promise and failure of verbal text to manifest visual image figured the relationship between epigram as engraved monument for viewing and anthologized poem for reading.[87]

This brings us to a particular group of Hellenistic ecphrastic epigrams, and one which closely parallels the letter games of our seven Iliac tablets. The poems pose as pseudo-pictorial evocations of specific objects, and are preserved in the fifteenth book of the *Palatine Anthology* (*Anth. Pal.* 15.21–2, 24–7).[88] Although the ancient name is disputed, there is some evidence that they were called *technopaegnia*—i.e. playful exercises in both the artefactual and poetic senses of *technê*.[89] Six Greek examples are known to us: three are attributed to Simmias of Rhodes, and probably date to the early third century BC;[90] a fourth is (falsely) ascribed to Theocritus;[91] and the remaining two poems are perhaps Imperial in date, attributed to Dosiadas and Besantinus respectively.[92] All six epigrams share a common conceit: they use their verse lengths to figure 'calligrammatically' the visual appearance of the objects that they evoke—an egg, an axe, a statue of Eros, pan pipes, and two altars. The original presentation of these epigrams is unclear.[93] Two of the poems attributed to Simmias (*Anth. Pal.* 15.22, 27) seem to have made semantic sense only when readers physically *unscrambled* their sequence of increasing and decreasing choriambic verses. Readers, in other words, had first

[87] See above, pp. 113–16.

[88] On these poems, see e.g. Ernst 1976; 1984; 1991: especially 54–94; Simonini and Gualdoni 1978 (*non uidi*); Strodel 2002: especially 273–8; Guichard 2006; Männlein-Robert 2007b: 140–54; Manuwald and Manuwald 2007: 178–84; Luz 2008 and 2010: 327–53; Squire 2009: 167–9 and 2010d. Such poems were also written in Latin: cf. Laevius' calligrammatic poem on a *Pterygium Phoenicis* in the first century BC (see Morel (ed.) 1963: 60–1, frg. 22, with discussion in Courtney (ed.) 1993: 119, 136–7 and Ernst 1991: 95–6); note too Optatian's various poems—not just his Latin grid poems (see above, pp. 219–22), but also the picture poems figuring a water organ, pan pipes, and an altar (cf. Levitan 1985: 255 on poems 20, 26 (Fig. 116) and 27; I have not seen Polara 1996).

[89] On the significance of the name (derived from Ausonius), see Strodel 2002: 275: 'Die besondere τέχνη besteht dabei darin, daß dieser Sinnträger, der dem Gedicht den Namen gibt, noch eine zusätzliche optische Dimension durch die figurative Darstellung erhält.' Guichard 2006: 83–4 is more sceptical about the term's Hellenistic currency, as well as its relationship to the particular 'calligrammatic' poems that survive.

[90] Strodel 2002: 158–262 provides a commentary on Simmias' poems and their subsequent scholia, although the most thoughtful discussion remains Ernst 1991: 58–74.

[91] For a fully referenced discussion of the poem and its authorship, see Männlein-Robert 2007b: 150–4, together with the commentary in Strodel 2002: 158–98; for the figurative and allusive games, see Ernst 1991: 74–82. The choice of dactylic verses (rather than iambic or lyric, as in the other Greek examples) is surely significant, and a further indication of the concealed metapoetics: 'we may speculate that the poet of the *Syrinx* rejected Simmias' polymetric patterns and enclosed his *technopaignion* in recitative dactylics to mark out how the bucolic Theocritus used only dactylic hexameters' (Fantuzzi and Hunter 2004: 40–1).

[92] See Ernst 1991: 83–90 and Strodel 2002: 59–62, as well as below, p. 235 n. 102.

[93] For a concise and well-referenced overview, see Guichard 2006: especially 85–9. The key discussion is Strodel 2002: 48–130, who argues that the presentation in the surviving codices reflects later Byzantine conventions.

λεῦσσέ με τὸν Γᾶς τε βαθυστέρνου ἄνακτ' Ἀκμονίδαν τ' ἄλλυδις ἑδράσαντα·
μηδὲ τρέσῃς, εἰ τόσος ὢν δάσκια βέβριθα λάχναι γένεια.
τᾶμος ἐγὼ γὰρ γενόμαν, ἁνίκ' ἔκραιν' Ἀνάγκα,
πάντα δὲ Γᾶς εἶκε φραδαῖσι λυγραῖς
ἑρπετά, πάνθ' ὅσ' ἕρπει
δι' αἴθρας.

Χάους δέ,
οὔτι γε Κύπριδος παῖς
ὠκυπέτας οὐδ' Ἄρεος καλεῦμαι·
οὔτι γὰρ ἔκρανα βίαι, πραϋνόωι δὲ πειθοῖ·
εἶκε δέ μοι Γαῖα Θαλάσσας τε μυχοὶ χάλκεος Οὐρανός τε·
τῶν δ' ἐγὼ ἐκνοσφισάμαν ὠγύγιον σκᾶπτρον, ἔκρινον δὲ θεοῖς θέμιστας.

FIGURE 115. 'The Wings of Eros' (*Anth. Pal.* 15.24): 'picture poem' attributed to Simmias, probably early third century BC; text and typesetting after Christine Luz.

to tackle the opening line, then the last (followed by the second, and then the second-to-last, etc.), thereby undermining the figurative appearance of the calligram as they read it: just as seeing the picture meant reordering the poem, reading the poem entailed collapsing the picture.[94] Alternatively, perhaps we should imagine the reverse scenario: maybe the poems worked like logogrammatic riddles, their physical appearance *disguised* by their original, more prosaic appearance. In which case, the games must have proceeded the other way round: readers had quite literally to 'figure out' the picture from the clues latent in the *unfigured* poem, drawing the picture, and captioning the *griphos* poem ('*Egg*!', '*Axe*!').[95]

Like the *Tabulae*, the Greek *technopaegnia* delight in occupying a range of different ontological registers. 'Look at me' (λεῦσσέ με) reads the opening instruction of one of the earliest poems, attributed to Simmias, laid out in the shape of 'the wings of Eros' (15.24: αἱ πτέρυγες Ἔρωτος) (Fig. 115).[96] This

[94] See especially Männlein-Robert 2007b: 142–50 on *Anth. Pal.* 15.27, along with Luz 2008: 22–7 on the poem's punning *termini technici*.

[95] Cf. Luz 2008: 23: 'Der Leser muss also, wenn er das Gedicht in der Figur lesen will, mit den Augen auf- und niederspringen, und kommt am Schluss der Lektüre in der Mitte des Textkörpers an.' Contrast the literal-minded interpretations of nineteenth- and twentieth- century scholars, tending to debate whether they were 'not really poems at all but rather designed as inscriptions to fit the shape of their specific objects' (as Cameron 1995: 37 maintains): cf. Gow and Page (eds.) 1965: 2.511–16, with further bibliography in Strodel 2002: 265–71.

[96] On the poem, see Ernst 1991: 58–63, along with Luz 2008: 27–8. Strodel 2002: 209–10 lists parallels for this use of the 'seeing' verb, but is blind to the most obvious conceit: its significance within a *picture* poem. It is worth comparing how Greek and Latin authors appear sometimes to have signalled the visual properties of their acrostics with similar imperative prompts: cf. Bing 1990: 281 n. 1, on Aratus *Phaen.* 778, 799 (σκεπτέο); Feeney and Nelis 2005: 645–6 and Somerville 2010: 204 on Verg. *G.* 1.424–5 (*si uero ...sequentis | ordine respicies*).

```
      V I D E S·V T A R A S T E M·D I C A T A·P Y T H I O
      F A B R E·P O L I T A·V A T I S·A R T E M·V S I C A
  S I C·P V L C H R A·S A C R I S·S I M A G E N S·P H O E B O·D E C E N S
  H I S·A P T A·T E M P L I S·Q V I S·L I T A N T·V A T V M·C H O R I
5    T O T·C O M P T A·S E R T I S·E T·C A M E N A E·F L O R I B V S
      H E L I C O N I I S·L O C A N D A·L V C I S·C A R M I N V M
      N O N·C A V T E·D V R A M E·P O L I V I T·A R T I F E X
      E X C I S A·N O N·S V M·R V P E·M O N T I S·A L B I D I
      L V N A E·N I T E N T E·N E C·P A R I·D E·V E R T I C E
10   N O N·C A E S A·D V R O·N E C·C O A C T A·S P I C V L O
      A R T A R E·P R I M O S·E M I N E N T E S·A N G V L O S
      E T·M O X·S E C V N D O S·P R O P A G A R E·L A T I V S
      E O S Q V E·C A V T E·S I N G V L O S·S V B D V C E R E
      G R A D V·M I N V T O·P E R·R E C V R V A S·L I N E A S
15   N O R M A T A·V B I Q V E·S I C·D E I N D E·R E G V L A
      V T·O R A·Q V A D R A E·S I T·R I G E N T E·L I M I T E
      V E L·I N D E·A D·I M V M·F V S A·R V R S V M·L I N E A
      T E N D A T V R·A R T E·L A T I O R·P E R·O R D I N E M
      M E·M E T R A·P A N G V N T·D E·C A M E N A R V M·M O D I S
20   M V T A T O N V M·Q V A M·N V M E R O·D V M·T A X A T·P E D V M
      Q V A E·D O C T A·S E R V A T·D V M·P R A E C E P T I S·R E G V L A
      E L E M E N T A·C R E S C V N T·E T·D E C R E S C V N T·C A R M I N V M
      H A S·P H O E B E·S V P P L E X·D A N S·M E T R O R V M·I M A G I N E S
      T E M P L I S·C H O R I S Q V E·L A E T V S·I N T E R S I T·S A C R I S
            5        10        15        20        25        30        35
```

FIGURE 116. Optatian Porphyry, poem 26 (Polara).

exhortation to look is of course commonplace in ecphrastic epigram,[97] as is the use of the first person pronoun—as though the poem were actually part of the material object attached to it, imbued with a voice of its own.[98] In this epigram, though, we really *can* (hope to) see the image ecphrasized: in a *mise en abyme* of replications, the speaking first person of the epigram refers at once to the god Eros himself, his statue, its calligrammatic image, the dedicatory inscription

[97] For a helpful (but not exhaustive) list of examples, see Rossi 2001: 17 n. 13.

[98] Typical are the first-person pronouns and personal adjectives that abound in the poems on Myron's cow: see e.g. *Anth. Pal.* 9.713.2, 714.1, 719.1, 720.1, 721.1, 723.1, 729.1, 730.1, 742.1, 742.3, 742.5, 794.1, 797.1. For the earlier tradition of Greek 'ventriloquist epigram'—objects 'speaking' in the first person, see Burzachechi 1962, with further comments in Stehle 1997: 312–17; Keesling 2003: 17–21; Tueller 2008: 16–27. But the Hellenistic innovation lay in appropriating this language within the context of poems circulating in isolation from their purported epigrammatic objects: see e.g. A. Petrovic 2005; Männlein-Robert 2007b: 157–67; Tueller 2008: especially 141–65; Squire 2010a: 608–16.

Ὀλὸς οὖ με λιβρὸς ἱρῶν
Λιβάδεσσιν οἷα κάλχη
Ὑποφοινίηισι τέγγει·
Μαύλιες δ᾽ ὕπερθε πέτρης Ναξίης θοούμεναι
Παμάτων φείδοντο Πανός· οὐ στροβίλωι λιγνύι
Ἰξὸς εὐώδης μελαίνει τρεχνέων με Νυσίων.
Ἐς γὰρ βωμὸν ὀρῆις με μήτε γλούρου
Πλίνθοις μήτ᾽ Ἀλύβης παγέντα βώλοις,
Οὐδ᾽ ὃν Κυνθογενὴς ἔτευξε φύτλη
Λαβόντε μηκάδων κέρα,
Λισσαῖσιν ἀμφὶ δειράσιν
Ὅσσαι νέμονται Κυνθίαις,
Ἰσόρροπος πέλοιτό μοι·
Σὺν οὐρανοῦ γὰρ ἐκγόνοις
Εἰνάς μ᾽ ἔτευξε γηγενής,
Τάων ἀείζωιον τέχνην
Ἔνευσε πάλμυς ἀφθίτων.
Σὺ δ᾽, ὦ πιὼν κρήνηθεν, ἥν
Ἶνις κόλαψε Γοργόνος,
Θύοις τ᾽ ἐπισπένδοις τ᾽ἐμοὶ
Ὑμηττιάδων πολὺ λαροτέρην
Σπονδὴν ἄδην. ἴθι δὴ θαρσέων
Ἐς ἐμὴν τεῦξιν· καθαρὸς γὰρ ἐγώ
Ἰὸν ἱέντων τεράων, οἷα κέκευθ᾽ ἐκεῖνος,
Ἀμφὶ Νέαις Θρηικίαις ὃν σχεδόθεν Μυρίνης
Σοί, Τριπάτωρ, πορφυρέου φὼρ ἀνέθηκε κριοῦ.

FIGURE 117. 'The Altar of Besantinus' (*Anth. Pal.* 15.25): 'picture poem' attributed to Besantinus, date uncertain; text and typesetting after Christine Luz.

attached to it, and the papyrus scroll that represents all of these levels and more.[99]

Such combined artistic and poetic *technê* is a recurrent theme in the *technopaegnia*, just as it is on our verso *Tabulae* texts. An explicit example comes in Besantinus' figure poem on an altar (*Anth. Pal.* 15.25). Like a similar-looking Latin epigram by Optatian (Fig. 116), as well as another Greek altar poem by Dosiadas (*Anth. Pal.* 15.26), Besantinus' poem mirrors the figurative altar subject of the letter diagram on tablet 4N (Figs. 105, 117).[100] But it also reflects the complex visual and verbal puzzle involved. Besantinus' altar, the poet boasts, is not composed of material gold or silver, but has instead been crafted by the *Muses* 'whose immortal *technê* the king of the gods granted' (τάων ἀείζῳον τέχνην | ἔνευσε πάλμυς

[99] Cf. *Anth. Pal.* 15.21, a poem expressly concerned with sound and ending with a homage to Calliope, at once mute *and* invisible (ἔλλοπι κούρᾳ, | Καλλιόπᾳ, | νηλεύστῳ, vv. 18–20).

[100] Optatian's twenty-sixth poem can be found in Polara (ed.) 1973: 103–5: notice again the opening invitation to *see* the object (*uides*, v. 1). I reserve full discussion of the verso of tablet 4N for chapter 7, especially pp. 307–10, 348–9, 369.

ἀφθίτων, *Anth. Pal.* 15.25.16).[101] Still more remarkable is the way in which, as with the *Tabulae* 'magic square' inscriptions, Besantinus' picture poem could be read along a vertical as well as a horizontal axis: an acrostic runs along its left-hand margin, revealing an otherwise hidden verbal message within the poem's spatial mode of presentation (᾽Ολύμπιε, πολλοῖς ἔτεσι θύσειας, 'Olympian, may you sacrifice for many years').[102] Just as the Iliac tablet inscriptions flaunt their combined visual–verbal *technê*, so does this picture poem knowingly exhibit a sequential-cum-spatial *technê*—a *technê* that can be both read and viewed, decipherable all at once, from left to right, and indeed from top to bottom. The *technê* of the *technopaegnia* tallies with the *technê* of the tablets' turn-tabled texts: glide wherever you like.[103]

GRASPING *GRAMMATA*

Comparison with the *technopaegnia* adds a further rebuff to the suggestion that the tablets' verso inscriptions were common, trivial, or unschooled objects. One of the few surviving literary references to the *technopaegnia* confirms, rather, that these were deemed highly demanding and challenging poems. Referring to Dosiadas' calligrammatic poem on an altar (*Anth. Pal.* 15.26), Lucian expressly compares such epigrams to the arcane and riddling glosses of Lycophron's *Alexandra* (*Lex.* 25).[104]

The tablets' relationship with the *technopaegnia* is important and revealing. But the *Tabulae* nevertheless dabble once again with a slightly different

[101] There can be no doubting the Callimachean literary resonance here, as in other *technopaegnia*. Cf. Strodel 2002: 277: 'Insgesamt lassen sich die Technopaegnien ohne weiteres in den Rahmen des hellenistischen Umfeldes einordnen . . . Die literarische Richtung . . . ist am ehesten mit dem dichterischen Œevre und Programm des Kallimachus vergleichbar.'

[102] As noted by Courtney 1990: 6, who identifies the 'Olympian' as 'probably Hadrian'. But the second-century date is by no means certain. Strodel 2002: 61–2 challenges on metrical grounds the Hellenistic attribution of e.g. Wojaczek 1969: 121–2; Ernst 1984: 311–15 (= 2002: 24–8) and 1991: 86–8. However, Strodel's condemnation of the 'kunstlose[e]' 'Aneinanderreihung der verschiedensten Versmaße' is rather unfair—and no certain criterion for dating.

[103] Even Horsfall 1979a: 29 admits of tablet 4N that 'it is hard to avoid supposing that Theodorus or one of his workmen here had in mind a verse antecedent of this type': 'theirs was a workshop endowed with abundant technical skill and flickering *Gelehrsamkeit* which were regularly put to trivial and bizarre uses'.

[104] See *Lex.* 25: 'We do not praise those poets who write poems full of rare words [τοὺς κατάγλωττα γράφοντας ποιήματα]. But your compositions—to compare prose with verse—would be like the *Altar* of Dosiadas and the *Alexandra* of Lycophron, and whoever else is still more infelicitous in his voice than these poets [καὶ εἴ τις ἔτι τούτων τὴν φωνὴν κακοδαιμονέστερος].' The residual pun of the Greek verb *graphein* (both 'to write' and 'to draw') should not go unnoticed, nor should the final recourse to *voice* specifically (adding a third dimension to the letter lines). On the enigmatic conundrums of the *technopaegnia*, see Sistakou 2008: 53–4, who also compares the riddling names of Lycophron's *Alexandra* at 54 n. 95.

organizational principle, flipping the pictorial–poetic games even of the Greek and Latin calligrams themselves. If the verso inscriptions resemble the *technopaegnia* in their two-way flow of visual and verbal signs, their textual and artefactual *technê* is in one sense even more multiplex. Whatever viewers make of their diagrammatic layout, they are free, as readers, to proceed in (almost) any direction. This is where the real innovation of the tablets comes into play: for our freedom in *reading* (or should that be viewing?) on one side of the tablets has important ramifications for our modes of *viewing* (reading?) on the other.

We have already observed how the *Tabulae* imagery encourages a range of different viewing strategies: the rectos of the tablets at once lay out events in order and undermine the suggestion of any verbally derived narrative sequence. But the 'magic square' inscriptions expressly promote and legitimize the practice. Demonstrating that there is no single definitive mode of narratological interpretation, they incite us to experiment with different means of determining meaning (Fig. 118). So it is that the multidirectional reading modes on the reverse of the tablets parallel the multidirectional viewing modes on their obverse: just as the images of the recto call upon viewers to play with new strategies for viewing—to choose their own adventure—so too does the spatial layout of the verso inscriptions call for innovative strategies of reading. 'Grasp the middle letter [*gramma*]', as the epigrams on tablets 2NY and 3C instruct, 'and glide *whichever way you choose*'.

In this connection, it is worth noting that *both* sides of the tablets are in fact inscribed with *grammata*. Just as the letters of the verso are arranged in neatly ordered grids, the obverse images are laid out in tidy units which are likewise accompanied by a variety of alphabetic inscriptions. As we have said, some of these obverse inscriptions name the protagonists, while others summarize the action (whether in keywords, prose synopsis, or more elaborate epigrammatic poems). Still more 'letters' are used to label the 24 books of the *Iliad* themselves, numbering them according to the letters of the alphabet: tablets 2NY and 3C are just two of seven tablets that literally and explicitly lay out their subjects from *alpha* (i.e. book 1) to *omega* (book 24: such book letters are to be found on tablets 1A, 2NY, 3C, 6B, 11H, ?12F, 20Par). So to which side does the instruction to 'grasp the middle *gramma* and glide whichever way you choose' properly refer? If the gloss pertains to the letters of the verso, it also has relevance for the alphabetically organized and labelled zones of the recto: we are granted freedom to roam not only across the letter diagram of each reverse, but also the lettered diagrams of the obverse epic scenes: devise your *own* 'order of Homer' (τάξιν Ὁμήρου)![105]

[105] For the phrase and its significance on the Capitoline tablet, see above, pp. 195–6.

FIGURE 118. Reconstruction of the 'magic square' on the reverse of tablets 2NY and 3C, showing the multidirectional outward progression from the central *gramma*.

But the semantic register of the word *gramma* is more complex still. For Hellenistic poets, the significance of the term lay in its reference as much to the 'strokes' of a pictorial image as to those of an alphabetic letter. The noun *gramma* was therefore no less ambivalent than the Greek verb *graphein*, meaning at once 'to write' and to 'to draw': as the aphorism attributed to Menander puts it, 'those who have understood *grammata* look upon them twice' (διπλῶς ὁρῶσιν οἱ μαθόντες γράμματα).[106] When,

[106] For the Menandrian *sententia*, see Pernigotti (ed.) 2008: 294, no. 180, with discussion in Battezzato 2008: 1–2. More generally on the pun, see Männlein-Robert 2007b: 123–7; cf. eadem 2007a: 255–6 (with further references on the two uses in nn. 28 and 29) and Tueller 2008: especially 141–54 (whose suggestion it is to translate *grammata* as 'strokes': 143 n. 4). The most important discussion of this pun from a Greek *visual* perspective is Lissarrague 1992. *Anth. Plan.* 125 provides a neat verbal comparandum, and in a related Homeric context: water has (appropriately) washed away a painted *eikón* of Odysseus' shipwreck, we are

in Theocritus' fifteenth *Idyll*, Praxinoa exclaims 'what painters have depicted such true *grammata!*' (ποῖοι ζωογράφοι τἀκριβέα γράμματ' ἔγραψαν, Theoc. *Id.* 15.81), the self-reflexive reference is simultaneously to the tapestry that Praxinoa describes and to the virtual reality of the poet's larger verbal description (as if voiced by this fictional character herself—'what *writers* of living beings have *written* such true *letters*').[107] We find the same wordplay in Herodas' fourth mime (knowingly alluding to Theocritus, it seems):[108] responding to a supposed image, but within a poem that itself vacillates between visual performance, audible narrative and readable text, Cynno exclaims that 'true indeed, my dear, are the hands of Ephesian Apelles in all his images/letters [*grammata*]' (ἀληθιναί, φίλη, γὰρ αἱ Ἐφεσίου χεῖρες | ἐς πάντ' Ἀπελλέω γράμματ', 4.72–3).[109]

As Irmgard Männlein-Robert has shown, this pun on *grammata* (no less than on the 'hands' behind them) was also a favourite among Hellenistic epigrammatists, who composed words on pictures. The conceit seems to have taken its lead from a somewhat earlier poem by Erinna, purportedly penned on a painting of Agatharchis (*Anth. Pal.* 6.352):[110]

> ἐξ ἀταλᾶν χειρῶν τάδε γράμματα· λῷστε Προμαθεῦ,
> ἔντι καὶ ἄνθρωποι τὶν ὁμαλοὶ σοφίαν.
> ταύταν γοῦν ἐτύμως τὰν παρθένον ὅστις ἔγραψεν,
> αἰ καὐδὰν ποτέθηκ', ἦς κ' Ἀγαθαρχὶς ὅλα.

These *grammata* are the work of delicate hands. Most excellent Prometheus, humans have a wisdom that matches your own. If the person who so accurately depicted/described [*egrapsen*] this girl had only also added her voice, you would be Agatharchis complete.

Within an epi*gramma*tic intervention about the respective resources of words and images, Erinna's poem flirts with its iconotextual liminality between the two

told, but the true image of the story is written/painted in the immortal pages of Homer (εἰκὼν ἀφθάρτοις ἐγγράφεται σελίσιν, *Anth. Plan.* 125.4).

[107] On the staged contest between visual and verbal *sophia* in this idyll, see above, p. 112.

[108] For the pun, and a broader discussion of the mime's 'Agon der Künste', see especially Männlein-Robert 2006 and 2007b: 279–82; there is also a survey of bibliography in G. Zanker (ed.) 2009: 122–9.

[109] Cf. also Herod. *Mim.* 4.23–4, where Cynno asks Coccale whether she does 'not see these *grammata* on the base' (οὐχ ὁρῆς κεῖνα | ἐν τῇ βάσι τὰ γράμματ'). In this second example, the choice of verb underscores the pun: the inscription on the base may be written, but it is nevertheless designed for seeing (ὁρῆς). For the behind-the-scenes metapoetics—the *Mimiambs* as transcribed written text that itself poses as visible theatrical performance—the key discussion is Hunter 1993 (= 2008: 1.189–205).

[110] For commentary on the poem and its Simonidean backdrop (painting as 'silent poetry': cf. below, p. 339 n. 91), see especially Skinner 2001: 206–9; Gutzwiller 2002a: 88–91; Meyer 2007: 197–8; Männlein-Robert 2007b: 38–43; Tueller 2008: 142–3. The ascription to Erinna is debated, as is Erinna's date (probably mid fourth century): cf. West 1977: 114–15, with responses in Pomeroy 1978; Cavallini 1991: 132–5; Neri 2003: 31–2.

media—as 'lines' that are at once drawn and written by the delicate hands of the female poet herself. 'Erinna uses this term [γράμματα]', writes Männlein-Robert, 'specifically because of its ambiguity and hints not only at the painting, but also at her own poem'; in this case, the written verb ἔγραψεν paints out the analogy, drawing together the pictorial and poetic *sophia*.[111] Related wordplays pepper the posthumous prose ecphrastic tradition too—from allegorical texts like the *Tablet of Cebes*, to set-piece descriptions such as Lucian's *On the Hall* or the *Imagines* of Philostratus.[112] To cite just one example, one might consider the proem of the Younger Philostratus' *Imagines*, explicitly comparing words with pictures. Within a text that openly interrogates the relationship between visual and verbal *phantasia*, responding all the while to the ancestral *grammata* of his purported grandfather, Philostratus declares that 'the art of painting shows by means of the *gramma* that which the poets are able to speak' (γραφικὴ τε ὁμοίως, ἃ λέγειν οἱ ποιηταὶ ἔχουσι, ταῦτ' ἐν τῷ γράμματι σημαίνουσα, *Imag*. praef. 6).[113]

In the context of the *Tabulae Iliacae*, the dual register of the word *gramma*—as both drawn letter and drawn picture tradition—gives the epigrammatic instruction an additional significance, and one that again pertains to *both* sides of the tablets. For are we being asked to move outwards from the central *letter* of the 'magic square' inscription on the verso? Or to proceed from the central *image* adorning the recto? Which *grammata* are for reading, so to speak, and which are for viewing? Tablet 2NY develops the conceit with particular sophistication. On this verso, the central letter diagram seems to have been framed (so far as we can tell) by a series of apparent 'nonsense' *grammata*—Μ, Π, Λ, Ε—each drawn in large and looming lettering (Fig. 119). Introduced as a sort of pictorial adornment, these alphabetical/numerical/visual signs appear to have had no *verbal* significance ('mple'!). In a literal sense, though, the inscribed *grammata* shake up our reading of the *grammata*-arranged books on the recto. The subsequent challenge is to think visually about the depicted episodes, and outside the verbal

[111] Männlein-Robert 2007a: 255–6. For the significance of the noun *sophia* in v. 2, cf. above, pp. 114–15. For the 'epigrammatic' etymology, see below, p. 275.

[112] Cf. above, p. 123 n. 121. On Lucian's *On the Hall*, see the bibliography collected in Squire 2009: 240 n. 5—to which Cistaro 2009: 42–7 and Webb 2009: 172–4 should now be added.

[113] Like his (self-declared) grandfather, Philostratus the Younger posits a visual–verbal distinction while simultaneously undermining it: the etymology of these ποιηταί shows them to be 'makers' (ποιεῖν) rather than simply speakers; moreover, the defining feature of the described *Imagines* that follow is the pictures' capacity to (be made to) speak. The author develops the conceit in the concluding section of his proem (*Imag*. praef. 7): 'But in order that our *gramma* may not proceed on its own [ἀλλ' ἵν' ἡμῖν μὴ ἐφ' ἑνὸς τὸ γράμμα προίοι], let it be assumed that someone is present—for whom we must articulate [διαρθροῦν] each detail—in order that the *logos* too might have its suitable counterpart [ἵν' οὕτω καὶ ὁ λόγος τὸ ἁρμόττον ἔχοι]'. Philostratus' self-confessed text on pictures at once writes its letters and paints them, all the while leaving its viewer-readers to join the *grammata* dots together: only then will we see/read the underlying *phantasia* (cf. below, pp. 331–3).

FIGURE 119. Reverse of tablet 2NY.

terms of the boxed epic text. Just what might happen if you jumble the individual units—cornering *Iliad* book 16 (*pi*) with other *grammata* like books 12 (*mu*) and 11 (*lambda*), for example?[114] Shuffle the *grammata* in your hands—and then put them together anew!

But what, then, of the specific instruction to move from the *central* 'letter'—the *gramma* in the middle? Again, the instruction seems to have been multi-sided. As

[114] Although noted by Valenzuela Montenegro 2004: 185, the letters have yet to receive either commentary or explanation. One might compare here the 'nonsense inscriptions' of Archaic and Classical Attic painted pottery (see Immerwahr 1990: especially 44–5 for bibliography)—Greek *grammata* which served related ornamental, onomatopoeic, and visual functions (cf. Lissarrague 1985; 1990: 125–35; 1992: 191–7; 1999; Henderson 1994: especially 90–4, 103–13).

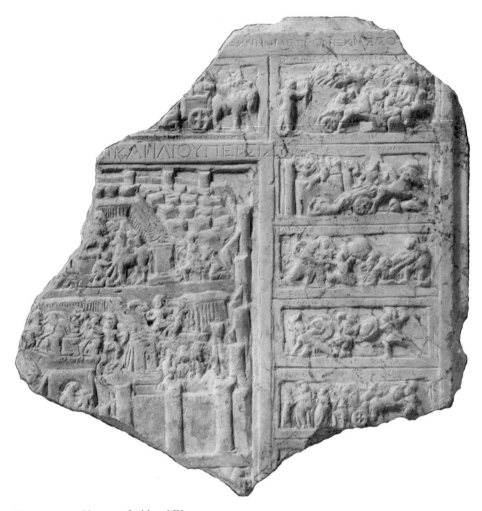

FIGURE 120. Obverse of tablet 2NY.

we explored in the previous chapter (pp. 148–58), the centre of several composi-
tions was reserved for a particular iconographic schema: the group of Aeneas,
Anchises, and Ascanius escaping from Troy, as best surviving on the Capitoline
tablet (Figs. 49–50). Of course, the Capitoline tablet was inscribed only on its
obverse: interestingly, it is the only signed 'Theodorean' tablet not to contain a
verso magic square. Still, we find we find the same Aeneas schema in the middle
of at least two recto fragments which certainly did contain 'magic square' inscrip-
tions on their verso, and which also preserve this instruction about the central
gramma: the group is clear to see on tablet 2NY (Fig. 120), and it very likely also
appeared in the middle of tablet 3C (as perhaps too on 7Ti).[115] In the case of

[115] See above, p. 178, n. 115.

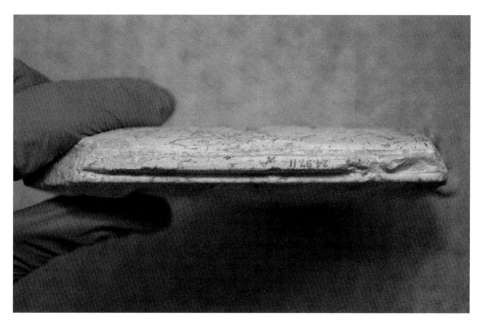

FIGURE 121. Side view of tablet 2NY turned in the hand (as seen from the top of the surviving fragment).

these tablets, the instruction to move outwards from the central *gramma* of the verso might equally apply to the central *gramma* of the recto. Just as we (are told to) proceed from the middle letter of the 'magic square' on the reverse, so too are we invited to set our sights around the target figurative group at the obverse centre. The pivotal importance goes unspoken. But on these tablets there is a diagrammatic clue: our stories are to orbit around a nodal narrative bullseye, as we flip from the central *gramma* of the one side to that of the other (Fig. 121).[116]

The fragmentary state of tablets 2NY and 3C means that we cannot know which scenes radiated around the axial Aeneas. As we observed in the previous chapter, however, the Capitoline tablet certainly did forge connections between the various adventures of Aeneas, and across horizontal, vertical, and diagonal planes (Fig. 122): Aeneas occurs in three different places in the *Ilioupersis* scene, as well as in friezes *omicron* (surrounding the central panel, immediately to its lower right) and *nu* (i.e. in the bottom register, towards the lower right-hand corner). Just as the reverse 'magic square' texts of tablets 2NY and 3C proceed from the centre to the corners, then, it is likely that their obverse imagery played with a

[116] Petrain 2006: 64–5 makes a related point independently: 'Certainly an injunction to start at the center fits very well with the central panel of the *Capitolina* . . . The magic squares of the *Tabulae* may thus imply that a viewer may start with Aeneas' escape and then continue to whatever other scenes on the *Tabulae* catch his fancy.'

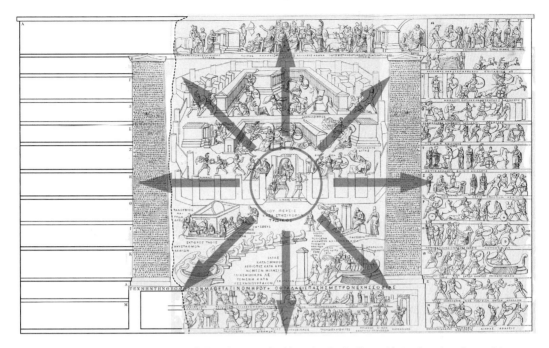

FIGURE 122. Reconstruction of the obverse of tablet 1A (Capitoline tablet), showing the multi-directional outward progression from the central *gramma*.

similar structural arrangement—a suggested pictorial progression (albeit in non–Iliadic, non-verbal, non-chronological order), across a variety of spatial axes. Glide whichever way you choose. But wherever you go, your *grammata* run rings around the unvoiced *gramma* of Aeneas...

CONCLUSION: SQUARING TEXTS WITH IMAGES

This chapter began with Roland Barthes and his poststructuralist account of subjective reading. We can now see how the *jouissance* involved in reading the diagrammatic inscriptions on the reverse of seven tablets replicates and inverts the *jouissance* of viewing their obverse imagery (and vice versa). Rather than demonstrate some 'Egyptian' connection—still less showcase some 'Trimalchion-esque' triviality—these diagrammatic inscriptions probe the interconnected dynamics of visual and verbal communication. What is more, they do so with an incontrovertible degree of metaliterary—and indeed metapictorial—self-reflexivity.[117]

[117] On the 'meta-picture', see Mitchell 1994: 35–82.

FIGURE 123. Reconstruction of the 'magic square' on the reverse of tablets 2NY and 3C, highlighting the figurative *grammata* patterns formed through the repetition of single letters.

The point is perhaps clearest on the truly square 'magic square' inscriptions of tablets 2NY, 3C, and 20Par. As we have seen, both recto and verso of these objects were framed within a series of quadrangles. On the one hand (i.e. the reverse side), each individual letter of the diagrammatic inscription is bounded in a single square, and those single squares are collectively arranged to form a single overarching grid. On the other hand (i.e. the obverse side), the images are contained within boxed pictorial units, structured around a central quadrangular composition (the *Ilioupersis*). If both obverse and reverse of these tablets therefore tabulate their contents—bounding their images and texts within a series of quadrangular surrounds—both sides also push against the confines of their

physical and conceptual frame. The images of the obverse may be laid out *sequentially*, but connections between the pictographic units undermine the rectilinearity: iconographic correspondences collapse the suggestion of systematic verbal order (*taxis*). Similarly, although the letters of the diagrammatic inscriptions on the reverse are laid out *spatially*, they nevertheless maintain a unilateral sort of verbal logic: however they are read, there is only one coherent set of words to be formed from each word search ('the *Iliad* of Homer: the *technê* is Theodorean'). Just as the recto images at once imply and undermine the suggestion of their working as texts, so too the reverse inscriptions embody the (in)capacity of alphabetical symbols to function like and unlike pictures.

So just how free are we to read (or indeed see) in 'whatever way we choose'? Despite the invitation of unregulated play, numerous rules in fact govern the game: one need only re-view the hexameter instruction written above the verso diagram ('seize the middle letter!'), or re-read the imperative instructions of the recto ('understand the order of Homer!', at least as inscribed on tablet 1A). On the verso, as on the recto, the tablets appear to have it both ways: there both are rules, and there are no rules.

Once again, the verso inscriptions figure the point graphically. Yes, we can proceed wherever we like. But there are nonetheless limits. For the magic to work, readers of these 'magic squares' must obey a textual progression behind and within the picture: regardless of their precise interpretive path, they must move from centre to margin, resisting the constant danger of turning inwards rather than out—of heading *back* to the inscription's 'start' rather than making it to one of the four 'final' corners (***PHMHPOYΘ* **). However we proceed, moreover, look how our literal interpretation is visually distracted along the way. To arrive at the text, the readerly journey must not stall around a single alphabetic *gramma*—it must not get sidelined by the concentric rows of eight *lambdas*, 16 *iotas*, 24 *alphas*, 32 *sigmas*, etc., each forming a series of framed ornamental lozenge shapes inside the square (Fig. 123): these *grammata* might figure visual, psychedelic, 'lucy-in-the-sky-with-diamonds' patterns, but they make no *verbal* sense (*IIIIIIII, ΛΛΛΛΛΛΛΛΛΛΛΛΛΛΛΛ, AAAAAAAAAAAAAAAAAA-AAAAAAA*, etc.).[118] As ever, the verso games transpose those of the recto. Just as the pseudo-sequentiality of the squares on the obverse at once can and

[118] On the visual properties of this arrangement, see Bua 1971: 15: 'La lettera iniziale resta nascosta al centro della figura, come imprigionata in una serie di losanghe costituite dal ripetersi continuo delle stesse lettere, le quali, via via che si allontanano dal centro, si allargano con ingannevole effetto ottico. Lo sguardo non coglie dapprima che un intreccio indecifrabile, il quale si ricompone in un senso compiuto soltanto quando la mente ha afferrato il segreto del giuocho.' The visual pattern is all the more striking in the 12-sided diagram on the verso of tablet 5O (Fig. 104), presumably adapted to suit the circular shape of the tablet (cf. below, p. 307): each of the longest four sides of the figure was adorned with the same letter, accentuating the diagram's internal lozenge-shaped patterns.

cannot contain the stories depicted, the pseudo-spatiality of the reverse squares plays with the promise and failure of this two-dimensional shape to contain the words inscribed within.

How, then, to put the four sides of these two obverse and reverse quadrangles together? Can the squared visual and verbal games of each recto and verso lead to a *third* dimension, beyond the limits of text and image? What might *technê* 'cubed' look like? As we query these quadrangular quandaries, the tablets frazzle us with frantic frenetic flipping: they gyrate backwards and forwards from words (un)contained in images to images (un)contained in words. If each side of the tablet plays individually with the relations between seeing and reading, their reverse arrangement keeps us rotating from one mode to the other, not only *within* each side, but also *between* them. The result makes for a truly heady spin.

The Art and Poetics of Scale

As the preceding chapters have demonstrated, the *Tabulae Iliacae* are intently intermedial objects which probe the boundaries between what can be viewed and what can be read. This aspect, I have argued, holds equally true for both sides of the reliefs, whether we look to their obverse *grammata* (chapter 4), or to the reverse 'magic squares' surviving on seven different examples (chapter 5). As self-conscious attempts at visualizing epic poetry—no less than at verbalizing those visions once more—the tablets interrogate what it means to inscribe images from texts, and vice versa to draw texts out of images.

But for any ancient viewer (or indeed modern museum-goer) by far the most arresting aspect of these objects is not the pictures, nor their lettered inscriptions, but rather the tablets' minute *scale*. These are truly minuscule reliefs: it is only by getting close up and personal—by straining and squinting—that we can make heads or tails of their squiggles at all. The *Tabulae* turn their subjective viewers-cum-readers into giants: holding the tablets, turning them at will, audiences dwarf the grand epic heroes over whom they tower.

If the diminutive dimensions imply a sort of interpretive intimacy, they also establish a certain hierarchy—a certain power relationship—between viewing subject and object viewed. Whether responding to the recto imagery, or indeed skipping across the verso diagram inscriptions, size implies freedom on the one hand, and regulation on the other. Their scale makes the tablets almost unique within the annals of 'classical art history'. Whereas most architectural friezes structure our viewing *around* or *within* a much larger monument—think, for example, of the Ionic frieze that frames the Parthenon, the continuous Telephus frieze within the Pergamon altar, or else the spiralling bands of Trajan's or Marcus Aurelius' columns in Rome[1]—viewing these tiny tablets does not entail physical movement: thanks to the size of the figurative units, our eyes are free to meander at will. Miniaturization, in short, yields a sort of hermeneutic control. At the same time, the *extent* of the miniaturization means that exegetic authority

[1] The classic discussion of viewing the Parthenon frieze is R. Osborne 1987, now supplemented by Marconi 2009. On the Telephus frieze, see A. Stewart 1996: especially 39–45. On Trajan's column, see Veyne 1991: 311–42 and 2002; Settis 1992.

always slips through our fingers: are there not *grammata* so small as to be invisible/unreadable even to the most authoritative gaze?

As with the miniaturist 'manuscripts' of Myrmecides, Callicrates, and others the miniature scale of the Iliac tablets is therefore bound up with their larger art of literary visualization. The conceit of representing the grand in the small extends and contracts the fiction of objectifying texts—the tablets' artificial materialization of words in pictures, all the while turning those pictures back into words. The scale of the tablets becomes a figurative yardstick for measuring visual–verbal relations at large.

This chapter expands upon this little point, contextualizing our small tablets within much grander Graeco-Roman discourses about the semantics of size. As we shall see, such thinking about scale loomed large within the Alexandrian cultural imaginary, occupying artists and writers alike. By depicting the largest of literary genres in the most minuscule of mediums, the tablets embody a thoroughly Hellenistic concern with combining the minute with the massive (and vice versa). If the tablets therefore encapsulate what Jim Porter has labelled a 'dynamic *contrast* of extremes', they do so by bringing together related discourses about size *and* medium: they juggle a mode of synopsis that is at once big *and* small, and verbal *and* visual.[2]

MEASURING UP *METRON*

Before proceeding, it is worth remembering just how small these tablets really are (cf. p. 32, Table 1). We said in the second chapter that the largest surviving Capitoline fragment (1A) measures just 30 x 25 cm, and seems originally to have been only marginally bigger (*c.*40 cm in width): although once inscribed with 400 or so figures, the tablet was still small enough to be held the hands and light enough to be passed around a room.[3] Tablet 19J is admittedly later in date, and different in subject. But its excellent state of preservation nevertheless demonstrates the point: all four sides of the tablet survive intact, and the whole relief measures just 25 x 24 cm. The fragmentary nature of the other tablets makes speculation about sizes and scales inherently tricky. Still, we can be confident of Sadurska's assessment that the *Tabula Capitolina* is among the largest of the tablets, and that almost all of them were both smaller in scale and squarer in shape.

[2] See Porter forthcoming (discussed further below, p. 273). This chapter has greatly benefited from discussions with Jim Porter: my sincere thanks.

[3] For the tablets' weights, see above, p. 70.

Insufficient attention has been paid to the tablets' scale. Photographic reproductions in monographs and articles—as indeed in the book in hand—perhaps makes this inevitable: while drawings and details help us to see more clearly what the tablets depict, they eclipse the original challenges of doing so; what is more, such reproductions have only fuelled scholarship's residual drive to compare the minutiae of the 'illustrating' miniature with the letter of the 'illustrated' text.[4] The catalogue conventionally follows suit, writing more and more about these tiny objects, out of all proportion with their original size.[5] Nicholas Horsfall is explicit about the process, suggesting that the *Tabulae Iliacae* inscriptions 'are easily legible with a magnifying glass'. Here the semantics of size are simultaneously effaced and dismissed: 'the *serious* lover of art cannot have derived much pleasure from pictures so tiny that the sculptor could add little if anything of his own interpretations and emotions'.[6]

But the artists behind our tablets clearly *chose* to operate to these dimensions. This makes a *reductio ad absurdum* of the habitual suggestion that the tablets simply 'copied' some other, larger medium. We have already encountered this hypothesis in chapter 4, in the context of (supposed) Hellenistic 'illustrated manuscripts' (pp. 129–36). But the philological strategy is a favourite among classicists of all shapes and sizes. Although delivering many important philological observations along the way, Nikolai Kazansky proffers a closely related thesis about the Capitoline tablet, relating its images to a series of bigger mosaics. Supposing that the 'originals' behind the tablets adorned a luxury ship of Hieron II in the second century BC, Kazansky argues that the '*Tabulae Iliacae* were reproductions of a very large and famous picture'.[7] Quite apart from the fact that there is no evidence to support this suggestion, Kazansky assumes that scale is inversely proportional to quality (the greater the reduction, the smaller the quality). For Kazansky, the size of the tablets is consequently turned into accidental defect: 'the carved figures, though very expressive, are *too* small…one

[4] On the deceptiveness of the 'innocent' photograph in such academic contexts, cf. Huet 1996.

[5] So it is that e.g. Sadurska 1964: 14 was more interested in the information that different scales might yield about different workshops than in the semantic stakes (attributing tablets 11H, 13Ta, and 17M to her 'third' group because of their similar measurements: cf. above, pp. 54–6). Valenzuela Montenegro 2004 likewise dedicates only one page to the issue of scale in her grand catalogue (412; cf. eadem 2002: 67), downsizing the critical aesthetic stakes.

[6] Horsfall 1994: 79 (my emphasis, and discussed above, p. 15); cf. idem 1979a: 34 on 'illustrations… equally simple and so small that the artist could add little if anything of his own emotions and interpretations to the narrative'.

[7] See Kazansky 1997: 74–8 (quotation from 74): the key text is Ath. 5.207c, referring to mosaics 'on which the entire story of the *Iliad* was wonderfully wrought' (ἐν οἷς ἦν κατεσκευασμένος πᾶς ὁ περὶ τὴν Ἰλιάδα μῦθος θαυμασίως). For Kazansky, this derivation explains the literary and visual 'inaccuracies' in the iconographic details of the Capitoline tablet: 'the craftsmen who made the copies were not the best in Rome, they produced copies for art-lovers who wished to have a replica of a famous masterpiece' (78).

thing we can be sure of from the beginning: the *Tabula Iliaca Capitolina* is a copy and not an original work, which is likely to have been much larger'.[8]

That the *Tabulae* explicitly encourage audiences to ponder their scale is clear from the two epigrams of tablets 1A and 2NY. As we saw in the third chapter (pp. 102–21), the allusive language of these inscriptions makes much of their shared literary and visual register: materializing *sophia* and *technê*, the tablets present themselves as products of poetic craftsmanship as well as of artistic dexterity. But the additional reference to *metron* in both inscriptions magnifies the issue of their size: the tablets, the inscriptions state, provide the '*metron* of all wisdom (πάσης μέτρον ... σοφίας, tablet 1A), or else the '*technê* and *metron* of wisdom' (τ]έχνην μέτρον ... σο[φίας], tablet 2NY). In each case, the *metron* of the object mediates its self-pronounced *sophia* and/or *technê*.

So what does the word *metron* mean? On the micro-level, the term refers to the *metrical* measure of epic: ironically, the pentameter of these elegiac couplets promises to grant access to the very *hexameter* of their Homeric textual models. On a macro-level, though, there is a small-scale pun here on physical size: Theodorus' self-avowed *technê* lies not only in turning Homeric epics into pictures (and then back into this virtuoso couplet), but also in inverting grand Homeric epic.[9] Better, perhaps, each tiny tablet is presented in both collaboration and competition with the Homeric poems: while inviting us to learn the 'order of Homer', the *technê* of Theodorus simultaneously provides a *new* yard-stick against which to size up the textual prototype.[10]

As with the references to *sophia* and *technê*, the avowed concern with *metron* relates at once to the verbal and visual qualities of the tablets. But it also relates these miniature objects to a much larger critical discourse about scale and aesthetics.[11] As Plato had argued in the early fourth century, 'measure' and 'proportion' (*metriotês* and *symmetria*) are best conceived in association with beauty and goodness (*Phlb.* 64e);[12] conversely, Plato defines ugliness as the *lack* of

[8] Ibid. 56 (my emphasis).

[9] For the two meanings, see LSJ s.v. μέτρον, II.1 and I.1. One might compare the associated wordplays on *metron* in Simmias' calligrammatic poem on an egg, referring both to the physical size of the object and to the metrical games of the poem which literally figures the egg through its increasing and decreasing verse lengths, losing a metrical foot in each line (*Anth. Pal.* 15.27.9, 20); cf. Optatian's Latin picture poem in the shape of an altar (Fig. 116), which likewise promises *metrorum imagines* in its penultimate line. Related puns can be detected in numerous other epigrams besides, many of them in artistic contexts: cf. e.g. *Anth. Pal.* 7.421.10, 649.3; 9.107.4, 505.13, 541.6, 768.6; 10.102.4; 14.126.2; *Anth. Plan.* 224.2.

[10] The conceit is arguably all the stronger in the epigram on the recto of tablet 2NY, which seems to bind *technê* to *metron* through hendiadys.

[11] For the best introduction to this theme, and its relevance for Hellenistic art, see Onians 1979: 120–1.

[12] 'For measure and proportion are everywhere associated with beauty and virtue' (μετριότης γὰρ καὶ συμμετρία κάλλος δήπου καὶ ἀρετὴ πανταχοῦ ξυμβαίνει γίγνεσθαι); Bury (ed.) 1897: 156 ad loc. compares *Plt.* 284b, *Ti.* 87d and *Resp.* 486e (and cf. ibid. 175–6); for general discussion on the Platonic and Pythagorean

measured proportion (*ametria*: *Soph.* 228a).[13] Aristotle went even further in associating aesthetic beauty with size: 'greatness of soul rests in greatness of size, just as beauty resides in a large body; small people may be neat and well proportioned, but they cannot be beautiful' (ἐν μεγέθει γὰρ ἡ μεγαλοψυχία, ὥσπερ καὶ τὸ κάλλος ἐν μεγάλῳ σώματι, οἱ μικροὶ δ' ἀστεῖοι καὶ σύμμετροι, καλοὶ δ' οὔ, *Eth. Nic.* 4.3., 1123b6–8).

Already by the early fourth century BC, scale was sized up as having an intermedial aesthetic significance, as applicable to the forging of literary texts as to the making of visual artefacts. Even in the fifth century, the related concept of *symmetria*—literally, the proportions or measure of each part against every other—had developed into the single most important criterion for evaluating sculpture, canonized by the works of Polyclitus (both crafted and written): thanks in part to Polyclitus' *Canon*, the concept would develop into 'one of the most deeply rooted and abiding features of ancient Greek thought, both artistic and philosophical'.[14] But because size was bound up with the appreciation of beauty, it was also deemed critical to *poetic* criticism. Aristotle epitomizes the point in the seventh chapter of his *Poetics*: as in all other spheres of human experience, Aristotle writes, the perfect poem must be contained within the perfect length (1450b34–1451a6):

ἔτι δ' ἐπεὶ τὸ καλὸν καὶ ζῷον καὶ ἅπαν πρᾶγμα ὃ συνέστηκεν ἐκ τινῶν οὐ μόνον ταῦτα τεταγμένα δεῖ ἔχειν ἀλλὰ καὶ μέγεθος ὑπάρχειν μὴ τὸ τυχόν· τὸ γὰρ καλὸν ἐν μεγέθει καὶ τάξει ἐστίν, διὸ οὔτε πάμμικρον ἄν τι γένοιτο καλὸν ζῷον (συγχεῖται γὰρ ἡ θεωρία ἐγγὺς τοῦ ἀναισθήτου χρόνου γινομένη) οὔτε παμμέγεθες (οὐ γὰρ ἅμα ἡ θεωρία γίνεται ἀλλ' οἴχεται τοῖς θεωροῦσι τὸ ἓν καὶ τὸ ὅλον ἐκ τῆς θεωρίας), οἷον εἰ μυρίων σταδίων εἴη ζῷον· ὥστε δεῖ καθάπερ ἐπὶ τῶν σωμάτων καὶ ἐπὶ τῶν ζῴων ἔχειν μὲν μέγεθος, τοῦτο δὲ εὐσύνοπτον εἶναι, οὕτω καὶ ἐπὶ τῶν μύθων ἔχειν μὲν μῆκος, τοῦτο δὲ εὐμνημόνευτον εἶναι.

For something to be beautiful, whether it be a living creature or anything else composed of parts, not only must it have those parts arranged in good order, it must also have a certain magnitude of its own; for beauty consists in magnitude and *taxis* alike. It follows from this that a very small creature would not be beautiful, for our view of it is almost instantaneous and therefore confused; nor would a very large creature be beautiful, since being unable to view it all at once, we lose the effect of

stakes ('the feeling that measure must be an essential element in perceptible phenomena', 16), see Pollitt 1974: 16–17.

[13] 'But what is deformity if not the presence of the quality of disproportion, which is always ugly?' (ἀλλ' αἶσχος ἄλλο τι πλὴν τὸ τῆς ἀμετρίας πανταχοῦ δυσειδὲς ἐνὸν γένος;).

[14] See Pollitt 1974: 14–22, 256–8 (quotation from 15). On *symmetria*, cf. Squire 2011: 7–15 (with further bibliography). Among the most revealing testimonia is the opening sentence of Philostratus the Elder's *Imagines*, penned almost seven centuries later: 'it is through *xummetria* that *technê* partakes of reason (*logos*)' (ξυμμετρίαν . . . δι' ἣν καὶ λόγου ἡ τέχνη ἅπτεται, *Imag.* I praef. I: cf. above, pp. 112–13).

unity and cohesion (just think, for instance, of a creature a thousand miles long!). As then creatures and other organic structures must have a certain magnitude, and yet a magnitude that can also be easily taken in by the eye [εὐσύνοπτον], so it is with plots: they must have sufficient length on the one hand, but that length must be easily remembered on the other.[15]

In practical terms, Aristotle's prescriptions translate into an effective balancing act: size (μέγεθος) has to be weighed against order (τάξις), each commensurable with the other. The nature of mimesis means that, provided it remains coherent, the longer the literary work, the better it will be (ἀεὶ μὲν ὁ μείζων [sc. ὅρος] μέχρι τοῦ σύνδηλος εἶναι καλλίων ἐστὶ κατὰ τὸ μέγεθος 1451a10–11). But if length is necessarily a virtue, it must always be pragmatically proportioned. Despite the generic differences between epic and tragedy, what matters for *both* literary forms is that *taxis* can be grasped in one single viewing.[16] Because beauty consists in magnitude *and* arrangement, the ideal poem is one that allows us to 'see', as Aristotle puts it, both the beginning and the end, and at one and the same time (δύνασθαι γὰρ δεῖ συνορᾶσθαι τὴν ἀρχὴν καὶ τὸ τέλος, 1459a19–20).[17]

(IN)COMMENSURABLE *SYNOPSES*

Aristotle's language encapsulates a concern with not only size, but also its interassociation with a certain mode of perception. The size of a poem is conceived in terms of the *visibility* of its plot: experiencing a text, an audience must be able to view the relationship between its various parts—to *see* both 'collectively' and 'all at once' (συνορᾶσθαι). An overly large epic plot, writes Aristotle in the twenty-third chapter, is 'not properly visible all at once' (οὐκ εὐσύνοπτος, 1459a33).

Aristotle is talking about epic texts specifically: even though the scale of tragedy gives it the edge over epic, the *Iliad* is still the yardstick against which to measure the genre. As such, Aristotle prefigures the conceptual thinking behind the Iliac tablets: in their figurative engagements with epic, the *Tabulae Iliacae* visualize Aristotle's concept of 'synopsis' in a quite literal sense. True to the

[15] For some clarification of Aristotle's meaning here, see Lucas (ed.) 1968: 93–4. The comparison of good poetry with an organic, living body is taken from Pl. *Phdr.* 264b–c, as noted by Ford 2002: 265 (cf. ibid. 240–4). Halliwell 1989 offers an excellent overview of the text, while Hutchinson 2008: 67–72 is useful on this particular passage and its Hellenistic reception. The excellent discussion of Purves 2010: 24–32 appeared while this book was in proofs.

[16] In the final analysis, the scale of tragedy as poetic form must give it the advantage over epic: cf. Halliwell 1989: 176–7: 'the shorter scope of tragedy is deemed a matter of superior coherence and concentration' (177).

[17] Aristotle's comments relate to what, in the hands of later Stoic philosophers, develops into a fully fledged theory of *phantasia*—of the 'mind's eye' which transcends categorizations of visual and verbal: the bibliography is vast, but see e.g. Webb 2009: 107–30 (with extensive further references).

remit of 'syn-thesis', the tablets do not just 'put' all the different stories 'together'; they also allow us to '*see*' those various stories all at once—'synoptically'. Combining the beginning and ends of their stories in a single pictorial field—enabling audiences to view the *Iliad* collectively and in one go—the tablets exploit both scale and medium to outsize even Homer himself. The challenge is not only to understand the order (*taxis*) of Homer, but also to improve upon it.

By relating the *Iliad* to a still larger cycle of epic stories, beyond Homer alone, the tablets go even further, offering a 'cyclical' mode of synopsis that relates to a collective vision of the overarching structural *mythos*. As the prominent inscription on the Capitoline tablet puts it (written in large letters at the original lower centre of the tablet, below the pivotal Aeneas), the subject relates to something even bigger than the *Iliad*, or indeed Homeric poetry: the theme is 'Trojan' (*ΤΡΩΙΚΟΣ*) (Figs. 58–9). The fact that the adjective lacks a noun has led to different interpretations: does it relate to a *kyklos* (a 'cycle' of poetry), or perhaps a *pinax* (a 'tablet'—whether for writing, painting, or engraving)?[18] But whatever we make of the adjective, its importance lies in its evocation of a collective literary landscape: if the tablet leaves unstated the precise nature of this visual–verbal 'Trojan' collage, it also arranges its various scenes around the word, offering a circular and kaleidoscopic vision of the 'Trojan' epic past.

The Capitoline tablet provides the measure of this conceit in other ways besides. Remember, for example, how the upper frieze juxtaposes the beginning and end of the *Iliad* in its single band (Figs. 64, 68–9), or how iconographic parallels fuse events from the *Ilioupersis*, *Iliad*, and *Little Iliad* into one (Figs. 71–5). As we saw in the fourth chapter, the central *gramma* of Aeneas (Figs. 49–50) also associates the eventual sack of Troy with the later founding of Rome—a subject that lies *beyond* this 'Trojan' visualization proper.[19] In Aristotelian terms, our little tablet does better in its self-proclaimed *taxis* than the mass of scrolls bearing the epic poems depicted: this is the *ultimate* 'perpetual song' (*perpetuum . . . carmen*, Ov. *Met.* 1.4). Despite (as indeed because of) the size, we are looking upon an *un*abridged version of 'Troy Story'—a sort of full 'director's cut' which, unlike Homer's shortened version, will not shirk from representing the 'total Troy' (Stat. *Achil.* 1.7: *tota . . . Troia*).[20]

[18] For bibliography, see Valenzuela Montenegro 2004: 32, supplemented by Petrain 2010: 51–3. The subject of the adjective is surely left *purposefully* vague: might we not interpret the word in relation to the 'Trojan' cityscape in which it features, for example, or even read it in association with the Aeneas group above (i.e. an epithet for *Trojan* Aeneas, together with his latter-day 'Trojan' Roman descendants)?

[19] See above, pp. 148–58.

[20] For the promise of Statius' *complete* Trojan 'soap opera', see above, p. 94 n. 30. In this connection, the boast of visualizing the Stesichorean version of Troy's fall perhaps had additional significance. After all, Stesichorus was famous for turning heavy epic into lighter lyric: comparing him with Homer, and noting how he 'sings of great wars and famous leaders' (*maxima bella et clarissimos canentem duces*), Quintilian

Regardless of their different subjects, other tablets demonstrate this same self-consciousness about scale and medium. Like the alleged '*Iliad* in a nutshell', or Myrmecides' and Callicrates' 'Homeric' sesame seeds, the tablets take the biggest subjects—the texts and events weighted with the greatest cultural authority—and turn them into light little artefacts. The miniature format contains truly gargantuan themes: just as the tablets encompass both scales of the word–image spectrum in their visual–verbal frame, they encapsulate both extremes of size, simultaneously little *and* large. This oscillation is figured not just in the iconography and decoration, but also materially—through the equally multistable medium of the marble. Marble, after all, is hardly the most amenable material for such finely wrought reliefs: why not ivory, wood (especially if the objects were painted), or else something still lighter and more portable?[21] As medium, marble smacks of the monumental and the permanent: it brings to mind much larger and distinctly Roman-looking 'tablets'—the Fasti, for example, monumentally inscribed into the Roman cultural psyche; it seems a far cry from the tablets' intimate miniaturizations of the effete and literary Greek. But this was surely the point. The marble medium bestows on these 'lightweight' objects an inherent sense of hulking *matter*: the *grauitas* of marmoreal monumentality tempers (and playfully contradicts) the appearance of minute insubstantiality.[22] As always, materials carry semantic weight: the associations of the marble form added their own medial dimension to the tablets' intermedial size games.

The marble medium also differentiates the 'Homeric' images of the tablets from contemporary images in other materials. Unlike the fragile 'Megarian' Homeric cups introduced in the second chapter (Figs. 20–1), the tablets do not generally represent individual episodes from individual books of the *Iliad* or *Odyssey*: most of them depict whole poems and cycles. Quite apart from practical differences in production, the *Tabulae Iliacae* offer holistic synopses in ways that the cups cannot: the cups present their scenes in bands that wrap *around* their three-dimensional surface, so that viewers have to turn them in their hands. The

tells how Stesichorus 'made his lyre bear the weight of epic song' (*epici carminis onera lyra sustinentem, Inst.* 10.1.62).

[21] For the tablets' materials, see above, p. 64. Of course, other non-extant tablets might very well have been made in other media (especially perishable wood). At any rate, the application of paint (cf. above, pp. 64–5) must have added a significance of its own: it at once highlights and covers up differences between substance and surface appearance—a dialectic sutured over further dialectics about the visual vs verbal, big vs small, the Greek vs the Roman, etc.

[22] On marble and monumentality, see e.g. E. V. Thomas 2007: especially 1–14, along with Corbier 2006: 9–50, especially 12–23; on the monumental Roman Fasti and their (Imperial) frame of reference, see Feeney 2007: 167–211, especially 172–82 on the Fasti Capitolini. For some introductory comments on marble monumental materials monumentalizing a grand Roman imperialist ideology, cf. Schneider 2006: 290.

tablets, by contrast, arrange their recto scenes on a single flat surface.[23] Comparison with the 'Iliadic' friezes of the Casa del Criptoportico (Pompeii, I.6.2), Casa del Sacello Iliaco (Pompeii I.6.4), and Casa di Octavius Quartio (Pompeii II.2.2) only reinforces the point. Although rendering them within the domestic space of the house, and on a smaller scale, these mural paintings follow the precedent of much larger monumental friezes: viewers have to walk *around* the room to put the stories together (Figs. 47–8). The size, medium, and composition of the *Tabulae Iliacae* is quite different. True to the prescription, (the people holding) these visual–verbal synopses really do hold the promise of viewing stories collectively and all at once.

Not all of the tablets present Homeric subjects, of course. While thirteen tablets certainly do engage with the *Iliad*, others take on different themes, as we explained in the second chapter. But whether bringing together miscellaneous 'Trojan' poems, miniaturizing the grand sweep of chronicled history (18L, 22Get), or summarizing *all* the deeds of the larger-than-life Heracles (19J), the objects materialize the same concern for treating the big through the small. They do so in no less self-referential ways. When tablets 1A and 7Ti label one of their depicted subjects the '*little* Iliad' of Lesches (Ἰλιὰς μικρά [1A] and Ἰλιὰς μεικρά [7Ti]), for example, one has to wonder if the name carries a descriptive as well as titular significance—identifying their explicit poetic subject (the mini-epic of Lesches), certainly, but also playing upon the miniaturized 'Iliadic' objects (could you make the *Iliad* any smaller?).[24] And how exactly should we understand the reference to the 'collection of lords' (ἀνά]κτων σύνθεσ[ις) in the 'magic square' inscription of tablet 15Ber (Figs. 125–6)?[25] Regardless of any relation to the Homeric 'lords' depicted on the obverse (Fig. 124) the words simultaneously nod to the mastery of the *artist*, able to offer an epic precis in so small a space. If this tablet provides a 'synthesis' of scale, it also constitutes a synthesis of media. There is no better testimony to the artist's masterful combination of the verbal with the visual, and of the small with the large, than this sort of verso tabulation: the *grammata* mediate the pictures in make-believe words, but the visual–verbal figuration squares a pithy series of letters within a much bigger two-dimensional diagram.

[23] When we look at the 'Megarian' cups themselves (Fig. 20) (as opposed to artificial line drawings (Fig. 21)) we are never able to see the whole representation of each spiralling episode: see L. Giuliani 2003: 263–80, especially 272–6. The use of the *circular* space of the cup—encouraging viewers to construct and deconstruct different stories, leading them round and round—had been a favourite game among Attic vase painters too, especially (but not exclusively) on sympotic kylix cups: for a well-referenced discussion, see A. Steiner 2007: 94–128.

[24] For the inscriptions, see Valenzuela Montenegro 2004: 32, 199.

[25] On this particular 'magic square' inscription (not without its problems of reconstruction), see above p. 208, n. 25. With each box measuring the best part of a centimetre in height, the constituent parts of the 'magic square' are much larger than in other examples: the verso 'synthesis' is not only both visual and verbal, but also literally both big and small.

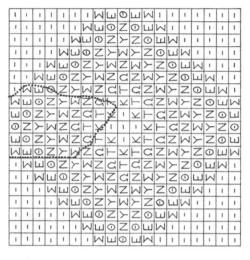

FIGURE 126. Possible reconstruction of the 'magic square' on the reverse of tablet 15Ber.

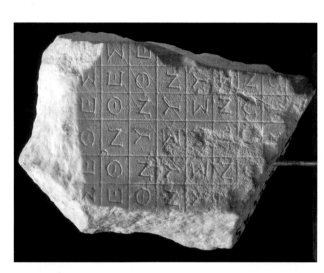

FIGURE 125. Reverse of tablet 15Ber.

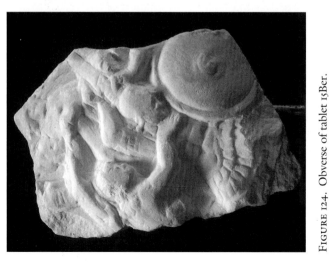

FIGURE 124. Obverse of tablet 15Ber.

As tablet 15Ber so nicely demonstrates, translations of scale and medium comprise two sides of one and the same issue. Just as the tablets pitch the comparative resources of pictures against those of words, they ask us to measure each discourse in relation to the other: do words outsize images, or do images outsize words? In this sense, the self-aware fiction of the miniature itself replicates the fictions of text as image and image as text. Susan Stewart pithily captures the point in what she labels the miniature's 'exaggeration of interiority'—its replication of replication:[26]

> Even to speak of the miniature is to begin with imitation, with the second-handedness and distance of the model. The miniature comes into the chain of signification at a remove: there is no original miniature; there is only the thing in 'itself', which has already been erased, which has disappeared from this scene of arriving-too-late.[27]

Miniatures, according to Stewart, offer a new vision *and* version of the world—'a metaphor for the interior space and time of the bourgeois subject'.[28] So too with the (double-sided) '*technê* squared' of the Iliac tablets: the miniature proportions draw knowing attention to the distance between original and copy—the make-believe of words turned into pictures and pictures turned into words. The effect might be compared to that of a Russian doll, each quadrangle containing more and more quadrangles framed within. When it comes to the tablets, though, the replications pertain to medial form as well as to size. In each image there lies a text, and in each text there lies another image, in an endless recession of both scale *and* medium: the games of expansion and summation are figured through intermedial play.

Different tablets offer different strategies for sizing up image against text, no less than text against image. If the Capitoline tablet (Fig. 4) situates its pictorial friezes alongside a prose résumé of the *Iliad* (itself a monumentalized digest of an established mythographic genre),[29] the two-line epigram provides an even more abridged verbal epitome of the tablet's visual rationale. In a synoptic spectrum of scale and form, the object oscillates between both different sizes and different media. The receding replications at once diminish and expand: the whole Trojan War, its encapsulation in the *Iliad*, the visual depiction of that poem, the monumental (albeit miniature) verbal abridgement that is inscribed on two pilasters, the series of identifying labels, the inscribed literary titles of the texts, and not least the mini-epigram that purports to bring all these different registers together in the name of 'Theodorean *technê*'. The New York tablet (2NY)

[26] See S. Stewart 1993: 44, expanded in the context of her discussion of the 'doll house' at 61 and 171.
[27] Ibid. 171.
[28] Ibid. xii.
[29] See above, pp. 94–6.

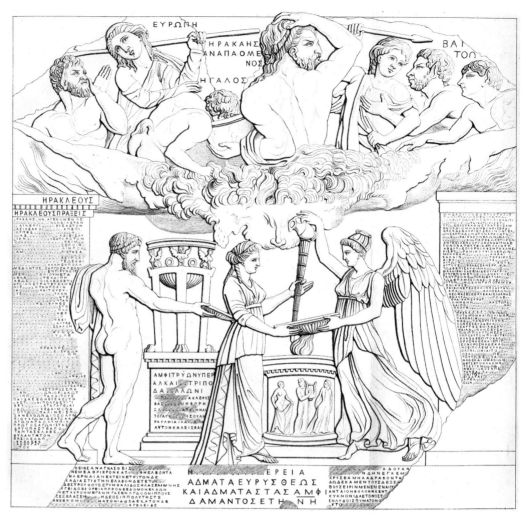

FIGURE 127. Drawing of the obverse of tablet 19J.

proffers a similar epigrammatic summary on its recto (Figs. 36, 120). This time, however, the object confers an additional reverse title for its images in the inscribed 'magic square' (Fig. 119): the diagrammatic text simultaneously expands and summarizes—and inscribes and depicts—a grand little picture text for the textual subjects depicted on its recto. Epigrammatic encapsulations recur on other tablets too, often within or adjacent to the pictorial field: we have said that tablets 6B and 12F both encapsulate each book of the *Iliad* in verse,[30] while a pair of elegiac couplets likewise tops and tails tablet 17M.[31] Still more revealing in

[30] See above, pp. 96–7.
[31] See above, p. 97.

this regard is tablet 19J, composed of a series of pictures above, then two monumentalizing pilasters below that epitomize Heracles' deeds in verbal language, and then, at the very bottom of the tablet, one further synopsis—this time a truly miniature epyllion in just 19 hexameter verses (Fig. 127).[32] Words and pictures, the gargantuan and the miniature: each becomes a kaleidoscopic *metron* for measuring the other.

Where does this concern with size come from, and why does it come in for magnification on the tablets? In the remainder of this chapter, my aim is to reconstruct the aesthetic intellectual and literary resonances at work, situating our tiny little *Tabulae* within a much larger cultural context—as pertinent to the visual as to the verbal arts of the Hellenistic Greek and Roman world. I do so by expanding upon three interrelated little themes: first, the discourse of size in contemporary visual culture ('The artefactual rhetoric of the miniature'); second, the relation to Callimachus and Hellenistic literary traditions ('Literary *leptotês* and the dynamics of scale'); and third, Hellenistic epigram—in particular, epigram's encapsulation of big visual subjects through a pithy, monumental-cum-literary mode of synopsis ('Epigrammatic materializations of the grand in the small'). Each miniature excursus could be extended ad infinitum. My objective, rather, is to size up this grand intellectual background before returning to the *Tabulae Iliacae*, homing in on one particular detail: namely, their attribution to 'Theodorean *technê*'.

THE ARTEFACTUAL RHETORIC OF THE MINIATURE

We begin, then, with scale as artificial artistic conceit. Size had always been important within Graeco-Roman visual culture. From the very beginnings of the Greek figurative tradition, differences in scale had been employed to signal differences in power, hierarchy, and status: one might think of individual Archaic attempts to outsize each other in the dimensions of their sculpted *kouroi*, cult statues, and monumental temples, for example; or the way in which such grand theological concerns (towering statues realizing the other-worldliness of the gods) were miniaturized on the human stage (differences in scale embodying social distinctions between master and slave).[33] Greek artists had long thought

[32] See above, pp. 47, 97–9. Examples can be multiplied. Tablets 1A, 2NY, 3C, 6B, 9D, 11H, 12F, 20Par, and 21Fro, for example, all provide verbal prose titles for a number of visual scenes depicted, while the related *lemmata* on the recto of tablet 14G are paired with a single image of Homer reading a scroll.

[33] Cf. e.g. Snodgrass 1986: 55–6 on differently sized Archaic Greek temples as a 'medium of rivalry between peer polities' (55), together with R. Osborne 2004. On the theological stakes of sculptural size, see e.g. Gordon 1979: 13–14 and D. T. Steiner 2001: 97–8, along more generally with Vernant 1991: 27–49, Squire 2011: 157–67, and Platt forthcoming: ch. 2.

about the hermeneutics of size. But the issue was magnified in the arts of the Hellenistic and Roman worlds.[34]

One celebrated example is the emergence of *mini*-statuettes, rescaled after the grandest of 'masterworks'. In her important book on what she calls 'ancient sculptural copies in miniature', Elizabeth Bartman has shown how the second century BC witnessed the rise of a new form of sculptural copy: artists shrank some of the most canonical statue types from the fifth and fourth centuries into have-at-home replicas.[35] This newfound popularity, Bartman explains, is related to a Hellenistic 'shift of taste', whereby the 'miniature stood again on the cutting edge of artistic invention': 'intended primarily for private viewing in domestic settings, the miniature copy offers a different view of ancient artistic values than the monumental work that once dominated a stoa or forum'.[36]

'Miniature' is not quite the right word here. The sorts of 'copies' Bartman discusses might be smaller than their 'originals', but they are not tiny in the self-conscious manner of a modern-day 'micro-sculptor' like Willard Wigan (Fig. 128). Still, the comparison is relevant for the *Tabulae Iliacae* because of the associated interrogation of what the 'normal-' or 'life-sized' might be: by altering the dimensions of celebrated image types, these statuettes pose questions about the subjectivity and perspective of the individual viewer.[37] In this sense, at least, Bartman's 'miniatures' warrant comparison with some of the smallest statues known to us from antiquity, not least the alleged works by Myrmecides and Callicrates, of Homeric sesame-seed fame. The works of both artists were already proverbial by the first century BC: Varro tells how audiences viewed Myrmecides' sculptures against black thread so as 'to see them more easily' (*Ling.* 7.1: *ut…facilius uideant*), for example, and Pliny likewise relays how Callicrates' sculpted ants were so small that their 'feet and other limbs

[34] In addition to John Onians's analysis of the Hellenistic 'power of the small' (Onians 1979: 119–50, quotation from 128), see Bartman 1992: 168–71 (on the Hellenistic and Roman 'conceit of the mighty rendered small', 169); Beard and Henderson 2001: 147–202 (on size as materializing power); Porter 2010b: 481–90 and forthcoming (on size as a category of Hellenistic critical theory).

[35] See Bartman 1992. Bartman's study is generally stronger in its revisionist ideological critique of the 'copy' than in its evaluation of size, suggesting that 'size played only a minor role in the definition of the form', so that 'miniature copies deserve parity with their larger counterparts' (11): 'To the ancients, it would seem, a miniature copy was a copy and a copy was simply a statue' (15). Statues are never 'simple', but they are still less simple when they evoke other statues, especially when rendered in a lesser physical size; as S. Stewart 1993: 38 would put it, miniaturized 'signification' is paradoxically 'increased rather than diminished by its minuteness'.

[36] Bartman 1992: 147, 4. Bartman would presumably associate this development with what Jeremy Tanner has labelled the 'invention of art history in ancient Greece', epitomizing a new Hellenistic 'etiquette of cultured viewing' (Tanner 2006: especially 205–76, quotation from 276; cf. idem 2010).

[37] On subjectivity in Hellenistic art (and poetry), see especially G. Zanker 2004, who (briefly) discusses size in relation to the *Spinario* at 134–6; much more detailed is C. Kunze 2002: especially 61–134.

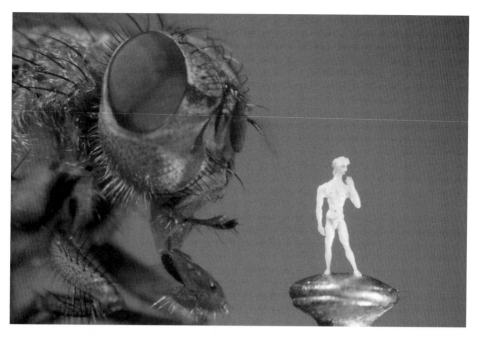

FIGURE 128. Willard Wigan, *Micro David* (2008): Michelangelo's David, set upon the head of a pin and against a 'Goliath' housefly; carved by hand from a single grain of sand ('David' is less than a millimetre in height).

cannot fully be seen' (*HN* 36.43: *formicarum pedes atque alia membra peruidere non est*).[38]

Closer to the Iliac tablets in date and geographical context are the miniatures of Campanian wall painting. Here too size could be harnessed for hermeneutic effect. The cyclical friezes from oecus h of the Casa di Octavius Quartio (Figs. 47–8) provide one example: with the Heracles frieze almost three times the size of the Iliadic, the antics of Heracles quite literally dwarf the grand themes of Homeric epic, while simultaneously challenging the rationale of the arrangement (does bigger necessarily imply better?).[39] Size was also one of the ways in which the

[38] For the collected stories about Myrmecides and Callicrates, see Overbeck 1868: 422–3, nos. 2192–201; cf. *KLA* 2: 96, s.v. 'Myrmekides'; *KLA* 1: 393, s.v. 'Kallikrates (IV)'; there is an additional unnoted reference at Gal. *Protr.* 9.2. On Myrmecides, see also below, pp. 287–8. Many related Hellenistic size games could be cited: consider, for example, how the Pergamon altar juxtaposes different scales on a single monument (viewers had to step up over the gargantuan Gigantomachy frieze on the outside to arrive at the half-lifesize Telephus frieze within: cf. Onians 1979: 144–6); or how the 'Little Attalid group' in Athens downsized the dying Giants, Amazons, Persians, and Gauls; or indeed how subsequent Roman copyists extracted these 'Little Attalid' victims *without* reproducing the victors (viewers themselves now lord it over the wreathing little characters beneath them: cf. A. Stewart 2004: especially 181–236; Paus. 1.25.2 gives the size of each 'Little Attalid' statue as two cubits—i.e. around one metre).

[39] See above, pp. 145–7. A similar discourse can be reconstructed on the Esquiline Odyssey frieze (cf. p. 77 n. 152), where individual figures are miniaturized against a series of humungous epic landscapes; this probably also explains the extant frieze's expanded interest in the larger-than-life Laestrygonian subjects.

'Four Styles' of Pompeian painting probed the painted picture's potential to replicate reality: the vacillations of size—the reduction and enlargement of a vignette within the overall mural frame—was central to the exploration of *trompe l'œil* painterly illusionism.[40] So it is that the eponymous 'Second Style' frieze of the Pompeian Villa dei Misteri transformed its human figures into near life-size dimensions, while the frieze of cupids from room q of the Casa dei Vettii (Pompeii VI.15.1) are reduced to Liliputian figures, subjugated within the overall design of this 'Fourth Style' wall.[41] Miniaturization could be applied to all manner of subjects, and in all manner of different ways: the delicate little friezes in triclinium c of the Villa Farnesina (placed above the impressionistic outlines of suggestive landscapes, all set against a black ground),[42] the perfectly tiny 'villas' floating amidst the delicate aediculae in the 'Black Room' at Boscotrecase (Fig. 129),[43] or the 'Fourth Style' rustic scenes of the Praedia di Giulia Felice (Pompeii II.4.3), dwarfed by the so-called 'still lifes' above.[44] In each case, variations in scale are manipulated to explore the limits of painterly representation: like the Iliac tablets, the painted imagery draws attention to the viewer's own perspective—his relation to the convincing (or otherwise) make-believe of the two-dimensional surface facade.

Engraved gems and sealstones replicated related themes.[45] As Verity Platt has shown, gems frequently take on grand subjects, so that 'the magnitude of the object depicted is at odds with the miniaturism of the depiction itself';[46] indeed

[40] For some introductory comments, see Clarke 2005: 270–2. More generally on illusionism in Campanian wall painting, see e.g. Platt 2009a: 58–69 and Squire 2009: 374–89.

[41] Croisille 2005: 142–50 offers a well-referenced overview of the Villa dei Misteri frieze, and Gazda et al. 2000 provides a book-length survey; for the *mise en abyme* of representational issues, however, the critical discussion remains Henderson 1996. On room q of the Casa dei Vettii, see *PPM* 5: 541–65, nos. 125–59, along with Clarke 1991: 214–20.

[42] See Ling 1991: 41–2 and Sanzi di Mino (ed.) 1998: 47–55. More generally on the 'semiotic slipperiness' (45) of this villa's wall paintings, cf. Platt 2009a.

[43] Cf. Blanckenhagen and Alexander 1990: 10–12: 'With the introduction of the central vignette, floating but compact, which establishes a new fashion, the bucolic landscape takes on a strange character and suggests a different meaning' (12).

[44] See Squire 2009: 384, along with Bragantini and Sampaolo (eds.) 2007: 372–3, no. 172 (for further bibliography). Cf. also cubiculum m of the Villa di P. Fannius Synistor at Boscoreale with its large glass bowl of fruits set above the miniature, impressionistic, and monochrome landscape below (Squire 2009: 402).

[45] For some introductory comments on gems as *miniature* objects, see Henig 1990: 52–7; there is an excellent general bibliographic guide in Wünsche and Steinhart (eds.) (2010): 108–10. As Platt 2006: 237 puts it, the 'tiny dimensions' of gems 'demand intimacy, a prolonged and careful viewing whereby the tiny image which forms the matrix of impression expands by force of the multitude of signs it carries until it occupies huge dimensions within the mind'.

[46] Ibid. 237. Cf. eadem 2007: especially 90–1, on intaglios engraved with the image of Eros self-consciously replicating the 'macro power of the micro god'. No less self-conscious about the dynamics of scale are miniaturist gems depicting the gigantic battle of the Gigantomachy (see e.g. Zazoff 1983: 208 n. 91 on a Hellenistic sardonyx); compare also Hellenistic and Roman gems that, like the Iliac tablets, take the grand themes of epic poetry and cut them down to tiny glyptic size (for a preliminary survey, see Toso 2007).

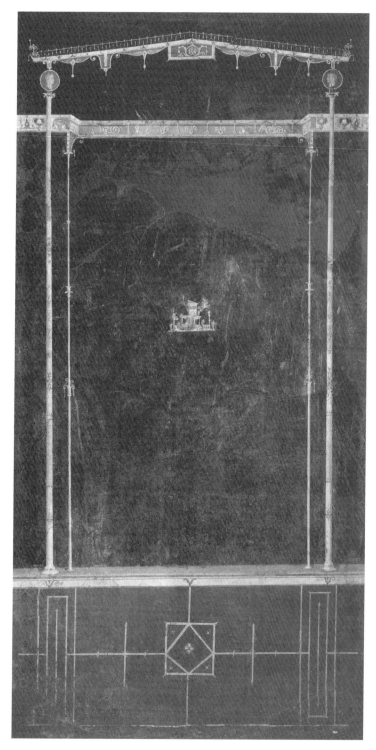

FIGURE 129. Central panel of the north wall of the 'black room' (15) of the Augustan villa at Boscotrecase, last decade of the first century BC (Metropolitan Museum of Art, New York: Rogers Fund, 1920, 20.192.1; height: 2.33m).

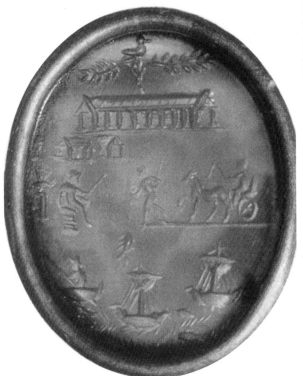

FIGURE 130. Carnelian gem with landscape scenes in modern gold ring, first century AD (Hermitage Museum, Saint Petersburg inv. K1488; 1.9 x 1.4 cm).

the way in which one first-century Cornelian gem (1.8 x 1.4 cm) is engraved with a whole landscape—buildings, chariot, fisherman, sea, and boats, all topped with foliage (Fig. 130)—parallels precisely the miniaturized villa scenes of contemporary Roman wall painting (Fig. 129).[47] Such conceits of size were maximized in the hands of Roman Imperial artists, furnishing us with the biggest examples of the little medium. On the Gemma Augustea and the appropriately labelled sardonyx 'Grand Cameo of France' (Fig. 131), for instance, the whole genre has been rescaled to accommodate the larger-than-life Imperial subjects: measuring around 31 cm by 26.5 cm, the 'Grand Cameo of France' is both big *and* small, encompassing not just the whole Roman Empire (witness the captive barbarians below), but also time immemorial (even the dead Augustus features among those in the jewelled upper register).[48] As with the small, silver 'Boscoreale

[47] Hermitage K1488, discussed by Platt 2006: 237. Platt ibid. 240 also cites the earlier fifth-century BC example of a scaraboid whose female figure is inscribed with the word *MIKES* (a possible Doric form of the adjective *micros*, according to Henig (ed.) 1994: 33–4, no. 53): if the seal belongs to a woman named Mike, might there perhaps be 'a pun on the miniaturism of the medium ("This is a picture of a tiny girl", or even, "This is tiny")'?

[48] Cf. Beard and Henderson 2001: 195–7: 'all this pomp and bluster, but now on an incongruously tiny scale' (197). On the identity of the figures, see Jucker 1976: 248–9, with new challenges by L. Giuliani and Schmidt 2010.

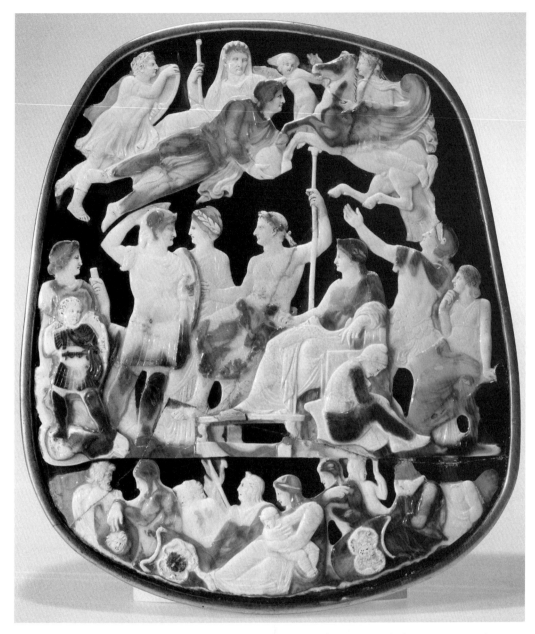

FIGURE 131. 'Grand Cameo of France', *c.* AD 25 (La Bibliothèque Nationale de France: Monnaies, Médailles et Antiques inv. 264; height: 31 cm; width: 26.5 cm).

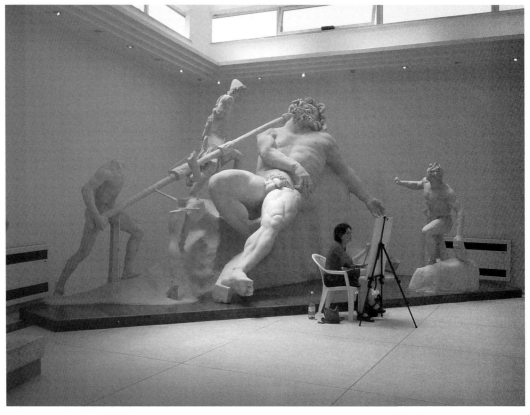

FIGURE 132. Plaster reconstruction of the Sperlonga Polyphemus group (with seated human figure to convey the scale); marble statue probably late first century BC.

cups' of roughly similar date, the Emperor makes a cameo appearance, placed within the grasp of the Imperial subject. But such topsy-turvy reductions of scale simultaneously enlarge the underlying power dynamics: is the Emperor in our hands, or are *we* in the hands of the *Emperor*?[49]

To corroborate the point, we might paradoxically turn to some of the largest marble free-standing sculptural installations known to us: those from Sperlonga. The Sperlonga statues have already been mentioned in the second chapter (pp. 78–9): floating in the centre of this theatrical, Disney-style 'Homerland', a

[49] On the Boscoreale cups, see Kuttner 1995, along with Beard and Henderson 2001: 193–5. I would add only that the depicted themes of subjugation and control are themselves played out in the viewer's active handling—that the 'carnivalesque' inversions of size have to be understood against the carnival of the *cena* at large. Within the alcohol-soaked playground of a dinner, one might pet, fondle, and manhandle this toy-boy emperor all one likes; but the scope of Imperial power is maximized all the more the morning after. I omit further reference here to the uses of scale in Roman portraiture: suffice it to say that size was of particular importance in political portraits—whether in the case of the colossal gold statue of Nero erected beside the Domus Aurea, or the 'three-foot' statues once erected in the Forum (*tripedaneas . . . statuas*, Plin. *HN* 34.24); for a recent overview and bibliographic guide to miniature portraits, see R. Thomas 2007.

soaring Scylla was shown destroying Odysseus' ship (her scaly body vastly out-scaling those of her human victims); to the left and right are two Iliadic episodes—the theft of the Palladium and the so-called Pasquino group; behind, in an additional, recessed grotto that evokes the grisly cave of the Cyclops, we see the huge Polyphemus just before his final come-uppance (Fig. 25). In terms of their size, the sculptures hold true to the dimensions of their larger-than-life epic subjects: the Cyclops and Odysseus installation alone is estimated to have measured some 6 x 3.5 x 2 metres (Fig. 132).[50] For ancient viewers, though, the sculptures seem to have been experienced not at close quarters, but (for the most part) from the triclinium attached to the cave. Distance implies a scale of its own—a remove from the imposing size of the larger-than-life subjects: however overpowering the epic statues, the leisurely discussions of the cena afforded a different perspective.[51]

We find precisely this conceit—and within a related 'at table' context—in statues of the so-called 'Heracles Epitrapezios' type.[52] The prototype was apocryphally attributed to Lysippus in the fourth century BC, but we know of the image only from later copies (over 20 of which survive); similar objects are also described in a pair of epigrams by Martial (9.43–4) and a single poem by Statius (*Silv.* 4.6), both written in the later first century AD.[53] The scale of Lysippus' original sculpture is unknown—in fact, Lysippus quite possibly created more than one 'original'. It is significant, though, that subsequent artists rendered the subject in *both* extremes of

[50] Following Andreae and Parisi Presicce (eds.) 1996: 358. For the semantics of Polyphemus' size, cf. Plin. *HN* 35.74 on Timanthes' painting of the sleeping Cyclops: although working on a 'small tablet' (*paruola tabella*), Timanthes is said to have captured the gigantic scale (*magnitudinem*) by juxtaposing a group of satyrs, shown measuring the Cyclops' thumb. At Sperlonga, Polyphemus' inflated size conspicuously inflates his sexuality: not only are Polyphemus' legs spread in Faun-porn manner (cf. Squire 2003: 33–4 and Spivey and Squire 2008: 127–30 on the iconographic bond(age) with the 'Barberini Faun'), but the lolling penis is distended to truly gigantic proportions. For the magnified erotics of seeing and size here, compare e.g. Sen. *Q. Nat.* 1.16.2, on the legendary Hostius Quadra, said to have used distorting mirrors to liven up his sex life—'delighting in the misleading size of his penis as if it were true' (*falsa magnitudine ipsius membri tamquam uera gaudebat*: see especially Bartsch 2006: 106–14 and Elsner 2007a: 178–9).

[51] On the significance of viewing from a triclinium that could be reached by boat but not by foot, see e.g. Salza Prina Ricotti 1979: 130–48 and Kuttner 2003: 117–19. A semicircular path led around the cave's basin, and a number of seats were hewn from the rock of its north and south mouths (as well as at its north-east recess): the statues could therefore be viewed both in proximity within the cave and at a 'safer' distance beyond it. The Faustinus epigram, apparently added to the grotto in the fourth century AD, further developed the conceit, contrasting this miniature, ten-line hexameter ecphrastic poem with the 'immense work' (*immensum...opus*, v. 2) of the cave: if the poem protests that these visual images outsize any verbal description, it also undermines the claim, evoking each gargantuan group in a series of miniature, *cento*-like Virgilian verbal allusions (cf. Squire 2007 and 2009: 202–38).

[52] The most detailed discussion of the statue's 'conceit of the small' is Bartman 1992: 147–86 (with earlier bibliography at 147 n. 1); cf. Beard and Henderson 2001: 197–9 on the statue type's 'play with reduction and enlargement in the Age of Imitation' (199).

[53] On Statius' poem, and its relation to Martial's epigrams, see Coleman (ed.) 1988: 173–6, along now with Bonadeo 2010: 43–56: both poems associate the statuette with a single owner, Novius Vindex, and probably date to the AD 90s.

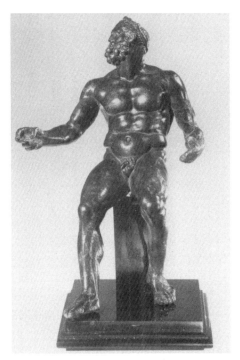

FIGURE 133. Bronze statuette of 'Heracles Epitrapezios' (first century AD?): height 0.17 m.

FIGURE 134. Marble statue of 'Heracles Epitrapezios', between second century BC and early first century AD (Chieti Museo Archeologico inv. 6029; height: 2.40 m).

size. One version (apparently the most prevalent) shrinks the mighty Heracles to a pocket-sized statuette—a suitable *hors d'oeuvre* for the loaded table (e.g. Fig. 133). But a second type magnifies that suave little *amuse-gueule* into a twice life-size giant (Fig. 134).[54] Book reproductions can be deceptive here: rendered at a twice life-size scale, Fig. 134 (2.4 m high) is in the flesh over 14 times bigger than Fig. 133 (0.17 m). So which statue 'originally' compressed or inflated which—the big one, or the small? To which image should we grant the upper hand? And where is the proper balance between the two extremes—should viewers lord it over Heracles, or does Heracles lord it over us?[55] In this respect, the size of the statue is bound up

[54] The best-surviving example (Fig. 134) was discovered in 1960 at Alba Fucens (some 40 miles west of Rome), but fragments of similar colossal statues have been found in Urbino and Sabratha: see Bartman 1992: 152–7, who concludes that the smaller statue preceded the larger (166–8). My own view aligns with that of Pollitt 1986: 50–1: 'it seems more probable to conclude that the Epitrapezios type was produced from the beginning on several scales rather than that the Alba type is a "blow up" of a single Lysippan original' (51). Bonadeo 2010: 24–42 gives a more detailed review of the scholarly bibliography.

[55] Cf. Beard and Henderson 2001: 199: 'If one game was to reduce the giant hero to pint-size . . . this in turn created the possibility for reinflating the image. It set up a two-way relation between miniature and colossus: now the "pint-size" is not automatically to be taken for a reduced copy of the "heavyweight".'

with the wordplay of its titular tag. If both statue and statuette visually represent 'Heracles Epitrapezios', both versions differently capture the verbal caption: the Greek term *epitrapezios* can describe both possibilities—Heracles *'on* the table', as well as Heracles *'at* the table'.[56] Whether Heracles is shown above or below life-size—born small with greatness thrust upon him, or born great only to be saddled with trivial trials—each version simultaneously encompasses the other: just as the 'tiny' statuette belittles its 'larger-than-life' heroic subject (transforming him into a table decoration), the 'colossal' statue inflates that schema by restoring the hero to his superhuman feast.[57]

LITERARY *LEPTOTÉS* AND THE DYNAMICS OF SCALE

That the 'Heracles Epitrapezios' statue came to be celebrated in Latin poetry is also significant. Martial and Statius both delighted in the contrasting scales embodied in the statuette: it is 'slight in appearance but mighty in impression', as Statius puts it (Stat. *Silv.* 4.6.37–8: *paruusque uideri | sentirique ingens*); in Martial's words, the statue is 'a gigantic god in a miniature bronze' (Mart. 9.43.2: *exiguo magnus in aere deus*).[58] In each case, the dynamics of scale take on metapoetic significance: the dimensions of the statue serve as a wordy gauge for sizing up the power of poetry. Statius nicely develops the point (*Silv.* 4.6.43–6):[59]

> . . . tam magna breui mendacia formae.
> quis modus in dextra, quanta experientia docti
> artificis, curis pariter gestamina mensae
> fingere et ingentis animo uersare colossos.

[56] For the pun, see e.g. Bartman 1992: 151, 167 and Coleman (ed.) 1988: 174. To my mind, the playful games of scale at once miniaturize and expand the playful games of the statue's title: questions as to whether or not Heracles is really big or small are layered over questions about this miniature but all-important verbal tag.

[57] I would consequently take issue with Bartman 1992: 167, who suggests that 'it is of course only as a small-scale work that the Herakles Epitrapezios could fully exploit the visual and verbal implications of its name'. Still, Bartman is surely right to compare other examples of size play, both among the works of Lysippus, and among other statues of Heracles (168–9). One example lies in the games subsequently played with Lysippus' fourth-century BC 'Farnese Heracles': if the famous statue from the Baths of Caracalla 'enlarged and exaggerated a familiar form until, like a blown-up photograph, the forms dissolve and lose meaning' (Marvin 1983: 382), terracotta figurines brought Heracles back down to sub-mortal size. My favourite example is in Cambridge (Fitzwilliam GR.88a.1937, with discussion and photograph in Vassilika 1998: 80, no. 38): not only is Lysippus' Heracles miniaturized, he swaps his customary brawny attributes for the brainy trappings of the *himation*-clad Greek philosopher.

[58] For discussion, see Coleman (ed.) 1988: 183–4, Bartman 1992: 147–51, and Newlands 2002: 73–87. As Henderson 2002: 211 n. 17 puts it, 'writers could play with the artists' play with different extremes of scale'.

[59] For the contested v. 43 (a line seems to be missing), see Coleman (ed.) 1988: 185.

...so great is the deception of that tiny form. What dexterous skill of proportion—what trial of the artist's skilled craftsmanship—at once to fashion by his pains a table ornament and to imagine in his mind a great colossus.

This 'great deception' (*magna . . . mendacia*) holds true not only for the statuette, but also for the poem that now mediates it.[60] On the one hand, Statius (like Martial) delights in the conceit that his text might ecphrastically evoke Lysippus' statuette—that words might communicate the visual image through verbal language (4.6.32–58). On the other, this make-believe of medium is layered over the fictions of size. In both cases, moreover, Statius and Martial add their own carefully scaled deceptions, so that each poem playfully mirrors the size games of the statue. At 109 lines (the second-longest poem in the book), Statius' lengthy composition hardly captures the tiny scale of its professed artistic subject; and just as soon as we judge Martial's 14-line epigram to be over, a second poem reopens the subject. Both poets therefore exploit the scope of their writerly medium to represent the paradoxical dynamics of this at once miniature and gargantuan sculpted image-turned-text. As the Heracles Epitrapezios statuette itself demonstrates, all such deceptions can prove themselves deceptive: perhaps the qualitative and quantitative scale of these texts *does* translate its visual subject into verbal language after all . . .

The Latin poems on 'Heracles Epitrapezios' bring us to a crucial point about the aesthetics of size: the fact that this miniature discourse extends *across* media. By at least the late first century BC, a specific term was coined to encapsulate the idea: *micrologia*. Comparing authors with artists, Dionysius of Halicarnassus writes how both sorts of craftsmen must pay attention to micro-*technê* alike (*Comp.* 25). For the man writing political speeches (κατασκευάζοντι λόγους πολιτικούς), this means 'belittling none of the smallest details' in a given case (μηδενὸς τῶν ἐλαχίστων ὀλιγωρεῖν); for the artist, by extension, it means applying the 'skills and efforts of the hands' (χειρῶν εὐστοχίας καὶ πόνους)—demonstrating the exactness of one's *technê* (κατατρίβειν τῆς τέχνης τὴν ἀκρίβειαν) via details like veins, facial down, the bloom of the skin, and other such *micrologiae* (καὶ τὰς τοιαύτας μικρολογίας). The mini-term used here captures Dionysius' grander point: although talking about *visual* details, the word returns us to writers (like

[60] For the literary and aesthetic games, see Bonadeo 2010: 66–70, 211–14. Not for nothing does Statius' response to this statuette offer a knowing reply to Callimachus' own reply to the artist-Telchines at the beginning of the *Aetia* (cf. above pp. 120–1)—but from the explicit perspective of art as well as from poetry: 'the Telchines in their caves under Mount Ida', we are told, could not have produced such a *jeu d'esprit* (*tale nec Idaeis quicquam Telchines in antris, Silv.* 4.6.47). For the allusion, see Newlands 2002: 77–8: 'By rejecting the art of the Telchines, the statue of Hercules is brought strikingly within the orbit of the Callimachean literary aesthetic' (78).

Dionysius himself) who are dealing with *logoi* explicitly. *Micrologia* is both a visual *and* a verbal phenomenon.[61]

One of the most revealing articulations of this shared visual–verbal discourse comes in the most unlikely looking of places: Pliny the Elder's story about a 'line painting' by Apelles and Protogenes (*HN* 35.81–3).[62] Apelles, writes Pliny, once travelled to the island of Rhodes where Protogenes lived and took the opportunity to meet the fellow painter. After finding only a 'large panel painting fixed to an easel' (*tabulam amplae magnitudinis in machina aptatam*)—but not the artist himself—Apelles decided to leave Protogenes a sign of his visit: he 'navigated across the panel a coloured line of the greatest subtlety' (*lineam ex colore duxit summae tenuitatis per tabulam*). On returning and seeing the subtlety (*suptilitatem*) of that single brushstroke, Protogenes instantly recognized Apelles' hand: nobody else could have crafted such a self-contained work (*absolutum opus*). Protogenes thereupon proceeded to paint a second, still thinner line in separate colour across the first (*alio colore tenuiorem lineam*): should Apelles come back, let him see Protogenes' retort! Apelles did return. And he was duly taken aback ('reddening' out of shame, *erubescens*, as the Plinian rubric nicely puts it). Loath to be defeated, however, Apelles nevertheless painted an even finer line through Protogenes' second brushstroke, in a third colour, thereby leaving no room for further subtlety (*tertio colore lineas secuit nullum relinquens amplius suptilitati locum*). Protogenes saw the line and immediately admitted defeat—rushing off to seek out the virtuoso victor. As for the painting, it is said to have been removed to Rome, where it could be seen until destroyed by fire in AD 4.

What does the story mean within our analysis of the art and poetics of scale? Here is Pliny's final evaluation (*HN* 35.83):

> . . . placuitque sic eam tabulam posteris tradi omnium quidem, sed artificum praecipuo miraculo. consumptam eam priore incendio Caesaris domus in Palatio audio, spectatam nobis ante, spatiose nihil aliud continentem quam lineas uisum effugientes, inter egregia multorum opera inani similem et eo ipso allicientem omnique opere nobiliorem.

> Protogenes decided that this panel should be handed down to posterity as it was, to be admired as a marvel by everyone, but especially by artists. I am informed that the painting was burnt in the first fire which occurred in the emperor's palace on the

[61] For discussion, see Pollitt 1974: 183–4.

[62] For the story (= Overbeck 1868: 347–8, no. 1841), other possible ancient allusions to it, and its modern reception, see van de Waal 1967 and Gage 1981; on the anecdote's implications for the ' "subsemiotic" marks' of painting (823) and the 'ontological instability of the mark' (841), see Elkins 1995. My thinking about the passage has greatly learned from Verity Platt's paper, '*Linea summae tenuitatis*: Taste, skill and abstraction in Roman painting', delivered as part of our co-organized panel on 'Naturalism and its discontents in Graeco-Roman art and text' at the January 2008 Annual Meeting of the American Philological Association in Chicago.

Palatine. It had previously been much admired by us: its vast surface contained nothing but lines which receded from sight [*lineas uisum effugientes*]; among the outstanding works of many artists it looked like an empty space [*inani simile*]— alluring for that reason, and more esteemed than every masterpiece.

The commentary provides a rare glimpse into an artistic tradition deliberately downsized by modern scholars. Quite apart from the story's ramifications for conceptualizing artistic agency (the painterly trace as artistic 'signature'), the anecdote points to ancient concerns with the non-figurative and abstract. The rhetoric of representation as 'capture' has been turned inside out: these 'lines' are worth seeing precisely because they *evade* being seen (*lineas uisum effugientes*). This *absolutum opus* might make us think of Clement Greenberg and the modernist tradition. Peruse most textbooks on Greek and Roman art, though, and you will find no mention of such dialectics between the mundane and the meaningful on the one hand, and between the vacant and the valuable on the other.[63]

For the immediate purposes of this chapter, what is most interesting about Pliny's anecdote is its recourse to the language of contemporary literary criticism. The tablet is large (*tabulam amplae magnitudinis*), but Apelles' and Protogenes' three brushstrokes display a 'line of extreme thinness' (*lineam . . . summae tenuitatis*)—a 'subtlety' (*suptilitatem*) that ultimately 'leaves no room for further subtlety' (*nullum relinquens amplius suptilitati locum*). The qualities of *suptilitas* and *tenuitas* ('thinness', 'subtlety', 'finesse') materialized by such brushwork are consonant with contemporary criteria for judging texts: the Latin words translate still more suggestive Greek terms, derived from the critical language of 'Hellenistic poetry in particular. As with the story about the *Iliad* in a nutshell, encapsulating the *Natural History*'s vision of encyclopaedic encapsulation, meta-literary reflection is to be read between the lines of Pliny's artistic anecdote: these painted little *lineae* parallel the subtlety of the Plinian text at large.[64]

Pliny's language derives from one Hellenistic Greek poet in particular: Callimachus. What Pliny calls *suptilitas* and *tenuitas* translate the Callimachean

[63] For one exception, albeit in a different context, see Porter 2010a: 173–4. The Virgilian resonance of Pliny's description should not go unnoticed: by looking like 'empty space' (*inani similem*), Apelles' and Protogenes' painting recalls the most epic 'empty' or 'insubstantial' image (*pictura . . . inani*) in Roman literary history—that on which Aeneas 'feasts his soul' at *Aen.* 1.464 (see above, pp. 156–7).

[64] On the language of *suptilitas* in Roman art criticism, see Pollitt 1974: 441–4 (along with 194–6 on *leptotēs*). We find the terminology burlesqued—again in the context of Apelles—in Petron. *Sat.* 83, where Eumolpus sees a fantastic series of paintings '*not* yet overcome by the defacement of time' (*uidi nondum uetustatis iniuria uictas*), including the *rudimenta* of Protogenes and a painting of Apelles, before which Eumolpus not only marvels (like Pliny) but even collapses into effete worship (*adoraui*): 'for the edges of the images had been given realistic definition with such *suptilitas* that you would think that the picture was also of their souls' (*tanta enim suptilitate extremitates imaginum erant ad similitudinem praecisae, ut crederes etiam animorum esse picturam*; for discussion, see Elsner 2007a: 183–4). Might Petronius be lampooning the dilettantism of such stories about the Apelles–Protogenes line painting in particular?

concept of *leptotês*—a sort of literal and metaphorical 'finesse'. 'A big book is a big evil' (μέγα βιβλίον μέγα κακόν, frg. 465 Pf.), as Callimachus famously put it, spurning the grand in favour of the small.[65] The most concise articulation of this aesthetic position comes in the programmatic preface to Callimachus' *Aetia*, a four-book elegiac miscellany. What matters, writes Callimachus, is quality, not quantity. In seeking the path untrodden, one should emulate the delicate singing of the cicada, not the braying donkey: the poet must 'feed the sacrificial victim to be as fat as possible, but, my friend, nourish a slender Muse' (ἀοιδέ, τὸ μὲν θύος ὅττι πάχιστον | θρέψαι, τὴν Μοῦσαν δ᾿ ὠγαθὲ λεπταλέην, vv. 23–4).[66] Apollo himself recommends something similar in the *Hymn* composed in his honour: the poet should shun the 'great stream' (μέγας ῥόος, Callim. *Hymn* 2.108) and venture instead to the 'small trickle which rises up pure and unsullied from a holy fountain' (πίδακος ἐξ ἱερῆς ὀλίγη λιβὰς ἄκρον ἄωτον, 2.112).[67]

We have already come across this aesthetic in the third chapter, noting how the Capitoline epigram resonates against Callimachean soundings of *sophia* and *technê* in the opening of the *Aetia*.[68] As critical idea, we noted, *leptotês* provides an aesthetic model both for the tablet's games with medium, and for its conceits of scale. But to call this simply an 'aesthetics of the miniature', as many scholars continue to do, is not quite right.[69] As Jim Porter has argued, the rhetoric of *leptotês* is important for encompassing *both* extremes of scale: because of the toil and labour (*ponos*) involved in the process, the smaller the poem, the 'greater' the effort of producing (or indeed reading) it. It all comes down to one's individual subjective perspective. 'The Hellenistic aesthetic is not one of simple refinement and smallness of scale', Porter writes, but instead 'produces sharply contrastive effects': 'at issue here is a *dynamic* of extremes, not a choice between them'.[70] Recall the story of Apelles and Protogenes: not only are the little lines painted on the great empty swathes of a large board, they also recede into practical invisibility—making the work more distinguished than every other (*omnique opere nobiliorem*, *HN* 35.83).

[65] The bibliography is vast, but Gutzwiller 2007: 29–36 gives a grand synopsis; cf. Bulloch 1985: 557–61 and Vogt 1966: 86–8. For the direct association of *suptilitas* and *elegentia* with Callimachean *ars*, cf. e.g. Vitr. 4.1.10.

[66] For a superlative discussion of the imagery, see Asper 1997: 177–89 (along with 153–60 on vv. 9–12); for the context within the *Aetia* prologue, see Fantuzzi and Hunter 2004: 66–76, with further references.

[67] On the passage's relevance to the *Aetia* prologue, see Hopkinson (ed.) 1988: 87; more generally on the allusive metapoetics, see Asper 1997: 109–34. Cf. also Callim. *Epigr.* 28 Pfeiffer (= *Anth. Pal.* 12.43) in which the poet declares his distaste for the cyclic poem (ἐχθαίρω τὸ ποίημα τὸ κυκλικόν, v. 1) and his refusal to drink from a common spring (οὐδ᾿ ἀπὸ κρήνης | πίνω, vv. 3–4).

[68] See above, pp. 120–1.

[69] e.g. Stephens 2004: 75–6.

[70] Porter forthcoming: 288.

Anyone who has struggled over the abstruse allusions condensed into a single verse of Callimachus or Lycophron will recognize the point: the length of effort expended on unpacking each word, phrase, and sentence is at odds with the semblance of concision and brevity.[71] The microcosmic issue of size therefore sums up all manner of macroscopic anxieties about the 'burden of the past'.[72] The great library at Alexandria encapsulates the thinking.[73] In this single monumental complex the whole world of literature past and present was collected, with each and every scroll duly classified, catalogued, and arranged (according to a newly conceived indexical system, reflected in Callimachus' own *Pinakes*—a list of authors and works in 120 volumes).[74] As with the texts composed inside the library, readers recede through a comprehensive spectrum: from each organized tiny reference (within each organized individual *pinax*), to whole texts, *oeuvres*, and genres—and then finally beyond, to the great masses that stretch unordered beyond the library doors. Overwhelmed by the scale of this new cultural perspective, literary *leptotēs* certainly means a lightness of touch. But each detail also holds the capacity for infinite expansion. Like the lines on the Apellean and Protogenean *tabula*, every microscopic trace of agency, however carefully crafted, draws attention to the bigger picture—and to the sheer *vastness* of the empty canvas.

EPI*GRAMMATIC* VISIONS OF THE GRAND IN THE SMALL

Before returning to the Iliac tablets, it is important to emphasize the larger leverage of literary *leptotēs*. We might venture to any number of texts here: to the genre of the so-called Greek 'epyllion', with its scaled-down 'epic' subjects, styles, and size, for instance; to the subsequent development of such models in the hands of Roman neoteric poets (most famously Catullus 64); or to the *Ilias Latina*'s simultaneous reproportioning of the *Iliad* and translation of it into Latin.[75] Instead, though, I want to return to a genre that is at once bigger and smaller in scope: epigram.

[71] In the case of Callimachus' work, at least, there was also a lot of it—some 800 books, according to the *Suda*: Sharrock and Ash 2002: 145–54 provide a concise introductory guide.

[72] For the phrase, see Bate 1970. The foundational analysis is Bing 1988: 50–90; cf. Fantuzzi and Hunter 2004: 1–41.

[73] For an introduction to the Alexandrian library, see e.g. Canfora 1988: especially 7–22, along with Pfeiffer 1968: 87–104 and Blum 1991: 95–123.

[74] On the *pinakes*, see Blum 1991: especially 124–81, 226–43, along with Pfeiffer 1968: 128–34.

[75] For a brief overview of Hellenistic 'epic in a minor key' (including works by Callimachus, Theocritus, Moschus, and Aratus), see Fantuzzi and Hunter 2004: 191–245, along with Ambühl 2010. On the 'genre' of epyllion (a term for which there is little ancient authority), see especially Gutzwiller 1981: 2–3; Merriam 2001: 1–24; Sistakou 2008: 121–35. On Catullus' sixty-fourth poem, see Laird 1993; W. Fitzgerald 1995: 140–68; and Elsner 2007a: 67–109, especially 68–73. On the *Ilias Latina*, see above, p. 93. For a stimulating

We have already said something about epigram and its history, at least in relation to poems penned on pictures. Although the genre had served a variety of functions in Archaic and Classical Grece—as funerary epitaphs, ad hoc compositions at the symposium, or inscribed votive dedications at the sanctuary—the later fourth and especially third centuries BC witnessed a change in conceptual mode: we see a rapid expansion in the form's popularity, facilitated in part by the transition from epigrams inscribed in stone to compilations anthologized within the papyrus. In their new literary guise, epigrams became more aware than ever of their (lost) epigraphic quality—i.e. their epi-grammatic status as monumentally inscribed *grammata*.[76] Such self-reflexivity about form and presentation made epigram the perfect mini-vehicle for thinking through larger questions about past and present: as short poetic ripostes, epigrams offered witty rejoinders to the established greats of the Greek literary tradition. The past remoulded in the image of present, the big revisited through the small, the monumental artefact refashioned through the literary papyrus: epigram arguably offered the most *leptos* encapsulation of Hellenistic *leptotês* at large.[77]

As we noted in the third chapter, this explains, at least in part, the popularity of a new type of epideictic epigram, one that explicitly engaged with well-known paintings and sculptures. The conceit of these new, 'ecphrastic' epigrams is that they were actually attached to the visible objects which they evoke, referring deictically to 'this' painting or 'that' statue.[78] In such poems—known today

discussion of scale and narrative in Hellenistic epic itself, see Hutchinson 2008: 66–89. It is also worth noting the fifth book of Philodemus' *On Poems*, which confirms Callimachus' long-lasting aesthetic-cum-philosophical impact even in the mid first century BC: for a review, see Fantuzzi and Hunter 2004: 71–2, 449–61.

[76] Cf. above, pp. 113–16, 230–1. Fantuzzi and Hunter 2004: 283–91 offer a concise introduction to the Hellenistic genre and its earlier prehistory, concluding that 'Hellenistic "literary epigrams", which were funerary or dedicatory, gradually moved ever further from any necessary basis in the contexts of real life and became fictional works of the imagination' (292). Specifically on the 'epi-grammatic' terminology, cf. e.g. Gutzwiller 1998: 47–9 and Meyer 2005: 27–33.

[77] For Hellenistic epigrammatic treatments of Homer, see the bibliography cited above, p. 96 n. 38.

[78] A long gloss on a small but big point here: namely, the 'ecphrastic' status of these epigrams. There has been much debate on the anachronism of the modern title (cf. e.g. Lauxtermann 1998: especially 326–9; Rossi 2001: 15–16; Gutzwiller 2004a: 361–2 and 2004b: 85 n.1; Chinn 2005: especially 248–52; A. Petrovic 2005: 38–9; Männlein-Robert 2007a: 251–2 and 2007b: especially 37–8; Webb 2009: 2). In a series of important and stimulating articles, Graham Zanker has led the bid to abandon the term, at least in association with pre-Byzantine epigram: 'like the current use of the word "ekphrasis" itself, the name of the category is a modern invention'; 'these poems were very rarely intended to give a vivid description . . . They were poems *about* statues, paintings and gems' (G. Zanker 2003: 61, 62, recapitulated in 2004: 184–5 n. 26). Zanker is surely right in claiming that the classification did not hold the same weight in the Hellenistic Greek world as it has done subsequently. But the discussion has often been framed in the wrong terms. Most critically, there remains a problem with the assumption that, in order to qualify as an ecphrasis, a text had to evoke the formal and physical traits of the object described: the hypothesis rests on a simplistic definition of associated ecphrastic *enargeia*, variously described as 'literary pictorialism', 'pictorial representation of fine art', 'vivid

mostly from the *Planudean Anthology*, as well the ninth book of the *Palatine Anthology*—the fissure between absent visual object and present verbal text served as a metaliterary gauge for measuring the proximity and distance between physical monument and graphic representation: ecphrastic epigram interrogated the replicative fictions of the artistic object, ecphrastic copy, and literary anthology. A number of examples have already been discussed—the poems on Myron's cow (with their shared artistic and poetic vocabulary of *technê* and *sophia*), for example, or Erinna's epigram on a *gramma* of Agatharcis.[79] But the discovery and subsequent publication in 2001 of a newly discovered 'poetry book' by Posidippus of Pella (*P. Mil. Vogl.*, inv. 1295) provides one of the best demonstrations of how Hellenistic epigram interwove discourses of size and sight.

Although there is no 'table of contents', we know from various heading titles that the papyrus was arranged into ten thematically discrete, albeit overlapping, groups: the anthology starts with poems on gemstones (*Lithica*), and proceeds to treat omens, dedications, epitaphs, the making of statues (*Andriantopoeica*), equestrians, shipwrecks, cures, and 'turns' (the tenth title is tantalizingly lost).[80] We will return to Posidippus' *Andriantopoeica* later (pp. 287–90). For now, I want to say something about the programmatic opening with the *Lithica*, relating these 20 epigrams to the big-cum-small and visual-cum-verbal aesthetic of Hellenistic encapsulation, and of the Iliac tablets in particular.

It is no accident that the poems of Posidippus, a contemporary of Callimachus, begin with a series of miniature gems that figure the polished delicacy of epigrammatic artistry (the work is λεπτή, as the first poem programmatically puts it: 1.4 A–B). The poems are certainly small, the longest (19 A–B) totalling only 14 lines; as such, the 'jewelled' style and size mirrors the self-conscious miniature artifice of Greek and Roman gems themselves (e.g. Figs.

and precise copy of the subject', and 'a more empiricist particularism in pictorial representation, and one quite close to modern Realism' (idem 1981: 39–44; cf. 1987: 39–42, 2003, and 2004: 28–30). Zanker argues that 'given epigram's naturally small format, it must limit explicit, detailed description … They were very rarely intended to give a visual description of the appearance of the works of art they celebrate' (2003: 61, 62). But epigrams toy with their promise and failure to visualize their subjects in much more sophisticated ways: aware that, no matter how descriptive their evocations, they offered readers a *different* sort of visualization from images, they actively interrogate what it means to view, and what it means to represent viewing through words (cf. Squire 2010d). As such, epigrams on artworks clearly fit into a longer tradition of Greek thinking about words visualizing pictures, later rationalized in the *Progymnasmata* of the first centuries AD; the ecphrastic games of epigrams on artworks also offer a clear parallel for those materialized through the *Tabulae Iliacae* (cf. below, pp. 341–9, 360–7).

[79] See above, pp. 114–15, 238–9.

[80] Following the English titles of Frank Nisetich's translation in Gutzwiller (ed.) 2005: 17–41; for the meaning of the ninth title (*tropoi*), see Obbink 2004. For two polished overviews (with extensive bibliography), see Prioux 2008: 159–252 and Bing 2009: 177–93. On the *Lithica* specifically, I have particularly learned from Hunter 2002 (revised and expanded as 2004 and 2008: 1.457–69); Kuttner 2005; Petrain 2005; Prioux 2006: 131–8 and 2008: 159–200; Fuqua 2007; Porter forthcoming.

130–1).[81] But Posidippus' objects-cum-poems also vacillate in their scale and scope. These are not *just* 'miniatures', as so often claimed:[82] each microcosmic specimen forms part of a much larger macrocosm, one little poem leading effortlessly on to the next. For all their diminutions of scale, the stones constitute a 'great marvel' (θαῦμα ... μέγα, 15.7 A–B), both individually, and as a collective.[83]

The literary archetype here is the epic armour fashioned by Hephaestus in the eighteenth book of the *Iliad*. As the following chapter explores, Achilles' 'great and mighty shield' (σάκος μέγα τε στιβαρόν τε, *Il.* 18.478), adorned with 'many wondrous things' (δαίδαλα πολλά, 18.482), is destined to be a forged poetic prodigy such that 'in future, many among the multitude of men shall marvel, whoever looks upon it' (οἷά τις αὖτε | ἀνθρώπων πολέων θαυμάσσεται, ὅς κεν ἴδηται, 18.466–7). But Posidippus simultaneously appropriates and adapts the Homeric model. Where the *Iliad* evoked Achilles' great shield within the grand frame of epic, Posidippus offers a series of *fragmented* ecphrases. And yet, as an assemblage, Posidippus' epigrams measure up to something no less monumental in scope. Not only do these (poems on) gemstones cover a vast geographic area, they bring together the whole cosmos—both far-flung lands (India, Persia, and Arabia),[84] as well as the very elements of the universe (earth, water, fire, and air).[85] Once again, the shield of Achilles provides the pictorial–poetic paradigm. Both Homer and Posidippus offer framed visions of the world in words.[86] With the *Lithica*, though, it is the *collection* of poetic objects that contributes the totality—all this within an epigrammatic sequence that itself forms just one small part of a much larger anthological 'cabinet'.[87] A series of paradoxical dialectics are at work here, figured in the very image of these

[81] For the metapoetic point, see especially Petrain 2005.

[82] Cf. e.g. Gutzwiller 2004b: 93.

[83] Cf. Platt 2007: 90–1 on the *Lithica* materializing a 'sense of contradiction...playing upon the contrasts between the miniaturism of gem stones and the magnitude of the natural forces which have created them'. As Fuqua 2007 emphasizes, scales also shift programmatically *between* the *Lithica*, shuffling from the personal to the grand (e.g. poems 8 and 9 A–B: cf. ibid. 282–3), and ending in the 'major shift' to the 'larger scale' of poems 19 and 20 A–B (when the poet 'expands from the miniaturist art of the preceding *Lithica* to subjects on a larger scale', ibid. 286). Cf. Lavigne and Romano 2004: especially 22 on how these themes were reflected in the formal presentation of the manuscript, and Hunter 2004: 97 on size as a theme on which certain some poems explicitly dwelled (on 18 A–B and Callim. *Ia.* 6).

[84] Some examples: India: 1.1, 2.4, 8.5 A–B; Persia: 4.5, 5.2 A–B; Arabia: 7.1, 10.10 A–B. Note too how the *Lithica* end with the exhortation that all Ptolemy's 'land and shores' be kept free from earthquakes (γαῖαν ... καὶ αἰγιαλούς, 20.6 A–B).

[85] Some examples: sea: 12.1, 16.2, 19.2 A–B; mountains: 7.1 A–B; air: 14.6 A–B. Cf. Bing 2005: 120, on how 'the stones exemplify in their geographical distribution and social construction both the territorial and cultural/artistic aims of the Ptolemies and of their poet, Posidippus'.

[86] See below, pp. 303–70, especially 325–37.

[87] On ecphrasis itself as a figure for Hellenistic 'anthological fragmentation' (specifically, in regard to Theoc. *Id.* 1.26–60), cf. Goldhill 1991: 240–6.

jewelled 'stones': not just between art and nature (elaborate entities crafted by both natural and human artifice), but also between artefact and poem, image and text, and the grand and the small. Like the Iliac tablets, Posidippus' poems play out a recession of both scale *and* media. In the case of the *Lithica*, moreover, that recession is itself figured through the function ascribed to these great-little sealstones, destined to go on replicating their aesthetic of replication, both artistically (forging representations in wax) and poetically (giving rise to still more poetic responses).[88]

In this connection, allow me to introduce one final epigrammatic case study, and one somewhat closer to the *Tabulae Iliacae* in date: the epigrams of Martial. As we have already said of the two poems on 'Heracles Epitrapezios' (9.43–4), Martial offers the ultimate in both minimization *and* maximization.[89] By 'minimization' I do not just mean that each poem is composed of only a few lines. Rather, Martial allows his readers to zoom in or out at whim. This is particularly true of his thirteenth and fourteenth books of poems, in which each epigram is supplied with an even shorter title—a mini-summation of every minuscule couplet (Mart. 14.2):

> Quo uis cumque loco potes hunc finire libellum:
> uersibus explicitum est omne duobus opus.
> lemmata si quaeris cur sint ascripta, docebo:
> ut, si malueris, lemmata sola legas.

You can finish this book at any place you choose. Every performance is completed in two lines. If you ask why headings are added, I'll tell you: so that, if you prefer, you may read the headings only.

Small poems, then, with even smaller *lemmata*: as with the Iliac tablets, readers are to free select their own scale (*si malueris*)—proceeding 'whichever way they choose'.[90] For all the diminutions of individual epigrammatic size, however, the

[88] Cf. Squire 2010a: 622–4 on *Anth. Pal.* 9.746, 747, 750—poetic gems impressed with the image of (the epigrams on) Myron's cow. The poetic anthology therefore proves no less deceptive than the stone described in epigram 13 A–B ('this stone is wily', κ[ερδα]λέη λίθος ἥδε, 13.1 A–B; 'a marvel of deception', θαῦμα ἀπάτης, 13.2 A–B). In each case the illusory effects of the gems, or the images 'written' upon them, replicate the illusion of epigrams evoking those jewelled objects in words, within a programmatic collection of *Lithica* whose very title suggests not the epigrams of the anthology, but epigram itself as a literary genre *inscribed* on stone (and indeed the poet as 'stoneworker', λιθουργός: 3.1, 15.7 A–B: cf. Schur 2004).

[89] My analysis has particularly learned from the recent studies by William Fitzgerald and Victoria Rimell: cf. W. Fitzgerald 2007: especially 2–3 and Rimell 2008: especially 7–14 ('One of the most basic dynamics of Martial's poetics . . . is its simultaneous shrinking down of big to small, and magnification or elevation of the small. In this way the most lowly genre can aim for epic status, and objective measurements are utterly subjectivised, when it suits: short can seem long, a thin book can become fat in the reading, and vice versa, and simplicity can be deceptive', 94).

[90] For the invention, see B.-J. Schröder 1999: 176–9, although downplaying the metapoetics. For the associated *lemmata* of the Iliac tablets, see above p. 99. For their related instruction to proceed 'whichever way you choose', see above, pp. 202–5.

total number of poems amount to a truly grand collective vision. As the poet reminds us, the miniature scale of the epigrams should not distract from the size of each book, nor from the scale of the larger collection. Many littles make a much (8.29):[91]

> Disticha qui scribit, puto, uult breuitate placere;
> quid prodest breuitas, dic mihi, si liber est?

> He who writes distichs wishes, I suppose, to please by brevity. What use is brevity, tell me, if it is a book?

Just as Imperial Rome encapsulates the whole world within its cosmopolis, these Lilliputian poems give a Brobdingnagian perspective to the monumental facture of empire: Martial offers a grand picturesque mosaic comprised of neatly ordered epigrammatic *tesserae*. The totality arguably proves no less comprehensive in scope than Pliny's *Natural History*. And like Pliny's exhaustively encyclopaedic 'catalogue of culture', sized up in a miniature opening table of contents, Martial's kaleidoscopic project is at once small *and* grand—microscopic in its pointillist precision, but macroscopic in its all-encompassing frame.[92]

This aesthetic framework helps us to understand one of the most remarkable sequences of poems, clustered towards the end of Martial's fourteenth book of *Apophoreta* (published in *c.* AD 84–5).[93] Martial pens 14 epigrams (14.183–96), each one imagined to accompany a materialized and miniaturized version of a literary work. The list takes in 14 of the most canonical works of Greek and Roman literature (albeit with some witty surprises along the way).[94] All of the 'greats' are included, the majority of them summ(on)ed up in bound codex form: Homer, Virgil, Menander, Cicero, Propertius, Livy, Sallust, Ovid, Tibullus, Lucan, Catullus, Calvus. In each case, the text has been physically shrunk so as to be inscribed on a tiny scroll or book. Here, for example, is the epigram on

[91] On this epigram and parallels, see Rimell 2008: 111.

[92] The phrase 'catalogue of culture' is taken from Carey 2003; on the scale of the *Natural History*, see above, pp. 6–7.

[93] The two most important discussions of these poems are Roman 2001: 130–8 (especially 134–5) and Prioux 2008: 311–28.

[94] The series starts, for example, not with Homer's *Iliad* and *Odyssey* (see below, p. 283) but with his puny *Batrachomyomachia* (14.183)—a mischievous sequence played out in the parallel structure of the following two poems (14.185–6), treating first Virgil's *Culex* and then his grander works (albeit with no explicit mention of the *Aeneid*): cf. Prioux 2008: 315, 323. The inversions are made all the more complex by the poet's declaration to have ordered the book's epigrams according to a dialectic of 'rich' and 'poor' lots (*diuitis alternas et pauperis accipe sortes*, 14.1.5, with discussion and bibliography in Leary (ed.) 1996: 13–21): the structural framework translates the sequence of poems into a dialectic catalogue of metapoetic preference (cf. Lausberg 1982: 246; Roman 2001: 134 n. 76; Holzberg 2002: 47; S. Lorenz 2002: 100–3; Prioux 2008: 313–14).

Livy, saddled either side of a poem on Propertius' *Monobyblos* and another on Sallust (14.190):[95]

> Pellibus exiguis artatur Liuius ingens,
> quem mea non totum bibliotheca capit.

Vast Livy, for whom complete my library does not have room, is compressed in tiny skins.

Twentieth-century scholars tended to take this reference to 'Titus Livy in the sheets' (*Titus Liuius in membranis*) at pedantic face value: predictably, arguments were waged as to whether this epigram was intended to accompany a 'miniature' text of all completed 142 books (now brought together in one miniature volume?), or an abridged epitome (offered as a 'Christmas present' at the Saturnalia?).[96] Certainly, we know that such miniaturist feats *could* be manufactured, at least come later antiquity (albeit never quite to this scale). The best surviving example—the smallest ancient codex known to us—is the Cologne Mani-Codex (Codex Manichaicus Coloniensis), probably produced in fifth-century Egypt (Figs. 135–6).[97]

But whatever the 'realities' of book production in the first centuries AD, there is a metapoetic dimension to Martial's epigrammatic games with scale. The question is what Livy's totalizing mode of history has to offer not Martial's literal library, but rather his metaliterary *bibliotheca* of epigrams.[98] Juvenal complains of historians like Livy that their 'pages run into the thousands' (*millensima pagina*

[95] On the juxtaposition, see Prioux 2008: 316–17.

[96] Cf. e.g. Kenyon 1932: 92–4; Oliver 1951: 248 n. 52; Kleberg 1967: 76; Starr 1987: 217; McDonnell 1996: 479 n. 44. As S. Lorenz 2002: 108–9 and Prioux 2008: 264–8, 314–15 make clear, there can be little room for the literalism of Lehmann 1945, who reads these poems as referring to a *real* library, just as he reconstructs the preceding epigrams in terms of an actual museological display (in the *templum nouum diui Augusti*: see especially 262–3): Lehmann has established form on this interpretive manoeuvre, as his literalist reconstruction of the gallery behind Philostratus' *Imagines* demonstrates (cf. Bryson 1994 on Lehmann 1941).

[97] My thanks to Doug Lee for alerting me to this vellum codex. For an introduction to the presentation, see Koenen and Römer (eds.) 1985: vii–xxv ('Der Kodex ist der kleinste erhaltene Kodex aus der Antike', viii) and Gardner and Lieu 1996: 154–61 (suggesting that 'a glass-bottle filled with water was the most likely enlarging tool', 154); there is a facsimile edition in Koenen and Römer (eds.) 1985, and an *editio minor* in Koenen, Römer, and Heinrichs (eds.) 1988; for an English translation, see Cameron and Dewey (eds.) 1979. The codex measures 38 x 45 mm, although the actual space used for writing is only 24 x 35 mm, with 23 lines featured per page: the letter height is therefore less than 1 mm. Some suggest that 'ces livres miniatures étaient utilisés comme amulettes' (Legras 2002: 93; cf. McGurk 1994: 7–8, 20–1). In any case the miniaturist presentation was evidently judged suitable for capturing the mystique of the Manichaean subject: within a treatise 'Concerning the Birth of [Mani's] Body', what better way to get disciples thinking about materiality and spirituality than through a presentational mode that both celebrates and transcends the embodied form...

[98] Various additional references develop the theme (as Prioux 2008: 318 notes): the closing 'sources' (*fontes*) of Calvus' *De aquae frigidae usu* (14.196.1), for example, as well as the 'long paths' (*longas . . . uias*) of Cicero's works (14.188.2), both of which at once spring from and lead to the path of Callimachean poetics.

FIGURE 135. Two pages from the Cologne Mani-Codex (Codex Manichaicus Coloniensis: Die Kölner Papyrus-Sammlung inv. 4780, Quire 3b, pp. 60–1); height: 4.3 cm; width: 6.8 cm; the width of each textual column is 2.5 cm.

FIGURE 136. Detail of the right-hand page.

surgit, 4.100); immediately after commenting on Livy's work, Pliny too declares that storehouses are now needed, not books (*thesauros oportet esse, non libros*, *HN* praef. 16). Like Columella after him (*Rust.* 11.3.65), Pliny would devise a special indexing system to cut his own multi-tomed encyclopaedia back down to size.[99] Martial uses his poetic medium to affect something similar: he exploits the generic measure of epigram to size Livy up (or rather down). Thanks to the magical might of Martial's metapoetic miniaturization, the towering tomes of 'giant Livy' are turned into a teeny-tiny *Taschenbuch*.[100]

The same holds equally true of the other authors introduced in these poems. In each case, the physical miniaturization of the gigantic text figures the poetic reductions of epigram as genre: 'how small a quantity of parchment has managed to contain vast Maro' (*quam breuis immensum cepit membrana Maronem*, 14.186.1).[101] The (meta)literary metaphor stages an encapsulation of both size *and* form: we regress backwards and forwards from each gargantuan text, through each supposed miniaturization of it, to each epigram and titular abbreviation. In every case, moreover, the receding dynamics of scale are figured in terms of the vacillating representational status of the epigrams at hand—as 'original' poems, miniaturized copies, two-line epigraphs, and a series of epigrams collected in a book (each with its own self-contained title, and together comprising the not-so-miniature anthology of Martial's total output).[102] Scale proves no less dynamic than Martial's mode of monumental-literary synopsis:

[99] For the history and ideology of this Imperial and imperialist technology, see B.-J. Schröder 1999: 93–159 on the indexes not only of Pliny and Columella, but also (after them) Hyginus, Vegetius, Palladius, Isidorus, Cassiodorus, and Augustine. It is worth noting the intellectual connection between such indexical tables and the pairing of pictures and textual summaries the *Tabulae Iliacae*: in both scenarios, audiences are faced with an object as well as a diagram instructing how to use the object; but the *Tabulae* actively probe the paratextual qualities of the summary—the hermeneutic excesses between monumental artefact and epitome guide.

[100] Observe here the additional little significance of the word *ingens*. The whole issue of size might make us think of Livy's own metaliterary proem, in which Livy declares that his 'subject involves immense work' (*res est praeterea immensi operis*)—thereby associating the 'huge' task of writing Rome's history with that of founding the city in the first place (cf. e.g. Gowers 1995: 26).

[101] For the point, cf. Prioux 2008: 316: 'Il me semble que le principal critère de classement observé par Martial repose en réalité sur des considérations esthétiques et sur des préférences littéraires.' But I am not convinced by Prioux's suggestion of any straightforward dialectic here between the poetic poles of *leptotês* and *semnotês* (which the author relates to that of e.g. Posidippus' *Andriantopoeica*: cf. Prioux 2007: 108–13 and 2008: 159–252). Although played out at different extremes, the *leptotês* of this sequence means that the little is always in the large and that the large is always in the little. For does not even vast (*ingens*) Livy prove *leptos* when compressed in 'tiny skins' (*pellibus exiguis*, 14.190.1)?

[102] The ecphrastic aspect of these verbal poems on visual materializations of verbal texts is all the more resonant given their sequence *within* the book: the epigrams on miniature manuscripts follow on from a series of poems on statues which prove no less polysemic in their games of figuration, metapoetics, and scale (cf. Prioux 2008: 253–335, especially 254–311, on Mart. 14.170–82).

just as the big is metamorphosed into the small (and the small into the big), each of Martial's poems occupies at once a *variety* of different ontological registers.[103]

WHAT'S IN A NAME?
THE 'GREAT SUBTLETY' OF THE 'THEODOREAN' DETAIL

Martial's miniature epigrams bring us squarely back to the *Tabulae Iliacae*, and indeed to our opening 'Iliad in a nutshell'.[104] After all, the very first 'mini-books' described relate to the works of Homer—'Homer in handheld tablets of parchment' (*Homerus in pugillaribus membraneis*, 14.184):

> Ilias et Priami regnis inimicus Ulixes
> multiplici pariter condita pelle latent.

> The *Iliad* and *Ulysses*, hostile to Priam's kingdom, lie hidden together, stored in many layers of skin.

As with the marmoreal Iliac tablets, Martial's miniature manuscript 'stores' a large corpus of verse (likewise 'concealed' [*condita*] here through the presentational format). The resulting objects work on a variety of levels: the miniature Homer is multilayered—literally *multiplex*.[105] Specific conceits also mirror those of the Iliac tablets. One of the jokes of Martial's epigram, for example, is that the tiny codex brings together the *Iliad* and the *Odyssey*—Priam and Ulysses become imaginary book buddies, not literary enemies: it is as though the whole epic cycle is rolled out, the *Iliad* and the *Odyssey* merging one into the other (*pariter*). As we have seen (p. 182), at least one tablet (6B) seems to have united the poems in a similar way, representing scenes from the *Odyssey* in between the two halves of the *Iliad*. Like Martial's (poem on the) Homeric miniature manuscript, the *Tabulae* mediate the maximal in the minimal. But they go still further in materializing Martial's metapoetic make-believe. Where Martial delivers a text on a minimanuscript that objectifies a text, the tablets really do occupy both realities at once: they are both texts and artefacts—monuments *and* manuscripts.

This chapter has covered a lot of ground in a little space. Before proceeding, let me therefore attempt a synopsis of my own. I hope to have established three overarching points. First, that the *Tabulae Iliacae* demonstrate a knowing and

[103] As Prioux 2008: 319 notes, there is a monumental-cum-literary model for such abbreviations in the canonical *pinakes* of Callimachus.

[104] The association is noted by Horsfall 1983: 147 n. 36. Typically, though, Horsfall concludes that 'Martial has *serious* readers of complete and continuous texts in mind, and that is something Theodorus' clientele were not' (my emphasis).

[105] For the same 'multilayered' image, cf. Mart. 14.192.1 (on the works of Ovid).

playful self-consciousness about their scale, reproportioning the grand into the small, just as they recalibrate the verbal into the visual (and vice versa). Their gesture of miniaturization, second, has to be understood within a much larger cultural context: that context pertains to the aesthetic criticisms of Greek philosophy, certainly, but it also takes us to the Hellenistic aesthetic of *leptotês*—a quality applicable to the visual arts as much as to the literary. Third and finally, the concept of *leptotês* has to be understood as a dynamic contrast of extremes that brings together the big *and* the small, as well as the artefactual and the literary. I have concentrated on certain comparanda—among them, the poems on 'Heracles Epitrapezios', Pliny's tale of Apelles and Protogenes, Podisippus' *Lithica*, and Martial's epigrams on a series of miniature manuscripts (though we might equally have chosen others). To my mind, the Iliac tablets offer the ultimate epitomization of the aesthetic: these synopses play upon paradoxical extremities of size as well as upon the vacillations of medium.

I want to end this chapter by returning to one particular detail about the tablets, or rather the 'Theodorus' with whom so many of them associate themselves.[106] As we saw in the third chapter, the epigram on the obverse of the *Tabula Capitolina* boasts of its 'Theodorean *technê*', as perhaps did the New York tablet epigram (2NY). The verso of that New York tablet likewise flaunts this attribution—as, in fact, did a total of five different 'magic square' inscriptions. One tablet (4N), moreover, certainly parades the name on *both* its verso and its recto. There are therefore at least seven, and quite possibly eight, references to 'Theodorus', and on six different tablets:

1A (recto): [τέχνην τὴν Θεοδ]ώρηον μάθε τάξιν Ὁμήρου
ὄφρα δαεὶς πάσης μέτρον ἔχῃς σοφίας.

2NY (recto): [–∪∪| – Θεοδώρηον μάθε τάξιν Ὁμήρου
ὄφρα δαεὶς τ]έχνην μέτρον ἔχῃς σο[φίας].

(verso): [Ἰλι]ὰς Ὁμήρου Θεοδώρηος ἡ{ι} τέχνη

3C (verso): [Ἰλιὰς Ὁμήρου] Θεοδώρηος ἡ{ι} τέχνη

4N (recto): ἀσπὶς Ἀχιλλῆος Θεοδώρ[ηος καθ' Ὅμηρον][107]

(verso): ἀσπὶς Ἀχιλλῆος Θεοδώρηος καθ' Ὅμηρον

[106] The following section of this chapter extends ideas that were first aired in Squire 2010c: 84–90: my particular thanks to Jim Porter for his generous suggestions and advice, and to David Petrain for first challenging me to find corroborative material evidence for my argument. Two brief sentences in the conclusion of Petrain's doctoral dissertation tentatively hint at a possible related association (Petrain 2006: 188): 'Though Theodorus is a common name, the adjective is far less widespread, and it seems at least possible that the use of the adjective on the *Tabulae* is meant to activate an association between our Theodorus and the more famous Samian, renowned for his miniature work even in Praeneste. If so, our Theodorus would be shrewdly capitalizing on the reputation of a famous namesake in order to advertise his own skill in miniaturizing the Epic Cycle.'

[107] On the reconstruction, see below, p. 307.

5O (verso): [ἀσπὶς] Ἀχιλλεῖος Θεοδώρηος ἡ τ[έχνη]
20Par (verso): ['Ἰλιας Ὁμ]ήρου Θεοδώρει[ος ἡ τέχνη][108]

Scholars have speculated widely (and wildly) about the identity of this Theodorus.[109] Some have imagined a possible connection with 'Theorus'—the supposed painter of the 'Trojan' paintings displayed in Rome (Plin. *HN* 35.144).[110] Others, focussing on the meaning of the noun *technê*, have understood Theodorus not as the artist of the tablets, but rather as the grammarian mythographer responsible for the epic epitomization.[111] Nikolai Kazansky, on the other hand, has fancifully argued that the signature refers not to the maker of the tablets, but rather to the (unattested) name of an earlier artist—responsible for crafting the Iliadic mosaics on Hieron II's third-century ship.[112] By far the most common manoeuvre, though, is to characterize Theodorus as an Egyptian craftsman. This interpretation is premised upon the supposedly 'Egyptian' formulation of the seven 'magic square' inscriptions already discussed. As we have seen, the assumption has very little to recommend it.[113]

 We should say from the outset that Theodorus is an exceedingly common name. Loewy's catalogue of Greek artist signatures includes at least one other artist signing his work under this title,[114] and Diogenes Laertius lists no fewer than twenty persons by the name, and from all different parts of the Mediterranean—a Theban sculptor, three painters, and an epigrammatist among them (2.103–4).[115] But it is surely no coincidence that, among the most celebrated figures called 'Theodorus', at least by the first century AD, was an Archaic Greek

[108] For the practical explanation behind this variant spelling, see above, p. 209.

[109] For a review, see Valenzuela Montenegro 2004: 350–8 (concluding of Theodorus that it is 'nicht möglich, ihn mit einer aus den literarischen Quellen bekannten Persönlichkeit zu identifizieren', 350); cf. *KLA* 2: 450–1, s.v. 'Theodoros (XI)' (omitting reference to tablet 20Par).

[110] Cf. e.g. Sadurska 1959: 122 and 1964: 9–10; Valenzuela Montenegro 2004: 350–1.

[111] See above, pp. 105–6. Still others have drawn attention to a certain Theodorus of Ilium, to whom the Suda attributes an independent *Troica* of his own: e.g. Sadurska 1959: 10; Bua 1971: 13; Horsfall 1979a: 27 n. 6 (though concluding that 'the name is exceedingly common').

[112] Kazansky 1997: 74–9 ('I suggest that Hieron's mosaic on the ship was the prototype for the *Tabula Iliaca Capitolina*, and that Theodorus was one of the artists invited by Hieron II', 77): the speculation is unfounded (see above, pp. 249–50); in any case Athenaeus names Archias of Corinth as the man in charge of the project (Ath. 5.206f).

[113] See above, p. 210 n. 34. Will 1955: 437 is less specific, but suggests 'un artiste provincial'.

[114] On a second-century BC 'Theodorus' signature from Argos, see Loewy 1885: 188, no. 263. In fact, the *Künstlerlexikon der Antike* lists twenty craftsmen named 'Theodorus': *KLA* 2: 445–52, s.v. 'Theodoros'.

[115] Hence the conclusion of Lippold 1932: 1893: 'der Name ist viel zu häufig, als daß wir versuchen könnten, ihn mit einem der Homonymen zu identifizieren'. For known inscribed occurrences of the name, see *LGPN* 1.214–15; 2.215–17; 3A.202–3; 3B.190–1; 4.164–5; 5A.213–14. Solin 2003: 78–80 counts 97 instances.

craftsman from Samos. Pliny the Elder offers the most detailed description (*HN* 34.83):[116]

> Theodorus, qui labyrinthum fecit Sami, ipse se ex aere fudit. praeter similitudinis mirabilem famam magna suptilitate celebratur: dextra limam tenet, laeua tribus digitis quadrigulam tenuit, tralatam Praeneste paruitatis ut miraculum: pictam eam, currumque et aurigam, integeret alis simul facta musca.

> Theodorus, who made the labyrinth at Samos, cast himself in bronze. Besides its marvellous reputation as a likeness, it is celebrated for its great *suptilitas*. In his right hand he holds a file, and with three fingers in his left hand he held a little four-horse chariot that was carried off to Praeneste as a marvel of miniaturization: a fly that was made at the same time would cover the whole painted thing—chariot and the charioteer alike—with its wings.

Pliny's description is almost certainly corrupt—which is why some editors posit *fictam* in the final clause ('the fly would cover the *moulded* quadriga'), while others prefer *totam* ('the fly would cover the *whole* quadriga': one thinks, once again, of the contemporary works of Willard Wigan (Fig. 128)). The general thrust is nevertheless unambiguous: for Pliny, Theodorus' renown rests in his aptitude for miniature artistic invention. Such was the sculptor's *magna suptilitas* that he rendered in the left hand of his self-portrait a tiny chariot and horses—something so small as to be held between three fingers, and so esteemed as to have been trotted off to Praeneste, a miniaturist wonder in its own right (*paruitatis ut miraculum*).[117]

The fact that Pliny labels this Theodorean wonder an example of *suptilitas* draws us back to the general aesthetic of *leptotēs*, and in particular Pliny's lines about the *suptilitas* of Apelles' and Protogenes' line painting. The author surely intends us to see the paradox: like the lithe handicraft of Apelles and Protogenes, Theodorus' miniaturist precision might stretch to infinitesimal details, but it is nevertheless founded upon great skill. Rendering his subject with grand subtlety (*magna suptilitate*), Theodorus offers a wonder of truly tiny proportions (*paruitatis . . . miraculum*).[118]

[116] On Theodorus of Samos, see Overbeck 1868: 50–3, nos. 284–93, together with Pollitt 1990: 27–8, 181–2, A. Stewart 1990: 1.244–6 (with further bibliography), Mattusch 2008: 423–4, and *KLA* 2:445–7, s.v. 'Theodoros (I)'.

[117] On Pliny's description, and its derivation, see Metzler 1971: 175–9. Metzler concludes that Pliny's account stems from an earlier Hellenistic source, and not from any first-hand autopsy. Although harder to explain in terms of textual transmission, my own reading of the final sentence would prefer *totam* (understanding the *-que* of *currumque et aurigam* epexegetically): so minuscule is the *quadrigula* that the wings of a sculpted fly would cover the *whole* thing—chariot and charioteer alike.

[118] English translation finds it harder to convey the paradoxical 'maximal minimalism' (and 'finesse laid on thick') implied by the Latin phrase *magna suptilitas*: *suptilitas* entails both a physical quality and an aesthetic judgement (cf. *OLD* s.v. 'subtilitas').

Pliny's reference would not perhaps have added up to much had it not been for the recent discovery of Posidippus' epigrams. Posidippus provides a wholly independent reference to Theodorus' miniature chariot and charioteer, in the context of one of his nine poems on statues, or *Andriantopoeica* (67 A–B):[119]

$$]. \, ἄντυγος \, ἐ<γ>γύθεν \, ἄθρει$$
$$τῆς \, Θεοδωρείης \, χειρὸς \, ὅσος \, κάματος·$$
$$ὄψει \, γὰρ \, ζυγόδεσμα \, καὶ \, ἥνια \, καὶ \, τροχὸν \, ἵππων$$
$$ἄξονα \, <θ>' \, [ἡνιό]χου \, τ' \, ὄμμα \, καὶ \, ἄκρα \, χερῶν.$$
$$ὄψει \, δ' \, εὖ \, [\quad μήκ]εος, \, ἀλλ' \, ἐπὶ \, τῷδε$$
$$ἑζομέν[ην \, ἂν \, ἴσην \, ἅρματι] \, μυῖαν \, ἴδοις.$$

...of the rim, observe at close quarters...how great was the labour of the Theodorean hand. For you will see bands, reins, the ring for the horses' bit, the bit's axle, the charioteer's eye, and the fingertips of his hands. You will see clearly...of its size, but you could see a fly of the same size as the chariot sitting upon it.

There can be no doubt that Posidippus is referring to the same artist as the Elder Pliny—hence not only the reference to Theodorus' miniature chariot and charioteer, but also the fly.[120] Pliny knew his Greek epigrams, and it is not overly far-fetched to think that he might have known this particular poem, or at least others in their mould. Elsewhere, Pliny discusses Apelles' painting of Aphrodite Anadyomene, which 'is praised in Greek poems' (*uersibus Graecis...laudatur, HN* 35.91), and Pliny cites other instances of artworks made famous by epigram.[121]

It would be futile to speculate about whether or not Pliny 'really' saw Theodorus' statue, or even the miniature chariot removed to Praeneste. As with the apocryphal '*Iliad* in a nutshell', Pliny relies on a library of texts—and a good deal of hearsay. But it is worth noting that the *Natural History* has recourse to a similar anecdote in two other places, both in association with the artistry not of Theodorus, but of Myrmecides.[122] Myrmecides, we recall, had attributed to

[119] On the Posidippan reference to Theodorus, see especially d'Angiò 2001; cf. Bastianini and Gallazzi 2001: 193–4; Bernsdorff 2002: 38; Gutzwiller 2002b: 55–6; Kosmetatou 2004: 204–5; Sens 2005: 222–4; Prioux 2007: especially 40 n. 62, 122–4 and 2008: 208; Männlein-Robert 2007b: 71–3. Among the most important discussions of Posidippus' *Andriantopoeica* are Gutzwiller 2002b; Esposito 2005; Sens 2005; A. Stewart 2005; Männlein-Robert 2007b: 53–81; Prioux 2007: especially 108–13.

[120] Similarly, the mood of Posidippus' final ἂν... ἴδοις matches Pliny's apodotic subjunctive *integeret*.

[121] Cf. Squire 2010b: 148–52. One might also compare Pliny's discussion of Myron's bronze heifer (*HN* 34.57–8). Just as Pliny comments upon Theodorus' 'marvellous reputation' (*mirabilem famam*) and relays how Theodorus' portrait 'is celebrated for its great precision' (*magna suptilitate celebratur, HN* 34.83), Pliny uses the same *celebrare* verb in the context of Greek epigrams on Myron's cow (which certainly included one poem by Posidippus—66 A–B, placed directly before the epigram on Theodorus): Myron's artwork, writes Pliny, is praised in a series of epigrams that were themselves admired and celebrated (*celebratis uersibus laudata, HN* 34.57).

[122] On the relation between these Theodorus and Myrmecides anecdotes, cf. Bartman 1992: 170.

him the sesame seed inscribed with Homer (Plut. *Mor.* (*Comm. not.*) 1083d–e, Ael. *VH* 1.17): among other 'miniatures of marble' (*paruola marmorea*), writes Pliny, Myrmecides was responsible for a 'four-horse chariot and driver' which 'a fly covered with its wings' (*Myrmecides cuius quadrigam cum agitatore operuit alis musca*, *HN* 36.43); earlier in the *Natural History*, Pliny also ascribes to Myrmecides a 'four-horse chariot of ivory that a fly's wings could cover, and a ship that a little bee could conceal with its wings' (*quadriga ex eadem materia, quam musca integeret alis, fabricata et naue, quam apicula pinnis absconderet*, *HN* 7.85).[123] It was perhaps thanks to epigrams like Posidippus' that the fly became the standard miniaturist measure; indeed, perhaps this is why Pliny duplicates the anecdote, and in the context of two different artists.

Whatever we conclude about Pliny, we can be sure from the new Posidippus that Theodorus' miniaturism was already iconic even in the early third century BC. As in Posidippus' other eight poems on 'statues' (*Andriantopoeica*), concerned only with the A-list of the art (Lysippus, Hecataeus, Cresilas, Myron, Theodorus, Chares), the poet assumes that his readers will know both sculptor and sculpture alike: Posidippus did not feel the need to provide contextual information, nor to mention that this image was a self-portrait.[124] Instead the epigram homes in on the miniature scale of Theodorus' craft: Theodorus' sculptural feat is made to (pre)figure the *leptotēs* of Posidippan poetry.[125] This explains the poet's earlier reference to Theodorus, this time in the *Lithica* (9 A–B). In that earlier epigram, Posidippus does not mention Theodorus by name, describing instead the miniature seal ring of Polycrates—an artistic object rendered (significantly) with the insignia of the poet. In a famed passage of his *Histories*, though, Herodotus informs us that it was Theodorus who crafted the miniature object, so beloved by the Samian tyrant (Hdt. 1.51).[126] Taken together, the two small poems on Theodorus, both celebrating an aesthetic of the well-crafted but little object, bring together some of the larger themes structuring Posidippus' petite anthology: not only does Theodorus forge a mini-connection between the *Lithica* and *Andriantopoeica*, the reference to the tiny chariot and charioteer also foreshadows

[123] For the passages, see Overbeck 1868: 423, nos. 2196–7. Overbeck also compares Apul. Gramm. *De orthograph.* (cited on 51, no. 293), which glosses that 'Myrmecides was a sculptor remarkable for his miniature marble works of plastic art, and better than Theodorus and Callicrates' (*Myrmecides...fuit sculptor admirandus in minutis marmoreis operibus formandis, meliorque Theodoro et Callicrate*): Pliny was evidently not alone in associating the works of Myrmecides with those of Theodorus.

[124] Cf. Bastianini and Gallazzi 2001: 193: 'Posidippo, senza descrivere la scultura nel suo complesso, si sofferma esclusivamente sulla perfezione dei dettagli visibili nella pur piccolissima quadriga.'

[125] For the point, see especially Prioux 2007: 40 n. 62: 'Théodore...était cité parce qu'il préfigurait, par son *limae labor*, les qualités miniaturistes de la poésie alexandrine.'

[126] On epigram 9 A–B, see especially Kuttner 2005: 154–6, concluding that 'the story was widely proverbial, not just anecdotal' (155). For the collected ancient sources on the ring of Polycrates, see Pollitt 1990: 215–16, with discussion in Zwierlein-Diehl 2007: 9–10.

in miniature the various horse and rider statues of Posidippus' *Hippica* (described in poems 71–88 A–B), just as the Archaic sculptor foreshadows Posidippus' present poetic aesthetic.[127]

For ancient readers of his epigrams, Posidippus' emphasis on Theodorus' *miniature* artistry must have been especially striking. Theodorus of Samos was much more renowned for his grander works—among them, a giant silver crater holding over 4,000 gallons, dedicated by Croesus at Delphi (Hdt. 1.51, 3.41), a golden vine constructed for Darius I (Hdt. 7.27; Ath. 12.514), and a temple dedicated to Hera at Samos (so large as to receive the nickname 'labyrinth': Plin. *HN* 34.83 and cf. 36.90).[128] What seems to have interested Posidippus, by contrast, is Theodorus' capacity to craft *both* extremes of magnitude: his penchant for the large *and* the little, each within the other.[129] This explains Posidippus' emphasis on Theodorus' finely wrought chariot group—a miniature, as it were, on the grandest scale: despite (or rather because of) its size, Posidippus presents Theodorus' quadriga as the result of immense labour (ὅσος κάματος)—precisely the paradox that Pliny articulates, labelling the 'miracle of tininess' (*paruitatis... miraculum*) a work of great subtlety (*magna suptilitas*).[130]

In this context, as numerous scholars have now shown, there is an additional significance in the placement of Posidippus' poem on Theodorus. This (miniature epigram on a) miniature object is set directly before a poem evoking Chares' giant colossus of Rhodes (68 A–B). Chares' statue, in contrast to Theodorus', is so huge that it matches the magnitude of earth (γᾶς μεγ[έθει παρ]ισ[ῶ]ν, 68.6 A–B).[131] Theodorus' art—with its great labour, but diminutive scale—is exploited to play out a much larger Hellenistic concern with contrasting

[127] One might also note how poem 9 A–B, on Theodorus' seal ring, is itself prefigured by a gem engraved with an image that foreshadows the subject of the miniaturist statue described in 67 A–B—'an engraved chariot under him [*sc.* the emblem of Darius] which is spread out to the length of a span' (ἅρμα δ' ὑπ' αὐτὸν | γλυφθὲν ἐπὶ σπιθαμὴν μήκεος ἐκτέταται, 8.3–4 A–B).

[128] On the Temple of Hera at Samos, see Pollitt 1990: 181–2, described by Herodotus as 'the largest temple of all temples that I have seen' (Hdt. 3.60). As Kuttner 2005: 156 concludes, 'none could miss Posidippus' polemic for little poems like his own in AB 9 and 67, which choose to celebrate Theodorus' tiny things, not his colossal temple, images and vessels'.

[129] Cf. Hahn 2001: 252–3 n. 44 on Theodorus' grandest and littlest works as 'related feats of *techne*' (252).

[130] As Sens 2005: 224 rightly notes, comparing e.g. *Anth. Pal.* 7.11 (= Asclepiades 28 GP), κάματος refers both to the toil of the artist and to its material product—all the while labouring the parallel Callimachean literary aesthetic.

[131] On the antithesis, see Gutzwiller 2002b: 56–7: 'This pair of epigrams thus provides a progression from the miniaturization of Theodorus, to the human-sized statuary of Myron, to the colossal artistry of Chares' (57); Coleman (ed.) 2006: 19–21 (ad Mart. *Spect.* 2.1); Männlein-Robert 2007b: 72–4: 'beide Werke zeigten dann extreme Ausformungen in den technischen Möglichkeiten der Bronzekunst' (73); Prioux 2007: 122–3: 'De fait, les *andriantopoiika* juxtaposent deux épigrammes centrées sur la notion de mesure... La première oeuvre est si petite qu'elle pourrait être recouverte par "une mouche"... la seconde est au contraire si grande que sa taille peut être comparée à celle "de la terre"' (122); eadem 2008: 239–52.

opposites, themselves made to prefigure the metapoetic games of Posidippan epigram: the big in the small, and the small in the big.[132]

What, though, has all this to do with the *Tabulae Iliacae*? The evident *celebrity* of this Samian Theodorus (no less than the association of his *visual* arts with a *literary* programme of *leptotês*) should give us pause for thought: as ever with the tablets, there seems more to this detail than the unassuming inscriptions might lead us to think. The apparent signature might appear small—perhaps even trivial. But, to my mind, a tall tale of a grand artistic attribution is concealed behind the reference: for those who choose to pursue it, there could be a deliberate and knowing allusion to the small-scale craftsmanship of an Archaic Greek artist. Piotr Rypson suggested a similar association between the two figures, fancifully relating the 'labyrinths' of the 'magic square' inscriptions to Theodorus as the artist responsible for the 'labyrinth' at Samos.[133] My suggestion is different: that the name is planted as an onomastic riddle—causing us to think of a sculptor explicitly celebrated for his great reputation for small things.

The association between the Theodorus of the tablets and the Archaic artist helps us to make sense of one of the most puzzling but ignored aspects of all six inscribed signatures: their adjectival form.[134] So far in this book, I have generally referred to the artist or workshop by means of a simple proper noun: 'Theodorus'. If we look at the Greek of each and every surviving inscription, however, we instead find an archaizing possessive adjective, 'Theodorean': in each case, the reference is to a *technê* (Θεοδώρηος ἡ τέχνη: 1A, 2NY, 3C, 20Par) or Achillean shield (ἀσπὶς Ἀχιλλῆος Θεοδώρηος: 4N, cf. 5O) that concerns or pertains to Theodorus.[135] This is no simple signature, and, as far as I can tell, there is no epigraphic parallel for this use of the adjective instead of the usual nominative or genitive substantive—at least in comparable surviving artistic inscriptions, whether Greek or Latin.[136] Posidippus, on the other hand, now supplies an

[132] Of course, the great *size* of Chares' Rhodian colossus does not imply little labour: as Lucian has the statue on Rhodes declare, 'there is *technê* in me and precision of workmanship, even with my great size' (καὶ πρόσεστιν ἡ τέχνη καὶ τῆς ἐργασίας τὸ ἀκριβὲς ἐν μεγέθει τοσούτῳ, *J Tr.* 11).

[133] See Rypson 1986: 76, and cf. Ernst 1991: 392. Valenzuela Montenegro 2004: 350 n. 2061 is rightly sceptical of Rypson's argument: 'Diese Spekulationen sind an den Haaren herbeigezogen.'

[134] Cf. Sadurska 1964: 9 on 'cette façon de signer, étrange et exceptionnelle'. Ridgway 1990: 264 suggests that this 'adjectival form accompanied by *techne* . . . may suggest that he [*sc.* Theodorus] was the owner of a workshop rather than the actual carver'—but this is mere speculation.

[135] On this '"archaisierende" Tendenz', see Valenzuela Montenegro 2004: 352, who rightly points out 'Parallelen für dieses so genannte Zugehörigkeitsadjektiv finden sich dazu bei den Tragikern, Pindar und vor allem Homer'; on the significance of the 'ponderous adjective'; cf. Petrain 2006: 186–7. Needless to say, the archaizing form befits a (pseudo-)Archaic sculptor. In the case of tablets 1A, 2NY, 3C, 4N, and 20Par, moreover, the strange adjectival form is all the more conspicuous for being pitched against the genitive noun 'Homer'.

[136] I have found no comparable instance among the 'artist signatures' collected in Loewy 1885 (who touches on the tablets at 300–1, nos. 454–5); Toynbee 1951 (who does not mention the peculiar adjectival

unambiguous textual parallel for our little 'epi(c)thet', describing the 'great labour of the *Theodorean* hand' (τῆς Θεοδωρείης χειρὸς ὅσος κάματος).[137] As for the specific association with *technê* on the *Tabulae Iliacae*, this pairing is wholly in keeping with the intermedial play of the tablets: like Posidippus' handwritten epigram on Theodorean handicraft, the *Tabulae* are both sculpted artefacts and written poems. Indeed, it is perhaps significant that a fragment of Callimachus attests to this very collocation: an iambic poem on one of Pheidias' statues articulates precisely its 'Pheidian *technê*' (ἁ τέχνα δὲ Φειδία, frg. 196.1 Pf.), in a formulation that itself recalls the programmatic opening of Callimachus'*Aetia*.[138]

Posidippus' concern with the contrasting *extremes* of Theodorus' labour perfectly encapsulates the *Tabulae*'s larger aesthetic of the grand in the small (and the other way round). But the fact that Theodorus is known from epigram is in and of itself important. The tablets provide us with a game not only of size, but also of media: the scaled *visual* artifice that epigram had *verbally* celebrated is here inverted; we really can now see the *technê* that epigram, as poem, could only describe.

PSEUDONYMS AND PEN NAMES

To be absolutely clear: I am of course not suggesting that the Theodorus of our tablets was in fact the *same* artist as the one responsible for the famous self-portrait, golden vine, or seal ring; there is an obvious historical discrepancy between those Archaic artistic creations and our early Imperial objects. Who this Archaic artist 'really' was—or indeed, whether he really existed—is, for our purposes, unimportant.[139] Given the stories that evidently grew up around

'Theodorean form', 22); Guarducci 1974: 377–561; or Calabi Limentani 1958: 151–80. Nor is there any similar artist adjectival inscription surviving from Rome (at least none catalogued in *IGUR* 4: 1–116, nos. 1491–656).

[137] I owe the term 'epi(c)thet' to Martin Dinter (cf. Dinter 2005: 156 on 'epi(c)gram'). On Posidippus' adjective, see Bastianini and Gallazzi 2001: 193, who compare poem 70.3–4 A–B ([χ]ειρῶν | τῶν Λυσιππε[ίων]), and note that the form was already attested in association with a fourth- or third-century atheist philosopher.

[138] For the comparison between the Callimachus fragment and the *Tabulae* formulation, see Porter forthcoming; for Callimachus' knowing metapoetics, see I. Petrovic 2006: 32–3. There are numerous Latin comparanda for artists' names turned into heroic-sounding adjectives: e.g. Prop. 1.2.22 (*Apelleis...tabulis*); Stat. *Silv.* 2.2.63–72 (*Apellei...colores*; *Phidiacae...manus*; *Polycliteo...caelo*); ibid. 5.1.4–6 (*Apelleo...colore*; *Phidiaca...manu*); or indeed the hidden 'Apellean' reference within the third poem of Optatian Porphyry poem cited above (p. 221 n. 56). In terms of epigraphic material, I know of at least two parallels for this use of the noun *technê* within an artistic signature, but both accompany genitive nouns, not adjectives (Loewy 1885: 257, no. 363; 273, no. 393; cf. Burford 1972: 210–18).

[139] Although Pausanias knew of the sculptor, he declares he has seen no surviving work by Theodorus, 'at least in bronze' (Paus. 10.38.6–7).

Theodorus, at least by the third century BC, my tentative suggestion is that the *Tabulae* allude to a 'Theodorean *technê*' that at least some viewers and readers could associate with the earlier artist. The tablets lay claim to an intermedial *technê* of scale that is expressly descended from the poetic celebration of Theodorus' ancient handiwork: as a boasting retort to the Homeric subjects depicted—a pseudo-manifesto of style—the 'Theodorean' adjective serves a descriptive as well as (pseudo-)identificatory function.

This 'pseudonymous' attribution is a small detail in my overall argument—about the sophistication of the tablets, their intermedial play, and the aesthetic of *leptotês*. If I am right, however, the implications are enormous. When classical archaeologists deal with artistic 'signatures', they tend always to take them at face value—as articulations of 'real' identities. But my hypothesis about 'Theodorean *technê*' suggests that attributions might hold hermeneutic significance in and of themselves: Greek and Roman art engages with the same sorts of 'name games' rife in so many other areas of Greek and Roman culture.[140]

So what kind of parallels are there for this sort of artistic alias in the Greek and Roman world? We touched upon one (arguably no less self-conscious) pen name at the end of the second chapter: the anecdote about Parrhasius and Mys, renowned for crafting the shield of the Athena Promachos, but mischievously appropriated as the artists-cum-epigrammatists behind a very different grand-cum-small, visual-cum-verbal project (Ath. II.782b: see pp. 83–5). Once we begin looking for them, though, we find numerous artists working under make-believe identities, and as early as in Late Archaic and Classical Greece. Take Attic vase painting.[141] Given the evident Athenian celebrity of the early Classical mural painter Polygnotus (originally from Thasos), it is significant that three different red-figure vase painters appear to have signed their work with this single name.[142] Likewise, the Cartellino Painter labels five of his vases with the title 'Douris', although it is evident that both painting and inscription are by a different Late Archaic vase painter—a knowing and deliberate allusion to a more sought-after artist? Rather mischievously, we find the same 'Douris' name appearing on two further vases, again markedly distinct in style from Douris' regular hand, and usually attributed to the Triptolemus Painter (working at the

[140] For one very early instance of such onomastic play, see above, p. 85 n. 171 on 'Nestor's cup'. More generally on artistic agency in the Roman world, cf. Squire forthcoming b. In terms of literary exempla, compare e.g. Henderson 2001: 95–118 on Phaedrus 5.7, with its recourse to 'Princeps' as an euphemous 'stage name' for an artiste.

[141] For two good introductions to the forged 'identities' of Archaic and Early Classical Greek vase painters, see Keuls 1997: 283–92 and Neer 2002: 87–134. Sincere thanks to Georg Gerleigner for his help here.

[142] See Matheson 1995: 3. The literary sources for the mural painter are discussed by Pollitt 1990: 126–41.

height of Douris' popularity).[143] 'It is hard to imagine that an artist as good as the Triptolemos Painter needed to forge Douris' signature in order to sell his own work,' Diana Buitron-Oliver writes; 'it seems more likely that he was teasing, and that in this sophisticated, late archaic world there might have been a certain cachet in owning such a "forgery".'[144]

As for the later Greek and Roman worlds, it is clear that subsequent artists also exploited 'signatures' for related interpretive effect. One example is the pair of silver cups from near Hoby, already introduced in the second chapter (Figs. 26, 137). Both cups are in fact signed by a single artist named 'Cheirisophos', the one in Greek characters (*XEIPIΣOΦOΣ EΠOIEI* —written above a sleeping Greek soldier), the other in the Roman alphabet (CHIRISOPHOS EPOI—to the left of the reclining Philoctetes (Fig. 138)). The name is usually taken at face value, referring to a 'Greek working in the west for a Roman patron'.[145] But whatever the 'real' artist (*cheirotechnês*) it is worth taking the title literally—as a boast by someone 'clever' (*sophos*) with his 'hands' (*cheires*).[146] The claim to *sophia* returns us, of course, to the epigrams of tablets 1A and 2NY, which parade a combined visual–verbal 'wisdom' in similar manner (above, pp. 102–21); by extension, the reference to 'hands' encompasses both a literary and an artistic dimension, following a standard pun of Greek ecphrastic epigram.[147] As on the *Tabulae*, the 'cleverly handled' Cheirisophian ascription works on a variety of different levels: the *sophia* lies not just in the translation of *epos*-style *poiêsis* into 'made' epic pictures (*EΠOIEI*, *EPOI*), but also in the downsizing of hefty epic themes into such finely crafted cups (themselves summed up in this miniature trademark name). There is an additional twist in the translation of the Greek script on one

[143] For the Cartellino Painter vases, see *ARV²* 1.452, nos. 1–5; on the Triptolemos Painter vases, see Beazley 1945: 41–2 on *ARV²* 1.365, no. 59, along with Immerwahr 1990: 86 and Buitron-Oliver 1995: 1–2.

[144] Ibid. 2.

[145] Toynbee 1951: 52. Cf. D. E. E. Kleiner 1992: 109; C. W. Müller 1994: 341; Naumann-Steckner 2007: 296–7; E. U. R. Thomas 2007: 333–4; Marvin 2008: 183–6. For the independent argument that 'der für das ikonographische Konzept Verantwortliche . . . ein gebildeter Mann gewesen sein [muß]', see C. W. Müller 1994: 349. The name 'Silius' was written underneath each cup, probably referring to the owner.

[146] Such puns on artists' names were *de rigueur* by the first century AD. For some fleeting examples, see e.g. Elsner 2007a: 183–4 (for possible puns on 'Protogenes', 'Apelles', and 'Zeuxis' in Petron. *Sat.* 83.1–2, cf. below, p. 302 n. 172 on *Sat.* 50). One of my favourite examples are the make-believe fruits of Possis ('Mr Could-You?')—moulded so convincingly that 'you could' not distinguish them by their appearance from the real thing (*ut non posses aspectu discernere a ueris*, Plin. *HN* 35.155).

[147] Hellenistic epigrams on artworks frequently draw attention to the 'hand' of the artist, whether labelling it as 'cunning' (δαιδαλέη χείρ, *Anth. Pal.* 9.826.1), 'delicate' (ἐξ ἀταλᾶν χειρῶν, *Anth. Pal.* 6.352.1), or 'bold' (θαρσ]αλέα χείρ, Posid. 65.1 A–B). The same holds true for the poems on Myron's cow (e.g. Posid. 66.3 A–B, *Anth. Pal.* 9.716.2, 726.2, and Auson. 72.4), and indeed the conceit is a mainstay of Posidippus' *Lithica* and *Andriantopoeica* at large (in addition to Posid. 65.1 A–B and 66.3, see e.g. 7.3, 9.3, 14.2, 62.3, 67.2,4, 70.3). In each case, the 'hand' of the artist crafting an image with chisel or brush mirrors that of the poet crafting the poetic picture with his stylus.

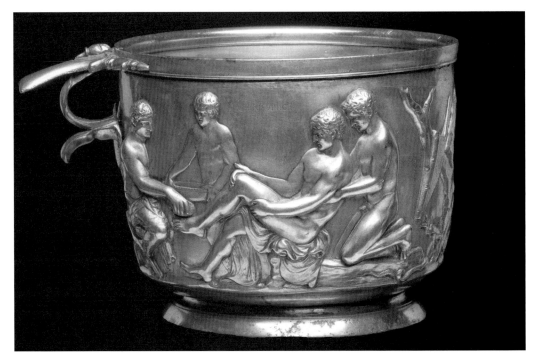

FIGURE 137. Silver 'Hoby cup' of the healing of Philoctetes' foot, first century BC (Dnf. 9/20; height: 10.6 cm; diameter: 13.5 cm).

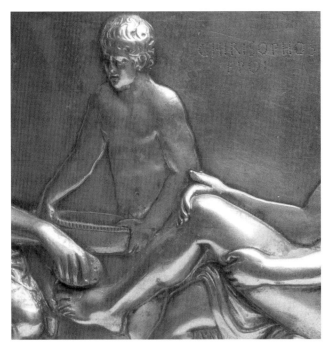

FIGURE 138. Detail of the 'Chirisophos epoi' inscription.

cup into the Latin alphabet of the other, reminding us that part of the *sophia* lay not only in the pairing of different themes, but also in the contemporary Roman relevance of the Greek myth.[148] In this connection, the hand-crafted touch of setting the name 'Chirisophos' beside Machaon—the doctor who extends his *own* hands over Philoctetes' pus-ridden foot—should not go unnoticed: the *sophia* of our artist is also assimilated with the healing hands of the prototypical 'chiropodist'. Nifty in his handling, this Cheirisophos. What to make of that handling, though, now lies in the hands of the drinking viewer: can our nifty interpretive handiwork match the *sophia* of the artist's hands?[149]

The name 'Cheirisophos' does not seem to allude to a famed craftsman in the way that the earlier 'Douris' or 'Polygnotus' signatures seem to have done.[150] But other contemporary artists certainly did stake such a claim. We know of some five 'Myrons' working in Imperial Italy, for instance, all of them apparently distinct from their more famous fifth-century Athenian namesake;[151] we also know of at least one 'Praxiteles' working in Imperial Athens.[152] Still more puzzling is a certain 'Phidias' who signs a marble statue of Thoth set up in the Campus Martius in the second century AD (Fig. 139), and who claims paternal descent, along with his purported 'brother' Ammonius, from yet another person of the same

[148] Cf. C. W. Müller 1994: 341–5 on the supposed association between Achilles and the *princeps*—reflected in a 'Moment artifizieller Verspieltheit' (341), whereby the Greek is transliterated into Latin.

[149] For an overview of other inscriptions on Roman silverware, see Naumann-Steckner 2007. Worth comparing too is Mart. 8.51—a laboured epigram on the labour of identifying the hands labouring behind Roman tableware ('Whose work is in this cup? Is it that of learned Mys or Myron? Is this the hand of Mentor, or rather yours, Polyclitus?', *Quis labor in phiala? docti Myos anne Myronos? | mentoris haec manus est an, Polyclite, tua?*, vv. 1–2).

[150] It might nevertheless be noted that we know of at least one other sculptor named 'Cheirisophos' from Archaic Crete (cf. *KLA* 1: 136, s.v. 'Cheirisophos (I)', derived from Paus. 8.53.7). In what follows, I have based research upon the catalogues of Greek artist inscriptions collected in Loewy 1885 and Marcadé 1953–7. Toynbee 1951 is the best survey of Roman artistic signatures, supplemented now by E. U. R. Thomas 2007 (unaware, it seems, of Toynbee's earlier survey); cf. also Guarducci 1974: 377–561; Calabi Limentani 1958: 151–180; Burford 1972: 208–11; *IGUR* 4: 1–116, nos. 1491–656. All of the examples discussed have further references in *KLA*: needless to say, many more instances might have been cited.

[151] Cf. P. Stewart 2008: 22–3. For a 'Myron' from Verona, see *AE* 1998: 591 (with Buonopane 1998); on a 'Myron' who had attributed to him an early Imperial marble bust probably from Palestrina, see *CIL* 6.29796, with Loewy 1885: 319, no. 488a; for 'Myron' as a painter in Anzio, see *CIL* 10.6638, with Calabi Limentani 1958: 156, no. 34; cf. also *IGUR* 4: 75–7, nos. 1578–9 for two more possible 'Myrons' working in Rome, in addition to a second-century BC 'Myron' working on Delos (Marcadé 1953–7: 2.78). Other artists claimed to be the 'sons of Myron', including a first-century artist working on Delos (see Loewy 1885: 183–5, nos. 252–5; cf. also ibid. 284, no. 417, from Athens).

[152] On this 'Praxiteles', see Loewy 1885: 228–9, nos. 318, 319). Compare references to 'sons of Praxiteles'—both in Herodas (*Mim.* 4.23–4) and in surviving epigraphic culture (cf. Loewy 1885: 379–80, nos. 555–6). The use of such celebrated patronymics was clearly widespread: in addition to Cephisidotus and Timarchus, who both claim to be 'sons of Praxiteles', Marcadé 1953–7 lists an 'Aristandrus, son of Scopas', a 'Hephaestion, son of Myron', and a 'Phyles, son of Polygnotus'.

name.[153] Of course, there were clearly 'dynasties' of craftsmen in both the Greek and Roman worlds, handing down their skills from one generation to the next, all the while preserving a common family name: Andrew Stewart has even argued that we can trace a clan of artists working under the name 'Praxiteles' almost continuously from *c.*400 BC until the end of the first millennium BC.[154] But since we know of these 'artists' *only* through their 'signatures', we should be wary of reconstructing too straightforward a history. The statue of Thoth by 'Phidias' and 'Ammonius', part of a larger installation of Egyptianizing sculptures, demonstrates the point only too well: any viewer with even a smattering of art historical knowledge must have appreciated the irony—and its potential cultural (or indeed cultic) implications for the Eastern-looking statue at hand.

FIGURE 139. Statue of Thoth signed (on the left-hand lateral side) by 'Phidias' and 'Ammonius', second century AD (Musei Vaticani: Museo Gregoriano Egizio inv. 34).

[153] See *CIL* 6.857 (with Loewy 1885: 267–8, no. 382, *IGUR* 4: 82–4, no. 1588, and P. Stewart 2008: 22). For the Iseum Campense in Rome where the statue was erected, see Roullet 1972: 23–35 (listing this statue at 125, no. 245).
[154] See A. Stewart 1979: 101–14 (especially 102–3, with appendix at 157–74); cf. Toynbee 1951: 19–20; Ling 2000: 91–2; P. Stewart 2008: 30–1.

That artists could take on false or misleading identities is also clear from literary texts. As Phaedrus relates in his *Fables*, there could be a financial incentive in doing so (5 praef. 4–9):[155]

> ut quidam artifices nostro faciunt saeculo,
> qui pretium operibus maius inueniunt nouis,
> si marmori adscripserunt Praxitelen scabro,
> trito Myronem argento, tabulae Zeuxidem.
> adeo fucatae plus uetustati fauet
> inuidia mordax quam bonis praesentibus.

… just as certain artists do these days: they get a better price for their new works if they write 'Praxiteles' on their rough marble, 'Myron' on the worn silver, 'Zeuxis' on a painting. So much does biting envy privilege counterfeit age over the goods at hand.

As long as customers strove to possess an authentic 'Praxiteles', 'Myron', or 'Zeuxis', it seems, artists stood to gain from assuming the identities of their more celebrated forebears: forged 'antiques' are to be preferred over 'present goods/virtues' (*bonis praesentibus*). Phaedrus is writing within a few decades of the *Tabulae Iliacae*. Admittedly, his comments on artistic signatures are in one sense rather different from my suggestion about the appropriated 'Theodorean' pen name: there is no way of knowing whether the *Tabulae* feign to be antique objects in the manner of Phaedrus' complaint. But the tablets' association with 'Theodorean *technê*' arguably carried a related sort of hermeneutic significance: this intriguing Archaic ascription invited audiences to view the present objects in terms of the legendary artistic creations of the past; to approach this mini-conceit of artistic agency, moreover, as part and parcel of their overarching *technê*—their receding fictions as words turned into images, images turned back into words, and small objects derived from big names. Not even the artistic attribution can be taken at its word.

That artistic signatures could be harnessed for this sort of playful effect is evident from all manner of other artistic media.[156] But it is especially clear

[155] The source is discussed by Mustilli 1960: 578–9 and noted by Loewy 1885: 319, in association with no. 488a: Loewy further compares Zenobius 5.82, attesting that 'many other artists sign their works with another name' (καὶ ἄλλοι γὰρ πολλοὶ ἐπὶ τῶν οἰκείων ἔργων ἕτερον ἐπιγεγράφασιν ὄνομα). On the context of Phaedrus' proem, which introduces Aesop as a sort of literary 'designer label' of its own, see Henderson 2001: 151–62, especially 153.

[156] For one tentative example from the realm of Roman wall painting—in fact, the only surviving painter inscription from Pompeii (*CIL* 4.7535)—cf. Platt 2002a: 101–5, on the signed painting in the Casa di Octavius Quartio, Pompeii II.2.2 ('Lucius the painter has trapped us, as Apuleius's Lucius, in a dialectic between seeing and being seen', 103). More credible, perhaps, is Wyler 2006: 216 on the 'Seleukos' signature in cubiculum d of the Villa Farnesina, suggesting that the ascription is deliberately 'fake', 'made up in order to emphasize the quality of the workshop and therefore the taste and wealth of the owner'.

from the inscriptions engraved on Greek and Roman intaglios.[157] Although
Gisela Richter could list the titles of only seven engravers mentioned in ancient
literary sources (at least before the 2001 publication of Posidippus' *Lithica*),
extant gem signatures preserve over 60 names.[158] What is particularly fascinating
about these signatures is the way in which so many are derived from famous
sculptors and painters. We find Hellenistic and Roman gem cutters claiming to
be the Michelangelo or van Gogh of their day—'Sostratus',[159] 'Phidias',[160]
'Scopas',[161] 'Polyclitus',[162] 'Pamphilus';[163] in one case, we even find an engraver
who calls himself after the mythical Daedalus—laying claim to the ultimate in
artistic innovation (Fig. 140).[164] Other engravers assumed the names of the most
celebrated artists working in their medium. One amethyst, for example, appar-
ently associated its maker with Apollonides, the famous third-century BC
engraver (Plin. *HN* 37.8), even though the gem was crafted at a considerably
later date (and indeed inscribed in Latin letters).[165]

[157] For a basic survey of intaglio artist inscriptions, with a pertinent warning about modern forgeries,
see Richter 1956: xxxi–xli, who identifies 6 Archaic Greek, 7 Classical, 16 Hellenistic, and 39 Roman
engravers; cf. eadem 1968: 14–19 (on 'Greek' gems) and 1971: 129–35 (on 'Roman' gems); Guarducci
1974: 515–30; Zazoff 1983: 439–40 (an index of signatures); Zwierlein-Diehl 2005 and 2007: 549–50
(another index of signatures). Vollenweider 1966 provides the most detailed analysis of signed Late
Republican and Augustan gems, with a helpful index of signatures at 139–41.

[158] See Richter 1956: 34; Zwierlein-Diehl 2007: 549–50 lists eight names known from literary sources
and 58 surviving signatures.

[159] See Vollenweider 1966: 32–6: in addition to two signed fragments of sardonyx in Naples, there is a
signed white onyx cameo in the British Museum; cf. Richter 1971: 149–50, nos. 700–4; Zwierlein-Diehl
2007: 112–13 (with Abb. 439–41).

[160] See Richter 1968: 139–40, no. 531, on a jacinth ringstone in the British Museum; cf. Plantzos 1999:
120, no. 197; Zazoff 1983: 206 n. 76.

[161] See Vollenweider 1966: 26–7, on a signed first-century jacinth ringstone once held in the Arch-
äologisches Institut der Universität Leipzig; cf. Richter 1968: 168, no. 676; Plantzos 1999: 133, no. 618;
Zwierlein-Diehl 2007: 123 (with Abb. 485).

[162] See Richter 1971: 147, no. 688, on a lost Carnelian intaglio; cf. Zwierlein-Diehl 2007: 266 (with Abb.
863).

[163] See Vollenweider 1966: 27, on two amethysts in the Cabinet des Médailles, Paris; cf. Richter 1971:
146–7, nos. 686–7; Plantzos 1999: 129, no. 470; Zwierlein-Diehl 2007: 110 (with Abb. 428).

[164] See Richter 1968: 168, no. 675, on a (?) third-century BC garnet ringstone in Paris signed
ΔΑΙΔΑΛΟΣ; cf. Vollenweider 1974: 1.71–2; Zazoff 1983: 207 n. 86; Plantzos 1999: 133, no. 611; Platt
2006: 244; Zwierlein-Diehl 2007: 108 (with bibliography under Abb. 427).

[165] Cf. Richter 1973–4: 632–3, rather prosaically concluding that, although 'evidently ancient', 'the name
is that of the owner of the stone' (633). For the gem, representing the head of a silenos, and housed in the
British Museum, see Walters 1926: 171, no. 1570. Such playful pseudonyms should also make us wary of
straightforwardly attributing a sardonyx cameo signed by Tryphon to the celebrated gem cutter of *Anth.
Pal.* 9.544 (Adaeus IX G–P): see Vollenweider 1966: 36–7, Richter 1971: 150, no. 706, and Zwierlein-Diehl
2007: 113 (with Abb. 442) on MFA Boston no. 99.101. As for the authenticity of gems like these, I can only
bow to the expert opinion of the scholars cited: there can be little doubt that most if not all the gems and
their inscriptions are genuinely ancient.

FIGURE 140. Garnet ring stone in Paris, with 'Daidalos' inscription, probably early second century BC; height 26 mm.

FIGURE 141. White and dark blue onyx ring stone of Heracles and Cerberus in Berlin, signed by 'Dioscurides'; (?) *c*.40–30 BC; height: 24.5 mm.

FIGURE 142. Crystal gem (convex on both sides) with a bust of Athena in Berlin, signed by Eutyches 'the son of Dioscurides'; (?) *c*.20–10 BC; height: 37 mm.

Such playful *noms de plume* should probably make us suspicious of other more 'believable' gem and sealstone signatures. Whether or not the surviving intaglios signed by 'Dioscurides' have anything to do with the famous artist responsible for the Emperor Augustus' 'official' seal ring (e.g. Fig. 141),[166] it is surely significant that no fewer than three subsequent gem cutters claimed 'Dioscurides' as their 'father' (e.g. Fig. 142, inscribed with the words *EYTYXHΣ* | *ΔΙΟΣΚΟΥΡΙΔΟΥ* | *ΑΙΓΕΑΙΟΣ ΕΠΟΙ* | *ΕΙ* —'Eutyches, son of Dioscurides, the Aegean, made it').[167] As on the *Tabulae*, these inscriptions did not just convey a claim about authorship. They also amount to a boast of ancestral skill: of *technê*. As such, the signatures change *how* we make sense of the images seen. In the case of sealstones, moreover, these games of authorial attribution are themselves framed by the fictions of replication that inhere in the medium—the carefully forged gem as itself the source for an infinite number of further 'forged' impressions in wax. Every stamp plays out the fiction, distancing duplication from original, while giving the impression that that the copy is the prototype. Such little forgeries of artistic agency replicate still larger (dis)simulations of form, appearance, and facture.[168]

CONCLUSION: THE FICTIONS OF *TECHNÊ*

One does not have to accept this 'pen name' argument to appreciate the over-arching argument of this chapter. Size evidently mattered to the tablets. What is more, the issue of scale at once encapsulates and expands the tablets' intermedial

[166] Cf. Plin. *HN* 37.8 and Suet. *Aug.* 50: for discussion of the surviving gems signed by 'Dioscurides', see Vollenweider 1966: 56–64 (of the five discussed at least three are genuine); Richter 1971: 142–4, nos. 664–73, 162, no. 758; Henig (ed.) 1994: 91–2, no. 165; Plantzos 1999: 96–7 (with inventory at. 96 n. 238); Zwierlein-Diehl 2007: 117–19. For bibliography on Fig. 141 specifically, inscribed with the word *ΔΙΟΣΚΟΥΡΙΔΟΥ*, see Zazoff 1983: 316 n. 61 and Zwierlein-Diehl 2007: Abb. 462a: note the potential ambiguity of the objective/subjective genitive form, at once claiming 'Dioscurides' as craftsman and boasting a stylistic or paternal relationship with him (as in the supposed patronymic of Fig. 142).

[167] See Vollenweider 1966: 65–73, on 'Herophilus', 'Eutyches', and 'Hyllus'. Vollenweider simply concludes in favour of a workshop originating with Dioscurides: 'Der aus Aigai stammende Künstler hat in Rom eine Werkstatt, ja, eine Dynastie von Steinschneidern gegründet...Sie haben wahrscheinlich zusammen die Werkstatt ihres Vaters weitergeführt und sind im Dienste der kaiserlichen Familie geblie-ben' (64, 65); cf. Plantzos 1999: 96 n. 238: 'Dioskourides' three sons...were also gem-cutters and made sure to point out their inheritance in their signatures'; Zwierlein-Diehl 2005: 339–41 and 2007: 119–22 (together with Abb. 468). For these and other Roman stonecutters, see Zazoff 1983: 316–23 (with collected bibliography on Fig. 142 at 317–18 n. 71).

[168] Cf. Platt 2006: 243–4: 'Such consciousness of the original presence of the "artist"...reminds the viewer of each impression of its direct relationship to the "original" object, encouraging him or her to remain "medium aware".'

mode of synopsis, presented for our visual delight no less than our reading pleasure.

As for my Theodorean theory, there will of course be sceptics: let me repeat that Theodorus was an exceedingly common name. As ever, though, the question must be about *how* the tablets play their name game: my suggestion is that these objects hold the knowing potential for this level of micro-interpretation; and yet, anticipating a rival perspective, they simultaneously allow audiences to dismiss the speculative detail (i.e. to see it as 'excessively grand', 'overblown', 'out of all proportion'). In more practical terms, the idea of a *nom de plume* has much to recommend it. Quite apart from accounting for the adjectival form 'Theodorean', the celebrity of 'Theodorus' helps to explain the familiarity and renown that the tablets assume, pitching 'Theodorean *technê*' against Homeric epic itself (on 1A, 2NY, 3C, 20Par), even equating 'Theodorean *technê*' with the 'Achillean shield' (on 4N, 5O).[169] On the level of iconography and epigraphy, moreover, the association helps to make sense of the stylistic diversity of inscriptions and images that are usually attributed to a single artist or workshop. While, as we saw in the second chapter, Anna Sadurska has taken the inscriptions literally, assigning all of the 'Theodorean'-inscribed tablets to one master artist,[170] Nina Valenzuela Montenegro has shown that even those signed with this 'Theodorean' attribution were in fact made by disparate hands. The diversity of styles and scripts means that—whatever their workshop organization—these tablets were crafted by different craftsmen, all of them working under a single onomastic banner.[171]

Quite how many audiences might have appreciated the witticism is impossible to say. Certainly, the reference seems to have been judged sufficiently droll to be repeated up to eight times, with the name always inscribed in the same adjectival form, and most often in visual–verbal 'magic square' diagram (a clue to the forged message lying in the artifice of the medium?). As such, the *grammata* of the signature constitute a complementary countdown conundrum—still more microscopic minutiae for viewer-readers to ponder upon, should they so desire

[169] Cf. Kazansky 1997: 57: 'The name of Theodorus appears first, followed in the same line by that of Homer [in the Capitoline epigram]. If he had been a little-known artist he would hardly been [*sic*] given equal prominence with Homer; it stands to reason that Theodorus' fame must have been comparable to Homer's.' But there is no evidence for Kazansky's rival interpretation that Theodorus was a celebrated *mosaicist*: see above, pp. 249–50. For the 'Achillean' adjective on tablets 4N and 5O, see above, p. 208 n. 22.

[170] See above, p. 55 on Sadurska 1964: 10–15; Sadurska had earlier concluded (1959: 123) that 'le Théodoros qui exécutait les premières tables iliaques lui-même a engagé, après sa réussite, quelques artisans'.

[171] See Valenzuela Montenegro 2004: 298–304, noting the differences between tablets 1A and 3C in particular: 'Dass die Tafeln mit der Signatur alle von einer Hand stammen, wie Sadurska sagt, ist m. E. unplausibel . . . Deshalb ist anzunehmen, dass in der Werkstatt des Theodoros verschiedene, mehr oder minder befähigte Künstler arbeiteten' (300, 302); cf. Bua 1971: 13–14. In fact Bienkowski 1891: 201 had articulated a similar conclusion over a century earlier, on the basis of tablets 4N and 5O.

('glide whichever way you choose'). 'Trimalchio' might not have got the joke; rather, I suspect, Petronius would have milked Trimalchio's 'uneducated' reaction for some wholly clever comic effect—catering to those elite readers who *were* in the know.[172] In any case, it is by now clear that these recherché tablets cater to a more self-critical class of reader-cum-viewer: however small in size, they are much grander in cultural, literary, and intellectual scope.

How very like the *Tabulae* to exploit authorship to stage yet another charade of *technê*. The tablets, we have said, are visual–verbal objects in which images belie words, and words belie images; in each case, the fictions of medium are sutured over the fictions of scale. Small visual appearances signify big verbal texts: there is always more than meets the eye. So too with their attribution. The unassuming detail is just one further feature which, depending on perspective, contains the capacity to bear macroscopic significance. The stories lie in *your* hands: come figure.

[172] In this capacity, note how Trimalchio is made to embark on one such name game during the course of his dinner party (Petron. *Sat.* 50; cf. Sen. *Tranq.* 1.7). His bronze cups, Trimalchio explains, are genuinely 'Corinthian'. Yet this is not because the cups are imported from Corinth, but rather because Trimalchio's dealer is named 'Corinthus': 'for what betokens "Corinthian" unless one has a "Corinthus"?' (*quid est autem Corintheum, nisi quis Corinthum habet?*). If the etymological play reminds of the 'clever-handed' Cheirisophos (Fig. 138), it also recalls the word games of the Iliac tablets at large, which were also likely enjoyed in a related cena context.

Ecphrastic Circles

One of the overarching theses of this book is that the Iliac tablets play with a combined literary and artistic tradition of contemplating mediality, synopsis, and scale. The macroscopic games played out by these microscopic objects resonate against both visual and verbal precedents. Indeed, the *Tabulae Iliacae* knowingly and self-consciously invite us to cross-question this dichotomy in the first place.

The earliest and grandest precedent for these intellectual games, though, comes in Homer's *Iliad* itself. In the eighteenth book, the poet embarks on a grand description of the armour that Hephaestus forges for Achilles, focussing on a shield (*Il.* 18.478–608).[1] This 'great and mighty shield' (σάκος μέγα τε στιβαρόν τε, 18.478, 609), evoked in some 130 lines of text, came to epitomize a dynamic both of intermediality (text as image and image as text), and of scale (the big in the small and the small in the big): on the one hand, the passage constituted the prototypical verbal representation of a visual object, the 'touchstone for ekphrasis in ancient Greek and Latin literature';[2] on the other, this image-turned-text was seen (or rather read) to encapsulate not only the whole poem, but also the whole cosmos in its *retournelle* rings. As a self-contained representation of the cosmos, circumscribed around the shield, and circling from images to words, the description presented the ultimate in synopsis: it constituted a model of replication that itself came in for endless copying in the Greek and Roman cultural imaginary.

Given their closely related concerns, it should come as no surprise that a number of our tablets engage with this Homeric passage directly. While some surviving fragments incorporated the subject within their overall compositional scheme (tablets 1A, 6B, 13Ta, 20Par), two surviving objects substantiate the very

[1] For selective bibliography, see below p. 334 n. 71. Becker 1995: 51–77 surveys other descriptions of artworks in the *Iliad*. In this chapter, as throughout this book, I resist the miniature typographic distinction that has established itself (following Becker ibid. 3 n. 2), whereby '"Shield" refers to the Homeric description of the object, while "shield" refers to the imagined object itself'. This seems to me unhelpful: as we shall see, the two are interdependent—without the 'shield' there is no 'Shield', and without the 'Shield' there is no 'shield'.

[2] Ibid. 3.

shield that Homer described (tablets 4N, 5O): they literalized the Homeric literary description, turning words composed on an object back into an artefact itself—the 'great and mighty shield' marvellously materialized in miniature. The meta-ecphrastic complexity of these two tablets—their radiating recessions of representation—will boggle the mind of even the hardened sceptic: the two *Tabulae* offer a *material* encapsulation of the prototypical *literary* encapsulation of visual–verbal synthesis.

This penultimate chapter zooms in on tablets 4N and 5O, revealing them to embody and miniaturize all the arguments of the preceding pages. But my circumscription also zooms out beyond formal description. The tablets will take pivotal centre stage. In order to view and to read them, however, we have to run rings around their own encircling ideas of pictorial–poetic representation. As with the tablets themselves, there is an inevitable tension between descriptive commentary and conceptual contextualization: by turning to parallel images and texts, my aim is both to look closely at the two little tablets, and to read them against much larger discourses about mediation, replication, and emulation.

For this reason, I begin with what can be seen on the two fragmentary tablets, relating the images back to the Homeric textual prototype ('A shield fit for Achilles'). Like the five-layered shield of Achilles itself, the chapter then orbits around the shield tablets in five roundabout ways. First, I examine the larger literary reception of the Homeric description, showing how later Greek and Latin authors draw out ideas of ecphrastic replication already prefigured in the Homeric text ('Homeric ecphrasis: verbalizing the visual'). Second, I show how our two make-believe 'shields' knowingly turn around this ecphrastic tradition, visualizing the images that ecphrasis could only verbally circumscribe: where the *Iliad* evokes the shield and its images in words, our artefacts substantiate the forged poetic object, transforming text back into tangible tablet ('Ecphrasis in reverse: visualizing the verbal'). Third, I relate such medial play back to the tablets' games of scale, once again looking to contemporary literary comparanda ('The great and mighty shield?'). Fourth, I associate tablet 4N's marvellous conceits to its greatest marvel of all—the minuscule *grammata* inscribed around its recto rim, which further invert the tablet's inversions of medium and size, writing out the full ecphrastic text of the ecphrasized visual object ('Texts of images of texts of images'). Fifth and finally, I conclude with a further game of verbal ascription, latent in the graphic clues of the Theodorean attribution ('A final flip—and a "god-given" twist').

The tablets' circling conceits very much anticipate my own mode of ecphrastic circumlocution in this chapter. What takes me some 70 pages of text, however, the tablets make visible together and all at once. Such is their wondrous mode of visual-cum-verbal, gigantic-cum-miniature, all-encompassing synopsis: in a word, their *technê*.

A SHIELD FIT FOR ACHILLES

Let me begin with some basics: where tablets 4N and 5O were found, how they compare, and what they represent.[3] The two objects were discovered in Rome within a very short time of one another.[4] Although both tablets display orangey-pinkish hues, they are made of different materials: tablet 5O (Figs. 143–4) is carved from light pinkish palombino, while tablet 4N is composed of a more reddish stone (Figs. 145–6).[5] The two objects also differ in scale. Tablet 4N— which is considerably better preserved than tablet 5O—was the smaller of the two objects, at just 17.8 cm in original diameter and 1.29 kg in mass (2 lb 13.5 oz; the original weight must have been under 2 kg): like the other *Tabulae Iliacae*, it was both small and light enough to be passed around a room, fitting within a pair of hands, to be turned with only minimal effort.[6] The fragmentary state of tablet 5O

[3] On tablet 4N, the most detailed analysis still remains Bienkowski 1891; for further discussions, see Stuart Jones 1912: 172–5, no. 83a; Sadurska 1964: 43–6; Guarducci 1974: 430–2; Hardie 1985: 20–1; Amedick 1999: especially 159–69; Valenzuela Montenegro 2002: 78–9 and 2004: 239–49 (with further references collected at 239); Pasquariello 2004: 113–15; Bottini and Torelli (eds.) 2006: 244–5, no. 55. On tablet 5O, see Bienkowski 1891: 199; Stuart Jones 1912: 175–6, no. 83b; Sadurska 1964: 46–7; Amedick 1999; 180–2; Valenzuela Montenegro 2004: 250–1 (with further references collected at 250). This chapter passes over residual questions about whether these two tablets were 'copies' of some lost Alexandrian 'original' (cf. above, pp. 61–3): in the case of tablets 4N and 5O, the hypothesis dates back to Bienkowski 1891, developed by e.g. Fittschen 1973: 3 and especially Amedick 1999: 195–205 ('wahrscheinlicher ist es, daß diese Werkstatt den Schild des Achilleus vollständig nach einem Vorbild kopierte', 196). Two observations suffice. First, there are differences as well as similarities between tablets 4N and 5O (see below, p. 324), and both display a complex compositional relationship with tablet 6B (see below, pp. 357–8): this precludes any straightforward notion of 'copying'. Second, and still more importantly, the tablets play with the very theme of replication (by Hephaestus, Homer, the 'Theodorean' artist, etc.): speculation about the two tablets' 'origins' seems to have formed part of what it 'originally' meant to respond to them.

[4] Tablet 5O has no firm provenance, but preliminary reports indicate that it was found in Rome (and subsequently given to the Capitoline Museums by Augustino Castellani in 1874): see Bienkowski 1891: 198–9. Tablet 4N was discovered a little later in 1882, recycled within a mediaeval wall near the Basilica di Santa Maria della Vittoria on the Via Venti Settembre, and likewise handed over to the Capitoline Museums: ibid. 183–4, with 184 n. 1.

[5] In the absence of formal petrographic analysis, the stone is probably best identified as giallo antico: for the various identifications, see Amedick 1999: 159 n. 17. Bienkowski 1891: 185 and Lippold 1932: 1889 both specify giallo antico, but Sadurska 1964: 43 labels the stone 'pierre rouge Porta Santa' (without explanation); Valenzuela Montenegro 2004: 239 settles simply for 'weiß-roter Stein'. Whether giallo antico or porta santa, this was evidently a material of the highest quality and cost. But Sadurska's suggestion is surely mistaken. Admittedly, there are parallels in colour with certain porta santa exempla (with their 'Ähnlichkeit mit kaltem Roastbeef'—Mielsch 1985: 55!); the stone, however, does not display any of the typical variegations in colour: giallo antico offers much closer parallels (cf. e.g. Mielsch 1985: 56, no. 529).

[6] *Contra* Sadurska 1964: 46, who deems that the tablet functioned as an *oscillum* (cf. above, pp. 53–4, 69 n. 122): 'L'état de conservation de la table N, et particulièrement la ligne de cassure qui passe par le milieu supérieur du pourtour du bouclier, semblent indiquer que la table N était une sorte d'oscille. On pouvait avoir percé un trou à cet endroit, pour y passer une ficelle permettant de suspendre l'objet entre les colonnes d'un péristyle ou aux branches d'un arbre' (and cf. ibid. 47 on tablet 5O). I cannot see how the tablet's state of preservation offers any such indication: there is no piercing, and the considerable thickness and not insubstantial weight suggests against suspension from a single 'ficelle'. And why decorate an object (especially its outer rim) with such minute details if displayed in this distant manner?

FIGURE 143. Obverse of tablet 5O.

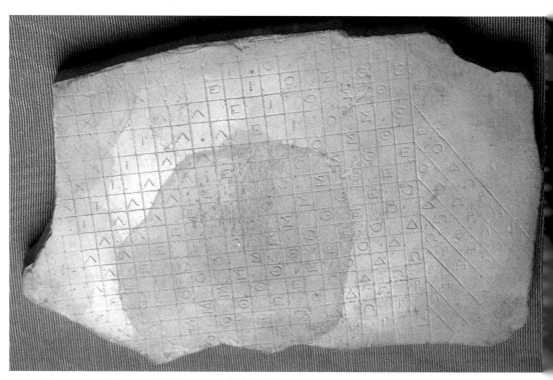

FIGURE 144. Reverse of a plaster cast of tablet 5O.

means that we cannot be sure of its original size, although it was certainly larger than tablet 4N: the surviving fragment measures 10 x 15.5 cm, and it probably had an original diameter of around 45 cm.[7]

As far as their compositions are concerned, both objects seem to have been made to related designs. Like tablet 4N, tablet 5O was almost certainly round in shape: this presumably explains why the letter diagrams on the reverse of both tablets are not square or lozenge (as on other, quadrangular tablets), but rather arranged into decorative patterns. As we noted in chapter 5, the 'magic square' of 5O is not square at all, but designed with 12 sides (Fig. 104), well suited to the tablet's circular surface area: proceeding from the central missing *alpha*, the *grammata* reveal a hidden caption for the object—'the Achillean shield: the *technê* is Theodorean' ([ἀσπὶς] Ἀχιλλεῖος Θεοδώρηος ἡ τ[έχνη]). The 614 inscribed boxes of tablet 4N contain a related message, although this time concealed in a hexameter and laid out in the figurative form of an altar (Fig. 145; cf. Fig. 105 for a drawing): 'the Achillean shield: Theodorean, after Homer' (ἀσπὶς Ἀχιλλῆος Θεοδώρηος καθ᾽ Ὅμηρον). Despite their different shapes, both reverse inscriptions confirm a close association with other *Tabulae Iliacae*: as we have said, seven tablets were inscribed with such diagrammatic texts on their verso (2NY, 3C, 4N, 5O, 7Ti, 15Ber, 20Par); the 'Theodorean' attribution of both tablets, moreover, establishes an additional connection with tablets 1A, 2NY, 3C, and 20Par.[8]

There is much more to be said about these 'magic squares', and about the one on tablet 4N in particular. The principle of arrangement is arguably much harder to grasp on this verso than on the others: there was evidently no epigrammatic instruction as to how to proceed (as on the reverse of tablets 2NY and 3C); in practical terms, moreover, the figurative arrangement of the letters (and the absence of empty squares between them) makes it rather more difficult to find the middle letter, and thereby to decode the picture. It was for this reason, perhaps, that the artist struck upon the idea of adding a second inscription

[7] Sadurska 1964: 47 reconstructs a diameter of *c*.40 cm; Valenzuela Montenegro 2004: 251 fancifully suggests that it could have been 80 cm ('m.E. ist es möglich, dass die Tafel sogar doppelt so groß war'). Sadurska and Valenzuela Montenegro derive their conjectures from comparison with the obverse of tablet 4N (see below, p. 324). But both overlook the more compelling evidence of the verso 'magic square' inscription (Figs. 104, 144). Given the likelihood of Bua's reconstruction, the total width of the 12-sided 'magic-square' would have been just under three times the total width of the surviving fragment (i.e. 3 x 15.5 cm). These general dimensions tally with what can be surmised about compositional relationship between the rectos of tablet 5O and 4N: although some two or three times the size of the ultra-mini tablet 4N, then, tablet 5O was probably not all that much larger than the other *Tabulae*.

[8] For the two verso 'magic square' inscriptions, and their relation to other examples, see above pp. 198–210, along with pp. 234–5 on tablet 4N's relation to figurative *technopaegnia*. On the 'Theodorean' attribution, and its significance, see above, pp. 283–302: we return to the theme below, pp. 367–70.

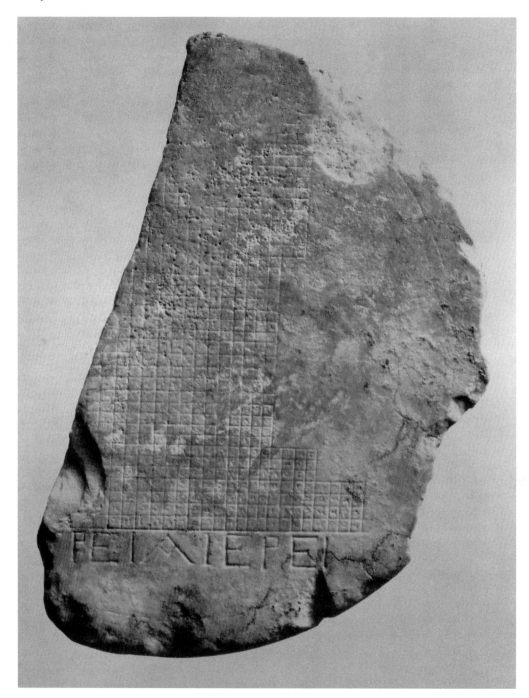

FIGURE 145. Reverse of tablet 4N.

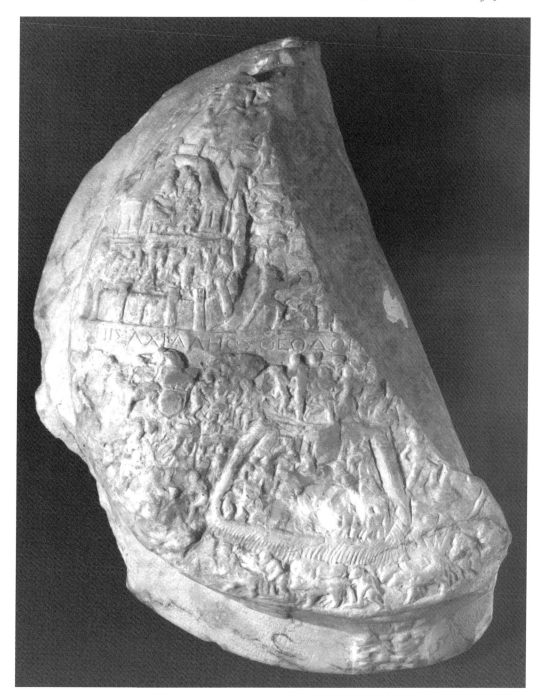

FIGURE 146. Obverse of tablet 4N.

below: *IEPEIAIEPEI*.[9] The text is most often interpreted as evidence for some votive function, as we mentioned in chapter 2: the letters *IEPEIAIEPEI* are thought to translate into the words 'priestess to the priest' (ἱέρεια ἱερεῖ)—a priestess, that is to say, dedicated this offering for or to a priest.[10] Gallavotti offers an ingenious parallel reading—which must remain at least plausible—whereby the tablet (or more properly its subject as described in the 'magic square' inscription above) 'will speak to the priestess' (ἱερείᾳ ἐρεῖ).[11] Whichever reading we choose to privilege, it is not necessary to take the palindrome at its word: neither this supposed 'dedicatory' inscription, nor indeed the 'altar' hexameter depicted above, provides straightforward evidence of a cultic context.[12] Whatever verbal sense we may or may not find in these letters, moreover, they provide a visual clue as to how to proceed with the picture puzzle above. Like the altar diagram of letters, this palindrome can be read from both right to left and from left to right.[13] Still more importantly, the graphic presentation offers a hint about the all-crucial *alpha* at the centre of the altar diagram above. Not only is the *alpha* of the palindrome inscription accentuated through its width (the largest of all the inscribed letters); the particular form of its crossbar, transformed into the shape of an upturned lozenge-shaped box, prefigures the conceit of the boxed rebus above. The grid that contains each individual *gramma* in the 'magic square' is itself here contained *within* the middle *gramma* of the palindrome text.

[9] There can be no doubting the reconstruction, as proposed by Bienkowski 1891: 201. For the inscription, see Sadurska 1964: 45 and Valenzuela Montenegro 2004: 349–50, as well as the discussion below, pp. 348–9, 369 n. 155.

[10] See especially Bienkowski 1891: 201; Sadurska 1964: 9, 18–19, 45; Horsfall 1979a: 32–3; Valenzuela Montenegro 2004: 349–50, 404 (with further references); Luz 2010: 189. It is surely more viable to understand ἱέρεια as ἱερεῖα (neuter plural rather than feminine singular): for the priest, at least, this is 'sacrificial stuff'.

[11] See Gallavotti 1989: 51 (with n. 7)—noting the 'speaking' Achillean shield of *Anth. Pal.* 9.116. Valenzuela Montenegro 2004: 349 consides this to be 'eine sehr interessante Idee'. Petrain 2006: 180 n. 102, on the other hand, comments on the 'intrinsic unlikelihood' of the reading, stating that 'the tablets do not customarily note iota subscript as required by Gallavotti's reading'. But the interpretation is very much in tune with the epigram's self-aware games with voice and vision: here, as elsewhere, the tablet is open to a multitude of different exegetic possibilities.

[12] See *contra* e.g. Bua 1971: 6, who labels the inscription 'forse come una dedica scherzosa'. Sadurska 1964 offers conflicting conclusions about the inscription: on the one hand, she suggests 'une teinte d'humeur'—namely, that 'cette "prêtrise" ne peut sans doute signifier autre chose qu'un titre d'honneur donné à des personnes des milieux aristocratiques romains, qui exerçaient ce genre de fonctions d'un caractère purement représentatif' (9); later, though, she concludes that 'elle prouve, me semble-t-il, que la table a été commandée pour être offerte à une personne définie qui assumait des fonctions sacerdotales... il prouve que l'objet était bien un cadeau' (45). My own suggestion is that the make-believe 'cultic' palindrome inscription, like the altar of *grammata* above, is part of a 'Theodorean' game with the Homeric 'gifts of the gods' (below, pp. 367–70).

[13] For related *uersus recurrentes* or *karkinoi stichoi*, see above, pp. 222–4.

As we turn tablet 4N over, the first thing we notice about the recto, as opposed to the verso, is its three-dimensionality: where the altar diagram and inscription were carved within a flat sculptural plane, the obverse exploits the full convex space of this make-believe object. It is not just that the imagery within the central circular field is rendered in greater sculptural depth; the area around and beneath that frame is also itself adorned with further figures and adornments. These three-dimensional details are not immediately visible head-on (and make the object exceedingly difficult to photograph). Rather, they emerge gradually as we look around the object, turning it in our hands, and inspecting its multilayered visual surface (e.g. Fig. 156).

So what can actually be seen? Beginning with the inner circular zone, the first thing to notice is a horizontal inscription, flexing its ways across the tablet's centre. The final letters of the inscription are missing, leading to two different reconstructions: either 'the Achillean shield: Theodorean, after Homer' (ἀσπὶς Ἀχιλλῆος Θεοδώρ[ηος καθ᾽ Ὅμηρον]), duplicating the hidden message of the verso,[14] or else 'the Achillean shield: the *technê* is Theodorean' (ἀσπὶς Ἀχιλλῆος Θεοδώρ[ηος ἡ τέχνη]).[15] Either way, the inscription has a visual as well as a verbal purpose: it cuts through the circular visual field to make two equally-sized sections, dividing the upper register from the lower band.

As for the iconographic composition of tablets 4N and 5O, this has received remarkably little commentary, virtually none of it in English.[16] I therefore begin with a more minute mode of analysis. Focussing on the better-surviving tablet 4N, my aim is to demonstrate how the pictorial details engage with the Homeric ecphrastic description. Because the pictorial composition plays with the poetic arrangement of the Iliadic text, it might be useful to lay out the Homeric description in tabular form (Table 4).[17] I should also say that the following close-up images combine photographs of the original tablet (Figs. 149, 151, together with Colour Plates VIII.10–XIII.16) with photographs of a plaster cast held in Göttingen (Figs. 150, 153–6, 167–9): the convex shape means that

[14] See Bienkowski 1891: 185, followed by Hardie 1985: 21.

[15] As suggested by Sadurska 1964: 45, on the basis of the verso inscription on tablet 5O. A final decision is impossible, but the spacing of the letters—with the delta of 'Theodorean' placed at the centre of the line, forming its seventeenth letter—makes Bienkowski's suggestion of 31 letters more convincing than Sadurska's supplement with 28 (cf. Valenzuela Montenegro 2004: 239–40).

[16] The only recent anglophone exception known to me is Hardie 1985: 20–1, along with the fleeting reference of Stansbury-O'Donnell 1995: 316.

[17] Of course, such a tabulated presentation is almost as artificial as the ecphrasized object from which it descends: the structure of the text is much more subtle about its interwoven connections—see Stanley 1993: especially 9–13, and below, pp. 334–7.

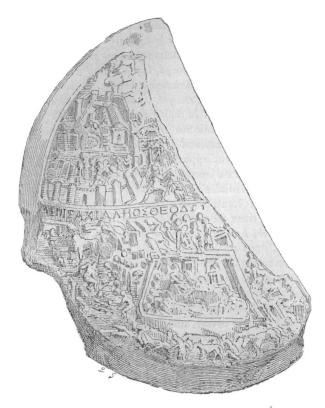

FIGURE 147. Drawing of the obverse of tablet 4N (commissioned by Étienne Michon, published 1899).

TABLE 4. Table detailing the structural framework of the Homeric description of the shield of Achilles (*Il.* 18.483–608), adapted from Byre 1992: 33–4.

The Homeric description of Achilles' shield (*Il.* 18.483–608)

1. Earth, sky, sea, sun, moon, and constellations (vv. 483–9)
2. Two cities:
 a. A city at peace: wedding processions with dancing and music, a lawsuit in the agora (vv. 490–508)
 b. A city at war: a siege, some inhabitants marching out to ambush their enemy's herdsmen, a battle (vv. 509–40)
3. A field being ploughed: the ploughmen are offered wine whenever they reach the end of the field (vv. 541–9)
4. A king's domain: labourers harvesting the crop, the king silently looking on, a meal being prepared (vv. 550–60)
5. A vineyard: young men and women gathering grapes to the accompaniment of a boy's music (vv. 561–72)
6. A herd of cattle: two lions attacking one of the bulls, herdsmen and their dogs pursuing them (vv. 573–86)
7. A sheep pasture (vv. 587–9)
8. A dancing floor filled with joyful dancers (vv. 590–606)
9. The Ocean around the shield's rim (vv. 607–8)

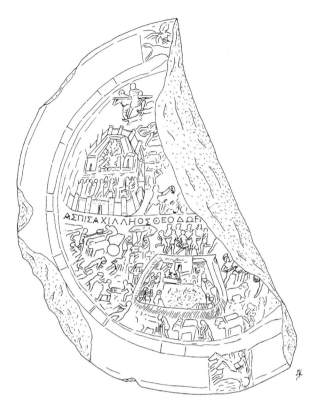

FIGURE 148. Drawing of the obverse of tablet 4N (by Margitta Krause, commissioned by Rita Amedick, published 1999).

two-dimensional photography will never do the tablet justice, but the damaged surface sometimes makes it easier to see certain features on a cast-copy rather than on the marble original. Two drawings are also reproduced here for reference—the first commissioned by Étienne Michon at the end of the nineteenth century (Fig. 147), the second by Rita Amedick at the end of twentieth (Fig. 148)—although by no means every aspect of these drawings reproduces the surviving three-dimensional surface.

Of course, when looking at an image, as opposed to reading a text, viewers can choose any detail from which to start. But I let the Homeric description lead my descriptive path and begin with the centre-left of the tablet's upper band (Fig. 149), dominated by the image of a city, surrounded by a ring of walls (Fig. 150). The iconography is typical of other such city scenes on the tablets: it recalls various depictions of Troy, visualized at the moment of its fall (in the centre of tablets 1A, 2NY, 3C, 6B, 7Ti, 8E, 9D), or the cityscapes in the background of tablets 11H and 12F. As on these other tablets, a number of different viewpoints are combined—an oblique 'bird's-eye' view of the city, as well as

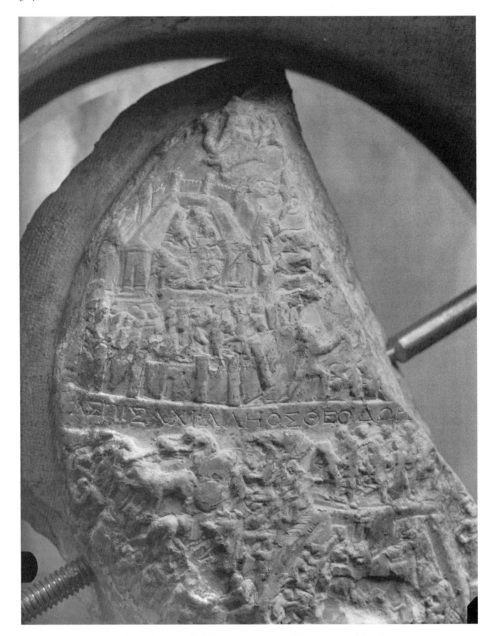

FIGURE 149. Detail of the obverse of tablet 4N: upper and lower central bands.

so-called 'central perspective'.[18] In the middle of the walls is a symmetrically framed gate, and within the city we can see a three-sided portico, as again found on many other tablets. A series of human figures are arranged symmetrically between the two facing colonnades: the surface is badly worn, but two figures

[18] See above, pp. 158–9 on tablet 1A.

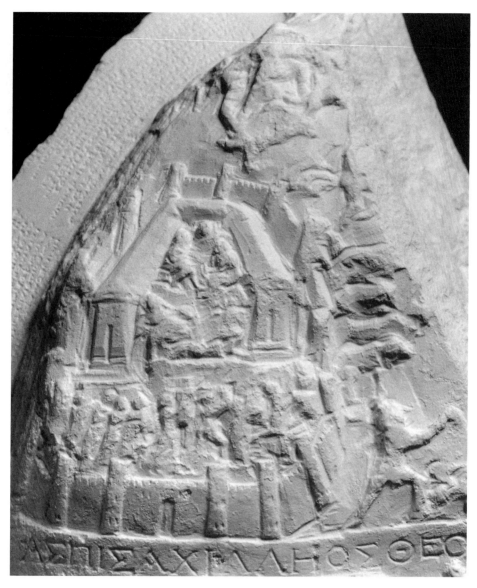

FIGURE 150. Detail of plaster cast of the tablet 4N (Archäologisches Institut und Sammlung der Gipsabgüsse, Göttingen inv. A1695): obverse, upper left-hand band.

seem to sit at the top, one figure stands below, and at the bottom are two more figures placed on either side of an outstretched body.[19]

As Bienkowski first noted, this cityscape clearly relates to the city at peace described at *Iliad* 18.491–508. The Homeric ecphrasis arranges the scene as the

[19] Cf. Bienkowski 1891: 187–8; Stuart Jones 1912: 172–3, no. 83a; Sadurska 1964: 44; Amedick 1999: 170; Valenzuela Montenegro 2004: 241.

first vignette to be evoked after the opening image of the shield's cosmic frame, associated with numerous 'marriages and feasts' (γάμοι τ᾽... εἰλαπίναι τε, v. 491). According to the Homeric ecphrasis, the city folk gather in the agora after an argument arises about a murder: thanks to the city's rules of law and order, enacted through the decree of the city's elders, the affair is settled peacefully (vv. 496–508). The tablet scene evidently has the Homeric text in mind: it invites audiences to identify the outstretched figure as the murdered man, surrounded perhaps by the plaintiff and defendant, with the elders then represented above.[20] Underneath the judgement scene, and this time structured not from top to bottom but along a horizontal plane, we see a procession from left to right: a group first of four figures on the left, then two figures in the middle (behind the gate, and carrying what Bienkowski identified as a *kithara* and double *aulos*), and finally three more figures to the right (one of them dancing?).[21] Bienkowski interpreted the scene as a marriage procession, taking its inspiration from *Il.* 18.491–6, and adduced iconographic parallels from Attic vase painting.[22]

The right-hand section of this upper band is almost entirely lost, but we can be confident about its subject: the composition was symmetrical, so that a second city—the city at war (*Il.* 18.509–40)—balanced the first.[23] The Homeric poet sets up this juxtaposition between the two scenes explicitly, stating that Hephaestus represented 'two fine cities of men' (ἐν δὲ δύω ποίησε πόλεις μερόπων ἀνθρώπων | καλάς, vv. 490–1), and further contrasting them syntactically ('in this one... around the other one...': ἐν τῇ μέν... τὴν δ᾽ ἑτέρην πόλιν ἀμφὶ..., vv. 491, 509). In this case, the Homeric verbal contrast is turned into a physical juxtaposition, each city set against the other. According to *Il.* 18.509–40, the theme of war dominates the scenography both within this second city and outside it: because the city is under siege (vv. 509–15), the men head out from the city walls to stage an ambush on their unsuspecting enemy (vv. 516–40). This possibly explains the figure just above the inscribed band, as well as the various animals and additional figures above him (to the right of the city at peace): Homer narrates how, before the full-on battle, the besieged city dwellers lie in wait, falling upon an unsuspecting pair of herdsmen as they mind their flock (vv. 520–9). Hearing the disturbance of the ambush, the soldiers besieging the

[20] See Bienkowski 1891: 187: 'Evidentemente è rappresentata una scena di giudizio.' Valenzuela Montenegro 2004: 242 is right in suggesting not only Hellenistic models, but also later Roman iconographic prototypes for the scene (*contra* Amedick 1999: 169–72).

[21] See Bienkowski 1891: 188–9, with further comments by Sadurska 1964: 44; Amedick 1999: 170; Valenzuela Montenegro 2004: 242.

[22] See Bienkowski 1891: 188: 'una pompa nuziale rivolta a destra'.

[23] The right-hand cityscape was surely rendered according to the same perspective as the cityscape to the left, establishing a perfect visual symmetry between the two: see Valenzuela Montenegro 2004: 243 (*contra* Amedick 1999: 174–6).

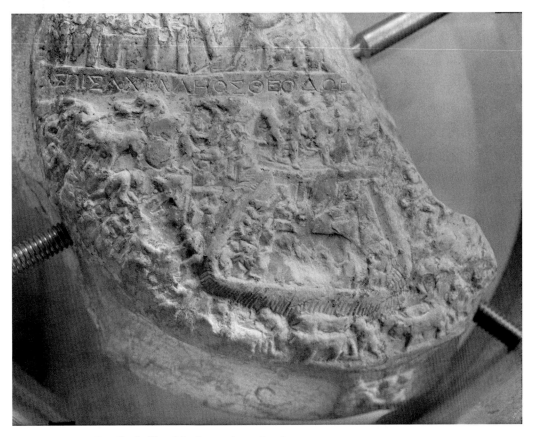

FIGURE 151. Detail of tablet 4N: obverse, lower band.

city set out to meet their foe (vv. 530–40): perhaps the ensuing battle was represented between the two cities, at the centre of this upper band.[24]

Crossing the 'Theodorean' inscription that runs across the middle of the tablet, I proceed now to tablet 4N's lower band (Fig. 151): a number of different scenes are contained here with very little formal or spatial distinction between them. Once again, the surface is severely damaged, although slightly more of the tablet's lower section survives than of its upper band. Despite difficulties of interpretation—by no means all of them attributable to the tablet's state of survival—it is clear that a variety of subjects are combined here, relating to a series of discrete landscape scenes: the Homeric descriptions of ploughing (*Il.* 18.541–9), harvesting (vv. 550–60),

[24] Are the remains of one such duel to be seen at the centre of the tablet—the surviving figure above the *theta* of the inscription engaged in combat with a second, now lost, figure to the right (cf. Sadurska 1964: 44; Amedick 1999: 172–7; Valenzuela Montenegro 2004: 242–3)? Bienkowski 1891: 194–5, on the other hand, relates the animals here to a much later part of the description (vv. 573–86), although there are serious difficulties with this interpretation (cf. Hardie 1985: 21–2 n. 74 and Valenzuela Montenegro 2004: 243).

gathering the grapes (vv. 561–72), pasture (vv. 573–86, 587–9), and dancing (vv. 590–606). Unlike the Homeric text, which arranges the scenes in linear order, proceeding from one to the other, this visual representation denies any straightforward sequence, zigzagging from the lower centre to the upper centre of the band: we move first from the scenes of ploughing at the bottom of the circular zone to scenes of reaping at its upper left; we then proceed horizontally from the central left to the vineyard scene at the centre, and horizontally again to the scenes of herding at the centre right; finally, we shift in reverse horizontal direction, ending with the scene of dancing which occupies the upper middle register of this lower section of the tablet (Fig. 152 shows my own textual ploughing of this lower visual field).[25]

A detail of the Göttingen plaster cast can again help us here (Fig. 153). The lowest scene, relating to the ploughing of the land (*Il.* 18.541–9), radiates around the bottom circular field: three individual figures steer three groups of oxen, moving from right to left.[26] The procession leads our attention in a clockwise direction, and to the various related scenes of harvesting represented in the left-hand section of this band (vv. 550–60). The figures above are easier to make out than those below: they include two oxen pulling a cart and various figures preparing a meal to the right (an animal hanging from a tree, with a series of figures below attending to it: vv. 558–60).[27] The harvesting of the grapes (vv. 561–72) is rendered in the centre of the tablet's lower band—the vine contained within what looks like a four-sided fence or walled terrace.[28] The animal to the right of this structure, together with the figure carrying the lance above it, suggests that this side of the section related to the scene of herdsmen guarding their cattle—in particular, their attempt to stave off two lions that attack the herd (vv. 573–86).[29] Finally (as it were), circling below the inscribed 'Theodorean' name at the original lower centre of the tablet, nine figures are to be seen, all holding hands and arranged in a ring (Fig. 154). This relates to vv. 590–606, where fine-clad maidens hold hands and dance alongside youths who 'spin

[25] For a more detailed description of these lower scenes, see Bienkowski 1891: 189–93; Stuart Jones 1912: 173; Sadurska 1964: 44–5; Amedick 1999: 177–84; Valenzuela Montenegro 2004: 243–6. Discrepancies between these different commentaries testify to the damaged surface of the tablet: I refer to them only when they seem significant.

[26] Cf. Amedick 1999: 178–9 (comparing Philostratus the Younger, *Imag.* 10.12): does the number of oxen refer to the Homeric description whereby the land is ploughed three times (*Il.* 18.541–2)?

[27] The figures near the rim are the best surviving, and at least one of them holds something in the hands (identified by Bienkowski 1891: 190 as a sickle, following *Il.* 18.551). To the immediate left of the ploughing oxen, at the bottom of the scene, is a seated figure which Bienkowski ibid. 191 identified as a king (after *Il.* 18.556–7: cf. Amedick 1999: 179–80; Valenzuela Montenegro 2004: 245).

[28] There is an entrance to the vineyard in the middle of the upper wall: at least five figures can be determined, but the scene is badly damaged (cf. Amedick 1999: 182; Valenzuela Montenegro 2004: 245–6).

[29] As suggested by Sadurska 1964: 45. Bienkowski 1891: 195, by contrast, locates this scene in the upper section of the tablet (cf. above, p. 317 n. 24)—'così la quarta scena che si riferisce alla vita rustica, fu trasferita dal segmento inferiore del disco al superiore'. Further animals and pens may well have been represented at the missing right-hand extremity of the band, as described in *Il.* 18.587–9.

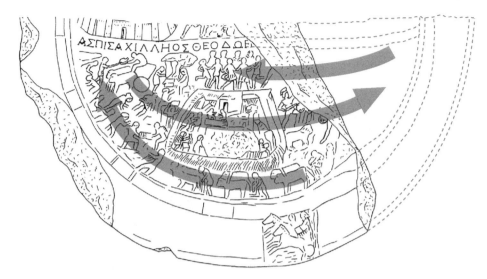

FIGURE 152. Diagram highlighting the approximate arrangement of Homeric landscape scenes on the lower band of the obverse of tablet 4N.

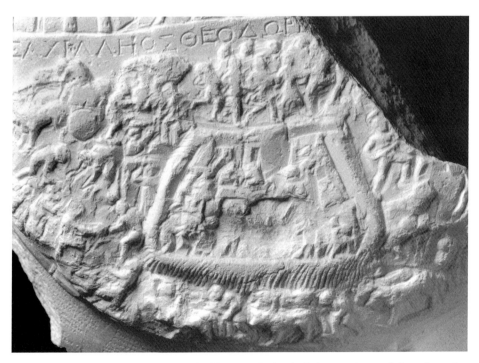

FIGURE 153. Detail of a plaster cast of tablet 4N (Archäologisches Institut und Sammlung der Gipsabgüsse, Göttingen inv. A1695): obverse, lower band.

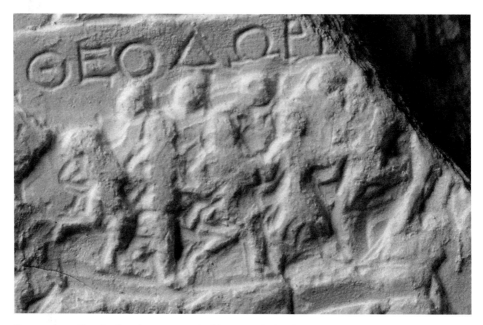

FIGURE 154. Detail of a plaster cast of tablet 4N (Archäologisches Institut und Sammlung der Gipsabgüsse, Göttingen inv. A1695): obverse, 'Theodorean' name and dancing troupe.

nimbly on their cunning feet' ($\theta\rho\acute{\epsilon}\xi\alpha\sigma\kappa\sigma\nu$ $\acute{\epsilon}\pi\iota\sigma\tau\alpha\mu\acute{\epsilon}\nu\sigma\iota\sigma\iota$ $\pi\acute{\sigma}\delta\epsilon\sigma\sigma\iota$ | $\acute{\rho}\epsilon\hat{\iota}\alpha$ $\mu\acute{\alpha}\lambda$' . . . , vv. 599–600).[30] Here, at the lower axis of the tablet, the ring formation nicely mirrors the circularity of the object as a whole.

So far I have concentrated on the inner zone of tablet 4N. As we have said, though, the object uses its full three-dimensional shape to render different subjects in different visual fields. Most important here is the tablet's outer rim. According to the Homeric text, this is where Hephaestus represented 'the river Ocean' (*Il.* 18.607–8):

$$\acute{\epsilon}\nu \; \delta\grave{\epsilon} \; \tau\acute{\iota}\theta\epsilon\iota \; \pi\sigma\tau\alpha\mu\sigma\hat{\iota}\sigma \; \mu\acute{\epsilon}\gamma\alpha \; \sigma\theta\acute{\epsilon}\nu\sigma\varsigma \; \mathrm{'}\Omega\kappa\epsilon\alpha\nu\sigma\hat{\iota}\sigma$$
$$\check{\alpha}\nu\tau\upsilon\gamma\alpha \; \pi\grave{\alpha}\rho \; \pi\upsilon\mu\acute{\alpha}\tau\eta\nu \; \sigma\acute{\alpha}\kappa\epsilon\sigma\varsigma \; \pi\acute{\upsilon}\kappa\alpha \; \pi\sigma\iota\eta\tau\sigma\hat{\iota}\sigma.$$

On it he also set the great might of the river Ocean, around the outermost rim of the well-made shield.

It is with this same image of the encircling Ocean that Homer ends the description. In a piece of circular ring composition that takes its lead from the circular shape of the shield, however, the Homeric evocation closes as it opens—by drawing attention

[30] Amedick 1999: 185–90 suggests that all of these 'landscapes' should be understood as allegorized references to the seasons ('sie sind Beispiele für szenische, nicht personifizierte Darstellungen der Jahreszeiten', 206). There are (unsurprisingly) iconographic parallels between these scenes and representations of the seasons, but it is hard to see why we should read the relief in these allegorical terms (cf. Valenzuela Montenegro 2004: 247–8, also noting the absence of 'Spring').

to its concentric design, and recalling the image of the sea with which the evocation began.[31] Here are the opening lines of the shield description (*Il.* 18.483–9):

> ἐν μὲν γαῖαν ἔτευξ’, ἐν δ’ οὐρανόν, ἐν δὲ θάλασσαν,
> ἠέλιόν τ’ ἀκάμαντα σελήνην τε πλήθουσαν,
> ἐν δὲ τὰ τείρεα πάντα, τά τ’ οὐρανὸς ἐστεφάνωται,
> Πληιάδας θ’ Ὑάδας τε τό τε σθένος Ὠρίωνος
> Ἄρκτον θ’, ἣν καὶ Ἄμαξαν ἐπίκλησιν καλέουσιν,
> ἥ τ’ αὐτοῦ στρέφεται καί τ’ Ὠρίωνα δοκεύει
> οἴη δ’ ἄμμορός ἐστι λοετρῶν Ὠκεανοῖο.

On it he fashioned the earth; on it the heavens; on it the sea, and the indefatigable sun and the full moon. On it he fashioned all the constellations which crown the heaven: the Pleiades, the Hyades, the mighty Orion and the Bear which men also call by the name Wagon—circling around itself, watching over Orion, and alone taking no part in the baths of Ocean.

Tablet 4N exploits the space of the outer rim to offer a creative revision of these scenes. We will return to the band's 'waving' graphic decoration at the end of this chapter (pp. 360–7). For now, it is enough to note how the outer rim leads us to both the beginning *and* the end of the Homeric ecphrasis. Amid this sloping band, placed towards the top (Fig. 155) and bottom (Fig. 156), we find two figures riding a team of horses, symbolizing an infinite chronological and geographical span: we are looking, it seems, at personifications of Helios and Selene—the Sun above, and the Moon below—each spinning around the object in clockwise order.[32]

[31] On the ring composition, see e.g. DuBois 1982: 17; Stanley 1993: especially 9–13; Becker 1995: 147–8. Numerous scholars (e.g. Fittschen 1973: 6–7; Heffernan 1993: 12–13) point out that the Homeric shield is never *explicitly* introduced as circular (as opposed to e.g. the 'ten circles', κύκλοι δέκα, of Agamemnon's shield at *Il.* 11.33); a further difficulty lies in the precise sense of πτύχες at *Il.* 18.481. But the metaphorical circularity of the shield is fundamental both to the arrangement of scenes and their mode of description: vv. 607–8, for instance, very much depend upon the assumed circularity of both object and ecphrasis alike (cf. e.g. L. Giuliani 2003: 39). More than that, the very subjects described circulate, turn, and revolve, mirroring the movement of the object and ecphrastic description: note the constellation of the Bear which circles ever in its place, for example (ἥ τ’ αὐτοῦ στρέφεται, v. 488); the description of the ploughmen 'spinning' their teams in furrowing the land (δινεύοντες … στρέψαντες … στρέψασκον, v. 543, 544, 546); and the youths compared to a potter at his wheel (vv. 600–2) who 'spin nimbly on their cunning feet' (θρέξασκον ἐπισταμένοισι πόδεσσι | ῥεῖα μάλ’, vv. 599–600; compare the related verbs ἐδίνεον and ἐδίνευον at vv. 494, 606). The artist of tablet 4N clearly recognized the visual and verbal significance of the concentric shape, not least in the dancing scene in its lower centre which recalls the overarching design of the circular object. Ancient commentators also remarked upon the circular shape explicitly, not least Philostratus the Younger, whose circular Achillean shield is also moulded after the image of the dancing circle described (ἐν κύκλῳ … κύκλῳ: *Imag.* 10.19, 20).

[32] This follows Bienkowski's original interpretation, with Helios above and Selene below (Bienkowski 1891: 196–7; cf. Sadurska 1964: 45 and Valenzuela Montenegro 2004: 241). Amedick 1999: 165 identifies the figures in reverse order without explaining her rationale.

FIGURE 155. Detail of a plaster cast of tablet 4N (Archäologisches Institut und Sammlung der Gipsabgüsse, Göttingen inv. A1695): obverse, upper oblique band with Helios.

So much for Homer's 'indefatigable sun' and 'full moon' (*Il.* 18.484). But what of the various constellations—'all the constellations which crown the heaven' (v. 485)? These too, it seems, were symbolized on the tablet, albeit in a third, more oblique band, stretching between the object's outer rim and its inner circle. The question, of course, was how to suggest all these vast subjects through visual

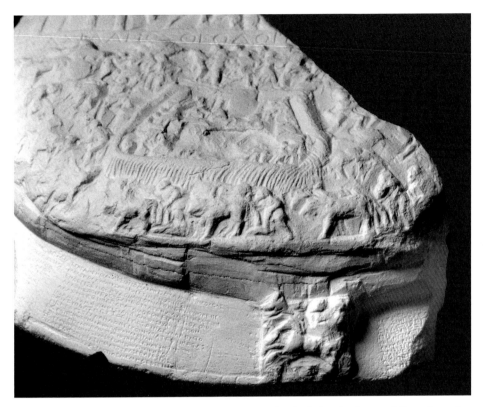

FIGURE 156. Detail of a plaster cast of tablet 4N (Archäologisches Institut und Sammlung der Gipsabgüsse, Göttingen inv. A1695): obverse, lower oblique band with Selene and spaces for astrological markings.

means. The artist seems to have had recourse to Zodiacal emblems: six square embossed spaces can be detected around the surviving portion of the tablet (cf. Figs. 148, 156), including among them the indications of what Bienkowski identified as 'Capricorn' and 'Scorpio'; the proportions suggest that there must once have been twelve such raised square designs, corresponding to the twelve signs of the Zodiac.[33] The allusion seems to be to Crates' famous allegorical interpretation of the Homeric ecphrasis. Working in Pergamon in the mid second century BC, Crates suggested that the shield prefigured the intricacies of

[33] See Bienkowski 1891: 186, 197; cf. Hardie 1985: 21 and 1986: 341–3; Gundel 1992: 108–9, 224, no.56; Amedick 1999: 190–4; Valenzuela Montenegro 2004: 241, 246 (with more detailed bibliography). One has to share Amedick's doubts about Bienkowski's specific identifications, at least on the grounds of what can be seen today ('eine Beobachtung, die ich nicht nachvollziehen kann': Amedick 1999: 193 n. 141). But Amedick nevertheless accepts that this band *was* decorated, and at least six such markings can be determined; comparison can also be made to the outer rim of the shield on tablet 6B (Fig. 162) which very clearly showed the signs of the Zodiac.

his own cosmology, whereby each and every constellation was charged with astrological importance: where Homer evokes 'all the constellations', the tablet follows Crates in alluding to them through a series of discrete astrological symbols, thereby incorporating the celestial heavens into the artefact's miniature design.[34]

The fragmentary nature of tablet 5O means that we cannot be sure about its overall arrangement. But the general composition—reproduced on a somewhat larger scale—was clearly related to that of 4N.[35] The obverse fragment (Fig. 143) comes from the approximate centre of the recto shield (as confirmed by the 'magic square' inscription on the verso):[36] comparing the bipartite composition of tablet 4N, it seems likely that the fragment derives from the upper central section of an original lower register. Where tablet 4N bisects the upper and lower parts of the tablet with its central 'Theodorean' inscription, tablet 5O was perhaps less strict in dividing the two sections: in the upper part of the fragment we see a city wall, perhaps even belonging to the Homeric city at peace (*Il.* 18.490–508).[37] Underneath are a number of landscape vignettes, all of them grouped together: to the left is a small building, and in front of it are (from left to right) a small animal (a dog?), a single male figure, a pair of oxen pulling a laden cart, and two more figures. The oxen and wagon find a clear parallel in the harvesting scene on tablet 4N (in the central upper part of the lower panel, below the letter *chi*, relating to *Il.* 18.550–60: Fig. 153). Once we have located that specific detail, it is easier to determine how the remainder of the fragment, to the right of the wagon, compares: as on tablet 4N, an animal was shown hanging upside down from a tree, prepared by two figures adjacent to it (cf. vv. 558–60); to the right of that group, moreover, there survives a single figure, moving in a clockwise direction. This seems to have formed part of the group of dancers that is similarly depicted below the 'Theodorean' name on tablet 4N (cf. vv. 590–606).[38]

[34] For artistic comparanda, see Hardie 1985: 19–20, along with the bibliography cited by Fittschen 1973: 2 n. 5. On ancient allegorical interpretations of the shield more generally, used to figure 'l'organisation et les cycles du monde', see Buffière 1956: 155–68, at 155; Porter 1992: especially 91–103; Kalligeropoulos and Vasileiadou 2008: 447–8.

[35] Cf. Bienkowski 1891: 199: 'è quindi molto probabile, che la disposizione di questo esemplare sia stata uguale o almeno simile a quella del frammento descritto in primo luogo'. The author also argues that tablet 5O displays an 'esecuzione molto migliore, favorita anche dal materiale più tenero e fino'.

[36] Cf. Bua 1971: 11. The verso preserves a section from near the central right-hand side of the 'magic square', just as the recto preserves a fragment from near the central left-hand side of the obverse composition.

[37] Cf. Valenzuela Montenegro 2004: 251.

[38] Cf. Bienkowski 1891: 199; Sadurska 1964: 47; Valenzuela Montenegro 2004: 251 ('sie zählt sicherlich zu einer Gruppe von Reigentänzern, wie man nach Schild N vermuten kann').

HOMERIC ECPHRASIS: VERBALIZING THE VISUAL

The maker(s) of our two objects clearly thought long and hard about the Homeric description, and how to turn its words back into pictures. He/they responded to it, moreover, in highly sophisticated ways—from the carefully composed vignettes contained within the central circular frame, to the oblique internal band and outer rim of tablet 4N. As so often with the Iliac tablets, the objects do not just visualize the Homeric poems, they also give us an insight into their ancient study—in this case, the allegorical interpretations of a learned scholar like Crates.

But why decide to focus upon this Homeric passage in particular? What was the significance of materializing the Homeric description of Achilles' shield? And how does the thinking relate to what we have said about the other Iliac tablets?

In order to answer those questions, it is necessary to put the tablets aside for a moment and look at other responses to the Homeric passage at around the same time. The point to emphasize is this: that the shield of Achilles became the prototypical and definitive ancient Greek and Latin example of ecphrasis, whereby an author set out to represent a seeable visual subject through readable verbal language. The Homeric model, as Philip Hardie puts it, quickly established itself as the prototype 'for all later ecphrases of works of art in ancient literature'.[39]

Although the full reception of the Homeric passage lies beyond the scope of this chapter, the abridged essentials can be briefly sketched. The earliest known imitation dates from around the early sixth century BC—the evocation of the shield of Heracles, again forged by Hephaestus, and described as part of hexameter poem attributed to Hesiod.[40] The poet responsible for this *Shield* took the Homeric model and remoulded it, allowing the description to comprise two-fifths of the poem's 481 verses. Other poets emulated not only the Homeric description, but also the larger narrative structure in which Homer embedded it, turning a purported visual object into a miniature textual artefact refracting the grander themes of the poem. Two of the most famous imitations are Apollonius' description of Jason's cloak in the *Argonautica* (1.730–67) and the shield of Aeneas in the eighth book of Virgil's *Aeneid* (8.626–731), but many other examples might be cited, among them Quintus of Smyrna's own description of Achilles' shield (in a third-century AD epic self-consciously set in Homer's aftermath: Quint. Smyrn.

[39] Hardie 1985: 11; cf. e.g. Fittschen 1973: 1: 'die Fülle der Schilderungen anderer Gegenstände der Kunst oder des Kunsthandwerks ist von der Art der homerischen Beschreibung geprägt'.

[40] See especially Becker 1995: 23–40 on *Sc.* 139–320. Despite conspicuous (and knowing) adaptations, the passage is 'clearly written in imitation of Homer' (Kurman 1974: 2).

5.6–101).[41] Epic poets were not the only ones to turn to the Achillean shield as ecphrastic archetype: as we shall see, Homer constituted the paradigm for *all* ancient verbal evocations of a visual stimulus, and across a whole spectrum of different literary genres. The Homeric archetype, writes Jaś Elsner, 'was to have a fundamental influence not only on other epic uses of ekphrasis but also on the place of ekphrasis in other kinds of fictional narratives'.[42]

By the first century AD, Greek handbooks on rhetoric—so-called *Progymnasmata*—came to rationalize the phenomenon, labelling it 'ecphrasis' explicitly.[43] Indeed, one of the earliest surviving examples of the genre (composed by Theon, perhaps in the first century AD) introduced the Homeric description of Achilles' armour (παρὰ ... Ὁμήρῳ Ὁπλοποιΐα) as a self-declared example of 'ecphrases of manners' (τρόπων ... ἐκφράσεις).[44] In her recent discussion of these rhetorical guidebooks, Ruth Webb rightly argues that ancient ecphrasis was conceived in much broader terms than 'descriptions of artworks' alone: Theon's *Progymnasmata*, she notes, was in fact the only such handbook to cite the particular example of the Homeric passage.[45] To my mind, however, these peculiarities have more

[41] On Apollonius' ecphrasis, see e.g. Goldhill 1991: 308–11; Clauss 1993: 120–9; Hunter 1993: 52–9; Knight 1995: 165–7. For the Virgilian shield of Aeneas, see below, pp. 329–30. On Quintus of Smyrna's imitation, see Baumbach 2007: 112–28. References to subsequent Greek and Latin 'shield descriptions' are collected in Fittschen 1973: 1 n. 1: note in particular Zeitlin 1982 and Hardie 1985: 11–15 on the described shields of the fifth-century Athenian stage.

[42] Elsner 2002: 3. One of the most revealing examples (omitted here for the sake of space) is Theoc. *Id.* 1.26–60: cf. Halperin 1983: especially 176–83; Goldhill 1991: 240–6; Männlein-Robert 2007b: 214, 303–7.

[43] On the rhetoric of ecphrasis in the *Progymnasmata*, the most important analysis is now Webb 2009 (with references to the author's earlier work); cf. Bartsch 1989: 7–14; Maffei 1991: 591–3; Becker 1995: 24–31; Elsner 1995: 24–6 and 2002: 1–3; Goldhill 2007: 3–8; Cavero 2008: especially 283–9. The *Progymnasmata* attributed to Theon, Hermogenes, Aphthonius, and Nicolaus are conveniently collected in translation in Kennedy 2003. The most pertinent passages concerning ecphrasis have been handily combined with English translation in the appendix of Webb 2009: 197–211: Theon, *Prog.* 118.6–120 (see Patillon and Bolognesi (eds.) 1997: 66–9); Hermog. *Prog.* 10.47–50 (see Rabe (ed.) 1913: 22–3); Aphthonius, *Prog.* 12.46–9 (see Rabe (ed.) 1926: 36–41); Nicolaus, *Prog.* (see Felten (ed.) 1913: 67–71). On the function of these handbooks more generally, see G. Anderson 1993: 47–53; Webb 2001: especially 294–6 (developed in eadem 2009: especially 39–59); and Goldhill 2007: 3–8.

[44] Theon, *Prog.* 118.7 (see Patillon and Bolognesi (eds.) 1997: 67). Heath 2002–3 argues for a later date, identifying Theon with a known fifth-century rhetorician of the same name, and questioning the attribution of another *Progymnasmata* to Hermogenes. But the evidence remains inconclusive, and comparisons with Quintilian suggest that the *Progymnasmata*'s rhetoric for discussing ecphrasis stretches back at least to the early Empire.

[45] For the polemic, see especially Webb 1999: 11–15 and 2000: 221, developed in 2009: especially 1–38: 'The ancient and modern categories of ekphrasis are thus formed on entirely different grounds, and are ultimately incommensurate, belonging as they do to radically different systems' (2009: 7–8). Cf. eadem 1999: 7–9 and 2009: 70 on Theon's recourse to Homer, concluding that Theon 'could hardly be further from treating it [*sc.* Homer's ecphrasis] as a description of an "objet d'art", or even as a work of poetry', but 'simply lists the passage alongside other accounts of how military equipment and machines were made'.

to do with the peculiar genre of the *Progymnasmata* than with ancient ideas about ecphrasis.[46] Philostratus the Younger had no qualms in introducing his 17 painting-descriptions as an 'ecphrasis of works of painting/description' (γραφικῆς ἔργων ἔκφρασις, *Imag.* praef. 1), drawing upon the Homeric shield specifically (*Imag.* 10.5–20).[47] And while scholia on the *Iliad* identified a broad range of passages from the poem as ecphrastic, they certainly do use the word 'ecphrasis' in conjunction with the Homeric shield.[48]

So what did this term 'ecphrasis' mean? Regardless of the specific examples that they cite, the *Progymnasmata* all agree in their basic definition: 'ecphrasis is a descriptive speech which vividly brings the subject shown before the eyes' (ἔκφρασίς ἐστι λόγος περιηγηματικὸς ἐναργῶς ὑπ' ὄψιν ἄγων τὸ δηλούμενον).[49] As Hermogenes adds, ecphrasis is an 'interpretation that almost brings about seeing through hearing' (τὴν ἑρμηνείαν διὰ τῆς ἀκοῆς σχεδὸν τὴν ὄψιν μηχανᾶσθαι) and its two chief 'virtues' are *enargeia* ('vividness') and *saphêneia* ('clarity'):[50] it was through *enargeia* and *saphêneia* that a listener could be expected to arrive at the same inner vision—the same *phantasia*—that the scene or object had originally brought to the mind's eye of the artist, speaker, or writer.[51] The textbooks

[46] As Webb 2009: 3 explains, she focusses 'on the rhetorical theory and practice of ekphrasis' because 'it is in the rhetoricians' schools that ekphrasis was defined, taught and practised and it is therefore in the domain of rhetoric that we can find a substantial explanation of what ekphrasis was, how it functioned and what its purpose was'. Webb offers a superlative review of the scope and rhetorical objectives of the *Progymnasmata*. But it seems misleading to reconstruct ideas about ecphrasis from these sources alone (cf. Squire 2008). Ecphrasis is a discourse that cuts across different genres—and indeed different media (as the Iliac tablets so spectacularly show): it is therefore necessary to zoom out beyond the *Progymnasmata* as well as to zoom in on their minutiae.

[47] On Philostr. Min. *Imag.* 10, see below, pp. 331–3, 340–1. Cf. Altekamp 1988: 97–100 on the 'ecphrastic' title of Callistratus' descriptions of statues. Much later (in the ninth century), John of Sardis' commentary on Aphthonius would also adduce the Elder Philostratus' *Imagines* as an example of an ecphrastic text: see Rabe (ed.) 1928: 215.

[48] See e.g. schol. T on *Il.* 18.610 (Erbse (ed.) 1969–88: 4.570). Francis 2009: 8 n. 22 is therefore wrong (though typical of a now widespread misunderstanding) in concluding of the Homeric description that 'such scenes are not specifically termed ekphraseis in antiquity'.

[49] For the (apparent) earliest articulation of the phrase in the *Progymnasmata*, see Theon, *Prog.* 118.7 (Patillon and Bolognesi (eds.) 1997: 66). But the words are repeated verbatim by Hermogenes and Aphthonius, and very closely echoed in the phrasing of Nicolaus. Indeed, Hermog. *Prog.* 10.47 (see Rabe (ed.) 1913: 22) even qualifies the definition with the phrase ὡς φασίν ('as they say'), as if acknowledging its formulaic derivation.

[50] Hermog. *Prog.* 10.48 (see Rabe (ed.) 1913: 23). Cf. Nicolaus, *Prog.* on how elements of ecphrasis 'bring the subjects of the speech before our eyes and almost make the audience into spectators' (ὑπ' ὄψιν ἡμῖν ἄγοντα ταῦτα, περὶ ὧν εἰσιν οἱ λόγοι, καὶ μόνον οὐ θεατὰς εἶναι παρασκευάζοντα, Felten (ed.) 1913: 70). The 'almosts' (σχεδόν/μόνον οὐ) used by Hermogenes and Nicolaus will prove critical in the discussion that follows: as Goldhill 2007: 3 likewise concludes of Hermogenes' discussion of ecphrasis, 'the qualification "almost" is important' since 'rhetorical theory knows well that its descriptive power is a technique of illusion, semblance, of making to appear'; cf. Becker 1995: 28 (with the Greek and Latin comparanda cited in n. 49).

[51] Cf. Hermog. *Prog.* 10.49 (see Rabe (ed.) 1913: 23). The bibliography on *enargeia*, especially in relation to Quintilian's comments (*Inst.* 8.3.64–5) and Stoic notions of *phantasia* (see below, p. 339 n. 92), is

subcategorize the trope in different ways, with Theon, Hermogenes, Aphthonius, and Nicolaus all distinguishing between what they call ecphrastic 'deeds', 'characters', and 'places'; indeed, it is Nicolaus alone who mentions artistic imagery ('a man bronze or in pictures/descriptions [*graphais*]: ἄνθρωπον χαλκοῦν ἢ ἐν γραφαῖς).[52] When we remember the purpose (not to mention pedigree) of the *Progymnasmata*, however, it is not terribly surprising that such examples should go unmentioned, nor that more is not made of the paradigmatic Homeric example. These texts were not concerned with the literary archaeology of the trope. Interested in the immediate rhetorical pay-offs—ecphrasis as part of a 'spin-doctoring' art of persuasion—they tended to cite case studies that better suited the immediate needs of their target audiences (drawn above all from prose historians, especially Thucydides).[53] Once categories and exempla had been established, they were largely repeated from one textbook to the next, and in near formulaic manner.[54]

Whatever else we make of this rhetoric for rationalizing ecphrasis, there can be little doubting the debt to the Homeric model. Even though the *Progymnasmata* make little reference to Homer or the shield of Achilles specifically, their conceptual framework for theorizing ecphrasis derives from literary and critical engagements with the Homeric text. The description of Achilles' shield was viewed as not only the earliest example of Greek or Latin ecphrasis, but also its founding paradigm: in fact, as we shall see, it was impossible to think about 'seeing through hearing' *without* harking back to the Homeric archetype.

To reconstruct this ecphrastic discourse, we therefore have to look beyond the confined perspectives of the *Progymnasmata*, setting their theories of ecphrastic representation against a broader range of texts. Three examples can suffice to demonstrate what I mean: the Virgilian description of the shield of Aeneas (*Aen.* 8.626–728), Lucian's witty revision of the Iliadic ecphrasis in his *Icaromenippus*, and Philostratus the Younger's ecphrasis of the ecphrasis within the context of a purported gallery of paintings (*Imag.* 10). After briefly reconstructing the intellectual stakes, we will be better placed to look back at the Homeric description of the shield itself: as we shall see, all three ecphrastic

substantial: see e.g. Graf 1995: especially 143–9; Dubel 1997; Bartsch 2007; Webb 2009: 87–130 (summarizing e.g. 1997a; 1997b; 1999: 13–15; 2000: 221–5).

[52] Quoted from Felten (ed.) 1913: 69, and discussed by Webb 2009: 46, 82–4. On the distinction between ecphraseis of *pragmata*, *prosopa*, and *topoi*, see Webb ibid. 55–6, 61–86, and her appendix at 213–14.

[53] The same can be said of Quintilian (e.g. *Inst.* 8.3.64–5), whose relationship with the *Progymnasmata* is discussed by e.g. Goldhill 2007: 3–5 and Webb 2009: 87–106.

[54] The point is best brought out by Bartsch 1989: 7–14, in the context of the Greek novel: 'The approach these handbooks take proves to be relatively dry and matter-of-fact; they provide guidelines for content and procedure rather than provide suggestions on function in a literary context, and their theory, if it deserves the name, strays within bounds too narrow to reveal how such passages might be manipulated for broader aims' (9).

passages play upon themes already written into the Homeric model, and our two Iliac tablets provide their own associated mode of materialist meta-ecphrastic commentary.

We have already alluded to Virgil's engagement with *Iliad* 18, describing the shield that Vulcan crafted for Aeneas in the eighth book of the *Aeneid* (vv. 626–728).[55] Virgil clearly both adopted and adapted the *Iliad*'s ecphrastic model. Where Homer has Hephaestus forge the whole world on the shield, Vulcan's act of manufacture is rendered already complete: we see Aeneas seeing the prophetic scenes *after* they have been crafted (but before they have been fulfilled by his descendants).[56] Hephaestus' cosmological images are likewise exchanged for a cosmos of Roman history and Imperial expansion—'the story of Italy and the triumphs of Rome' (*res Italas Romanorumque triumphos*, v. 626), rendered alongside battles that have prophetically already been fought, all laid out 'in order' (*pugnataque in ordine bella*, v. 629).[57] Although recent discussion of this passage has tended to hang upon Aeneas' reaction—what does it mean for Virgil's Augustan epic to have its hero 'marvel and delight in the image of things that he does not know' (*miratur rerumque ignarus imagine gaudet*, v. 730)?[58]—as a verbal representation of a visual representation, the text comes out of the same conceptual framework for rationalizing ecphrasis preserved in the *Progymnasmata*. Not for nothing does Virgil begin by drawing narrative attention to 'the shield's *non*-narratable texture' (*clipei non enarrabile textum*, v. 625): where the *Progymnasmata* emphasize the capacity of words to bring about seeing (or at least *almost* to do so),[59] Virgil's opening gambit is negatively orientated, provocatively asserting the *impossibility* of representing the shield's complete visual fabric through the narrative verbal text.[60] Composed within a few decades of the Iliac

[55] Among the many discussions of this Virgilian ecphrasis, I have found Hardie 1986: 336–76, Putnam 1998: 119–88, and Boyle 1999: 153–61 particularly insightful.

[56] The classic (albeit highly ideologized) discussion of the difference is in the sixteenth to nineteenth chapters of Lessing's *Laocoon*, first published in 1766: see Lessing 1984: 78–103, and the analysis in Becker 1995: 13–22.

[57] For this concept of *order* in Virgilian ecphrasis, see above, p. 156 n. 82 on *Aen.* 1.456. On the Virgilian adaptation of Homer—forging a 'universal shield, whose underlying theme is the creation of a Roman cosmos' (Hardie 1985: 29)—see Hardie 1986: especially 336–76.

[58] See especially DuBois 1982: 47–8: 'The glorious presence of Augustus triumphant on that shield, the culmination of the Roman past, is undercut by the silence and ignorance of his ancestor Aeneas' (48).

[59] Cf. Webb 2009: 105: 'rhetoricians tend to place emphasis on the *ability* of words to create presence, rather than the problematic nature of that presence'.

[60] Faber 2000 offers one of the best discussions of the phrase, reminding of its debt to the pseudo-Hesiodic *Shield of Heracles* (especially e.g. *Sc.* 144: οὔ τι φατειός and ibid. 230: οὐ φαταί); cf. also Laird 1996: 77–9 on Servius' late fourth-century gloss. It is worth noting how the *e-* prefix of the Latin *enarrabile* captures the *ek-* of Greek 'ecphrasis', implying 'ein "völlig und restlos deutliches Machen"' (Graf 1995: 143); in Virgil, though, this idea of completeness is teasingly turned inside out through the negative *non*. Similarly, as Bartsch 1998: 327–8 argues, *textum* refers not just to the visual texture of the object, but also

tablets, Virgil's Latin adaptation of the Greek Homeric model testifies both to the epic celebrity of the Homeric lines, and to the sophistication with which they came to be theorized. Homeric ecphrasis had come to encapsulate much larger ideas of representation, fiction, and emulation.

Virgil does not refer to the shield of Achilles explicitly: while replicating the Homeric ecphrasis, the scenes are updated to suit the new epic hero Aeneas (and the new epic vision of first-century BC Augustan Rome). But other authors discuss their literary relationship with Homer outright, exploring the underlying ecphrastic stakes. One such text is Lucian's *Icaromenippus*, written in the second century AD. Lucian's dialogue purports to narrate the remarkable travels of a certain Menippus (named, satirically, after the Syrian 'inventor' of prosimetric Menippean satire?). Menippus is said to have undergone a remarkable journey through space—hence the dialogue's title: Menippus is 'Icarean' because, like Icarus, he has travelled through the skies (albeit without Icarus' sticky end).[61]

So what could Menippus see? In the ensuing description of Menippus' 'aerial' view of the earth, Lucian draws on the Homeric ecphrasis specifically. His actual vision, the space traveller is said to say, lies beyond verbal description: like the *non enarrabile textum* of Aeneas' shield, it is something *non*-narrative ('to tell it all from first to last, my friend, would be impossible in such a case, where even seeing was a work in its own right'; πάντα μὲν ἐξῆς διελθεῖν, ὦ φιλότης, ἀδύνατον, ὅπου γε καὶ ὁρᾶν αὐτὰ ἔργον ἦν, *Icar.* 16). Pressed for particulars, Menippus teasingly falls back on Homer: the sight generally confirms Homer's vision of the world, as described in the description of Achilles' shield (16).

τὰ μέντοι κεφάλαια τῶν πραγμάτων τοιαῦτα ἐφαίνετο οἷά φησιν Ὅμηρος τὰ ἐπὶ τῆς ἀσπίδος. οὗ μὲν γὰρ ἦσαν εἰλαπίναι καὶ γάμοι, ἑτέρωθι δὲ δικαστήρια καὶ ἐκκλησίαι, καθ᾽ ἕτερον δὲ μέρος ἔθυέ τις, ἐν γειτόνων δὲ πενθῶν ἄλλος ἐφαίνετο.

However, the main features of the events appeared such as Homer says they appeared on the shield. In one place there were banquets and weddings, elsewhere there were sessions of courts and assemblies, in a different part someone was sacrificing and close at hand someone else was mourning a death.

The way in which Lucian stage-manages Menippus' response testifies not only to the Second Sophistic obsession with Homer, but also to the meta-ecphrastic sophistication of Greek ecphrasis and self-conscious relation with Homeric

to the literary texture of this ecphrasis: Virgil, in other words, describes a *textum* adorned with stories which Aeneas can *see*, but which (unlike Vulcan, the poet, and the audience) Aeneas is unable to make *readable*. As opposed to the maker of this shield (who is 'not ignorant of prophecy', *haud uatum ignarus*, *Aen.* 8.627), or indeed the Virgilian craftsman of the poem (able to characterize the ignorance or otherwise of his cast), Aeneas looks at the shield, but nevertheless remains *ignarus* of its narratives (v. 730).

[61] For the generic literary backdrop of the 'fantastic journey', see Bichler 2006. Cf. Schmidt 1973 on the much-contested *Book of Abraham*, discussing this passage at 123–5.

precedent. Menippus' ecphrastic sight playfully cites Homer's own, translating epic verse into this 'live' Lucianic dialogue, and updating the Homeric scenes in terms of more contemporary geographical stereotypes.[62] Within a dialogue that itself stages a make-believe conversation between two friends—a spoken discussion about the marvellously fantastic (and fabricated?), now in turn represented through this marvellous written text—the author satirizes the earnest sincerity with which texts like the *Progymnasmata* theorize ecphrasis: for a *vision* of what was seen, *read* Homer! In case we had missed the irony, the author has Menippus end the description by likening the whole scene to 'many choral dancers, and still more choral bands' (πολλοὺς χορευτάς, μᾶλλον δὲ πολλοὺς χορούς, 17), all singing and dancing at once: if the analogy nods wittily to the sheer number of poetic replications of the Homeric ecphrasis (while recalling the choral dancing that closes the Iliadic image: *Il.* 18.590–606), the description also asks the audience to imagine not *visible images*, but rather *audible sounds*.[63] Lucian, in other words, quotes the ecphrastic paradigm of the Homeric shield, all the while inverting rhetorical definitions of the trope. Whereas the *Progymnasmata* declare that spoken words 'almost bring about seeing through hearing', Lucian gets at his vision of the Homeric text by likening it to what can be heard: in a recession of words and pictures, this 'descriptive speech which vividly brings the subject shown before the eyes' in fact takes us *back* to the verbal description of the Homeric text. Such is the high-flying satire of 'Menippean' poetry-turned-prose.

Not long after Lucian was writing in the late second century AD, and with no less self-consciousness, Philostratus the Younger offered a related ecphrasis of the Homeric object-cum-description.[64] Philostratus developed Lucian's visual-

[62] In a series of simultaneous vignettes all happening at the same time (ἀπάντων δὲ τούτων ὑπὸ τὸν αὐτὸν γινομένων χρόνον, *Icar.* 17), the Getae fight, the Scythians ride their wagons, the Egyptians work the land, the Phoenicians trade, the Cilicians are engaged in piracy, and the Spartans whip themselves; the Athenians, on the other hand, all the while attend court (resembling the figures in the agora of the Homeric city at peace).

[63] Cf. *Icar.* 17: 'With each one full of emulation and carrying his own tune and striving to outdo his neighbour in loudness of voice, can you imagine, by Zeus, what the song would be like?' (φιλοτιμουμένου δὲ ἑκάστου καὶ τὸ ἴδιον περαίνοντος καὶ τὸν πλησίον ὑπερβαλέσθαι τῇ μεγαλοφωνίᾳ προθυμουμένου, ἆρα ἐνθυμῇ πρὸς Διὸς οἷα γένοιτ᾽ ἂν ἡ ᾠδή;). On the 'sounds' of the Homeric shield, see below, pp. 335–6.

[64] Besides the brief commentary in Pasquariello 2004, there is very little bibliography on the passage (references are collected in Amedick 1999: 162–3 n. 21). Amedick 1999 compares numerous aspects of the Philostratean description with the pictorial details of tablets 4N and 5O: treating the text as 'eine Paraphrase der homerischen Schildbeschreibung in Prosa' and 'ein wichtiges Dokument der Rezeptionsgeschichte' (162), however, Amedick offers no comment about the ecphrastic games at play. Lesky 1940 delivers an admirable survey of how the Homeric shield influences the descriptions of Philostratus the Elder's *Imagines*—but omits any reference to this subsequent passage, or indeed to Philostratus the Younger at all. The *Imagines* of the Younger Philostratus are clearly ripe for reappraisal: Philostratus' playful mimesis of his purported grandfather's text has always been seen as unoriginal and uncreative

verbal conceits still further, evoking Homer's *poetic* evocation of the shield within a *pictorial* evocation of a purported gallery of paintings (*Imag.* 10). The description of the shield comes rather unexpectedly within a larger ecphrasis about 'Pyrrhus or the Mysians'. But the shield subsequently dominates the tableau, occupying some three-quarters of its overall length (10.5–20). As often, the speaker starts his peroration by drawing attention to the picture's literary archaeology—the 'chorus of poets' who have treated the theme (ποιητῶν . . . χορός, 10.1): Philostratus' inverted ecphrasis ironically begins by recalling the chorus with which the Homeric shield description closes. The programmatic opening therefore sets up all the ambiguities that follow: punning on the shared language of *graphê*, *graphein*, and *gramma*, Philostratus leaves us guessing whether the (description of this) tableau is an image derived from a text, or a text derived from an image. The *graphê* before us, Philostratus narrates, 'speaks' the same things as the poets (φησὶ δὲ καὶ ἡ γραφὴ ταῦτα, 10.1).[65]

The Philostratean ecphrasis stages a *mise en abyme* of both images within the image and texts within the text. Our description proceeds from Homer's evocation of the whole city of Troy, to a band of Mysians and Greeks facing each other, to Pyrrhus and Eurypylus in particular, and then to the armour worn by each character (itself bequeathed by each hero's father—wherein lie still further epic tales: *Imag.* 10.2–4). Only very briefly—and at the end of the long ecphrasis of the shield—does the author return to the narrative frame of Pyrrhus' victory over Eurypylus (10.21): in the same way that the circular Homeric ecphrasis encompasses everything within its descriptive frame, the ring composition of this tableau takes us on a dizzying tour of the epic past, ending where it begins. Where Homer embeds his ecphrastic description of the shield within the narrative of the poem, though, Philostratus' multilayered text situates the evocation within yet another ecphrasis: the ecphrasis of the shield is turned from a small detail within the narrative fabric of the picture (and indeed of the Homeric poem from which it descends) to the grand focus of our attention. This is not just an

(cf. e.g. P. Friedländer 1912: 90, who, after treating Philostratus the Elder, simply declares: 'übergehen wir, wie billig, die Nachahmer Philostrats, den jüngeren Namensvetter und den Kallistratos . . .'); but of course this *mise en abyme* of replication is precisely what makes the text so interesting and sophisticated. For a survey of the little bibliography that there is, see Ghedini 2004.

[65] Ancient commentators on the *Iliad* evidently associated such conceits with the Homeric model in *Iliad* 18. One Byzantine commentator on the Homeric text, for example, even talked about the 'picture-gallery quality' of Homer's shield description: he calls it *pinakographikos* (with the usual pun, whereby the adjective relates both to a 'picture gallery' and to 'writing about a picture gallery'). See Eustathius ad *Il.* 18.607 (van der Valk 1971–87: 4.272): '[The verse is] clearly imitating the manner of a painting/described picture—which the descriptive authors emulated—because Homer put the Ocean around his making of the cosmos in circular formation' (δῆλον δὲ ὡς πάνυ δεξιῶς πινακογραφικῷ χαρακτῆρι, ὃν οἱ περιηγούμενοι ἐζήλωσαν, τῇ κατ' αὐτὸν Ὁμήρου κοσμοποιΐᾳ κύκλῳ τὸν Ὠκεανὸν περιέθετο). On *periêgêsis*, and its relation to the discussions of ecphrasis in the *Progymnasmata*, see Webb 2009: 54–5, 75.

ecphrasis of an ecphrasis within an ecphrasis—a verbal description of a purported painting derived from the Iliadic shield of Achilles, now transformed into just one part of a still larger evocation of a picture of Pyrrhus (itself descended from the Homeric poem). By the same sophisticated logic, the passage is also made to interrogate the respective powers of *uisus* and *uox*: it asks us whether true 'insight' lies in the visual faculty of the eye, or in the auditory powers of the ear.[66] Philostratus drives home the point via the multiple references to our actual *seeing* the (painting of the) shield described.[67] The irony cannot have gone unnoticed, at least among those who knew their *Progymnasmata*: the more the author compels us to look, the more he disappears behind textual precedent. Just as the *Progymnasmata* prescribe, our seeing is dependent upon our hearing, and our hearing leads full circle to our seeing: the ecphrastic vision might be vivid, but it is a vision that takes us back to the verbal opacity of the Homeric ecphrastic text.

For our immediate purposes, what is most remarkable about the Younger Philostratus' text is its recourse to Homeric ecphrasis as an aetiological figure for its own games of visual and verbal replication. The ecphrastic *mise en abyme* that Philostratus stage-manages—the described image of the shield within this image description—duplicates the Homeric ecphrasis' own verbal replication of the shield's replicative strategies.[68] 'If one were to look at this armour', writes Philostratus, 'one will find none of Homer's impressions to be missing: instead, the *technê* reveals accurately everything that is there' (θεωρῶν δέ τις τὰ ὅπλα λεῖπον εὑρήσει τῶν Ὁμήρου ἐκτυπωμάτων οὐδέν, ἀλλ' ἀκριβῶς ἡ τέχνη δείκνυσι τἀκεῖθεν πάντα, *Imag.* 10.5).[69] We will return shortly to the topos of *technê* at stake here—the familiar Greek pun on the shared craftsmanship of words *and* pictures. For now, though, it is enough to show how the Younger Philostratus—like Virgil and Lucian before him—is expanding upon themes of pictorial–poetic replication themes already present in Homer.[70]

[66] The classic discussion of the cultural dynamics at work here is Boeder 1996 (discussing the *Imagines* of the Elder Philostratus at 137–70).

[67] e.g. ὁρᾷς, *Imag.* 10.5; ὁρᾷς, 10.6; ὁρᾷς, 10.7 (twice); ἰδού, 10.8; ὁρᾷς, 10.8 (twice); ὁρᾷς, 10.9; ὁρᾷς, 10.10 (twice); ἰδεῖν, 10.10; ὁρᾷς, 10.11; ἰδού, 10.12; ὁρᾷς, 10.13; ὁρᾷς, 10.17; ὁρᾷς, 10.19.

[68] Cf. Pasquariello 2004: 112 on this 'meraviglioso caso di *ekphrasis* nell'*ekphrasis*' (with the list of allusions in n. 10): 'Filostrato descrive lo scudo così come lo aveva rappresentato Omero, punto dopo punto'.

[69] Contrast Philostratus the Younger's emphasis on totality here (πάντα) with the *non enarrabile* texture of the Virgilian ecphrastic object (*Aen.* 8.625). On the force of ἐκτυπωμάτων—referring to reliefs that are physically forged, and to impressions that are intellectually shaped in the mind—see below, pp. 340–1 n. 97.

[70] The point has most recently been championed by Francis 2009, comparing Homeric ecphrasis with Hes. *Theog.* 570–615 and *Op.* 60–109: 'The relationship between word and image in ancient ekphrasis is, from its beginning, complex and interdependent, presenting sophisticated reflection on the conception and process of both verbal and visual representation . . . The very idea of representing a visual work of art with artistic words entailed a level of sophistication which had already begun to think abstractly about these modes of representation' (3, 16); cf. Becker 1995: 23–40, for a similar reading of the *Progymnasmata* in the

To elaborate the point, we need to look back at the Iliadic description of Achilles' shield itself. Although there is a huge bibliography on this passage, I restrict myself to just two essential points.[71] The first concerns the way in which the Homeric poet stages—like Virgil, Lucian, and Philostratus—a multilayered series of replications within his own poetic representation of the shield's 'wonders'. Just before Homer's ecphrasis begins, the poet has Hephaestus declare that the shield will be an object of amazement—'such that anyone among the multitude of men who look upon it will marvel' (οἷά τις αὖτε | ἀνθρώπων πολέων θαυμάσσεται, ὅς κεν ἴδηται, 18.466–7).[72] Shortly afterwards—in the description of the first city at peace—we hear of a group of women who *themselves* marvel at the scenes before them (θαύμαζον, v. 496).[73] Our supposed visual reaction to the described shield is therefore quite literally prefigured in the later description of its characters: the ecphrasis stages a receding sequence of representations, whereby future audiences of this text are said to look in wonder at visual subjects who are themselves said to look in wonder at what they see.[74]

light of the pseudo-Hesiodic *Shield*, with its 'acceptance of the illusion proposed by the ekphrasis' and 'complementary breaking of that illusion' (24–5).

[71] Of the many discussions of *Il.* 18.478–608, I have benefited from the following in particular: Marg 1957: 20–37; Taplin 1980; Lynn-George 1988: 174–200; Becker 1990 and 1995; M. W. Edwards (ed.) 1991: 200–33; Byre 1992; Heffernan 1993: 10–22; Stanley 1993: 3–26; Simon 1995; Aubriot 1999; Primavesi 2002: 192–208; L. Giuliani 2003: 39–47; Scully 2003; Francis 2009: especially 8–13; d'Acunto and Palmisciano (eds.) 2010.

[72] For discussion, see Becker 1995: 98. On the foundational phenomenology of 'wondering' before an image, see Prier 1989, along with Vernant 1991: especially 164–85.

[73] See especially Becker 1995: 109–10: '*Thauma* (wonder) characterizes both the reaction of these women to the procession and an anticipated reaction of a viewer to the shield . . . Such a consonance gives the visual arts another similarity to the world they represent; the referent and the medium each elicit *thauma* . . . both Hephaistus and the narrator can give us images with *noos, sthenos,* and *audê*, and both elicit marvel or wonder (*thauma*).'

[74] This is just one of several recessions in the ecphrasis: compare, for example, the descriptions of warriors in the city at war on this shield 'gleaming in their armour' (τεύχεσι λαμπόμενοι, *Il.* 18.510; cf. also v. 522)—raising the question of what in turn might be represented on *their* shields. In fact everything about this sung ecphrasis—which itself describes further songs heard within the image—suggests a *mise en abyme* of artistic replication: in the context of Hephaestus 'making many Daedalic adornments with cunning skill' on the shield (ποίει δαίδαλα πολλὰ ἰδυίῃσι πραπίδεσσιν, v. 482; cf. πάντοσε δαιδάλλων, v. 479; δαίδαλα πάντα 19.13), it is surely significant that the dancing floor at vv. 590–2 is compared to one that Daedalus himself 'fashioned for fair-haired Ariadne' (Δαίδαλος ἤσκησεν καλλιπλοκάμῳ Ἀριάδνῃ, v. 592): Daedalus' act of artistic creation is replicated on Hephaestus' own (and vice versa). Perhaps most sophisticated of all is one of the images within the context of that Daedalic dancing floor: the poet likens the dance crafted by Hephaestus to a *further* act of artistic production—'a potter sitting by his wheel situated between his hands and making trial of whether it will turn' (ὡς ὅτε τις τροχὸν ἄρμενον ἐν παλάμῃσιν | ἑζόμενος κεραμεὺς πειρήσεται, αἴ κε θέῃσιν, 18.601–2). This verbal simile, spinning the ecphrasis of an image being made back to an image of artistic production, was not wasted on Philostratus the Younger, who in turn uses it within his own ecphrasis of the painting of the ecphrasis (*Imag.* 10.19): as ever, Philostratus draws out *mises en abyme* already present in the Homeric text.

This leads to a second point, about the relationship between 'seeing' these wonders and 'hearing' of them through this wondrous description. Although Hephaestus talks of future generations *looking upon* the shield (ὅς κεν ἴδηται, *Il.* 18.467), the description that follows knowingly encompasses not just things seen, but also things heard. The ecphrasis evokes all manner of different sounds, from flutes and lyres (vv. 493–5, 525–6, 569) to cheering (v. 502), loud-voiced heralds (v. 505), and the tumult and lowing of cattle (vv. 530–1, 580) and the barking of dogs (v. 586).[75] Within the poetic recitation of the picture, we even hear of a depicted recitation of song: sat in the midst of a group of dancers, a boy is shown 'among them playing delightfully on his clear-toned lyre, finely singing the Linus song with his delicate voice' (τοῖσιν δ' ἐν μέσσοισι πάϊς φόρμιγγι λιγείῃ | ἱμερόεν κιθάριζε, λίνον δ' ὑπὸ καλὸν ἄειδε | λεπταλέῃ φωνῇ, 569–71).[76]

The Homeric ecphrasis certainly offers a verbalization of the visual, then. But as the various sounds described along the way make resonant, the shield is itself a multimedial entity: like the ecphrasis replicating it in words, this visible artefact appeals to the eyes *and* to the ears. Better, I think, we are dealing with the prototypical dialectic (and slippage) between 'seeing' and 'hearing' in the first place—a phenomenon that, as we have seen, would come to define ecphrasis as rationalized rhetorical trope.[77] The complex games of Hellenistic ecphrastic epigram are only a short step away,[78] as, indeed, are the mind-

[75] For an excellent discussion, see Männlein-Robert 2007b: 13–17: 'so wird in der Schildbeschreibung ausdrücklich geschrieen, gesungen, gebrüllt und musiziert' (15). She cites the following examples (15 nn. 11–12): *Il.* 18.493–5, 497, 502, 505, 525–6, 530, 556–7, 569–72, 574–6, 580–1, 586, 604–5. Among these various noises, note the *negative* sound of a king standing 'in silence' among those harvesting his estate (βασιλεὺς δ' ἐν τοῖσι σιωπῇ, 18.556): as Francis 2009: 10 comments, silence is a 'condition paradoxically easy to describe in words but difficult to do in mute images' (cf. Becker 1995: 131–2). Here, I would suggest, is the primal scene behind the Simonidean comparison of the arts—whereby painting is 'silent poetry' and poetry is 'talking painting'.

[76] See Männlein-Robert 2007b: 13–14: 'Indem er diese Figuren in seine dichterische Darstellung des Bildmediums einarbeitet, erzeugt er eine mise-en-abyme-Struktur' (14); cf. Becker 1995: 135–7. Männlein-Robert also compares the scene of the singer at (what she labels) *Il.* 18.604 (μετὰ δέ σφιν . . . θεῖος ἀοιδός), although only *Ath.* 5.181a–b preserves the verse, and it is usually rejected (cf. Revermann 1998: especially 34–5).

[77] Not for nothing will the pseudo-Hesiodic *Shield* turn the Homeric miracle of sight (θαυμάσσεται, ὅς κεν ἴδηται, 18.467) into a miracle of speech (cf. Becker 1995: 35–6): the wonder of the Pseudo-Hesiodic text is that it takes Homer's great wonder for viewing and self-consciously turns it into a 'great wonder to tell' (θαῦμα μέγα φράσσασθ', *Sc.* 218).

[78] For the point, see Männlein-Robert 2007b: 17. The epigrams on the shield of Achilles surviving in *Anth. Pal.* 9.115, 115B, 116 provide a miniature case study: one of the epigrams gives the shield a voice of its own (it 'shouts', 'summoning' its owner, βοᾷ . . . ἐκκαλέουσα, *Anth. Pal.* 9.116.1–2), while another plays with the suggestion that it is an epideictic epigram, set against the *real* shield displayed in Salamis (*Anth. Pal.* 9.115B), and perhaps even inscribed on the shield's visual surface. The poems knowingly turn Homer's verbally mediated image into a *speaking* replication of that visible object represented in words; at the same time, they shrink the Homeric description to a single elegiac couplet. As such, the multimedial shield described by Homer, at once intended to be seen and to be read, figures the ambiguous ontology of

bending fabrications of Second Sophistic authors like Philostratus the Younger.[79]

The Homeric description also sets the agenda for the discussions of ecphrasis centuries later in the *Progymnasmata*. As we have said, one of the specific characteristics of ecphrasis to which the *Progymnasmata* draw explicit attention is its fictiveness: hearing *almost* (σχεδόν) brings about seeing, as Hermogenes relates. We have already suggested that Virgil, Lucian, and Philostratus develop this thinking, and we could have mentioned countless other examples. Once again, however, all these authors take their theoretical lead from the Iliadic prototype. For arguably the most marvellous thing about the Homeric shield—and the poetic replication of it in words—is its capacity to seem what it is not: 'the shield repeatedly celebrates in each spectacle an artful carnival of contrariety', as Michael Lynn-George nicely puts it.[80] Amid the vivid descriptions of the scenes and actions actively crafted onto the shield are a series of reminders about the shield's 'real' medium—its artificial manufacture out of bronze, tin, silver, and gold (e.g. vv. 474–5, 480, 517, 549, 562, 563, 574, 577, 598).[81] Still more explicit is a detail of one of the landscape scenes, describing the effects of the plough (*Il.* 18.548–9):

ἡ δὲ μελαίνετ᾽ ὄπισθεν, ἀρηρομένη δὲ ἐῴκει
χρυσείη περ ἐοῦσα· τὸ δὴ περὶ θαῦμα τέτυκτο.

epigram between inscribed physical monument and anthologized literary fiction (cf. Squire 2010a: 608–16).

[79] There can be no doubt that Philostratus the Younger read the Homeric ecphrasis in these terms. The ecphrastic sounds of Homer echo in the Philostratean description (of the painting of the Homeric description) of the shield, while Philostratus adds audible innovations of his own—the women in the city at peace not just marvelling at the sights but also shouting for joy (*Imag.* 10.7), for example, or Homer's cheering in the agora and the 'loud-voiced' heralds (*Il.* 18.502, 505) now transformed back into silence (*Imag.* 10.8). Philostratus plays endlessly on the tropes of seeing and hearing, as when he predicts we shall want to *hear* about the stars depicted rather than just seem them (ἀκοῦσαι, 10.6), or when— punning further on the language of *technē*—he asks us, upon seeing a group of herdsmen, whether 'the simple and autochthonous aspect of their music does not reach you, a highland strain without *technē*' (ἢ οὐ προσβάλλει σε τὸ λιτὸν καὶ αὐτοφυὲς τῆς μούσης καὶ ἀτεχνῶς ὄρειον, 10.10). That Philostratus' description resonates with the *specific* rhetoric of theorizing ecphrasis in the *Progymnasmata* is most spectacularly demonstrated at *Imag.* 10.17: the marvel of the picture's cows is not their colour (χρόας οὐκ ἂν θαυμάσειας), explains the speaker, but rather the fact that you can 'virtually *hear* the cows mooing in the painting/ description [*graphē*] (τὸ δὲ καὶ μυκωμένων ὥσπερ ἀκούειν ἐν τῇ γραφῇ —the onomatopoeic verb reproducing that of *Il.* 18.580. In an amazing play on the technical language preserved in the *Progymnasmata* (cf. p. 327), Philostratus asks whether it is not this *image*, but rather these *sounds,* that are the height of *enargeia* (πῶς οὐκ ἐναργείας πρόσω; *Imag.* 10.17).

[80] Lynn-George 1988: 181.

[81] See especially *Il.* 18.478 (ποίει), 482 (ποίει), 483 (ἔτευξ᾽), 490 (ποίησε), 541 (ἐτίθει), 550 (ἐτίθει), 561 (τίθει), 573 (ποίησε), 587 (ποίησε), 607 (τίθει), 609 (τεῦξε). 'The audience is deliberately reminded that these are but images, representations in metal', as Francis 2009: 12–13 concludes (13).

And the field grew black behind [the ploughman] and looked as if it had been ploughed, although it was made of gold. This was the greatest marvel of his craftmanship.

The *marvel* (θαῦμα) of this fictive detail leads us back to Hephaestus' prediction of our marvelling before the shield (θαυμάσσεται, v. 467), as well as to the marvelling human subjects depicted within in (θαύμαζον, v. 496).[82] But it is no coincidence that Aphthonius makes the concept of *thauma* fundamental to the account of rhetorical ecphrasis in his *Progymnasmata*.[83] Like the verbal evocation of the shield in words, the Homeric object on which the ecphrasis is modelled slips *between* different ontological registers: it attempts to convince us of its reality while acknowledging its status as representation. The shield is now raw matter, now worked image. Indeed it is the oscillation between the two that makes the shield (like the ecphrasis mediating it) so wondrous.

From the perspective of subsequent writers, writes Deborah Tarn Steiner, such references serve as a 'reminder of the *techne* on which the marvel depends'.[84] The craftsmanship of the smith god Hephaestus would be assimilated with that of the poet: the *technê* of *visually* mediating these scenes through relief imagery becomes a figure for the poet rendering the imagery through language. As a verbal replication of an image, the Homeric ecphrasis moulds its *own* fictions of representation within the ecphrasized picture represented.

ECPHRASIS IN REVERSE: VISUALIZING THE VERBAL

By the time our two *Tabulae Iliacae* were sculpted, this concept of *technê*—the idea of Homer as consummate artist, and of his poetic forging of (Hephaestus' forging of) Achilles' shield as a sort of picture in words—was evidently widespread. A number of ancient critics drew explicit attention to Homeric ecphrasis as a *poiêsis* that combined poetic and pictorial forms of 'making'. Homer, as Lucian puts it another of his playful Second Sophistic ecphrases, is (described as) 'the best of painters/describers' (ὁ ἄριστος τῶν γραφέων, *Imag.* 8).[85]

[82] cf. Rabe (ed.) 1926: 41. For discussion, see Becker 1995: 128–30, who nicely compares schol. T on *Il.* 18.548–9 (Erbse (ed.) 1969–88: 4.551): 'This is unbelievable, and Homer himself made it believable through his amazement' (ἄπιστον δέ, καὶ αὐτὸς διὰ τοῦ θαυμάζειν πιστὸν εἰργάσατο); cf. Becker 2003: 11.

[83] Becker 1995: 29–30 provides an excellent discussion. The Homeric aesthetic of wonder, as Becker subsequently puts it, accordingly 'acknowledges the untranslatability of a particular aspect of the image' (129 n. 239).

[84] D. T. Steiner 2001: 21–2 (quotation at 22).

[85] For a scintillating survey, see Zeitlin 2001: 218–33. One might compare Dio Chrysostom's twelfth ('Olympic') *Oration*, analysing the respective 'graphic' materializations of Zeus derived from Homer and Pheidias: see Zeitlin ibid. 220–3; Betz 2004; Platt 2009b: 149–54.

Many critics commented specifically on the Homeric *technê* behind the shield of Achilles. The description of Homer as a 'poet who loves *technê*' (ποιητὴς φιλότεχνος) dates back at least to the time of Aristarchus in second-century BC Alexandria;[86] discussing the tradition that the poet was blind, Cicero declares that 'we actually *view* his work—not as poetry, but as a picture' (*at eius picturam non poësim uidemus*, *Tusc.* 5.39.114).[87] In his later commentary on the shield of Achilles passage, Eustathius goes even further, talking about the 'picture-gallery quality' (πινακογραφικὸς χαρακτήρ) of the Homeric evocation of the shield, labelling it as something imitated by subsequent 'descriptive' authors (οἱ περιηγούμενοι).[88] One need only look at the paintings of the Grand Masters, adds Maximus of Tyre: have Polygnotus and Zeuxis not learned their *technê* from Homer himself (Max. Tyr. 26.5)?

A treatise on the *Life of Homer*—attributed to Plutarch, but more likely composed *c.* AD 200—encapsulates this underlying idea.[89] Evaluating all of the different skills and genres that could be said to originate with Homeric epic—medicine, tragedy, comedy, even epigram among them—the author argues that Homer must also be considered a proto-painter (*Vit. Hom.* 216):[90]

εἰ δὲ καὶ ζωγραφίας διδάσκαλον Ὅμηρον φαίη τις, οὐκ ἂν ἁμαρτάνοι. καὶ γὰρ εἴπέ τις τῶν σοφῶν ὅτι ἐστὶν ἡ ποιητικὴ ζωγραφία λαλοῦσα, ἡ δὲ ζωγραφία ποιητικὴ σιωπῶσα. τίς οὖν πρῶτος ἢ τίς μᾶλλον Ὁμήρου τῇ φαντασίᾳ τῶν νοημάτων ἔδειξεν ἢ τῇ εὐφονίᾳ τῶν ἐπῶν ἐκόσμησε θεούς, ἀνθρώπους, τόπους, πράξεις ποικίλας; ἀνέπλασε δὲ τῇ ὕλῃ τῶν λόγων καὶ ζῷα παντοῖα καὶ μάλιστα τὰ ἀλκιμώτατα, λέοντας, σύας, παρδάλεις· ὧν τὰς μορφὰς καὶ διαθέσεις ὑπογράψας καὶ ἀνθρωπείοις πράγμασι παραβαλὼν ἔδειξεν ἑκατέρας τὰς οἰκειότητας. ἐτόλμησε δὲ καὶ θεοῖς μορφὰς ἀνθρώπων εἰκάσαι· ὁ δὲ τὴν ἀσπίδα τῷ Ἀχιλλεῖ κατασκευάσας Ἥφαιστος καὶ ἐντορεύσας τῷ χρυσῷ γῆν, οὐρανόν, θάλασσαν, ἔτι δὲ μέγεθος Ἡλίου καὶ κάλλος Σελήνης καὶ πλῆθος ἄστρων στεφανούντων τὸ πᾶν καὶ πόλεις ἐν διαφόροις τρόποις καὶ τύχαις καθεστώσας καὶ ζῷα κινούμενα καὶ φθεγγόμενα, τίνος οὐ φαίνεται τέχνης τοιαύτης δημιουργοῦ τεχνικώτερος;

[86] Cf. e.g. schol. A on *Il.* 1.8–9 (Erbse (ed.) 1969–88: 1.11) and on *Il.* 2.681 (ibid. 1.322), and schol. T on *Il.* 11.102 (ibid. 3.144–5). For discussion, see Schenkeveld 1970: 163–4, 175–6: 'According to Aristarchus, Homer was a poet who took his art very seriously and who was, moreover, a perfect craftsman' (176); cf. Porter 1992: 74–5.

[87] 'What district, what shore, what spot of Greece', Cicero continues, 'has Homer not depicted so vividly that he has made us see the things which he himself would not have seen? What aspect and form of battle, what front line of combat, what rowing crew, what movements of men and of animals?' (*quae regio, quae ora, qui locus Graeciae, quae species formaque pugnae, quae acies, quod remigium, qui motus hominum, qui ferarum non ita expictus est, ut quae ipse non uiderit, nos ut uideremus effecerit*).

[88] See above, p. 332 n. 65 (on Eustathius ad *Il.* 18.607: van der Valk 1971–87: 4.272). Eustathius is surely thinking of writers like Philostratus the Younger.

[89] On the date of the text, see Keaney and Lamberton (eds.) 1996: 10–29.

[90] For the passage, see ibid. 306–9, along with Hillgruber (ed.) 1994–9: 2.435–8.

If one were to say that Homer was a teacher of painting as well, this would be no exaggeration, for as one of the sages said, 'Poetry is speaking painting and painting is silent poetry'. Who before, or who better than Homer, displayed for the mind's eye gods, men, places, and various deeds, or ornamented them with the euphony of verse? He sculpted in the medium of language all kinds of beasts and in particular the most powerful: lions, boars, leopards; by describing their forms and dispositions and drawing on human matters for comparison, he demonstrated the special properties of each. He dared also to give the gods human shape. But Homer's Hephaestus, making the shield of Achilles and sculpting in gold the earth, the heavens, the sea, even the mass of the sun and the beauty of the moon, the swarm of stars that crowns the universe, cities of various sorts and fortunes, and moving, speaking creatures—what practitioner of such *technê* does he not seem to excel?

Pseudo-Plutarch cites the evidence of the Achillean shield overtly, framing his discussion of Homeric *technê* in terms of Simonides' famous analogy between 'silent' painting and 'talking' poetry. While pictures remain silent, the Homeric imagery contains 'moving, speaking creatures' (ζῷα κινούμενα καὶ φθεγγόμενα): the graphic quality of Homer's language means that—in the author's metaphor— the poet is able to 'sculpt' through language (ἀνέπλασε . . . τῶν λόγων).[91] Homer, it seems, possesses a unique capacity that at once likens him to the visual artist and gives him the upper technical hand: he appeals not simply to our physical sense of sight, but reveals things directly, providing a sort of *intellectual* insight 'to the *phantasia* of our thoughts' (τῇ φαντασίᾳ τῶν νοημάτων).[92] Pseudo-Plutarch reinforces the point in the chapter that follows, moving from the Achillean shield to other examples 'where Homer's creations are such that we seem to *see* them rather than *hear* them' (again echoing the *Progymnasmata*'s rhetoric for discussing ecphrasis).[93] The clear analogy between the *technê* of Hephaestus and Homer might be left unspoken, but it is clear to see: as the author asks us, who can claim

[91] For the Simonidean comparison, see Plut. *Mor.* (*De glor. Ath.*) 346f (= Simon. frg. 190b Bergk): 'Simonides says that painting is silent poetry and poetry is talking painting' (ὁ Σιμωνίδης τὴν μὲν ζωγραφίαν ποίησιν σιωπῶσαν προσαγορεύει, τὴν δὲ ποίησιν ζωγραφίαν λαλοῦσαν); on the aphorism—'frequently repeated' as Plutarch elsewhere describes it (*Mor.* (*Quomodo adul.*) 17e)—see e.g. Carson 1992; Manieri 1995; Sprigath 2004; Männlein-Robert 2007b: 20–2. Cf. also Männlein-Robert ibid. 31 on Pl. *Phdr.* 275d: Plato contrasts the silence of painting with the capacity of words to go on repeating themselves without end.

[92] On *phantasia*, and its relation to concepts of ecphrasis, see especially Rouveret 1989: 383–405; Elsner 1995: 26–7; Benediktson 2000: 163–88; Männlein-Robert 2003; Webb 2009: 107–30; Squire 2010d; cf. below p. 354 n. 131.

[93] *Vit. Hom.* 217 (Keaney and Lamberton (eds.) 1996: 308–9): 'Let us look to another of the many examples that show that Homer's creations are such that we seem to see them rather than hear them . . .' (ἴδωμεν δὲ καὶ ἐπὶ ἄλλου ἑνὸς ἐκ πολλῶν παραδείγματος ὅτι ὁρωμένοις μᾶλλον ἢ ἀκουομένοις ἔοικε τὰ ποιήματα).

to be more artistic—to have more *technê* (τέχνης τοιαύτης . . . τεχνικώτερος)—than Hephaestus, as described by Homer?[94]

If the *technê* of Hephaestus' forging the shield—and, by extension, the *technê* of the poet who forges the ecphrasis—was something that literary critics explicitly noted, it was also something with which numerous Greek and Roman writers explicitly played. Of course, Homer does not associate Hephaestus' labour with *technê* specifically, instead comparing his 'many cunning adornments' (δαίδαλα πολλά, *Il.* 18.482) to the creations of Daedalus himself (vv. 590–2).[95] Still, later authors dwelled explicitly on the combined pictorial and poetic *technê* of the Iliadic ecphrasis. Quintus of Smyrna, for example, ends his description of the shield by commenting on its 'countless crafted elements' (μυρία . . . τεχνήεντα, 5.97)—referring at once to the *technê* of the imagined artist, and to Quintus' own craftsmanship in poetically representing that pictorial object (modelled after the visual–verbal *technê* of Homeric precedent).[96] Philostratus the Younger introduces a similar pun, as we have already mentioned: purporting to gaze upon the very picture of Homer's text of the shield, the speaker tells how 'if one were to look at this armour, he will find none of Homer's impressions to be missing: instead, the *technê* reveals accurately everything that is there' (θεωρῶν δέ τις τὰ ὅπλα λεῖπον εὑρήσει τῶν Ὁμήρου ἐκτυπωμάτων οὐδέν, ἀλλ' ἀκριβῶς ἡ τέχνη δείκνυσι τἀκεῖθεν πάντα, *Imag.* 10.5). Part of the witticism here lies in Philostratus' equation between the *technê* of Hephaestus and that of Homer (and by extension, between the *technê* of the painter and that of the speaker describing it): if the verb ἐκτυπόω literally refers to a metalworker striking or smiting his material, it can also refer metaphorically to the 'impression' of an image in the mind—i.e. the ecphrastic art upon which Philostratus is himself engaged.[97] When the speaker

[94] There is additional *technê* in the phrasing: reread the final clause quoted above (*Vit. Hom.* 216) – does the τέχνη τοιαύτη refer to the *technê* of Hephaestus, or to that of Homer? As Keaney and Lamberton (eds.) 1996: 27 put it, 'the creator of Hephaestus and the shield is assimilated to his creation and the global and comprehensive artifact of Hephaestus becomes, implicitly, the Homeric *corpus*'.

[95] See Becker 1995: 96–100 (as well as above, p. 334 n. 74).

[96] Cf. Quint. Smyrn. 5.97–8: 'Countless other crafted elements were placed upon the shield by the immortal hands of clever Hephaestus' (ἄλλα δὲ μυρία κεῖτο κατ' ἀσπίδα τεχνήεντα | χερσὶν ὑπ' ἀθανάτης πυκινόφρονος Ἡφαίστοιο).

[97] Significantly, Philostratus the Younger returns to this opening pun when closing his own description of the shield—knowingly layering *his* 'impressions' onto the literal and metaphorical impressions of Hephaestus, Homer, and the supposed artist of the picture (as well as those of the speaker): 'you have enough of the impressions' (ἱκανῶς ἔχεις τῶν ἐκτυπωμάτων, *Imag.* 10.20; for a related wordplay, in an overtly 'self-reflexive' context—a statue of Narcissus—cf. Callistratus, *Imag.* 5.5, declaring that the speaker has 'modelled' [ἀποτυπωσάμενος] a descriptive image of Narcissus after the material statue that he had seen). Other similar puns are to be found in discussions of the Homeric ecphrasis: cf. schol. T on *Il.* 18.476–7, where the poet is said to have 'divinely sculpted [*dieplasen*] the sculptor [*ton plastên*, i.e. the divine Hephaestus], wheeling him out as if on to a theatrical stage, and showing us his workshop in full view', δαιμονίως τὸν πλάστην αὐτὸς διέπλασεν, ὥσπερ ἐπὶ σκηνῆς ἐκκυκλήσας καὶ δείξας ἡμῖν ἐν φανερῷ τὸ ἐργαστήριον

adds that 'the *technê* reveals accurately everything that is there', there can be no doubting the multilayered ontology of the visual–verbal 'shield': the *technê* of Hephaestus' shield, the *technê* of Homer in describing it, the *technê* of this painting in turning it back to an image, the *technê* of the speaker in evoking it, and the *technê* of Philostratus in 'smiting' all of these levels within the 'images' of his written text (while himself *also* imitating the words and pictures of his purported grandfather). Each *technê* marvellously morphs into the next, leaving us wondering just exactly which 'craftsman' (δημιουργός) should be judged to have worked 'more wisely' (σοφώτερον, *Imag.* 10.7)—god, poet, painter, speaker, or present writer.[98] Or as Philostratus more succinctly puts it of the painting described, exactly 'what *is* the *technê*?' (τίς δ' ἡ τέχνη; *Imag.* 10.18)?

At this point, we are ready to return to tablets 4N and 5O. For if Philostratus the Younger responds directly to Pseudo-Plutarch's question—'what practitioner of *technê* can be found to excel such *technê* as that of Homer's Hephaestus?'—the *Imagines* nevertheless does so in words. The *technê* of our two tablets is different in one critical sense: by visualizing the shield for us physically to see—by turning the Homeric ecphrasis of the image inside out, visualizing the object that the Homeric poet verbalized—the artist offers a *pictorial* retort to *poetic* modes of textual *technê*. Literary ecphrasis is here literalized—transformed from audible-cum-readable letters to actual artefact for viewing. Instead of evoking the shield in yet more words, the reliefs take on the convex, circular, three-dimensional form of the Homeric shield. Where Philostratus purports to verbalize a visualization of Homer's verbal description of the image, the tablets offer ecphrasis in reverse gear, promising not 'seeing through hearing' (as the *Progymnasmata* would have it) but rather, as it were, 'hearing through seeing': we get at the 'absent' ecphrastic text by means of this 'present' ecphrasized object. Indeed, at least one of the tablets drew explicit attention to the *technê* involved (and by means of a pseudo-pictorial 'magic square' inscription): the *shield* might be Achillean, as the verso of tablet 5O puts it, but the *technê* is all Theodorean ([ἀσπὶς] Ἀχιλλεῖος Θεοδώρηος ἡ τ[έχνη]).

There had been earlier visual representations of Achilles' shield, some of them developing closely related themes (and in comparably sophisticated ways).[99] The

(Erbse (ed.) 1969–88: 4.526; on the philosophy behind such 'sculpted' *plasmata*, see e.g. Webb 2009: 168–9, and cf. e.g. Männlein-Robert 2007b: 90–2 on *Anth. Pal.* 9.713–42).

[98] On the combined literary and artistic register of *sophia* in the context of the *Tabulae Iliacae*, see above, pp. 102–21.

[99] See e.g. Johansen 1967: 92–127, 178–84, Fittschen 1973: 2–3, and Hardie 1985: 18–22; cf. *LIMC* 1.1: 122–8, s.v. 'Achilleus' nos. 506–41a, and *LIMC* 4.1: 631, s.v. 'Hephaistos' nos. 1–10. Among the most complex and earliest images comes on the name vase of the Foundry Painter in Berlin (Antikensammlung, Staatliche Museen zu Berlin 2294), brilliantly discussed by Neer 2002: 77–85. While the scenes of sculptural production on the outside of the vase plays upon the 'pervasive facetiousness about the craft of making

theme was an especially popular subject in Pompeian 'Fourth Style' wall paint-ings which showed Thetis at Hephaestus' forge: rendering the shield as their compositional focal point, artists evidently puzzled over how best to render Homer's verbal description through imagery (resorting to miniature emblems like Zodiacal signs, busts, animals, and snakes); one even deflected the question of what the shield 'actually' looked like, turning the pictorial field into a blank space for re-versed subjective reflection (we look at Thetis looking at herself looking (Fig. 157)).[100] But the tablets are unique among surviving archaeological object for actually *materializing* the Homeric artefact in tangible form. The shield is transformed into something multisided and three-dimensional. Here to have and to hold is antiquity's ecphrasis par excellence: the objects now substantiate through images what Homer's verbal representation of a purported visual repre-sentation could only circumscribe through words.

Needless to say, the translation from poem to picture results in what modern scholarship inevitably deems 'discrepancies' between word and image. As so often, scholars have focussed on the details without thinking about the bigger picture: a series of short-sighted grumbles ensue. If we compare the Homeric description of harvesting (*Il.* 18.550–60) with the corresponding scenes on both tablets, for example, we note that Homer does not mention any ox-drawn cart, whereas this detail is clearly visible on both tablets (Figs. 143, 151).[101] Predictably, such minutiae are seized upon as evidence for the poor quality of these supposed 'illustrations'. In his archaeological survey of artistic representations of Achilles' shield, Klaus Fittschen calls the objects 'wholly naive', noting their 'failure' to abide by the structure of the Homeric description.[102] In a passing reference to

images', Neer argues (83), the interior tondo represents—or rather fails to represent—Hephaestus in his own divine forge, handing over Achilles' armour to Thetis. By turning the Homeric description of the shield into a simple schematic blazon (an eagle bearing a snake, surrounded by just four stars), the tondo interrogates the 'limitations of the painter's own *tekhnē*' (ibid.): the painter compares his two-dimensional art with the three-dimensional art of sculpture, all the while framing that comparison in terms of a dialectic between mortal and immortal craftsmanship on the one hand, and between representations in words and images on the other. 'In good sympotic fashion,' as Neer concludes, 'the Foundry Cup expressly thematizes the slips, swerves, and disruptions that characterize both pictorial and graphic metamorphoses . . . The result is a dialectic of word and image, seeming and truth, blacksmith and deity' (85).

[100] Fig. 157 is from the north wall of triclinium e in the Casa di Paccius Alexander, Pompeii IX.1.7: see *PPM* 8: 878, no. 17. On Pompeian wall paintings of the shield, cf. Hardie 1985: 18–20, Gury 1986: especially 432–8, Balensiefen 1990: 56–9, and Hodske 2007: 216–18. For the symbolic 'shielding' function of the mirror (and the symbolic 'deflecting' function of the shield) in such images, cf. Taylor 2008: 137–68, especially 152–8.

[101] As noted by e.g. Hardie 1985: 21 and Valenzuela Montenegro 2004: 245.

[102] Fittschen 1973: 3: Homer, Fittschen suggests, organized the pictorial narratives around a series of concentric rings, whereas both tablets render them in a series of vertically arranged sections ('Umgeben von den Tierkreiszeichen werden die Schildszenen auf ganz naive Weise in horizontal gegliederten Streifen geschildert'). Cf. Bottini and Torelli (eds.) 2006: 245 on tablet 4N's supposed 'rapida realizzazione del relievo' and 'mancanza di proporzioni'.

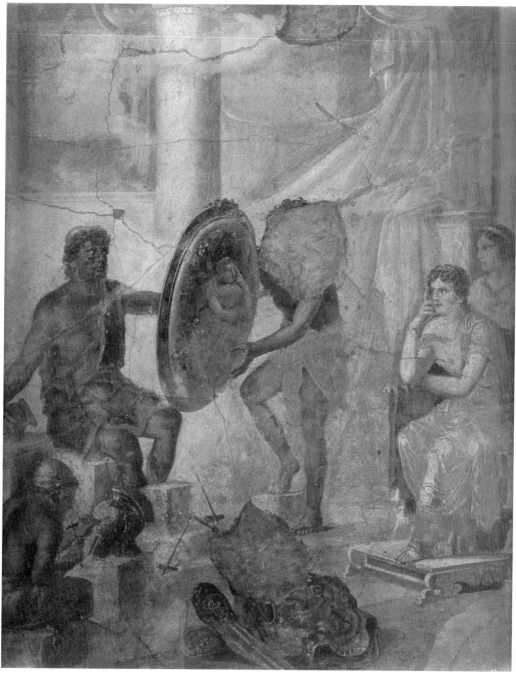

FIGURE 157. 'Fourth Style' wall painting of Thetis and Hephaestus from the Casa di Paccius Alexander, Pompeii IX.1.7 (Museo Archeologico Nazionale di Napoli inv. 110338).

tablets 4N and 5O, Mark Stansbury-O'Donnell proves no less dismissive: 'in both cases the artist has abandoned the circular arrangement of scenes described in the *Iliad* in favour of a simplified, abridged and friezelike composition, which may improve legibility on this scale but hardly does justice to the original description'.[103]

Such complaints are not only unfair, but overlook the meta-ecphrastic fun and games. Most critically of all, they fail to engage with the literary dimensions of the Homeric poem, supposing instead some fanciful 'real' or 'original' object behind the *Iliad*'s forged ecphrastic replication. Here, for example, is how Stansbury-O'Donnell evaluates the layout of the Homeric shield of Achilles in his important book on ancient Greek pictorial narrative:[104]

> According to the poet, the shield of Achilles was round and divided into five concentric bands. The first, innermost zone was a picture of the cosmos with earth, sky, and water. In the next zone were two cities, one of peace and one of war, each with several scenes. In the third zone were agricultural scenes: ploughing, reaping, a vineyard, herding, lions attacking an ox, and finally a meadow with sheep. The fourth contained a dancing floor with young men and women with two acrobats and a crowd of onlookers. Around the rim was the Ocean.

The implication here is that some sort of 'objective' image lies in or behind the Homeric description. There is a long artistic tradition of proceeding in this fashion. If classical archaeologists have attempted to draw the image out of the Homeric text (Fig. 158)—organizing the scenes back into five concentric bands, just as Stansbury-O'Donnell suggests—neoclassical artists like John Flaxman turned the Homeric description back into monumental bronze object (Fig. 159).[105] 'Homer . . . has described this shield . . . so exactly and in such detail

[103] Stansbury-O'Donnell 1995: 316. The author's fleeting dismissal of tablet 4N as representing 'two scenes set in registers above one another' hardly does justice to the compositional complexity. Much more favourable is Bienkowski 1891: 194: 'Le discrepanze che trovammo, sono isolate e insignificanti e si possono tutte spiegare o col diverso linguaggio dell'arte e della poesia ovvero con la natura del lavoro e la ristrettezza dello spazio.' Where modern critics have chastised tablet 4N for departing from some 'objective' image behind the object of Homeric ecphrasis, it is worth noting that its material proportions in one literal sense measure up to the Homeric model: after all, the division of scenes into upper and lower parts, each of equivalent size, pays visual homage to the approximate verbal space allocated to each scene—the 51 lines dedicated to the two cities on the one hand (*Il.* 18.490–540), and the 66 lines on the landscape that follow on the other (vv. 541–606).

[104] Stansbury-O'Donnell 1999: 42.

[105] For this particular archaeological reconstruction, see Murray 1890: 1.42–57 ('In restoring the Shield of Achilles as described by Homer, the process was first to make a tracing of each scene from an authoritative publication of the ancient work of art selected to illustrate it, and next to draw from these tracings the various scenes on a uniform scale', ibid. 1.viii). Fittschen 1973: 3–4 lists other reconstructions of the shield from the sixteenth century onwards.

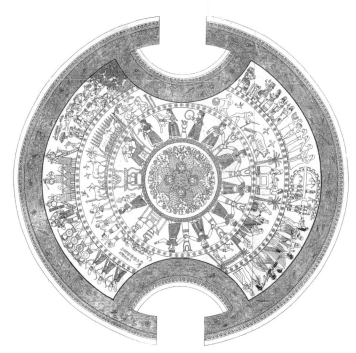

FIGURE 158. Reconstruction of the shield of Achilles by A. S. Murray and W. H. Rylands in the late nineteenth century.

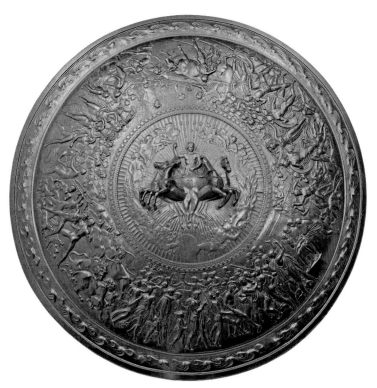

FIGURE 159. Shield of Achilles, designed by John Flaxman, made by Rundell, Bridge, and Rundell, chased by William Pitts, c.1824: the chariot of the Sun is shown at the centre, with a single continuous frieze running around it (Fitzwilliam Museum inv. 12198; diameter: 89.5 cm).

that it was not difficult for modern artists to produce a drawing of it exact in every part', as Gotthold Ephraim Lessing wrote in his 1766 *Laocoon*.[106]

The conspicuous differences between Figs. 158 and 159—and still more their deviation from an ancient 'reconstruction' like tablet 4N—visualize an important point about the Homeric ecphrastic description: namely, that the text provides remarkably little information about the physical design of the shield described.[107] So too with the shield's supposed division into five discrete and separate bands. If we look back to the poem, we find no such delineation of scenes, as Stansbury-O'Donnell and others have assumed, and only a very vague opening impression of the shield's design (*Il.* 18.478–82):

> ποίει δὲ πρώτιστα σάκος μέγα τε στιβαρόν τε
> πάντοσε δαιδάλλων, περὶ δ' ἄντυγα βάλλε φαεινὴν
> τρίπλακα μαρμαρέην, ἐκ δ' ἀργύρεον τελαμῶνα.
> πέντε δ' ἄρ' αὐτοῦ ἔσαν σάκεος πτύχες· αὐτὰρ ἐν αὐτῷ
> ποίει δαίδαλα πολλὰ ἰδυίῃσι πραπίδεσσιν.

First he made a shield great and mighty, adorning it cunningly in every part, and around it he set a bright rim of three parts that glittered, and from it he fastened a silver baldric. Five were the layers of the shield itself, and on it he made many adornments with cunning skill.

After this initial evaluation, the poet proceeds to catalogue the represented subjects in a long list.[108] As we have observed, we only return to the overall design at the very end of the ring-composed description when Hephaestus is said to have 'set the great might of river Ocean around the outermost rim of the well-made shield' (*Il.* 18.607–8).[109] These are the only clues that the Homeric poet delivers about the compositional arrangement. The inventory of scenes catalogued inbetween might be introduced by variations on the same formula—detailing some nine or so subjects that Hephaestus is said to have represented 'on' and 'in' the

[106] See Lessing 1984: 94–5 [ch. 18]. The supposed 'exactness' of the forged image forged does not stop Lessing from supposing that the images were rendered on *both* sides of the shield (98 [ch. 19]): 'obviously, not everything Homer says can be combined into a single picture' (99–100 [ch. 19]).

[107] Cf. Stanley 1993: 5–6: 'In purely graphic terms, such reconstructions are beset by difficulties inherent in the poet's refusal to specify the relevant position of the scenes...The poet's decision to avoid calling attention to the physical design of the finished product in favor of the act of fabrication places emphasis on Hephaistos' point of view, as the poet presents it through his own verbal arrangement.'

[108] Note, though, the artful structure of that list: see especially Stanley 1993: 1–13 (with chart 1.1 at p. 10): 'In the description as a whole, then, the poet uses refrain-composition, ringing devices, and interlocking form to emphasize the integrity of individual elements and establishes connection between them through repeated introductory phrases' (12).

[109] See above, pp. 320–1. The rim is brilliantly discussed by Lynn-George 1988, noting that 'even the very border of the shield, the all-encompassing rim which would frame the work as an enclosed totality, is part of a relation which resists a rounding off' (189).

shield.[110] But nowhere is there any suggestion as to *how* these scenes spatially relate to each other. It is unfair to criticize the Homeric poet for what some have deemed the 'vagueness' of this account:[111] to assume that the description set out to translate some 'real' object into poetry would be as intellectually wrong-headed as to suppose that there is only one, objective reconstruction for the object behind the poem.[112]

Our two tablets take up these games of visual–verbal suggestion while developing them in new and sophisticated ways. Once again, they invert the theoretical scope of the ecphrasis. The Homeric description promises to shed its verbal cocoon and hatch into images, all the while frustrating any such movement through the opacity of its description. In the same way that the depicted imagery leaves its narrative outcomes unspoken—who wins the lawcourt scene in the city at peace? what happens in the battle over the city at war? do the herdsmen finally scare off the lions?[113]—the Homeric words occlude the hidden clues about physical form: 'exactly what Hephaestus wrought on the shield', James Heffernan concludes, 'is ultimately impossible to visualize'.[114] The two *Tabulae Iliacae*, on the other hand, now provide a visual impression of the shield, but play with the difficulties of reconstructing the text from the images at hand. In materializing the shield, the tablets offer a *pictorial* commentary on Homer's *verbal* commentary on the challenges of moving from image to ecphrastic text (or indeed from ecphrastic text back to ecphrasized object): how in short, are we to turn these pictures back into narrative words? We have already noted how the upper and lower scenes of tablet 4N experiment with different organizational strategies, arranging them according to conflicting spatial rationales: the two city scenes in

[110] The passages are as follows (all introduced by the same adverbial preposition, a particle, and active verb): ἐν μὲν…ἔτευξ' (*Il.* 18.483), ἐν δὲ…ποίησε (v. 490), ἐν δ' ἐτίθει (v. 541), ἐν δ' ἐτίθει (v. 550), ἐν δ' ἐτίθει (v. 561), ἐν δ'…ποίησε (v. 573), ἐν δὲ…ποίησε (v. 587), ἐν δὲ…ἤσκησεν (vv. 590, 592), ἐν δὲ τίθει (v. 607). This counting of nine scenes follows e.g. Byre 1992: 33–4. But such accountancy is always open to question: how, for example, to make sense of the other subjects represented alongside the earth in vv. 483–9 (ἐν μὲν…ἐν δ'…ἐν δὲ…ἐν δὲ), or the spatial relationship between the cities at war and peace (ἐν τῇ μὲν, τὴν δ' ἑτέρην πόλιν ἀμφὶ, vv. 491, 509)?

[111] e.g. Willcock (ed.) 1984: 271 ('the picture is a little confused, as if Homer himself is deceived by what he is imagining'); cf. P. Friedländer 1912: 2, who romantically claims that the poet's 'jugendliche Freude an belebter Erzählung' means that he is 'einfach nicht imstande, eine bildmäßige Vorstellung…festzuhalten'.

[112] Cf. Taplin 1980: 3: 'the decoration of the shield is derived from poetic invention, not from history'.

[113] See Lynn-George 1988: 176–86 (on scenes 'constructed as an anticipation of an end which is always still to come', 183); cf. Byre 1992: 38–40; Heffernan 1993: 17–18; Primavesi 2002: 200–1. See also L. Giuliani 2003: 40–2 on how this is reflected in the use of tenses, as also argued in Primavesi 2002: 194–201 (counting 88 verbs with a 'durativen oder perfektischen Aspekt', as opposed to just 14 'Prädikate[n] im Aorist'). Of course, Homeric differentiations of tense were never quite as clear-cut as for later Greek authors, but the point nevertheless stands.

[114] Heffernan 1993: 14. Cf. Lynn-George 1988: 178: 'The shield's structure combines a spatial indeterminacy with a fracturing of space into a multiplicity of different, separate sites—a plurality of places combined with a certain placelessness.'

the section above are assembled symmetrically and privilege a horizontal axis; the scenes in the lower section, by contrast, begin at the bottom of the tablet, meandering upwards from right to left, then left to right, and finally from right to left once again (Fig. 152). As on other tablets, this compositional layout raises questions about the respective resources of images and texts—the differences between the linear progression of words, and the spatial arrangement of pictures. In the case of tablets 4N and 5O, though, those questions are themselves prefigured by the poetic subject depicted: this visual representation of a verbal representation is made to mirror the complexities of Homer's verbal representation of a visual representation.

As if there could be any doubting the complex visual–verbal games here, it is worth remembering how the 'magic squares' on the verso of each tablet turn the tables once more. Just as the recto of tablet 4N challenges us to find the immaterial text behind the materialized imagery, the verso (Figs. 105, 145) invites viewer-readers to unscramble the altar picture and recognize the words that lie behind it (offering a title for the obverse scenes). The question of how to make sense of the *grammata* on the verso—whether to take the letters literally, or rather to view them figuratively as palindromic patterns—replays in miniature the conceptual dilemmas of the tablet at large, which at once visualizes and verbalizes the Homeric verbalization of the Hephaestan visualization of the shield. Where one side takes the ecphrastic description of Homeric epic and actualizes it in pictures, the other side reverses the gesture, turning the picture back into verbal language—albeit into a hexameter verse that is now itself arranged as an altar-shaped picture.

So too with the verso's palindrome inscription below (Figs. 105, 145). I can only partly agree with Nina Valenzuela Montenegro's assessment that 'the subject of the palindrome is a game of letters, and no deeper significance is attached to it'.[115] Not only does the formal presentation of the text situate these *grammata* between visual and verbal modes (in the manner of the altar 'magic square' above). The way in which the palindrome letters pretend to be both artefact and representation also harks back to the Homer-derived visual–verbal themes of the recto. On the one hand, these are just letters, detached from the make-believe altar of letters above. On the other, the *grammata* pose as monumental dedicatory inscription—a make-believe *representation* of an inscription, chiselled into the altar of letters depicted above.[116] So is this a *verbal* text for reading, written

[115] Valenzuela Montenegro 2004: 404: 'jedoch handelt es bei (*sic*) diesem Palindrom um ein Buchstabenspiel, dem keine tiefere Bedeutung zukommt'.

[116] Contrast the interpretation of Horsfall 1979a: 33: 'It is possible that their presence was prompted merely by the existence of a tempting empty space below the altar-shaped "magic square", to be filled in with a comparable, if less exacting and less striking "jeu de lettres", perhaps prompted by some association between "altar" and "priest".' My suggestion is that this is not in fact 'empty space' at all; rather, the

independently of the altar? Or does it form part of the *visual* replication of that object—a pictorial mimesis of the *grammata* carved on some 'real' altar (at once visualized and verbalized in the diagram)? For anyone actually trying to speak the letters out loud, the difficulties of shuffling backwards and forwards between image and text must have been plain to hear: *IEREIAIEREI!* The repeating vowels and diphthongs (quite apart from the aspirates) make it inherently tricky to turn these graphic *grammata* back into sounds: despite the order of their *visual* form, the letters amount to a tongue-tying phonetic jingle. So what sort of 'verbivocalvisual' sense might inhere in this mumbo-jumbo nonsense?[117] Like the verbal shield of Achilles visualized on the recto, the verso demands to be read and viewed simultaneously—as text, as image, and as a mirage of each medium in the words or pictures of the other.

THE GREAT AND MIGHTY SHIELD?

The way in which the two Iliac tablets turn the readable description of the shield into graspable artefact is one way in which they replicate the wonder or *thauma* of (Homer's evocation of) Hephaestus' creation. But another manufactured marvel lies in their scale—the way in which they offer a *miniaturized* version of the Homeric account, especially in the case of tablet 4N. The original Homeric ecphrasis made much of the shield's magnitude: in another ring composition that verbally replicates the circular shape of the shield, Homer opens and closes the description by labelling the magnificent object a 'great and mighty shield' (σάκος μέγα τε στιβαρόν τε, *Il.* 18.478, 609).[118] So grand is Achilles' armour, indeed, that it is forged with no fewer than twenty bellows (v. 470), worked on a 'great anvil' (μέγαν ἄκμονα, v. 476) and forged with a 'mighty hammer' (ῥαιστῆρα κρατερήν, v. 477).[119] Hephaestus forges something *über*-lifesize: a superhuman shield for a superhuman hero. Once again, though, tablet 4N inverts the textual description. If the Homeric shield is marvellous for its magnitude, tablet 4N, is a materialized miracle of *miniature* mimesis: the tablet has a diameter of just 17.8 cm—no larger than a small frisbee or supper plate.

As always with the *Tabulae Iliacae*, discourses of scale are sutured over those of visuality: the tablets offer a synopsis that encompasses both the big in the small

inscription purports to be attached to the *actual* altar that is at once depicted and inscribed above. What mattered, in other words, was the visual–verbal *make-believe*.

[117] I take the term 'verbivocalvisual' from James Joyce and Marshall McLuhan, via Mayer 1979: 39.

[118] Cf. Becker 1995: 149 on how the phrase 'brings us back to where we started this long description'— the phrase 'encircles the Shield, as the depiction of Oceanus encircled the shield'.

[119] On the programmatic significance of the adjectives, see Becker 1995: 95.

and the verbal in the visual (and vice versa). What is particularly remarkable about
tablet 4N, however, is the way in which it replicates its own replicative conceits
after the replicative model of Homeric ecphrastic replication. The Homeric shield
of Achilles might be gigantic, but once we read it more closely (or indeed look at
it from the more distant perspective of the larger poem) we find a much more
complex discourse about size and proportion. Although the shield is said to
encapsulate the whole cosmos in its representation, its verbal description in fact
zooms in and out, moving from the grand to the small and back again: as we have
already noted, the universal frame of the description's beginning and close—the
opening evocation of the sun, moon, sea, and stars (*Il.* 18.483–9) and the final
evocation of the 'great might of river Ocean' around its outer rim (vv. 607–8)—yields
to a series of miniature human vignettes in between (vv. 490–606).[120] Within each of
those miniature sections, moreover, we see subjects that are both little and large, in
an ever-changing kaleidoscope of perspectives.[121] Take the following description
of Ares and Athena venturing into battle, presented as greater in size than the
mortals whom they accompany setting out from the city at war (vv. 516–19):

> ...ἦρχε δ' ἄρα σφιν Ἄρης καὶ Παλλὰς Ἀθήνη
> ἄμφω χρυσείω, χρύσεια δὲ εἵματα ἔσθην,
> καλὼ καὶ μεγάλω σὺν τεύχεσιν, ὥς τε θεώ περ
> ἀμφὶς ἀριζήλω· λαοὶ δ' ὑπ' ὀλίζονες ἦσαν.

Ares and Pallas Athena led them, both of them in gold, and both wearing golden
clothes. The two of them were fair and tall in their armour, for they were both gods
and clear to view among the rest. As for the people around them, they were smaller.

Andrew Becker has drawn attention to the recessions of media in this passage:
Ares and Athena are both *rendered* in gold (namely, this part-golden shield), but
they also *wear* golden clothing. So where, then, does reality end and replication
begin (within this poetic replication of a forged artistic object)?[122] Still more
intriguing in this regard is the scaling of different realities by means of Ares' and
Athena's described size. The two gods form but one detail within the larger
element of the city at war, and that cityscape is further split into two sections
(inside the city and outside it)—all the while forming part of a scene of *two* cities

[120] Cf. Hardie 1986: 340: on the shield as 'a microcosm of society, offering for our inspection a wide-
ranging sample of human activities on earth . . . framed by schematic cosmic images'. Virgil's ecphrasis of
Aeneas' shield of course plays upon closely related themes: as Elsner 2007a: 83 puts it, the Virgilian
ecphrasis describes an object 'at great length for an ekphrasis but with great brevity for the great history of
Rome from Romulus to Augustus'.

[121] Cf. Heffernan 1993: 12 on the 'drastic disparities of scale in the scenes described', so that single scenes
'include both a multitude of spectators and a close-up view'.

[122] Cf. Becker 1995: 118–19: 'These lines point yet again to the oft-asked question: What is being
described—the work of art or the world represented by the work? The answer, as so often on this ekphrasis,
is that these lines describe both the surface of the work and the world depicted therein' (118).

within this little vignette within the shield. Within the ecphrastic frame of an object oscillating from the macro to the micro, and within just one detail of one single scene, however, we witness yet another recession of scales. Yes, Ares and Athena comprise just two tiny visual *minutiae* within the description of the shield. But they are simultaneously described as being *bigger* than all the people surrounding them.[123]

Such miniature size games must be understood in relation to the ecphrastic synopsis at large. The description of the shield does not just encapsulate the subjects of the poem, Oliver Taplin suggests, but also offers a *rival* vision of its themes and epic—one that is larger than the poem.[124] Peace and war, city and country, geographical detail and vast span of the cosmos: the shield offers a miniaturized image of the epic while also also stretching beyond it. Hephaestus' all-encompassing artefact puts everything in perspective, while leaving room for the interpretive vision of the future audience that will encounter it.

Ancient commentators drew explicit attention to this micro-/macro-cosmic quality of the Homeric ecphrasis. Especially noteworthy are those allegorists who read the description in terms of later cosmological conceptions of the universe. We have already mentioned Crates of Mallus, and we have said that tablet 4N's Zodiacal rim may ultimately derive from Crates' allegorical interpretation. But the idea that the frame of Homer's shield represented the *entire* cosmos seems to have been common in antiquity.[125] Heraclitus' *Homeric Problems* preserves the most extensive allegorical interpretation of the shield, seeing it as describing 'the origin of the universe in a grand creative idea' (μεγάλη καὶ κοσμοτόκῳ διανοίᾳ τὴν τῶν ὅλων...γένεσιν, *Quaest. Hom.* 43.1).[126] Such reading strategies stretch back at least to Hellenistic Alexandria: relating a line of Aratus' cosmological poem *Phaenomena* to the Homeric passage, a scholion on Aratus says that Homer rendered on the shield of Achilles nothing less than

[123] With typical sophistication, Philostratus the Younger seizes upon the visual detail of the gods' size, as verbalized by Homer, as a visual device for what the painter wanted to *say*: 'for this, it seems, is what the *technê* speaks...' (τουτὶ γάρ, μοι δοκεῖν, ἡ τέχνη φησί, *Imag.* 10.9).

[124] Taplin 1980: 4–11: 'The shield is a microcosm...It is as though Homer has allowed us temporarily to stand back from the poem and see it in its place—like a "detail" from the reproduction of a painting—within a larger landscape, a landscape which is usually blotted from sight by the all-consuming narrative in the foreground' (12). As Henderson 1993 rightly responds, however, the 'microcosmic' ecphrasis simultaneously visualizes how the poem's 'macrocosmic' significance remains forever open ('reading Homer...is not to reach a verdict, find out the truth, press home an answer', 59). Cf. e.g. Gärtner 1976: 51–60; DuBois 1982: especially 17–18; Byre 1992: especially 43; and the full bibliography cited in Becker 1995: 5 n. 9.

[125] For discussion, see Hardie 1985: 15–17 and 1986: 340–3; Porter 1992: 91–3.

[126] Not for nothing does the same sentence cite this '*great* [μεγάλη] creative idea' as itself a *lesser* example of allegory (ἐλάττω τεκμήρια περὶ τῶν ἠλληγορημένων).

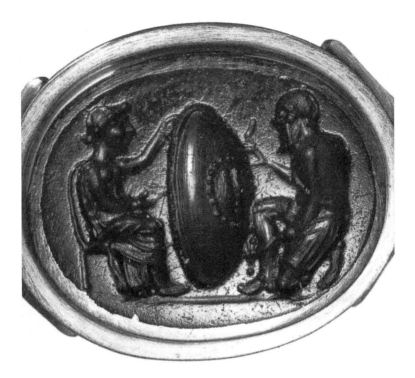

FIGURE 160. Carnelian gem of Thetis and Hephaestus crafting the shield of Achilles, mid first century BC (Kunsthistorisches Museum, Wien, inv. ANSA IX b 679; height: 12 mm; width: 9.2 mm; depth: 2.6 mm).

a 'replication of the cosmos' (κόσμου μίμημα).[127] We find the same idea in Ovid's *Metamorphoses* where, in his bid to inherit Achilles' armour, Ajax describes it as 'a shield engraved with the image of the vast world' (*clipeus uasti caelatus imagine mundi*, *Met.* 13.110).[128] A related paradox evidently appealed to the artist of a microscopic first-century BC Carnelian intaglio, which depicts Thetis and Hephaestus (hammer in hand) on either side of the shield (Fig. 160). Not only does this tiny seal further miniaturize the shield's universal microcosm, the shape of that encased shield is itself recalled in the rounded form of the gem that encases and represents it. Gem, shield, circular pattern within: we are faced with a series of diminishing circles each within and around the other. With each use, moreover, this miniature image of the world is set to go on replicating its own replication, stamped into soft wax.[129]

[127] See Martin (ed.) 1974: 71 for the scholion ad Aratus, *Phaen.* 26.

[128] For discussion, see Hardie 1985: 16–17.

[129] On the intaglio (Vienna Kunsthistorisches Museum IX B 679), see *LIMC* 8.1: 10, s.v. 'Thetis' no. 35 (and cf. e.g. *LIMC* 8.1: 288, s.v. 'Vulcan' nos. 49, 51, 53).

Still more remarkable is the way in which ancient critics explicitly associated the size of the Homeric description with its visual qualities. Among the most enlightening discussions here is the analysis by one of Imperial Rome's most sophisticated—and conspicuously undervalued—readers: Pliny the Younger. Within an ecphrastic letter of his own—evoking his Tuscan villa, and self-consciously framing the act of doing so with the standard rhetoric for discussing ecphrasis—Pliny draws upon the respective sizes of the 'shields' described by Homer and Virgil, explicitly associating the visual power of these verbal descriptions with their perfectly proportioned length (*Ep.* 5.6.42–4):[130]

> In summa—cur enim non aperiam tibi uel iudicium meum uel errorem?—primum ego officium scriptoris existimo, titulum suum legat atque identidem interroget se quid coeperit scribere, sciatque si materiae immoratur non esse longum, longissimum si aliquid accersit atque attrahit. uides quot uersibus Homerus, quot Vergilius arma hic Aeneae Achillis ille describat; breuis tamen uterque est quia facit quod instituit. uides ut Aratus minutissima etiam sidera consectetur et colligat; modum tamen seruat. non enim excursus hic eius, sed opus ipsum est. similiter nos ut parua magnis, cum totam uillam oculis tuis subicere conamur, si nihil inductum et quasi deuium loquimur, non epistula quae describit sed uilla quae describitur magna est. uerum illuc unde coepi, ne secundum legem meam iure reprendar, si longior fuero in hoc in quod excessi.

> In sum—for why should I not state my opinion, be it right or wrong—I consider that it is a writer's first duty to read his title: to keep asking himself what it is he has set out to write, and to realise that the text is not long when he sticks to his subject, but that it becomes too long when he drags in something extraneous to it. You see the number of lines in which Homer and Virgil describe the armour of Achilles and Aeneas; but each author is brief, because he carries out what he intended. You see too how Aratus traces and tabulates the infinitesimal stars; but he keeps to the proper limits. For this is not a digression but the work itself. So it is with us—to compare little with large—when we try to set the entire villa before your eyes: provided that our conversation does not introduce anything like a digression, it is not the letter describing the villa but rather the villa described which is great. But to get back to where I began, so that I am not rightly condemned by the terms of my own law, if I linger any longer in this digression . . .

Pliny's discussion of ecphrasis explicitly turns on issues of scope and scale: it is in turn relevant to the synoptic thinking of our two Iliac tablets in three interrelated ways.

First and foremost, Pliny makes recourse to the Homeric description of Achilles' armour as the *prototypical* example of ecphrastic writing. Homer

[130] The passage is briefly discussed by e.g. Bergmann 1995a: 408; Henderson 2002: 18–20 and 2003: 121–2; and at greater length by Chinn 2007: especially 269–70, 276–8, and Goldhill forthcoming. More generally on the politics and poetics of size in Pliny's letters, see Whitton 2010: 'For Pliny, size matters', as Whitton puts it (119), citing this letter in n. 11.

provides the ecphrastic model after which Virgil's evocation of Aeneas' shield and Aratus' discussions of the stars are modelled, and also foreshadowing the author's own project in this letter. Pliny does not use the word 'ecphrasis' explicitly, but the letter's self-confessed objective of 'setting the entire villa before your eyes' (*totam uillam oculis tuis subicere*) recalls the technical language of the Greek *Progymnasmata*, as well as that used by Latin authors like Cicero and Quinti-lian.[131] The two references to *seeing* the number of lines employed by Homer, Virgil, and Aratus (*uides...uides*) drive home the point: the author invites his reading audience to 'see' in turn how he himself plays upon the familiar topos that ecphrasis brings about 'seeing' through 'hearing'. In this way, Pliny offers an important and timely corrective to the skewed perspectives of the *Progymnasmata*: Pliny clearly viewed the Homeric description of Achilles' shield as the paradigm for all ecphrastic writing, including his own in this letter.[132]

This unabashedly long letter, second, is concerned not solely with visuality, but also with length, as testified by the multitude of words about size, scale, and numbers: *longum, longissimum, quot...quot, breuis, minutissima, magna, longior*, etc. By any measure, Homer's description of Achilles' armour is long (just look at how many lines it occupies!). Still, Homer, like Virgil, is never-theless short because he sticks to his subject and does not digress (*breuis tamen uterque est quia facit quod instituit*). As the case of Aratus is said to prove, there is a close correlation between the visual 'work' described and the textual 'work' (*opus*) describing it: true to an Aristotelian idea of synopsis, Aratus' 'very tiny' representations (*minutissima*) are crafted to fit the macroscale of the poem—'for this is not a digression but the work itself (*non enim excursus hic eius, sed opus ipsum est*).[133] For Pliny, citing the example of Achilles' armour

[131] Cf. e.g. Cic. *Or.* 139 on the speaker who 'will put a matter before the eyes through speech' (*rem dicendo subiciet oculis*), and Quint. *Inst.* 9.2.40 on the art of 'placing before the eyes' (*illa...sub oculos subiectio*); cf. also ibid. 6.2.29–30 on *phantasiae* (or *uisiones*) 'through which images of things absent are represented to the mind in such a way that we seem to see them with our eyes and to have them present before us' (*per quas imagines rerum absentium ita repraesentantur animo, ut eas cernere oculis ac praesentes habere uideamur*). Significantly, Pliny's language of 'describing' (*describat...describit...describitur*) and of the *excursus* (an 'expedition') also translates Greek concepts of *periêgêsis* and *diêgêsis*—echoing the standard terminology for framing ecphrasis in the Greek *Progymnasmata* (cf. e.g. Webb 2009: 54–5). On Pliny's debt to such theories here, see Chinn 2007: 272–5.

[132] See Chinn ibid. 277–8 on Pliny's citation of Homer as 'generic antecedent' for ecphrasis—'not simply as a rhetorical exercise that can draw on authors such as Homer for inspiration, but as a literary trope that begins with Homer...Pliny's synchronic account posits the Homeric shield of Achilles as the source of all ekphrastic types'. As such, the text offers an important corrective to those who have analysed ancient ecphrasis from the perspective of the *Progymnasmata* alone (see above, pp. 326–8): there clearly existed 'in Pliny's time a conception of ekphrasis that is more "modern" than we might have expected' (Chinn 2007: 265).

[133] On Aratus' programmatic concern with *leptotés*, see above, p. 225.

explicitly, the visuality of a text goes hand in hand with its scale: size matters within ecphrasis, in short, precisely because visual impressions are proportional to scale.

It is in this connection, third, that Pliny relates his own ecphrasis to those of the other authors mentioned—comparing, as he puts it 'the little with the large' (*ut parua magnis*). But which is which? According to Pliny's own definition, Homeric and Virgilian ecphrasis is both big *and* small. In similar vein, Pliny's imitation of such ecphrastic models in this letter encompasses both scales of the size spectrum simultaneously: in one sense, his ecphrasis of the villa is a modestly downsized replication of the 'greats' of ecphrastic writing; and yet, to apply Pliny's own criteria of looking at length, we see that this letter is by far the largest of all Pliny's texts (1521 words)—considerably longer than any comparandum by Homer, Virgil, or Aratus. This self-conscious aside towards the end of the letter might be small, but its ironic implications are great. While offering a digression (*quod excessi*) about the need not to digress (*excursus*), Pliny closes his letter by self-consciously returning to the themes of its opening (*uerum illuc unde coepi*). In doing so, he imitates the ring-compositional structure of the prototypical Homeric ecphrasis—the circular shield of Achilles. Going round in circles, Pliny does indeed 'keep on asking himself what he had set out to write' (*atque identidem interroget se quid coeperit scribere*): since ecphrasis is by definition an excursus, this *excursus* on excursus leads us to see how his text is not in fact long at all . . .

Pliny the Younger's comments on the visibility and size of the Homeric shield lead us roundly back to the intellectual games of the *Tabulae Iliacae*. Tablet 4N plays upon a closely related set of topoi, albeit in different ways. On the one hand, this object literalizes Pliny's objective of laying its subject before the reader's eyes (*oculis tuis subicere*): we now see the actual shield that Homer described, not just the numerous verses describing it (*uides quot uersibus* . . .). On the other hand, the tablet's visual–verbal synopsis is matched by a parallel synopsis in scale: thanks to its small size, the object shows us just how brief (*breuis*) these many verses are. The tablet renders literally visible Homer's readable verses on the shield. In doing so, however, this tiny object also materializes the brevity of the seemingly lengthy Homeric text.

True to Pliny's prescription, tablet 4N is something both readable *and* seeable, and both big *and* small. We have in our hands a visualized miniature replica of the shield that, precisely because of its size, measures up to Homer's grand ecphrastic model. Pliny would have delighted in the conceit: this *opus* encompasses all of these extremes at once, circling back and forth from one to the other, a true marvel to behold.

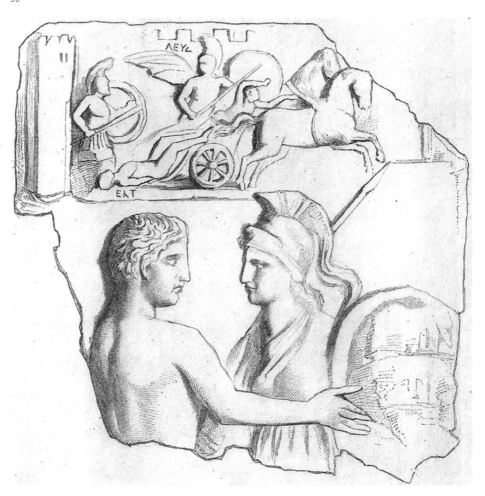

FIGURE 161. Drawing of the obverse of tablet 13Ta.

FIGURE 162. Detail from a drawing of the obverse of tablet 6B.

TEXTS OF IMAGES OF TEXTS OF IMAGES

It is worth pausing here to remember that tablets 4N and 5O were not the only *Tabulae* to represent the Homeric shield of Achilles. Whether or not fragment 13Ta depicted the shield, as seems likely (Fig. 161),[134] we certainly see it emblazoned as a programmatic emblem towards the top of tablet 6B, between the

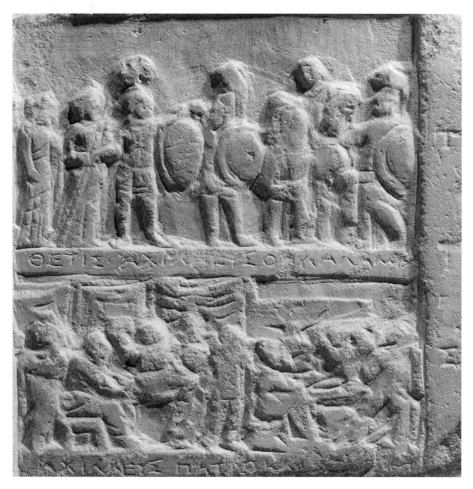

FIGURE 163. Detail of the obverse of tablet 20Par, relating to *Iliad* books *sigma* (18) and *tau* (19).

[134] See Robert 1875: 268–71—rejected by Sadurska 1964: 68, but defended by Valenzuela Montenegro 2004: 212. The debate revolves around the detail that it is not Thetis shown holding the shield, but rather Athena. Still, the compositional prominence given to the shield, and the fact that the left-hand figure reaches out to it with his right hand, suggests some sort of programmatic significance. After inspecting the tablet at first hand, it is also clear that the shield was decorated: Valenzuela Montenegro 2004: 211 notes a 'Vielzahl von vor allem vertikal und horizontal verlaufenden Linien', but these in fact seem to comprise a castellated city similar to the one found in the frieze above; the 1895 museum register corroborates the suggestion, likewise talking of the shield's 'bird's eye view of a walled town and ships', which would tally with the cityscapes on tablets 4N and 5O (my thanks to Alex Truscott at the British Museum for his help).

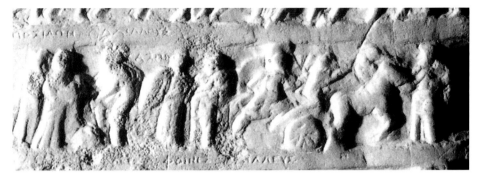

FIGURE 164. Detail of the obverse of tablet 1A (Capitoline tablet), showing frieze *tau*.

upper frieze of the *Iliad* and the central image of the *Ilioupersis* (Fig. 162).[135] If this nineteenth-century drawing of the (lost) tablet is to be believed, the shield's rim was adorned (like tablet 4N) with the signs of the Zodiac, and at its centre was depicted a circular Gorgoneion.[136] Internally, the shield seems to have been divided into a series of rectangular compartments, recalling the four-sided frame of the tablet in which all of the images are contained. So it is that the tiny but all-encompassing visualization of the shield is turned into a heraldic symbol for the tablet's miniaturist visualization at large (Fig. 79): in the same way that the Homeric ecphrasis serves as a microcosm of the poem, the image looks to the Homeric ecphrasis as an epitome of *all* the subjects that this tablet makes visually present.[137]

[135] For discussion, see Bienkowski 1891: 197–8; Sadurska 1964: 49; Amedick 1999: 192; Valenzuela Montenegro 2004: 151. The figure holding the shield to the left is named as Thetis, but we cannot be sure of the identity of the symmetrical figure who must once have appeared on the missing right-hand side: most commentators have suggested Achilles, while Gury 1986: 430 n. 21 proposed Hephaestus (cf. Valenzuela Montenegro 2004: 151 n. 922, sticking with Achilles). The question has to be left open (cf. O. Jahn 1873: 20), but another Nereid seems to me the most likely candidate.

[136] As suggested by e.g. O. Jahn 1873: 20, Bienkowski 1891: 197, and Valenzuela Montenegro 2004: 151. Amedick 1999: 192 instead argues that this was a personification of the Earth—examining the tablets in the self–declared terms of 'wortgetreue Illustration'. But the explanation is not convincing, and note how the Gorgoneion motif is described in the context of Agamemnon's shield at *Il.* 11.36–7.

[137] Because this miniaturized symbol of miniature visualization was *itself* adorned with barely perceptible visual scenes, moreover, it faces us with an unending *mise en abyme* of miniature replications, squared within the circular confines of this image of the (text of the) shield. Something similar arguably occurs on tablet 17M (Figs. 15, 30): here, the motif of two women holding Achilles' shield is transformed into two female personifications of Europe and Asia holding Alexander the Great's shield. Quite apart from the scenes of singing and dancing represented on the altar below (a song *artistically* represented within this visual representation of an altar), note how the epigram in the upper and lower frame provides a verbal commentary on the image: it associates Alexander with a macrocosm of 'earth' and 'Ocean' (...γαίης Ὠκεανὸς...), connecting him with the Aeacidae. As Philip Hardie argues, the epigram offers 'a universalist interpretation of Alexander's conquests' which 'extend over the entire *oikoumene*'; 'they are the achievement of one with a suitable genealogy, descended on the one side from Heracles and Zeus, and on the other side

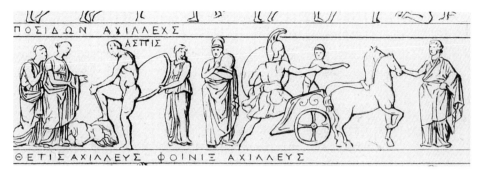

FIGURE 165. Drawing of the same detail.

Fragment 6B preserved only the left-hand side of the original tablet, and so we cannot be sure how the tablet treated the actual making of the shield in the frieze relating to *Iliad* 18. But tablets 20Par and 1A represent precisely these episodes, granting viewers visual access to the very forge at which Hephaestus is described as having worked: like tablet 1A, tablet 20Par seems to depict the shield twice, first at the moment of its original forging (to the right of band *sigma*) and then above to the left of band *tau*, where Thetis hands the shield over to Achilles (Fig. 163).[138] In both cases, the surface of the shield seems to have been left uninscribed—unsurprisingly, perhaps, given their tiny proportion.

With the Capitoline tablet, though, something remarkable happens. On frieze *sigma*, relating to book 18, an inscription labels the scene: besides Hephaestus (named on the right), the three craftsmen hammering the shield are accompanied by the word ὁπλοποιία—referring at once, perhaps, to the physical making of the shield, and to the poetic crafting of the Homeric *poiêsis*.[139] But in frieze *tau* above, where Thetis is shown handing over the armour to her son (as described in *Il.* 19.1–39), another inscription is used to characterize the object (Figs. 164–5):[140] although the minuscule surface of the

from Achilles' (Hardie 1985: 29–30). The very composition of the tablet, structured around this historical shield image, drives home the point: the heroic Alexander is honoured with a shield of epic deeds, modelled after the Homeric shield of Achilles.

[138] For general discussion, see Valenzuela Montenegro 2004: 223–4. Although tablet 2NY preserves an inscription relating to this scene (ibid. 186), no images survive below. On the scene on tablet 1A, see ibid. 66–9; for 20Par, see ibid. 181.

[139] Cf. the laconic summary of the episode on the monumental pilaster inscription, which simply declares that Thetis went to Hephaestus to ask him for the armour, and that Hephaestus 'willingly makes (*poiei*) it for her' (ὁ δ' αὐτῇ προθύμως ποιεῖ).

[140] For discussion of the frieze, see Valenzuela Montenegro 2004: 69–71, 224: we find the same scene on tablets 20Par (see ibid. 181–2) and 2NY (ibid. 186–7), but neither the inscriptions nor the specific iconography of tablet 1A are paralleled on the other examples. For the iconography of this episode, see Kemp-Lindemann 1975: 152–64 and *LIMC* 1.1: 122–8, s.v. 'Achilleus' nos. 506–41a.

shield is once again left uninscribed, it has nonetheless been *verbally* identified; the label—hardly necessary to identify the scene—is moreover written *within* the pictorial plane of the relief rather than in the space below (as with every other inscription in these Iliadic friezes). At the very moment when the Homeric poem promises readers ecphrastic access to an image, this relief—which conversely promises viewers verbal access to the poem—offers instead a single *word*: ἀσπίς ('shield').[141]

While other *Tabulae Iliacae* parallel the games of visualizing and verbalizing the Homeric ecphrasis, tablets 4N and 5O go further in substantiating the shield as holistic, three-dimensional artefact. The layering of different levels of representation within these physical objects is a wonder in its own right, and one that responds directly to the projected *thauma* of the Homeric ecphrasis: their remarkable synopsis embodies at once the supposed artistic *technê* of Hephaestus' craftsmanship, the poetic *technê* of Homer's description, and the *technê* of this artist's artistry. Like the shield, and the Homeric ring composition circumscribing it, the cycle is circular, moving from object to text to object: the round shield of Hephaestus is turned back from the words of the ecphrasis into a convex object for us to revolve, turn, and twist in our hands.

But where does the circle end? It is in regard to this question that we should understand tablet 4N's greatest wonder of all. When we inspect the outermost sloping rim of tablet 4N, in the band adorned with Helios and Selene, we find something truly amazing—at first almost imperceptible, but then drawing in our gaze. According to the Homeric description, as we have said, this outer space was reserved for the 'great might of River Ocean', placed 'around the outermost rim of the well-made shield' (*Il.* 18.607–8). Hidden in the waving lines of tablet 4N, however, is something rather different (Figs. 166–9): the full inscribed text of the Homeric description radiates around the object, laid out for us to see in its entirety (18.483–?608).[142] Originally there must have been 10 symmetrically arranged columns, each containing between 10 and 15 verses, and proceeding in anticlockwise order around the tablet. In keeping with the fragmentary state of the tablet, some three-fifths of the text is preserved, up to and including a sixth column in its lower right-hand side (vv. 483–557).[143] The lines have been carefully proportioned,

[141] As Valenzuela Montenegro 2004: 69 n. 69 confirms, the inscription ist 'deutlich zu erkennen', even though it goes unmentioned by Sadurska 1964: 30. Neither Valenzuela Montenegro nor the detailed publication of Mancuso 1909: 684 comment on its extraordinary position.

[142] Cf. Amedick 1999: 167: 'Der Entwurf sah demnach hier eine Darstellung des Okeanos vor, dessen Position am Rand des Schildes Homer ausdrücklich nennt. Auf der Tabula Iliaca wurde Okeanos von den Textkolumnen verdrängt.'

[143] The remains of six columns can still be seen, inscribed respectively with vv. 483–92, 493–504, 505–19 (damaged), 520–32 (severely damaged), 533–45, and 546–57 (severely damaged; in a different hand?); each column proceeds outwards from the inside of the circular tablet. There is no lacuna in the text, despite the

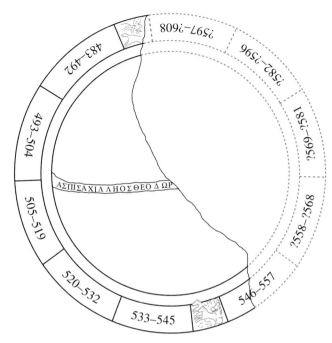

FIGURE 166. Drawing of the obverse of tablet 4N, showing the distribution of verses from *Iliad* 18 around the rim.

and although verse divisions in the missing right-hand section of the tablet must remain speculative, we can be confident about the general layout (Fig. 166).[144]

Quite apart from the content of the text, the gesture of placing these Homeric lines in the outer ring—where Homer situates the Ocean—has a philological significance of its own. After all, 'Homer Oceanus' had long been associated with

usual labelling of these lines as '483–519, 533–557' (cf. e.g. West (ed.) 1998: 1.xliv, no. 276; compare the orthographic notes contained in the 'Online Homer Multitext Project' at http://www.stoa.org/homer/homer.pl, after typing 'p276' into the witness field). This error is attributable to Bienkowski 1891: 202, who omits reference to a fifth column, and labels the fifth column as the fourth ('delle dieci colonne...sono rimaste soltanto le cinque...e parte della sesta, la prima delle quali contiene soli dieci versi (483–492), la seconda ne conta dodici (493–504), la terza quindici (505–519), la quarta tredici (533–545), la sesta non più di dodici (546–557)'). Lippold 1932: 1889 claims that there were 11 rather than 10 columns of text, but the proportions clearly suggest otherwise: if the text stops with v. 608, there are 51 lines missing; divided between four additional columns, each would include an average of 12.75, approximating the average of 12.33 lines included in each column on the extant left-hand section.

[144] The line divisions for the missing columns hypothesized in Fig. 166 follow sentence breaks. Interestingly, though, this is not always the case with the tablet's surviving left-hand section: sentences are complete at the end of vv. 519, 532, and 557, but not at the end of vv. 492, 504, and 545. On the state of the inscription, its orthography, and the relation to (late Hellenistic/early Imperial) versions of the text, there are some preliminary comments in Bienkowski 1891: 201–7. There is a desperate need for a first critical transcription of the surviving verses (see above, p. 16 n. 40): this will be published as a separate article-length study, co-authored with Christopher Whitton.

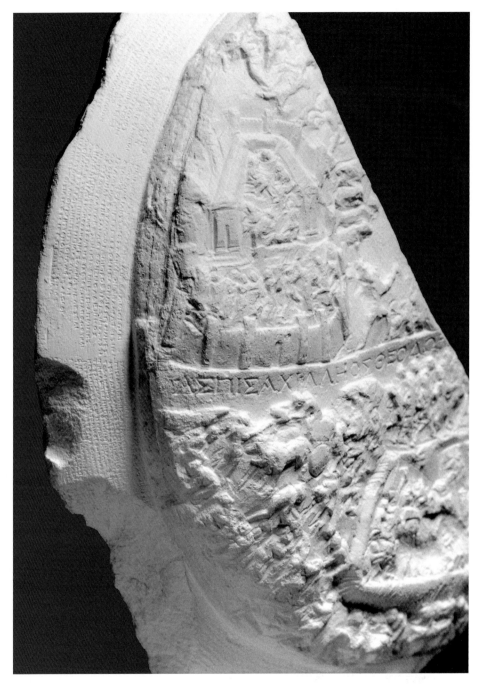

FIGURE 167. Detail of a plaster cast of tablet 4N (Archäologisches Institut und Sammlung der Gipsabgüsse, Göttingen inv. A1695): obverse, outer rim. The first three columns of text can be seen here: *Il.* 18.483–92 (top), vv. 493–504 (upper centre), and vv. 505–19 (lower centre); a fourth column, to the right (on the damaged part of the rim at the bottom) was inscribed with vv. 533–45.

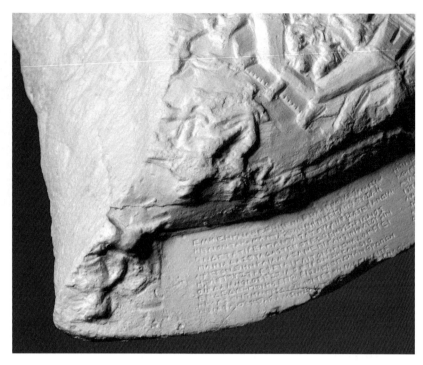

FIGURE 168. Detail of a plaster cast of tablet 4N (Archäologisches Institut und Sammlung der Gipsabgüsse, Göttingen inv. A1695): obverse, upper section of the outer rim, with Helios (now turned upside down: contrast Fig. 155) and the 'city at peace' now seen to the top right; the column is inscribed with *Il*. 18.483–92.

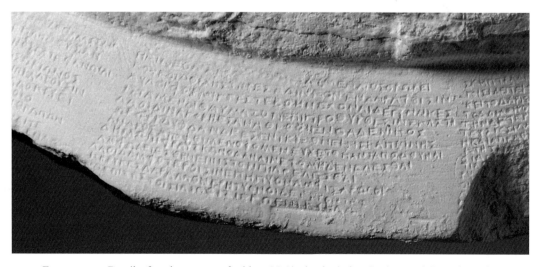

FIGURE 169. Detail of a plaster cast of tablet 4N (Archäologisches Institut und Sammlung der Gipsabgüsse, Göttingen inv. A1695): obverse, outer rim, with central column inscribed with *Il*. 18.493–504.

the sea—the ebb and flow of Homer's poetry proving the fountainhead of every subsequent literary spring.[145] 'Homer', writes Quintilian, 'like his own Ocean—which he calls the source of all rivers and springs—provided a model and origin for all forms of eloquence' (*Hic enim, quem ad modum ex Oceano dicit ipse omnium amnium fontiumque cursus initium capere, omnibus eloquentiae partibus exemplum et ortum dedit, Inst.* 10.1.46). The artist behind tablet 4N sculpts the descriptive poem of the Ocean-like Homer precisely where, according to Homer's poetic description, Hephaestus had fashioned the Ocean—i.e. around the rim of the strongly wrought (πύκα ποιητοῖο) shield.[146]

But it is the *ontological* ramifications of inscribing the Homeric text around the tablet's rim that I want to emphasize here. In a literal and metaphorical sense, the graphic presentation of the Homeric ecphrasis continues the circle from image to text and back again: just as the Homeric description moves from object (Hephaestus' shield) to poem (the ecphrasis of book 18), we move here from image (the visualization of that verbal portrayal) back to text (the verbalization of that visual portrayal). So it is that the whole Iliadic text is made to circumscribe the materialized circumscription of the Homeric circumscription of the object. The complexity of this manoeuvre is mind-blowing: this text is a *verbal* representation of a *visual* representation of a *verbal* representation of the *visual* representations of (and indeed in) the shield (Fig. 170). Like the radiating bands of Homer's cosmic description, encompassed in the described image of the shield, all of these replicative levels are monumentalized within the combined visual–verbal parameters of the tablet. But does the poem verbalize the object, or the object visualize the poem? Which comes first—the verbally visualized text, or the visually verbalized image? Is the 'original' object a text for reading, or an object for viewing? Like the text circulating around the make-believe shield, these questions circulate around the object without closure: the true *technê* is that, despite the artefact's size, it is both visual *and* verbal in

[145] On Homer as 'Ocean', see the sources collected in F. Williams (ed.) 1978: 98–9 (by no means exhaustive, but suggesting the 'frequency and persistence of the conception', 98): the comparison explains Pseudo-Longinus' famous simile about the poet of the *Odyssey* in relation to that of the *Iliad* (*Subl.* 9.13). Petrain 2010: 55 makes the suggestion independently: 'In fact they [*sc.* the artists] did include the ocean, but represented it by means of a learned substitution that gives visual form to a common metaphor for describing Homer's poetry and its importance.'

[146] Although the text is corrupt, we find the final Oceanic lines of the Homeric description imitated at the end of Callistratus' described gallery of statues (cf. Bäbler and Nesselrath (eds.) 2006: 133). Callistratus' last image concerns not a statue but a painting: we see Athamas surrounded by a closely related image of the rivers of Ocean ('Ωκεανός . . . ποταμοῦ, *Imag.* 14.5). Callistratus, in other words, closes his circle of ecphrastic responses to images—themselves derived from a series of poetic texts—with the prototypical circular sculpted picture behind Homer's own ring-composed ecphrasis. For an introduction to Callistratus' ontological games, see Costantini 2006.

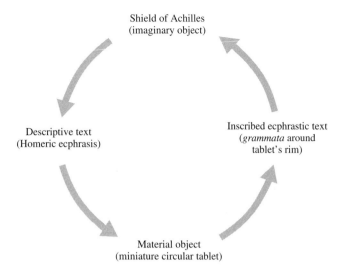

Shield of Achilles
(imaginary object)

Inscribed ecphrastic text
(*grammata* around
tablet's rim)

Descriptive text
(Homeric ecphrasis)

Material object
(miniature circular tablet)

FIGURE 170. The ecphrastic image-text circle, as materialized together and all at once on tablet 4N.

pictorial–poetic scope—a miracle of medium, and a micro-macro marvel of *metron*.[147]

It is worth restating just *how* small this object really is: the diameter of the whole object is 17.8 cm, and this writing is crammed into the outer rim; the entire sloping band measures less than 2 cm, and most letters are only around 1 mm in height. We should also stress that, owing to the colourations of the original marble, it is considerably easier to read the text on the Göttingen plaster cast than on the original object: one need only compare Figs. 167–9 with Colour Plates XI.12–XII.15. The minuscule scale of the writing makes the Homeric lines all but imperceptible—at least as letters rather than as figurative decoration. They are 'written with the smallest letters, almost invisible to the naked eye', noted Bienkowski in 1891—reminiscent, perhaps, of the 'subtle' lines of Apelles and Protogenes' wondrously subtle line painting, which were likewise said to recede from sight (*lineas uisum effugientes*, Plin. *HN* 35.83).[148]

[147] It is worth emphasizing that the columns of text proceed (from top left) in anticlockwise order (Fig. 166). These columns thereby circulate in the *opposite* direction from Helios and Selene, who are also depicted in this outer ring, but who both face in *clockwise* direction (Figs. 148, 155, 156). Such gestures have to be understood in light not only of the playful compositional layout of this tablet (see above, pp. 347–8 and Fig. 152), but also the *taxis* of images and texts on other *Tabulae Iliacae* (see chapter 4 above).

[148] Bienkowski 1891: 200 ('scritti con lettere piccolissime quasi invisibili all'occhio nudo'); cf. ibid. 201. Compare also Valenzuela Montenegro 2002: 78–9 and 2004: 240: 'die Lettern sind fast zu klein, um mit bloßem Auge gelesen zu werden'. For the Apelles and Protogenes story, see above, pp. 271–3.

It is at this stage that Nicholas Horsfall resorts to his microscope, judging the text 'easily legible with a magnifying glass'.[149] Now, tablet 4N does indeed contain the capacity for such enlargement: if we only change the perspective according to which we view, the little *can* become large; with effort—indeed, with additional *technê*—the scrawls for seeing can morph back into letters for reading. In fact, this is part of the wonder—the tablets' endless ability to be more than they seem. But the recourse to the magnifying glass must increase rather than decrease the object's meta-ecphrastic scope. Pliny the Younger nicely captures the conceit when he writes how the mirage of ecphrasis always makes deceptions out of appearances. This is especially the case with an object like tablet 4N, which inverts the ecphrasis only to invert it once more. Here the challenge is not to see but to read: were we to think, given the tablet's size, that the Homeric text is *short* (*breuis*), we only have to look at the text to see how many verses there actually are (*uides quot uersibus Homerus . . . arma . . . Achillis . . . describat*, Plin. *Ep.* 5.6.42).

As always, size matters on the *Tabulae*. On the one hand, the proportions of the *grammata* around the rim of tablet 4N return us to the aesthetic discourses discussed in the previous chapter; above all, they recall the Hellenistic rhetoric of *leptotês* (think back, for example, to those miniature literary 'greats' monumentalized in Martial's *Apophoreta* epigrams, 14.183–96: above, pp. 279–83). On the other hand, it is clear that the dialectics of scale epitomize larger discourses about visibility and lisibility: it is not just Hephaestus' 'great and mighty shield' which is here miniaturized, but the written text that mediates that description through language.

A wonder of medium, then, and a wonder of size. To my eyes, though, it is the tablet's recourse to Archaic Greek precedent that proves the grandest *thauma* of all. Just as the Iliadic text tantalized readers with the promise of viewing the images described (ἴδηται, *Il.* 18.467)—of almost bringing about seeing through hearing—this reversed ecphrasis (of a reversed ecphrasis ad infinitum) teases viewers into thinking that they can actually read the poem that the material object visualizes. By quite literally shrinking the text—making it all but illegible, and yet not invisible—the tablet toys with the scope not of verbal *grammata* visualizing an object, but rather of visual *grammata* verbalizing a text: the rim at once monumentalizes the 'original' poem represented, and shrinks away from manifesting it as lisible entirety. Such *gramma* size games parallel what W. J. T. Mitchell has called the 'ecphrastic hope', 'ecphrastic fear', and 'ecphrastic indifference' of verbal language: just as literary ecphrasis toys with our written access to a visual referent, this pictorial object plays with our visual access to the

[149] Horsfall 1979a: 33. It is difficult to see how such work could have been done without such magnification tools, despite the *communis opinio* that Greek and Roman craftsmen did not use lenses (cf. e.g. Plantzos 1997: especially 457–9).

readable text.[150] Whether or not we manage to read it, the more we try to make legible sense of the microscopic letter lines—squinting at the squiggles, following the sequence of minute strokes from left to right, from inside the shield to its outer rim, and then in a circle from top left to top right—the more we lose sight of the accompanying imagery. Round and round we go, *mutatis mutandis*: the games of reading the visualized ecphrastic text encapsulate those of viewing the verbalized ecphrastic object.

CONCLUSION: A FINAL FLIP—AND A 'GOD-GIVEN' TWIST

Viewer-readers do not have to stick to the obverse of tablet 4N. There is always the possibility of flipping the object over—of ending (or indeed beginning) with the picture poem enshrined on the reverse. If, as we have seen, the tablet's reverse adds a new twist to the circular games of visual and verbal replication played out on its obverse, it also adds a new dimension to its games of size. The image-text which at once depicts and labels the tablet's subject scales down the 130 or so hexameters of epic into a *single* hexameter verse (ἀσπὶς Ἀχιλλῆος Θεοδώρηος καθ᾽ Ὅμηρον). As on the recto, these verso visual–verbal *grammata* are simultaneously big *and* small: the 31-letter title might be minimal, but its image is simultaneously maximized, forming a picture out of no fewer than 614 gridded squares.[151] The circular games of image and text on the one hand, and of the big and the small on the other, continue not just around the obverse of the tablet, then: such conceits of circumscription also oscillate from obverse to reverse and back again, each side verbalizing (or should that be visualizing?) the other.

But I conclude this chapter by returning one last time to the Homeric ecphrasis from which tablet 4N derives. As we have said, *Iliad* 18 prescribes a mode of responding to the ecphrastic object at hand. The proper response to the shield will be *thauma*: 'anyone among the multitude of men who looks upon it shall marvel', Hephaestus tells Thetis (τις αὖτε | ἀνθρώπων πολέων θαυμάσσεται, ὅς κεν ἴδηται, 18.466–7).[152] In fact, though, the *Iliad* predicts some different 'lookings upon' the shield. In the following book, the *Iliad* narrates how Thetis carries the newly crafted weapons to Achilles (noisily clashing along the way: ἀνέβραχε, 19.13). So what will the 'multitude of men' make of the imagery? We hear first about the reactions of the Myrmidons (*Il.* 19.14–15):

[150] For the terms, see Mitchell 1994: 151–81, adapted from idem 1992.

[151] Before we conclude that this 'magic square' offers some last word—a one-line, pictorial–poetic epigrammatic retort to the epic subjects of the other side—it is worth recalling that this text was most likely also cited on the tablet's obverse, cutting along its central horizontal axis (above, p. 311): where the reverse replicates the visual–verbal games of the obverse, the obverse replicates the verso's same verbal—but not visual—mode of replication.

[152] See above, pp. 334–5, 337.

> Μυρμιδόνας δ' ἄρα πάντας ἕλε τρόμος, οὐδέ τις ἔτλη
> ἄντην εἰσιδέειν, ἀλλ' ἔτρεσαν.

Terror seized all the Myrmidons: not a single one could look at it face on, but all were afraid.

The terrified response of the mighty Myrmidons is quite different from that imagined by Hephaestus: gripped with fear (ἕλε τρόμος), they tremble before the weapons; never mind *thauma*, the Myrmidons cannot even *look* at the shield (εἰσιδέειν). Achilles, on the other hand, has an alternative reaction (19.15–19):

> αὐτὰρ Ἀχιλλεὺς
> ὡς εἶδ', ὥς μιν μᾶλλον ἔδυ χόλος, ἐν δέ οἱ ὄσσε
> δεινὸν ὑπὸ βλεφάρων ὡς εἰ σέλας ἐξεφάανθεν·
> τέρπετο δ' ἐν χείρεσσιν ἔχων θεοῦ ἀγλαὰ δῶρα.
> αὐτὰρ ἐπεὶ φρεσὶν ᾗσι τετάρπετο δαίδαλα λεύσσων
> αὐτίκα μητέρα ἣν ἔπεα πτερόεντα προσηύδα.

When Achilles saw it, anger flooded him all the more, and his eyes were terrible to see beneath his brows, as if they were flame. He rejoiced holding the splendid gifts of the god in his hands. But when he had taken his fill of pleasure at looking at the crafted things, he immediately addressed his mother with winged words.

As he looks upon the weapons (λεύσσων), Achilles is himself here turned into pseudo-ecphrastic object: we hear first how his two eyes (ὄσσε) become angry, and then how that anger gives way to delight (τέρπετο . . . τετάρπετο), so that Achilles can finally contemplate the finely ornamented armour (δαίδαλα—the adjective returning us to the opening description of the shield at *Il.* 18.479, 482).

All this has important repercussions for our tablets: the 'original' epic poem in some sense prefigures the audience's own responses to the shield reproductions at hand. Just as Achilles delighted in grasping Hephaestus' weapons in his hands (τέρπετο δ' ἐν χείρεσσιν ἔχων), viewers grasp these make-believe copies and take on the role of Achilles—or indeed those of the Myrmidons, Hephaestus, or Thetis; whoever they choose to become, audiences become players in the epic drama—according to a prototypical game of 'stars in their eyes'. Once again, the size of the tablets is also important. Whether actors play terrified or delighted, the conspicuously *supra*-human dimensions of the *Tabulae* make for *super*human sorts of agents: we marvel, just as Hephaestus had predicted (*Il.* 18.467), and just like the marvelling figures depicted on the shield (vv. 496, 549). Holding the splendid gifts of the god in our hands—ἐν χείρεσσιν ἔχων θεοῦ ἀγλαὰ δῶρα—our reactions play out the heroic dramas of the fictional epic text.

But look closely at the Greek here: 'gifts of the god', θεοῦ δῶρα. Can this really be coincidence? The words which Homer uses to describe Hephaestus' gifts

prefigure precisely the 'Theo-dorean' attribution of our two shield *Tabulae*—the reference to 'the Theodorean shield of Achilles' on both sides of tablet 4N (ἀσπὶς Ἀχιλλῆος Θεοδώρηος), and the additional association with 'Theodorean *technê*' on the verso of tablet 5O, ([ἀσπὶς] Ἀχιλλεῖος Θεοδώρηος ἡ τ[έχνη]). Just when we thought we had them in our grasp, the objects elude us once more, raising further questions about how literally—or yes, how figuratively—we should take them. The previous chapter has already found one level of significance in these 'signatures'—a cryptic reference to 'Theodorean' miniaturism, as celebrated both by Posidippus and in Pliny's *Natural History*.[153] Needless to say, that interpretation remains open (indeed, more so now than ever, given the *magna suptilitas* of the particular *paruitatis miraculum* to hand: Plin. *HN* 34.83). But within objects that delight in always being more than they seem, these tablets simultaneously present a rival etymology, literalizing the very 'gifts of the gods' that they purport to replicate.[154]

In the case of objects as sophisticated as these, I cannot consider the pun accidental. Through their name, as through their form, the tablets occupy a number of different ontological levels together and all at once: is the shield 'god-given' ('Theo-dorean') because it has been donated by Hephaestus, because it has been handed down to us through the divine poetry of Homer, or because it has been tendered within our intellectual grasp, thanks to 'Mr-God's-Gift' (or indeed Mr-Give-a-Gift-To-The Gods)?

Looking back at the verso of tablet 4N, there had been a literal-cum-pictorial clue all along: the picture-poetic diagram in the form of an altar (Figs. 105, 145). True to the hidden hexameter, the 'Achillean' shield is here made 'Theodorean' both literally *and* figuratively—dedicated at this semblance of an altar. The artist takes the 'god-given gifts' of Hephaestus, as it were, and returns the favour, offering a make-believe dedication of his own.[155] On a group of artefacts expressly concerned with the mediating effects of both imagery and language, and deriving their replicative games from Homer himself, there must have seemed no better way of depicting the artist's (pseudo-)name, punning on a detail of the Homeric text even while reproducing it.

[153] See above, pp. 283–302.

[154] For the Iliadic phrase—in a closely related context—cf. *Aen.* 8.617: Virgil translates the Greek gifts of the god into the gifts of the goddess Venus (*deae donis*), as ever paying close attention to the Homeric prototype.

[155] This might shed further light on the palindrome below (pp. 307–10, 348–9), whereby these 'holy things' are dedicated back to the 'priestly' Homer. Valenzuela Montenegro 2004: 350 cites e.g. Lib. *Or.* 52.42 (ἱερεὺς φιλοσοφίας) and argues 'das Wort ἱερεύς kann auch metaphorisch gebraucht werden, im Sinne von Eingeweihten oder Anhänger—also in diesem Falle des Homer'. On the Theodorean name's potential religious significance, compare Petsalis-Diomidis 2010: 132–3 on Aristid. *HL* 4.53, where the author is given the new name by Asclepius because 'everything of mine was a gift of the god'; cf. also Parker 2000.

This is not just an onomastic mini-pun. The minute detail encapsulates all-encompassing questions about medial and miniaturist replication (and about how to visualize/verbalize it through drawn/written *grammata*). Is the 'Achillean shield' the actual object given by the god (as at least described by Homer)? Or is the shield only 'Achillean' in its replication of that object—a 'Theodorean' imitation *'after* Homer', in an endless *mise en abyme* of visual–verbal craftsmanship?[156] Given these parallel adjectival forms, 'Achillean' and 'Theodorean', just where *are* the boundaries to be located between prototype and imitation, image and text, grand shield and minuscule make-believe miniature? If the 'Theodorean' reference works as an artistic signature, it leaves us guessing as to *whose* signature it ultimately signifies: it simultaneously makes the object *the* shield of Achilles (given by Hephaestus), and *a* shield of Achilles (copyrighted to 'Theodorean' *technê*—via Homer).

The very fact that the object is 'Theodorean' renders it not only a visual and verbal entity, then, nor something simultaneously big *and* small: it also makes for an original *and* a copy. Hephaestus' forging of the shield, as forged by Homer, becomes the subject of an endless *mise en abyme* of further forgeries in both medium and size. Theodorus' replicated 'godly gifts' replicate anew the Homeric model of ecphrastic replication: for our contemplation, amazement, and not least delight.

[156] The shield, we recall, was 'such as no mortal man could accomplish/bring to an end', μηδὲ βροτὸν ἄνδρα τελέσσαι (*Il.* 19.22). Note too how the phrase καθ᾽ Ὅμηρον arguably encompasses both a *derivative* acknowledgement of Homer's cultural authority ('after Homer') and an *original* challenge to it ('responding to Homer').

Taking the Tablets

The miniaturist marvel around the rim of the 'shield of Achilles' brings us full circle to the anecdotes with which this book began: the story of the 'Iliad in a nutshell', no less than those about Callicrates and Myrmecides, with their seminal Homeric *grammata*. Indeed, tablet 4N serves as an *in nuce* synopsis of my arguments in this book as a whole—the pyrotechnics with which the Iliac tablets Catherine-wheel from the little to the large, and from image to text. I hope to have demonstrated just some of the many adventures to be had—the games that the objects play with and upon their viewing-reading audiences.

Throughout, this book has sought to combine formal analysis of the tablets with contextual circumscription about their larger cultural and intellectual backdrop. For this reason, I have structured the chapters thematically: we have proceeded from a survey of the material (chapter 2), through an investigation of the tablets' inscriptions, images, and reverse diagrams (chapters 3, 4, and 5), to a discussion of their scale (chapter 6), and finally to one particular case study—the two tablets modelled after a specific Homeric passage (chapter 7). Needless to say, there is much more to be said, not least about social context. Suffice it to repeat the suggestion of the second chapter: that the intimacy of these handheld objects is best understood in terms of the 'Bildungskult' of the Roman villa, and within the cultural and social parameters of the cena in particular (Fig. 171).[1]

Rather than offer any further summation of my arguments—already sized up on pp. 19–24 above—I want to end by returning to some of the broader themes with which the book opened. If our interpretation of these little tablets is correct, their repercussions must prove grand indeed. This final chapter therefore broadens its focus to inspect the bigger picture: it examines the importance of the *Tabulae* first within the contemporary disciplinary spectrum of 'classics', and second within still larger debates about media, politics, and power. Behind the 'playful' facade, there are 'serious' lessons to be learned: the tablets can have a *remedial* effect, both within the field of Graeco-Roman cultural history, and indeed beyond it.

[1] The term 'Bildungskult' is taken from Paul Zanker: see e.g. P. Zanker 1995a: especially 193–4; 1999; 2002b: 353 (in the context of second-century Roman 'Grabrhetorik').

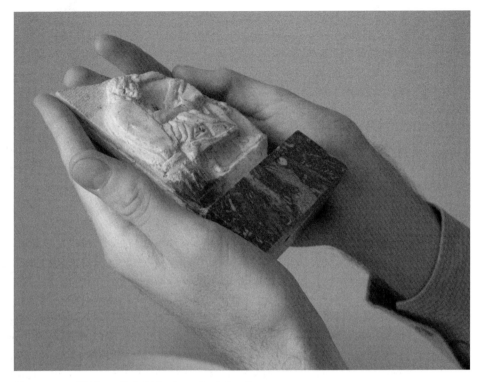

FIGURE 171. Tablet 14G, held in the author's hands.

FROM THE SMALL TO THE BIG—OR THE BIG TO THE SMALL

What, then, might our tiny tablets mean within the larger (or indeed smaller) project of classics, classical archaeology, and classical art history? There is much that could be said here—about the history of the discipline, different national traditions, and the (radically shrinking) state of university funding in Britain. But I single out just three specific issues, of particular relevance to the study of the Graeco-Roman world in Britain and North America: first, the segregation of the 'Greek' from the 'Roman'; second, the segregation of the 'material' from the 'visual'; and third, the segregation of 'classical philology' from 'classical archaeology'.[2]

My first observation relates to this term 'Graeco-Roman' at large. In North American Universities, and increasingly in Britain, there is a growing pressure to

[2] There is now a plethora of relevant critical histories of classical archaeology specifically, as well as predictions about its future: among the most important are Snodgrass 1987 and 2007; I. Morris 1994; Marchand 1996; Shanks 1996; Sichtermann 1996: especially 9–27; Dyson 2006; Millett 2007. For a sharp-sighted diagnosis of the state of British classical archaeology, see Elsner 2007b.

identify oneself as *either* a 'Hellenist' or a 'Romanist'.[3] This has in part to do with the vicissitudes of the academic job market, especially in the States: universities identify specific lacunae in their departments, and search committees are set in prescriptive motion—pigeon-holing incoming faculty into established categories, classes, and types. But why must we draw such distinctions between 'Greece' and 'Rome' in modern national terms, with all their straightforward assumptions of cultural scope, geography, and chronology?[4] This may or may not work for the study of Greek and Latin languages and literatures (I for one remain deeply sceptical: remember the bilingualism of a classic 'Latinist' like Cicero). But whatever we make of the disciplinary *taxis* of classical philology, we have ended up modelling 'Greek' and 'Roman' archaeology after the study of Greek and Latin texts.[5]

Even the most cursory consideration of these terms reveals how ill-equipped they are for thinking about 'Graeco-Roman' objects. So much of what we know about Greek sculpture is filtered through Roman channels—from the various 'copies' of established Greek 'originals' to the narrative histories preserved in Pliny's *Natural History*. By the same token, we can say nothing about Roman visual culture unless we understand its self-conscious relationship with the Greek. The question of reconciling the 'Greekness' of 'Roman' visual culture with its own ('autochthonous', 'native', 'national') innovations—both in form and in display—has long since dominated the study of Roman visual culture: the spirit of Adolf Furtwängler, who pioneered methods of *Kopienkritik* and *Meister-*

[3] For one reflection of this endemic academic division (at the level of the classical archaeological textbook), see the essays in Alcock and Osborne (eds.) 2007—organized into ten themes, but discussed according to a single Greek vs Roman dichotomy.

[4] On modern myths of national self-identity governing archaeological research (not only in the case of labels like 'Greek' and 'Roman', but also still knottier supposed ethnic terms like 'Macedonian'), see e.g. D. D. Fowler 1987 and Cuno 2008: especially 1–20.

[5] Interestingly, this problem is most conspicuous in the Anglo-American tradition. It is certainly not found in German departments of classical archaeology, at least not to anything like the same extent: cf. e.g. the discussion of 'Greek' and 'Roman' classical archaeology in what has become the standard German-language textbook (Hölscher (ed.) 2002: 14): 'In der Tat sind die beiden Kulturen nur in wechselseitigem Verhältnis zu verstehen: Die griechische ist sehr weitgehend in der Rezeption und Vermittlung durch Rom überliefert; und die römische ist im wesentlichen auf der Grundlage der griechischen errichtet.' Cf. also Hölscher 2000: 9, on the need to study material 'in einem gemeinsamen griechisch-römischen Horizont'. The difference between Anglo-American and German traditions is partly to be explained via their respective disciplinary histories: from the late nineteenth century onwards, classical archaeology in Germany came to be studied in isolation from philology and history; as a result, German classical archaeology freed itself from the stark philological division between 'Latinistik' and 'Gräzistik'. In British and American 'classics' departments, by contrast, classical languages continue to exert a much greater influence—so that classical archaeology often still 'takes its orientation from, and adapts its narrative to, the lead given by literary sources' (Snodgrass 2002: 183). On the particular tradition of francophone classical archaeology, with its closer ties with anthropology, see Lissarrague and Schnapp 2000.

forschung over a century ago, dies hard;[6] the associated rhetoric of deeming 'Greek' art original (i.e. 'good'), and 'Roman' art its secondary hand-me-down, dies still harder.[7] But one of the reasons that the Second Sophistic has proved so useful a heuristic category in recent years—in art historical circles as well as among philologists—is that it *resists* such schematic segregation.[8] Although typically focussing on Greek rather than Latin texts, work on the Second Sophistic has shown that these categories of the 'Greek' and 'Roman' were as ideologized in the ancient world as they are in the modern. For us, as for 'Greeks' and 'Romans' themselves, there is always an agenda behind such delineation. Far from objective labels—still less meaningful job descriptions—'Greek' and 'Roman' are inherently fluid categories, especially when approached from the perspective of the material and visual record.[9]

The *Tabulae Iliacae* provide a case in point. By any standards, the tablets are at once 'Greek' *and* 'Roman' objects.[10] On the one hand, they are all inscribed in Greek, and six of them associate themselves with a Greek 'Theodorean' artist (arguably leading back to the Greek annals of Greek art history). Greek too are the epic histories depicted, with their (Greek) characters individually labelled (in

[6] The issue of 'Roman copies' of 'Greek originals' has attracted a substantial revisionist bibliography, following on from Ridgway 1984 in particular: see e.g. Bartman 1992: 9–48; Marvin 1993 and 2008: 137–50; Hallett 1995; Fullerton 1997 and 2003: especially 102–12; Gazda (ed.) 2002; P. Stewart 2003: especially 231–6; Perry 2005: especially 1–27; Junker and Stähli (eds.) 2008; Kousser 2008: 1–16.

[7] For one thought-provoking overview of the cultural and intellectual stakes, see Beard and Henderson 2001: especially 65–105. On the issue in the context of the *Tabulae Iliacae*, see Valenzuela Montenegro 2004: 15 ('Hier wirkt also noch das Bild der erhabenen griechischen Kunst und der römischen "Dekadenzzeit"').

[8] The three foundational works are arguably Bowersock 1969, Bowie 1970, and G. Anderson 1989, but one of the more recent key interventions is Whitmarsh 2001: especially 90–130; the contributions in Goldhill (ed.) 2001, Borg (ed.) 2004, and Konstan and Saïd (eds.) 2006 survey some of the (now vast) subsequent bibliography. For Second Sophistic *paideia* in the context of *Latin* as well as Greek texts, cf. e.g. Riess 2008: especially x–xii; on 'the Second Sophistic' as a useful category for approaching Graeco-Roman Imperial art, cf. e.g. Elsner 1998 and Ewald 2004: 229–31.

[9] For the point, see in particular P. Zanker (ed.) 1974. C. Kunze 2008 has recently challenged the position, arguing 'daß die Unterschiede zwischen "Griechischem" und "Römischem" auf dem Gebiet auch der Bildenden Kunst doch bedeutsamer sind als gemeinhin angenommen' (106). Furtwängler would no doubt have approved of such (highly learned) attempts to separate the 'Roman' from the 'Greek', so as to turn to 'dem griechischem Bereich' and concentrate on the 'ursprüngliche Funktion' (87). But I remain unconvinced, and would cite the tablets as a prime example.

[10] Sadurska 1964: 19–20 anticipated the point long before the revaluation of Roman 'copies' in the late 1980s and 1990s: 'Les tables iliaques, bien qu'exécutées par des sculpteurs d'origine grecque—comme c'est le cas de presque toutes les sculptures romaines—bien qu'elles résultent de la littérature grecque—comme presque toute l'iconographie romaine—ne sont pas moins romaines que ne l'est l'Ara Pacis ou la statue d'Auguste de Prima Porta' (20). Valenzuela Montenegro 2004 is rather more prescriptive in her delineation between the 'Greek' and 'Roman', characterizing the tablets as 'trotz griechischer Inschriften—inhaltlich und ikonographisch typische Produkte der römischen Kunst' (10). But what exactly do these labels mean?

Greek) and their (Greek) plots frequently summarized. Likewise two tablets preserve programmatic Greek elegiac couplets on their rectos, alluding to a series of Greek literary precedents, while others offer Greek poetic syntheses, also engaging with a Greek epigrammatic tradition. We could go on—drawing attention to the Greek reverse inscriptions, their relation to Greek picture poems, or the Greek *leptotês* at play behind these Callimachean little-large objects: everything about these tablets leads us to expect a 'Greek' clientele. And yet these tablets all seem to have ended up in Rome—either in the city itself, or in the area immediately surrounding it.[11] At the literal and metaphorical heart of several tablets, moreover, lies a 'Greek' epic tradition turned conspicuously 'Roman': for all the Archaic Greek paraphernalia, the central *gramma* has an undeniably Augustan social, mythological, cultural, literary, and political relevance.[12] The contemporary ring of the pivotal Aeneas myth might go unmentioned. But the Virgilian allusion was nonetheless clear. Published in *c.*19 BC, and heralded as a deliberate outsizing of Homeric epic models, the 12 books of the *Aeneid* likewise subsume the Greek within the political confines of a new Roman Imperial order.[13] Image and text, big and small, Greek and Roman: the tablets insist on such delineations only to point to their cultural fabrication.

A second and still larger observation relates to the aforementioned issue of provenance, and more broadly to the relationship between classical 'archaeology' and 'art history'. The concept of 'context' has been much debated among self-styled 'material culturalists' in recent years,[14] and art historians have likewise shown how objects at once define and are defined by their parameters of use.[15] But talk of 'context' has also served to draw oversimplistic distinctions between the study of 'archaeology' and 'art history'. 'Field survey', 'petrography', 'quantitative analyses': according to one badge-wearing 'Greek archaeologist' (James Whitley), these are some of the many ways in which 'classical archaeology' defines

[11] On the tablets' archaeological findspots, see above, pp. 65–7.

[12] See above, pp. 148–58, and cf. e.g. Schefold 1975: 130: 'Dieses etwas ungeschickte Zurechtmachen einer griechischen Überlieferung beweist, daß etwas Neues, Ungriechisches beabsichtigt ist, die Monumentalisierung der epischen Vorgeschichte Roms, zusammengeschlossen um Aeneas' Rettung, das den Römern wichtigste Ereignis.' The point is arguably all the clearer on tablets 18L and 22Get, which chronicle the defining events of the Greek past in terms of the present year AD 15/16 (see above, pp. 49–51, 60).

[13] As the Latin elegist Propertius described Virgil's composition of the *Aeneid* in the 20s BC, 'something *bigger* than the *Iliad* is being born' (*nescio quid maius nascitur Iliade*: 2.34.66)—this in spite of the fact that Virgil's combined Iliadic-Odyssean song of 'arms and a man' (*arma uirumque cano*, *Aen.* 1.1) in effect condenses 48 Homeric books into 12—albeit books that are individually greater in length. In this sense, the tablets outsize Virgil's outsizing of Homer by further expanding and shrinking the Greek epic scenography.

[14] For some (different postprocessualist) examples, see Hodder 1987; Trigger 1989: 348–57; Shanks 1996: 119–55.

[15] Foundational is Bal and Bryson 1991: especially 176–80; cf. Bryson 1991. For a good overview, see Mattick 2003.

itself against its effete 'art historical' sibling. 'Classical art historians', James Whitley continues, 'can continue to study sculpture and "vase painting" without having to take a close interest in broken pottery from survey or excavation, or bothering overmuch about the contexts in which such art was found or used'. But these academics are not proper 'classical archaeologists'. Whitley is trenchant about his own material-culturalist position: 'all art is material culture . . . Classical art history therefore is archaeology, or it is nothing'.[16]

The problem here lies with the prescriptive way in which archaeologists have so often equated 'context' with provenance (and vice versa). Of course, the championing of findspots is understandable: when operating alongside an illicit antiquities trade, fed by deplorable (non-)methods of excavation, it is quite right that archaeologists should emphasize the importance of where an object comes from; reasonable, too, that they should point to the artifice of modern ideals of 'aesthetics'—the need to understand (what we call) 'art' in relation to its material, topographical, and environmental landscapes.[17] But provenance is only *part* of the matrix that bestows meaning on objects. What is more, the fetishization of findspots can provide an all too convenient excuse for shirking formal engagement with what can actually be seen—with 'material' culture as also 'visual' culture. To express the point more strongly, I am convinced that we can say something about an object even when we do not know its provenance: for 'context' must always entail *more* than provenance alone.[18]

That this will strike so many as controversial is perverse—and unique to the study of objects as opposed to texts.[19] Once again, however, the Iliac tablets can deliver a miniaturist antidote to the larger disciplinary malaise. As with so much Graeco-Roman material, excavated before the development of scientific methods of archaeological excavation, we have very little information about the provenance of these tablets. By looking closely at the objects, and by comparing them with each other, it is nevertheless possible to reach some macroscopic conclusions about function, purpose, and significance. When dealing with materials as portable and mobile as these miniature *Tabulae*, moreover, we have had cause to

[16] Whitley 2001: xxiii. Whitley's phraseology is borrowed from Willey and Phillips 1958: 2—proposing that 'American archaeology is anthropology, or it is nothing' (discussed by e.g. Gosden 1999: 1–11). More generally on the validity of 'art history' as a meaningful concept when dealing with Graeco-Roman antiquity, see Platt and Squire (eds.) 2010.

[17] Cf. e.g. Brodie, Doole, and Watson 2000: 12: 'Most, if not all, collectors (and some academics and curators too) regard antiquities as works of art . . . but claims of art cannot be allowed to justify destruction and illegal looting. Many objects marketed as works of art have been ripped from historical buildings or monuments.' For the general issue, see S. Scott 2006 and Squire 2010b: 140–1.

[18] Contrast e.g. Clarke 2008: reviewing Elsner 2007a, Clarke puts forward the curious claim that 'if we want to see with Roman eyes, we have to exclude [*sc.* Pompeian] paintings without archaeological context'.

[19] Although 'pseudo'-texts only rarely make it on to undergraduate syllabuses (especially when their contexts are problematic: e.g. Calpurnius Siculus' *Eclogues*), we do not hear the same complaints, or at least to the same degree, in philological circles.

remember that objects can have as many 'contexts' as they do users. In some ways, the very lack of information about provenance liberates rather than restricts analysis: where archaeologists often tend to freeze-frame particular display contexts, the *Tabulae* clearly had different functions, at different times and places, and among different clientele.

So, to respond to James Whitley's larger quip, are you reading 'classical archaeology' or 'classical art history' (or indeed neither)? The tablets show just how fabricated and unhelpful these distinctions ultimately are: the best tradition of classical archaeology has long since been orientated to the formal as well as the contextual properties of objects; moreover, the best tradition of classical art history was not only derived (at least in part) from the empirical study of Graeco-Roman materials, but also concerned with moving from minute formal analysis to the bigger picture of cultural history.[20] To talk of the *Tabulae Iliacae* in solely 'material' terms—zooming out to focus on sociological, political, and economic pragmatics alone—would be to engage in a severely impoverished mode of analysis. Most critically of all, it would be to lose sight of the ways in which the Iliac tablets themselves foreshadow these (and other) methodological questions. As I have tried to show, the tablets challenge their users not only to look, touch, and engage, but also to scrutinize the acts of doing so: they stage much more self-reflexive intellectual questions about *how* we should respond. 'Context', on the other hand, is all too often cited as a sort of objective 'will to power'—a definitive and scientific 'origin' for an object that eliminates the subjective interests of the modern-day onlooker.[21]

Third and finally, this book is offered as a small-scale intervention in arguably the biggest challenge facing (what we variously define as) classics, classical

[20] See e.g. Elsner 2006 on Riegl's concept of 'Kunstwollen', grounded in the study of Roman/late antique sculpture.

[21] To pre-empt one response, a brief word on what some will no doubt deem the 'postmodernism' or '(post-?)poststructuralism' of this book. Countless 'postmodern' texts later, I remain less convinced than ever as to what the term means, or what the charge of 'postmodernism' should entail: to my mind, the stakes have more to do with the underlying ideologies of those defining themselves *against* (what they call) the 'postmodernists'—or those who refuse point-blank to engage with the demanding texts in question (finding it easier, and politically more expedient, to trash the proverbial bogeyman). Such is academia, of course. But what makes me *angry* about the charge is the downright imperialist assumption of linear *advancement* (or for that matter degeneracy): that only 'postmoderns' are capable of understanding conceptual complexity, according to some simple, linear, forward march of human thinking; that things were somehow much simpler in antiquity—so why bother with sophisticated, new-fangled 'theory'? What is so humbling (and humanizing) about the humanities—and about the holistic study of Graeco-Roman antiquity in particular—is the realization that ideas, concepts, and discourses are endlessly recycled from one age to another; like Umberto Eco, I am therefore convinced that 'postmodernism is not a trend to be chronologically defined...every period has its own postmodernism, just as every period would have its own mannerism' (Eco 1994: 66). The Iliac tablets testify to this: in my book, this is ultimately what makes them so inspirational.

archaeology, and classical art history in the early twenty-first century: namely, the endemic disciplinary urge to segregate the study of texts for reading from objects for viewing. As I have argued elsewhere, this is not a problem peculiar to the field of classics; it is symptomatic of a much deeper-seated ideology of 'words' and 'pictures'. Despite contemporary calls to 'interdisciplinarity', moreover, the problem seems to be getting worse rather than better.[22]

It is crucial to understand the historiography of this issue within the larger disciplinary field. Originally, the study of Graeco-Roman art was inextricable from that of its literature: Johann Joachim Winckelmann, whose 1764 *Geschichte der Kunst des Alterthums* provided the ideological foundations for both classical art history and indeed art history generally, was trained first and foremost as a philologist.[23] In nineteenth-century Germany, where Winckelmann's work had the greatest impact, being a classical archaeologist still entailed knowing one's classical texts. But the late nineteenth and early twentieth centuries witnessed a profound change. Fuelled by the scientific excavation of key Greek and Roman sites, *Archäologie* was transformed into a subject in its own right—both within the study of Graeco-Roman antiquity, and indeed within the academy at large. In Germany, where this book was written, there remains relatively little traffic between departments (or indeed libraries) of 'Klassische Archäologie', 'Klassische Philologie', and 'Alte Geschichte': since the late nineteenth century 'Klassische Altertumswissenschaft' has been neatly divided into philological, archaeological, and historical camps; since at least the Second World War, moreover, there has been remarkably little scope for crossing (sub-?)disciplinary *Grenzen*.[24]

The British (and to some extent North American) concept of 'classics' is rather different: it never witnessed the same fragmentation of German 'Altertumswissenschaft'. In terms of university training, at least, there is an idealist emphasis on learning about literary, epigraphic, material, and visual sources at one and the same time. But there are increasing signs of fragmentation. The tensions between 'Hellenists' and 'Romanists' on the one hand, and 'material' and 'visual' culturalists on the other, have only served to exasperate the problem: with what (sub-)disciplines should the study of Graeco-Roman 'art' ally, align, and affiliate itself?

[22] See Squire 2009: especially 1–12, 429–32.

[23] On Winckelmann's subsequent (philological) influence on the discipline, see in particular Bianchi-Bandinelli 2000: 29–50 and Marvin 2008: especially 103–19.

[24] For the historiography of German classical archaeology (and a modern-day defence), see e.g. Hölscher (ed.) 2002: 11–15, along with 73–5; cf. Hölscher 2000: 10–14, and above, p. 373 n. 5. Needless to say, this situation brings advantages as well as disadvantages: above all, it has nurtured a level of formalist training that many in the anglophone tradition have abandoned in favour of (text-based) cultural contextualism.

As with all attempts to categorize, structure, and delineate, these questions miniaturize much larger questions of ideology. We are dealing not just with differently organized materials, but with different ways of organizing knowledge per se. Fundamental are the inherent sociological stakes. Where texts are deemed inherently elite entities, preserving the perspective of a small ancient minority who could read and write, the archaeological record is judged all-encompassing: not everyone produces or has access to written words, but all human beings leave material traces behind them, regardless of their class, ethnicity, or gender.[25] This ideological dimension perhaps explains why so many British and American classical archaeologists feel such antagonism to (what they perceive as) 'art history': they think that to engage in visual rather than purely material analysis—to look qualitatively at objects as well as to treat them as quantitative data—is to assume not only an anachronistic category of art, but one that is inherently dilettante and elitist (recall James Whitley's prescription: 'all art is material culture').[26] A related antagonism beleaguers philological attitudes to the venture of art history. Among classical philologists, though, there is an equally entrenched logocentric assumption that texts are more valuable than objects—that working with pictures is inherently 'easier' than working with words.[27] The contemporary study of Graeco-Roman visual culture consequently finds itself in a disciplinary no-man's-land *between* archaeology and philology: it is exiled from the trenches, and yet uncomfortable in the library; it wants to pay more than material attention to objects, and yet not reduce images to textual narratives (or indeed read them as structurally *inferior* to texts).[28]

It is here that the Iliac tablets prove their most remedial. As objects designed both to be seen *and* to be read—and at one and the same time—they reveal the forged artifice of our modern ideological, cultural, and academic segregations. In order to begin understanding the *Tabulae*, we have to pay attention to their

[25] For just one example, see e.g. Clarke 2003: 1–13 and 2007: 16, complaining of the art historical privileging of 'literary texts, written by or for elite men, thereby excluding the other 98 per cent of Roman society'. Clarke accordingly defends his own mode of 'looking' at Roman art in isolation from Greek and Latin texts.

[26] The crucial contribution here is Bourdieu 1984: especially 5–7, on the 'cultural capital' upon which (post-Enlightenment) systems of aesthetics derive; cf. e.g. idem 1987: 203: 'The work of art exists as such...only if it is apprehended by spectators possessing the disposition and the aesthetic competence which are tacitly required.'

[27] The classic articulation is Curtius 1948: 23: 'Pindars Gedichte zu verstehen, kostet Kopfzerbrechen; der Parthenonfries nicht... Die Bilderwissenschaft ist mühelos, verglichen mit der Bücherwissenschaft' (for discussion, see Squire 2009: 15–17).

[28] Cf. Donohue 2003: especially 4: 'The study of ancient art exists uneasily in a disciplinary no-man's land. Within art history it holds a marginal position; within textually based disciplines it is seen as irrelevant; and within many forms of archaeology it is variously condemned as effete, exclusive, destructive, or simply lacking validity.'

textual-cum-material-cum-visual qualities. Along the way, the tablets tease us into rethinking such structural distinctions, understanding their words as material and visual entities, and indeed their images as texts. Remember the circles of the previous chapter—image, text, image, text, ad infinitum (Fig. 170). These *grammata* require us to reintegrate modes of analysis that, in modern disciplinary terms, are in dire danger of drifting apart: we can no longer sustain the 'parallel worlds' model of approaching ancient 'art' and 'text', however conveniently it suits modern academe.[29] We have to rethink our own assumptions of *taxis*.

The Iliac tablets therefore serve to treat a number of academic maladies: in a nutshell, our adventures with them encourage us to be more adventurous in crossing pseudo-sectors between the Greek and the Roman, the material and the visual, and the lisible and visible. Ultimately, though, it is in the field of Imperial visual culture that the tablets must have their greatest impact. This is an area in which practitioners have recently been voicing considerable dissent. Over the last decade or so, a host of new studies have challenged the traditional disciplinary divide between the 'sophistication' of early Imperial Latin literature and the mundane 'functionality' of the contemporary visual field: focussing on issues of Roman 'representation', 'replication', and 'emulation', scholars have shown how artists exploited visual subjects, styles, and forms in much more knowing and self-referential ways.[30] The old certainties are slowly being challenged, and the age-old question of 'what is Roman about Roman art?' imploded from within.[31] Earlier, toward the end of the twentieth century, came various attempts to rehabilitate the 'Roman' in relation to the 'Greek'—understanding 'Roman art' to do duty as communicative 'propaganda', for example, or else as serving some pretty ornamental and mundane function in the *Bilderwelt* of domestic 'decoration' (one thinks in particular of the ground-breaking work of Paul Zanker and Tonio Hölscher).[32] But the Iliac tablets go much further. As this book has demonstrated, these objects materialize a level of visual and verbal sophistication that we are quite unused to associating with (what we delineate as) 'Roman' visual culture. It is a response that I frequently encountered during lectures on the *Tabulae*, among

[29] The 'parallel worlds' model is encapsulated by Small 2003, but cf. e.g. Ling 1995: 249 n. 10 on how 'the influence of literature upon art was of a very general kind'. For the point in the context of the Iliac tablets, cf. e.g. Sadurska 1964: 5: 'L'étude de ces objets [*sc.* les tables iliaques] pourrait contribuer en outre à enrichir l'histoire de la sculpture gréco-romaine et jeter de la lumière sur l'influence réciproque de la littérature et de l'art.'

[30] I think in particular of Bergmann 1995b; Gazda (ed.) 2002; Perry 2005; Trimble and Elsner (eds.) 2006; Elsner 2007a; Marvin 2008; Trimble forthcoming. Varner 2006 is typical of such revisionist camps, discussing Roman art as something 'pervasively intertextual and multivalent' (209).

[31] For the question, see most famously Brendel 1979; on the historiography, see especially Kampen 2003 and Elsner's introduction to Hölscher 2004 (xv–xxxi).

[32] For the two respective debts, see e.g. P. Zanker 1987 (translated as idem 1988) and Hölscher 1987 (translated as idem 2004; cf. more recently the essays in Hölscher and Hölscher (eds.) 2007).

audiences of classical archaeologists, especially (though not exclusively) in Germany and Austria: 'this sort of artistic "play"', as one retort had it, 'just doesn't seem *Roman*'.

The assumptions at work here take us back to the artificial segregation of not only the Greek from the Roman, but also Graeco-Roman archaeology/art history from classical philology. Needless to say, the thinking is decidedly one-sided: we need only venture to adjacent literature departments—the tablets *are* very much in tune with the playful games of Latin poets like Catullus, Ovid, and Martial (all roughly contemporary with them).[33] If the tiny tablets are typical of anything in first-century BC and first-century AD Rome, we have therefore to rethink the field at large: we must realign our readings of Imperial material and epigraphic culture in terms of our views of Augustan poetry, with all its self-aware allusivities, sophistications, and complexities; by the same token, we have to review our readings of Greek and Latin literary cultures in the light of contemporary visual resources. The reciprocal lessons of the *Tabulae Iliacae* are at once metaliterary *and* metapictorial: taking the tablets means rethinking some of our grandest canonical assumptions, and in a variety of different disciplinary perspectives.

THE GR8 DB8

These lessons could not come at a more critical moment, and not just in the academic confines of classics as a discipline. In a (post-)postmodern world still spinning from the supposed 'linguistic' and 'pictorial' turns of the last century, there has never been a better time to heed the tablets' lessons about medium and message.[34] With the close of the 'noughties', the issues with which the *Tabulae Iliacae* play matter today more than ever—intellectually, socially, culturally, ideologically, politically. This endows these microscopic objects with a still larger macroscopic significance: as visual–verbal synopses acutely attentive to their form, the *Tabulae* can engage with the 'gr8 db8s' (as David Crystal might put it) of our own multimedia age.[35]

[33] For the Roman cultural bond between 'song' and 'play', encapsulated in the concept of *ludus*, see Habinek 2005: 110–57.

[34] For the 'linguistic turn' (the way in which verbal systems functioned as central structuring agents of early twentieth-century philosophy and cultural history), see Rorty 1967. For the later 'pictorial turn', see Mitchell 1994: 11–34, and ibid. 106 on 'the increasing mediatisation of reality in postmodernism'; cf. also idem 2002: 240–1.

[35] See Crystal 2008. The phenomenon is by no means unique to (British) English: cf. Crystal 2008: 123–48.

Some will find Crystal's title—formulated in the ludic 'slanguage' of 'textese'—facetious, even downright offensive. But that surely demonstrates the point—the medium *as* the message ('the great debate'). The question here concerns nothing less than the cultural ownership of media—how language should be used, to what communicative ends, and via which means of cultural control, authority, or intervention. The 'Old Order' sees this as a choice between received wisdom and anarchy: witness the furore of a best-selling book like Lynn Truss's *Eats, Shoots and Leaves*—the all-out battle, waged over the killer apostrophe ('Come inside for CD's, Video's, DVD's, and book's').[36] The real anxiety here is less about the supposed corruption of language than the idea(l)s deemed to lie behind it: in an almost Platonic sense, the 'breakdown' of established communicative conventions is assumed to signal the breakdown of communication at large. If communication crumbles, the reasoning runs, so too will the ideas communicated: something as tiny as a textese message threatens all-out intellectual, social, and political Armageddon.[37]

These are battles that have long been waged, and over 'miniature' forms no less original, innovative, and ludic than the SMS text message. Think back to Aelian's dismissal of the *Iliad* and *Odyssey* on the sesame seed: such flippancies will not earn the approval of a serious person, as Aelian puts it, for what are these things if not a waste of time (above, p. 3)? It is in this capacity that the *Tabulae Iliacae* can connect with our own cultural perspectives some 2,000 years after their production. On the one hand, these objects prefigure an 'Enlightened' sense of semiotic totality, control, and order—in their size and scope as much as in their combined visual and verbal form. But if the tablets encapsulate a dream of stability, in which 'signifieds' perfectly align with 'signifiers' (and vice versa), they simultaneously expose the fiction. Such representational 'containment' is dependent on the subjective engagement of the audience responding to it. Indeed, the *Tabulae* champion the reader-viewer's share explicitly: 'glide whichever way you choose'.

In political terms, this is a truly radical message because it puts the individual in the driving seat. That message must have been all the more radical in the context of the late first century BC and early first century AD. Despite all their ostensible bows to Augustan myth-mongering—remember the centrality of Aeneas, the 'middle *gramma*' on the obverse of at least three tablets—the *Tabulae* show how,

[36] For this 'zero tolerance approach to punctuation', see Truss 2004. The example quoted comes on the first page—'anger gives way to a righteous urge to perpetrate an act of criminal damage with the aid of a permanent marker' (2), apparently.

[37] Crystal 2008: 9 quotes an editorial from (predictably) the *Daily Mail* on 28 September 2007, calling SMS texters 'vandals who are doing to our language what Genghis Khan did to his neighbours eight hundred years ago. They are destroying it: pillaging our punctuation; savaging our sentences; raping our vocabulary. And they must be stopped.'

behind the 'official' take of the Augustan dictatorship, there are countless other stories to be told. To magnify the fictions of representation might *seem* like harmless fun. But the *Tabulae* simultaneously make a transparency out of the forged political *status quo*. When, writing under Augustus, Vitruvius embarks on his famous tirade against the artificial *monstra* of contemporary wall painting, a similar set of ideological stakes were arguably in play: by representing 'things that are not, are not able to be, nor have been', such paintings threatened not only the conventions of *artistic* illusionism, but also the political illusions that propped up Augustan power.[38] As with the trappings of (what we now call 'Third Style' Pompeian) wall paintings—what could be more harmless than fanciful reed stalks, tendrils, and candelabra?—the explosive power of the tablets lay in their synthetic exposé of representational-cum-political *ueritas*. The *Tabulae Iliacae* at once monumentalize and overturn the 'official' *taxis* of Augustan Rome.

These issues speak to us today more than ever. 'No pictures should be tolerated but those established on the basis of truth', writes Vitruvius, anticipating count-less more recent political attempts to censure, steer, and control; 'nor if they are made artificially elegant is that reason to judge them immediately good, unless they have sure modes of justification (carried through without violation)'.[39] In antiquity, as in modernity, the courage to see (or read) things otherwise has always proved revolutionary: claims of degeneracy are quick to follow.

But think back to the period when the Iliac tablets were first circulating. Such championing of individual subjectivity had revolutionary potential: deconstruct-ing stories as politicized as those of Rome's Trojan origins could prove risky indeed. The obvious comparison is with Ovid, revisiting (and 'changing') the Virgilian Trojan myth in the final books of his *Metamorphoses*, or else rebranding Augustan Rome's monumental landscape into an effective red light district (all in the thoroughly *un*-Augustan effort to get laid: *Ars am.* 1.67–88). Like the tablets, Ovid takes the sorts of play so rife in Hellenistic elite intellectual life and brings them to bear on the contemporary political arena. When Ovid advises would-be lovers to *make up* stories about triumphal spectacles, we are very much in *Tabulae* territory: Ovid's alternative take poses a subversive threat to Augustan razzle-dazzle; sure enough, exile ensues.[40] No wonder, perhaps, that our 'Theodorean'

[38] Vitr. *De arch.* 7.5.4: *Haec autem nec sunt nec fieri possunt nec fuerunt* (with bibliography in Elsner 1995: 323 n. 40). On the political conditioning of this viewpoint, see now Platt 2009a, a long with Elsner 1995: 51–8 and McEwen 2003: especially 229.

[39] Vitr. *De arch.* 7.5.4: *Neque enim picturae probari debent quae non sunt similes ueritati, nec si factae sunt elegantes ab arte, ideo de his statim debet recte iudicari, nisi argumentationis certas rationes habuerint sine offensionibus explicatas.*

[40] See Ov. *Ars am.* 1.219–28, instructing boys to 'speak the real names if you can, but if not, at least make them likely' (*et erunt quae nomina dicas, | si poteris, uere, si minus, apta tamen*, vv. 227–8). There is a good introductory discussion in C. Edwards 1996: 23–5.

band opted for that *nom de plume*. A dangerous thing, empowering the individual . . .

'Glide whichever way you choose'. The instruction is not 'purely academic' (whatever that might mean): the *Tabulae* are hardly the prerogative of some 'ivory tower' far, far away. The stakes of these ludic little objects loom as large today as ever. Lives depend—as they always have done—on our critical ability to see and read beyond appearances, whether in Imperial Rome, or indeed the Western democracies of the twenty-first century ('simply stated, there is no doubt that Saddam Hussein now has weapons of mass destruction'). It is a lesson that we prove reluctant to learn, and reiteratively so. But that makes the *sophia* of the tablets' *technê* all the more weighty. For the tablets' *ultimate* fiction lies in their apparent frivolity. Seriousness must be premised upon play. And play best prepares us for getting serious.[41]

[41] My adventures with the *Tabulae* here reach their temporary libertarian close. But this can never be 'game over'. As always with these objects, there remains scope for a reverse hermeneutic flip. After all, the tablets (like the epigrammatic instructions on 1A, 2NY, and 3C) simultaneously make an imperative out of interpretive free play: like their magic squares, they paradoxically *order* audiences to depart from established orders ('glide whichever way you choose!'), programming us into challenging programmes—the ultimate 'dictatorship of relativity'. Encapsulated in this unobtrusively esoteric place, then, lies a secret of empire— and a conspicuous demonstration of our own imperial complicity: we are granted exegetic freedom, and simultaneously shown, through playing the game, how we can never live up to the promise of free exegesis. Choose *your* own adventure! In a nutshell: *sine fine* . . .

APPENDICES

INVENTORY OF THE TABLETS

The objective of this appendix is not to give a full description of the tablets, their imagery, or their inscriptions: for these, see Nina Valenzuela Montenegro's 2004 catalogue with detailed bibliography on each tablet (up until 2002) and transcriptions of most Greek texts (with German translations). Instead, my aim is to provide a brief overview of each object, indexing the book's discussions, while also providing thumbnail pictures of photographs, details, and drawings. Most information about size and material follows that listed by Sadurska—to which Valenzuela Montenegro is usually also indebted; only occasionally have my own measurements proved substantially different, and (where appropriate) I have also indicated my different estimates of original size.

Tablet 1A ('The Capitoline tablet'/*Tabula Capitolina*) (*Tabula Iliaca Capitolina*) Rome, Musei Capitolini, Sala delle Colombe, inv. 316

pp. 12–13, Fig. 4

Dimensions of surviving fragment (height, width, thickness): 25 x 30 x 1.5 cm.
Original surface area (following Sadurska): 25 x *c.*40 cm.
Material: 'Calcite (calcium carbonatum CaCO$_3$) très blanc, compact, qui ressemble au stuc de marbre' (Sadurska); 'Palombino' (Valenzuela Montenegro).
State: Left-hand side of the obverse lost (pp. 34–5), but upper, right-hand, and lower edges survive, including both right-hand corners.
Provenance: Villa at Messer Paolo in Rome (pp. 66, 72).
Obverse: *Iliad, Ilioupersis, Aethiopis, Little Iliad* (? *Cypria*: p. 171).

See pp. 13–14, 34–9, 148–77. Subject defined as 'Trojan' (p. 253). 24 friezes representing the *Iliad* adorn the left- and right-hand sides, books 1–12 on the left (arranged from top to bottom—but now lost), and 13–24 on the right (from bottom to top: pp. 34–5, 166–7); books are labelled on the right-hand side from *nu* to *omega* (letters contained in upper left-hand corner of each frieze, although only those pertaining to books N, O, Π, P, Σ, and T can be seen); protagonists and subjects are labelled below each frieze (with one notable exception: p. 177 n. 114). The frieze pertaining to *Iliad* 1 extends over the upper centre of the relief, joining up with book 24 (pp. 167–71)—just one of the tablet's many spatial games (pp. 165–76). At the tablet's centre is the *Ilioupersis* ascribed to Stesichorus (pp. 18–19, 35, 106–8), with prominence given to the exploits of Aeneas (pp. 59, 148–58, 242–3); below are shown in two separate friezes the *Aeithiopis* and *Little Iliad*, combined in a self-standing frame (pp. 172–5). Literary subjects and authors are named in inscriptions at the tablet's lower centre (p. 35). Pilasters to the left and right of the central *Ilioupersis* provide a prose summary of Iliadic events (only the pilaster on the right survives: pp. 34–5, 94–6, 167 n. 104, 257; books 13–15 are omitted, pp. 94–5; compare similar-looking pilasters on tablets 8E, 14G, and 19J). A programmatic epigram inscribed within the lower *Aethiopis/ Little Iliad* frame associates the tablet with 'Theodorean *technê*': [τέχνην τὴν Θεοδ]ώρηον μάθε τάξιν Ὁμήρου | ὄφρα δαεὶς πάσης μέτρον ἔχῃς σοφίας, 'Understand [the *technê* of Theo-] dorus, so that, knowing the order of Homer, you may have the measure of all wisdom' (pp. 102–21, 195–6).

Reverse: Uninscribed (no bevelled edge).

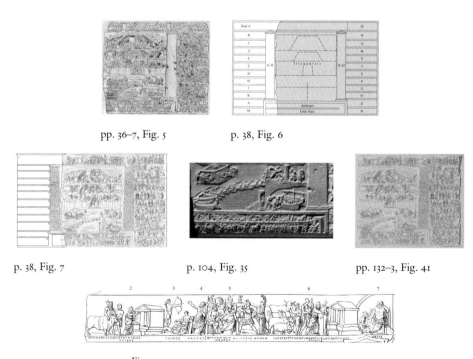

pp. 36–7, Fig. 5 p. 38, Fig. 6

p. 38, Fig. 7 p. 104, Fig. 35 pp. 132–3, Fig. 41

pp. 134–5, Fig. 42

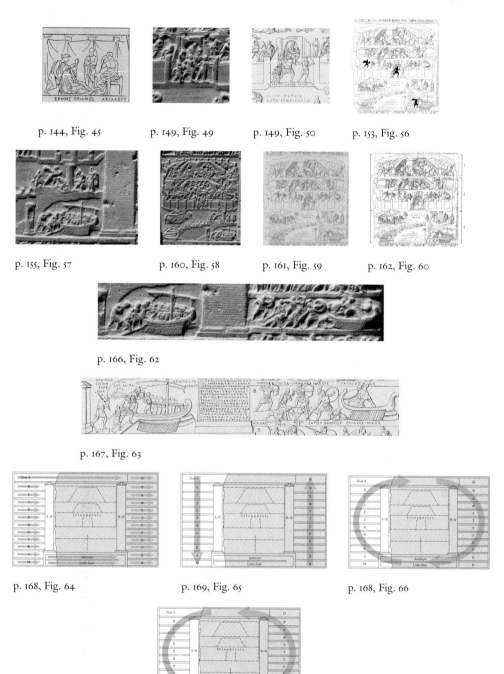

p. 144, Fig. 45 p. 149, Fig. 49 p. 149, Fig. 50 p. 153, Fig. 56

p. 155, Fig. 57 p. 160, Fig. 58 p. 161, Fig. 59 p. 162, Fig. 60

p. 166, Fig. 62

p. 167, Fig. 63

p. 168, Fig. 64 p. 169, Fig. 65 p. 168, Fig. 66

p. 169, Fig. 67

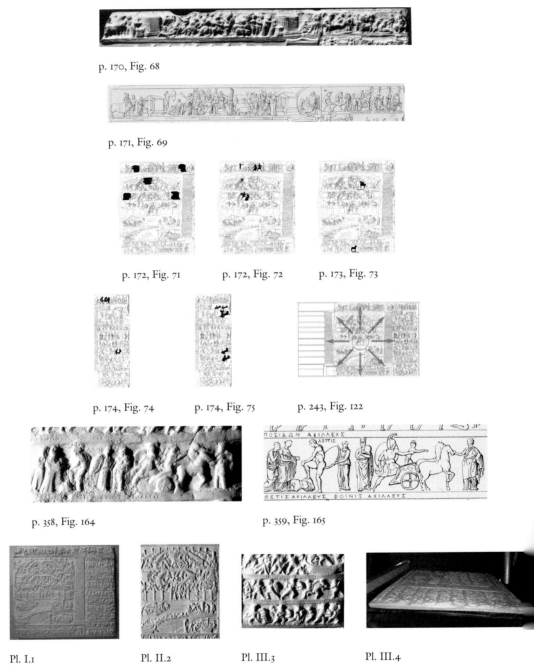

p. 170, Fig. 68

p. 171, Fig. 69

p. 172, Fig. 71 p. 172, Fig. 72 p. 173, Fig. 73

p. 174, Fig. 74 p. 174, Fig. 75 p. 243, Fig. 122

p. 358, Fig. 164 p. 359, Fig. 165

Pl. I.1 Pl. II.2 Pl. III.3 Pl. III.4

Tablet 2NY
(*Tabula New York*)
New York, Metropolitan Museum of Art, inv. 24.97.11

p. 241, Fig. 120 p. 240, Fig. 119

Dimensions: 18.1 x 17.6 x 2.5 cm.

Original surface area (following Sadurska): 29 x 29 cm (although height probably larger: pp. 178–80, n. 116; cf. Squire forthcoming e).

Material: 'Marbre blanc, à grain fin' (Sadurska).

State: Fragment comes from upper right-hand corner, preserving parts of the upper and right-hand edges.

Provenance: Unknown (purchased in Rome in 1924).

Obverse: *Iliad, Ilioupersis*, but probably also others (pp. 178–80 n. 116). The inscription in the upper frame of the central *Ilioupersis* scene is fragmentary, but seems to refer only to the *Iliad* and *Ilioupersis* ([*ΙΛΙΑΣ ΚΑΤΑ ΟΜΗΡΟ*]*Ν ΚΑΙ ΙΛΙΟΥ ΠΕΡΣΙΣ*).

See pp. 39, 178–81, 240–3. Central image of the *Ilioupersis*, with prominence given to Aeneas (as on the Capitoline tablet): pp. 177–8. Scenes from the *Iliad* circulate around the image, one metope for each book (sections from books 19–24 surviving, along with a partial inscription relating to book 18: on the arrangement, see pp. 178–81). Books of the *Iliad* are named after alphabetical letters (e.g. *ΙΛΙΑΔΟΣ Τ*) and described in short *lemmata*; numerous characters are also named in the inscriptions. On the very top of the tablet, there is a programmatic epigrammatic inscription, closely related to the elegiac couplet on tablet 1A (τ]έχνην μέτρον ἔχης σο[φίας], '...*technê* you may have the measure of wisdom': pp. 104–5.

Reverse: 'Magic square' inscription (pp. 199–210, 239–43), associating the tablet with 'Theodorean *technê*' (['Ιλι]ὰς 'Ομήρου Θεοδώρηος ἡ{ι} τέχνη, 'The *Iliad* of Homer: the *technê* is Theodorean'); the reverse inscription is closely related to those of tablets 3C and 20Par. Remains of an inscription above explain the device (γράμμα μέσον καθ[ελὼν παρολί σθα]νε οὗ ποτε βούλει, 'Grasp the middle letter [*gramma*] and glide whichever way you choose'; alternatively γράμμα μέσον καθ[ορῶν παραλάμβα]νε οὗ ποτε βούλει, 'Look for the middle letter and continue with whichever/wherever you choose', pp. 204–5, 236–43). Around the central grid of letters, above and to the left, other alphabetic letters are inscribed in a much larger size (*Μ, Π, Λ, Ε*: see pp. 239–40). Like the recto, the verso has a framed outer rim.

p. 105, Fig. 36 p. 179, Fig. 77

p. 179, Fig. 78 p. 204, Fig. 103 p. 242, Fig. 121

Pl. IV.5 Pl. V.6

Tablet 3C
(*Tabula Veronensis I*)
Paris, Cabinet des Médailles (Département des Monnaies, Médailles et Antiques), Bibliothèque Nationale de France, inv. 3318

p. 41, Fig. 8 p. 202, Fig. 100

Dimensions: 10 x 10 x 2.2 cm.

Original surface area (following Sadurska): 24 x 26 cm.

Material: 'Marbre jaune à grain fin dont la surface a une teinte brun foncé' (Sadurska).

State: Part of the left-hand and upper edges survive, including a (damaged) left-hand corner. Some clear traces of gold paint (pp. 64–5).

Provenance: Rome or environs (exact place unknown); possibly recovered alongside tablet 9D.

Obverse: *Iliad* (named in the upper frame of the *Ilioupersis* representation: $IΛIAΣ$ $O[MHPOY]$), *Ilioupersis*.

See pp. 39, 131, 170–1. Friezes relating to the *Iliad* are structured around a central *Ilioupersis* scene (which evidently gave prominence to Aeneas: pp. 177–8). Layout is in many ways analogous to tablet 1A (e.g. book 1 stretching over the upper centre of the tablet: pp. 167, 170–1); here, though, the left- rather than right-hand side of the tablet survives, and there are no inscribed pilasters dividing the two registers. Friezes relating to *Iliad* 1–5 survive (does the frieze of *Iliad* 1 in fact begin with the *Cypria*—p. 171?). Each frieze is labelled with

identificatory inscriptions below; to the right, inscribed in the frame of the *Ilioupersis* scene, are letters detailing the Iliadic book (from *alpha* to *epsilon*) and giving short *lemmata* titles.

Reverse: 'Magic square' inscription (pp. 199–210), associating the tablet with 'Theodorean *technê*' ([ʾΙλιὰς ʿΟμήρου] Θεοδώρηος ἥ{ι} τέχνη, 'The *Iliad* of Homer: the *technê* is Theodorean'); the reverse inscription is closely related to those of tablets 2NY and 20Par. An inscription above explains the device (γράμμα μέσον καθ[ελὼν παρολίσθα]νε οὖ ποτε βούλει, 'Grasp the middle letter [*gramma*] and glide whichever way you choose'; alternatively γράμμα μέσον καθ[ορῶν παραλάμβα]νε οὖ ποτε βούλει, 'Look for the middle letter and continue with whichever/ wherever you choose', pp. 204–5, 236–43). Verso decorated with a marked outer rim.

 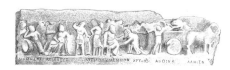

p. 134, Fig. 43 p. 171, Fig. 70

p. 203, Fig. 101 p. 204, Fig. 103

Pl. VI.7 Pl. VII.8 Pl. VII.9

Tablet 4N
(*Tabula Aspidis I*)
Rome, Musei Capitolini, Sala delle Colombe, inv. 83a

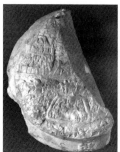

p. 309, Fig. 146 p. 308, Fig. 145

Dimensions: 17.8 cm in diameter (depth of 4.2 cm): this is the original diameter.

Material: Palombino (p. 305 n. 5)?

State: Circular tablet, missing around a third from its upper right-hand side.

Provenance: Rome (Via Venti Settembre: p. 305 n. 4).

Obverse: Shield of Achilles (after *Il.* 18.478–608).

See pp. 311–24, 341–9, 360–7. A central inscription divides the central circular field (probably reading ἀσπὶς Ἀχιλλῆος Θεοδώρ[ηος καθ' Ὅμηρον], 'The shield of Achilles: Theodorean, after Homer': p. 311). Above it are (on the left) the 'city of peace' and (now lost, but on the right) the 'city of war': pp. 313–17. Below are various landscape scenes, with their order and sequence playfully laid out: pp. 317–20, 347–8. Between the inner and outer field, stretching vertically between the two, were once the 12 signs of the Zodiac (pp. 322–5). In the outer rim of the three-dimensional shield, Helios and Selene ride in clockwise order (pp. 320–1); between them, in ten columns of microscopic text running in anticlockwise order (p. 365 n. 147), is the entire minute text of the Homeric ecphrasis, in letters of around 1 mm in height: pp. 360–7.

Reverse: 'Magic square' inscription in the shape of an altar (pp. 199–210, 234–5, 307–10, 348–9, 369), labelling the subject 'Theodorean': ἀσπὶς Ἀχιλλῆος Θεοδώρηος καθ' Ὅμηρον, 'The shield of Achilles: Theodorean, after Homer'. Underneath, another palindromic inscription (*IEPEIAIEPEI*: pp. 307–10, 348–9, 369). Does the 'Theodorean' attribution play an additional name game with the 'original' Homeric text (pp. 367–70)?

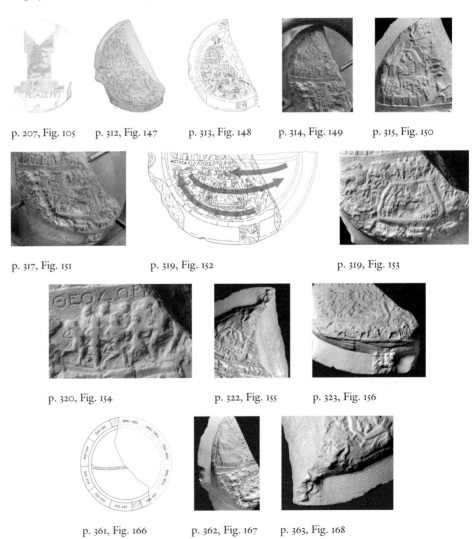

p. 207, Fig. 105 p. 312, Fig. 147 p. 313, Fig. 148 p. 314, Fig. 149 p. 315, Fig. 150

p. 317, Fig. 151 p. 319, Fig. 152 p. 319, Fig. 153

p. 320, Fig. 154 p. 322, Fig. 155 p. 323, Fig. 156

p. 361, Fig. 166 p. 362, Fig. 167 p. 363, Fig. 168

p. 363, Fig. 169

p. 365, Fig. 170

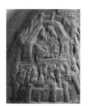

Pl. VIII.10

Pl. IX.11

Pl. X.12

Pl. XI.13

Pl. XI.14

Pl. XII.15

Pl. XIII.16

Tablet 5O
(*Tabula Aspidis II*)
Rome, Musei Capitolini, Sala delle Colombe, inv. 83b

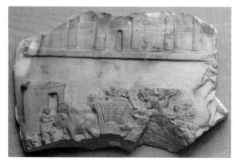

p. 306, Fig. 143

p. 306, Fig. 144

Dimensions: 10 x 15.5 x 1.5 cm.
Original surface area: Diameter of *c*.45 cm (p. 307 n. 7)?
Material: 'Palombin rose' (Sadurska).
State: Broken on all sides.
Provenance: Rome (see above, p. 305 n. 4)?
Obverse: Shield of Achilles (after *Il*. 18.478–608).

See pp. 324, 341–9. Only a small section of the shield survives—with part of the 'city at peace' perhaps above, and scenes of harvesting below; comparison can be made with a similar section of tablet 4N (p. 318), although this tablet is larger in size. The fragment evidently preserves a section from the central left-hand composition of the obverse (p. 324).

Reverse: 12-sided 'magic square' inscription, labelling the subject 'Theodorean' ([ἀσπὶς] Ἀχιλλεῖος Θεοδώρηος ἡ τ[έχνη], 'The Achillean shield: the *technê* is Theodorean', pp. 199–210, 307, 341, 368–9).

p. 206 Fig. 104

Tablet 6B
(*Tabula Sarti*)
Lost (though known from a nineteenth-century drawing by Emiliano Sartis)

p. 180, Fig. 79

Dimensions: Unknown (original dimensions also unknown).
Material: Unknown.
State: The fragment preserved parts of the tablet's upper and left sides. According to the drawing, there are two holes—one to the centre left of the upper frame, the other at the lowest edge of the surviving fragment, although most likely modern additions (pp. 67–8 n. 120).
Provenance: Unknown.

Obverse: *Iliad*, *Ilioupersis*, and *Odyssey* (according to the inscription in the upper band which makes reference to the 48 'rhapsodic books': *ΙΛΙΑΔΑ ΚΑΙ Ο]ΔΥΣΣΕΙΑΝ ΡΑΨΩΔΙΩΝ ΜΗ' ΙΛΙΟΥΠΕΡΣ[ΙΝ*, p. 44 n. 44).

See pp. 39, 182, 283. Scenes from the *Iliad* are structured in friezes around a central scene of the *Ilioupersis*; friezes relating to books 1–9 survive. As on tablets 1A and 3C, the first book of the *Iliad* stretches across the centre of the tablet (pp. 170–1). No formal borders separate the individual *Iliad* scenes from the central *Ilioupersis* (p. 182). Two figures hold an emblematic shield of Achilles in the upper centre of the tablet, above the *Ilioupersis* scene (pp. 357–8); a Gorgoneion features in the shield's centre, surrounded by Zodiacal signs. Characters of the Iliadic friezes are identified with inscriptions within and underneath each band. Books are labelled at the left-hand side of each frieze (*epsilon* to *theta* surviving); each book is also summarized in a single verse (catalectic anapaestic tetrameter?), as apparently on tablet 12F (pp. 96–7).

Reverse: No record of any inscription.

p. 181, Fig. 80 p. 356, Fig. 162

Tablet 7Ti
(*Tabula Thierry*)
Lost (though obverse photographed in 1882)

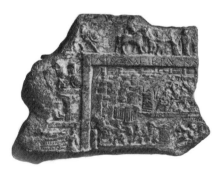

p. 177, Fig. 76

Dimensions: 7 x 10 cm (thickness not known).

Original surface area (following Sadurska): 17.5 x 20 cm.

Material: Unknown (Rayet 1882: 17 [= Rayet 1888: 184]: 'une sorte de pierre intermédiaire entre le marbre et le calcaire lithographique').

State: Parts of the upper and lower left-hand edges survive.

Provenance: Near the Temple of Hercules Victor in Tivoli, probably from a villa (pp. 66–7, 72).

Obverse: *Aethiopis, Ilioupersis* (p. 185): although fragmentary, an inscription on the upper band of the *Ilioupersis* scene mentions a *Little Iliad* (*ΙΛΙΑΣ ΜΕΙΚΡΑ ΚΑ[ΤΑ ΛΕΣΧΗΝ ΠΥΡΡΑΙΟΝ*, according to Rayet 1882: 18 [= Rayet 1888: 185]; Bua 1971: 11 n. 16 suggests instead *ΙΛΙΑΣ ΜΕΙΚΡΑ ΚΑ[Ι ΙΛΙΟΥ ΠΕΡΣΙΣ*).

See pp. 39, 177–8, 185. A central depiction of the *Ilioupersis* (with possible prominence given to Aeneas: pp. 177–8), framed by scenes of the *Aethiopis*: the precise subjects of the (five?) *Aethiopis* scenes are difficult to make out—the inscriptions seem to have named the Amazon Penthesilea, Agamemnon, and Achilles (among others).

Reverse: Reported 'magic square' inscription (['Ιλίου Π]έρσις, 'The sack of Troy': pp. 199–210).

Tablet 8E
(*Tabula Zenodotea*)
Paris, Cabinet des Médailles (Département des Monnaies, Médailles et Antiques), Bibliothèque Nationale de France, inv. 3321

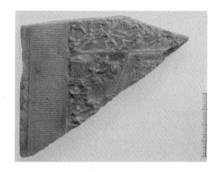

p. 42, Fig. 10

Dimensions: 8 x 11 x 0.8 cm.

Original surface area (following Sadurska): 22 x 23 cm; the relief's remarkable thinness must have made it exceptionally light among the tablets (p. 70).

Material: 'Marbre jaune à grain fin, très compact' (Sadurska).

State: Left-hand edge of the obverse survives, complete with bevelled edge. A possible trace of gold paint (p. 65 n. 105).

Provenance: Unknown (not 'the South of France' as sometimes claimed: p. 65).

Obverse: *Ilioupersis*.

See pp. 39, 99–101. A central image of the *Ilioupersis*, framed to the left (and originally once also to the right) with an inscribed pillar (compare 1A, 14G, 19J). The layout reminds of tablet 1A, albeit without the Iliadic friezes, and with some compositional changes (p. 39 n. 39). In this case, moreover, the pilasters are inscribed with a debate, associated with Zenodotus, about the number of days treated in the first book of the *Iliad* (pp. 99–101). The area of text is minuscule: 8.5 x 2.3 cm, inscribed with 64 lines. The inscription nevertheless finds room to mention Aeneas (p. 178 n. 115).

Reverse: Uninscribed (without bevelled edge).

p. 102, Fig. 34 Pl. XIV.17

Tablet 9D
(*Tabula Veronensis II*)
Paris, Cabinet des Médailles (Département des Monnaies, Médailles et Antiques), Bibliothèque Nationale de France, inv. 3319

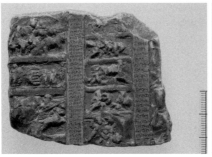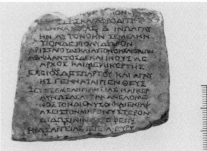

p. 41, Fig. 9 p. 199, Fig. 95

Dimensions: 5.5 x 6.7 x 1.3 cm.
Original surface area (following Sadurska): 24 x 24 cm. (cf. Squire forthcoming e).
Material: 'Marbre blanc-jaunâtre à grain fin' (Sadurská).
State: Broken on all sides. A possible trace of gold paint on the recto (p. 65 n. 105), and verso inscriptions highlighted through the application of dark paint (p. 65).
Provenance: Rome or environs (exact place unknown); possibly recovered alongside tablet 3C.
Obverse: *Iliad, Aethiopis, Ilioupersis*.
See pp. 39, 186–7. A central depiction of the *Ilioupersis* (on the right of the surviving fragment), with books 22–4 depicted on the far left, and five scenes from the *Aethiopis* depicted on the right (between the *Iliad* and *Ilioupersis* scenes). The *Iliad* scenes proceed from bottom to top, the *Aethiopis* scenes from top to bottom (cf. tablet 20Par): pp. 189–90. The *Ilioupersis* scene is labelled (in the frame to the left) with short inscriptions identifying the action; the *Aethiopis* scenes are also inscribed to their left, including short phrases that label each scene; similar *lemmata* were perhaps once inscribed to the left of the Iliadic scenes.
Reverse: Inscribed with a genealogy of the Theban hero Cadmus, similar to that found on the obverse of tablet 10K (pp. 47 n. 45, 99).

p. 101, Fig. 33 p. 188, Fig. 85 p. 188, Fig. 86 p. 189, Fig. 87

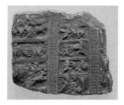
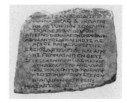

Pl. XV.18 Pl. XV.19

Tablet 10K
(*Tabula Borgiana*)
Naples, Museo Archeologico Nazionale, inv. 2408

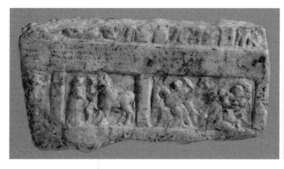
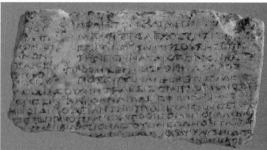

p. 200, Fig. 96 p. 200, Fig. 97

Dimensions: 4.5 x 8.5 x 1.1 cm (original surface area unknown).
Material: 'Marbre jaunâtre' (Sadurska).
State: Broken on all sides.
Provenance: Unknown (in the collection of Cardinal Borgia-Velletri by 1784).
Obverse: A Theban cycle.
See pp. 44–7, 192. A single horizontal band survives, divided into three scenes: characters are inscribed, but pictorial subjects are too fragmentary and damaged to recognize. The inscribed columns of text above are easier to read: these proceed not from left to right, but rather from right to left (p. 192); they relate to the genealogy of Cadmus, and are closely related to those on tablet 9D (pp. 47 n. 45, 99). The barely surviving left-hand column relates to (?)Eurydice, the surviving column to the right deals with the birth of Dionysus, and the two columns to the right of that deal with the birth of Cadmus himself.
Reverse: Inscribed with various texts: a column on the left (only the right-hand letters survive), and a column about the birth of Erichthonius on the right; beneath, in the space divided into two columns above, is a list of epic poems and their lengths: pp. 47 n. 45, 99, 192.

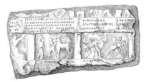

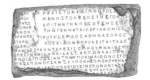

p. 193, Fig. 91 p. 193, Fig. 92

Tablet 11H
(*Tabula Rondanini*)
Warsaw, Muzeum Narodowe, inv. 147975 MN

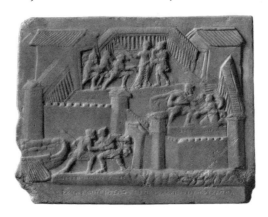

p. 44, Fig. 12

Dimensions: 11 x 14.5 x 0.6 cm (Sadurska 1961).

Original surface area (following Sadurska): 11 x 14.5 cm.

Material: 'Palombino légèrement crème, très dense' (Sadurska).

State: Upper right-hand corner restored in plaster (not the upper left-hand corner, as Valenzuela Montenegro claims); both lower corners broken, but parts of all four original sides are preserved.

Provenance: Unknown (in the collection of Giuseppe Rondanini by 1757).

Obverse: *Odyssey* 10 (as inscribed at the bottom: p. 185).

See pp. 39, 44, 185. The subject is the Circe episode: the architectural composition is exploited to divide the episode into three different moments, each one identified with inscriptions. Odysseus and Hermes appear in the lower register (left); Odysseus recurs in the centre-right scene above, this time with drawn sword, and with Circe on her knees in supplication; in the top scene above stands Circe (in the middle), with Odysseus to the right, and three of Odysseus' companions to the left (shown as dressed pigs walking on two legs).

Reverse: Uninscribed (no bevelled edge).

p. 186, Fig. 84

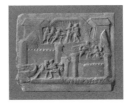

Pl. XVI.20

Tablet 12F
(*Tabula Parensis*)
Paris, Cabinet des Médailles (Département des Monnaies, Médailles et Antiques), Bibliothèque Nationale de France, inv. 3320

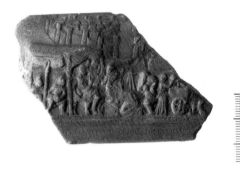

p. 43, Fig. 11

Dimensions: 5 x 7 x 1.2 cm.
Original surface area (following Sadurska): 5 x 8 cm.
Material: Palombino (Jahn); 'marbre jaune à grain fin, de teinte brunâtre à la surface' (Sadurska).
State: Parts of the upper and lower edges survive.
Provenance: Vigna Nicolai in Rome, near S. Paolo Fuori Le Mura.
Obverse: *Iliad* 24.
See pp. 39, 185–6. Scene of the ransom of Hector, with a cityscape of Troy behind (pp. 185–6, 313). Underneath, a single verse summary of the book, possibly in catalectic anapaestic tetrameter (as on tablet 6B: pp. 96–7, 258).
Reverse: Uninscribed (though bevelled along the upper, lower and right-hand edges).

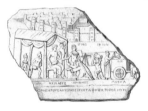
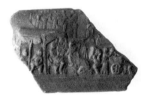

p. 95, Fig. 29 Pl. XVII.21

Tablet 13Ta
(*Tabula Tarentina*)
London, British Museum, inv. Sc. 2192

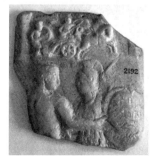

p. 68, Fig. 22

Dimensions: 9 x 8.7 x 0.6 cm.

Original surface area (following Sadurska): 15 x 8.5 cm.

Material: Giallo antico.

State: Parts of the upper, left-hand, and right-hand edges survive (including a damaged upper left-hand corner). There is a small hole in the upper centre of the tablet, perhaps suggesting that it was designed to be hung (p. 68 n. 121).

Provenance: Unknown (probably not Tarentum as sometimes claimed: p. 65).

Obverse: *Iliad*.

See pp. 39, 186. The upper scene clearly relates to the twenty-second book of the *Iliad*, with Achilles dragging the body of Hector around the city walls (the same schema appears on tablets 1A, 2NY, and 9D): the first three letters of Hector's name are still decipherable below (though there is no surviving indication of any naming inscription beside Achilles, as recorded in the British Museum's 1895 inventory: [ΑΧ]ΙΛΛΕΥΣ). The lower scene is harder to identify: it shows a nude male figure standing next to Athena (his hand touching the prominent shield that Athena holds). Is this the shield of Achilles (p. 357 n. 134)?

Reverse: Uninscribed (no bevelled edge).

p. 356, Fig. 161 Pl. XVIII.22

Tablet 14G
(*Tabula Homerica*)
Berlin, Staatliche Museen, Antike Sammlungen, inv. Sk. 1755

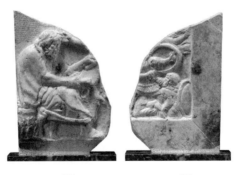

p. 200, Fig. 98 p. 200, Fig. 99

Dimensions: 10.3 x 7 x 2.2 cm (original surface area unknown).

Material: ' "Speckstein", pierre tachetée, gris-jaune' (Sadurska).

State: Parts of the left and lower edges survive, including the corner (hence the frame on the reverse side); base reattached to a modern marble stand (no longer possible to see the

original surface); possible indication of a grooved left-hand side (pp. 69–70); two holes have been drilled into the side of the tablet (one towards the top, the other towards the bottom), though these were for ease of modern display. The colouring to the bottom left of the recto seems to derive from fire damage.

Provenance: Unknown (Rome or environs, according to museum records: in the collection of J. P. Bellori by the second half of the seventeenth century).

Obverse: Portrait of Homer with a verbal summary of the *Iliad*.

See pp. 43, 99, 198. Homer sits reading his epic, surrounded by verbal *lemmata* drawn from the *Iliad* (the surviving inscriptions relate to the fourteenth to eighteenth books: p. 99): the text seems to have occupied a pilaster, cut off to the left by the tablet's original frame (hence the two vertical lines to the right of the surviving text, above Homer's head: compare the pilasters on tablets 1A, 8E, 19J). Homer sits on an altar adorned with a scene of a *citharoedus* and three other figures, similar to that found on tablets 17M and 19J. A figure was originally shown standing next to him (observe the outstretched arm to the top right of the fragment, with the hand touching Homer's head).

Reverse: A single image of an epic battle scene surrounded by a make-believe slatted frame (p. 70 n. 124).

 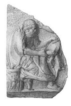

p. 69, Fig. 23 p. 100, Fig. 31 p. 100, Fig. 32

p. 372, Fig. 171

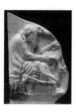

Pl. XIX.23 Pl. XX.24

Tablet 15Ber
(*Tabula Dressel*)
Berlin, Staatliche Museen, Antike Sammlungen, inv. Sk. 1813

p. 256, Fig. 124 p. 256, Fig. 125

Dimensions: 9.3 x 6.5 x 2.4 cm (not the 0.3 cm claimed by Sadurska and Valenzuela Montenegro; original surface area unknown).

Material: 'Marbre blanc-crème, très compact' (Sadurska).

State: Broken on all sides; a hole in the side of the tablet (towards the bottom) for ease of modern display.

Provenance: Unknown (most likely Rome, according to museum records).

Obverse: *Iliad* (?).

See pp. 39, 255–6. The scene is very fragmentary, but perhaps represents Aphrodite rescuing Paris from battle against Menelaus (*Iliad* 3)?

Reverse: 'Magic square' inscription in (?) lozenge shape (ἀνά]κτων σύνθεσ[ις, 'a collection of lords': pp. 119–210, 255–6); letters are inscribed to a larger scale than in other examples (p. 255 n. 25).

p. 256, Fig. 126 Pl. XXI.25 Pl. XXI.26

Tablet 16Sa
(*Tabula Tomassetti*)
Rome, Museo Sacro del Vaticano (Biblioteca Vaticana), inv. 0066

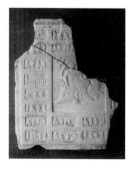

p. 45, Fig. 13

Dimensions: 20.4 x 17.2 x 1.6 cm.

Original surface area (following Sadurska): 20.4 x 22 cm.

Material: 'Marbre blanc' (Sadurska).

State: Parts of the lower, left, and upper edges survive, along with the lower left-hand corner. Some traces of gold and red paint (p. 64).

Provenance: A 'Roman field' (in 1882).

Obverse: *Odyssey.*

See pp. 44, 182–5. 24 single metopes, relating to the 24 books of the *Odyssey,* snake around a central image of Poseidon on a dolphin (Poseidon alone is inscribed on this relief: p. 182 n. 121); of these, 14 survive (relating to books 3–16?). The Roman numeral book inscriptions are modern additions—and mistaken. The order of books was knowingly playful (pp. 182–5): the first book of the poem seems to have been placed at the top of the third column from the left, so that episodes opening the poem are set against those closing it at the top right. Weitzmann argued that each picture derives from events narrated at the beginning of each book (p. 136 n. 16). The object is dismissed as an 'imitation' by Valenzuela Montenegro, but there is no reason to think the tablet stylistically later than the others (p. 61 n. 91).

Reverse: Uninscribed.

5	3	1	24
6	4	2	23
7			22
8	POSEIDON		21
9			20
10			19
11	14	15	18
12	13	16	17

p. 183, Fig. 81 p. 183, Fig. 82

Tablet 17M
(*Tabula Chigi*)
Rome, Palazzo Chigi, no inventory (lost?)

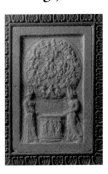

p. 48, Fig. 15

Dimensions: 15.5 x 9 cm (these are the original dimensions); the modern frame prevents from measuring thickness.

Material: Giallo antico (with black veins).

State: All four corners survive intact.

Provenance: A villa near Laurentum (pp. 66–7).

Obverse: The victories of Alexander at Gaugamela (Arbela).

See pp. 47–9. Personifications of Europe and Asia hold a large shield with battle scenes: the composition perhaps draws on other representations of the shield of Achilles, and can be compared with tablet 6B in particular (pp. 358–9 n. 137). The altar with *citharoedus* (and two other figures) below is very similar to those found on tablets 14G and 19J (pp. 49, 60). An inscription beneath the shield associates it with the 'third battle, after all the others, against Darius in Arbela' in 331 BC. The tablet's frame is inscribed with an epigram on Alexander's victories—one couplet above, and one below (p. 97). Did the tablet have a particular Augustan political reference in the aftermath of Actium (p. 49)? There is no reason to think the tablet stylistically later than others (p. 61 n. 92).

Reverse: Uninscribed.

p. 98, Fig. 30

Tablet 18L
(*Chronicum Romanum*)
Rome, Musei Capitolini, Sala delle Colombe, inv. 82

p. 50, Fig. 16

p. 51, Fig. 17

Dimensions: 8 x 9 x 1.6 cm, (original surface area unknown)

Material: Yellow palombino.

State: Broken on all sides.

Provenance: Rome (Sadurska), although precise provenance unknown.

Obverse: Life of Alexander?

See pp. 47–51. The precise subject is not known (p. 47 n. 50).

Reverse: Two columns of text, chronicling Greek and Roman history from the time of Solon's Athens to Sulla's Rome: the columns proceed from right to left (pp. 192, 198–9). As a chronicle, the text bears comparison with that on 22Get. Dates are counted back from the current year of AD 15/16 (pp. 50–1, 58, 60).

p. 194, Fig. 93 p. 194, Fig. 94

Tablet 19J
(*Tabula Albani*)
Rome, Villa Albani, inv. 957

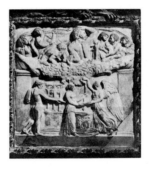

p. 46, Fig. 14

Dimensions: 25 x 24 cm (these are the original dimensions); the modern frame prevents from measuring thickness.

Material: 'Marbre blanc jaunâtre' (Sadurska).

State: Reconstructed from two large and two small fragments; all four corners restored in plaster and set in a modern frame; other parts also likely to have been restored (Cain 1989: 192). Traces of dark paint in the inscriptions (p. 65).

Provenance: Unknown (in the Palazzo Farnese by the first half of the eighteenth century).

Obverse: Deeds of Heracles.

See pp. 47, 60–1, 258–9. In addition to the upper depiction of Heracles among the gods, the hero's deeds are summarized in prose (on the pilaster to the left and right, which recall those of tablets 1A, 8E, and 14G: p. 95 n. 34), and then in an 'epyllion' of nineteen hexameters in the lower frame (pp. 97–9, 258–9). The altar in the lower centre of the tablet, complete with *citharoedus* and two other figures, recalls those of tablets 14G and 17M. The tablet is later than the others—witness, most conspicuously, the use of the drill: it seems to be an imitation of earlier tablets, dating from the middle of the second century AD (pp. 60–1).

Reverse: Uninscribed.

p. 258, Fig. 127

Tablet 20Par
(*Tabula Froehner I*)
Paris, Cabinet des Médailles (Département des Monnaies, Médailles et Antiques), Bibliothèque Nationale de France, Froehner, inv. VIII.148

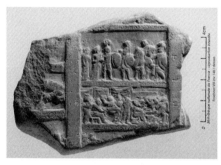

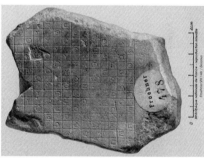

p. 190, Fig. 88 p. 203, Fig. 102

Dimensions: 6.5 x 8.8 x 2 cm.
Original surface area (estimated: cf. Squire forthcoming e): 25 x 29 cm.
Material: Palombino.
State: Broken on all sides. A possible trace of gold paint (p. 65 n. 105).
Provenance: Unknown, but probably Rome (Sadurska 1966: 653 n. 3).
Obverse: *Iliad, Aethiopis* (and other subjects: pp. 187–90).
See pp. 39, 187–90. To the right of the fragment is probably the *Ilioupersis*: to the left, we see first (in the three fragmentary scenes of the left-hand column) events most likely drawn from the *Aethiopis*, and then (in the best-surviving middle column) their antecedents in the *Iliad* (relating to books 17–20, arranged from bottom to top); the left and right columns do not align. The layout interestingly compares with that of tablet 9D (p. 190). Characters and events of the Iliadic scenes are identified with inscriptions. To the right, letters identify the individual books of the poem—*sigma* (book 18) and *tau* (book 19: on the representation of the shield of Achilles, see p. 359).
Reverse: 'Magic square' inscription (pp. 199–210), associating the tablet with 'Theodorean *technê*': [Ἰλιὰς Ὁμ]ήρου Θεοδώρει[ος ἡ τέχνη], 'The *Iliad* of Homer: the *technê* is Theodorean'); the reverse inscription is closely related to those of tablets 2NY and 3C, helping us to reconstruct the overall shape and composition of the tablet (p. 187; for the variant spelling, see p. 209).

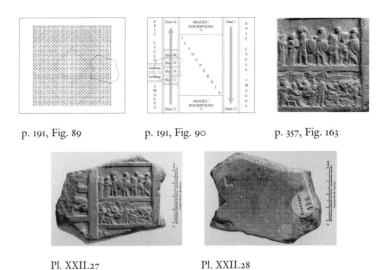

p. 191, Fig. 89 p. 191, Fig. 90 p. 357, Fig. 163

Pl. XXII.27 Pl. XXII.28

Tablet 21Fro
(*Tabula Froehner II*)
Paris, Cabinet des Médailles (Département des Monnaies, Médailles et Antiques), Bibliothèque Nationale de France, Froehner, inv. VIII.146

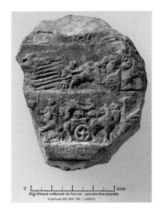

p. 184, Fig. 83

Dimensions: 7 x 6.4 x 1.8 cm (original surface area unknown).

Material: Palombino.

State: Broken on all sides; the remains of a ridged edge at the bottom of the verso (mirroring that below the lower frieze of the recto) suggests that the fragment comes from the lower section of the original composition (p. 185 n. 123).

Provenance: Unknown (purchased in Rome in 1887).

Obverse: *Iliad*.

See pp. 39, 185. Scenes relating to books 23 and 24 survive, proceeding from top to bottom (nothing from the frieze above, presumably relating to book 22, can be determined). Inscriptions on the lower scene identify its subjects, and comparison can be made with similar scenes on tablets 1A and 2NY (pp. 178 n. 116, 185 n. 123).

Reverse: Uninscribed (although see above on grooved lower edge).

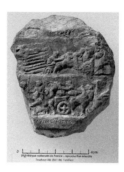

Pl. XXIII.29

Tablet 22Get
(*Tabula Gettiensis*)
Malibu, J. Paul Getty Museum (Getty Villa), inv. 81.AA.113

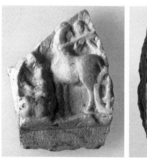

p. 52, Fig. 18 p. 53, Fig. 19

Dimensions: 7.5 x 5 x 2 cm (original surface area unknown).

Material: Palombino.

State: Broken on all sides (although lower section seems to preserve part of the lower frame, as confirmed by detailing towards the base of the verso); possible traces of a tenon (p. 69).

Provenance: Unknown.

Obverse: Scene from the life of Alexander?

See pp. 47–51. Scene difficult to interpret, but possibly drawn from the tradition of the *Alexander Romance*. Underneath the image is part of an inscribed frame—the text is written in the first person, and possibly pertains to a letter to Alexander by Darius.

Reverse: A chronicle of Greek and Roman history, bearing comparison with that of tablet 18L (pp. 49–50). Dates are counted back from the current year of AD 15/16 (pp. 30–1, 58, 60); the inscribed text is possibly indebted to Apollodorus of Athens' second-century *Chronica* (p. 102 n. 52).

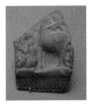

Pl. XXIV.30 Pl. XXIV.31

APPENDIX II

'TABLET 23Ky' (*Tabula Cumaea*)?

While this book was in production, Carlo Gasparri published what he claimed to be 'un nuovo rilievo della serie delle "*tabulae iliacae*"', excavated in 2006 (Gasparri 2009). The tablet was found in a layer of modern fill at the eastern end of the forum at Cumae, to the north-west of Naples. Although I have not yet been able to handle it myself, it seemed appropriate to add a note on the fragment here, and to explain my decision to delay references until this point—a decision, it has to be said, driven partly by the practicalities of the publishing process.

The relief measures 5.3 x 9.5 x 1 cm and is composed of 'calcare giallognolo o marmo giallo antico' (Gasparri 2009: 251). The lower and right-hand edges of the recto survive (Fig. 172), allowing us to reconstruct the relief's original quadrangular shape. Particularly interesting is the verso inscription, which preserves the remains of an intriguing grid pattern (Fig. 173).

The subject of the recto is difficult to gauge (Fig. 172). At the centre is a decorated round altar which, although worn, may find parallels in those of tablets 14G, 17M, and 19J ('forse due figure in lotta, di cui quella a d. caduta sulle ginocchia (?)', ibid. 251). To the immediate left of the altar are two nude male figures, and to the right are two more figures (the right-hand character armed with a spear and shield): the two central protagonists are clearly engaged in an act of libation. Gasparri hypothesizes that 'le maggiori dimensioni', as well as the iconography, point to divine protagonists: he consequently identifies the armed figure as a possible Ares/Mars, and the 'due personaggi nudi' as perhaps depicting Apollo and Dionysus.

To my mind, these identifications are speculative at best. For one thing, the figures actually occupy different scales, with the second figure from the left markedly shorter in stature (a slave? a youth? a mortal among the gods?). For another, this nude figure is also puzzlingly seen from behind (hence the pronounced buttocks), unlike the nude protagonist to the left. The iconography of the taller nude figure would seem to suggest a man leaning on a spear (mirroring the iconography of the corresponding figure on the right?): with the left hand on the hip, and the crossed legs, the schema has something of a Praxitelean Satyr about it. Interestingly, however, the figure seems emphatically uninterested in the action going on around him. How are we to explain such behaviour? No other extant tablet provides a parallel for the scene. In my opinion, any supposed connection with epic, still more with the *Aeneid*, would therefore be overhasty (*pace* Gasparri ibid. 254, who tentatively suggests *Il.* 16.220–49 or *Aen.* 12.161–94): we first need to get to grips with the puzzling iconography.

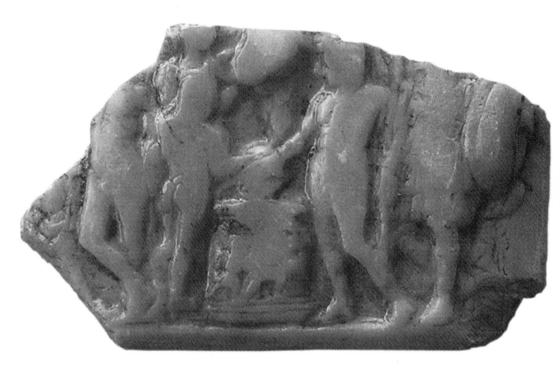

FIGURE 172. Obverse of a supposed 'tablet 23 Ky'.

FIGURE 173. Reverse of a supposed 'tablet 23Ky'.

The grid inscribed on the tablet's reverse side may look somewhat more promising (Fig. 173). Is this a 'magic square' of the sort encountered on tablets 2NY, 3C, 4N, 5O, 7Ti, 15Ber, and 20Par (pp. 199–210)? The shape of this design is particularly interesting: 'il retro presenta una quadrettatura ottenuta con sottili linee incise, disposta in modo da comporre un rettangolo tra due fasce più larghe' (ibid. 251). Gasparri seems to suggest that this upside-down 'T' shape originally had a 'disegno simmetrico' with elongated top and bottom (i.e. an 'I' shape), using it to reconstruct the relief's supposed original dimensions (9.5 cm in width and at least 6 cm in height). Were we to want to emphasize the connection with the Iliac tablets, we might more convincingly compare the reverse of tablet 4N: are these miniature squares, like those of tablet 4N, in fact distributed in the shape of an altar base (cf. Figs. 105, 145, as well as e.g. Figs. 116–17; although the detail goes unmentioned in the report, the grid seems in fact to have *two* steps at its base, just as on tablet 4N)?

The reverse decoration is certainly intriguing. But I am not yet convinced of a definite connection with the Iliac tablets. If this is indeed a 'magic square', the design and execution would be wholly unique. First, no letters have been inscribed within the grid, so that all the miniature boxes are in fact left blank (as far as I know, no traces of paint survive anywhere on the tablet, although we cannot disprove that these letters were originally painted; we would in any case have to ask why the artist had chosen to inscribe the grid and yet paint the letters). Second, these inscribed boxes within the grid are much smaller than those found on other tablets (each appears to be around 2 mm by 2 mm; those of tablet 3C, for instance, are each over 5×5 mm). Third, and perhaps less decisively, the grid stretches to the relief's lowest extremity, without leaving any empty outer frame (as in every other extant example). While we cannot disprove Gasparri's explanation that the fragment was either unfinished or else perhaps abandoned 'per un incidente o errore di lavorazione' (ibid. 255), these details must, at the very least, give pause for thought.

Are we dealing, then, with a newfound twenty-third tablet ('tablet 23Ky')? Gasparri certainly concludes as much, arguing on the grounds of the tablet's material, reduced size, miniaturist style, reverse grid, and stylistic execution. But this is not quite the same 'stile miniaturistico' as found on most other reliefs (the figures are all at least 4 cm tall). Of all the tablets examined in this book, moreover, this would be the only instance of a relief without lettered text (and, it has to be said, on a fairly sizeable extant fragment). While there are tablets with scenes of comparable size and composition—the closest parallel is perhaps tablet 13Ta, but Gasparri also notes a likeness to tablets 14G, 17M, and 19J on the basis of 'il gusto per una composizione unitaria, che utilizza figure di "grandi" proporzioni' (ibid. 254) – these are themselves the exception not the rule. The recourse to stylistic comparisons alone (the 'condizioni lacunose del marmo': ibid.) is also unconvincing, not least because the obverse surface is so heavily worn.

It is of course easy to understand why scholars are keen on the *Tabula Iliaca* identification. For one thing, it would provide a firm provenance for one of the tablets. For another, the identification has local cultural political stakes, testifying to what Gasparri calls the 'interessi culturali e . . . modelli di riferimento, anche nelle

sfera privata, della *élite* Cumana della prima età imperiale' (ibid. 255; as far as we can tell, though, all of the other tablets seem to have been discovered somewhat closer to Rome—see above, pp. 65–7).

In my view, conclusions about this relief have so far proved premature. There can be no doubt that more tablets will turn up both in museum storerooms and in the ground; indeed, we know of at least one tablet written about in the eleventh century but lost without trace today (cf. e.g. Dostálová 1986). Perhaps this Cumaean relief did take its inspiration from the Iliac tablets, adapting themes and compositions for a new, South Italian market; if so, it would testify to the popularity and importance of the genre in the first century AD (cf. above pp. 60–1 on tablet 19J). But it is inappropriate to bandy names about before executing a detailed analysis of what is to be seen: a much more detailed study of the iconography and style is required.

A final note on the larger interpretive stakes. As we said in the second chapter, there is always a subjective element in drawing up the classificatory boundaries of the 'corpus': the simultaneous analogies and disparities between the objects classed together as 'Iliac tablets' means that the category must remain fluid and flexible. In any case, this classification is itself an academic invention, devised for the sake of scholarly convenience (cf. pp. 51–4, 57–8). In some ways the relief resembles the other tablets discussed in this book; in other ways, it does not. In the absence of any more detailed iconographic study, it therefore seems appropriate to end this book by leaving the question of 'tablet 23Ky' open: as so often with the tablets, 'glide whichever way you choose'.

BIBLIOGRAPHY

Abbondanza, L. (2001) 'Immagini della phantasia: i quadri di Filostrato maior tra pittura e scultura', *MDAI(R)* 108: 111–34.

Acosta-Hughes, B. and S. A. Stephens (2002) 'Rereading Callimachus' *Aetia* Fragment 1', *CPh* 97: 238–55.

Acosta-Hughes, B., E. Kosmetatou, and M. Baumbach (eds.) (2004) *Labored in Papyrus Leaves: Perspectives on an Epigram Collection Attributed to Posidippus (P.Mil.Vogl. VIII 309)*. Cambridge, MA.

Adler, A. (ed.) (1928–38) *Suidae Lexicon*. Five volumes. Leipzig.

Ahlberg-Cornell, G. (1992) *Myth and Epos in Early Greek Art*: *Representation and Interpretation*. Jonsered.

Aichholzer, P. (1983) *Darstellungen römischer Sagen*. Vienna.

Alcock, S. E. and R. Osborne (eds.) (2007) *Classical Archaeology*. Malden, MA and Oxford.

Allan, J. (1946) 'A Tabula Iliaca from Gandhara', *JHS* 66: 21–3.

Altekamp, S. (1988) 'Zu den Statuenbeschreibungen des Kallistratos', *Boreas* 11: 77–154.

Ambühl, A. (2010) 'Narrative hexameter poetry', in J. J. Clauss and M. Cuypers (eds.), 151–65.

Amedick, R. (1999) 'Der Schild des Achilleus in der hellenistisch-römischen ikonographischen Tradition', *JdI* 114: 157–206.

Anderson, G. (1989) 'The *pepaideumenos* in action: Sophists and their outlook in the early Empire', *ANRW* 2.33.1: 80–208.

——(1993) *The Second Sophistic: A Cultural Phenomenon in the Roman Empire*. London and New York.

Anderson, M. J. (1997) *The Fall of Troy in Early Greek Poetry and Art*. Oxford.

Andreae, B. (1973) *Römische Kunst*. Freiburg, Basel, and Vienna.

——(1999) *Odysseus. Mythos und Erinnerung*. Munich.

——and C. Parisi Presicce (eds.) (1996) *Ulisse. Il mito e la memoria. Catalogo della mostra: Roma, Palazzo delle Esposizioni, 22 febbraio – 2 settembre 1996*. Rome.

Antonio, A. (1913) 'Gli acrostici nella poesia sepolcrale latina', *Athenaeum* 1: 288–94.

Ashby, T. (1910) 'The Classical topography of the Roman Campagna: Part III, Section II', *PBSR* 5: 213–432.

Asper, M. (1997) *Onomata allotria. Zur Genese, Struktur und Funktion poetologischer Metaphern bei Kallimachos*. Stuttgart.

Aubreton, R. and F. Buffière (eds.) (1980) *Anthologie grecque, Tome XIII. Anthologie de Planude*. Volume 13. Paris.

Aubriot, D. (1999) 'Imago Iliadis: le bouclier d'Achille et la poésie de l'Iliade', *Kernos* 12: 9–56.

Aurigemma, F. (1953) 'Appendice: tre nuovi cicli di figurazioni ispirate all'Iliade in case della Via dell' Abbondanza in Pompei', in V. Spinazzola (ed.), *Pompei alla luce degli scavi nuovi di Via dell'Abbondanza (anni 1920–23)*, 867–1008. Rome.

Austin, C. and G. Bastianini (eds.) (2002) *Posidippi Pellaei quae supersunt omnia*. Milan.

Austin, R. P. (1938) *The Stoichedon Style in Greek Inscriptions*. Oxford.

Bäbler, B. and H.-G. Nesselrath (eds.) (2006) *Ars et verba. Die Kunstbeschreibungen des Kallistratos: Einführung, Text, Übersetzung, Anmerkungen, archäologischer Kommentar*. Munich and Leipzig.

Bal, M. (1991) *Reading 'Rembrandt': Beyond the Word-Image Opposition*. Cambridge.
——and N. Bryson (1991) 'Semiotics and art history', *Art Bulletin* 73: 174–208.
Balensiefen, L. (1990) *Die Bedeutung des Spiegelbildes als ikonographisches Motiv in der antiken Kunst*. Tübingen.
Baratte, F. (1996) *Histoire de l'art antique. L'art romain*. Paris.
Barchiesi, A. (1994) 'Rappresentazioni del dolore e interpretazione nell'Eneide', *A&A* 40: 109–24.
——(1996) 'La guerra di Troia non avrà luogo: il proemio dell'Achilleide di Stazio'. *Annali dell'Istituto Universario Orientale di Napoli*. 18: 45–62.
——(1997) 'Virgilian narrative: (*b*) Ecphrasis', in C. Martindale (ed.), 271–81.
——(2005) 'Learned eyes: Poets, viewers, image makers', in K. Galinsky (ed.), 281–305.
Barnes, T. D. (1975) 'Publilius Optatianus Porfyrius', *AJPh* 96: 173–86.
Barthélemy, J. J. (1761) *Mémoire sur les anciens monuments de Rome*. Paris.
Barthes, R. (1974) *S/Z*. Trans. R. Miller. New York.
——(1977) *Image – Music – Text*. Trans. S. Heath. New York.
——(1990) *The Pleasure of the Text*. Trans. R. Miller. Oxford.
Bartman, E. (1992) *Ancient Sculptural Copies in Miniature*. Leiden.
——(1994) 'Sculptural collecting and display in the private realm', in E. K. Gazda (ed.), 71–88.
Bartsch, S. (1989) *Decoding the Ancient Novel: The Reader and the Role of Description in Heliodorus and Achilles Tatius*. Princeton.
——(1998) '*Ars* and the man: The politics of art in Virgil's *Aeneid*', *CPh* 93: 322–42.
——(2006) *The Mirror of the Self: Sexuality, Self-Knowledge, and the Gaze in the Early Roman Empire*. Chicago.
——(2007) 'Wait a moment, *phantasia*: Stoic ecphrasis', *CPh* 102: 83–95.
Bastianini, G. and A. Casanova (eds.) (2002) *Il papiro di Posidippo un anno dopo. Atti del convegno internazionale di studi, Firenze, 13–14 giugno 2002*. Florence.
Bastianini, G. and C. Gallazzi (2001) *Posidippo di Pella. Epigrammi. P.Mil.Vog. VIII 309*. Milan.
Bate, W. J. (1970) *The Burden of the Past and the English Poet*. London.
Battezzato, L. (2008) 'Techniques of reading and textual layout in ancient Greek texts', *CCJ* 55: 1–23.
Baumbach, M. (2007) 'Die Poetik der Schilde: Form und Funktion von Ekphraseis in den *Posthomerica* des Quintus Smyrnaeus', in M. Baumbach and S. Bär (eds.) *Quintus Smyrnaeus: Transforming Homer in Second Sophistic Epic*, 107–42. Berlin.
——, A. Petrovic, and I. Petrovic (eds.) (2010) *Archaic and Classical Greek Epigram*. Cambridge.
Baxandall, M. (1985) *Patterns of Intention: On the Historical Explanation of Pictures*. New Haven.
Beagon, M. (ed.) (2005) *Pliny the Elder on the Human Animal:* Natural History Book 7. Oxford.
Beard, M. and J. Henderson (2001) *Classical Art: From Greece to Rome*. Oxford.
Beaujou, J. (1982) 'A-t-il existé une direction des musées dans la Rome impériale?', *Académie des Inscriptions et Belles-lettres* 1982: 671–88.
Beazley, J. D. (1945) *Potter and Painter in Ancient Athens*. Oxford.
Beck, D. (2007) 'Ecphrasis, interpretation, and audience in *Aeneid* 1 and *Odyssey* 8', *AJPh* 128: 533–49.
Becker, A. S. (1990) 'The Shield of Achilles and the poetics of Homeric description', *AJPh* 111: 139–53.

——(1995) *The Shield of Achilles and the Poetics of Ekphrasis*. Lanham, MD.

——(2003) 'Contest or concert? A speculative essay on ecphrasis and rivalry between the arts', *CML* 23: 1–14.

Beger, L. (1699) *Bellum et excidium Trojanum ex antiquitatum reliquiis, tabula praesertim, quam Raphael Fabrettus edidit, Iliaca delineatum, et adjecto in calce commentario illustratum*. Berlin.

Bejor, G., M. Castoldi, and C. Lambrugo (2008) *Arte greca: Dal decimo al primo secolo a.C.* Milan.

Benediktson, D. T. (2000) *Literature and the Visual Arts in Ancient Greece and Rome*. Norman, OK.

Bergmann, B. (1994) 'The Roman house as memory theatre: The House of the Tragic Poet in Pompeii', *Art Bulletin* 76: 225–56.

——(1995a) 'Visualising Pliny's villas', *JRA* 8: 406–20.

——(1995b) 'Greek masterpieces and Roman recreative fictions', *HSPh* 97: 79–120.

——(1999) 'Rhythms of recognition: Mythological encounters in Roman landscape painting', in F. de Angelis and S. Muth (eds.), 81–107.

Bernabé, A. and A. I. Jiménez San Cristóbal (2008) *Instructions for the Netherworld: The Orphic Gold Tablets*. Trans. M. Chase. Leiden.

Bernard, E. (1969) *Inscriptions métriques de l'Égypte gréco-romaine*. Paris.

Bernsdorff, H. (2002) 'Anmerkungen zum neuen Poseidippus', *GFA* 5: 11–44.

Bethe, E. (1945) *Buch und Bild im Altertum*. Leipzig.

Bettenworth, A. (2007) 'The mutual influence of inscribed and literary epigram', in P. Bing and J. S. Bruss (eds.), 69–93.

Betz, H. D. (2004) 'God, concept and cultic image: The argument in Dio Chrysostom *Oratio* 12, *Olympikos*', *ICS* 29: 131–42.

Bianchi-Bandinelli, R. (1954) *Continuità ellenistica nella pittura di età medio- e tardo-romana*. Rome.

——(1955) *Hellenistic-Byzantine Miniatures of the Iliad (Ilias Ambrosiana)*. Olten.

——(1970) *Rome, the Centre of Power: Roman Art to AD 200*. London.

——(2000) *Introduzione all'archeologia classica come storia dell'arte antica*. Sixteenth edition. Rome.

Bichler, R. (2006) 'An den Grenzen zur Phantastik: Antike Fahrtenberichte und ihre Beglaubigungsstrategien', in N. Hömke and M. Baumbach (eds.) *Fremde Wirklichkeiten: Literarische Phantastik und antike Literatur*, 237–59. Heidelberg.

Bielefeld, D. (1965) Review of Sadurska 1964, *Gnomon* 37: 430–1.

Bienkowski, P. (1891) 'Lo scudo di Achille', *MDAI(R)* 6: 183–207.

Biering, R. (1995) *Die Odysseefresken vom Esquilin*. Munich.

Bing, P. (1988) *The Well-Read Muse: Present and Past in Callimachus and the Hellenistic Poets*. Göttingen.

——(1990) 'A pun on Aratus' name in verse 2 of the *Phaenomena*', *HSPh* 93: 281–5.

——(1995) 'Ergänzungsspiel in the epigrams of Callimachus', *A&A* 41: 115–31.

——(1998) 'Between literature and the monuments', in M. A. Harder, R. F. Regtuit, and G. C. Walker (eds.) *Genre in Hellenistic Poetry*, 21–43. Leuven.

——(2005) 'The politics and poetics of geography in the Milan Posidippus section one: On Stones (AB 1–20)', in K. Gutzwiller (ed.), 119–40.

——(2009) *The Scroll and the Marble: Studies in Reading and Reception in Hellenistic Poetry*. Ann Arbor, MI.

——and J. S. Bruss (2007) 'Introduction to the study of Hellenistic epigram', in eidem (eds.), 1–26.

——(eds.) (2007) *Brill's Companion to Hellenistic Epigram Down to Philip*. Leiden.

Blanck, H. (1992) *Das Buch in der Antike*. Munich.

Blanckenhagen, P. H. von (1957) 'Narration in Hellenistic and Roman art', *AJA* 61: 78–83.

——and C. Alexander (1990) *The Augustan Villa at Boscotrecase*. Second edition. Mainz.

Blass, F. (1997) 'Eudoxi ars astronomica qualis in charta Aegyptiaca superest', *ZPE* 115: 79–101.

Blum, L. (1991) *Kallimachos: The Alexandrian Library and the Origins of Bibliography*. Trans. H. H. Wellisch. Madison, WI.

Bodel, J. (2001) 'Epigraphy and the ancient historian', in idem (ed.) *Epigraphic Evidence: Ancient History from Inscriptions*, 1–56. London and New York.

Boeder, M. (1996) *Visa est Vox. Sprache und Bild in der spätantiken Literatur*. Frankfurt am Main.

Boehm, G. and H. Pfotenhauer (eds.) (1995) *Beschreibungkunst–Kunstbeschreibung. Ekphrasis von der Antike bis zur Gegenwart*. Munich.

Boehringer, E. and R. Boehringer (1939) *Homer: Bildnisse und Nachweise. Band I: Rundwerke*. Breslau.

Bolmarcich, S. (2002) 'Sepulchral epigrams on Homer', in M. A. Harder, R. F. Regtuit, and G. C. Wakker (eds.), 67–83.

Bonadeo, A. (2010) *L'Hercules Epitrapezios Novi Vindicis. Introduzione e commento a Stat.* silv. 4,6. Naples.

Bondy, L. W. (1981) *Miniature Books: Their History from the Beginnings to the Present Day*. London.

Borbein, A. H., T. Hölscher, and P. Zanker (eds.) (2000) *Klassische Archäologie. Eine Einführung*. Berlin.

Borg, B. (ed.) (2004) *Paideia: The World of the Second Sophistic*. Berlin.

Borghini, G. (ed.) (1989) *Marmi antichi*. Rome.

Boschung, D., and H. Hellenkemper (eds.) (2007) *Kosmos der Zeichen. Schriftbild und Bildformel in Antike und Mittelalter*. Wiesbaden.

Bottini, A. and M. Torelli (eds.) (2006) *Iliade. Catalogo della mostra: Roma, Colosseo, 9 settembre 2006 – 25 febbraio 2007*. Milan.

Bourdieu, P. (1984) *Distinction: A Social Critique of the Judgement of Taste*. Trans. R. Nice. London.

——(1987) 'The historical genesis of a pure aesthetic', *Journal of Aesthetics and Art Criticism* 46: 201–10.

Bowersock, G. W. (1969) *Greek Sophists in the Roman Empire*. Oxford.

Bowie, E. (1970) 'The Greeks and their past in the Second Sophistic', *Past & Present* 46: 3–41.

——(1989) 'Greek sophists and Greek poetry in the Second Sophistic', *ANRW* 2.33.1: 209–58.

——and J. Elsner (eds.) (2009) *Philostratus*. Oxford.

Bowra, C. M. (2001) *Greek Lyric Poetry from Alcman to Simonides*. Oxford.

Boyd, B. W. (1995) '*Non enarrabile textum*: Ecphrastic trespass and narrative ambiguity in the *Aeneid*', *Vergilius* 41: 71–90.

Boyle, A. (1999) '*Aeneid* 8: Images of Rome', in C. Perkell (ed.) *Reading Virgil's* Aeneid: *An Interpretive Guide*, 148–61. Norman, OK.

Bragantini, I. and V. Sampaolo (eds.) (2007) *La pittura pompeiana*. Milan.

Brand, U. (1992) 'Akrostichon', *HWRh* 1: 313–17.

Brendel, O. (1953–4) 'Der Affen-Aeneas', *MDAI(R)* 60/61: 153–9.

——(1979) *Prolegomena to the Study of Roman Art*. New Haven.

Brenner, J. and N. Horsfall (1987) *Roman Myth and Mythography*. London.

Bresciani, E. (1980) 'I testi demotici della stele "enigmistica" di Moschione e il bilinguismo culturale nell'Egitto', *Egitto e vicino Oriente* 3: 117–45.

Brillante, C. (1993) 'L'invidia dei Telchini e l'origine delle arti', *Aufidus* 19: 7–42.

Brilliant, R. (1967) *The Arch of Septimius Severus in the Roman Forum*. Memoirs of the American Academy in Rome 29. Rome.

——(1984) *Visual Narratives: Story-telling in Etruscan and Roman Art*. Ithaca, NY and London.

Brinkmann, V. and R. Wünsche (eds.) (2004) *Bunte Götter. Die Farbigkeit antiker Skulptur*. Munich.

Brinkmann, V. and A. Scholl (eds.) (2010) *Bunte Götter. Die Farbigkeit antiker Skulpturen. Katalog zur Ausstellung in Berlin, Pergamonmuseum, 13.07.2010–03.10.2010*. Munich.

Brodersen, K. and J. Elsner (eds.) (2009) *Images and Texts on the 'Artemidorus Papyrus': Working Papers on P. Artemid. (St John's College, Oxford)*. Stuttgart.

Brodie, N. J., J. Doole, and P. Watson (2000) *Stealing History: The Illicit Trade in Cultural Material*. Cambridge.

Bromer, A. C. and J. I. Edison (2007) *Miniature Books: 4,000 years of Tiny Treasures*. New York.

Brown, E. L. (1963) *Numeri Vergiliani: Studies in 'Eclogues' and 'Georgics'*. Brussels.

Bruneau, P. (1984) 'Les mosaïstes antiques: avaient-ils des cahiers de modèles?', *Revue archéologique* 1984: 241–72.

——(2000) 'Les mosaïstes antiques: avaient-ils des cahiers de modèles? (Suite probablement sans fin)', *Ktema* 25: 191–7.

Brüning, A. (1894) 'Über die bildlichen Vorlagen der ilischen Tafeln', *JdI* 9: 136–65.

Bruss, J. S. (2005) *Hidden Presences: Monuments, Gravesites, and Corpses in Greek Funerary Epigram*. Leuven.

Bryson, N. (1991) 'Semiology and visual interpretation', in N. Bryson, M. A. Holly, and K. Moxey (eds.) *Visual Theory: Painting and Interpretation*, 61–73. Middletown, CT.

——(1994) 'Philostratus and the imaginary museum', in S. D. Goldhill and R. Osborne (eds.), 255–83.

Bua, M. T. (1971) 'I giuochi alfabetici delle *tavole iliache*', *MemLinc* 8:16: 1–35.

Buffière, F. (1956) *Les mythes d'Homère et la pensée grecque*. Paris.

Buitron-Oliver, D. (1995) *Douris: A Master-Painter of Athenian Red-Figure Vases*. Mainz.

Bulas, K. (1929) *Les illustrations antiques de l'Iliade*. Eus Supplementa 3. Lvov.

——(1950) 'New illustrations to the *Iliad*', *AJA* 54: 112–18.

——(1966) 'Tabulae Iliacae', *EAA* 7: 579–80.

Bulloch, A. W. (1985) 'Hellenistic poetry', in P. E. Easterling and B. M. W. Knox (eds.) *The Cambridge History of Classical Literature. Volume 1: Greek Literature*, 541–621. Cambridge.

Buonocore, M. (ed.) (1996) *Vedere i classici. L'illustrazione libraria dei testi antichi dall'età romana al tardo medioevo*. Rome.

Buonopane, A. (1998) 'Statuarius: un nuovo documento epigrafico', *ZPE* 120: 292–4.

Buranelli, S. le Pera, and R. Turchetti (eds.) (2003) *Sulla Via Appia da Roma a Brindisi. Le fotografie di Thomas Ashby: 1891–1925*. Rome.

Burford, A. (1972) *Craftsmen in Greek and Roman Society*. London.

Burgess, J. S. (2001) *The Tradition of the Trojan War in Homer and the Epic Cycle*. Baltimore.

Burn, L. (2004) *Hellenistic Art: From Alexander the Great to Augustus*. London.

Burstein, S. M. (1984) 'A new *Tabula Iliaca*: The Vasek Polak chronicle', *The J. Paul Getty Museum Journal* 12: 153–62.

Burton, J. B. (1995) *Theocritus' Urban Mimes: Mobility, Gender and Patronage*. Berkeley.

Bury, R. G. (ed.) (1897) *The Philebus of Plato*. Cambridge.

Burzacchini, G. (ed.) (2005) *Troia tra realtà e leggenda*. Palma.

Burzachechi, M. (1962) 'Oggetti parlanti nelle epigrafi greche', *Epigraphica* 24: 3–54.

Byre, C. S. (1992) 'Narration, description, and theme in the Shield of Achilles', *CJ* 88: 33–42.

Cahn, H. A. and A. Kaufmann-Heinimann (eds.) (1984) *Der spätrömische Silberschatz von Kaiseraugst*. Derendingen.

Cain, H. U. (1989) 'Votivrelief an Herakles', in P. C. Bol (ed.) *Forschungen zur Villa Albani. Katalog der antiken Bildwerke I: Bildwerke im Treppenhausaufgang und im Piano nobile des Casino*, 192–7. Berlin.

Calabi Limentani, I. (1958) *Studi sulla società romana. Il lavoro artistico*. Milan.

Calderini, A. (1953) *Ilias Ambrosiana. Cod F. 205 P. Inf., Bibliothecae Ambrosianae Mediolanensis*. Preface by A. M. Ceriani. Bern.

Cameron, A. (1993) *The Greek Anthology: From Meleager to Planudes*. Oxford.

——(1995) *Callimachus and his Critics*. Princeton.

Cameron, R. and A. J. Dewey (eds.) (1979) *The Cologne Mani Codex (P. Colon. inv. nr. 4780)*. Missoula, MT.

Camille, M. (1985a) 'Seeing and reading: Some visual interpretations of medieval literacy and illiteracy', *Art History* 8: 26–49.

——(1985b) 'The book of signs: Writing and visual difference in Gothic manuscript illumination', *Word & Image* 1: 133–48.

——(1992) *Image on the Edge: The Margins of Medieval Art*. London.

Campbell, D. A. (ed.) (1991) *Greek Lyric III*. Cambridge, MA.

Canciani, F. (1990) 'Tabulae iliacae', *EV* 5: 3–6.

Canfora, L. (1988) 'Le biblioteche ellenistiche', in G. Cavallo (ed.), 3–28.

——(2007) *The True History of the So-Called Artemidorus Papyrus*. Bari.

Cappelli, R. (1998) 'The painted frieze from the Esquiline and the Augustan myth of origins', in A. La Regina (ed.) *Palazzo Massimo alle Terme*, 51–8. Milan.

Carey, S. (2003) *Pliny's Catalogue of Culture: Art and Empire in the* Natural History. Oxford.

Carlini, A. (1982) 'Omero, Stesicoro e la "firma" di Teodoro', in L. Beschi, G. Pugliese Carratelli, G. Rizza, and S. Settis (eds.) *ΑΠΑΡΧΑΙ. Nuove ricerche e studi sulla Magna Grecia e la Sicilia antica in onore di Paolo Enrico Arias*, Volume 2, 631–3. Pisa.

Carruthers, M. (1990) *The Book of Memory*. Cambridge.

——(1998) *The Craft of Thought: Meditation, Rhetoric, and the Making of Images, AD 400–1200*. Cambridge.

Carson, A. (1992) 'Simonides painter', in R. Hexter and D. Seldon (eds.) *Innovations of Antiquity*, 51–64. New York and London.

Carter, J. and S. Morris (eds.) (1995) *The Ages of Homer: A Tribute to Emily Townsend Vermeule*. Austin, TX.

Cassieri, N. (2000) *La grotta di Tiberio e il Museo Archeologico Nazionale di Sperlonga*. Rome.

Cavallini, E. (1991) 'Due poetesse greche', in F. de Martino (ed.) *Rose di Pieria*, 97–135. Bari.

Cavallo, G. (ed.) (1988) *Le biblioteche nel mondo antico e medievale*. Rome.

Cavero, L. M. (2008) *Poems in Context: Greek Poetry in the Egyptian Thebaid 200–600 AD*. Berlin.

Chaniotis, A. (1988) *Historie und Historiker in den griechischen Inschriften. Epigraphische Beiträge zur griechischen Historiographie*. Stuttgart.

——(2010) 'The best of Homer: Homeric texts, performances and images in the Hellenistic world and beyond. The contribution of inscriptions', in E. Walter-Karydi (ed.), 257–78.

Childs, W. A. P. (1979) 'The Achilles silver-plate in Paris', *Gesta* 18: 19–26.

Chinn, C. M. (2005) 'Statius *Silv.* 4.6 and the epigrammatic origins of ekphrasis', *CJ* 100: 247–64.

——(2007) 'Before your very eyes: Pliny *Epistulae* 5.6 and the ancient theory of ekphrasis', *CPh* 102: 265–80.

Cistaro, M. (2009) *Sotto il velo di Pantea*. Imagines *e* Pro Imaginibus *di Luciano*. Messina.

Clarke, J. R. (1991) *The Houses of Roman Italy, 100 BC–AD 250: Ritual, Space and Decoration*. Berkeley.

——(1998) *Looking at Lovemaking: Constructions of Sexuality in Roman Art, 100 B.C.–A.D. 250*. Berkeley.

——(2003) *Art in the Lives of Ordinary Romans: Visual Representations and Non-Elite Viewers in Italy, 100 BC–AD 315*. Berkeley.

——(2005) 'Augustan domestic interiors: Propaganda or fashion?', in K. Galinsky (ed.), 264–78.

——(2007) *Looking at Laughter: Humor, Power and Transgression in Roman Visual Culture, 100 BC–AD 250*. Berkeley.

——(2008) 'How to look like Venus', *TLS* 5479 (4 April 2008), 30.

Clauss, J. J. (1993) *The Best of the Argonauts: The Redefinition of the Epic Hero in Book One of Apollonius' Argonautica*. Berkeley.

——(1997) 'An acrostic in Vergil (*Eclogues* 1.5–8): The chance that mimics choice', *Aevum Antiquum* 10: 267–87.

——(1999) *Cassiano Dal Pozzo und die Archäologie des 17. Jahrhunderts*. Munich.

——and M. Cuypers (eds.) (2010) *A Companion to Hellenistic Literature*. Malden, MA.

Coarelli, F. (1998) 'The Odyssey frescoes of the Via Graziosa: A proposed context', *PBSR* 66: 21–37.

Coleman, K. (ed.) (1988) *Statius:* Silvae *IV*. London.

——(ed.) (2006) *Martial:* Liber Spectaculorum. Oxford.

Collingwood, R. G. (1930) *The Archaeology of Roman Britain*. London.

Colpo, I., I. Favaretto, and F. Ghedini (eds.) (2007) *Iconografia 2006: Gli eroi di Omero. Atti del convegno internazionale (Taormina, Giuseppe Sinopoli Festival, 20–22 ottobre 2006)*. Rome.

Connors, C. (1998) *Petronius the Poet: Verse and Literary Tradition in the* Satyricon. Cambridge.

Conticello, B. and B. Andreae (1974) *Die Skulpturen von Sperlonga*. AntP 14. Berlin.

Cook, R. M. (1983) 'Art and epic in Archaic Greece', *BABesch* 58: 1–10.

Coralini, A. (2001a) 'Una stanza di Ercole a Pompei: la sala del doppio fregio nella Casa di D. Octavius Quartio (II 2,2)', in I. Colpo, I. Favaretto, and F. Ghedini (eds.), 331–43.

——(2001b) *Hercules Domesticus. Immagini di Ercole nelle case della regione vesuviana (I Secolo a.C.–79 d.C.)*. Naples.

Corbier, M. (1995) 'L'écriture dans l'image', in H. Solin, O. Salomies, and U.-M. Liertz (eds.) *Acta Colloquii Epigraphici Latini, Helsingiae, 3–6 Sept. 1991 Habiti*, Commentationes Humanarum Litterarum 104, 113–61. Helsinki.

——(2006) *Donner à voir, donner à lire. Mémoire et communication dans la Rome ancienne*. Paris.

Corswandt, I. (1982) *Oscilla. Untersuchungen zu einer römischen Reliefgattung*. Berlin.

Costantini, M. (2006) 'Marmoréen, mais encore: introduction à Callistrate', in M. Costanini, F. Graziani, and S. Rolet (eds.), 93–111.

——, F. Graziani, and S. Rolet (eds.) (2006) *Le défi de l'art. Philostrate, Callistrate et l'image sophistique*. Paris.

Courtney, E. (1990) 'Greek and Latin acrostics', *Philologus* 134: 1–13.

——(ed.) (1993) *The Fragmentary Latin Poets*. Oxford.

——(ed.) (1995) *Musa Lapidaria: A Selection of Latin Verse Inscriptions*. Atlanta, GA.

Croisille, J.-M. (2005) *La peinture romaine*. Paris.

Crystal, D. (2008) *Txting: The Gr8 Db8*. Oxford.

Cuno, J. (2008) *Who Owns Antiquity? Museums and the Battle over our Ancient Heritage*. Princeton and Oxford.

Curtius, E. R. (1948) *Europäische Literatur und lateinisches Mittelalter*. Bern.

Cutler, A. (1990) 'The *Disputà* Plate in the J. Paul Getty Museum and its Cinquecento context', *The J. Paul Getty Museum Journal* 18: 5–32.

d'Acunto, M. and R. Palmisciano (eds.) (2010) *Lo scudo di Achille nell'Iliade. Esperienze ermeneutiche a confronto*. Pisa.

d'Ambra, E. (ed.) (1993) *Roman Art in Context: An Anthology*. Englewood Cliffs, NJ.

Damschen, G. (2004) 'Das lateinische Akrostichon: Neue Funde bei Ovid sowie Vergil, Grattius, Manilius und Silius Italicus', *Philogus* 148: 88–115.

d'Angiò, F. (2001) 'Posidippo di Pella, P.Mil. Vogl. VIII 309, col. X, I. 38 – col. XI, II. 1–5 e Plinio il vecchio (*Nat. Hist.* XXXIV 83)', *Analecta Papyrologica* 13: 91–102.

Danielewicz, J. (2005) 'Further Hellenistic acrostics: Aratus and others', *Mnemosyne* 58: 321–34.

d'Arms, J. (1999) 'Performing culture: Roman spectacle and the banquets of the powerful', in B. Bergmann and C. Kondoleon (eds.) *The Art of Ancient Spectacle*, 301–20. New Haven.

Davies, M. (1989) *The Epic Cycle*. London.

——(ed.) (1991) *Poetarum Melicorum Graecorum Fragmenta*. Oxford.

Davis, W. (1992) *Masking the Blow: The Scene of Representation in Late Prehistoric Egyptian Art*. Berkeley.

——(1993) 'Narrativity and the Narmer palette', in P. J. Holliday (ed.), 14–54.

Day, J. W. (2007) 'Poems on stone: The inscribed antecedents of Hellenistic epigram', in P. Bing and J. S. Bruss (eds.), 29–47.

de Angelis, F. and S. Muth (eds.) (1999) *Im Spiegel des Mythos. Bilderwelt und Lebenswelt/Lo specchio del mito. Immaginario e realtà*. Wiesbaden.

Debiasi, A. (2004) *L'epica perduta. Eumelo, il Ciclo, l'occidente*. Rome.

de Jong, I. J. F. (2007) 'Homer', in I. J. F. de Jong and R. Nünlist (eds.) *Time in Ancient Greek Literature*, 17–38. Leiden.

de Longpérier, A. (1845) 'Fragment inédit de Table Iliaque', *Revue de philologie* 1: 438–46.

Dench, E. (2005) *Romulus' Asylum: Roman Identities from the Age of Alexander to the Age of Hadrian*. Oxford.

de Rossi, G. M. (1979) *Forma Italiae: Regio I, vol. 15, Bovillae*. Florence.

Derrida, J. (1976) *Of Grammatology*. Trans. G. Chakravorty. Baltimore.

de Vos, M. (1991) 'La fuga di Enea in pitture del I sec. d.C.', *Kölner Jahrbuch für Vor- und Frühgeschichte* 24: 113–23.

——(1993) 'Eracle e Priamo. Trasmissione di potere: mitologia e ideologia imperiale', in A. Mastrocinque (ed.) *Ercole in Occidente. Atti del colloquio internazionale Trento, 7 marzo 1990*, 81–9. Rome.

de Wit, J. (1959) *Die Miniaturen des Vergilius Vaticanus*. Amsterdam.

Dinter, M. (2005) 'Epic and epigram: Minor heroes in Virgil's *Aeneid*', *CQ* 55: 153–69.

Disraeli, I. (1881) *Curiosities of Literature. A New Edition, edited, with memoir and notes, by his son, the Earl of Beaconsfield*. Three volumes. London.

Dix, T. K. and Houston, G. W. (2006) 'Public libraries in the city of Rome', *MÉFRA* 118: 671–717.

Donohue, A. A. (2003) 'Introduction', in A. A. Donohue and M. D. Fullerton (eds.), 1–12.

——and M. D. Fullerton (eds.) (2003) *Ancient Art and its Historiography*. Cambridge.

Doria, C. (1979) 'Visual writing forms in antiquity: The *versus intexti*', in R. Kostelanetz (ed.), 63–92.

Dostálová, R. (1986) '*Tabula iliaca (Odysseaca) Ducaena*: au sujet d'une épître de Psellos', *Byzantinoslavica* 47: 28–33.

Dresken-Weiland, J. (1991) *Reliefierte Tischplatten aus theodosianischer Zeit*. Vatican City.

Dreyfus, R. and E. Schraudolph (eds.) (1996) *Pergamon: The Telephos Frieze from the Great Altar. Volume 1*. San Francisco.

Dubel, S. (1997) '*Ekphrasis* et *enargeia*: la déscription antique comme parcours', in B. Lévy and L. Pernot (eds.) *Dire l'évidence*, 249–64. Paris.

DuBois, P. (1982) *History, Rhetorical Description and the Epic*. Cambridge.

——(2007) 'Reading the writing on the wall', *CPh* 102: 45–56.

Dunbabin, K. (1996) 'Convivial spaces: Dining and entertainment in the Roman villa', *JRA* 9: 66–80.

Dyson, S. (2006) *In Pursuit of Ancient Pasts: A History of Classical Archaeology in the Nineteenth and Twentieth Centuries*. New Haven.

Eco, U. (1994) *Reflections on the Name of the Rose*. Trans. W. Weaver. Second edition. Reading.

Edmonds, R. G. (ed.) (2010) *The 'Orphic' Gold Tablets and Greek Religion: Further along the Path*. Cambridge.

Edwards, C. (1996) *Writing Rome: Textual Approaches to the City*. Cambridge.

Edwards, J. S. (2005) 'The *carmina* of Publilius Optatianus Porphyrius and the creative process', in C. Deroux (ed.) *Studies in Latin Literature and Roman History*, Volume 12, 447–66. Brussels.

Edwards, M. W. (ed.) (1991) *The* Iliad*: A Commentary. Volume 5, Books 17–20*. Cambridge.

Elkins, J. (1995) 'Marks, traces, "traits," contours, "orli," and "splendores": Nonsemiotic elements in pictures', *Critical Inquiry* 21: 822–60.

——(1999) *The Domain of Images*. Ithaca, NY.

Elleström, L. (ed.) (2010) *Media Borders, Multimodality and Intermediality*. Basingstoke.

Elmer, D. F. (2005) 'Helen *Epigrammatopoios*', *ClAnt* 24: 1–39.

Elsner, J. (1993) 'Seductions of art: Encolpius and Eumolpus in a Neronian picture gallery', *PCPhS* 39: 30–47.

——(1995) *Art and the Roman Viewer: The Transformation of Art from the Pagan World to Christianity*. Cambridge.

——(ed.) (1996) *Art and Text in Roman Culture*. Cambridge.

——(1998) *Imperial Rome and Christian Triumph: The Art of the Roman Empire AD 100–450*. Oxford.

——(2002) 'Introduction: The genres of ekphrasis', *Ramus* 31: 1–18.

——(2006) 'From empirical evidence to the big picture: Some reflections on Riegl's concept of *Kunstwollen*', *Critical Inquiry* 32: 741–66.

——(2007a) 'Archéologie classique et histoire de l'art en Grande-Bretagne', *Perspective* 2007: 231–42.

——(2007b) *Roman Eyes: Visuality and Subjectivity in Art and Text*. Princeton.

——(2009) 'P.Artemid.: The images', in K. Brodersen and J. Elsner (eds.), 3–50.

——and M. J. Squire (forthcoming) *Seeing and Not Seeing in Philostratus the Elder's Imagines.*

Erath, G. (1997) *Das Bild der Stadt in der griechischen Flächenkunst.* Frankfurt am Main.

Erbse, H. (ed.) (1969–88) *Scholia Graeca in Homeri Iliadem (Scholia Vetera).* Seven volumes. Berlin.

Ernst, U. (1976) 'Die Entwicklung der optischen Poesie in Antike, Mittelalter und Neuzeit: Ein literarhistorisches Forschungsdesiderat', *Germanisch-romanische Monatsschrift* 26: 379–85.

——(1984) 'Zahl und Maß in den Figurengedichten der Antike und des Frühmittelalters: Beobachtungen zur Entwicklung tektonischer Bauformen', in A. Zimmermann (ed.) *Mensura. Maß, Zahl, Zahlensymbolik im Mittelalter*, 310–32. Berlin.

——(1986) 'The figured poem: Towards a definition of genre', *Visible Language* 20: 8–27.

——(1991) *Carmen figuratum. Geschichte des Figurengedichts von den antiken Ursprüngen bis zum Ausgang des Mittelalters.* Cologne.

——(2002) *Intermedialität im europäischen Kulturzusammenhang. Beiträge zur Theorie und Geschichte der visuellen Lyrik.* Berlin.

Esposito, E. (2005) 'Posidippo, Eronda e l'arte Tolemaica', in M. di Marco, B. M. Palumbo, and E. Lelli (eds.), 191–202.

Evans, J. (2004) 'The astrologers' apparatus: A picture of professional practice in Greco-Roman Egypt', *Journal for the History of Astronomy* 35: 1–44.

Ewald, B. (2004) 'Men, muscle, and myth: Attic sarcophagi in the cultural context of the Second Sophistic', in B. Borg (ed.), 229–67.

Faber, R. (2000) 'Vergil's "Shield of Aeneas" (*Aeneid* 8.617–731) and the "Shield of Heracles"', *Mnemosyne* 53: 49–57.

Fabretti, R. (1683) *De columna Traiani syntagma. Accesserunt explicatio ueteris tabellae anaglyphae Homeri Iliadem, atque ex Stesichoro, Arctino et Lesche Ilii excidium continentis, & Emissarii Lacus Fucini descriptio.* Rome.

Fantuzzi, M. and R. Hunter (2004) *Tradition and Innovation in Hellenistic Poetry.* Cambridge.

Fedeli, P. (1988) 'Biblioteche private e pubbliche a Roma e nel mondo romano', in G. Cavallo (ed.), 29–64.

Feeney, D. C. (2007) *Caesar's Calendar: Ancient Time and the Beginnings of History.* Berkeley.

——and D. Nelis (2005) 'Two Virgilian acrostics: Certissima signa?', *CQ* 55: 644–6.

Felten, J. (ed.) (1913) *Nicolaus*, Progymnasmata. Leipzig.

Ferrua, A. (1946) 'Tavole lusorie scritte', *Epigraphica* 8: 53–73.

——(1964) 'Nuove *tabulae lusorie* iscritte', *Epigraphica* 26: 3–44.

Fittschen, K. (1973) 'Der Schild des Achilleus', *Archaeologia Homerica* 2: N.1.1–28. Göttingen.

Fitzgerald, J. T. and L. M. White (eds.) (1983) *The Tabula of Cebes.* Chico, CA.

Fitzgerald, W. (1995) *Catullan Provocations: Lyric Poetry and the Drama of Position.* Berkeley.

——(2007) *Martial: The World of the Epigram.* Chicago.

Flores, E. and G. Polara (1969) 'Specimina di analisi applicate a strutture di "Versspielerei" latina', *Rendiconti dell'Accademia di Archeologia, Lettere e Belle Arti di Napoli* 44: 111–26.

Ford, A. (2002) *The Origins of Criticism: Literary Culture and Poetic Theory in Classical Greece.* Princeton.

Foucault, M. (1974) *The Order of Things: An Archaeology of the Human Sciences*. Second edition. London.

——(1983) *This is Not a Pipe*. Ed. and trans. J. Harkness. Berkeley.

Foucher, L. (1964) 'L'art de la mosaïque et les poètes latins', *Latomus* 23: 247–57.

Fowler, B. H. (1989) *The Hellenistic Aesthetic*. Bristol.

Fowler, D. D. (1987) 'Uses of the past: Archaeology in the service of the state', *American Antiquity* 52: 229–48.

Fowler, D. P. (1983) 'An acrostic in Vergil (*Aeneid* 7.601–4)?', *CQ* 33: 298.

——(1991) 'Narrate and describe: The problem of ecphrasis', *JRS* 81: 25–35.

Francis, J. A. (2009) 'Metal maidens, Achilles' shield and Pandora: The beginnings of "ekphrasis"', *AJPh* 130: 1–23.

Frazer, A. (ed.) (1998) *The Roman Villa*: Villa Urbana. *First Williams Symposium on Classical Architecture at the University of Pennsylvania, April 21–22 1990*. Philadephia.

Friedländer, L. (ed.) (1886) *M. Valerii Martialis Epigrammaton Libri*. Two volumes. Leipzig.

Friedländer, P. (1912) *Johannes von Gaza und Paulus Silentiarius. Kunstbeschreibungen justinianischer Zeit*. Leipzig.

Froning, H. (1981) *Marmor-Schmuckreliefs mit griechischen Mythen im 1. Jh. v. Chr. Untersuchungen zu Chronologie und Funktion*. Berlin.

Froschauer, H. (ed.) (2008) *Zeichnungen und Malereien aus den Papyrussammlungen in Berlin und Wien. Mitteilungen aus der Papyrussammlung der österreichischen Nationalbibliothek (Papyrus Erzherzog Rainer, XXXI. Folge)*. Berlin.

Fuà, O. (1973) 'L'idea dell'opera d'arte "vivente" e la *bucola* di Mirone nell'epigramma Greco e Latino', *RCCM* 15: 49–55.

Fuchs, M. (2007) 'Le cheval de Troie version romaine: une machine de guerre', in I. Colpo, I. Favaretto, and F. Ghedini (eds.), 83–95.

Fuchs, W. (1973) 'Die Bildgeschichte der Flucht des Aeneas', *ANRW* 1.4: 615–32.

Fullerton, M. D. (1997) 'Imitation and intertextuality in Roman art', *JRA* 10: 427–40.

——(2003) '*Der Stil der Nachahmer*: A brief historiography of stylistic representation', in A. A. Donohue and M. D. Fullerton (eds.), 92–117.

Fuqua, C. (2007) 'Two aspects of the *Lithika*', *CPh* 102: 281–91.

Gage, J. (1981) 'A *locus classicus* of colour theory: The fortunes of Apelles', *Journal of the Warburg and Courtauld Institutes* 44: 1–26.

Gale, M. (2001) 'Etymological wordplay and poetic succession in Lucretius', *CPh* 96: 168–72.

Galinsky, K. (1969) *Aeneas, Sicily, and Rome*. Princeton.

——(1996) *Augustan Culture: An Interpretive Introduction*. Princeton.

——(ed.) (2005) *The Cambridge Companion to the Age of Augustus*. Cambridge.

Gallavotti, C. (1989) 'Planudea (IX)', *BollClass* 10: 49–69.

Gallazzi, C. and S. Settis (eds.) (2006) *Le tre vite del Papiro di Artemidoro. Voci e sguardi dall'Egitto greco-romano*. Milan.

Gallazzi, C., B. Kramer, and S. Settis (eds.) (2008) *Papiro di Artemidoro (P. Artemid.)*. Milan.

Gardner, I. M. F. and S. N. C. Lieu (1996) 'Narmouthis (Medinet Madi) to Kellis (Ismant El-Kharab): Manichaean documents from Roman Egypt', *JRS* 86: 146–69.

Gärtner, H. A. (1976) 'Beobachtungen zum Schild des Achilleus', in H. Görgemanns and E. A. Schmidt (eds.) *Studien zum antiken Epos*, 46–65. Meisenheim am Glan.

Gasparri, C. (2009) '23 Ky: un nuovo rilievo della serie delle "*tabulae iliacae*" dal Foro di Cuma', in G. Gasparri and G. Greco (eds.) *Cuma: indagini archeologiche e nuove scoperte*, 251–7. Pozzuoli.

Gazda, E. K. (ed.) (1994) *Roman Art in the Private Sphere: New Perspectives on the Architecture and Decor of the Domus, Villa, and Insula*. Ann Arbor, MI.

——(ed.) (2002) *The Ancient Art of Emulation: Studies in Artistic Originality and Tradition from the Present to Classical Antiquity*. Ann Arbor, MI.

——, C. Hammer, B. Longfellow, and M. Swetnam-Burland (2000) *The Villa of the Mysteries in Pompeii: Ancient Ritual, Modern Muse*. Ann Arbor, MI.

Geiger, J. (2008) *The First Hall of Fame: A Study of the Statues in the Forum Augustum*. Leiden.

Genette, G. (1997) *Paratexts. Thresholds of Interpretation*. Trans. J. E. Lewin. Cambridge.

Geyer, A. (1989) *Die Genese narrativer Buchillustration. Der Miniaturenzyklus zur Aeneis im Vergilius Vaticanus*. Frankfurt am Main.

——(2004) 'Filostrato Minore: la prospettiva dello storico dell'arte', in F. Ghedini, I. Colpo, and M. Novello (eds.), 179–90.

Ghedini, F. (2004) 'Premessa', in F. Ghedini, I. Colpo, and M. Novello (eds.), 1–3.

——(2007) 'Achille a Troia nel repertorio del IV–V Secolo d.C.: l'archetipo dell'eroe in un mondo che cambia', in I. Colpo, I. Favaretto, and F. Ghedini (eds.), 141–61.

——, I. Colpo and M. Novello (eds.) (2004) *Le Immagine di Filostrato Minore. La prospettiva dello storico dell'arte*. Rome.

Gigante, M. (1979) *Civiltà delle forme letterarie nell'antica Pompei*. Naples.

Giuliani, C. F. (1970) *Forma Italiae: Regio I, vol. 7, Tibur I–II*. Rome.

Giuliani, L. (1996) 'Rhesus between dream and death: On the relation of image to text in Apulian vase-painting', *BICS* 41: 71–86.

——(1998) *Bilder nach Homer. Vom Nutzen und Nachteil der Lektüre für die Malerei*. Freiburg.

——(2001) Review of A. Snodgrass (1998), *Gnomon* 73: 428–33.

——(2003) *Bild und Mythos. Geschichte der Bilderzählung in der griechischen Kunst*. Munich.

——(2006) 'Die unmöglichen Bilder des Philostrat: Ein antiker Beitrag zur Paragone-Debatte?', *Pegasus* 8: 91–116.

——(2010) 'Rhesos: On the production of images and the reading of texts', in E. Walter-Karydi (ed.), 239–56.

——and G. Most (2007) 'Medea in Eleusis, in Princeton', in C. Kraus, S. D. Goldhill, H. P. Foley, and J. Elsner (eds.) *Visualizing the Tragic: Drama, Myth, and Ritual in Greek Art and Literature. Essays in Honour of Froma Zeitlin*, 197–217. Oxford.

——and G. Schmidt (2010) *Ein Geschenk für den Kaiser. Das Geheimnis des Großen Kameo*. Munich.

Giuliano, A. (1996) 'L'illustrazione libraria di età ellenistica e romana e i suoi riflessi medievali', in M. Buonocore (ed.), 39–50.

Gladigow, B. (1965) *Sophia und Kosmos. Untersuchungen zur Frühgeschichte von Sophos und Sophia*. Hildesheim.

Gnoli, R. (1988) *Marmora romana*. Second edition. Rome.

Goldhill, S. D. (1991) *The Poet's Voice: Essays on Poetics and Greek Literature*. Cambridge.

——(1994) 'The naïve and knowing eye: Ecphrasis and the culture of viewing in the Hellenistic world', in S. D. Goldhill and R. G. Osborne (eds.), 197–223.

——(1996) 'Refracting Classical vision: Changing cultures of viewing', in T. Brennan and M. Jay (eds.) *Vision in Context: Historical and Contemporary Perspectives on Sight*, 17–28. New York.

——(ed.) (2001) *Being Greek Under Rome: Cultural Identity, the Second Sophistic, and the Development of Empire*. Cambridge.

——(2007) 'What is ekphrasis for?', *CPh* 102: 1–19.

——(forthcoming) 'The contexts of ekphrasis'.

——and R. Osborne (eds.) (1994) *Art and Text in Ancient Greek Culture*. Cambridge.

——(eds.) (1999) *Performance Culture and Athenian Democracy*. Cambridge.

Gordon, R. L. (1979) 'The real and the imaginary: Production and religion in the Graeco-Roman world', *Art History* 2: 5–34.

——(1980) 'Panelled complication', *Journal of Mithraic Studies* 3: 200–27.

Gore, J. and A. Kershaw (2008) 'An unnoticed acrostic in Apuleius *Metamorphoses* and Cicero *De divinatione* 2.111–12', *CQ* 58: 393–4.

Gosden, C. (1999) *Anthropology and Archaeology: A Changing Relationship*. London.

Gow, A. S. F. and D. L. Page (eds.) (1965) *The Greek Anthology. Hellenistic Epigrams*. Two volumes. Cambridge.

——(eds.) (1968) *The Garland of Philip*. Two volumes. Cambridge.

Gowers, E. (1995) 'The anatomy of Rome from Capitol to Cloaca', *JRS* 85: 23–32.

Graf, F. (1995) 'Ekphrasis: Die Entstehung der Gattung in der Antike', in G. Boehm and H. Pfotenhauer (eds.), 143–55.

——and S. Iles Johnston (2007) *Ritual Texts for the Afterlife: Orpheus and the Bacchic Gold Tablets*. New York.

Granino Cecere, M. G. (1995) 'Villa Mamurrana', *RendLinc* 9:6: 361–86.

Grant, R. M. (1983) 'Homer, Hesiod, and Heracles in Pseudo-Justin', *Vigiliae Christianae* 37: 105–9.

Grassigli, G. L. (2006) 'L'ultimo Achille: per una lettura dell'Achille tardoantico', in A. Bottini and M. Torelli (eds.), 124–37.

Graziani, F. (2006) '"La vérité en image": la méthode sophistique', in M. F. Costantini, F. Graziani, and S. Rolet (eds.), 137–51.

Grenfell, B. P. and A. S. Hunt (1900) *The Amherst Papyri: Being an Account of the Greek Papyri in the Collection of the Right Hon. Lord Amherst of Hackney, at Didlington Hall, Norfolk*. Two volumes. London.

Griffiths, J. G. (1971) '"Arepo" in the magic "Sator" square', *CR* 21: 6–8.

Grillo, A. (1988) *Tra filologia e narratologia. Dai poemi omerici ad Apollonio Rodio, Ilias Latina, Ditto-Settimio, Darete Frigio, Draconzio*. Rome.

Grishin, A. A. (2008) '*Ludus in undis*: An acrostic in *Eclogue* 9', *HSPh* 104: 237–40.

Gruen, E. (1992) *Culture and National Identity in Republican Rome*. London.

Guarducci, M. (1965) 'Il misterioso "quadrato magico": l'interpretazione di Jérome Carcopino e documenti nuovi', *ArchClass* 17: 219–70.

——(1974) *Epigrafia greca III. Epigrafi di carattere privato*. Rome.

——(1978) 'Dal gioco letterale alla crittografia mistica', *ANRW* 2.16.2: 1736–73.

Guéraud, O. and P. Jouguet (eds.) (1938) *Un livre d'écolier du IIIe siècle avant J.-C.* Cairo.

Guichard, L. A. (2006) 'Simias' pattern poems', in M. A. Harder, R. F. Regtuit, and G. C. Wakker (eds.), 83–9.

Gundel, H. G. (1992) *Zodiakos. Tierkreisbilder im Altertum. Kosmische Bezüge und Jenseitsvorstellungen im antiken Alltagsleben*. Mainz.

Gury, F. (1986) 'La forge du destin: à propos d'une série de peintures pompéiennes du IVe style', *MÉFRA* 98: 427–89.

Gutzwiller, K. (1981) *Studies in the Hellenistic Epyllion*. Königstein.

——(1998) *Poetic Garlands: Hellenistic Epigrams in Context*. Berkeley.

——(2002a) 'Art's echo: The tradition of Hellenistic ecphrastic epigram', in M. A. Harder, R. Regtuit, and G. C. Wakker (eds.), 85–112.

——(2002b) 'Posidippus on statuary', in G. Bastianini and A. Casanova (eds.), 41–60.

——(2004a) 'Seeing thought: Timomachus' Medea and ecphrastic epigram', *AJPh* 125: 339–86.

——(2004b) 'A new Hellenistic poetry book: P.Mil.Vogl. VIII 309', in B. Acosta-Hughes, E. Kosmetatou and M. Baumbach (eds.), 84–93.

——(ed.) (2005) *The New Posidippus: A Hellenistic Poetry Book*. Oxford.

——(2007) *A Guide to Hellenistic Literature*. Oxford.

Habinek, T. (2005) *The World of Roman Song: From Ritualized Speech to Roman Order*. Baltimore.

——(2009) 'Situating literacy in Rome', in W. A. Johnson and H. N. Parker (eds.), 114–41.

Hahn, R. (2001) *Anaximander and the Architects: The Contributions of Egyptian and Greek Architectural Technologies to the Origins of Greek Philosophy*. New York.

Hales, S. (2003) *The Roman House and Social Identity*. Cambridge.

Hallett, C. H. (1995) '*Kopienkritik* and the works of Polykleitos', in W. G. Moon (ed.) *Polykleitos, The Doryphoros, and Tradition*, 121–60. Madison, WI.

Halliwell, S. (1989) 'Aristotle's *Poetics*', in G. A. Kennedy (ed.) *The Cambridge History of Literary Criticism. Volume 1: Classical Criticism*, 149–83. Cambridge.

Halperin, D. M. (1983) *Before Pastoral: Theocritus and the Ancient Tradition of Bucolic Poetry*. New Haven.

Hanfmann, G. M. A. (1966) *Römische Kunst*. Wiesbaden.

Harder, M. A. (2007) 'Epigram and the heritage of epic', in P. Bing and J. S. Bruss (eds.), 409–28.

Harder, M. A., R. F. Regtuit, and G. C. Wakker (eds.) (2002) *Hellenistic Epigrams*. Leuven.

——(2006) *Beyond the Canon*. Leuven.

Hardie, P. (1985) '*Imago mundi*: Cosmological and ideological aspects of the shield of Achilles', *JHS* 105: 11–31.

——(1986) *Virgil's Aeneid: Cosmos and Imperium*. Oxford.

Haslam, M. (1992) 'Hidden signs: Aratus *Diosemeiai* 46ff., Vergil *Georgics* 1.424ff', *HSPh* 94: 199–204.

Hatherly, A. (1986) 'Reading paths in Spanish and Portuguese Baroque labyrinths', *Visible Language* 20: 52–64.

Heath, M. (2002–3) 'Theon and the history of the *Progymnasmata*', *GRBS* 43: 129–60.

Heffernan, J. (1993) *The Museum of Words: The Poetics of Ekphrasis from Homer to Ashberry*. Chicago.

Hellmann, M. C. (1983) 'Illustrations homériques: les tables iliaques', *Revue de la Bibliothèque Nationale* 9: 42–6.

Henderson, J. (1993) 'Illuminatio mea: Hen**dances**on (Taplin's Shield)', *LCM* 18: 58–62.

——(1994) '*Timeo Danaos*: Amazons in early Greek art and pottery', in S. D. Goldhill and R. Osborne (eds.), 85–137.

——(1996) 'Footnote: Representation in the Villa of the Mysteries', in J. Elsner (ed.), 234–76.

——(2001) *Telling Tales on Caesar: Roman Stories from Phaedrus*. Oxford.

——(2002) *Pliny's Statue: The Letters, Self-Portraiture and Classical Art*. Exeter.

——(2003) 'Portrait of the artist as a figure of style: P.L.I.N.Y.'s letters', *Arethusa* 36: 115–25.

Hendry, M. (1994) 'A Martial acronym in Ennius?', *LCM* 19: 108–9.

Henig, M. (1990) 'A house for Minerva: Temples, aedicule shrines, and signet-rings', in idem (ed.) *Architecture and Architectural Sculpture in the Roman Empire*, 152–62. Oxford.

——(ed.) (1994) *Classical Gems: Ancient and Modern Intaglios and Cameos in the Fitzwilliam Museum*. Cambridge.

Herklotz, I. (1999) *Cassiano Dal Pozzo und die Archäologie des 17. Jahrhunderts*. Munich.

Herter, H. (1934) 'Telchinen', *RE* 5.1: 197–224.

Heslin, P. J. (2005) *The Transvestite Achilles: Gender and Genre in Statius' Achilleid*. Cambridge.

Higbie, C. (2010) 'Divide and edit: A brief history of book divisions', *HSPh* 105: 1–31.

Hillgruber, M. (ed.) (1994–9) *Die pseudoplutarchische Schrift* De Homero. Two volumes. Stuttgart.

Hirsch-Luipold, R., R. Feldmaier, B. Hirsch, L. Koch, and H.-G. Nesselrath (2005) *Die Bildtafel des Kebes. Allegorie des Lebens*. Stuttgart.

Hitzig, H. and H. Blümner (eds.) (1896) *Pausaniae Graeciae descriptio. Edidit, Graeca emendauit, apparatum criticum adiecit Hermannus Hitzig; commentarium Germanice scriptum cum tabulis topographicis et numismaticis addiderunt Hermannus Hitzig et Hugo Bluemner. Voluminis prioris, pars prior. Liber primus: Attica*. Berlin.

Hodder, I. (1987) *The Archaeology of Contextual Meanings*. Cambridge.

Hodske, J. (2007) *Mythologische Bildthemen in den Häusern Pompejis. Die Bedeutung der zentralen Mythenbilder für die Bewohner Pompejis*. Stendal.

Hollander, J. (1995) *The Gazer's Spirit: Poems Speaking to Silent Works of Art*. Chicago.

Holliday, P. J. (ed.) (1993) *Narrative and Event in Ancient Art*. Cambridge.

——(2002) *The Origins of Roman Historical Commemoration in the Visual Arts*. Cambridge.

Hölscher, F. and T. Hölscher (eds.) (2007) *Römische Bilderwelten. Von der Wirklichkeit zum Bild und Zurück*. Heidelberg.

Hölscher, T. (1987) *Römische Bildsprache als semantisches System*. Heidelberg.

——(2000) 'Einleitung', in A. H. Borbein, T. Hölscher, and P. Zanker (eds.), 7–21.

——(ed.) (2002) *Klassische Archäologie. Grundwissen*. Stuttgart.

——(2004) *The Language of Images in Roman Art: Art as a Semantic System in the Roman World*. Trans. A. Snodgrass and A. M. Künzl-Snodgrass. Preface by J. Elsner. Cambridge.

Holzberg, N. (2002) *Martial und das antike Epigramm*. Stuttgart.

Hopkinson, N. (ed.) (1988) *A Hellenistic Anthology*. Cambridge.

Horak, U. (ed.) (1992) *Illuminierte Papyri, Pergamente und Papiere I*. Vienna.

Horsfall, N. (1979a) 'Stesichorus at Bovillae?', *JHS* 99: 26–48.

——(1979b) 'Some problems in the Aeneas legend', *CQ* 29: 372–90.

——(1983) 'Tabulae Iliacae in the collection Froehner, Paris', *JHS* 103: 144–7.

——(1989a) ' "The uses of literacy" and the *Cena Trimalchionis* I', *G&R* 36: 74–89.

——(1989b) ' "The uses of literacy" and the *Cena Trimalchionis* II', *G&R* 36: 194–209.

——(1994) 'The origins of the illustrated book', in B. Katz (ed.) *A History of Book Illustration: Twenty-Nine Points of View*, 60–88. Metuchen, NJ.

——(2003) *The Culture of the Roman Plebs*. London.

——(2008) *Virgil*, Aeneid *2: A Commentary*. Leiden.

Huet, V. (1996) 'Stories one might tell of Roman art: Reading Trajan's column and the Tiberius cup', in J. Elsner (ed.), 8–31.

Hunter, R. (1993) 'The production of Herodas' *Mimiamboi*', *Antichthon* 27: 31–44.

——(1996a) *Theocritus and the Archaeology of Greek Poetry*. Cambridge.

——(1996b) 'Mime and mimesis: Theocritus, *Idyll* 15', in M. A. Harder, R. F. Regtuit, and G. C. Wakker (eds.) *Theocritus*, 149–69. Groningen.

——(2002) 'Osservazioni sui *Lithika* di Posidippo', in G. Bastianini and A. Casanova (eds.), 109–19.

——(2004) 'Notes on the *Lithika* of Posidippus', in B. Acosta-Hughes, E. Kosmetatou, and M. Baumbach (eds.), 94–104.

——(2008) *On Coming After: Studies in Post-Classical Greek Literature and its Reception.* Two volumes. Berlin.

——(2009) *Critical Moments in Classical Literature: Studies in the Ancient View of Literature and its Uses.* Cambridge.

Hurwit, J. (1990) 'The words in the image: Orality, literacy and early Greek art', *Word & Image* 6: 180–97.

Hutchinson, G. O. (2008) *Talking Books: Readings in Hellenistic and Roman Books of Poetry.* Oxford.

Immerwahr, H. A. (1990) *Attic Script.* Oxford.

Jacques, J.-M. (1960) 'Sur un acrostiche d'Aratos', *RÉA* 62: 48–61.

Jahn, O. (1873) *Griechische Bilderchroniken. Aus dem Nachlasse des Verfassers herausgegeben und beendigt von A. Michaelis.* Bonn.

Jahn, S. (2007) *Der Troia-Mythos. Rezeption und Transformation in epischen Geschichtsdarstellungen der Antike.* Cologne.

James, L. (ed.) (2007) *Art and Text in Byzantine Culture.* Cambridge.

Johannsen, N. (2006) *Dichter über ihre Gedichte. Die Prosavorreden in den 'Epigrammaton libri' Martials und in den 'Silvae' des Statius.* Göttingen.

Johansen, K. F. (1967) *The* Iliad *in Early Greek Art.* Copenhagen.

Johnson, W. A. (2010) *Readers and Reading Culture in the High Roman Empire.* Oxford.

——and H. N. Parker (eds.) (2009) *Ancient Literacies: The Culture of Reading in Greece and Rome.* Oxford.

Johnson, W. R. (1976) *Darkness Visible.* Berkeley.

Jones, C. (1991) 'Dinner theatre', in W. Slater (ed.) *Dining in a Classical Context*, 185–98. Ann Arbor, MI.

Jucker, H. (1976) 'Der grosse Pariser Kameo', *JdI* 91: 211–50.

Junker, K. (2003) *Pseudo-Homerica. Kunst und Epos im spätarchaischen Athen.* Berlin.

——(2005) *Griechische Mythenbilder. Eine Einführung in ihre Interpretation.* Stuttgart.

——and A. Stähli (eds.) (2008) *Original und Kopie. Formen und Konzepte der Nachahmung in der antiken Kunst. Akten des Kolloquiums in Berlin, 17.–19. Februar 2005.* Wiesbaden.

Kaibel, G. (1878) *Epigrammata Graeca ex lapidibus conlecta.* Berlin.

Kalligeropoulos, D. and S. Vasileiadou (2008) 'Interpreting the representations on the Shield of Achilles', in S. A. Paipetis (ed.) *Science and Technology in Homeric Epics*, 443–50. New York.

Kampen, N. B. (2003) 'On writing histories of Roman art', *Art Bulletin* 85: 371–86.

Katz, J. T. (2007) 'An acrostic ant road in *Aeneid* 4', *MD* 59: 77–86.

——(2008) 'Vergil translates Aratus: *Phaenomena* 1–2 and *Georgics* 1.1–2', *MD* 60: 105–23.

Kay, N. M. (ed.) (2006) *Epigrams from the* Anthologia Latina: *Text, Translation and Commentary.* London.

Kazansky, N. N. (1997) *Principles of the Reconstruction of a Fragmentary Text (New Stesichorean Papyri).* St Petersburg.

Keaney, J. J., and R. Lamberton (eds.) (1996) *[Plutarch]: Essay on the Life and Poetry of Homer.* Atlanta, GA.

Keesling, C. M. (2003) *The Votive Statues of the Athenian Acropolis.* Cambridge.

Kemp-Lindemann, D. (1975) *Darstellungen des Achilleus in griechischer und römischer Kunst*. Bern.

Kennedy, G. A. (1998) *The* Latin Iliad: *Introduction, Text, Translation and Notes*. Fort Collins, CO.

——(2003) *Progymnasmata: Greek Textbooks of Prose Composition and Rhetoric*. Boston.

Kenyon, F. G. (1932) *Books and Readers in Ancient Greece and Rome*. Oxford.

Keuls, E. C. (1997) *Painter and Poet in Ancient Greece: Iconography and the Literary Arts*. Stuttgart and Leipzig.

Kirichenko, A. (2005) '*Hymnus invicto*: The structure of Mithraic cult images with multiple panels', *Göttinger Forum für Altertumswissenschaft* 8: 1–15.

Kleberg, T. (1967) *Buchhandel und Verlagswesen in der Antike*. Darmstadt.

Kleiner, D. E. E. (1992) *Roman Sculpture*. New Haven.

——(2005) 'Semblance and storytelling in Augustan Rome', in K. Galinsky (ed.), 197–233.

Kleiner, F. S. (2007) *A History of Roman Art*. Belmont, CA.

Knight, V. (1995) *The Renewal of Epic: Responses to Homer in the* Argonautica *of Apollonius*. Leiden.

Koenen, L. and C. Römer (eds.) (1985) *Der Kölner Mani-Kodex. Abbildungen und diplomatischer Text*. Bonn.

——, and A. Heinrichs (eds.) (1988) *Der Kölner Mani-Kodex. Über das Werden seines Leibes. Kritische Edition*. Opladen.

Konstan, D. and S. Saïd (eds.) (2006) *Greeks on Greekness: Viewing the Greek Past under the Roman Empire*. Cambridge.

Kontoleon, N. M. (1964) 'Zu den literarischen *anagraphaï*', *Akte des IV. Internationalen Kongresses für griechische und lateinische Epigraphik*, 192–201. Vienna.

Kopff, E. C. (1983) 'The structure of the Amazonia (*Aethiopis*)', in R. Hägg (ed.) *The Greek Renaissance of the Eighth Century: Tradition and Innovation*, 57–62. Stockholm.

Kosmetatou, E. (2004) 'Vision and visibility: Art historical theory paints a portrait of new leadership in Posidippus' *Andriantopoiika*', in B. Acosta-Hughes, E. Kosmetatou, and M. Baumbach (eds.), 187–211.

Kostelanetz, R. (ed.) (1979) *Visual Literature Criticism: A New Collection*. London and Amsterdam.

Kousser, R. M. (2008) *Hellenistic and Roman Ideal Sculpture: The Allure of the Classical*. Cambridge.

Krämer, S. (2005) ' "Operationsraum Schrift": Über einen Perspektivenwechsel in der Betrachtung der Schrift', in G. Grube, W. Kogge, and S. Krämer (eds.) *Schrift. Kulturtechnik zwischen Auge, Hand und Maschine*, 23–61. Munich.

Kranz, W. (1961) 'Sphragis: Ichform und Namensiegel als Eingangs- und Schlußmotiv antiker Dichtung', *RhM* 104: 97–124.

Krieger, M. (1992) *Ekphrasis: The Illusion of the Natural Sign*. Baltimore.

Kristeva, J. (1989) *Language – The Unknown: An Initiation into Linguistics*. Trans. A. M. Menke. New York.

Kunze, C. (2002) *Zum Greifen nah. Stilphänomene in der hellenistischen Skulptur und ihre inhaltliche Interpretation*. Munich.

——(2008) 'Zwischen Griechenland und Rom: Das "antike Rokoko" und die veränderte Funktion von Skulptur in späthellenistischer Zeit', in K. Junker and A. Stähli (eds.), 77–108.

Kunze, E. (1950) *Archaische Schildbänder. Ein Beitrag zur frühgriechischen Bildgeschichte und Sagenüberlieferung*. Berlin.

Kurman, J. (1974) 'Ecphrasis in epic poetry', *Comparative Literature* 26: 1–13.

Kurtz, E. and F. Drexl (eds.) (1941) *Michaelis Pselli scripta minora (magnam partem adhuc inedita)*. Milan.

Kuttner, A. (1995) *The Boscoreale Cups of Augustus: Studies in Augustan Art and Politics*. Berkeley.

——(2003) 'Delight and danger: Motion in the Roman water garden at Sperlonga', in M. Conan (ed.) *Landscape, Design, and the Experience of Motion*, Dumbarton Oaks Colloquium on the History of Landscape Architecture 24, 103–56. Washington, DC.

——(2005) 'Cabinet fit for a queen: The *Lithica* of Posidippus' gem museum', in K. Gutzwiller (ed.), 141–63.

Lafon, X. (2001) *Villa maritima. Recherches sur les villas littorales de l'Italie romaine*. Rome.

Laird, A. (1993) 'Sounding out ecphrasis: Art and text in Catullus 64', *JRS* 83: 18–30.

——(1996) '*Ut figura poesis*: Writing art and the art of writing in Augustan poetry', in J. Elsner (ed.), 75–102.

Lamberton, R. (1986) *Homer the Theologian: Neoplatonist Allegory and the Growth of the Epic Tradition*. Berkeley.

Lancha, J. (1997) *Mosaïque et culture dans l'Occident romain (Ier–IVe s.)*. Rome.

Langner, M. (2001) *Antike Graffitizeichnungen. Motiv, Gestaltung und Bedeutung*. Wiesbaden.

Lapatin, K. (2003) 'The fate of plate and other precious materials: Towards a historiography of ancient Greek minor (?) arts', in A. A. Donohue and M. D. Fullerton (eds.), 69–91.

Latacz, J. (ed.) (2008) *Homer. Der Mythos von Troia in Dichtung und Kunst. Eine Ausstellung des Antikenmuseums Basel, des Art Centre Basel und der Reiss-Engelhorn-Museen Mannheim*. Munich.

Laurens, P. (1989) *L'abeille dans l'ambre. Célébration de l'épigramme de l'époque alexandrine à la fin de la Renaissance*. Paris.

Lausberg, M. (1982) *Das Einzeldistichon. Studien zum antiken Epigramm*. Munich.

Lauxtermann, M. D. (1998) 'What is an epideictic epigram?', *Mnemosyne* 51: 525–37.

Lavigne, D. E. and A. J. Romano (2004) 'Reading the signs: The arrangement of the New Posidippus roll (*P. Mil. Vogl.* VIII 309, IV.7–VI.8)', *ZPE* 146: 13–24.

Leach, E. W. (1988) *The Rhetoric of Space: Literary and Artistic Representations of Landscape in Republican and Augustan Rome*. Princeton.

Leader-Newby, R. (2004) *Silver and Society in Late Antiquity: Functions and Meanings of Silver Plate in the Fourth to Seventh Centuries*. Aldershot.

Leary, T. J. (ed.) *Martial: Book XIV: The* Apophoreta. London.

Legras, B. (2002) *Lire en Égypte, d'Alexandre à l'Islam*. Paris.

Lehmann, K. (1941) 'The *Imagines* of the Elder Philostratus', *Art Bulletin* 23: 95–105.

——(1945) 'A Roman poet visits a museum', *Hesperia* 14: 259–69.

Lehnus, L. (1972) 'Note stesichoree (Pap. Oxy. 2506 e 2619)', *SCO* 21: 52–5.

Lesky, A. (1940) 'Bildwerk und Deutung bei Philostrat und Homer', *Hermes* 75: 38–53.

Lessing, G. E. (1984) *Laocoön: An Essay on the Limits of Painting and Poetry*. Trans. E. A. McCormick. Baltimore.

Leue, G. (1882-4) 'Zeit und Heimath des periegeten Dionysios', *Philologus* 42: 175–8.

Levitan, W. (1979) 'Plexed artistry: Aratean acrostics', *Glyph* 5: 55–68.

——(1985) 'Dancing at the end of the rope: Optatian Porfyry and the field of Roman verse', *TAPhA* 115: 245–69.

Lévy-Strauss, C. (1962) *La pensée sauvage*. Paris.

——(1966) *The Savage Mind*. Trans. J. Weightman and D. Weightman. London.

Lewis, S. (1995) *Reading Images: Narrative Discourse and Reception in the Thirteenth Century*. Cambridge.

Ling, R. (1991) *Roman Painting*. Cambridge.

——(1995) 'The decoration of Roman triclinia', in O. Murray and M. Tecuşan (eds.) *In Vino Veritas*, 239–51. London.

——(2000) 'Working practice', in R. Ling (ed.) *Making Classical Art: Process and Practice*, 91–107. Stroud and Charleston, SC.

Lippold, G. (1932) 'Tabula iliaca', *RE* 4.2: 1886–96.

Lissarrague, F. (1985) 'Paroles d'images: remarques sur le fonctionnement de l'écriture dans l'imagerie attique', in A.-M. Christin (ed.) *Ecritures II*, 71–95. Paris.

——(1990) *The Aesthetics of the Greek Banquet: Images of Wine and Ritual*. Trans. A. Szegedy-Maszak. Princeton.

——(1992) '*Graphein*: écrire et dessiner', in C. Bron and E. Kassapoglou (eds.) *L'Image en jeu. De l'antiquité à Paul Klee*, 189–203. Paris.

——(1999) 'Publicity and performance: Kalos inscriptions in Attic vase-painting', in S. D. Goldhill and R. Osborne (eds.), 359–73.

——and A. Schnapp (2000) 'Tradition und Erneuerung in der Klassischen Archäologie in Frankreich', in A. H. Borbein, T. Hölscher, and P. Zanker (eds.), 365–82.

Liversidge, M. J. H. (1997) 'Virgil in art', in C. Martindale (ed.), 91–104.

Livingstone, N. and G. Nisbet (2010) *Epigram*. *G&R* New Surveys in the Classics, no. 34. Cambridge.

Lobel, E. (1928) 'Nikander's signature', *CQ* 22: 114.

Löbl, R. (1997) *TEXNH – Techne. Untersuchungen zur Bedeutung dieses Wortes in der Zeit von Homer bis Aristoteles. Band I: Von Homer bis zu den Sophisten*. Würzburg.

——(2003) *TEXNH – Techne. Untersuchungen zur Bedeutung dieses Wortes in der Zeit von Homer bis Aristoteles. Band II: Von den Sophisten bis zu Aristoteles*. Würzburg.

——(2008) *TEXNH – Techne. Untersuchungen zur Bedeutung dieses Wortes in der Zeit nach Aristoteles. Band III: Die Zeit des Hellenismus*. Würzburg.

Loewy, E. (1885) *Inschriften griechischer Bildhauer*. Leipzig.

Lorenz, K. (2008) *Bilder machen Räume. Mythenbilder in pompeianischen Häusern*. Berlin.

——(forthcoming) 'Split screen aficianados: Heracles on top of Troy in the Casa di Octavius Quartio in Pompeii', in H. Lovatt and C. Vout (eds.) *Epic Visions*. Cambridge.

Lorenz, S. (2002) *Erotik und Panegyrik. Martials epigrammatische Kaiser*. Tübingen.

Lowden, J. (1999) 'The beginnings of Biblical illustration', in J. Williams (ed.), 9–59.

Lowenstam, S. (1993) 'The pictures on Juno's temple in the *Aeneid*', *CW* 87: 37–49.

——(1997) 'Talking vases: The relationship between the Homeric poems and the Archaic representations of epic myth', *TAPhA* 127: 21–76.

Lucas, D. W. (ed.) (1968) *Aristotle*, Poetics: *Introduction, Commentary, and Appendixes*. Oxford.

Luz, C. (2008) 'Das Rätsel der griechischen Figurengedichte', *MH* 37: 22–33.

——(2010) Technopaegnia. *Formspiele in der griechischen Dichtung*. Leiden.

Lynn-George, M. (1988) *Epos: Word, Narrative and the* Iliad. London.

Maffei, S. (1991) 'La sophia del pittore e del poeta nel proemio delle *Imagines* di Filostrato Maggiore', *ASNP* 21: 591–621.

Maiuri, I. (1950) 'La parodia di Enea', *Bollettino d'Arte* 35: 108–12.

Malkin, I. (1998) *The Returns of Odysseus: Colonization and Ethnicity*. Berkeley.

Manakidou, F. (1993) *Beschreibung von Kunstwerken in der hellenistischen Dichtung. Ein Beitrag zur hellenistischen Poetik*. Stuttgart.

Mancuso, U. (1909) 'La "tabula iliaca" del Museo Capitolino', *MemLinc* 5:14: 661–731.

——(1910) 'Tabulae Iliacae Capitolinae inscriptionem denuo recognitam percensuit artissimo adiecto apparatu [Humb. Mancuso]', *RendLinc* 5a: 19: 933–42.

——(1912) *La lirica classica greca in Sicilia e nella Magna Grecia*. Pisa.

Mango, M. M. and A. Bennett (1994) *The Sevso Treasure: Part One*. Ann Arbor, MI.

Manieri, A. (1995) 'Alcune riflessioni sul rapporto poesia–pittura nella teoria degli antichi', *QUCC* 50: 133–40.

Männlein-Robert, I. (2003) 'Zum Bild des Phidias in der Antike: Konzepte zur Kreativität des bildenden Künstlers', in T. Dewender and T. Welt (eds.) *Imagination—Fiktion—Kreation. Das kulturschaffende Vermögen der Phantasie*, 45–67. Munich and Leipzig.

——(2006) ' "Hinkende Nachahmung": Desillusionierung und Grenzüberspielungen in Herodas' viertem Mimiambos', in M. A. Harder, R. F. Regtuit, and G. C. Wakker (eds.), 205–27.

——(2007a) 'Epigrams on art: Voice and voicelessness in Hellenistic epigram', in P. Bing and J. S. Bruss (eds.), 251–71.

——(2007b) *Stimme, Schrift und Bild. Zum Verhältnis der Künste in der hellenistischen Dichtung*. Heidelberg.

Manuwald, A. and B. Manuwald (2007) 'Bilder zu Texten—Texte als Bilder: Griechische Vasenbilder und Figurengedichte', in D. Boschung and H. Hellenkemper (eds.), 163–85.

Maras, D. F. (ed.) (1999) *La Tabula Iliaca di Bovillae*. Boville.

Marcadé, J. (1953–7) *Recueil des signatures de sculpteurs grecs*. Two volumes. Paris.

Marchand, S. (1996) *Down from Olympus: Archaeology and Philhellenism in Germany, 1750–1970*. Princeton.

Marco, M. di, B. M. Palumbo, and E. Lelli (eds.) (2005) *Posidippo e gli altri. Il poeta, il genere, il contesto culturale e letterario. Atti dell'incontro di studio, Roma, 14–15 maggio 2004*. Pisa.

Marconi, C. (2009) 'The Parthenon frieze: Degrees of visibility', *Res: Anthropology and Aesthetics* 55/6: 156–73.

Marg, W. (1957) *Homer über die Dichtung*. Münster.

Marshall, P. K. (1983) 'Ilias Latina', in L. D. Reynolds (ed.) *Texts and Transmission: A Survey of the Latin Classics*, 191–4. Oxford.

Martin, J. (ed.) (1974) *Scholia in Aratum Vetera*. Stuttgart.

Martindale, C. (ed.) (1997) *The Cambridge Companion to Virgil*. Cambridge.

Marvin, M. (1983) 'Freestanding sculptures from the Baths of Caracalla', *AJA* 87: 347–84.

——(1993) 'Copying in Roman sculpture: The replica series', in E. d'Ambra (ed.), 161–88.

——(2008) *The Language of the Muses: The Dialogue Between Roman and Greek Sculpture*. Los Angeles.

Marzano, A. (2007) *Roman Villas in Central Italy: A Social and Economic History*. Trans. N. Bruno. Leiden.

Matheson, S. B. (1995) *Polygnotos and Vase Painting in Classical Athens*. Madison, WI.

Mattick, P., Jr. (2003) 'Context', in R. S. Nelson and R. Shiff (eds.) *Critical Terms for Art History*, 10–127. Chicago.

Mattusch, C. (2005) *The Villa dei Papiri at Herculaneum: Life and Afterlife of a Sculpture Collection*. Los Angeles.

——(2008) 'Metalworking and tools' in J. P. Oleson (ed.) *The Oxford Handbook of Engineering and Technology in the Classical World*, 418–38. Oxford.

——(ed.) (2008) *Pompeii and the Roman Villa*. London.

Mayer, P. (1979) 'On the need for a visual literature: What the "literature" offers', in R. Kostelanetz (ed.), 39–41.

McDonnell, M. (1996) 'Writing, copying, and autograph manuscripts in ancient Rome', *CQ* 46: 469–91.

McEwen, I. K. (2003) *Vitruvius: Writing the Body of Architecture*. Cambridge, MA.

McGill, S. (2005) *The Mythological and Secular Centos in Antiquity*. Oxford.

McGurk, P. (1994) 'The oldest manuscripts of the Latin Bible', in R. Gameson (ed.) *The Early Medieval Bible*, 1–23. Cambridge.

McLean, B. H. (2002) *An Introduction to Greek Epigraphy of the Hellenistic and Roman Periods from Alexander the Great down to the Reign of Constantine (323 BC–AD 337)*. Ann Arbor, MI.

McLeod, W. (1973) 'New readings in *I.G.*, XIV, 1285, II, Verso', *Hesperia* 42: 408–15.

——(1985) 'The "epic canon" of the Borgia table: Hellenistic lore or Roman fraud?', *TAPhA* 115: 153–65.

Merkelbach, R. (1989) 'Der Brief des Dareios im Getty-Museum und Alexanders Wortwechsel mit Parmenion', *ZPE* 77: 277–80.

——and M. L. West (eds.) (1970) *Hesiodi* Theogenia, Opera et Dies, Scutum, *Fragmenta Selecta*. Oxford.

Merriam, C. U. (2001) *The Development of the Epyllion Genre through the Hellenistic and Roman Periods*. Lewison, NY.

Metzler, D. (1971) *Porträt und Gesellschaft*. Münster.

Meyer, D. (2005) *Inszeniertes Lesevergnügen. Das inschriftliche Epigramm und seine Rezeption bei Kallimachos*. Stuttgart.

——(2007) 'The act of reading and the act of writing in Hellenistic epigram', in P. Bing and J. S. Bruss (eds.), 187–210.

Michel, C. (1974) 'Die "Weisheit" der Maler und Dichter in den *Bildern* des älteren Philostrat', *Hermes* 102: 457–66.

Micheli, M. E. (2006) 'Raffaele Fabretti illustratore di un ciclo epico', in M. Mazzoleni (ed.) *Raffaele Fabretti, archeologo ed erudite. Atti della Giornata di Studia, 24. maggio 2003*, 77–102. Vatican City.

Michon, H. (1899) 'Iliacae (Tabulae)', in C. Daremberg and E. Saglio (eds.) *Dictionnaire des antiquités grecques et romaines* 3.1: 372–82.

Mielsch, H. (1985) *Buntmarmore aus Rom im Antikenmuseum Berlin*. Berlin.

——(1987) *Die römische Villa. Architektur und Lebensform*. Munich.

——(1989) 'Die römische Villa als Bildungslandschaft', *Gymnasium* 96: 444–56.

Mikocki, T. (1990) *La perspective dans l'art romain*. Warsaw.

Miller, J. F. (2009) *Apollo, Augustus and the Poets*. Cambridge.

Millett, M. (2007) 'What is classical archaeology? Roman archaeology', in S. E. Alcock and R. Osborne (eds.), 30–52.

Milnor, K. (2009) 'Literary literacy in Roman Pompeii: The case of Vergil's *Aeneid*', in W. A. Johnson and H. N. Parker (eds.), 288–319.

Mitchell, W. J. T. (1986) *Iconology: Image, Text, Ideology*. Chicago.

——(1992) 'Ekphrasis and the other', *South Atlantic Quarterly* 91: 695–712.

——(1994) *Picture Theory: Essays on Verbal and Visual Representation*. Chicago.

——(2002) 'Showing seeing: A critique of visual culture', in M. A. Holly and K. Moxey (eds.) *Art History, Aesthetics, Visual Studies*, 231–50. New Haven.

——(2003) 'Word and image', in R. Nelson and R. Shiff (eds.) *Critical Terms for Art History*, 51–61. Second edition. Chicago.

——(2005) *What Do Pictures Want? The Lives and Loves of Images*. Chicago.

Morales, H. (2004) *Vision and Narrative in Achilles Tatius'* Leucippe and Clitophon. Cambridge.

Moraw, S. (2005) '"Ideale Nacktheit" oder Diskreditierung eines überkommenen Heldenideals? Der Streit um die Waffen des Achill auf einer spätantiken Silberschale',

in G. Fischer and S. Moraw (eds.) *Die andere Seite der Klassik. Gewalt im 5. und 4. Jahrhundert v. Chr.*, 213–25. Stuttgart.

Morel, W. (ed.) (1963) *Fragmenta Poetarum Latinorum Epicorum et Lyricorum praeter Ennium et Lucilium*. Second edition. Stuttgart.

Moreno, P. (1974) *Lisippo*. Rome.

Morgan, G. (1993) 'Nullam, Vare . . . Chance or choice in *Odes* 1.18', *Philologus* 137: 142–5.

Morris, I. (1994) 'Archaeologies of Greece', in idem (ed.), 8–47.

——(ed.) (1994) *Classical Greece: Ancient Histories, Modern Archaeologies*. Cambridge.

Morris, S. (1995) 'The sacrifice of Astyanax: Near Eastern contributions to the Trojan War', in J. Carter and S. Morris (eds.), 221–40.

Müller, C. W. (1994) 'Das Bildprogramm der Silberbecher von Hoby: Zur Rezeption frühgriechischer Literatur in der römischen Bildkunst der augusteischen Zeit', *JdI* 109: 321–52.

Müller, F. G. J. M. (1994) *The Wall Paintings from the Oecus of the Villa of Publius Fannius Synistor in Boscoreale*. Amsterdam.

Müller, K. and C. Robert (1884) 'Relieffragment mit Darstellungen aus dem Pinax des Kebes', *Archäologische Zeitung* 42: 113–30.

Münzer, F. (1897) *Beiträge zur Quellenkritik der Naturgeschichte des Plinius*. Berlin.

Murphy, T. (2004) *Pliny the Elder's Natural History: The Empire in the Encyclopedia*. Oxford.

Murray, A. S. (1890) *A History of Greek Sculpture*. Two volumes. London.

Mustilli, D. (1960) 'Falsificazione', *EAA* 3: 576–89.

Muth, S. (1998) *Erleben von Raum—Leben im Raum. Zur Funktion mythologischer Mosaikbilder in der römisch-kaiserzeitlichen Wohnarchitektur*. Heidelberg.

——(1999) 'Hylas oder "Der ergriffene Mann": Zur Eigenständigkeit der Mythenrezeption in der Bildkunst', in F. de Angelis and S. Muth (eds.), 109–29.

——(2005) 'Überflutet von Bildern: Die Ikonophilie im spätantiken Haus', in P. Zanker and R. Neudecker (eds.) *Lebenswelten. Bilder und Räume in der römischen Stadt der Kaiserzeit*, 223–42. Rome.

——(2007) 'Das Manko der Statuen? Zum Wettstreit der bildlichen Ausstattung im spätantiken Wohnraum' in F. A. Bauer and C. Witschel (eds.) *Statuen in der Spätantike*, 341–56. Wiesbaden.

Myres, J. N. L. (1958) *Homer and His Critics*. London.

Naas, V. (2002) *Le projet encyclopédique de Pline l'Ancien*. Rome.

Nadeau, R. (2010) *Les manières de table dans le monde gréco-romain. Table des hommes*. Rennes.

Naumann-Steckner, F. (2007) 'Foedula vivas—Pummelchen lebe hoch! Inschriften auf römischem Tafelsilber', in D. Boschung and H. Hellenkemper (eds.), 295–317.

Neer, R. T. (2002) *Style and Politics in Athenian Vase-Painting: The Craft of Democracy, ca. 530–470 B.C.E.* Cambridge.

Neri, C. (2003) *Erinna. Testimonianze e Frammenti*. Bologna.

Neudecker, R. (1988) *Die Skulpturenausstattung römischer Villen in Italien*. Mainz.

——(1998) 'The Roman villa as a locus for art collections', in A. Frazer (ed.), 77–91.

——(2004) 'Aspekte öffentlicher Bibliotheken in der Kaiserzeit', in B. Borg (ed.), 293–313.

Newby, Z. (2002) 'Reading programs in Greco-Roman art: Reflections on the Spada Reliefs', in D. Fredrick (ed.) *The Roman Gaze: Vision, Power and the Body*, 110–48. Baltimore.

——(2007a) 'Introduction', in Z. Newby and R. Leader-Newby (eds.), 1–16.

——(2007b) 'Reading the allegory of the Archelaos relief', in Z. Newby and R. Leader-Newby (eds.), 156–78.

——(2009) 'Absorption and erudition in Philostratus' *Imagines*', in E. Bowie and J. Elsner (eds.), 322–42.

——and R. Leader-Newby (eds.) (2007) *Art and Inscriptions in the Ancient World*. Cambridge.

Newlands, C. (2002) *Statius' Silvae and the Poetics of Empire*. Cambridge.

Nisbet, G. (2002) 'Barbarous verses: A mixed-media narrative from Greco-Roman Egypt', *Apollo* 485: 15–19.

——(2003) *Greek Epigram in the Roman Empire: Martial's Forgotten Rivals*. Oxford.

Obbink, D. (2004) '*Tropoi* (Posidippus AB 102–103)', in B. Acosta-Hughes, E. Kosmetatou, and M. Baumbach (eds.), 292–301.

Oliver, R. P. (1951) 'The First Medicean MS of Tacitus and the titulature of ancient books', *TAPhA* 82: 232–61.

Onians, J. (1979) *Art and Thought in the Hellenistic Age: The Greek World View, 350–50 BC*. London.

Osborne, M. J. (1973) 'The stoichedon style in theory and practice', *ZPE* 10: 249–70.

Osborne, R. (1987) 'The viewing and obscuring of the Parthenon frieze', *JHS* 107: 98–105.

——(2004) 'Monumentality and ritual in Archaic Greece', in D. Yatromanolakis and P. Roilos (eds.) *Greek Ritual Poetics*, 37–55. Cambridge, MA.

——and A. Pappas (2007) 'Writing on archaic Greek pottery', in Z. Newby and R. Leader-Newby (eds.), 131–55.

O'Sullivan, T. (2007) 'Walking with Odysseus: The portico frame of the Odyssey Landscapes', *AJPh* 128: 497–532.

Oswald, F. (1936–7) *Index of Figure-Types on Terra Sigillata ('Samian Ware')*. Liverpool.

Overbeck, J. A. (1868) *Die antiken Schriftquellen zur Geschichte der bildenden Künste bei den Griechen*. Leipzig.

Pack, R. A. (1960) *The Greek and Latin Literary Texts from Greco-Roman Egypt*. Second edition. Ann Arbor, MI.

Page, D. L. (ed.) (1941) *Select Papyri: Volume Three, Literary Papyri—Poetry*. Cambridge, MA.

——(1973) 'Stesichorus: The "Sack of Troy" and "The Wooden Horse" (*P. Oxy.* 2619 and 2803)', *PCPhS* 19: 47–65.

——(ed.) (1981) *Further Greek Epigrams: Epigrams before AD 50 from the Greek Anthology and Other Sources, Not Included in 'Hellenistic Epigrams' or 'The Garland of Philip'*. Revised and prepared for publication by R. D. Dawe and J. Diggle. Cambridge.

Pannuti, U. (1984) 'L'apoteosi di Omero: vaso argenteo del Museo Nazionale di Napoli', *Monumenti Antichi* 52 (= *Accademia Nazionale dei Lincei: Serie Miscellanea* 3.2): 43–61.

Paris, J. (1978) *Lisible, visible. Essai de critique générative*. Paris.

Parker, R. (2000) 'Theophoric names and the history of Greek religion', in S. Hornblower and E. Matthews (eds.) *Greek Personal Names and their Value as Evidence*, 53–80. Oxford.

Parsons, P. (2009) 'A papyrologist's view', in K. Brodersen and J. Elsner (eds.), 27–33.

Pasquariello, C. (2004) 'Pirro o i Misii', in F. Ghedini, I. Colpo, and M. Novello (eds.), 105–15.

Patillon, M. (ed.) (1997) *Hermogène, L'art rhétorique. Exercices préparatoires, états de cause, invention, catégories stylistiques, méthode de l'habilité*. Paris.

——and G. Bolognesi (eds.) (1997) *Aelius Théon*, Progymnasmata. Paris.

Paulcke, M. (1897) *De Tabula Iliaca Quaestiones Stesichoreae*. Dissertatio inauguralis, Königsberg.

Pernigotti, C. (ed.) (2008) *Menandri Sententiae*. Florence.

Perry, E. (2005) *The Aesthetics of Emulation in the Visual Arts of Ancient Rome*. Cambridge.

Petersen, L. H. (2006) *The Freedman in Roman Art and Art History*. Cambridge.

Petrain, D. (2005) 'Gems, metapoetics, and value: Greek and Roman responses to a third-century discourse on precious stones', *TAPhA* 135: 329–57.

——(2006) 'Epic manipulations: The *Tabulae Iliacae* in their Roman context'. Unpublished PhD dissertation, Harvard University.

——(2008) 'Two inscriptions from the *Tabulae Iliacae*: The epic canon of the Borgia Tablet (*IG* 14.1292.2) and the Roman Chronicle (*SEG* 33.802B)', *ZPE* 166: 83–4.

——(2010) 'More inscriptions from the *Tabulae Iliacae*', *ZPE* 174: 51–6.

Petrovic, A. (2005) 'Kunstvolle Stimme der Steine, sprich! Zur Intermedialität der griechischen epideiktischen Epigramme', *A&A* 51: 30–42.

Petrovic, I. (2006) 'Delusions of grandeur: Homer, Zeus and the Telchines in Callimachus' *Reply* (*Aitia* Fr. 1) and *Iambus* 6', *A&A* 52: 16–41.

Petsalis-Diomidis, A. (2010) *Truly Beyond Wonders: Aelius Aristides and the Cult of Asklepios*. Oxford.

Pfeiffer, R. (1968) *History of Classical Scholarship from the Beginnings to the End of the Hellenistic Age*. Oxford.

Picard, G.-C. (1962) *L'art romain*. Paris.

Pinkwart, D. (1965) *Das Relief des Archelaos von Priene und die 'Musen des Philiskos'*. Kallmünz.

Pinney, M. E. (1924) 'Miscellaneous Greek and Roman sculptures', *The Metropolitan Museum of Art Bulletin* 19: 239–43.

Plantzos, D. (1997) 'Crystals and lenses in the Graeco-Roman world', *AJA* 101: 451–64.

——(1999) *Hellenistic Engraved Gems*. Oxford.

Platt, V. J. (2002a) 'Viewing, desiring, believing: Confronting the divine in a Pompeian house', *Art History* 25: 87–112.

——(2002b) 'Evasive epiphanies in ekphrastic epigram', *Ramus* 31: 33–50.

——(2006) 'Making an impression: Replication and the ontology of the Graeco-Roman seal stone', in J. Trimble and J. Elsner (eds.), 233–57.

——(2007) 'Burning butterflies: Seals, symbols and the soul in antiquity', in L. Gilmour (ed.) *Pagans and Christians—From Antiquity to the Middle Ages*, 89–99. Oxford.

——(2009a) 'Where the wild things are: Locating the marvellous in Augustan wall painting', in P. Hardie (ed.) *Paradox and the Marvellous in Augustan Literature*, 41–74. Oxford.

——(2009b) 'Virtual visions: Phantasia and the perception of the divine in Philostratus' *Life of Apollonius of Tyana*', in E. Bowie and J. Elsner (eds.), 131–54.

——(forthcoming) *Facing the Gods: Epiphany and Representation in Graeco-Roman Art, Literature and Religion*. Cambridge.

——and M. J. Squire (eds.) (2010) *The Art of Art History in Graeco-Roman Antiquity* (= *Arethusa* 43.2).

——(eds.) (forthcoming) *Framing the Visual in the Graeco-Roman World*. Cambridge.

Polara, G. (1969) 'Specimina di analisi applicate a strutture di "Versspielerei" latina', *Rendiconti della Accademia di Archeologia, Lettere e Belle Arti, Napoli* 49: 111–36.

——(ed.) (1973) *Publilii Optatiani Porfyrii*, Carmina. *I. Textus adiecto indice verborum*. Turin.

——(1987) 'Optaziano Porfirio tra il calligramma antico e il carme figurato di età medioevale', *Invigilata Lucernis* 9: 163–73.

——(1996) 'Le parole nella pagina: grafica e contenuti nei carmi figurati latini', in M. Marin and M. Giarardi (eds.) *Retorica ed esegesi biblica. Il rilievo dei contenuti attraverso le forme*, 201–45. Bari.

Pollitt, J. J. (1974) *The Ancient View of Greek Art: Criticism, History and Terminology*. Cambridge.

——(1986) *Art in the Hellenistic Age*. Cambridge.

——(1990) *The Art of Ancient Greece: Sources and Documents*. Cambridge.

Pomeroy, S. B. (1978) 'Supplementary notes on Erinna', *ZPE* 32: 17–21.

Porter, J. (1992) 'Hermeneutic lines and circles: Aristarchus and Crates on the exegesis of Homer', in R. Lamberton and J. K. Keany (eds.) *Homer's Ancient Readers: The Hermeneutics of Greek Epic's Earliest Exegetes*, 67–114. Princeton.

——(2004) 'Vergil's voids', *Helios* 31: 127–56.

——(2010a) 'Why art has never been autonomous', in V. J. Platt and M. J. Squire (eds.), 165–80.

——(2010b) *The Origins of Aesthetic Thought in Ancient Greece: Matter, Sensation and Experience*. Cambridge.

——(forthcoming) 'Against *leptotes*: Rethinking Hellenistic aesthetics', in A. Erskine, L. Llewellyn-Jones, and S. Winder (eds.) *Creating a Hellenistic World*, 271–312. Swansea.

Powell, B. (1991) *Homer and the Origin of the Greek Alphabet*. Cambridge.

Prier, R. A. (1989) Thauma Idesthai: *The Phenomenology of Sight and Appearance in Archaic Greece*. Tallahassee, FL.

Price, M. T. (2007) *Decorative Stone: The Complete Sourcebook*. London.

Primavesi, O. (2002) 'Bild und Zeit: Lessings Poetik des natürlichen Zeichens und die homerische Ekphrasis', in J. P. Schwindt (ed.) *Klassische Philologie Inter Disciplinas. Aktuelle Konzepte zu Gegenstand und Methode eines Grundlagenfaches*, 187–211. Heidelberg.

Prioux, E. (2006) '*Materiae non cedit opus*: matières et sujets dans les épigrammes descriptives (IIIe siècle av. J.-C. – 50 apr. J.-C.)', in A. Rouveret, S. Dubel, and V. Naas (eds.) *Couleurs et matières dans l'antiquité. Textes, techniques et pratiques*, 127–60. Paris.

——(2007) *Regards alexandrins. Histoire et théorie des arts dans l'épigramme hellénistique*. Leuven.

——(2008) *Petits musées en vers. Épigramme et discours sur les collections antiques*. Paris.

Pugliara, M. (2004) 'Proemio', in F. Ghedini, I. Colpo, and M. Novello (eds.), 7–16.

Puppo, P. (2008) 'La Tabula "Chigi": un riflesso delle conquiste romane in Oriente', in J. M. Córdoba Zoilo, M. M. Montaña, M. Pérez Aparicio, I. L. Rubio, and S. Martínez (eds.) *Proceedings of the Fifth International Congress on the Archaeology of the Ancient Near East, Madrid, April 3–8 2006*, Volume 3, 65–70. Madrid.

——(2009) 'Le *Tabulae Iliacae: Studio per una riedizione*', in C. Ampolo (ed.) *Immagine e immagini della Sicilia e di altre isole del Mediterraneo antico*, 829–49. Pisa.

Purcell, N. (1995) 'Literate games: Roman urban society and the game of *Alea*', *Past & Present* 147: 3–37.

Purves, A. C. (2010) *Space and Time in Ancient Greek Narrative*. Cambridge.

Putnam, M (1998) *Virgil's Epic Designs: Ekphrasis in the* Aeneid. New Haven.

——(2001) 'The ambiguity of art in Virgil's *Aeneid*', *PAPHS* 145: 162–83.

Rabe, H. (ed.) (1913) *Hermogenis Opera*. Leipzig.

——(ed.) (1926) *Aphthonius* Progymnasmata. Leipzig.

——(ed.) (1928) *Ioannis Sardiani Commentarium in Aphthonii* Progymnasmata. Leipzig.

Ramage, N. H. and A. Ramage (2009) *Roman Art: Romulus to Constantine*. Fifth edition. Upper Saddle River, NJ.

Rayet, O. (1882) 'Note sur un fragment inédit de table iliaque du Cabinet de M. Thierry', *Mémoires de la Societé des Antiquaires de France* 43: 17–23.

——(1888) *Études d'archéologie et d'art*. Paris.

Reeve, M. D. (1996–7) 'A rejuvenated snake', *Acta Antiqua Academiae Scientiarum Hungaricae* 37: 245–58.

Reifferscheid, A. (1862) 'De usu tabularum iliacarum et similium', *Annali dell'Instituto di Corrispondenza Archeologica* 34: 104–15.

Reinach, S. (1909) *Répertoire de reliefs grecs et romains. Tome Premier: Les Ensembles*. Paris.

Reinhardt, U. (2008) 'Hellenistische Reliefbecher mit Szenen aus Dramen des Euripides und die antiken Anfänge textbegleitender Illustrierung', *Wiener Studien* 121: 85–102.

Revermann, M. (1998) 'The text of *Iliad* 18.603–6 and the presence of an *aoidos* on the Shield of Achilles', *CQ* 48: 29–38.

Richter, G. M. A. (1956) *Catalogue of Engraved Gems: Greek, Etruscan, and Roman*. Second edition. Rome.

——(1968) *Engraved Gems of the Greeks and Etruscans: A History of Greek Art in Miniature*. London.

——(1971) *Engraved Gems of the Romans: A Supplement to the History of Roman Art*. London.

——(1973–4) 'Inscriptions on engraved gems of the Roman period and some modern or problematical representations', *ArchClass* 25-6: 631–8.

Ridgway, B. (1984) *Roman Copies of Greek Sculpture: The Problem of the Originals*. Ann Arbor, MI.

——(1990) *Hellenistic Sculpture I: The Styles of ca. 331–200 BC*. Madison, WI.

——(2000) 'The Sperlonga sculptures: The current state of research', in N. T. de Grummond and B. S. Ridgway (eds.) *From Pergamon to Sperlonga: Sculpture and Context*, 78–91. Berkeley.

——(2005) Review of Schröder 2005, *JRA* 18: 624–30.

Riese, A. (ed.) (1869–70) *Anthologia Latina; sive Poesis Latinae Supplementum*. Two volumes. Leipzig.

Riess, W. (2008) 'Introduction', in idem (ed.) *Paideia at Play: Learning and Wit in Apuleius*, ix–xxi. Groningen.

Riffaterre, M. (1991) 'The mind's eye: Memory and textuality', in M. Brownlee, K. Brownlee, and S. G. Nichols (eds.) *The New Medievalism*, 29–45. Baltimore.

Rimell, V. (2002) *Petronius and the Anatomy of Fiction*. Cambridge.

——(2008) *Martial's Rome: Empire and the Ideology of Epigram*. Cambridge.

Ritti, T. (1969) 'Sigle ed emblemi sui decreti onorari greci', *MemLinc* 8:14: 259–360.

——(1973–4) 'L'uso di "immagini onomastiche" nei monumenti sepolcrali di età greca: alcune testimonianze epigrafiche, archeologiche e letterarie', *ArchClass* 25-6: 639–60.

——(1977) 'Immagini onomastiche sui monumenti sepolcrali di età imperiale', *MemLinc* 8:21: 257–396.

Robert, C. (1875) 'Frammento di una tavola iliaca', *Annali dell'Instituto di Corrispondenza Archeologica* 47: 267–72.

——(1881) *Bild und Lied*. Berlin.

——(1890) *Homerische Becher*. Berlin.

——(1919) *Archaeologische Hermeneutik. Anleitung zur Deutung klassischer Bildwerke*. Berlin.

Robertson, M. (1975) *A History of Greek Art*. Two volumes. Cambridge.

Roman, L. (2001) 'The representation of literary materiality in Martial's *Epigrams*', *JRS* 91: 113–45.

Rorty, R. (1967) *The Linguistic Turn: Recent Essays in Philosophical Method*. Chicago.

Rose, C. B. (2003) 'Ilion in the early empire', in C. Berns, H. von Hesberg, L. Vandeput, and M. Waelkens (eds.) *Patris und Imperium. Kulturelle und politische Idetität in den Städten der römischen Provinzen Kleinasiens in der frühen Kaiserzeit. Kolloquium Köln, November 1998*, 33–47. Leuven.

Rossi, L. (2001) *The Epigrams Ascribed to Theocritus: A Method of Approach*. Leuven and Paris.

Rotroff, S. I. (1982) *Hellenistic Pottery: Athenian and Imported Moldmade Bowls*. The Athenian Agora: Results of the Excavations Conducted by the American School of Classical Studies at Athens, Volume 22. Princeton.

Roullet, A. (1972) *The Egyptian and Egyptianizing Monuments of Imperial Rome*. Leiden.

Rouveret, A. (1987) 'Toute la mémoire du monde: la notion de collection dans la *NH* de Pline', in J. Pigeaud and J. Oroz (eds.) *Pline l'Ancien. Témoins de son temps*, 431–49. Salamanca and Nantes.

——(1988) 'Les tables iliaques et l'art de la mémoire', *Bulletin de la Societé Nationale des Antiquaires de France* 1988: 166–76.

——(1989) *Histoire et imaginaire de la peinture ancienne (Ve siècle av. J.-C. – Ier siècle ap. J.-C.)*. Paris.

Rudich, V. (1997) *Dissidence and Literature under Nero: The Price of Rhetoricization*. London and New York.

Rühl, M. (2006) 'Panegyrik im Quadrat: Optatian und die intermedialen Tendenzen des spätantiken Herrscherbildes', *Millennium* 3: 75–102.

Rumpf, A. (1951) 'Parrhasios', *AJA* 55: 1–12.

Russell, D. A. and D. Konstan (eds.) (2005) *Heraclitus: Homeric Problems*. Leiden.

Rypson, P. (1986) 'The Labyrinth poem', *Visible Language* 20: 65–95.

——(1996) 'Homo quadratus in labyrintho: The cubus or labyrinth poem', in G. E. Szönyi (ed.) *European Iconography East and West: Selected Papers of the Szeged International Conference, June 9–12 1993*, 7–21. New York.

Sadurska, A. (1959) 'Les problèmes de soi-disant tables iliaques', in J. Irmscher and K. Kumaniecki (eds.) *Aus der altertumswissenschaftlichen Arbeit Volkspolens*, 119–24. Berlin.

——(1961) 'Tabula odysséaque de Varsovie', *Atti del Settimo Congresso Internazionale di Archeologia Classica*, 1.451–4. Rome.

——(1963) 'Deux notes sur une inscription de la Tabula Capitolina', *Eos* 53: 35–7.

——(1964) *Les tables iliaques*. Warsaw.

——(1966) 'La vingtième table iliaque', in M. L. Bernhard (ed.) *Mélanges offerts à Kazimierz Michałowski*, 653–7. Warsaw.

Sage, M. (2000) 'Roman visitors to Ilium in the Roman Imperial and late antique period', *Studia Troica* 10: 211–31.

Salimbene, C. (2002) 'La Tabula Capitolina', *Bollettino dei Musei Comunali di Roma* 16: 5–33.

Salza Prina Ricotti, E. (1979) 'Forme speciali di triclinii', *Cronache Pompeiane* 5: 102–49.

Santoro, S. (2005) 'I temi iliaci nella pittura pompeiana', in G. Burzacchini (ed.), 97–123.

Sanzi di Mino, M. R. (ed.) (1998) *La Villa della Farnesina in Palazzo Massimo alle Terme*. Milan.

Sauron, G. (2009) *Dans l'intimité des maîtres du monde. Les décors privés des Romains*. Paris.

Saxl, F. (1931) *Mithras. Typengeschichtliche Untersuchungen*. Berlin.

Scaffai, M. (ed.) (1982) *Baebii Italici* Ilias Latina. *Introduzione, edizione critica, traduzione italiana e commento*. Bologna.

——(1985a) 'Ilias Latina', *EV* 2: 911–12.

——(1985b) 'Aspetti e problemi dell'"Ilias Latina"', *ANRW* 2.32.3: 1926–41.

Scafoglio, G. (2005) 'Virgilio e Stesicoro: una ricerca sulla *Tabula Iliaca Capitolina*', *RhM* 148: 113–25.

Schade, G. (2003) *Stesichorus. Papyrus Oxyrhynchus 2359, 3876, 2619, 2803*. Leiden.

Schapiro, M. (1973) *Words and Pictures: On the Literal and the Symbolic in the Illustration of a Text*. The Hague.

Schefold, K. (1949) *Orient, Hellas und Rom*. Bern.

——(1954) 'Die Troiasage in Pompeji', *Nederlands Kunsthistorisch Jaarboek* 5: 211–24.

——(1975) *Wort und Bild. Studien zur Gegenwart der Antike*. Mainz.

——(1976) 'Bilderbücher als Vorlagen römischer Sarkophage', *MÉFRA* 88: 759–814.

——(1997) *Die Bildnisse der antiken Dichter, Redner und Denker*. Second edition. Basel.

——and F. Jung (1989) *Die Sagen von den Argonauten, von Theben und Troia in der klassischen und hellenistischen Kunst*. Munich.

Schenkeveld, D. M. (1970) 'Aristarchus and *ΟΜΕΡΟΣ ΦΙΛΟΤΕΧΝΟΣ*: Some fundamental ideas of Aristarchus on Homer as a poet', *Mnemosyne* 23: 162–78.

Scherer, M. R. (1964) *The Legends of Troy in Art and Literature*. London.

Schilling, R. (ed.) (1977) *Pline l'Ancien. Histoire naturelle, livre VII*. Paris.

Schissel von Fleschenberg, O. (1913) 'Die Technik des Bildeinsatzes', *Philologus* 72: 83–114.

Schmid, S. G. (2003) 'Wieder einmal Sperlonga: Trink- und andere Geschichten in Latium', *Numismatica e antichità classiche* 23: 199–225.

——(2005) *Boire pour Apollon. Céramique hellénistique et banquets dans le Sanctuaire d'Apollon Daphnéphoros*. Gollion.

Schmidt, F. (1973) 'Le monde à l'image du bouclier d'Achille: sur la naissance et l'incorruptibilité du monde dans le "Testament d'Abraham"', *Bulletin de la société Ernest-Renan* 22: 122–6.

Schmitzer, U. (2005) 'Legittimazione del presente attraverso la costruzione del passato: Troia nella poesia latina di età imperiale', in G. Burzacchini (ed.), 23–45.

Schneider, R. M. (2006) 'Marble', *BNP* 8: 282–91.

——(2007) 'Friend and foe: The Orient in Rome', in V. S. Curtis and S. Stewart (eds.) *The Age of the Parthians: Volume 2*, 50–86. London.

Schönberger, O. and E. Kalinka (eds.) (1968) *Philostratos. Die Bilder*. Munich.

Schöne, R. (1866) 'Thersiteskopf aus einer statuarischen Gruppe', *Archäologische Zeitung* 24: 153–9.

Schröder, B.-J. (1999) *Titel und Text: Zur Entwicklung lateinischer Gedichtüberschriften. Mit Untersuchungen zu lateinischen Buchtiteln, Inhaltsverzeichnissen und anderen Gliederungsmitteln*. Berlin.

Schröder, S. F. (2004) *Katalog der antiken Skulpturen des Museo del Prado in Madrid. Band 2: Idealplastik*. Mainz.

Schur, D. (2004) 'A garland of stones: Hellenistic *Lithika* as reflections on poetic transformations', in B. Acosta-Hughes, E. Kosmetatou, and M. Baumbach (eds.), 118–22.

Scobie, S. (1979) 'An homage and an alphabet: Two recent works by Ian Hamilton Finlay', in R. Kostelanetz (ed.), 107–13.

Scott, D. (1990) 'The problem of illustrability: The case of *sonnets et eaux-fortes*', *Word & Image* 6: 241–58.

Scott, S. (2006) 'Art and the archaeologist', *World Archaeology* 38: 628–43.

Scully, S. (2003) 'Reading the shield of Achilles: Terror, anger, delight', *HSPh* 101: 29–47.

Seddon, K. (2005) *Epictetus' Handbook and the Tablet of Cebes. Guides to Stoic Living*. London and New York.

Sens, A. (2005) 'The art of poetry and the poetry of art: The unity and poetics of Posidippus' statue-poems', in K. Gutzwiller (ed.), 206–25.

Settis, S. (1992) 'Die Trajanssäule: Der Kaiser und sein Publikum', in A. Beyer (ed.) *Die Lesbarkeit der Kunst. Zur Geistes-Gegenwart der Ikonologie*, 40–52. Berlin.

Severy, B. (2003) *Augustus and the Family at the Birth of the Roman Family*. New York and London.

Shanks, M. (1996) *Classical Archaeology of Greece: Experiences of the Discipline*. London and New York.

Sharrock, A. and R. Ash (eds.) (2002) *Fifty Key Classical Authors*. London and New York.

Sichtermann, H. (1996) *Kulturgeschichte der klassischen Archäologie*. Munich.

Simon, E. (1995) 'Der Schild des Achilleus', in G. Boehm and H. Pfotenhauer (eds.), 123–41.

——(2001) 'Rom und Troia: Der Mythos von den Anfängen bis in die römische Kaiserzeit', in J. Latacz et al. (eds.) *Troia. Traum und Wirklichkeit*, 154–73. Stuttgart.

——(2008) 'Die Rezeption in Rom', in J. Latacz (ed.), 232–44.

Simonini, L. and F. Gualdoni (1978) *Carmi figurati greci e latini*. Pollenza.

Sinn, U. (1979) *Die homerischen Becher. Hellenistische Reliefkeramik aus Makedonien*. Berlin.

Sistakou, E. (2008) *Reconstructing the Epic: Close Readings of the Trojan Myth in Hellenistic Poetry*. Leuven.

Skinner, M. (2001) 'Ladies' day at the art institute: Theocritus, Herodas, and the gendered gaze', in A. Lardinois and L. McClure (eds.) *Making Silence Speak: Women's Voices in Greek Literature and Society*, 201–23. Princeton.

Slater, N. W. (1987) 'Against interpretation: Petronius and art criticism', *Ramus* 16: 165–76.

——(1990) *Reading Petronius*. Baltimore.

——(1999) 'The vase as ventriloquist: *Kalos*-inscriptions and the culture of fame', in E. A. Mackay (ed.) *Signs of Orality: The Oral Tradition and its Influence in the Greek and Roman World*, 143–62. Leiden.

——(2002) 'Dancing the alphabet: Performative literacy on the Attic stage', in I. Worthington and J. M. Foley (eds.) *Epea and Grammata: Orality and Written Communication in Ancient Greece*, 117–29. Leiden.

Small, J. P. (1997) *Wax Tablets of the Mind: Cognitive Studies of Memory and Literacy in Classical Antiquity*. London.

——(2003) *The Parallel Worlds of Classical Art and Text*. Cambridge.

Smith, R. R. R. (1991) *Hellenistic Sculpture: A Handbook*. London.

Snodgrass, A. M. (1979) 'Poet and painter in eighth-century Greece', *PCPhS* 205: 118–30.

——(1986) 'Interaction by design: The Greek city state', in C. Renfrew and J. F. Cherry (eds.) *Peer Polity Interaction and Socio-Political Change*, 47–58. Cambridge.

——(1987) *An Archaeology of Greece: The Present State and Future Scope of a Discipline*. Berkeley.

——(1998) *Homer and the Artists: Text and Picture in Early Greek Art*. Cambridge.

——(2002) 'A paradigm shift in Classical Archaeology?', *CArchJ* 12: 179–94.

——(2007) 'What is Classical Archaeology? Greek archaeology', in S. E. Alcock and R. Osborne (eds.), 13–29.

Solin, H. (2003) *Die griechischen Personennamen in Rom. Ein Namenbuch*. Second edition. Three volumes. Berlin.

Solomon, J. (2007) 'The vacillations of the Trojan myth: Popularization & classicization, variation & codification', *IJCT* 14: 482–534.

Somerville, T. (2010) 'Note on a reversed acrostic in Vergil *Georgics* 1.429–433', *CPh* 105: 202–9.

Spannagel, M. (1999) *Exemplaria Principis. Untersuchungen zu Entstehung und Ausstattung des Augustusforums*. Heidelberg.

Sparkes, B. A. (1971) 'The Trojan horse in Classical art', *G&R* 18: 54–70.

Speyer, W. (1975) 'Myrons Kuh in der antiken Literatur und bei Goethe', *Arcadia* 10: 171–9.

Sprigath, G. K. (2004) 'Das Dictum des Simonides: Der Vergleich von Dichtung und Malerei', *Poetica* 36: 243–80.

Spivey, N. J. (1995) 'Meanings and messages', *CArchJ* 5: 314–22.

——and M. J. Squire (2008) *Panorama of the Classical World*. Second edition. London.

Squire, M. J. (2003) 'Giant questions: Dining with Polyphemus at Sperlonga and Baiae', *Apollo* 497: 29–37.

——(2007) 'The motto in the grotto: Inscribing illustration and illustrating inscription at Sperlonga', in Z. Newby and R. Leader-Newby (eds.), 102–27.

——(2008) (published 2010) Review of Webb 2009, *Aestimatio* 5: 233–44.

——(2009) *Image and Text in Graeco-Roman Antiquity*. Cambridge.

——(2010a) 'Making Myron's cow moo? Ecphrastic epigram and the poetics of simulation', *AJPh* 131: 589–634.

——(2010b) 'Introduction: The art of art history in Graeco-Roman antiquity', in V. Platt and M. J. Squire (eds.), 133–63.

——(2010c) 'Texts on the tables: The *Tabulae Iliacae* in their Hellenistic literary context', *JHS* 130: 67–96.

——(2010d)(published 2011) 'Reading a view: Poem and picture in the *Greek Anthology*', *Ramus* 39: 73–103.

——(2010e) 'Toying with Homer in words and pictures: The *Tabulae Iliacae* and the aesthetics of play', in E. Walter-Karydi (ed.), 305–46.

——(2011) *The Art of the Body: Antiquity and its Legacy*. London.

——(forthcoming a) 'Picturing words and wording pictures: False closure in the Pompeian Casa degli Epigrammi', in F. Grewing and B. Acosta-Hughes (eds.) *False Closure: Encountering the End in Greek and Roman Literature and Art*. Heidelberg.

——(forthcoming b) 'What's in a name? Inscribing and ascribing artistic agency in the Roman world', in B. Borg (ed.) *The Blackwell Companion to Roman Art*. Oxford.

——(forthcoming c) 'Philostratus', in D. Newall and G. Pooke (eds.) *Art History: The Fifty Key Texts*. London.

——(forthcoming d) 'Running rings round Troy: Recycling the epic circle in Hellenistic and Roman visual culture', in M. Fantuzzi and C. Tsagalis (eds.) *A Companion to the Epic Cycle*. Cambridge.

——(forthcoming e) 'Three new *Tabulae Iliacae* reconstructions (tablets 2NY, 9D, 20Par)', *ZPE* 178.

Stanley, K. (1993) *The Shield of Homer: Narrative Structure in the Iliad*. Princeton.

Stansbury-O'Donnell, M. (1989) 'Polygnotus' *Iliupersis*. A new reconstruction', *AJA* 93: 203–15.

——(1990) 'Polygnotus' *Nekyia*: A reconstruction and analysis', *AJA* 94: 213–35.

——(1995) 'Reading pictorial narrative: The law court scene of the Shield of Achilles', in J. Carter and S. Morris (eds.), 315–34.

——(1999) *Pictorial Narrative in Ancient Greek Art*. Cambridge.

Starr, R. J. (1987) 'The circulation of literary texts in the Roman world', *CQ* 37: 213–33.

Stefanou, D. (2006) *Darstellungen aus dem Epos und Drama auf kaiserzeitlichen und spätantiken Bodenmosaiken. Eine ikonographische und deutungsgeschichtliche Untersuchung*. Munster.

Stehle, E. (1997) *Performance and Gender in Ancient Greece: Nondramatic Poetry and its Setting*. Princeton.

Steiner, A. (2007) *Reading Greek Vases*. Cambridge.

Steiner, D. T. (2001) *Images in Mind: Statues in Archaic and Classical Greek Literature and Thought*. Princeton.

Stephani, L. (1854) 'Der ausruhende Herakles: Ein Relief der Villa Albani', *Mémoires de l'Académie des Sciences de St Pétersbourg*, VI Série (Sciences politiques, histoire, philologie) 8: 1–288 (journal pages 253–540).

Stephens, S. A. (2004) 'Posidippus's poetry book: Where Macedon meets Egypt', in W. V. Harris and G. Ruffini (eds.) *Ancient Alexandria between Egypt and Greece*, 64–86. Leiden.

Stevenson, T. B. (1983) *Miniature Decoration in the Vatican Virgil. A Study in Late Antique Iconography*. Tübingen.

Stewart, A. (1979) *Attika: Studies in Athenian Sculpture of the Hellenistic Age*. London.

——(1990) *Greek Sculpture: An Exploration*. Two volumes. New Haven.

——(1996) 'A hero's quest: Narrative and the Telephus frieze', in R. Dreyfus and E. Schraudolph (eds.), 39–52.

——(2004) *Attalos, Athens and the Akropolis: The Pergamene 'Little Barbarians' and their Roman and Renaissance Legacy*. Cambridge.

——(2005) 'Posidippus and the truth in sculpture', in K. Gutzwiller (ed.), 183–205.

Stewart, P. (2003) *Statues in Roman Society: Representation and Response*. Oxford.

——(2004) *Roman Art*. *G&R* New Surveys in the Classics, no. 34. Oxford.

——(2008) *The Social History of Roman Art*. Cambridge.

Stewart, S. (1993) *On Longing: Narratives of the Miniature, the Gigantic, the Souvenir, the Collection*. Second edition. Baltimore.

Stieber, M. C. (2011) *Euripides and the Language of Craft*. Leiden.

Stirling, L. M. (2005) *The Learned Collector: Mythological Statuettes and Classical Taste in Late Antique Gaul*. Ann Arbor, MI.

Strocka, V. M. (1981) 'Römische Bibliotheken', *Gymnasium* 88: 298–329.

——(1993) 'Pompeji VI 17,41: Ein Haus mit Privatbibliothek', *MDAI(R)* 100: 321–51.

Strodel, S. (2002) *Zur Überlieferung und zum Verständnis der hellenistischen Technopaegnien*. Frankfurt am Main.

Stuart Jones, H. (1912) *A Catalogue of the Ancient Sculptures Preserved in the Municipal Collections of Rome: The Sculptures of the Museo Capitolino*. Oxford.

Stückelberger, A. (1994) *Bild und Wort. Das illustrierte Fachbuch in der antiken Naturwissenschaft, Medizin und Technik*. Mainz.

Sullivan, J. P. (1968) *The Satyricon of Petronius: A Literary Study*. Bloomington, IN.

Svenbro, J. (1993) *Phrasikleia: An Anthropology of Reading in Ancient Greece*. Trans. J. Lloyd. Ithaca, NY.

Tanner, J. (2006) *The Invention of Art History in Ancient Greece: Religion, Society and Artistic Rationalisation*. Cambridge.

——(2010) 'Aesthetics and art history writing in comparative historical perspective', in V. J. Platt and M. J. Squire (eds.), 267–88.

Taplin, O. (1980) 'The Shield of Achilles within the *Iliad*', *G&R* 27: 1–21.

——(2007) *Pots and Plays: Interactions between Tragedy and Greek Vase-Painting of the Fourth Century B.C.* Los Angeles.

Tarrant, R. (1997) 'Aspects of Virgil's reception in antiquity', in C. Martindale (ed.), 56–72.

Taylor, R. (2008) *The Moral Mirror of Roman Art*. Cambridge.

Thein, K. (2002) 'Gods and painters: Philostratus the Elder, Stoic *phantasia* and the strategy of describing', *Ramus* 31: 136–45.

Thomas, E. U. R. (2007) '*ΜΝΗΣΘΗ Ο ΑΓΟΡΑΖΩΝ*: Bemerkungen zum Selbstverständnis und zur Einschätzung von Künstlern und Kunsthandwerkern in der römischen Kaiserzeit', in D. Boschung and H. Hellenkemper (eds.), 319–39.

Thomas, E. V. (2007) *Monumentality and the Roman Empire: Architecture in the Antonine Age*. Oxford.

Thomas, R. (2007) '"Miniaturporträts" als "Propagandamittel"', in D. Boschung and H. Hellenkemper (eds.), 269–92.

Thomas, R. F. (ed.) (1988) *Virgil* Georgics, *Volume 1. Books I–II*. Cambridge.

Thurston, H. (1994) *Early Astronomy*. Ann Arbor, MI.

Too, Y. L. (2010) *The Idea of the Library in the Ancient World*. Oxford.

Torelli, M. (1997) 'Tavola rotonda e dibattito', in A. Stazio and S. Ceccoli (eds.) *Mito e storia in Magna Grecia. Atti del trentaseiesimo convegno di studi sulla Magna Grecia, Taranto 4–7 ottobre 1996*, 118–212. Taranto.

Toso, S. (2007) 'Iliade glittica: gli eroi attorno alle mura di Troia', in I. Colpo, I. Favaretto, and F. Ghedini (eds.), 249–57.

Toynbee, J. M. C. (1951) *Some Notes on Artists in the Roman World*. Brussels.

Trapp, M. (1997) 'On the *Tablet of Cebes*', in R. Sorabji (ed.) *Aristotle and After*, 159–180. London.

Trendall, A. D. and T. B. L. Webster (1971) *Illustrations of Greek Drama*. London.

Trigger, B. (1989) *A History of Archaeological Thought*. Cambridge.

Trimble, J. (forthcoming) *Replicating Women in the Roman Empire*. Cambridge.

——and J. Elsner (eds.) (2006) *Art and Replication: Greece, Rome and Beyond* (= *Art History* 29.2).

Truss, L. (2004) *Eats, Shoots & Leaves: The Zero Tolerance Approach to Punctuation*. London.

Tueller, M. A. (2008) *Look Who's Talking: Innovations in Voice and Identity in Hellenistic Poetry*. Leuven.

Turcan, R. (1993) *Mithra et le Mithriacisme*. Second edition. Paris.

Turner, E. G. (1987) *Greek Manuscripts of the Ancient World*. Second edition, revised by P. J. Parsons. London.

Tybout, R. (2011) 'Images, inscriptions and interpretation', *Mnemosyne* 64: 115–39.

Ungaro, L. (ed.) (2007) *The Museum of the Imperial Forums in Trajan's Market*. Milan.

Valenzuela Montenegro, N. (2002) (published 2004) 'Die Tabulae Iliacae als Kommentar in Bild und Text: Zur frühkaiserzeitlichen Rezeption des trojanischen Sagenkreises', in W. Geerlings and C. Schulze (eds.) *Der Kommentar in Antike und Mittelalter. Neue Beiträge zu seiner Erforschung, Band II*, 67–100. Leiden.

——(2004) *Die Tabulae Iliacae. Mythos und Geschichte im Spiegel einer Gruppe frühkaiserzeitlicher Miniaturreliefs*. Berlin.

van der Valk, M. (1971–87) *Eustathii Archiepiscopi Thessalonicensis commentarii ad Homeri Iliadem pertinentes ad fidem codicis Laurentiani editi*. Four volumes. Leiden.

van de Waal, H. (1967) 'The "linea summae tenuitatis" of Apelles: Pliny's phrase and its interpreters', *Zeitschrift für Ästhetik und allgemeine Kunstwissenschaft* 12: 5–32.

van Groningen, B. A. (ed.) (1966) *Theognis. Le premier livre édité avec un commentaire*. Amsterdam.

van Rossum-Steenbeek, M. (1999) *Greek Readers' Digests? Studies on a Selection of Subliterary Papyri*. Leiden.

Varner, E. R. (2006) 'Reading replications: Roman rhetoric and Greek quotations', in J. Trimble and J. Elsner (eds.), 280–303.

Vassilika, E. (1998) *Greek and Roman Art: Fitzwilliam Museum Handbooks*. Cambridge.

Vernant, J.-P. (1991) *Mortals and Immortals: Collected Essays*. Ed. F. Zeitlin. Princeton.

Veyne, P. (1967) Review of Sadurska 1964, *Revue Belge de Philologie et d'Histoire* 45: 642–3.

——(1991) *La société romaine*. Paris.

——(2002) 'Lisibilité des images, propagande et apparat monarchique dans l'Empire romain', *Revue historique* 621: 3–30.

Visconti, E. Q. (1830) *Opere varie italiene e francesi*. Volume three. Milan.

Vogt, E. (1966) 'Das Akrostichon in der griechischen Literatur', *A&A* 13: 80–95.

Volk, K. (2009) *Manilius and his Intellectual Background*. Oxford.

——(2010) 'Aratus', in J. J. Clauss and M. Cuypers (eds.), 197–210.

Vollenweider, M.-L. (1966) *Die Steinschneidekunst und ihre Künstler in spätrepublikanischer und augusteischer Zeit*. Baden-Baden.

——(1974) *Die Porträtgemmen der römischen Republik*. Two volumes. Mainz.

Vox, O. (1975) 'Epigrammi in Omero', *Belfagor* 30: 67–70.

Vürtheim, J. (1919) *Stesichoros' Fragmente und Biographie*. Leiden.

Wachter, R. (2001) *Non-Attic Greek Vase Inscriptions*. Oxford.

Wagner, P. (1995) *Reading Iconotexts: From Swift to the French Revolution*. London.

——(1996) 'Introduction', in idem (ed.) *Icons—Texts—Iconotexts: Essays on Ekphrasis and Intermediality*, 1–40. Berlin.

Wallace-Hadrill, A. (1998) 'The villa as cultural symbol', in A. Frazer (ed.), 43–53.

——(2008) *Rome's Cultural Revolution*. Cambridge.

Walter-Karydi, E. (ed.) (2010), Μύθοι, κείμενα, εικόνες. Ομηρικά έπη και αρχαία ελληνική τέχνη. Athens.

Walters, H. B. (1926) *Catalogue of Engraved Gems, Greek, Etruscan and Roman in the British Museum*. London.

Webb, R. (1997a) 'Mémoire et imagination: les limites de l'enargeia', in C. Lévy and L. Pernot (eds.) *Dire l'évidence. Philosophie et rhétorique antiques*, 229–48. Paris.

——(1997b) 'Imagination and the arousal of emotion in Greco-Roman rhetoric', in S. M. Braund and C. Gill (eds.) *The Passions in Roman Thought and Literature*, 112–27. Cambridge.

——(1999) 'Ekphrasis ancient and modern: The invention of a genre', *Word & Image* 15: 7–18.

——(2000) 'Picturing the past: Uses of ekphrasis in the *Deipnosophistae* and other works of the Second Sophistic', in D. Braund and J. Wilkins (eds.) *Athenaeus and his World: Reading Culture in the Roman Empire*, 218–26. Exeter.

——(2001) 'The *Progymnasmata* as practice', in Y. L. Too (ed.) *Education in Greek and Roman Antiquity*, 289–316. Leiden.

——(2009) *Ekphrasis, Imagination and Persuasion in Ancient Rhetorical Theory and Practice*. Farnham.

Webster, T. B. L. (1964) *Hellenistic Poetry and Art*. London.

——(1967) *Hellenistic Art*. London.

Weitzmann, K. (1941) 'A Tabula Odysseaca', *AJA* 45: 166–81.

——(1947) *Illustrations in Roll and Codex*. Princeton.

——(1958) 'Narration in early Christendom', *AJA* 61: 83–91.

——(1959) *Ancient Book Illumination*. Cambridge, MA.

——(1981) *Classical Heritage in Byzantine and Near Eastern Art*. London.

Welcker, F. G. (1829) 'Sur la table iliaque', *Annali dell'Instituto di Corrispondenza Archeologica* 1: 227–43.

West, M. L. (1969) 'Stesichorus redivivus', *ZPE* 4: 135–49.

——(ed.) (1971–2) *Iambi et Elegi ante Alexandrum Cantati*. Two volumes. Oxford.

——(1977) 'Erinna', *ZPE* 25: 95–119.

——(ed.) (1998) *Homeri Ilias*. Two volumes. Stuttgart.

——(2000) 'Geschichte des Textes', in J. Latacz (ed.) *Homers Ilias. Gesamtkommentar. Prolegomena*, 27–38. Munich and Leipzig.

——(2001) *Studies in the Text and Transmission of the Iliad*. Munich and Leipzig.

Whitley, J. (2001) *Archaeology of Ancient Greece*. Cambridge.

Whitmarsh, T. J. G. (2001) *Greek Literature and the Roman Empire*. Oxford.

Whitton, C. L. (2010) 'Pliny, *Epistles* 8.14: Senate, slavery and the *Agricola*', *JRS* 100: 118–39.

Wigan, W. (2009) *It's a Small World After All*. Birmingham.

Wilamowitz-Moellendorff, U. von (1899) 'Sitzungsberichte der archäologischen Gesellschaft zu Berlin', *Jahrbuch des Kaiserlich Deutschen Archäologischen Instituts* 13: 228–30.

Will, E. (1955) *Le relief cultuel greco-romain. Contribution a l'histoire de l'art de l'Empire romain*. Paris.

Willcock, M. M. (ed.) (1984) *The Iliad of Homer XIII–XXIV*. London.

Willey, G. R. and P. Phillips (1958) *Method and Theory in American Archaeology*. Chicago.

Williams, C. A. (ed.) (2004) *Martial Epigrams. Book Two*. Oxford.

Williams, F. (ed.) (1978) *Callimachus*, Hymn to Apollo. Oxford.

Williams, J. (1999) 'Introduction', in idem (ed.), 1–8.

——(ed.) (1999) *Imaging the Early Medieval Bible*. University Park, PA.

Winckelmann, J. J. (1760) *Description des pierres gravées du feu Baron de Stosch*. Florence.

——(2006) *History of the Art of Antiquity*. Trans. H. F. Mallgrave. Los Angeles.

Wiseman, B. (2007) *Lévi-Strauss, Anthropology and Aesthetics*. Cambridge.

Wojaczek, G. (1969) *Daphnis. Untersuchungen zur griechischen Bukolik*. Meisenheim an Glan.

Woodford, S. (1993) *The Trojan War in Ancient Art*. London.

——(2003) *Images of Myths in Classical Antiquity*. Cambridge.

Wright, D. (1993) *The Vatican Vergil: A Masterpiece in Late Antique Art*. Berkeley.

——(2001) *The Roman Vergil and the Origins of Medieval Book Illustration*. London.

Wünsche, R. and M. Steinhart (eds.) (2010) *Zauber in edlem Stein. Antike Gemmen: Die Stiftung Helmut Hansmann*. Lindenberg im Allgäu.

Wyler, S. (2006) 'Roman replications of Greek art at the Villa della Farnesina', in J. Trimble and J. Elsner (eds.), 213–32.

Zanker, G. (1981) '*Enargeia* in the ancient criticism of poetry', *RhM* 124: 297–311.

——(1987) *Realism in Alexandrian Poetry: A Literature and its Audience*. London.

——(1996) 'Pictorial description as a supplement for narrative: The labour of Augeas' stables in *Heracles Leontophones*', *AJPh* 117: 411–23.

——(2003) 'New light on the literary category of "ecphrastic epigram" in antiquity: The New Posidippus (col. X 7 – XI 19 P. Mil. Vogl. VIII 309)', *ZPE* 143: 59–62.

——(2004) *Modes of Viewing in Hellenistic Poetry and Art*. Madison, WI.

——(ed.) (2009) *Herodas*, Mimiambs. Warminster.

Zanker, P. (1968) *Forum Augustum. Das Bildprogramm*. Tübingen.

——(ed.) (1974) *Hellenismus in Mittelitalien*. Göttingen.

——(1978) 'Zur Funktion und Bedeutung griechischer Skulptur in der Römerzeit', in T. Gelzer, H. Flashar, and O. Reverdin (eds.) *Le classicisme à Rome aux iers. siècles avant et après J.C. Neuf exposés suivis de discussions*, 283–314. Geneva.

——(1979) 'Die Villa als Vorbild des späten pompejanischen Wohngeschmacks', *JdI* 94: 460–523.

——(1987) *Augustus und die Macht der Bilder*. Munich.

——(1988) *The Power of Images in the Age of Augustus*. Trans. A. Shapiro, Ann Arbor, MI.

——(1995a) *Die Maske des Sokrates. Das Bild des Intellektuellen in der antiken Kunst*. Munich.

——(1995b) *The Mask of Socrates: The Image of the Intellectual in Antiquity*. Trans. A. Shapiro. Berkeley.

——(1997) 'In search of the Roman viewer', in D. Buitron-Oliver (ed.) *The Interpretation of Architectural Sculpture in Greece and Rome*, 179–91. Hanover, NH.

——(1998) *Pompeii: Public and Private Life*. Trans. D. L. Schneider. Cambridge, MA.

——(1999) 'Mythenbilder im Haus', in R. F. Docter and E. M. Moorman (eds.) *Proceedings of the XVth International Congress of Classical Archaeology*, 40–8. Amsterdam.

——(2000) 'Bild-Räume und Betrachter im kaiserzeitlichen Rom', in A. H. Borbein, T. Hölscher, and P. Zanker (eds.), 205–26.

——(2002a) *Un'arte per l'impero. Funzione e intenzione delle immagini nel mondo romano*. Milan.

——(2002b) 'Die mythologischen Sarkophagreliefs als Ausdruck eines neuen Gefühlskultes. Reden im Superlativ', in K.-J. Hölkeskamp, J. Rüsen, E. Stein-Hölkeskamp, and H. T. Grütter (eds.) *Sinn (in) der Antike. Orientierungssysteme, Leitbilder und Wertkonzepte im Altertum*, 335–55. Mainz.

——(2007) *Die römische Kunst*. Munich.

Zarker, J. W. (1966) 'Acrostic carmina latina epigraphica', *Orpheus* 13: 138–51.

Zazoff, P. (1983) *Die antiken Gemmen*. Munich.

Zeitlin, F. I. (1971) '*Romanus* Petronius: A study of the *Troiae halosis* and the *Bellum civile*', *Latomus* 30: 56–82.

——(1982) *Under the Sign of the Shield: Semiotics and Aeschylus'* Seven Against Thebes. Rome.

——(2001) 'Visions and revisions of Homer', in S. D. Goldhill (ed.), 195–266.

Ziolkowski, J. M. and M. C. Putnam (eds.) (2008) *The Virgilian Tradition: The First Fifteen Hundred Years*. New Haven.

Zwierlein-Diehl, E. (2005) 'Gemmen mit Künstlerinschriften', in V. M. Strocka (ed.) *Meisterwerke. Internationales Symposion anläßlich des 150. Geburtstages von Adolf Furtwängler, Freiburg im Breisgau, 30. Juni – 3. Juli 2003*, 321–43. Munich.

——(2007) *Antike Gemmen und ihr Nachleben*. Berlin.

INDEX LOCORUM

GENERAL INDEX

For discussions of individual Tabulae Iliacae, *see Appendix I on pp. 387–412.*